Processing

Second edition

Processing:
a programming
handbook for
visual designers
and artists

Second edition

Casey Reas
Ben Fry

The MIT Press
Cambridge, Massachusetts
London, England

MIT Press books may be purchased at special quantity discounts for business or sales promotional use. For information, please email special_sales@mitpress.mit.edu.

This book was set in TheSerif and TheSansMono from LucasFonts by Toppan Best-set Premedia Limited. Printed and bound in the United States of America.

Library of Congress Cataloging-in-Publication

Reas, Casey.
 Processing : a programming handbook for visual designers and artists / Casey Reas and Ben Fry.—Second edition.
 pages cm
Includes bibliographical references and index.
 ISBN 978-0-262-02828-8 (hardcover : alk. paper) 1. Computer programming. 2. Computer graphics—Computer programs. 3. Digital art—Computer programs. 4. Art—Data processing. 5. Art and technology. I. Fry, Ben. II. Title.

QA76.6.R4138 2014
006.60285—DC23

 2014016283

10 9 8 7 6 5 4 3 2

For the ACG

15 26 29 30 32 33 34

35 37 43 45 66 85 91

92 93 104 106 108 110 112

114 151 154 157 158 160 164

166 168 172 178 181 183 189

190 193 197 201 203 211 214

Contents

218 221 270 272 275 294 297

299 311 319 321 323 325 328

329 338 342 351 352 355 376

416 420 421 432 440 442 443

455 460 462 466 481 483 506

520 527 533 538 543 550 554

Extended contents

Foreword

At MIT, the full-time graduate studio that I once administered attracted a uniquely gifted lot: people who had a fundamental balance issue in the way they approached the computer as an expressive medium. On the one hand, they didn't want the programming code to get in the way of their designs or artistic desires; on the other hand, without hesitation, they wrote sophisticated computer codes to discover new visual pathways. The two sides of their minds were in continual conflict. The conclusion was simple for them: Do both.

Hybrids that can fluidly cross the chasm between technology and the arts are mutations in the academic system. Traditionally, universities create technology students or art students—but never mix the two sides of the equation in the same person. During the 1990s, the mutants that managed to defy this norm would either seek me out, or else I would reach out to find them myself. Bringing these unique people together was my primary passion, and that's how I came into contact with Casey Reas and Ben Fry.

It is said that the greatest compliment to a teacher is when the student surpasses the teacher. This corner was turned quickly after I began to work with them, and the finishing blow came when Ben and Casey created Processing. They prominently elevated the call for visual experimentation with their timely mastery of the Internet to engage at first tens, hundreds, and then tens of thousands of hybrids all over the world. Wherever I might travel, young technology artists are always talking about Processing and ask me to pass on their thanks to Casey and Ben.

And now in my role as Design Partner at Kleiner Perkins Caufield & Byers, I can see the economic impact of the many hybrid design/engineering talents in Silicon Valley. These computational designers have brought needed craft and emotional sensitivity to the products of companies like Flipboard, Pinterest, Square, AirBnB, and Nest. If not by directly using Processing in their design process, the folks at these companies, and their teams, appreciate the work of "the processing guys"—a duo that has expanded to a boy band that now includes pixel magician Daniel Shiffman.

So it is here that I express my thanks to you, Ben and Casey. On behalf of all of the people who follow where Processing might take the field of computational art and design, I wish you more sleepless nights in the relentless pursuit of perfecting the bridge that connects the art-mind with the computer-mind. I look to your continued impact in the galleries, agencies, and startups of our world. All of us look to you to lead the way for when art on the computer becomes simply, art—without the icky technology connotations. We're all counting on you to take us there.

John Maeda
Design Partner
Kleiner Perkins Caufield & Byers

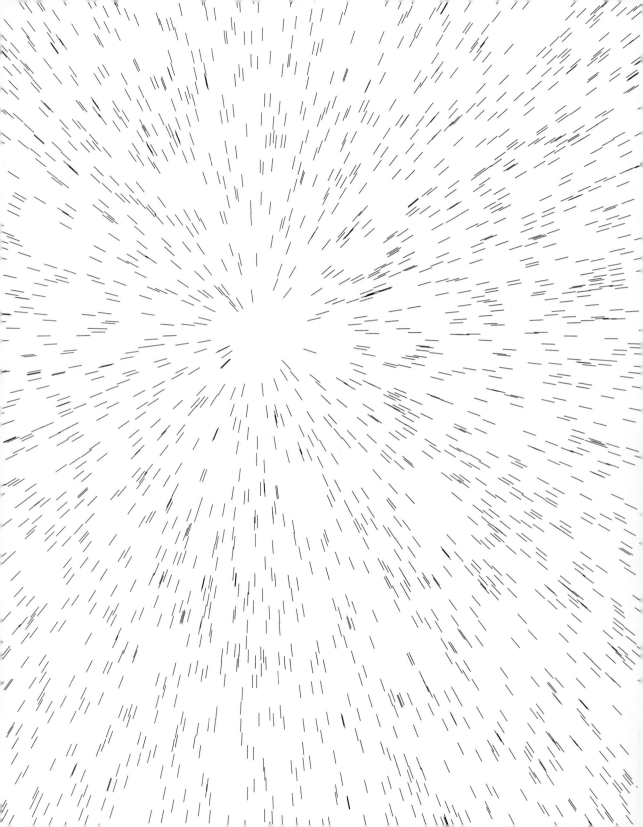

Preface

This book was written as an introduction to the ideas of computer programming within the context of the visual arts. It targets an audience of computer-savvy individuals who are interested in creating interactive and visual work through writing software but have little or no prior experience. We are tremendously excited about the potential of software as a medium for communication and expression, and we hope this book will open the potential to a wide audience.

Processing is the result of over ten years of software development and teaching experience. The ideas presented have been continually tested in the classrooms, computer labs, and basements of universities, art and design schools, and arts institutions. The authors have taught related courses at the University of California–Los Angeles, the Interaction Design Institute Ivrea, Harvard University, and Carnegie Mellon University and have given numerous workshops and lectures on this topic at conferences and institutions around the globe. The contents of this book have been continually improved through the generous feedback of students and fellow educators. The refined curriculum is presented here in book form with the intention of distributing the results of this endeavor to a larger and more diverse community.

Contents

Four types of content are featured in these pages. The majority of the book is divided into tutorial chapters that discuss specific elements of software and how they relate to the arts. These chapters introduce the syntax and concepts of software such as variables, functions, and object-oriented programming. They cover topics such as photography and drawing in relation to software. They feature many short, prototypical example programs with related images and explanation. More advanced professional projects from diverse domains including animation, performance, and installation are discussed in interviews with their creators (pp. 125, 247, 397, 579). The appendixes (p. 601) provide reference tables and more involved explanations of technical topics. The related media section (p. 627) is a list of references to additional material on associated topics. The technical terms used in the book are defined in the glossary (p. 633). The extension sections, featured online at *www.processing.org/handbook*, present concise introductions to further domains of exploration including computer vision, sound, and electronics.

This book is full of example programs written using the Processing programming language developed by the authors. Processing is a free, open source programming language and environment used by students, artists, designers, architects, researchers, and hobbyists for learning, prototyping, and production. Processing is developed by artists and designers as an alternative to proprietary software tools in the same

domain. The project integrates a programming language, development environment, and teaching methodology into a unified structure for learning and exploration. The software allows people to make a smooth transition from beginner to advanced programmer, and the Processing language is a good basis for future learning. The technical aspects of the language and the deeper programming concepts introduced in this text translate well to other programming languages, particularly those used frequently within the arts.

Most of the examples presented in this book have a minimal visual style. This represents not a limitation of the Processing software, but rather a conscious decision by the authors to make the code for each example as brief and clear as possible. We hope the stark quality of the examples gives additional incentive to the reader to extend the programs to her or his own visual language.

How to read this book

Learning with this book requires more than reading the words. It is also essential to run, modify, and interact with the code found within. Just as it's not possible to learn to cook without cooking, it's not possible to learn how to program without programming. Many of the examples can be fully understood only in motion or in response to the mouse and keyboard. The Processing software and all of the code presented in this book can be downloaded and run for future exploration. Processing can be downloaded from *www.processing.org/download* and the examples from *www.processing.org/ handbook*.

The code, diagrams, and images convey essential content to augment the text. Because this book was written for visually oriented people, it's assumed that diagrams and images will be read with as much care as the text. Typographic and visual conventions are used to assist reading. Code elements within the text are presented in a monospaced font for differentiation. Each code example is numbered sequentially to make it easy to reference. The numbers appear in the right margin at the first line of each example. The number "15-02" refers to the second example in chapter 15. Unfortunately, sometimes a code example wraps to the next page. When the abbreviation "cont." appears as a part of the code number, this signifies the code is *continued* from the previous page. Many of the code examples run differently when the variable values are changed. When numbers appear to the left of an image (p. 300), these numbers were used to produce that image.

Casey's introduction

I started playing with computers as a child. I played games and wrote simple programs in BASIC and Logo on my family's Apple IIe machine. I spent years exploring and testing it, but I preferred drawing, and my interest in computers dissipated. As a design student at the University of Cincinnati in the early 1990s, I started to use Adobe's Photoshop

and Illustrator programs during my first year, but I wasn't permitted to use them in my design studio classes until the third year. I spent the first two years of my education training my eyes and hands to construct composition and meaning through visual form. I focused my energy on drawing icons and letters with pencils and painting them with Plaka, a matte black paint. This was intensely physical work. I often produced hundreds of paper sketches while working toward a single refined image. I later focused my efforts on the design of printed materials including books, magazines, and information graphics. In this work I used software as a tool during an intermediate stage between concept and the final result on paper.

Over time, I shifted from producing printed media to software. When the multimedia CD-ROM industry emerged, I worked in that area to integrate my interests in sound, video, image, and information design. With the rise of the Internet in the mid-1990s, I focused on building large, database-integrated websites. As I shifted my work from paper to screen, static grids and information hierarchies evolved into kinetic, modular systems with variable resolutions and compositions. The time and energy once spent devoted to details of materials and static composition shifted to details of motion and response. I focused on building real-time processes to generate form, define behavior, and mediate interactions. To pursue these interests at a more advanced level, I realized I would need to learn to program computers. After a childhood of playing with computers and years of working with them professionally, I started down a new path.

In 1997, I met John Maeda and was introduced to the experimental software work of his students in the Aesthetics and Computation Group at MIT. They created a new type of work by fusing traditional arts knowledge with ideas from computer science. My new direction emerged as I experienced this work, and in 1998 I started learning to program computers in earnest. I began graduate studies at MIT the following year. My time there was personally transforming as I shifted from a consumer of software to a producer. I expanded my views of technology in relation to culture and the history of art.

While a graduate student at the MIT Media Lab, I was introduced to a culture of individuals who combined skills from more than one field of study. The knowledge in common was computing technology, and people had backgrounds in other disciplines including architecture, art, mathematics, design, and music. At that time, few software environments afforded both a sophisticated programming language *and* the ability to created refined graphics, so my predecessors and colleagues at MIT built their own software to meet their unique needs. These new software tools led to the emergence of a unique culture that synthesized knowledge from visual culture with knowledge from computer science. The desire to make this information accessible to people outside of technical fields and institutions has been my motivation for dedicating the last twelve years to developing Processing. I hope this book will act as a catalyst to increase software literacy within the arts.

Ben's introduction

Like lots of people who wind up in similar careers, I've always been interested in taking things apart to understand how they work. This began with disassembling and comparing the contents of household electronics, looking for similar components. Once I ran out of telephones and radios, I moved to software. The computer provided an endless range of questions, like having an infinite number of telephones. With a burnt-yellow binder that described "IBM BASIC by Microsoft," my father introduced me to the "for" loop, and I gradually taught myself programming—mostly by staring at others' code, sometimes modifying it to make it do something else. Over time, it became easier to write code from scratch.

I had a separate interest in graphic design, and I was curious about typography, layout, and composition. A family friend ran a design firm, and I thought that seemed like the most interesting job on earth. I later applied to design school, thinking of studying user interface design or creating "interactive multimedia CD-ROMs," the only possibilities I could see for intersecting my two interests. Attending design school was significant for me, because it provided thinking and creative skills that could be applied to other areas, including my interest in software.

In 1997, during my final year of undergraduate school, John Maeda gave a lecture at our program. It was overwhelming for several of us, including one friend who sat mumbling "Whoa, slow down..." as we watched from the back of the room. In the presentation, I finally saw the intersection between design and computation that I couldn't figure out before. It was a different perspective than building tools, which sounded mundane, or building interfaces, which also left something to be desired. A year later, I was lucky to have the opportunity to join John Maeda at MIT.

Pedagogy was a persistent theme during my six years working with John at the Media Laboratory. Casey, other students, and I contributed to the Design By Numbers project, which taught us a great deal about teaching computation to designers and gave us a lot of feedback on what people wanted. Casey and I began to see a similarity between this feature set and what we did in our own work at the "sketching" stage, and we started to discuss how we might connect the two in what would later be called Processing.

We wanted Processing to include lots of code that could be viewed, modified, and tested—reflecting the way in which I learned programming. But more important has been the community that has formed around the project, whose members are eager to share code with one another and help answer each other's questions. In a similar manner, the code for Processing itself is available, which for me has a lot to do with repaying the favor of a previous generation of developers who shared their code and answered my questions.

One of my personal goals for this project is to facilitate designers' taking control of their own tools. It has been more than twenty years since desktop publishing helped reinvent design in the mid-1980s, and we're overdue for more innovations. As designers have become fed up with available tools, coding and scripting have begun to fill the widening gap between what's in the designer's mind and the capability of the software

they've purchased. While most users of Processing will apply it to their own work, I hope that it will also enable others to create new design tools that come not from corporations or computer scientists, but from designers themselves.

Acknowledgments

This book is the synthesis of more than twenty years of studying visual design and software. John Maeda is the person most responsible for the genesis of Processing and this book. His guidance as our adviser in the Aesthetics and Computation Group (ACG) at the MIT Media Lab and the innovations of the Design By Numbers project are the foundation for the ideas presented here. Processing has also been strongly informed by the research and collaboration with our fellow graduate students at the ACG from 1999 through 2004. We are grateful for our collaboration with Peter Cho, Elise Co, Megan Galbraith, Simon Greenwold, Omar Khan, Axel Kilian, Reed Kram, Golan Levin, Justin Manor, Nikita Pashenkov, Jared Schiffman, David Small, and Tom White. We also acknowledge the foundation built by our predecessors in the ACG and the Visual Language Workshop.

While Processing's origin is at MIT, it has grown up within a set of other institutions including UCLA, the Interaction Design Institute Ivrea, the Broad Institute, and Carnegie Mellon. Casey's colleagues in Los Angeles and Ivrea have provided the environment for many of the ideas in this text to evolve. We thank UCLA faculty members Rebecca Allen, Mark Hansen, Erkki Huhtamo, Robert Israel, Willem Henri Lucas, Peter Lunenfeld, Rebeca Mendez, Vasa Mihich, Christian Moeller, Jennifer Steinkamp, Eddo Stern, and Victoria Vesna. We thank Ivrea faculty members and founders Gillian Crampton-Smith, Andrew Davidson, Dag Svanaes, Walter Aprile, Michael Kieslinger, Stefano Mirti, Jan-Christoph Zoels, Massimo Banzi, Nathan Shedroff, Bill Moggridge, John Thackara, and Bill Verplank. From the Broad Institute, we thank Eric Lander for funding Ben Fry's visualization research, most of which was built with Processing.

The ideas and structure of this book have been refined over the last decade of teaching at UCLA, Carnegie Mellon, Interaction Design Institute Ivrea, MIT, and Harvard. We're particularly grateful to the students in Casey's DESMA 28, 152A, and 152B classes for their ideas, effort, and energy. Casey's graduate students at UCLA have provided invaluable feedback: Gottfried Haider, Rhazes Spell, Eric Parren, Lauren McCarthy, David Wicks, Pete Hawkes, Andres Colubri, Michael Kontopoulos, Christo Allegra, Tyler Adams, Aaron Siegel, Tatsuya Saito, Krister Olsson, Aaron Koblin, John Houck, Zai Chang, and Andrew Hieronomi.

Processing was first introduced to students through workshops. We are grateful to the first institutions that took a chance on our new software in 2001 and 2002: Musashino Art University (Tokyo), ENSCI–Les Ateliers (Paris), HyperWerk (Basel), and the Royal Conservatory (Hague). Many universities have integrated Processing into their curriculum, and we're grateful to the pioneer faculty members and students at these institutions. They are too numerous to mention here. The students and faculty in New

York University's Interactive Telecommunication Program (ITP) deserve a special thank you for their early adoption and promotion, particularly Dan O'Sullivan, Tom Igoe, Josh Nimoy, Amit Pitaru, and Dan Shiffman.

The Processing software is a community effort. Over the last decade, the software has evolved through a continuous conversation. The goals of this book and of the Processing software have expanded and contracted as a result of invaluable suggestions and lively debates. The 2.0 release of the software was enabled by contributions from Andres Colubri, Dan Shiffman, Florian Jenett, Elie Zananiri, Patrick Hebron, Peter Kalauskas, David Wicks, Scott Murray, Philippe Lhoste, Cedric Kiefer, Filip Visnjic, and Jer Thorp.

It's impossible to make a list of everyone who has collaborated and contributed. The people who have formally contributed to the software include Andreas Schlegel, Jonathan Feinberg, Chris Lonnen, Eric Jordan, Simon Greenwold, Karsten Schmidt, Ariel Malka, Martin Gomez, Mikkel Crone Koser, Koen Mostert, Timothy Mohn, Dan Mosedale, Jacob Schwartz, Sami Arola, and Dan Haskovec.

This text has been rewritten and redesigned countless times. We're indebted to Shannon Hunt, who read and edited the first draft and also proofread the final manuscript. Karsten Schmidt and Larry Cuba read early chapters and provided feedback. Tom Igoe and David Cuartielles provided essential feedback for the Electronics extension. Rajorshi Ghosh and Mary Huang provided invaluable first edition production assistance. Anna Reutinger, Philip Scott, and Cindy Chi's assistance made the second edition possible. Chandler McWilliams executed a thorough technical review of the final first edition manuscript. Gottfried Haider scrutinized and greatly improved the second edition manuscript. The 3D Drawing chapter added for the second edition was adapted from Simon Greenwold's 3D extension chapter in the first edition.

We've enjoyed working with the folks at MIT Press, and we thank them for their dedication to this project. Doug Sery has guided us through every step of the publication process and that has made this book possible. For the first edition, we thank Katherine Almeida and the editorial staff for minding our Ps and Qs, and we are grateful for the production wisdom of Terry Lamoureux and Jennifer Flint. The anonymous reviewers of the proposal and draft provided extremely valuable feedback that helped to refine the book's structure. For the second edition, we thank Doug Sery and Katherine Almeida for their continued support as well as Susan Buckley and Mary Reilly.

We thank the many contributing artists and authors. They were generous with their time, and this book is greatly enhanced through their efforts.

Most important, Casey thanks Cait, Ava, Julian, Molly, Bob, and Deanna. Ben thanks Shannon, Augusta, Chief, Rose, Mimi, Jamie, Leif, Erika, and Josh.

1 Processing...

Processing relates software concepts to principles of visual form, motion, and interaction. It integrates a programming language, development environment, and teaching methodology into a unified system. Processing was created to teach fundamentals of computer programming within a visual context, to serve as a software sketchbook, and to be used as a production tool. Students, artists, design professionals, and researchers use it for learning, prototyping, and production.

The Processing language is a text programming language specifically designed to generate and modify images. Processing strives to achieve a balance between clarity and advanced features. Beginners can write their own programs after only a few minutes of instruction, but more advanced users can employ and write libraries with additional functions. The system facilitates teaching many computer graphics and interaction techniques including vector/raster drawing, image processing, color models, mouse and keyboard events, network communication, and object-oriented programming. Libraries extend Processing's ability to generate sound, send/receive data in diverse formats, and to work with video.

Software

A group of beliefs about the software medium set the foundation for Processing and inform decisions related to designing the software and environment.

Software is a unique medium with unique qualities
Ideas and emotions that are not possible to express in other media may be expressed in this medium. Software requires its own terminology and discourse and should not be evaluated in relation to prior media such as film, photography, and painting. History shows that technologies such as oil paint, cameras, and film have changed artistic practice and discourse, and while we do not claim that new technologies improve art, we do feel they enable different forms of communication and expression. Software holds a unique position among artistic media because of its ability to produce dynamic forms, process gestures, define behavior, simulate natural systems, and integrate other media including sound, image, and text.

Every programming language is a distinct material
As with any medium, different materials are appropriate for different tasks. When designing a chair, a designer decides to use steel, wood or other materials based on the intended use and on personal ideas and tastes. This scenario transfers to writing software. The abstract animator and programmer Larry Cuba describes his experience this way: "Each of my films has been made on a different system using a different

programming language. A programming language gives you the power to express some ideas, while limiting your abilities to express others."[1] There are many programming languages available from which to choose, and some are more appropriate than others depending on the project goals. The Processing language utilizes a common computer programming syntax that makes it easy for people to extend the knowledge gained through its use to many diverse programming languages.

Sketching is necessary for the development of ideas
It is necessary to sketch in a medium related to the final medium so the sketch can approximate the finished product. Painters may construct elaborate drawings and sketches before executing the final work. Architects traditionally work first in cardboard and wood to better understand their forms in space. Musicians often work with a piano before scoring a more complex composition. To sketch electronic media, it's important to work with electronic materials. Just as each programming language is a distinct material, some are better for sketching than others, and artists working in software need environments for working through their ideas before writing final code. Processing is built to act as a software sketchbook, making it easy to explore and refine many different ideas within a short period.

Programming is not just for engineers
Many people think programming is only for people who are good at math and other technical disciplines. One reason programming remains within the domain of this type of personality is that the technically minded people usually create programming languages. It is possible to create different kinds of programming languages and environments that engage people with visual and spatial minds. Alternative languages such as Processing extend the programming space to people who think differently. An early alternative language was Logo, designed in the late 1960s by Seymour Papert as a language concept for children. Logo made it possible for children to program many different media, including a robotic turtle and graphic images on screen. A more contemporary example is the Max programming environment developed by Miller Puckette in the 1980s. Max is different from typical languages; its programs are created by connecting boxes that represent the program code, rather than lines of text. It has generated enthusiasm from thousands of musicians and visual artists who use it as a base for creating audio and visual software. The same way graphical user interfaces opened up computing for millions of people, alternative programming environments will continue to enable new generations of artists and designers to work directly with software. We hope Processing will encourage many artists and designers to tackle software and that it will stimulate interest in other programming environments built for the arts.

Literacy

Processing does not present a radical departure from the current culture of programming. It repositions programming in a way that is accessible to people who are interested in programming but who may be intimidated by or uninterested in the type taught in computer science departments. The computer originated as a tool for fast calculations and has evolved into a medium for expression.

The idea of general software literacy has been discussed since the early 1970s. In 1974, Ted Nelson wrote about the minicomputers of the time in *Computer Lib/Dream Machines*. He explained "the more you know about computers ... the better your imagination can flow between the technicalities, can slide the parts together, can discern the shapes of what you would have these things do."[2] In his book, Nelson discusses potential futures for the computer as a media tool and clearly outlines ideas for hypertexts (linked text, which set the foundation for the web) and hypergrams (interactive drawings). Developments at Xerox PARC led to the Dynabook, a prototype for today's personal computers. The Dynabook vision included more than hardware. A programming language was written to enable, for example, children to write storytelling and drawing programs and musicians to write composition programs. In this vision there was no distinction between a computer user and a programmer.

Forty years after these optimistic ideas, we find ourselves in a different place. A technical and cultural revolution did occur through the introduction of the personal computer and the Internet to a wider audience, but people are overwhelmingly using the software tools created by professional programmers rather than making their own. This situation is described clearly by John Maeda in his book *Creative Code*: "To use a tool on a computer, you need do little more than point and click; to create a tool, you must understand the arcane art of computer programming."[3] The negative aspects of this situation are the constraints imposed by software tools. As a result of being easy to use, these tools obscure some of the computer's potential. To fully explore the computer as an artistic material, it's important to understand this "arcane art of computer programming."

Processing strives to make it possible and advantageous for people within the visual arts to learn how to build their own tools—to become software literate. Alan Kay, a pioneer at Xerox PARC and Apple, explains what literacy means in relation to software:

The ability to "read" a medium means you can access materials and tools created by others. The ability to "write" in a medium means you can generate materials and tools for others. You must have both to be literate. In print writing, the tools you generate are rhetorical; they demonstrate and convince. In computer writing, the tools you generate are processes; they simulate and decide.[4]

Making processes that simulate and decide requires programming.

Open

The open source software movement is having a major impact on our culture and economy through initiatives such as Linux, but it is having a smaller influence on the culture surrounding software for the arts. There are scattered projects, but companies such as Apple, Adobe, and Autodesk dominate software production and therefore control contemporary software tools used within the arts. As a group, artists and designers traditionally lack the technical skills to support independent software initiatives. Processing strives to apply the spirit of open source software innovation to the domain of the arts. We want to provide an alternative to available proprietary software and to improve the skills of the arts community, thereby stimulating interest in related initiatives. We want to make Processing easy to extend and adapt and to make it available to as many people as possible.

Processing probably would not exist without its ties to open source software. Using existing open source projects as guidance, and for important software components, has allowed the project to develop in a smaller amount of time and without a large team of programmers. Individuals are more likely to donate their time to an open source project, and therefore the software evolves without a budget. These factors allow the software to be distributed without cost, which enables access to people who cannot afford the high prices of commercial software. The Processing source code allows people to learn from its construction and by extending it with their own code.

People are encouraged to publish the code for programs they have written in Processing. The same way the "view source" function in web browsers encouraged the rapid proliferation of website-creation skills, access to others' Processing code enables members of the community to learn from each other so that the skills of the community increase as a whole. A good example involves writing software for tracking objects in a video image, thus allowing people to interact directly with the software through their bodies, rather than through a mouse or keyboard. One project shared online included code that made it possible to track the brightest object seen by the camera, but it couldn't track color, A more experienced programmer used this code as a foundation for writing more general code that could track multiple colored objects at the same time. This improved tracking code enabled Laura Hernandez Andrade, then a graduate student at UCLA, to build *Talking Colors*, an interactive installation that superimposes emotive text about the colors people are wearing on top of their projected image. Sharing and improving code allows people to learn from one another and to build projects that would be too complex to accomplish from scratch.

Education

Processing makes it possible to introduce software concepts in the context of the arts and also to open arts concepts to a more technical audience. Because the Processing syntax is derived from widely used programming languages, it's a good base for future learning. Skills learned with Processing enable people to learn other programming

languages suitable for different contexts including web development, computer graphics, and electronics.

There are many established curricula for computer science, but by comparison there have been very few classes that strive to integrate media arts knowledge with core concepts of computation. Using classes initiated by John Maeda as a model, hybrid courses based on Processing are being created. Processing has proved useful for short workshops ranging from one day to a few weeks. Because the environment is so minimal, students are able to begin programming after only a few minutes of instruction. The Processing syntax, similar to other common languages, is already familiar to many people, and so students with more experience can begin writing advanced syntax almost immediately.

In a one-week workshop at Hongik University in Seoul, the students were a mix of design and computer science majors, and both groups worked toward synthesis. Some of the work produced was more visually sophisticated and some more technically advanced, but it was all evaluated with the same criteria. Students like Soo-jeong Lee entered the workshop without any previous programming experience; while she found the material challenging, she was able to learn the basic principles and apply them to her ideas. During critiques, her strong visual skills set an example for the students from more technical backgrounds. Students such as Tai-kyung Kim from the computer science department quickly understood how to use the Processing software, but he was encouraged by the visuals in other students' work to increase his aesthetic sensibility. His work with kinetic typography was a good example of a synthesis between his technical skills and emerging design sensitivity.

Processing is also used to teach longer introductory classes for undergraduates and for topical graduate-level classes. It has been used at small art schools, private colleges, and public universities. At UCLA, for example, it is used to teach a foundation class in digital media to second-year undergraduates and has been introduced to the graduate students as a platform for explorations into more advanced domains. In the undergraduate Interactivity class, students read and discuss the topic of interaction and make many examples of interactive systems using the Processing language. Each week new topics such as kinetic art and the role of fantasy in video games are introduced. The students learn new programming skills, and they produce an example of work addressing a topic. For one of their projects, the students read Sherry Turkle's "Video Games and Computer Holding Power"[5] and were given the assignment to write a short game or event exploring their personal desire for escape or transformation. Leon Hong created an elegant flying simulation in which the player floats above a body of water and moves toward a distant island. Muskan Srivastava wrote a game in which the objective was to consume an entire table of desserts within ten seconds.

Teaching programming techniques while simultaneously introducing basic theory allows the students to explore their ideas directly and to develop a deep understanding and intuition about interactivity and digital media. In the graduate-level Interactive Environments course at UCLA, Processing is used as a platform for experimentation with computer vision. Using sample code, each student has one week to develop software that uses the body as an input via images from a video camera. Zai Chang

developed a provocative installation called White Noise where participants' bodies are projected as a dense series of colored particles. The particle shadow of each person is displayed with a different color, and when they overlap, the particles exchange, thus appearing to transfer matter and infect each other with their unique essence. Reading information from a camera is a simple action within the Processing environment, and this facility fosters quick and direct exploration within courses that might otherwise require weeks of programming tutorials to lead up to a similar project.

Network

Processing takes advantage of the strengths of web-based communities, and this has allowed the project to grow in unexpected ways. Thousands of students, educators, and practitioners across six continents are involved in using the software. The project website serves as the communication hub, but contributors are found remotely in cities around the world. Typical web applications such as forums host discussions between people in remote locations about features, bugs, and related events.

For the last decade, many classes taught using Processing have published the complete curriculum on the web, and students have published their software assignments and source code from which others can learn. The websites for Daniel Shiffman's classes at New York University, for example, include online tutorials and links to the students' work. The tutorials for his Procedural Painting course cover topics including modular programming, image processing, and 3D graphics by combining text with running software examples. Students maintain web pages containing all of their software and source code created for the class. These pages provide a straightforward way to review performance and make it easy for members of the class to access each other's work.

The Processing Forum, an online discussion system located at *http://forum .processing.org/*, is a place for people to talk about their projects and share advice. It has thousands of members, with a subset actively commenting on each other's work and helping with technical questions. For example, one post focused on a problem with code to simulate springs. Over the course of a few days, messages were posted discussing the details of Euler integration in comparison to the Runge-Kutta method. While this may sound like an arcane discussion, the differences between the two methods can be the reason a project works well or fails. This thread and many others like it have become concise Internet resources for students interested in detailed topics.

Context

The Processing approach to programming blends with established methods. The core language and additional libraries make use of Java, which also has elements identical to the C programming language. This heritage allows Processing to make use of decades of

programming language refinements and makes it understandable to many people who are already familiar with writing software.

Processing is unique in its emphasis and in the tactical decisions it embodies with respect to its context within design and the arts. Processing makes it easy to write software for drawing, animation, and reacting to the environment, and programs are easily extended to integrate with additional media types including audio, video, and electronics.

The network of people and schools using the software continues to grow. In the decade since the origin of the idea for the software, it has evolved organically through presentations, workshops, classes, and discussions around the globe. We plan to continually improve the software and foster its growth, with the hope that the practice of programming will reveal its potential as the foundation for a more dynamic media.

Notes

1. Larry Cuba, "Calculated Movements," in *Prix Ars Electronica Edition '87: Meisterwerke der Computerkunst* (H. S. Sauer, 1987), p. 111.

2. Theodore Nelson, "Computer Lib/Dream Machines," in *The New Media Reader*, edited by Noah Wardrip-Fruin and Nick Montfort (MIT Press, 2003), p. 306.

3. John Maeda, *Creative Code* (Thames & Hudson, 2004), p. 113.

4. Alan Kay, "User Interface: A Personal View," in *The Art of Human-Computer Interface Design*, edited by Brenda Laurel (Addison-Wesley, 1989), p. 193.

5. Chapter 2 in Sherry Turkle, *The Second Self: Computers and the Human Spirit* (Simon & Schuster, 1984), pp. 64–92.

Lines

Display window

```
Processing                                              Menu
File Edit Sketch Debug Tools Help

  (▶)(■)                                    Java ▼       Toolbar

  Lines        (▾)                                       Tabs

void setup() {
  size(100, 100);
  noLoop();
}

void draw() {
  diagonals(40, 90);
  diagonals(60, 62);                                     Text editor
  diagonals(20, 40);
}

void diagonals(int x, int y) {
  line(x, y, x+20, y-40);
  line(x+10, y, x+30, y-40);
  line(x+20, y, x+40, y-40);
}

                                                         Message area

                                                         Console

```

Figure 1-1 Processing Development Environment (PDE)
Use the PDE to create Processing sketches. Write the code in the text editor and use the
buttons in the toolbar to run, save, and export the code.

2 Using Processing

This chapter introduces the Processing Environment and the most basic elements for writing software.

Syntax introduced:
```
// (comment), /* */ (multiline comment)
";" (statement terminator), "," (comma)
print(), println()
```

Download, Install

The Processing software can be downloaded from the Processing website. Using a web browser, navigate to *www.processing.org/download* and click on the link for your computer's operating system. The Processing software is available for Linux, Macintosh, and Windows.

Environment

The Processing Development Environment (PDE) consists of a simple text editor for writing code, a message area, a text console, tabs for managing files, a toolbar with buttons for common actions, and a series of menus. When programs are run, they open in a new window called the display window.

Pieces of software written using Processing are called *sketches*. These sketches are written in the text editor. It has features for cutting/pasting and for searching/replacing text. The message area gives feedback while saving and exporting and also displays errors. The console displays text output by Processing programs including complete error messages and text output from programs with the `print()` and `println()` functions. The toolbar buttons allow you to run and stop programs.

Run	Compiles the code, opens a display window, and runs the program inside.
Stop	Terminates a running program.

The menus provide the same functionality as the toolbar in addition to actions for file management and opening reference materials.

File	Commands to manage and export files.
Edit	Controls for the text editor (Undo, Redo, Cut, Copy, Paste, Find, etc.)
Sketch	Commands to run and stop programs and to add media files and code libraries.
Tools	Tools to assist in using Processing (select a color, create fonts, etc.)
Debug	Features to assist in finding errors in a sketch.
Help	Reference files for the environment and language.

Each Processing sketch has its own folder. The main program file for each sketch has the same name as the folder and is found inside. For example, if the sketch is named *Sketch_123*, the folder for the sketch will be called *Sketch_123* and the main file will be called *Sketch_123.pde*. The PDE file extension stands for the Processing Development Environment.

A sketch folder sometimes contains other folders for media files and code libraries. When a font or image is added to a sketch by selecting "Add File" from the Sketch menu, a *data* folder is created. Files can also be added by dragging them into the text editor. For instance, if an image file is dragged into the Processing text editor, it is automatically copied to the current sketch's data folder. All images, fonts, sounds, and other kinds of data files loaded in the sketch must be in this folder.

Sketches are stored in the Processing folder, which will be in different places on your computer or network depending on whether you use PC, Mac, or Linux and on how the preferences are set. To locate this folder, select the "Preferences" option from the File menu (or from the Processing menu on the Mac) and look for the "Sketchbook location."

It is possible to have multiple files in a single sketch. These can be Processing text files (with the extension *.pde*) or Java files (with the extension *.java*). To create a new file, click on the arrow button to the right of the file tabs. This button enables you to create, delete, and rename the files that comprise the current sketch. You can write functions and classes in new PDE files and you can write any Java code in files with the JAVA extension. Working with multiple files makes it easier to reuse code and to separate programs into small subprograms. This is discussed in more detail in the Objects chapter (p. 359).

Export

The export feature packages a sketch to run outside of the Processing Development Environment. When code is exported from Processing, it is converted into Java code and then compiled as a Java application. Processing can export applications for the Linux, Macintosh, and Windows platforms. When a project is exported, a series of files is written to a new folder that contains the application, the source code for the sketch, and all required libraries for a specific platform. Every time a sketch is exported, the contents of the application folder are deleted and the files are written from scratch. Any changes previously made to the files within are lost.

Media files not needed for the application should be deleted from the data folder before it is exported to keep the file size small. For example, if there are unused images in the data folder, they will be included, thus needlessly increasing its size.

Additional and updated information about the Processing environment is available at *www.processing.org/reference/environment* or by selecting the "Environment" item from the Help menu of the Processing application.

Example walk-through

A Processing program can be as short as one line of code and as long as thousands of lines. This scalability is one of the most important aspects of the language. The following example walk-through presents the modest goal of animating a sequence of diagonal lines as a means to explore some of the basic components of the Processing language. If you are new to programming, some of the terminology and symbols in this section will be unfamiliar. This walk-through is a condensed overview of the entire book, utilizing ideas and techniques that are covered in detail later. Try running these programs inside the Processing application to better understand what the code is doing.

Processing was designed to make it easy to draw graphic elements such as lines, ellipses, and curves in the display window. These shapes are positioned with numbers that define their coordinates. The position of a line is defined by four numbers, two for each endpoint. The parameters used inside the line() function determine the position where the line appears. The origin of the coordinate system is in the upper-left corner, and numbers increase right and down. Coordinates and drawing different shapes are discussed on pages 21–32.

```
line(10, 80, 30, 40);   // Left line            2-01
line(20, 80, 40, 40);
line(30, 80, 50, 40);   // Middle line
line(40, 80, 60, 40);
line(50, 80, 70, 40);   // Right line
```

The visual attributes of shapes are controlled with other code elements that set color and gray values, the width of lines, and the quality of the rendering. Drawing attributes are discussed on pages 32–37.

```
background(0);          // Set the black background   2-02
stroke(255);            // Set line value to white
strokeWeight(5);        // Set line width to 5 pixels
line(10, 80, 30, 40);   // Left line
line(20, 80, 40, 40);
line(30, 80, 50, 40);   // Middle line
line(40, 80, 60, 40);
line(50, 80, 70, 40);   // Right line
```

A variable, such as x, represents a value; this value replaces the symbol x when the code is run. One variable can then control many features of the program. Variables are introduced on pages 51–56.

```
int x = 5;    // Set the horizontal position
int y = 60;   // Set the vertical position
line(x, y, x+20, y-40);    // Line from [5,60] to [25,20]
line(x+10, y, x+30, y-40); // Line from [15,60] to [35,20]
line(x+20, y, x+40, y-40); // Line from [25,60] to [45,20]
line(x+30, y, x+50, y-40); // Line from [35,60] to [55,20]
line(x+40, y, x+60, y-40); // Line from [45,60] to [65,20]
```

Adding more structure to a program opens further possibilities. The setup() and draw() functions make it possible for a program to run continuously—this is required to create animation and interactive programs. The code inside setup() runs once when the program first starts, and the code inside draw() runs continuously. One image frame is drawn to the display window at the end of each loop through draw().

In the following example, the variable x is declared as a global variable, meaning it can be assigned and accessed anywhere in the program. The value of x increases by 1 each frame, and because the position of the lines is controlled by x, they are drawn to a different location each time the value changes. This moves the lines to the right.

Line 14 in the code is an if structure. It contains a relational expression comparing the variable x to the value 100. When the expression is true, the code inside the block (the code between the { and } associated with the if structure) runs. When the relational expression is false, the code inside the block does not run. When the value of x becomes greater than 100, the line of code inside the block sets the variable x to −40, causing the lines to jump to the left edge of the window. The details of draw() are discussed on pages 65–72, programming animation is discussed on pages 431–438, and the if structure is discussed on pages 72–77.

```
int x = 0;    // Set the horizontal position
int y = 55;   // Set the vertical position

void setup() {
  size(100, 100);  // Set the window to 100 x 100 pixels
}

void draw() {
  background(204);
  line(x, y, x+20, y-40);     // Left line
  line(x+10, y, x+30, y-40);  // Middle line
  line(x+20, y, x+40, y-40);  // Right line
  x = x + 1;        // Add 1 to x
  if (x > 100) {    // If x is greater than 100,
    x = -40;        // assign -40 to x
  }
}
```

When a program is running continuously, Processing captures data from input devices such as the mouse and keyboard. This data can be used to affect what is happening in the display window. Programs that respond to the mouse are discussed on pages 83–101.

2-05

```
void setup() {
    size(100, 100);
}

void draw() {
    background(204);
    // Assign the horizontal value of the cursor to x
    float x = mouseX;
    // Assign the vertical value of the cursor to y
    float y = mouseY;
    line(x, y, x+20, y-40);
    line(x+10, y, x+30, y-40);
    line(x+20, y, x+40, y-40);
}
```

A *function* is a block of code within a program that performs a specific task. They make programs easier to read and change because they group related lines of code together. The diagonals() function in the following example was written to draw a sequence of three diagonal lines each time it is run inside draw(). Two *parameters*, the numbers in the parentheses after the function name, set the position of the lines. These numbers are passed into the function definition on line 12 and are used as the values for the variables *x* and *y* in lines 13–15. Functions are discussed in more detail on pages 333–358.

2-06

```
void setup() {
    size(100, 100);
}

void draw() {
    background(204);
    diagonals(40, 90);
    diagonals(60, 62);
    diagonals(20, 40);
}

void diagonals(int x, int y) {
    line(x, y, x+20, y-40);
    line(x+10, y, x+30, y-40);
    line(x+20, y, x+40, y-40);
}
```

Object-oriented programming is a way of structuring code into *objects*, units of code that contain both variables (data) and functions. This style of programming makes a strong connection between groups of data and the functions that act on this data. The diagonals() function can be expanded by making it part of a *class* definition. Objects are created using the class as a template. The variables for positioning the lines and setting their drawing attributes then move inside the class definition to be more closely associated with drawing the lines. Object-oriented programming is discussed further on pages 359–361.

```
Diagonals da, db;                                          2-07

void setup() {
  size(100, 100);
  // Inputs: x, y, speed, thick, gray
  da = new Diagonals(0, 80, 1, 2, 0);
  db = new Diagonals(0, 55, 2, 6, 255);
}

void draw() {
  background(204);
  da.update();
  db.update();
}

class Diagonals {
  int x, y, speed, thick, gray;

  Diagonals(int xpos, int ypos, int s, int t, int g) {
    x = xpos;
    y = ypos;
    speed = s;
    thick = t;
    gray = g;
  }

  void update() {
    strokeWeight(thick);
    stroke(gray);
    line(x, y, x+20, y-40);
    line(x+10, y, x+30, y-40);
    line(x+20, y, x+40, y-40);
    x = x + speed;
    if (x > 100) {
      x = -100;
```

```
        }
      }
    }
```

The variables used in the previous sketches each store one data element. If we want to have 20 groups of lines on screen, it will require 40 variables: 20 for the horizontal positions and 20 for the vertical positions. This can make programming tedious and can make programs difficult to read. Instead of using multiple variable names, we can use *arrays*. An array stores a list of data elements as a single name. A `for` loop can be used to cycle through each array element in sequence. Arrays are discussed on pages 415–430, and the `for` loop is discussed on pages 105–109.

```
int num = 20;
int[] dx = new int[num];   // Declare and create an array
int[] dy = new int[num];   // Declare and create an array

void setup() {
  size(100, 100);
  for (int i = 0; i < num; i++) {
    dx[i] = i * 5;
    dy[i] = 12 + (i * 6);
  }
}

void draw() {
  background(204);
  for (int i = 0; i < num; i++) {
    dx[i] = dx[i] + 1;
    if (dx[i] > 100) {
      dx[i] = -100;
    }
    diagonals(dx[i], dy[i]);
  }
}

void diagonals(int x, int y) {
  line(x, y, x+20, y-40);
  line(x+10, y, x+30, y-40);
  line(x+20, y, x+40, y-40);
}
```

This short walk-through serves to introduce, but not fully explain, some of the core concepts explored in this text. Many key ideas of working with software were mentioned only briefly and others were omitted. Each topic is covered in depth later in the book.

Coding is writing

Creating software is an act of *writing*. Before starting to write code, it's important to acknowledge the difference between writing a computer program and writing an Email or an essay. Writing in a human language allows the author to utilize the ambiguity of words and to have great flexibility in constructing phrases. These techniques allow multiple interpretations of a single text and give each author a unique voice. Each computer program also reveals the style of its author, but there is far less room for ambiguity. While people can interpret vague meanings and can usually disregard poor grammar, computers cannot. Some of the linguistic details of writing code are discussed here to prevent early frustration. If you keep these details in mind as you begin to program, they will gradually become habitual.

Comments

Comments are ignored by the computer but are important for people. They let the programmer write personal notes and remarks to others who read the code. Because programs use symbols and arcane notation to describe complex procedures, it is often difficult to remember how individual parts of a program work. Good comments serve as reminders when a program is revisited and to explain ideas to others reading the code. Commented sections appear in a different color than the rest of the code. This program explains how comments work:

2-09

```
// Two forward slashes are used to denote a comment.
// All text on the same line is a part of the comment.
// There must be no spaces between the slashes. For example,
// the code "/ /" is not a comment and will cause an error

// If you want to have a comment that is many
// lines long, you may prefer to use the syntax for a
// multiline comment

/*
  A forward slash followed by an asterisk allows the
  comment to continue until the opposite
*/

// All letters and symbols that are not comments are run
// by the computer. Because the following lines are not comments,
// they are run and draw a display window of 200 x 200 pixels
size(200, 200);
background(102);
```

Functions

Functions allow a program to draw shapes, set colors, calculate numbers, and execute many other types of actions. A function's name is usually a lowercase word followed by parentheses. The comma-separated elements between the parentheses are called parameters, and they affect the way the function works. Some functions have no parameters and others have many. This program demonstrates the `size()` and `background()` functions.

```
// The size function has two parameters. The first sets the width
// of the display window and the second sets the height
size(200, 200);
```
2-10

```
// This version of the background function has one parameter.
// It sets the gray value for the background of the display window
// in the range of 0 (black) to 255 (white)
background(102);
```

Expressions, Statements

Using an analogy to human languages, a software expression is like a phrase. Software expressions are often combinations of operators such as +, *, and / that operate on the values to their left and right. A software expression can be as basic as a single number or can be a long combination of elements. An expression always has a value, determined by evaluating its contents.

Expression	Value
5	5
122.3+3.1	125.4
((3+2)*-10) + 1	-49

Expressions can also compare two values with operators such as > (greater than) and < (less than). These comparisons are evaluated as `true` or `false`.

Expression	Value
6 > 3	true
54 < 50	false

One or more expressions create a statement, the programming equivalent of a sentence. It's a complete unit that ends with the statement terminator, the programming equivalent of a period. In the Processing language, the statement terminator is a semicolon.

Just as there are different types of sentences, there are different types of statements. A statement can define a variable, assign a variable, run a function, or

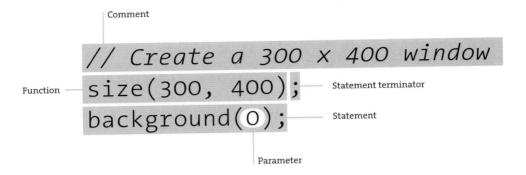

Comment

Function

Statement terminator

Statement

Parameter

Figure 2-1 Anatomy of a Processing sketch
Every sketch is composed of different language elements. These elements work together to describe the intentions of the programmer so they can be interpreted by a computer. The anatomy of a more complicated sketch is shown on page 68.

construct an object. Each will be explained in more detail later, but examples are shown here:

```
size(200, 200);      // Run the size() function
int x;               // Declare a new variable x
x = 102;             // Assign the value 102 to the variable x
background(x);       // Run the background() function
```
2-11

Omitting the semicolon at the end of a statement, a very common mistake, will result in an error message, and the program will not run.

Case sensitivity

In written English, some words are capitalized, and others are not. Proper nouns like Ohio and John and the first letter of every sentence are capitalized, while most other words are lowercase. In many programming languages, some parts of the language must be capitalized and others must be lowercase. Processing differentiates between uppercase and lowercase characters; therefore, writing "Size" when you mean to write "size" creates an error. You must be precise in typing lowercase and uppercase letters.

```
size(200, 200);
Background(102);   // ERROR! The B in "background" is capitalized
```
2-12

Whitespace

In many programming languages, including Processing, there can be an arbitrary amount of space between the program elements. Unlike the strict use of statement terminators and capitalization, spacing does not matter. The following two lines of code are a standard way to write a program:

```
size(200, 200);
background(102);
```
2-13

However, the whitespace between the code elements can be set to any amount, and the program will run the same way:

```
size

(    200,
   200)                    ;
background     (              102)
           ;
```
2-14

Console

When software runs, the computer performs operations at a rate too fast to perceive with human eyes. Because it is important to understand what is happening inside the machine, the functions `print()` and `println()` can be used to display data while a program is running. These functions don't send pages to a printer, but instead write text to the console (pp. 19, 20). The console can be used to display a variable, confirm an event, or check incoming data from an external device. Such uses might not seem clear now, but they will reveal themselves over the course of this book. Like comments, `print()` and `println()` can clarify the intentions and execution of computer programs.

```
// To print text to the console, place the desired output in quotes
println("Processing...");   // Prints "Processing..." to the console

// To print the value of a variable, rather than its name,
// don't put the name of the variable in quotes
int x = 20;
println(x);   // Prints "20" to the console

// While println() moves to the next line after the text
// is output, print() does not
print("10");
```
2-15

```
println("20");   // Prints "1020" to the console
println("30");   // Prints "30" to the console

// Use a comma inside println() to write more than one value
int x2 = 20;
int y2 = 80;
println(x2, y2);   // Prints "20 80" to the console

// Use the "+" operator to combine variables with custom
// text in between
int x3 = 20;
int y3 = 80;
println(x3 + " and " + y3);   // Prints "20 and 80" to the console
```

Reference

The reference for the Processing language complements this book. We advise opening the reference and reading it regularly while programming. The reference contains the nitty-gritty technical details and the book puts them into context. To open the reference, select the "Reference" option from the Help menu within Processing. It is available online at *www.processing.org/reference*.

3 Draw

This chapter introduces the coordinate system of the display window and a variety of geometric elements.

Syntax introduced:
```
size(), point(), line(), triangle(), quad(), rect(), ellipse(),
arc(), bezier()
background(), fill(), stroke(), noFill(), noStroke()
smooth(), noSmooth()
strokeWeight(), strokeCap(), strokeJoin()
ellipseMode(), rectMode()
```

Drawing a shape with code can be difficult because every aspect of its location must be specified with a number. When you're accustomed to drawing with a pencil or moving shapes around on a screen with a mouse, it can take time to start thinking in relation to the screen's strict coordinate grid. The mental gap between seeing a composition on paper or in your mind and translating it into code notation is wide, but easily bridged.

Coordinates

Before making a drawing, it's important to think about the dimensions and qualities of the surface to which you'll be drawing. If you're making a drawing on paper, you can choose from myriad utensils and papers. For quick sketching, newsprint and charcoal are appropriate. For a refined drawing, a smooth handmade paper and range of pencils may be preferred. In contrast, when you are drawing to a computer's screen, the primary options available are the size of the window and the background color.

A computer screen is a grid of small light elements called pixels. Screens come in many sizes and resolutions. We have three different types of computer screens in our studios, and they all have a different number of pixels. The laptops have 2,304,000 pixels (1920 wide × 1200 high), the flat panels have 3,686,400 pixels (2560 wide × 1440 high), and the older monitors have 786,432 pixels (1024 wide × 768 high). Millions of pixels may sound like a vast quantity, but most screens still produce a poor visual resolution compared to physical media such as paper. On the other hand, paper images are fixed, but screens have the advantage of being able to change their image many times per second.

Processing programs can control all or a subset of the screen's pixels. When the Run button is clicked, a display window opens and its pixels can be changed by Processing. It's possible to create images larger than the screen, but in most cases the window is the size of the screen or smaller.

The size of the display window is controlled with the `size()` function:

```
size(w, h)
```

The `size()` function has two parameters: the first sets the width of the display window and the second sets its height.

```
// Draw the display window 120 pixels
// wide and 200 pixels high
size(120, 200);
```
3-01

```
// Draw the display window 320 pixels
// wide and 240 pixels high
size(320, 240);
```
3-02

```
// Draw the display window 200 pixels
// wide and 200 pixels high
size(200, 200);
```
3-03

A position within the display window is defined by an x-coordinate and a y-coordinate. The x-coordinate is the horizontal distance from the origin and the y-coordinate is the vertical distance. In Processing, the origin is the upper-left corner of the display window and coordinate values increase down and to the right. The diagram on the left shows the coordinate system, and the diagram on the right shows a few coordinates placed on the grid:

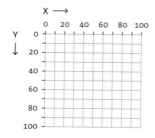

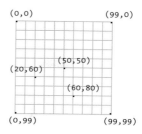

A position is written as the x-coordinate value followed by the y-coordinate, separated with a comma. The notation for the origin is (0,0), the coordinate (50,50) has an x-coordinate of 50 and a y-coordinate of 50, and the coordinate (20,60) is an x-coordinate of 20 and a y-coordinate of 60. If the size of the display window is 100 pixels wide and 100 pixels high, (0,0) is the pixel in the upper-left corner, (99,0) is the pixel in the upper-right corner, (0,99) is the pixel in the lower-left corner, and (99,99) is the pixel in the lower-right corner. This becomes clearer when we look at examples using `point()`.

Basic shapes

A point is the simplest visual element and is drawn with the `point()` function:

 point(x, y)

This function has two parameters: the first is the x-coordinate and the second is the y-coordinate. Unless specified otherwise, a point is the size of a single pixel.

```
// Points with the same X and Y parameters          3-04
// are drawn on the diagonal axis from the
// upper-left corner to the lower-right
point(20, 20);
point(30, 30);
point(40, 40);
point(50, 50);
point(60, 60);
```

```
// Points with the same Y parameter have the        3-05
// same distance from the top and bottom
// edges of the display window
point(50, 30);
point(55, 30);
point(60, 30);
point(65, 30);
point(70, 30);
```

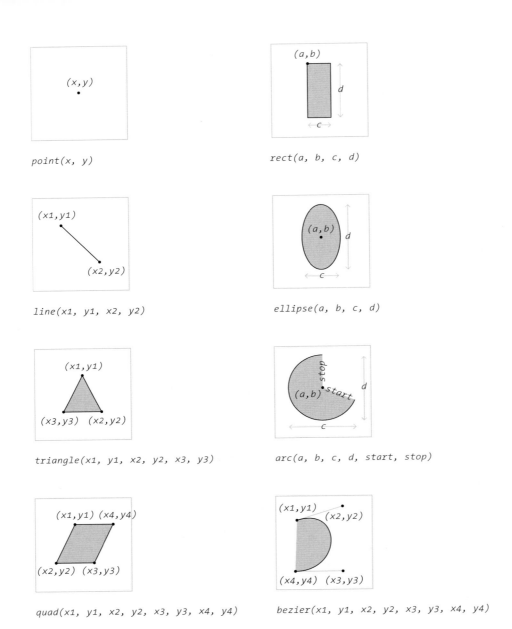

point(x, y)

rect(a, b, c, d)

line(x1, y1, x2, y2)

ellipse(a, b, c, d)

triangle(x1, y1, x2, y2, x3, y3)

arc(a, b, c, d, start, stop)

quad(x1, y1, x2, y2, x3, y3, x4, y4)

bezier(x1, y1, x2, y2, x3, y3, x4, y4)

Figure 3-1 Geometry Primitives
Processing has eight functions to draw simple shapes. These diagrams show the format for each. Replace the parameters with numbers (or variables) to use them within a sketch.

```
// Points with the same X parameter have the          3-06
// same distance from the left and right
// edges of the display window
point(70, 50);
point(70, 55);
point(70, 60);
point(70, 65);
point(70, 70);
```

```
// Place a group of points side by side          3-07
// to create a line
point(50, 50);
point(50, 51);
point(50, 52);
point(50, 53);
point(50, 54);
point(50, 55);
point(50, 56);
point(50, 57);
point(50, 58);
point(50, 59);
```

```
// Points drawn outside the display          3-08
// area will not cause an error,
// but they won't be visible
point(-500, 100);
point(400, -600);
point(140, 2500);
point(2500, 100);
```

It is possible to draw any line as a series of points, but lines are more simply drawn with the line() function. This function has four parameters, two for each endpoint:

```
line(x1, y1, x2, y2)
```

The first two parameters set the position where the line starts and the last two set the position where the line stops.

```
// When the y-coordinates for a line are the          3-09
// same, the line is horizontal
line(10, 30, 90, 30);
line(10, 40, 90, 40);
line(10, 50, 90, 50);
```

```
// When the x-coordinates for a line are the          3-10
// same, the line is vertical
line(40, 10, 40, 90);
line(50, 10, 50, 90);
line(60, 10, 60, 90);
```

```
// When all four parameters are different,             3-11
// the lines are diagonal
line(25, 90, 80, 60);
line(50, 12, 42, 90);
line(45, 30, 18, 36);
```

```
// When two lines share the same point they connect    3-12
line(15, 20, 5, 80);
line(90, 65, 5, 80);
```

The triangle() function draws triangles. It has six parameters, two for each point:

```
triangle(x1, y1, x2, y2, x3, y3)
```

The first pair defines the first point, the middle pair the second point, and the last pair the third point. Any triangle can be drawn by connecting three lines, but the triangle() function makes it possible to draw a filled shape. Triangles of all shapes and sizes can be created by changing the parameter values.

```
triangle(60, 10, 25, 60, 75, 65);   // Filled triangle       3-13
line(60, 30, 25, 80);    // Outlined triangle edge
line(25, 80, 75, 85);    // Outlined triangle edge
line(75, 85, 60, 30);    // Outlined triangle edge
```

```
triangle(55, 9, 110, 100, 85, 100);                            3-14
triangle(55, 9, 85, 100, 75, 100);
triangle(-1, 46, 16, 34, -7, 100);
triangle(16, 34, -7, 100, 40, 100);
```

The quad() function draws a quadrilateral, a four-sided polygon. The function has eight parameters, two for each point:

```
quad(x1, y1, x2, y2, x3, y3, x4, y4)
```

Changing the parameter values can yield rectangles, squares, parallelograms, and irregular quadrilaterals.

```
quad(38, 31, 86, 20, 69, 63, 30, 76);
```

3-15

```
quad(20, 20, 20, 70, 60, 90, 60, 40);
quad(20, 20, 70, -20, 110, 0, 60, 40);
```

3-16

Drawing rectangles and ellipses works differently than the shapes previously introduced. Instead of defining each point, the four parameters set the position and the dimensions of the shape. The rect() function draws a rectangle:

```
rect(a, b, c, d)
```

By default, the first two parameters set the location of the upper-left corner, the third sets the width, and the fourth sets the height. Use the same value for the third and fourth parameters to draw a square. The rect() function can be used in different ways that change the meaning of its parameters. See the rectMode() function on p. 37 for more information.

```
rect(15, 15, 40, 40);   // Large square
rect(55, 55, 25, 25);   // Small square
```

3-17

```
rect(0, 0, 90, 50);
rect(5, 50, 75, 4);
rect(24, 54, 6, 6);
rect(64, 54, 6, 6);
rect(20, 60, 75, 10);
rect(10, 70, 80, 2);
```

3-18

The ellipse() function draws an ellipse in the display window:

```
ellipse(a, b, c, d)
```

The first two parameters set the location of the center of the ellipse, the third sets the width, and the fourth sets the height. Use the same value for the third and fourth parameters to draw a circle.

```
ellipse(40, 40, 60, 60);   // Large circle
ellipse(75, 75, 32, 32);   // Small circle
```

```
ellipse(35, 0, 120, 120);
ellipse(38, 62, 6, 6);
ellipse(40, 100, 70, 70);
```

Curves

The most basic curve form, the arc, is a piece of an ellipse. To simplify drawing this shape, Processing includes an arc() function:

```
arc(a, b, c, d, start, stop)
```

Arcs are drawn along the outer edge of an ellipse defined by the first four parameters as explained for ellipse(). The start and stop parameters define the angles where the arc begins and ends. The angles for these parameters are radian values; radians are angles specified in relation to π. Radians are discussed on page 279, so for the following examples, the more common *degree* measurement is used for the angles. The degree measurement 0 is at the far right of the ellipse, with the angle growing clockwise around the shape:

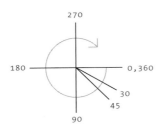

Degree values

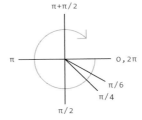

Radian values

The radians() function is used to convert the degree measurements to radians values to work with arc(). When one function is used as a parameter to another function, as seen below, the calculation happens first. For instance, the radian angle is first calculated with the radians() function, then the value is used as the parameter to arc().

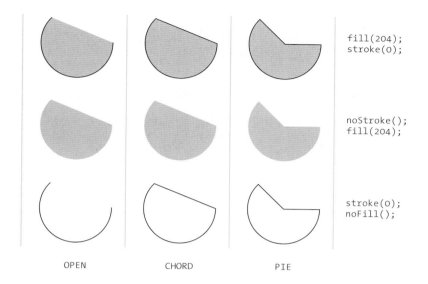

```
fill(204);
stroke(0);
```

```
noStroke();
fill(204);
```

```
stroke(0);
noFill();
```

OPEN CHORD PIE

Figure 3-2 Arcs

The position, size, and angles of an arc are defined with six parameters. A seventh parameter can be used to connect the ends of the arc in different ways. The figure shows how to use the OPEN, CHORD, and PIE parameters.

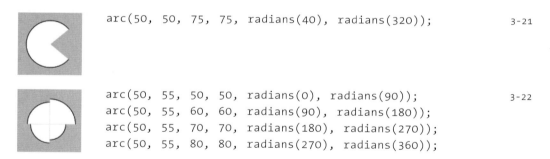

```
arc(50, 50, 75, 75, radians(40), radians(320));                3-21
```

```
arc(50, 55, 50, 50, radians(0), radians(90));                  3-22
arc(50, 55, 60, 60, radians(90), radians(180));
arc(50, 55, 70, 70, radians(180), radians(270));
arc(50, 55, 80, 80, radians(270), radians(360));
```

There is another version of arc() that can render the shape in different ways:

```
arc(a, b, c, d, start, stop, mode)
```

The mode parameter can be one of three options: OPEN, CHORD, or PIE. As you can see in figure 3-2, OPEN is the default mode, with CHORD and PIE rendering the shape in alternate ways. The following example shows all of the drawing options, with fill() and stroke(). Notice that when stroke is disabled, there's no visible difference between OPEN and CHORD.

```
// Top row, filled and stroked                                    3-23
arc(20, 20, 28, 28, radians(0), radians(225), OPEN);
arc(50, 20, 28, 28, radians(0), radians(225), CHORD);
arc(80, 20, 28, 28, radians(0), radians(225), PIE);
// Middle row, not stroked
noStroke();
arc(20, 50, 28, 28, radians(0), radians(225), OPEN);
arc(50, 50, 28, 28, radians(0), radians(225), CHORD);
arc(80, 50, 28, 28, radians(0), radians(225), PIE);
// Bottom row, not filled
stroke(0);
noFill();
arc(20, 80, 28, 28, radians(0), radians(225), OPEN);
arc(50, 80, 28, 28, radians(0), radians(225), CHORD);
arc(80, 80, 28, 28, radians(0), radians(225), PIE);
```

The bezier() function can draw curves that are more complex than an arc. A Bézier curve is defined by a series of control points and anchor points. A curve is drawn between the anchor points, and the control points define its shape:

```
bezier(x1, y1, x2, y2, x3, y3, x4, y4)
```

The function requires eight parameters to set four coordinate pairs. The curve is drawn between the first and fourth coordinate pairs, and the control points are defined by the second and third coordinate pairs. In software that uses Bézier curves, such as Adobe Illustrator, the control points are represented by the tiny handles that protrude from the edge of a curve.

```
bezier(32, 20, 80, 5, 80, 75, 30, 75);                            3-24
// Draw the control points
line(32, 20, 80, 5);
ellipse(80, 5, 4, 4);
line(80, 75, 30, 75);
ellipse(80, 75, 4, 4);
```

```
bezier(85, 20, 40, 10, 60, 90, 15, 80);                           3-25
// Draw the control points
line(85, 20, 40, 10);
ellipse(40, 10, 4, 4);
line(60, 90, 15, 80);
ellipse(60, 90, 4, 4);
```

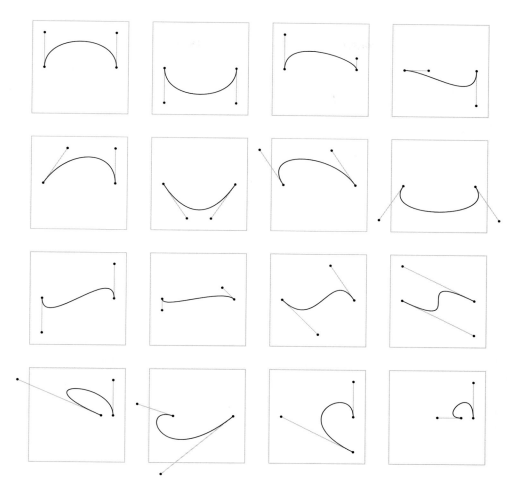

Figure 3-3 Bézier curves
The geometry of a Bézier curve is defined by anchor points and control points. The curve is drawn between the anchor points, but the shape of the curve is defined by the location of the control points.

Longer Bézier curves are made using the `bezierVertex()` function in combination with `vertex()` and `beginShape()`. This is explained on page 193. Another category of curves is defined by the `curveVertex()` function, defined on page 192.

Drawing order

The order in which shapes are drawn in the code defines which shapes appear on top of others in the display window. If a rectangle is drawn in the first line of a program, it is covered by an ellipse drawn in the second line of the program. Reversing the code order flips the visual result.

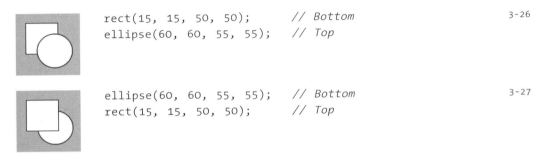

```
rect(15, 15, 50, 50);      // Bottom          3-26
ellipse(60, 60, 55, 55);   // Top
```

```
ellipse(60, 60, 55, 55);   // Bottom          3-27
rect(15, 15, 50, 50);      // Top
```

Gray values

The examples so far have used the default light-gray background, black lines, and white shapes. These default values are changed by the `background()`, `fill()`, and `stroke()` functions. The `background()` function sets the gray value of the display window with a number between 0 and 255. This range may be awkward if you're not familiar with selecting colors on a computer. The value 255 is white and the value 0 is black, with a range of gray values in between. If no background value is defined, the default value 204 (light gray) is used.

```
background(0);                                  3-28
```

```
background(124);                                3-29
```

```
background(230);
```

The fill() function sets the fill value of shapes, and the stroke() function sets the outline value of the drawn shapes. If no fill value is defined, the default value of 255 (white) is used. If no stroke value is defined, the default value of 0 (black) is used.

```
rect(10, 10, 50, 50);
fill(204);   // Light gray
rect(20, 20, 50, 50);
fill(153);   // Middle gray
rect(30, 30, 50, 50);
fill(102);   // Dark gray
rect(40, 40, 50, 50);
```

```
background(0);
rect(10, 10, 50, 50);
stroke(102); // Dark gray
rect(20, 20, 50, 50);
stroke(153); // Middle gray
rect(30, 30, 50, 50);
stroke(204); // Light gray
rect(40, 40, 50, 50);
```

Once a fill or stroke value is defined, it applies to all shapes drawn afterward. To change the fill or stroke value, use the fill() or stroke() function again.

```
fill(255);   // White
rect(10, 10, 50, 50);
rect(20, 20, 50, 50);
rect(30, 30, 50, 50);
fill(0);   // Black
rect(40, 40, 50, 50);
```

An optional second parameter to fill() and stroke() controls transparency. Set the parameter to 255 to make the shape entirely opaque; set it to 0 to make the shape totally transparent:

```
background(0);
fill(255, 220);   // High opacity
rect(15, 15, 50, 50);
rect(35, 35, 50, 50);
```

```
fill(0);
rect(0, 40, 100, 20);
fill(255, 51);    // Low opacity
rect(0, 20, 33, 60);
fill(255, 127);   // Medium opacity
rect(33, 20, 33, 60);
fill(255, 204);   // High opacity
rect(66, 20, 33, 60);
```

3-35

The stroke and fill of a shape can be disabled. The noFill() function stops Processing from filling shapes, and the noStroke() function stops lines from drawing and removes the outline from shapes. If noFill() and noStroke() are both used, nothing is drawn to the screen.

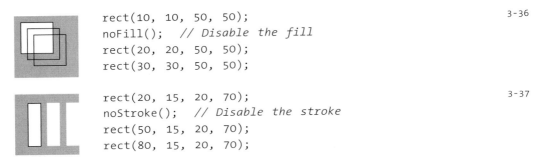

```
rect(10, 10, 50, 50);
noFill();  // Disable the fill
rect(20, 20, 50, 50);
rect(30, 30, 50, 50);
```

3-36

```
rect(20, 15, 20, 70);
noStroke();  // Disable the stroke
rect(50, 15, 20, 70);
rect(80, 15, 20, 70);
```

3-37

Defining fill and stroke colors is introduced in the next chapter (p. 32).

Attributes

In addition to changing the fill and stroke values, it is also possible to change attributes of the geometry. The noSmooth() and smooth() functions disable and enable smoothing (also called antialiasing). Smoothing is applied by default, so use noSmooth() to turn it off. Once smoothing has been turned off, use smooth() to enable it again.

```
ellipse(30, 48, 36, 36);
noSmooth();
ellipse(70, 48, 36, 36);
```

3-38

```
noSmooth();
ellipse(30, 48, 36, 36);
smooth();
ellipse(70, 48, 36, 36);
```

3-39

Line attributes are controlled by the strokeWeight(), strokeCap(), and strokeJoin() functions. The strokeWeight() function has one numeric parameter that sets the thickness of all lines drawn after the function is used. The strokeCap() function requires one parameter that can be either ROUND, SQUARE, or PROJECT.

ROUND makes round endpoints, and SQUARE squares them. PROJECT is a mix of the two that extends a SQUARE endpoint by the radius of the line. The strokeJoin() function has one parameter that can be either BEVEL, MITER, or ROUND. These parameters determine the way line segments or the stroke around a shape connects. BEVEL causes lines to join with squared corners, MITER is the default and joins lines with pointed corners, and ROUND creates a curve.

```
line(20, 20, 80, 20);    // Default line weight of 1
strokeWeight(6);
line(20, 40, 80, 40);    // Thicker line
strokeWeight(18);
line(20, 70, 80, 70);    // Thickest line
```
3-40

```
strokeWeight(12);
strokeCap(ROUND);
line(20, 30, 80, 30);    // Top line
strokeCap(SQUARE);
line(20, 50, 80, 50);    // Middle line
strokeCap(PROJECT);
line(20, 70, 80, 70);    // Bottom line
```
3-41

```
strokeWeight(12);
strokeJoin(BEVEL);
rect(12, 33, 15, 33);    // Left shape
strokeJoin(MITER);
rect(42, 33, 15, 33);    // Middle shape
strokeJoin(ROUND);
rect(72, 33, 15, 33);    // Right shape
```
3-42

Modes

By default, the parameters for ellipse() set the x-coordinate of the center, the y-coordinate of the center, the width, and the height. The ellipseMode() function changes the way these parameters are used to draw ellipses. The ellipseMode() function requires one parameter that can be either CENTER, RADIUS, CORNER, or CORNERS. The default mode is CENTER. The RADIUS mode also uses the first and second parameters of ellipse() to set the center, but causes the third parameter to set half of the width and the fourth parameter to set half of the height. The CORNER mode makes ellipse() work similarly to rect(). It causes the first and second parameters to

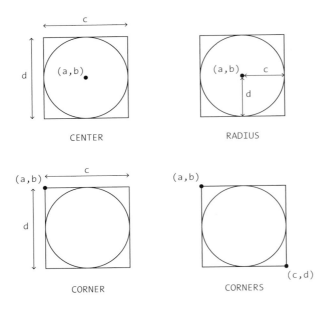

CENTER

RADIUS

CORNER

CORNERS

Figure 3-4 Drawing modes
The ellipseMode() *and*
rectMode() *functions change how*
ellipses and rectangles draw to the
screen. As shown in this figure, the
different parameters (e.g. CENTER)
adjust the position of the shapes. The
modes work the same for ellipse()
and rect(), *but the default mode*
for ellipse() *is CENTER and the*
default mode for rect() *is CORNER.*

position the upper-left corner of the rectangle that circumscribes the ellipse and uses the third and fourth parameters to set the width and height. The CORNERS mode has a similar affect to CORNER, but it causes the third and fourth parameters to ellipse() to set the lower-right corner of the rectangle.

```
noStroke();
ellipseMode(RADIUS);
fill(126);
ellipse(33, 33, 60, 60);   // Gray ellipse
fill(255);
ellipseMode(CORNER);
ellipse(33, 33, 60, 60);   // White ellipse
fill(0);
ellipseMode(CORNERS);
ellipse(33, 33, 60, 60);   // Black ellipse
```

3-43

In a similar fashion, the rectMode() function affects how rectangles are drawn. It requires one parameter that can be either CORNER, CORNERS, or CENTER. The default mode is CORNER, and CORNERS causes the third and fourth parameters of rect() to draw the corner opposite the first. The CENTER mode causes the first and second parameters of rect() to set the center of the rectangle and uses the third and fourth parameters as the width and height.

```
noStroke();
rectMode(CORNER);
fill(126);
rect(40, 40, 60, 60);      // Gray square
rectMode(CENTER);
fill(255);
rect(40, 40, 60, 60);      // White square
rectMode(CORNERS);
fill(0);
rect(40, 40, 60, 60);      // Black square
```

Exercises

1. On paper, draw a 4 × 4 grid of squares. Draw a different composition of lines and circles in each square.
2. Select one of the compositions from exercise 1 and code it.
3. Modify the code for exercise 2 to change the fill, stroke, and background values.
4. Create a composition with three ellipses to create an illusion of depth in the display window. Think about size, drawing order, and transparency.
5. Create a visual knot using only Bézier curves.

4 Color

This chapter introduces code elements and concepts for working with color in software.

Syntax introduced:
`blendMode()`, `colorMode()`

Working with color on screen is different from working with color on paper or canvas. While the same rigor applies, knowledge of pigments for painting (cadmium red, Prussian blue, burnt umber) and from printing (cyan, yellow, magenta) does not translate into the information needed to create colors for digital displays. For example, adding all the colors together on a computer monitor produces white, while adding all the colors together with paint produces black (or a strange brown). A computer monitor mixes colors with light. The screen is a black surface, and colored light is added. This is known as additive color, in contrast to the subtractive color model for inks on paper and canvas. This image presents the difference between these models:

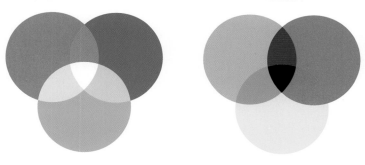

Additive color Subtractive color

The most common way to specify color on a computer is with RGB values. An RGB value sets the amount of red, green, and blue light in a single pixel of the screen. If you look closely at a computer monitor or television screen, you will see that each pixel is composed of three separate light elements of the colors red, green, and blue; but because our eyes can see only a limited amount of detail, the three colors mix to create a single color. The intensities of each color element are usually specified with values between 0 and 255 where 0 is the minimum and 255 is the maximum. Many other software applications also use this range. Setting the red, green, and blue components to 0 creates black. Setting these components to 255 creates white. Setting red to 255 and green and blue to 0 creates an intense red.

Selecting colors with convenient numbers can save effort. For example, it's common to see the parameters (0, 0, 255) used for blue and (0, 255, 0) for green. These combinations are often responsible for the garish coloring associated with technical images produced on the computer. They seem extreme and unnatural because they

don't account for the human eye's ability to distinguish subtle values. Colors that appeal to our eyes are usually not convenient numbers. Rather than picking numbers like 0 and 255, try using a color selector to choose colors more carefully. Processing's color selector is opened from the Tools menu. Colors are selected by clicking a location on the color field or by entering numbers directly. For example, in figure 4-1, the current blue selected is defined by an R value of 35, a G value of 211, and a B value of 229. These numbers can be used to recreate the chosen color in your code.

Color by number

In Processing, colors are defined by numeric parameters to the background(), fill(), and stroke() functions. By default, the first parameter defines the red color component, the second defines the green component, and the blue component is defined by the third. The optional fourth parameter to fill() or stroke() defines the transparency. The parameter value 255 means the color is entirely opaque, and the value 0 means it's completely transparent (it won't be visible).

```
background(242, 204, 47);
```
4-01

```
background(174, 221, 60);
```
4-02

```
background(129, 130, 87);
noStroke();
fill(174, 221, 60);
rect(17, 17, 66, 66);
```
4-03

```
background(129, 130, 87);
noFill();
strokeWeight(4);
stroke(174, 221, 60);
rect(19, 19, 62, 62);
```
4-04

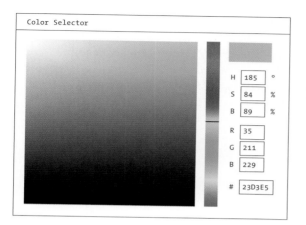

Color Selector

H	185	°
S	84	%
B	89	%
R	35	
G	211	
B	229	
#	23D3E5	

Figure 4-1 Color Selector
Drag the cursor inside the window or input numbers to select a color. The large square area determines the saturation and brightness, and the thin vertical strip determines the hue. The numeric value of the selected color is displayed in HSB, RGB, and hexadecimal notation.

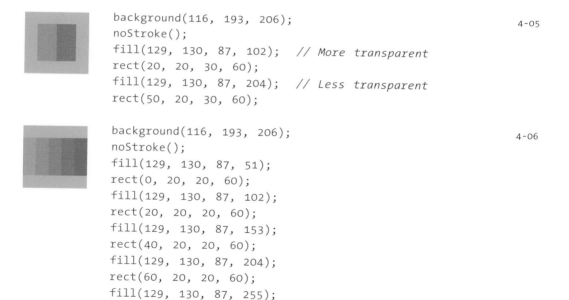

```
background(116, 193, 206);
noStroke();
fill(129, 130, 87, 102);   // More transparent
rect(20, 20, 30, 60);
fill(129, 130, 87, 204);   // Less transparent
rect(50, 20, 30, 60);
```
4-05

```
background(116, 193, 206);
noStroke();
fill(129, 130, 87, 51);
rect(0, 20, 20, 60);
fill(129, 130, 87, 102);
rect(20, 20, 20, 60);
fill(129, 130, 87, 153);
rect(40, 20, 20, 60);
fill(129, 130, 87, 204);
rect(60, 20, 20, 60);
fill(129, 130, 87, 255);
rect(80, 20, 20, 60);
```
4-06

```
background(56, 90, 94);
strokeWeight(12);
stroke(242, 204, 47, 102);    // More transparency
line(30, 20, 50, 80);
stroke(242, 204, 47, 204);    // Less transparency
line(50, 20, 70, 80);
```

4-07

```
background(56, 90, 94);
strokeWeight(12);
stroke(242, 204, 47, 51);
line(0, 20, 20, 80);
stroke(242, 204, 47, 102);
line(20, 20, 40, 80);
stroke(242, 204, 47, 153);
line(40, 20, 60, 80);
stroke(242, 204, 47, 204);
line(60, 20, 80, 80);
stroke(242, 204, 47, 255);
line(80, 20, 100, 80);
```

4-08

Transparency can be used to create new colors by overlapping shapes. The colors originating from overlaps depend on the order in which the shapes are drawn.

```
background(0);
noStroke();
fill(242, 204, 47, 160);    // Yellow
ellipse(47, 36, 64, 64);
fill(174, 221, 60, 160);    // Green
ellipse(90, 47, 64, 64);
fill(116, 193, 206, 160);   // Blue
ellipse(57, 79, 64, 64);
```

4-09

```
background(255);
noStroke();
fill(242, 204, 47, 160);    // Yellow
ellipse(47, 36, 64, 64);
fill(174, 221, 60, 160);    // Green
ellipse(90, 47, 64, 64);
fill(116, 193, 206, 160);   // Blue
ellipse(57, 79, 64, 64);
```

4-10

Blend

Colors can be mixed on screen according to the current blend mode of the sketch. By default, Processing replaces colors or blends them if transparency is used. The blendMode() function mixes pixels in different ways depending on a single parameter. When shapes and images are drawn to the screen, the pixels mix according to the rules of each blend mode. The mode options are BLEND, ADD, SUBTRACT, DARKEST, LIGHTEST, DIFFERENCE, EXCLUSION, MULTIPLY, SCREEN, and REPLACE. Like the fill and stroke settings, after the blend mode is set, it remains in that mode until is it changed again. A selection of the modes is explained in figure 4-2, and code samples follow.

```
size(100, 100);
stroke(153, 204);
strokeWeight(12);
background(0);
line(20, 20, 40, 80);
line(40, 20, 20, 80);
blendMode(ADD);    // Change blend mode
line(60, 20, 80, 80);
line(80, 20, 60, 80);
```

4-11

The default mode is BLEND, so after the mode is changed, restore the default by setting the mode back to BLEND. The next example is similar to the first, but it starts by changing the blend mode to ADD, then restores the default after.

```
size(100, 100);
stroke(153, 204);
strokeWeight(12);
background(0);
blendMode(ADD);        // Change blend mode
line(20, 20, 40, 80);
line(40, 20, 20, 80);
blendMode(BLEND);      // Restore default blend mode
line(60, 20, 80, 80);
line(80, 20, 60, 80);
```

4-12

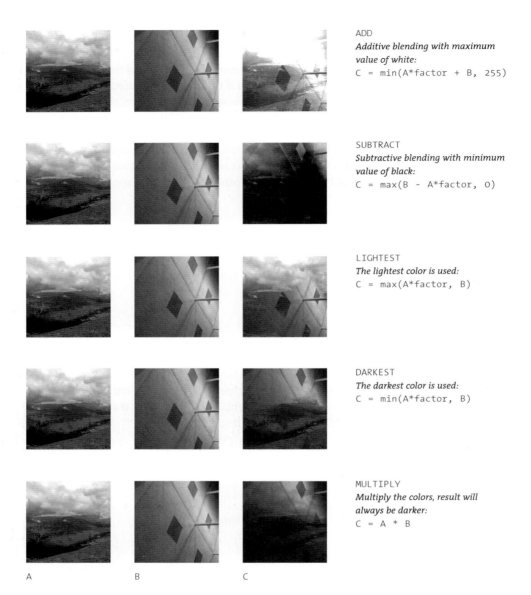

ADD
*Additive blending with maximum
value of white:*
```
C = min(A*factor + B, 255)
```

SUBTRACT
*Subtractive blending with minimum
value of black:*
```
C = max(B - A*factor, 0)
```

LIGHTEST
The lightest color is used:
```
C = max(A*factor, B)
```

DARKEST
The darkest color is used:
```
C = min(A*factor, B)
```

MULTIPLY
*Multiply the colors, result will
always be darker:*
```
C = A * B
```

A B C

Figure 4-2 Blending
The blendMode() *function changes the way colors are mixed when a
shape or image is drawn to the display window. The equations shown
with each description mathematically define each blending technique. In
the diagram, the letters A and B are the pixels of the source images, and
C is the pixels of the resulting image. The* factor *is the alpha
component (transparency) of the source image. Additional blend modes
are documented in the Processing reference.*

RGB, HSB

Processing uses the RGB color model as its default for working with color, but the HSB specification can be used instead to define colors in terms of their hue, saturation, and brightness. The hue of a color is what most people normally think of as the color name: yellow, red, blue, orange, green, violet. A pure hue is an undiluted color at its most intense. The saturation is the degree of purity in a color. It is the continuum from the undiluted, pure hue to its most diluted and dull. The brightness of a color is its relation to light and dark.

The colorMode() function sets the color space for a sketch. The parameters to colorMode() change the way Processing interprets color data. The first parameter is either RGB or HSB. The optional, additional parameters allow Processing to use different values to define the colors rather than the default of 0 to 255. Either a single parameter sets the range for all the color components, or three parameters set the range for each—either red, green, blue or hue, saturation, brightness, depending on the value of the first parameter.

```
// Set the range for the red, green, and blue values from 0.0 to 1.0      4-13
colorMode(RGB, 1.0);
```

A useful setting for HSB mode is to set the parameters respectively to 360, 100, and 100. The hue values from 0 to 360 are the degrees around the color wheel, and the saturation and brightness values from 0 to 100 are percentages. This setting matches the values used in many color selectors and therefore makes it easy to transfer color data between other programs and Processing:

```
// Set the range for the hue to values from 0 to 360 and the          4-14
// saturation and brightness to values between 0 and 100
colorMode(HSB, 360, 100, 100);
```

The following examples reveal the differences between hue, saturation, and brightness.

```
// Change the hue, same saturation and brightness          4-15
colorMode(HSB, 360, 100, 100);
noStroke();
fill(0, 100, 100);
rect(0, 0, 25, 100);
fill(90, 100, 100);
rect(25, 0, 25, 100);
fill(180, 100, 100);
rect(50, 0, 25, 100);
fill(270, 100, 100);
rect(75, 0, 25, 100);
```

RGB			HSB			HEX
255	0	0	360	100	100	#FF0000
252	9	45	351	96	99	#FC0A2E
249	16	85	342	93	98	#F91157
249	23	126	332	90	98	#F91881
246	31	160	323	87	97	#F720A4
244	38	192	314	84	96	#F427C4
244	45	226	304	81	96	#F42EE7
226	51	237	295	78	95	#E235F2
196	58	237	285	75	95	#C43CF2
171	67	234	276	71	94	#AB45EF
148	73	232	267	68	93	#944BED
126	81	232	257	65	93	#7E53ED
108	87	229	248	62	92	#6C59EA
95	95	227	239	59	91	#5F61E8
102	122	227	229	56	91	#667DE8
107	145	224	220	53	90	#6B94E5
114	168	224	210	50	90	#72ACE5
122	186	221	201	46	89	#7ABEE2
127	200	219	192	43	88	#7FCDE0
134	216	219	182	40	88	#86DDE0
139	216	207	173	37	87	#8BDDD4
144	214	195	164	34	86	#90DBC7
151	214	185	154	31	86	#97DBBD
156	211	177	145	28	85	#9CD8B5
162	211	172	135	25	85	#A2D8B0
169	209	169	126	21	84	#A9D6AD
175	206	169	117	18	83	#AFD3AD
185	206	175	107	15	83	#BAD3B3
192	204	180	98	12	82	#C1D1B8
197	201	183	89	9	81	#C5CEBB
202	201	190	79	6	81	#CACEC2
202	200	193	70	3	80	#CACCC5

Figure 4-3 Color by numbers
Every color in code is set by numbers, and there are more than 16 million colors to choose from. This diagram presents a few colors and their corresponding numbers for the RGB and HSB color models. The RGB column is in relation to colorMode(RGB, 255) *and the HSB column is in relation to* colorMode(HSB, 360, 100, 100).

```
// Change the saturation, same hue and brightness
colorMode(HSB, 360, 100, 100);
noStroke();
fill(180, 0, 80);
rect(0, 0, 25, 100);
fill(180, 25, 80);
rect(25, 0, 25, 100);
fill(180, 50, 80);
rect(50, 0, 25, 100);
fill(180, 75, 80);
rect(75, 0, 25, 100);
```
4-16

```
// Change the brightness, same hue and saturation
colorMode(HSB, 360, 100, 100);
noStroke();
fill(180, 42, 0);
rect(0, 0, 25, 100);
fill(180, 42, 25);
rect(25, 0, 25, 100);
fill(180, 42, 50);
rect(50, 0, 25, 100);
fill(180, 42, 75);
rect(75, 0, 25, 100);
```
4-17

It's easy to make smooth transitions between colors by changing the values used for *fill()* and *stroke()*. The HSB model has an enormous advantages over the RGB model when working with code because it's more intuitive. Changing the values of the red, green, and blue components often has unexpected visual results, while estimating the results of changes to hue, saturation, and brightness follows a more logical path. The following examples show a transition from red to green. The first example makes this transition using the RGB model. It requires calculating more than one color value, and the saturation of the color unexpectedly changes in the middle. The second example makes the transition using the HSB model. Only one number needs to be altered, and the hue changes smoothly and independently from the other color properties.

```
// Shift from red to green in RGB mode
colorMode(RGB, 255, 255, 255);
noStroke();
fill(206, 60, 60);
rect(0, 0, 20, 100);
fill(186, 89, 60);
rect(20, 0, 20, 100);
fill(166, 118, 60);
```
4-18

```
rect(40, 0, 20, 100);
fill(147, 147, 60);
rect(60, 0, 20, 100);
fill(108, 206, 60);
rect(80, 0, 20, 100);
```

```
// Shift from red to green in HSB mode
colorMode(HSB, 360, 100, 100);
noStroke();
fill(0, 70, 80);
rect(0, 0, 20, 100);
fill(25, 70, 80);
rect(20, 0, 20, 100);
fill(50, 70, 80);
rect(40, 0, 20, 100);
fill(75, 70, 80);
rect(60, 0, 20, 100);
fill(100, 70, 80);
rect(80, 0, 20, 100);
```

Hexadecimal

Hexadecimal (hex) notation is an alternative notation for defining color. This method is popular with designers working on the web because standards such as HyperText Markup Language (HTML) and Cascading Style Sheets (CSS) use this notation. Hex notation for color encodes each of the numbers from 0 to 255 into a two-digit value using the numbers 0 through 9 and the letters A through F. In this way three RGB values from 0 to 255 can be written as a single six-digit hex value. A few sample conversions demonstrate this notation:

RGB	Hex
255, 255, 255	#FFFFFF
0, 0, 0	#000000
102, 153, 204	#6699CC
195, 244, 59	#C3F43B
116, 206, 206	#74CECE

Converting color values from RGB to hex notation is not intuitive. Most often, the value is taken from a color selector. For instance, you can copy and paste a hex value from Processing's color selector into your code. When using color values encoded in hex notation, you must place a # before the value to distinguish it within the code.

```
// Code 4-03 rewritten using hex numbers
background(#818257);
noStroke();
fill(#AEDD3C);
rect(17, 17, 66, 66);
```

There's more information about hex notation in appendix D (p. 609).

Exercises

1. *Open the color selector and choose different colors. Record the RGB, HSB, and hexadecimal numbers for some of the colors you prefer.*
2. *Change code 4-08 to use the colors you discovered in exercise 1.*
3. *Modify codes 4-09 and 4-10 to use the* blendMode() *function. Notice how different colors respond to different modes and backgrounds.*
4. *Switch the color mode for code 4-05 to HSB and match the default RGB colors exactly.*
5. *Redraw your composition from exercise 2 to use hexadecimal color values.*

5 Variables

This chapter introduces different types of data and explains how to create variables, assign values, and operate on them.

Syntax introduced:
```
int, float, boolean, true, false, = (assign), color, color()
width, height
+ (add), - (subtract), * (multiply), / (divide), % (modulus)
() (parentheses)
boolean(), byte(), char(), float(), int(), str()
++ (increment), -- (decrement), += (add assign), -= (subtract
assign) *= (multiply assign), /= (divide assign), - (negation)
```

What is data? Data often consists of measurements of physical characteristics. For example, Casey's California driver's license states that his sex is M, his hair is BRN, and his eyes are HZL. The values M, BRN, and HZL are items of data associated with Casey. Data can be the population of a country, the average annual rainfall in Los Angeles, or your current heart rate. In software, data is stored as numbers and characters. Examples of digital data include a photograph of a friend stored on your hard drive, a song downloaded from the Internet, and a news article loaded through a web browser. Less obvious is the data continually created and exchanged between computers and other devices. For example, computers are continually receiving data from the mouse and keyboard. When writing a program, you might create a data element to save the location of a shape, to store a color for later use, or to continuously measure changes in cursor position.

Data types

Processing can store and modify many different kinds of data, including numbers, letters, words, colors, images, fonts, and boolean values (`true`, `false`). The computer stores each in a different way, so it has to know which type of data is being used to know how to manage it. For example, storing a word takes more room than storing one letter; therefore, storing the word *Cincinnati* requires more space than storing the letter *C*. If space has been allocated for only one letter, trying to store a word in the same space will cause an error. Every data element is represented as a sequence of bits (0s and 1s) in the computer's memory (more information about bits is found in Appendix D, p. 609). For example, 01000001 can be interpreted as the letter *A*, and it can also be interpreted as the number 65. It's necessary to specify the type of data so the computer knows how to correctly interpret the bits.

Numeric data is the first type of data encountered in the following sections of this book. There are two types of numeric data used in Processing: integer and floating-point. Integers are whole numbers such as 12, -120, 8, and 934. Processing represents integer data with the int data type. Floating-point numbers have a decimal point for creating fractions of whole numbers such as 12.8, -120.75, 8.125, and 934.82736. Processing represents floating-point data with the float data type. Floating-point numbers are often used to approximate analog or continuous values because they have decimal resolution. For example, using integer values, there is only one number between 3 and 5, but floating-point numbers allow us to express myriad numbers between such as 4.0, 4.5, 4.75, 4.825, etc. Both int and float values may be positive, negative, or zero.

The simplest data element in Processing is a boolean variable. Variables of this type can have only one of two values—true or false. The name boolean refers to the mathematician George Boole (b. 1815), the inventor of Boolean algebra—the foundation for how digital computers work. A boolean variable is often used to make decisions about which lines of code are run and which are ignored.

The following table compares the capacities of the data types mentioned earlier with other common data types:

Name	Size	Value range
boolean	1 bit	true or false
byte	8 bits	-128 to 127
char	16 bits	0 to 65535
int	32 bits	-2,147,483,648 to 2,147,483,647
float	32 bits	3.40282347E+38 to -3.40282347E+38
color	32 bits	16,777,216 colors

These data types are called *primitive* data types because they store a single data element. The types for storing text (String), images (PImage), and fonts (PFont) are different. Variables created from these data types are *objects*. Objects are usually composed of several primitive data types (or other objects) and can also have functions inside to act on their data. For example, a String object stores an array of characters and has functions that return the number of characters or the character at a specific location. These additional types of data are introduced and explained in Images (p. 163), Typography (p. 149), and Objects (p. 359).

Variables

A variable is a container for storing data. Variables allow a data element to be reused many times within a program. Every variable has two parts, a name and a value. If the number 21 is stored in the variable called *age*, every time the word *age* appears in the program, it will be replaced with the value 21 when the code is run. In addition to its name and value, every variable has a data type that defines the category of data it can hold.

A variable must be declared before it is used. A variable declaration states the data type and variable name. The following lines declare variables and then assign values to them:

```
int x;       // Declare the variable x of type int
float y;     // Declare the variable y of type float
boolean b;   // Declare the variable b of type boolean
x = 50;      // Assign the value 50 to x
y = 12.6;    // Assign the value 12.6 to y
b = true;    // Assign the value true to b
```

5-01

As a shortcut, a variable can be declared and assigned on one line:

```
int x = 50;
float y = 12.6;
boolean b = true;
```

5-02

More than one variable can be declared in one line if they have the same data type, and the variables can then be assigned separately:

```
float x, y, z;
x = -3.9;
y = 10.1;
z = 124.23;
```

5-03

When a variable is declared, it is necessary to state the data type before its name; but after it's declared, the data type cannot be changed or restated. If the data type is included again for the same variable, the computer will interpret this as an attempt to make a new variable with the same name. This will cause an error (an exception to this rule is made when each variable has a different scope, p. 80):

```
int x = 69;   // Assign 69 to x
x = 70;       // Assign 70 to x
int x = 71;   // ERROR! The data type for x is duplicated
```

5-04

The = symbol is called the assignment operator. It assigns the value from the right side of the = to the variable on its left. Values can be assigned only to variables. Trying to assign a constant to another constant produces an error:

```
// Error! The left side of an assignment must be a variable
5 = 12;
```

5-05

When working with variables of different types in the same program, be careful not to mix types in a way that causes an error. For example, it is not possible to fit a floating-point number into an integer variable:

```
// Error! It's not possible to fit a floating-point number into an int
int x = 24.8;
```

```
float f = 12.5;
// Error! It's not possible to fit a floating-point number into an int
int y = f;
```
5-07

Working with color data is a little different from creating integers and boolean variables because the color must first be constructed with the color() function. As with fill() and stroke(), the parameters to the color() function define the precise color. One parameter to the function defines a gray value, two parameters define a gray value with transparency, three parameters define a color value, and four parameters define a color value with transparency. Variables of the color data type can store all of these configurations.

```
color c1 = color(51);                    // Creates gray
color c2 = color(51, 204);               // Creates gray with transparency
color c3 = color(51, 102, 153);          // Creates blue
color c4 = color(51, 102, 153, 51);      // Creates blue with transparency
```
5-08

After a color variable has been defined, it can be used as the parameter to the background(), fill(), and stroke() functions.

```
color ruby = color(211, 24, 24, 160);
color pink = color(237, 159, 176);
background(pink);
noStroke();
fill(ruby);
rect(35, 0, 20, 100);
```
5-09

Variable names

The name of each variable is defined by the programmer; the name of the variable should describe its content. This makes programs easier to read and can reduce the need for verbose commenting. For instance, a variable storing the temperature of the room could logically have the following names:

```
t
temp
temperature
roomTemp
roomTemperature
```

Variables like t should be used minimally or not at all because they are cryptic—there's no hint as to what they contain. However, long names such as *roomTemperature* can also make code tedious to read. If we were writing a program with this variable, our preference might be to use the name *roomTemp* because it is both concise and descriptive. The name *temp* could also work, but because it's used commonly as an abbreviation for "temporary," it wouldn't be the best choice.

There are a few conventions that make it easier for other people to read your programs. Variables' names should start with a lowercase letter, and if there are multiple words in the name, the first letter of each additional word should be capitalized. There are a few absolute rules in naming variables. Variable names cannot start with numbers, and they must not be a reserved word. Examples of reserved words include int, if, true, and null. A complete list is found in Appendix B (p. 603). To avoid confusion, variables should not have the same names as elements of the Processing language such as line and ellipse. The complete Processing language is listed in the reference included with the software.

Another important consideration related to variables is the scope (p. 80). The scope of a variable defines where it can be used relative to where it is created.

Processing variables

The Processing language has built-in variables for storing commonly used data. The width and height of the display window are stored in variables called width and height. If a program doesn't include size(), the width and height variables are both set to 100. Test by running the following programs. The println() function is used to write the variable values to the Processing console, the area below the text editor:

```
println(width + ", " + height);    // Prints "100, 100" to the console    5-10

size(300, 400);                                                            5-11
println(width + ", " + height);    // Prints "300, 400" to the console

size(1280, 1024);                                                          5-12
println(width + ", " + height);    // Prints "1280, 1024" to the console
```

Using the width and height variables is useful when writing a program to scale to different sizes. This technique allows a simple change to the parameters of size() to alter the dimensions and proportions of a program, rather than changing values

throughout the code. Run the following code with different values in the `size()` function to see it scale to every window size.

```
size(100, 100);                                                        5-13
ellipse(width*0.5, height*0.5, width*0.66, height*0.66);
line(width*0.5, 0, width*0.5, height);
line(0, height*0.5, width, height*0.5);
```

You should always use actual numbers in `size()` instead of variables. When a sketch is exported, these numbers are used to determine the dimension of the program. More information about this can be found in the reference for `size()`.

Processing variables that store the cursor position and the most recent key pressed are discussed in the Interaction chapter (p. 83).

Arithmetic

In programming, the visual properties of an image on the screen are defined by numbers, which means that the image can be controlled mathematically. For example, a rectangle might have a horizontal position of 10, a vertical position of 10, a width and height of 55, and a gray value of 153. If the gray value is stored in the variable *grayVal* and 102 is added to this variable, the gray value will become 255, and the shape will appear white on screen. This is demonstrated succinctly in code:

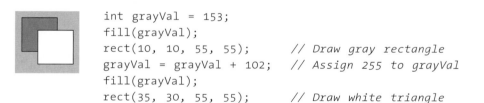

```
int grayVal = 153;                                                     5-14
fill(grayVal);
rect(10, 10, 55, 55);       // Draw gray rectangle
grayVal = grayVal + 102;    // Assign 255 to grayVal
fill(grayVal);
rect(35, 30, 55, 55);       // Draw white triangle
```

The expression to the right of the = symbol is evaluated before the value is assigned to the variable on the left. Therefore, the statement a=5+4 first adds 5 and 4 to yield 9 and then assigns the value 9 to the variable a.

Within the visual domain, addition, subtraction, multiplication, and division can be used to control the position of elements on the screen or to change attributes such as size or gray value. The + symbol is used for addition, the - symbol for subtraction, the * symbol for multiplication, and the / symbol for division.

```
int a = 30;                                                            5-15
line(a, 0, a, height);
a = a + 40;   // Assign 70 to a
strokeWeight(4);
line(a, 0, a, height);
```

```
int a = 30;
int b = 40;
line(a, 0, a, height);
line(b, 0, b, height);
strokeWeight(4);
// A calculation can be used as an input to a function
line(b-a, 0, b-a, height);
```

5-16

```
int a = 8;
int b = 10;
line(a, 0, a, height);
line(b, 0, b, height);
strokeWeight(4);
line(a*b, 0, a*b, height);
```

5-17

```
int a = 8;
int b = 10;
line(a, 0, a, height);
line(b, 0, b, height);
strokeWeight(4);
line(a/b, 0, a/b, height);
```

5-18

```
int y = 20;
line(0, y, width, y);
y = y + 6;  // Assign 26 to y
line(0, y, width, y);
y = y + 6;  // Assign 32 to y
line(0, y, width, y);
y = y + 6;  // Assign 38 to y
line(0, y, width, y);
```

5-19

```
float y = 20;
line(0, y, width, y);
y = y * 1.6;  // Assign 32.0 to y
line(0, y, width, y);
y = y * 1.6;  // Assign 51.2 to y
line(0, y, width, y);
y = y * 1.6;  // Assign 81.920006 to y
line(0, y, width, y);
```

5-20

The +, -, *, /, and = symbols are probably familiar, but the % is more exotic. The % operator calculates the remainder when one number is divided by another. The %, the code notation for modulus, returns the integer remainder after dividing the number to the left of the symbol by the number to the right.

Expression	Result	Explanation
9 % 3	0	3 goes into 9 three times, with no remainder
9 % 2	1	2 goes into 9 four times, with 1 as the remainder
35 % 4	3	4 goes into 35 eight times, with 3 remaining

Modulus can be explained with an anecdote. After a hard day of work, Casey and Ben were hungry. They went to a restaurant to eat dumplings, but there were only 9 dumplings left, so they had to share. If they share equally, how many dumplings can they each eat, and how many will remain? It's obvious that each can have 4 dumplings and 1 will remain. If there are 4 people and 35 dumplings, each can eat 8, and 3 will remain. In these examples, the modulus value is the number of remaining dumplings.

The modulus operator is often used to keep numbers within a desired range. For example, if a variable is continually increasing (0, 1, 2, 3, 4, 5, 6, 7, etc.), applying the modulus operator can transform this sequence. A continually increasing number can be made to cycle continuously between 0 and 3 by applying %4:

x	0	1	2	3	4	5	6	7	8	9	10
x % 4	0	1	2	3	0	1	2	3	0	1	2

Many examples throughout this book use % in this way.

Mind the data types

When working with mathematical operators and variables, it is important to be aware of the data types of the variables you're using. The combination of two integers will always result in an int. The combination of two floating-point numbers will always result in a float, but when an int and float are operated on, the result is a float.

```
println(4/3);      // Prints "1"                              5-21
println(4.0/3);    // Prints "1.3333334"
println(4/3.0);    // Prints "1.3333334"
println(4.0/3.0);  // Prints "1.3333334"
```

Integer values can be assigned to floating-point variables, but not vice versa. Assigning a float to an int makes the number less accurate, so Processing requires that you do so explicitly (discussed on page 59). Working with an int and a float will upgrade the int and treat both numbers as floating-point values, but the result won't fit into an int variable.

```
int a = 4/3;      // Assign 1 to a                            5-22
int b = 3/4;      // Assign 0 to b
int c = 4.0/3;    // ERROR!
int d = 4.0/3.0;  // ERROR!
```

```
float e = 4.0/3;      // Assign 1.3333334 to e
float f = 4.0/3.0;    // Assign 1.3333334 to f
```

5-22
cont.

The last two calculations require additional explanation. The result of dividing two integers will always be an integer: dividing the integer 4 by the integer 3 equals 1. This result is converted to a floating-point variable *after* the calculation has finished, so the 1 becomes 1.0 only once it has reached the left side of the = sign. While this may seem confusing, it can be useful for more advanced programs.

```
float a = 4/3;        // Assign 1.0 to a
float b = 3/4;        // Assign 0.0 to b
```

5-23

The rules of calculating int and float values can become obscured when variables are used instead of the actual numbers. It's important to be aware of the data types for variables to avoid this problem.

```
int i = 4;
float f = 3.0;
int a = i/f;          // ERROR! Assign a float value to an int variable
float b = i/f;        // Assign 1.3333334 to b
```

5-24

It's also important to pay attention to the value of variables to avoid making arithmetic errors. For example, dividing a number by zero is undefined in mathematics, but in software it just causes an error.

```
int a = 0;
int b = 12/a;         // ERROR! ArithmeticException: / by zero
```

5-25

Similarly, dividing by an extremely small number can yield an enormous result. This can be confusing when drawing shapes because they will not be visible in the display window.

```
float a = 0.0001;
float b = 12/a;       // Assign 120000.0 to b
```

5-26

Data conversion

Sometimes it is necessary or convenient to convert a value from one type of data to another, a task for which Processing has several functions. Some data type conversions are automatic and others need to be made explicit with functions written for data type conversion. As alluded to previously, automatic conversions are made between compatible types. For example, an int can be automatically converted to a float, but a float can't be automatically converted to an int:

```
float f = 12.6;
int i = 127;
f = i;   // Converts 127 to 127.0
i = f;   // Error: Can't automatically convert a float to an int
```

How does one know which data types are compatible and which require an explicit conversion? Conversions that involve a loss of information must be explicit. When converting an int to a float, nothing is lost. When converting a float to an int, however, the numbers after the decimal point are lost. Explicit conversions are a way of stating in code that this loss of information is intentional. The functions for explicit data type conversion are boolean(), byte(), char(), float(), int(), and str(). Each is used to convert other data types to the type for which the function is named.

The boolean() function converts the number 0 to false and all other numbers to true. It converts the string "true" to true and the string "false" to false.

```
int i = 0;
boolean b = boolean(i);   // Assign false to b
int n = 12;
b = boolean(n);           // Assign true to b
String s = "false";
b = boolean(s);           // Assign false to b
```

The byte() function converts other types of data to a byte representation. A byte can only be a whole number between -128 and 127; therefore, when a number outside this range is converted, its value wraps to the corresponding byte representation.

```
float f = 65.0;
byte b = byte(f);         // Assign 65 to b
char c = 'E';
b = byte(c);              // Assign 69 to b
f = 130.0;
b = byte(f);              // Assign -126 to b
```

The char() function converts other types of data to a character representation. More information about the char data type will be found later in the book (p. 144). An explanation of the numbering can be found in Appendix C (p. 604).

```
int i = 65;
byte y = 72;
char c = char(i);         // Assign 'A' to c
c = char(y);              // Assign 'H' to c
```

The float() function converts other types of data to a floating-point representation. It is most often used when making calculations. As discussed, dividing two integers will

always evaluate as an integer, which is a problem when working with fractions. For example, when the integer number 3 is divided by 6, the answer is the integer value 0 rather than the often desired floating-point value 0.5. Converting one of these values to a float allows the expression to evaluate to a floating-point value.

```
int i = 2;
int j = 3;
float f1 = i/j;            // Assign 0.0 to f1
float f2 = i/float(j);     // Assign 0.6666667 to f2
```

5-31

The int() function converts other types of data to an integer representation. It converts float values by dropping the values after the decimals rather than rounding. Many of the math functions only return float values, and it's necessary to convert them to integers for use in other parts of a program.

```
float f = 65.9;
int i = int(f);       // Assign 65 to i
char c = 'E';
i = int(c);           // Assign 69 to i
```

5-32

Order of operations

The *order of operations* determines which operators perform their calculations before others. For example, multiplication is always evaluated before addition regardless of the sequence of the elements. The expression 3+4*5 evaluates to 23 because 4 is first multiplied by 5 to yield 20 and then 3 is added to yield 23. The order of operations specifies that multiplication always precedes addition regardless of the order in which they appear in the expression. The order of operations for evaluating expressions can be changed by adding parentheses. For example, if an addition operation appears in parentheses, it will be performed prior to multiplication. The expression (3+4)*5 evaluates to 35 because 3 is first added to 4 to yield 7, which is then multiplied by 5 to yield 35. This is more concisely expressed in code:

```
float x = 3 + 4 * 5;       // Assign 23 to x
float y = (3 + 4) * 5;     // Assign 35 to y
```

5-33

In many cases, parentheses are necessary to force elements of an expression to evaluate before others, but sometimes they are used only to clarify the order of operations. The following lines calculate the same result because multiplication always happens before addition, but you may find the second line more clear.

```
float x = 10 * 20 + 5;       // Assign 205 to x
float y = (10 * 20) + 5;     // Assign 205 to y
```

5-34

The following table shows the operator precedence for the operators introduced so far. Items at the top precede those toward the bottom.

Multiplicative	* / %
Additive	+ -
Assignment	=

This means, for example, that division will always happen before subtraction and addition will always happen before assignment. A complete listing for the order of operations is listed in Appendix A (p. 601).

Shortcuts

There are many repetitive expressions in calculating the value of variables, so code shortcuts are used to make programs more concise. The increment operator ++ adds the value 1 to a variable, and the decrement operator -- subtracts the value of 1:

```
int x = 1;
println(x);      // Prints "1" to the console
x++;             // Equivalent to x = x + 1
println(x);      // Prints "2" to the console

int y = 1;
println(y);      // Prints "1" to the console
y--;             // Equivalent to y = y - 1
println(y);      // Prints "0" to the console
```
5-35

The value is incremented or decremented after the expression is evaluated. This often creates confusion and is shown in this example:

```
int x = 1;
println(x++);    // Prints "1" to the console
println(x);      // Prints "2" to the console
```
5-36

To update the value before the expression is evaluated, place the operator in front of the variable:

```
int x = 1;
println(++x);    // Prints "2" to the console
println(x);      // Prints "2" to the console
```
5-37

The add assign operator += combines addition and assignment. The subtract assign operator -= combines subtraction with assignment:

5-38

```
int x = 1;
println(x);    // Prints "1" to the console
x += 5;        // Equivalent to x = x + 5
println(x);    // Prints "6" to the console

int y = 1;
println(y);    // Prints "1" to the console
y -= 5;        // Equivalent to y = y - 5
println(y);    // Prints "-4" to the console
```

The multiply assign operator *= combines multiplication with assignment. The divide assign operator /= combines division with assignment:

5-39

```
int x = 4;
println(x);    // Prints "4" to the console
x *= 2;        // Equivalent to x = x * 2
println(x);    // Prints "8" to the console

int y = 4;
println(y);    // Prints "4" to the console
y /= 2;        // Equivalent to y = y / 2
println(y);    // Prints "2" to the console
```

The negation operator - changes the sign of value to its right. It can be used in place of multiplying a value by -1.

5-40

```
int x = 5;     // Assigns 5 to x
x = -x;        // Equivalent to x = x * -1
println(x);    // Prints "-5"
```

Exercises

1. *Think about different types of numbers you use daily and write them down. Are they integer or floating-point numbers?*
2. *Make a few* int *and* float *variables. Try assigning them in different ways. Write the values to the console with* println()*.*
3. *Create a composition that scales proportionally with different window sizes. Put different values into* size() *to test.*
4. *Use one variable to set the position and size for three ellipses.*
5. *Use multiplication to create a series of lines with increasing space between each.*

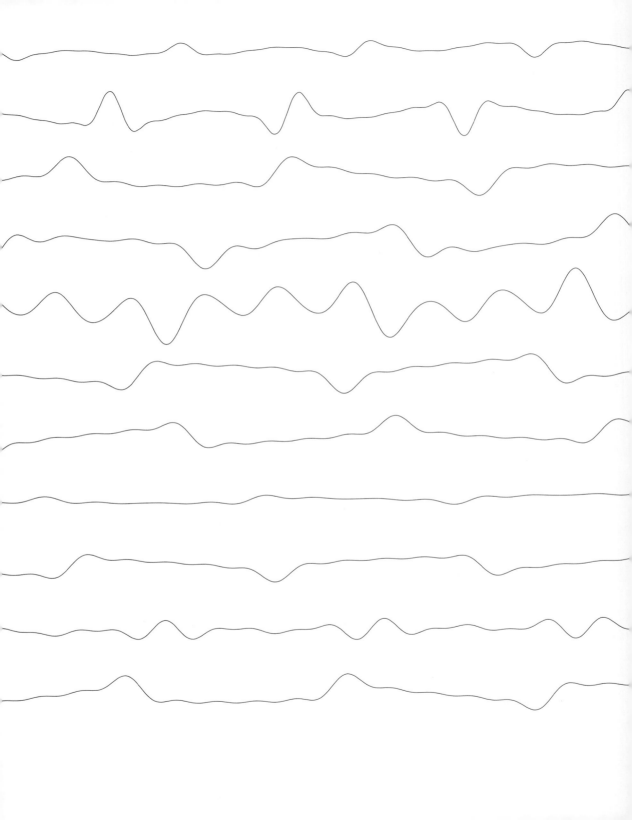

6 Flow

This chapter focuses on creating programs that run continuously, therefore making motion and interaction possible. The flow of these programs is further controlled with conditional structures and logical operators.

Syntax introduced:
```
draw(), {} (braces), frameRate(), frameCount, setup(), noLoop()
> (greater than), < (less than)
>= (greater than or equal to), <= (less than or equal to)
== (equality), != (inequality)
if, else
|| (logical OR), && (logical AND), ! (logical NOT)
```

The programs we've seen so far run each line of code in sequence from top to bottom. They run the first line, then the second, then the third, and so on. The program stops when the last line is run. It's often beneficial to change this order—sometimes skipping lines or repeating lines many times to create movement. Although the lines of code in a program are always positioned in an order from top to bottom on the page, this doesn't necessarily define the order in which each line is run. This order is called the *flow* of the program.

Looping

Sketches that create animation or respond to input from the mouse or keyboard must run their code continuously. This is achieved by adding a draw() function.

```
void draw() {
  statements
}
```

The name of the draw() function is preceded by the keyword void (p. 347) and is followed by a { (left brace), one or more statements, then a } (right brace). (Sometimes people alternatively call these squiggly characters *curly brackets*.)

The code inside a set of braces is called a *block*. The code inside a draw() block runs continuously from top to bottom until the program is stopped. Each time the code in the draw() block runs, the display window is updated and the code inside draw() starts running again from the first line. Please note that a program can have only *one* draw().

By default, the lines of code in the draw() block are run 60 times each second. This is more typically referred to as 60 frames per second, often abbreviated as *fps*. The frameRate() function is used to set the desired frames per second. A program will always attempt to run at the speed set by the parameter to the frameRate() function, but sometimes the ambitions of the programmer exceed the speed of the computer. The frameRate() function controls only the *maximum* frame rate—it can not speed up a program that runs slowly because of equipment limitations.

The frameCount variable always contains the number of frames displayed since the program started. A program with draw() keeps displaying frames (1, 2, 3, 4, 5, ...) until it is stopped, the computer is shut down, or the power goes out.

```
// Print each frame number to the console
void draw() {
    println(frameCount);
}
```
6-01

```
// Run at around 4 fps, print each frame number to the console
void draw() {
    frameRate(4);
    println(frameCount);
}
```
6-02

Changing visual elements from frame to frame creates animation. For example, changing a variable that defines the position of a line will cause it to move:

```
float y = 0.0;

void draw() {
    line(0, y, 100, y);
    y = y + 0.5;
}
```
6-03

When this code runs, the variables are replaced with their current values and the statements are run in this order:

```
float y = 0.0
line(0, 0.0, 100, 0.0)      ·········· Enter draw()

y = 0.5
line(0, 0.5, 100, 0.5)      ·········· Enter draw() for the second time

y = 1.0
line(0, 1.0, 100, 1.0)      ·········· Enter draw() for the third time

y = 1.5
Etc...
```

The variable y must be declared outside draw() for this program to move the line each frame. If the variable is declared inside draw(), it will be re-created each time the draw() block is run and reassigned to the same value, therefore placing the line in the same position.

The background of the display window does not refresh automatically, so lines will simply accumulate. To clear the display window at each frame, insert a background() function at the beginning of the draw() function. The background() function fills the entire display window with the specified color. It overwrites every pixel in the display window each time it is run. If the background() is not placed at the top of draw(), it will cover any element drawn earlier.

```
float y = 0.0;

void draw() {
    background(204);
    line(0, y, 100, y);
    y = y + 0.5;
}
```

The variable that controls the line position can be used for other purposes; it's a number that can be used to control any aspect of the program. In the next example, it's used to move the line *and* set the color of the background.

Variable name

Data type | Assignment operator

```
int y = 0;          Statement terminator

void setup() {
    size(300, 300);        The area between { and }
                           is a block
}
```

Return value

```
void draw() {
    line(0, y, 300, y);
    y = y + 4;             Parameters
}
```

Function

Expression

Figure 6-1 Anatomy of a Processing sketch 2
Each sketch can have only one setup() and one draw(). When the sketch starts, the code outside of
setup() and draw() is run. Next, the code inside setup() is run once. After that, the code inside
draw() is run continuously until the sketch is stopped. In this sketch, because the variable y is
declared outside of setup() and draw(), it's a global variable and can be accessed and assigned
anywhere within the sketch.

```
float y = 0.0;

void draw() {
  background(y * 2.5);
  line(0, y, 100, y);
  y = y + 0.5;
}
```

Controlling the flow

Some parts of a program need to be run once, rather than every frame. The setup()
function is run before draw() so that functions like size() aren't unnecessarily
executed on each frame. When a program is run, the code outside setup() and draw()
is handled first, then code inside setup() is run once, and finally the code inside
draw() is run in a continuous loop from top to bottom. In the following example, the
size and fill values don't change, so they are included in setup().

```
float y = 0.0;

void setup() {
  size(100, 100);
  fill(0);
}

void draw() {
  background(204);
  ellipse(50, y, 70, 70);
  y = y + 0.5;
}
```

When this code runs, the variables are replaced with their current values and the statements are run in this order:

```
float y = 0.0 ·············· Enter setup()
size(100, 100)

fill(0) ·············· Enter draw()
background(204)
ellipse(50, 0.0, 70, 70)

y = 0.5 ·············· Enter draw() for the second time
background(204)
ellipse(50, 0.5, 70, 70)

y = 1.0 ·············· Enter draw() for the third time
background(204)
ellipse(50, 1.0, 70, 70)

y = 1.5
Etc...
```

Variables that change with each iteration of draw() must be declared outside of both setup() and draw(). As mentioned, if the variable y in the preceding example were declared in draw(), it would be reassigned to 0.0 each time. The only statements that should occur outside setup() and draw() are variable declarations and assignments. Functions should not be run outside setup() and draw(); they will likely cause an error.

If a program only draws one frame, it can be written entirely inside setup(). The only difference between setup() and draw() is that setup() is run once before draw() starts looping, therefore shapes drawn within setup() will appear in the display window.

6-07

```
void setup() {
  size(100, 100);
  fill(0);
  ellipse(50, 50, 66, 66);
}
```

Use the noLoop() function to stop draw() from looping. This is another way to draw only one frame. This example is similar to the previous one, but runs the code in setup() once and then runs the code in draw() only once because noLoop() appears in setup().

6-08

```
void setup() {
  size(100, 100);
  fill(0);
  noLoop();
}
```

```
void draw() {
    ellipse(50, 50, 66, 66);
}
```

The complement to noLoop() is a function called loop() that makes a program begin to read the code in draw() continuously. It is discussed in more detail on p. 98.

Relational expressions

What is truth? It's easy to answer this difficult philosophical question in the context of programming because the logical notions of *true* and *false* are well defined. Code elements called *relational expressions* evaluate to true and false. A relational expression is made up of two values that are compared with a relational operator. In Processing, two values can be compared with relational operators as follows:

Expression	Evaluation
3 > 5	false
3 < 5	true
5 < 3	false
5 > 3	true

Each of these statements can be converted to English. Using the first row as an example, we can say, "Is three greater than five?" The answer "no" is expressed with the value false. The next row can be converted to "Is three less than five?" The answer is "yes" and is expressed with the value true. A relational expression, two values compared with a relational operator, evaluates to true or false—there are no other possible values. The relational operators are defined as follows:

Operator	Meaning
>	greater than
<	less than
>=	greater than or equal to
<=	less than or equal to
==	equivalent to
!=	not equivalent to

The following lines of code show the results of comparing the same group of numbers with different relational operators:

```
println(3 > 5);   // Prints "false"
println(5 > 3);   // Prints "true"
println(5 > 5);   // Prints "false"
```

```
println(3 < 5);    // Prints "true"
println(5 < 3);    // Prints "false"
println(5 < 5);    // Prints "false"

println(3 >= 5);   // Prints "false"
println(5 >= 3);   // Prints "true"
println(5 >= 5);   // Prints "true"

println(3 <= 5);   // Prints "true"
println(5 <= 3);   // Prints "false"
println(5 <= 5);   // Prints "true"
```

The equality operator, the == symbol, determines whether two values are equivalent. It is different from the = symbol, which assigns a value, but the two are often used erroneously in place of each other. The only way to avoid this mistake is to be careful and to remember to watch for it while proofreading code. It's similar to using "their" instead of "there" when writing in English—a mistake that even experienced writers sometimes make. The != symbol is the opposite of == and determines whether two values are not equivalent. In code, the exclamation mark is used to define "not."

```
println(3 == 5);   // Prints "false"
println(5 == 3);   // Prints "false"
println(5 == 5);   // Prints "true"

println(3 != 5);   // Prints "true"
println(5 != 3);   // Prints "true"
println(5 != 5);   // Prints "false"
```

Conditionals

Conditionals allow a program to make decisions about which lines of code run and which do not. They let actions take place only when a specific condition is met. Conditionals allow a program to behave differently depending on the values of their variables. For example, the program may draw a line or an ellipse depending on the value of a variable. The if structure is used in Processing to make these decisions:

```
if (test) {
    statements
}
```

The test must be an expression that resolves to true or false. When the test expression evaluates to true, the code inside the block, the area between the { (left brace) and } (right brace) is run. If the expression is false, the code is ignored.

One interesting aspect of code 6-04 is the way the y value continues to increase while the program runs. After the variable exceeds 100 and the line has moved off the screen, the number continues to grow. Place the `println(y);` statement at the bottom of the `draw()` to observe the value increase. An `if` structure can be used to reset this value after it exceeds a value defined within a relational expression. For instance, after the y variable increases past the height of the screen, it can be set to zero again within the block of an `if` structure. A `println()` is used to reveal the y value in the console.

6-11

```
float y = 0.0;

void draw() {
    background(204);
    line(0, y, 100, y);
    y = y + 0.5;
    if (y > height) {
        y = 0.0;
    }
    println(y);    // Print value of y to the console
}
```

The following example uses two `if` structures to make a decision about what to draw to the screen based on the value of the defined x variable. Because this variable is used in the test of the `if` structures, its value affects which lines of code are run. When the program starts, the ellipse draws because the value of x is less than 20. As the x value grows so that its no longer less than 20, the ellipse is no longer drawn. When the x value grows to greater than 80, the rectangle draws. During the time the x value is between 20 and 80, neither the ellipse nor the rectangle is drawn. A line is drawn continuously using the x value to visualize the current value of the variable.

6-12

```
float x = 0.0;

void setup() {
    size(100, 100);
}

void draw() {
    background(204);
    if (x < 20) {                        // If x is less than 20,
        ellipse(50, 50, 60, 60); // draw this ellipse
    }
    if (x > 80) {                        // If x is greater than 80
```

```
      rect(20, 20, 60, 60);    // draw this rectangle
    }
    line(x, 0, x, 100);
    x += 0.25;
  }
```

6-12
cont.

To run a different set of code when the relational expression for an if structure is not true, use the else keyword. The keyword else extends an if structure so when the expression associated with the structure is false, the code in the else block is run instead. The following example has a similar behavior to the previous example, but it works with only one if (augmented with an else), and there is never a time when the ellipse or rectangle is not drawn.

```
float x = 0.0;

void setup() {
  size(100, 100);
}

void draw() {
  background(204);
  if (x < 20) {                // If x is less than 20,
    ellipse(50, 50, 60, 60);   // draw this ellipse,
  } else {                     // else if x is not less,
    rect(20, 20, 60, 60);      // draw this rectangle
  }
  line(x, 0, x, 100);
  x += 0.25;
}
```

6-13

Conditionals can be embedded within other conditionals to further control a program's behavior. In the next example, the code for drawing a large or small ellipse can be reached only if x is less than 80. If this first expression evaluates to true, a second comparison of x determines which size to draw.

General case `if` structure

```
if (test) {
  statements
}
```

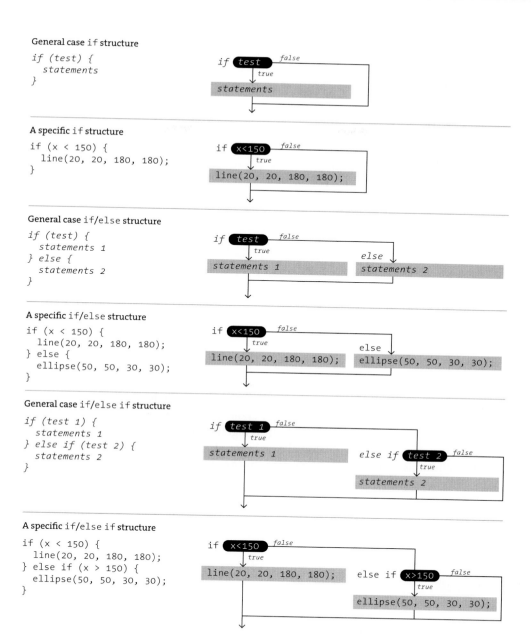

A specific `if` structure

```
if (x < 150) {
  line(20, 20, 180, 180);
}
```

General case `if/else` structure

```
if (test) {
  statements 1
} else {
  statements 2
}
```

A specific `if/else` structure

```
if (x < 150) {
  line(20, 20, 180, 180);
} else {
  ellipse(50, 50, 30, 30);
}
```

General case `if/else if` structure

```
if (test 1) {
  statements 1
} else if (test 2) {
  statements 2
}
```

A specific `if/else if` structure

```
if (x < 150) {
  line(20, 20, 180, 180);
} else if (x > 150) {
  ellipse(50, 50, 30, 30);
}
```

Figure 6-2 Decisions

The flow of an `if`, `else`, and `else if` structures in diagrams. The code inside each block is run if the test evaluates to `true`. For each set of diagrams, the general case shows the generic format and the specific case shows one example of how the format can be used within a sketch.

```
float x = 0.0;

void setup() {
  size(100, 100);
}

void draw() {
  background(204);
  if (x < 80) {
    if (x < 40) {
      ellipse(50, 50, 20, 20);   // Small circle
    } else {
      ellipse(50, 50, 60, 60);   // Large circle
    }
  } else {
    rect(20, 20, 60, 60);
  }
  line(x, 0, x, 100);
  x += 0.25;
}
```

Conditionals can be extended further by combining an else with an if. This allows conditionals to use multiple tests to determine which lines the program should run. This technique is used when there are many choices and only one can be selected at a time. When a series of conditionals is chained together with else, the order becomes critical. As soon as one of the relational expressions is true, the remaining tests are ignored. With this new technique, the following example presents a cleaner way to write the prior example that doesn't require embedding one if structure inside another.

```
float x = 0.0;

void setup() {
  size(100, 100);
}

void draw() {
  background(204);
  if (x < 40) {
    // If x is less than 40, draw a small circle
    ellipse(50, 50, 20, 20);
  } else if (x < 80) {
    // If the previous test was false and x is
    // also less than 80, draw a large circle
```

```
          ellipse(50, 50, 60, 60);
      } else {
          // If neither test was true, x is larger than
          // or equal to 80, so draw a rectangle
          rect(20, 20, 60, 60);
      }
      line(x, 0, x, 100);
      x += 0.25;
  }
```

This is the beginning of the journey with conditionals. The last few examples have revealed the basic components of how to use them, but only start to demonstrate why they are exciting. Later examples reveal more of their power to direct the flow of a program and more interesting applications.

Logical operators

Logical operators are used to combine two or more relational expressions and to invert logical values. They allow for more than one condition to be considered simultaneously. The logical operators are symbols for the logical concepts of AND, OR, and NOT:

Operator	Meaning
&&	AND
\|\|	OR
!	NOT

This table outlines all possible combinations and the results.

Expression	Evaluation
true && true	true
true && false	false
false && false	false
true \|\| true	true
true \|\| false	true
false \|\| false	false
!true	false
!false	true

The logical OR operator, two vertical bars (sometimes called pipes), makes the relational expression true if at least one part is true. The following example shows how to use it. It operates similarly to code 6-12, but notice that it needs only one if structure because of the logical OR operator.

```
float x = 0.0;

void setup() {
  size(100, 100);
}

void draw() {
  background(204);
  // The expression "x < 20" must be true OR "x > 80"
  // must be true. When one of them is true, the code
  // in the block runs.
  if ((x < 20) || (x > 80)) {
    rect(20, 20, 60, 60);
  }
  line(x, 0, x, 100);
  x += 0.25;
}
```

Compound logical expressions can be tricky to figure out, but they are simpler when looked at step by step. Parentheses are useful hints in determining the order of evaluation. Looking at the test of the if structure in line 12 of the previous example, first the variables are replaced with their values, then each subexpression is evaluated, and finally the expression with the logical operator is evaluated. For this demonstration, let's define the value of x as 15:

Step 1	`(x < 20)		(x > 80)`
Step 2	`(15 < 20)		(15 > 80)`
Step 3	`true		false`
Step 4	`true`		

The logical AND operator, two ampersands, allows the entire relational statement to be true only if both parts are true. The following example is similar to the last, but the relational operators are reversed and the logical OR operator is changed to the logical AND. The result has the opposite effect, the rectangle is now drawn when the x variable is between 20 and 80, rather than less than 20 or larger than 80.

```
float x = 0.0;

void setup() {
  size(100, 100);
}

void draw() {
  background(204);
  // The expression "x > 20" must be true AND "x < 80"
  // must be true. When both are true, the code
  // in the block runs.
  if ((x > 20) && (x < 80)) {
    rect(20, 20, 60, 60);
  }
  line(x, 0, x, 100);
  x += 0.25;
}
```

Technically, the steps shown are not the whole story. When using AND, the first part of the expression will be evaluated. If that part is false, then the second part of the expression won't even be evaluated. For example, in this expression...

(x > 20) && (x < 80)

...if x>20 evaluates to false, then x<80 is ignored for efficiency. This is called a *short circuit* operator. The same happens for the OR operator, where the first true statement will end evaluation. For example, if the expression is:

(x < 20) || (x > 80)

If x<20 is true, then the x>80 will be ignored, because the entire expression will evaluate to true, regardless of the value of x>80. Outside of efficiency, this has many practical applications in more advanced code.

The logical NOT operator is an exclamation mark. It inverts the logical value of the associated boolean variables. It changes true to false, and false to true. The logical NOT operator can be applied only to boolean variables.

```
boolean b = true;    // Assign true to b
println(b);          // Prints "true"
println(!b);         // Prints "false"
b = !b;              // Assign false to b
println(b);          // Prints "false"
println(!b);         // Prints "true"
println(5 > 3);      // Prints "true"
```

```
println(!(5 > 3));   // Prints "false"
int x = 5;
println(!x);   // ERROR! It's only possible to ! a boolean variable
```

```
                // Because b is true, the line draws
                boolean b = true;
                if (b == true) {          // If b is true,
                    line(20, 50, 80, 50);      // draw the line
                }
                if (!b == true) {         // If b is false,
                    ellipse(50, 50, 36, 36);   // draw the ellipse
                }
```

Variable scope

When setup() and draw() are added to a program, it becomes necessary to think about where variables are declared and assigned. The location of a variable declaration determines its *scope*—where it can be accessed within the program. The rule for variable scope is stated simply: variables declared inside any block can be accessed only inside their own block and inside any blocks enclosed within their block. Variables declared at the base level of the program—the same level as setup() and draw()— can be accessed everywhere within the program. Variables declared within setup() can be accessed only within the setup() block. Variables declared within draw() can be accessed only within the draw() block. The scope of a variable declared within a block, called a local variable, extends only to the end of the block.

```
int d = 51;   // Variable d can be used everywhere

void setup() {
   size(100, 100);
   int val = d * 2;   // Local variable val can only be used in setup()
   fill(val);
}

void draw() {
   int y = 60;   // Local variable y can only be used in draw()
   line(0, y, d, y);
   y -= 25;
   line(0, y, d, y);
}
```

When a variable is created within a block, it is destroyed when the program leaves the block. For instance, if a new variable is created inside an if block, it can be used within but cannot be accessed outside the block.

```
void draw() {
  int d = 80;   // This variable can be used everywhere in draw()
  if (d > 50) {
    int x = 10;   // This variable can be used only in this if block
    line(x, 40, x+d, 40);
  }
  line(0, 50, d, 50);
  line(x, 60, x+d, 60);   // ERROR! x can't be read outside block
}
```

Variable scope makes it possible to have more than one variable in a program with the same name, but it can make a program difficult to read and maintain. In general, including more than one variable with the same name is not recommended. The following example demonstrates this potentially confusing case.

```
int d = 45;              // Assign 45 to variable d

void setup() {
  size(100, 100);
  int d = 90;            // Assign 90 to local variable d
  rect(0, 0, 33, d);     // Use local d with value 90
}

void draw() {
  rect(33, 0, 33, d);    // Use d with value 45
}
```

In general, a variable inside a block with the same name as a variable outside the block is a common mistake that can be confusing to debug. If there are two variables that share the same name as seen in the setup() in the preceding example, the local variable defined within the block takes precedence over the more global variable.

Formatting code blocks

It's important to format code so the block structures are clear. The lines inside a block are typically offset to the right with spaces or tabs. When programs become longer, clearly defining the beginning and end of the blocks reveals the structure of the program and makes it more legible. This is the convention used most frequently in this book:

```
int x = 50;

if (x > 100) {
```

```
  line(20, 20, 80, 80);
} else {
  line(80, 20, 20, 80);
}
```

This is an alternative format that is sometimes used elsewhere:

```
int x = 50;

if (x > 100)
{
  line(20, 20, 80, 80);
}
else
{
  line(20, 80, 80, 20);
}
```

It's essential to use formatting to show the hierarchy of your code. The Processing environment will attempt basic formatting as you type, and you can use the "Auto Format" function from the Edit menu to clean up your code at any time. As an example of what to watch out for, the line() function in the following code fragment is inside the if structure, but the spacing does not reveal this at a quick glance. Avoid formatting code like this:

```
int x = 50;

if (x > 100) {
line(20, 20, 80, 80);   // Avoid formatting code like this
} else {                // because it makes it difficult to see
line(80, 20, 20, 80);   // what is inside the block
}
```

Exercises

1. Make the code in *draw()* run at one frame per second and display the current frame count to the console with *println()*.
2. Move a shape from left to right across the screen. When it moves off the right edge, return it to the left.
3. Utilize *noLoop()* to make a program run its *draw()* only one time.
4. Create a few relational expressions and print their evaluation with *println()*.
5. Create a composition with a series of lines and rectangles inside *draw()*. Use an *if* structure to select which lines of code run and which are skipped at each frame.

7 Interactivity

This chapter introduces mouse and keyboard input as a way to control the position and attributes of shapes on screen.

Syntax introduced:
```
mouseX, mouseY, pmouseX, pmouseY, mousePressed, mouseButton,
keyPressed, key, keyCode
mousePressed(), mouseReleased(), mouseMoved(), mouseDragged()
keyPressed(), keyReleased()
loop(), redraw()
noCursor(), cursor()
```

The screen forms a bridge between our bodies and the realm of circuits and electricity inside computers. We control elements on screen through a variety of devices such as touch pads, trackballs, and joysticks, but the keyboard and mouse remain the most common input devices for desktop computers.

The computer mouse dates back to the late 1960s, when Douglas Engelbart presented the device as an element of the oN-Line System (NLS), one of the first computer systems with a video display. The mouse concept was further developed at the Xerox Palo Alto Research Center (PARC), but its introduction with the Apple Macintosh in 1984 was the catalyst for its current ubiquity. The design of the mouse has gone through many revisions in the last forty years, but its function has remained the same. In Engelbart's original patent application in 1970 he referred to the mouse as an "X-Y position indicator," and this still accurately, but dryly, defines its contemporary use.

The physical mouse object is used to control the position of the cursor on screen and to select interface elements. The cursor position is read by computer programs as two numbers, the x-coordinate and the y-coordinate. These numbers can be used to control attributes of elements on screen. If these coordinates are collected and analyzed, they can be used to extract higher-level information such as the speed and direction of the mouse. This data can in turn be used for gesture and pattern recognition.

Keyboards are typically used to input characters for composing documents, email, and instant messages, but the keyboard has potential for use beyond its original intent. The migration of the keyboard from typewriter to computer expanded its function to enable launching software, moving through the menus of software applications, and navigating 3D environments in games. When writing your own software, you have the freedom to use the keyboard data any way you wish. For example, basic information such as the speed and rhythm of the fingers can be determined by the rate at which keys are pressed. This information could control the speed of an event or the quality of motion. It's also possible to ignore the characters

printed on the keyboard itself and use the location of each key relative to the keyboard grid as a numeric position.

The modern computer keyboard is a direct descendant of the typewriter. The position of the keys on an English-language keyboard is inherited from early typewriters. This layout is called QWERTY because of the order of the top row of letter keys. It was developed for typewriters to put physical distance between frequently typed letter pairs, helping reduce the likelihood of the typebars colliding and jamming as they hit the ribbon. This more than one-hundred-year-old mechanical legacy still affects how we write software today.

Mouse data

The Processing variables mouseX and mouseY (note the capital X and Y) store the x-coordinate and y-coordinate of the cursor relative to the origin in the upper-left corner of the display window. To see the actual values produced while moving the mouse, run this program to print the values to the console:

```
void draw() {                                                    7-01
   frameRate(12);
   println(mouseX + " : " + mouseY);
}
```

When a program starts, the mouseX and mouseY values are 0. If the cursor moves into the display window, the values are set to the current position of the cursor. If the cursor is at the left, the mouseX value is 0 and the value increases as the cursor moves to the right. If the cursor is at the top, the mouseY value is 0 and the value increases as the cursor moves down. If mouseX and mouseY are used in programs without a draw() or if noLoop() is run in setup(), the values will always be 0.

The mouse position is most commonly used to control the location of visual elements on screen. More interesting relations are created when the visual elements relate differently to the mouse values, rather than simply mimicking the current position. Adding and subtracting values from the mouse position creates relationships that remain constant, while multiplying and dividing these values creates changing visual relationships between the mouse position and the elements on the screen. In the first of the following examples, the circle is directly mapped to the cursor, in the second, numbers are added and subtracted from the cursor position to create offsets, and in the third, multiplication and division are used to scale the offsets.

```
void setup() {
  size(100, 100);
  noStroke();
}

void draw() {
  background(126);
  ellipse(mouseX, mouseY, 33, 33);
}
```

```
void setup() {
  size(100, 100);
  noStroke();
}

void draw() {
  background(126);
  ellipse(mouseX, 16, 33, 33);      // Top circle
  ellipse(mouseX+20, 50, 33, 33);   // Middle circle
  ellipse(mouseX-20, 84, 33, 33);   // Bottom circle
}
```

7-03

```
void setup() {
  size(100, 100);
  noStroke();
}

void draw() {
  background(126);
  ellipse(mouseX, 16, 33, 33);     // Top circle
  ellipse(mouseX/2, 50, 33, 33);   // Middle circle
  ellipse(mouseX*2, 84, 33, 33);   // Bottom circle
}
```

7-04

To invert the value of the mouse, subtract the mouseX value from the width of the window and subtract the mouseY value from the height of the screen.

```
void setup() {
  size(100, 100);
  noStroke();
}

void draw() {
  float x = mouseX;
  float y = mouseY;
  float ix = width - mouseX;    // Inverse X
  float iy = height - mouseY;   // Inverse Y
  background(126);
  fill(255, 150);
  ellipse(x, height/2, y, y);
  fill(0, 159);
  ellipse(ix, height/2, iy, iy);
}
```

The Processing variables pmouseX and pmouseY store the mouse values from the previous frame. If the mouse does not move, the values will be the same, but if the mouse is moving quickly there can be large differences between the values. To see the difference, run the following program and alternate moving the mouse slowly and quickly. Watch the values print to the console.

```
void draw() {
  frameRate(12);
  println(pmouseX - mouseX);
}
```

Draw a line from the previous mouse position to the current position to show the changing position in one frame and reveal the speed and direction of the mouse. When the mouse is not moving, a point is drawn, but quick mouse movements create long lines.

```
void setup() {
  size(100, 100);
  strokeWeight(8);
}
```

```
void draw() {
  background(204);
  line(mouseX, mouseY, pmouseX, pmouseY);
}
```

Use the mouseX and mouseY variables with an if structure to allow the cursor to select regions of the screen. The following examples demonstrate the cursor making a selection between different areas of the display window. The first divides the screen into halves, and the second divides the screen into thirds.

7-08

```
void setup() {
  size(100, 100);
  noStroke();
  fill(0);
}

void draw() {
  background(204);
  if (mouseX < 50) {
    rect(0, 0, 50, 100);    // Left
  } else {
    rect(50, 0, 50, 100);   // Right
  }
}
```

7-09

```
void setup() {
  size(100, 100);
  noStroke();
  fill(0);
}

void draw() {
  background(204);
  if (mouseX < 33) {
    rect(0, 0, 33, 100);    // Left
  } else if (mouseX < 66) {
    rect(33, 0, 33, 100);   // Middle
  } else {
    rect(66, 0, 33, 100);   // Right
  }
}
```

Use the logical operator && with an if structure to select a rectangular region of the screen. As demonstrated in the following example, when a relational expression is made to test each edge of a rectangle (left, right, top, bottom) and these are concatenated with a logical AND, the entire relational expression is true only when the cursor is inside the rectangle.

```
void setup() {
  size(100, 100);
  noStroke();
  fill(0);
}

void draw() {
  background(204);
  if ((mouseX > 40) && (mouseX < 80) &&
      (mouseY > 20) && (mouseY < 80)) {
    fill(255);
  } else {
    fill(0);
  }
  rect(40, 20, 40, 60);
}
```

This code asks, "Is the cursor to the right of the left edge and is the cursor to the left of the right edge and is the cursor beyond the top edge and is the cursor above the bottom?" The code for the next example asks a set of similar questions and combines them with the keyword else to determine which one of the defined areas contains the cursor.

```
void setup() {
  size(100, 100);
  noStroke();
  fill(0);
}

void draw() {
  background(204);
  if ((mouseX <= 50) && (mouseY <= 50)) {
    rect(0, 0, 50, 50);      // Upper-left
  } else if ((mouseX <= 50) && (mouseY > 50)) {
    rect(0, 50, 50, 50);     // Lower-left
  } else if ((mouseX > 50) && (mouseY <= 50)) {
    rect(50, 0, 50, 50);     // Upper-right
  } else {
    rect(50, 50, 50, 50);    // Lower-right
  }
}
```

Mouse buttons

Computer mice and other related input devices typically have between one and three buttons; Processing can detect when these buttons are pressed with the mousePressed and mouseButton variables. Used with the button status, the cursor position enables the mouse to perform different actions. For example, a button press when the mouse is over an icon can select it, so the icon can be moved to a different location on screen. The mousePressed variable is true if any mouse button is pressed and false if no mouse button is pressed. The variable mouseButton is LEFT, CENTER, or RIGHT depending on the mouse button most recently pressed. The mousePressed variable reverts to false as soon as the button is released, but the mouseButton variable retains its value until a different button is pressed. These variables can be used independently or in combination to control the software. Run these programs to see how the software responds to your fingers.

```
void setup() {
  size(100, 100);
}

void draw() {
  background(204);
  if (mousePressed == true) {
    fill(255);   // White
  } else {
    fill(0);     // Black
  }
  rect(25, 25, 50, 50);
}
```

7-12

```
void setup() {
  size(100, 100);
}

void draw() {
  if (mouseButton == LEFT) {
    fill(0);       // Black
  } else if (mouseButton == RIGHT) {
    fill(255);   // White
  } else {
    fill(126);   // Gray
  }
  rect(25, 25, 50, 50);
}
```

7-13

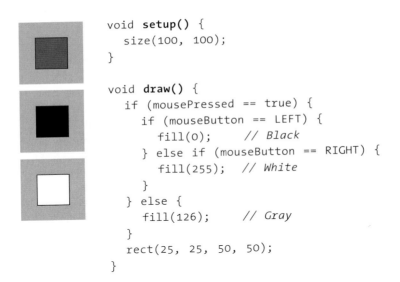

```
void setup() {
  size(100, 100);
}

void draw() {
  if (mousePressed == true) {
    if (mouseButton == LEFT) {
      fill(0);      // Black
    } else if (mouseButton == RIGHT) {
      fill(255);    // White
    }
  } else {
    fill(126);      // Gray
  }
  rect(25, 25, 50, 50);
}
```

Not all mice have multiple buttons, and if software is distributed widely, the interaction should not rely on detecting which button is pressed.

Keyboard data

Processing registers the most recently pressed key and whether a key is currently pressed. The boolean variable keyPressed is true if a key is pressed and is false if not. Include this variable in the test of an if structure to allow lines of code to run only if a key is pressed. The keyPressed variable remains true while the key is held down and becomes false only when the key is released.

```
void setup() {
  size(100, 100);
  strokeWeight(4);
}

void draw() {
  background(204);
  if (keyPressed == true) {   // If the key is pressed,
    line(20, 20, 80, 80);     // draw a line
  } else {                    // Otherwise,
    rect(40, 40, 20, 20);     // draw a rectangle
  }
}
```

```
int x = 20;
```

```
void setup() {
  size(100, 100);
  strokeWeight(4);
}

void draw() {
  background(204);
  if (keyPressed == true) {  // If the key is pressed
    x++;                     // add 1 to x
  }
  line(x, 20, x-60, 80);
}
```

The key variable stores a single alphanumeric character. Specifically, it holds the most recently pressed key. The key can be displayed on screen with the text() function (p. 150).

```
void setup() {
  size(100, 100);
  textSize(60);
}
```

```
void draw() {
  background(0);
  text(key, 20, 75);   // Draw at coordinate (20,75)
}
```

The key variable may be used to determine whether a specific key is pressed. The following example uses the expression key=='A' to test if the A key is pressed. The single quotes signify A as the data type char (p. 144). The expression key=="A" will cause an error because the double quotes signify the A as a String, and it's not possible to compare a String with a char. The logical AND symbol, the && operator, is used to connect the expression with the keyPressed variable to ascertain that the key pressed is the uppercase A.

```
void setup() {
  size(100, 100);
  strokeWeight(4);
}

void draw() {
  background(204);
  // If the 'A' key is pressed draw a line
  if ((keyPressed == true) && (key == 'A')) {
    line(50, 25, 50, 75);
  } else {   // Otherwise, draw an ellipse
    ellipse(50, 50, 50, 50);
  }
}
```

The previous example works with an uppercase *A*, but not if the lowercase letter is pressed. To check for both uppercase and lowercase letters, extend the relational expression with a logical OR, the || relational operator. Line 9 in the previous program would be changed to

```
if ((keyPressed == true) && ((key == 'a') || (key == 'A'))) {
```

Because each character has a numeric value as defined by the ASCII table (p. 605), the value of the key variable can be used like any other number to control visual attributes such as the position and color of shape elements. For instance, the ASCII table defines the uppercase *A* as the number 65, and the digit 1 is defined as 49.

```
void setup() {
  size(100, 100);
  stroke(0);
}

void draw() {
  if (keyPressed == true) {
    int x = key - 32;
    line(x, 0, x, height);
  }
}
```

```
float angle = 0;

void setup() {
  size(100, 100);
  fill(0);
}
void draw() {
  background(204);
  if (keyPressed == true) {
    if ((key >= 32) && (key <= 126)) {
      // If the key is alphanumeric,
      // use its value as an angle
      angle = (key - 32) * 3;
    }
  }
  arc(50, 50, 66, 66, 0, radians(angle));
}
```

Coded keys

In addition to reading key values for numbers, letters, and symbols, Processing can also read the values from other keys including the arrow keys and the Alt, Control, Shift, Backspace, Tab, Enter, Return, Escape, and Delete keys. The variable keyCode stores the ALT, CONTROL, SHIFT, UP, DOWN, LEFT, and RIGHT keys as constants. Before determining which coded key is pressed, it's necessary to check first to see if the key is coded. The expression key==CODED is true if the key is coded and false otherwise. Even though not alphanumeric, the keys included in the ASCII specification (BACKSPACE, TAB, ENTER, RETURN, ESC, and DELETE) will not be identified as a coded key. If you're making cross-platform projects, note that the Enter key is commonly used on PCs and UNIX and the Return key is used on Macintosh. Check for both Enter and Return to make sure your program will work for all platforms (see code 12-17).

```
int y = 35;

void setup() {
  size(100, 100);
}

void draw() {
  background(204);
  line(10, 50, 90, 50);
  if (key == CODED) {
    if (keyCode == UP) {
      y = 20;
    } else if (keyCode == DOWN) {
      y = 50;
    }
  } else {
    y = 35;
  }
  rect(25, y, 50, 30);
}
```

Events

A category of functions called *events* alter the normal flow of a program when an action such as a key press or mouse movement takes place. An event is a polite interruption of the normal flow of a program. Key presses and mouse movements are stored until the end of draw(), where they can take action that won't disturb drawing that's currently in progress. The code inside an event function is run once each time the corresponding event occurs. For example, if a mouse button is pressed, the code inside the mousePressed() function will run once and will not run again until the button is pressed again. This allows data produced by the mouse and keyboard to be read independently from what is happening in the rest of the program.

Mouse events

The mouse event functions are mousePressed(), mouseReleased(), mouseMoved(), and mouseDragged():

mousePressed()	*Code inside this block is run one time when a mouse button is pressed*
mouseReleased()	*Code inside this block is run one time when a mouse button is released*
mouseMoved()	*Code inside this block is run one time when the mouse is moved*
mouseDragged()	*Code inside this block is run one time when the mouse is moved while a mouse button is pressed*

The mousePressed() function works differently than the mousePressed variable. The value of the mousePressed variable is true until the mouse button is released. It can therefore be used within draw() to have a line of code run while the mouse is pressed. In contrast, the code inside the mousePressed() function only runs once when a button is pressed. This makes it useful when a mouse click is used to trigger an action, such as clearing the screen. In the following example, the background value becomes lighter each time a mouse button is pressed. Run the example on your computer to see the change in response to your finger.

```
int gray = 0;

void setup() {
  size(100, 100);
}

void draw() {
  background(gray);
}

void mousePressed() {
  gray += 20;
}
```

7-22

The following example is the same as the one above, but the gray variable is set in the mouseReleased() event function, which is called once every time a button is released. This difference can be seen only by running the program and clicking the mouse button. Keep the mouse button pressed for a long time and notice that the background value changes only when the button is released.

```
int gray = 0;

void setup() {
  size(100, 100);
}

void draw() {
  background(gray);
}

void mouseReleased() {
  gray += 20;
}
```

7-23

It is generally not a good idea to draw inside an event function, but it can be done under certain conditions. Before drawing inside these functions, it's important to think about the flow of the program. In this example, squares are drawn inside mousePressed() and they remain on screen because there is no background() inside draw(). But if background() is used, visual elements drawn within one of the mouse event functions will appear on screen for only a single frame, or, by default, 1/60th of a second. In fact, you'll notice this example has nothing at all inside draw(), but it needs to be there to force Processing to keep listening for the events. If a background() function were run inside draw(), the rectangles would flash onto the screen and disappear.

7-24

```
void setup() {
  size(100, 100);
  fill(0, 102);
}

void draw() { }  // Empty draw() keeps the program running

void mousePressed() {
  rect(mouseX, mouseY, 33, 33);
}
```

The code inside the mouseMoved() and mouseDragged() event functions are run when there is a change in the mouse position. The code in the mouseMoved() block is run at the end of each frame when the mouse moves and no button is pressed. The code in the mouseDragged() block does the same when the mouse button is pressed. If the mouse stays in the same position from frame to frame, the code inside these functions does not run. In this example, the gray circle follows the mouse when the button is not pressed, and the black circle follows the mouse when a mouse button is pressed.

7-25

```
int dragX, dragY, moveX, moveY;

void setup() {
  size(100, 100);
  noStroke();
}

void draw() {
  background(204);
  fill(0);
  ellipse(dragX, dragY, 33, 33);   // Black circle
  fill(153);
  ellipse(moveX, moveY, 33, 33);   // Gray circle
}
```

```
void mouseMoved() {        // Move gray circle
  moveX = mouseX;
  moveY = mouseY;
}

void mouseDragged() {   // Move black circle
  dragX = mouseX;
  dragY = mouseY;
}
```

7-25
cont.

Key events

Each key press is registered through the keyboard event functions `keyPressed()` and `keyReleased()`:

keyPressed()	*Code inside this block is run one time when any key is pressed*
keyReleased()	*Code inside this block is run one time when any key is released*

Each time a key is pressed, the code inside the `keyPressed()` block is run once. Within this block, it's possible to test which key has been pressed and to use this value for any purpose. If a key is held down for an extended time, the code inside the `keyPressed()` block might run many times in a rapid succession because most operating systems will take over and repeatedly call the `keyPressed()` function. The amount of time it takes to start repeating and the rate of repetitions will be different from computer to computer, depending on the keyboard preference settings. In this example, the value of the `boolean` variable `drawT` is set from `false` to `true` when the *T* key is pressed; this causes the lines of code to render the rectangles in `draw()` to start running.

```
boolean drawT = false;

void setup() {
  size(100, 100);
  noStroke();
}

void draw() {
  background(204);
  if (drawT == true) {
    rect(20, 20, 60, 20);
    rect(39, 40, 22, 45);
  }
}
```

7-26

```
void keyPressed() {
  if ((key == 'T') || (key == 't')) {
    drawT = true;
  }
}
```

Each time a key is released, the code inside the keyReleased() block is run once. The following example builds on the previous code; each time the key is released the boolean variable drawT is set back to false to stop the shape from displaying within draw().

```
boolean drawT = false;

void setup() {
  size(100, 100);
  noStroke();
}

void draw() {
  background(204);
  if (drawT == true) {
    rect(20, 20, 60, 20);
    rect(39, 40, 22, 45);
  }
}

void keyPressed() {
  if ((key == 'T') || (key == 't')) {
    drawT = true;
  }
}

void keyReleased() {
  drawT = false;
}
```

Event flow

As discussed previously, programs written with draw() display frames to the screen sixty frames each second. The frameRate() function is used to set a limit on the number of frames that will display each second, and the noLoop() function can be used to stop draw() from looping. The additional functions loop() and redraw()

provide more options when used in combination with the mouse and keyboard event functions.

If a program has been paused with noLoop(), running loop() resumes its action. Because the event functions are the only elements that continue to run when a program is paused with noLoop(), the loop() function can be used within these events to continue running the code in draw(). The following example runs the draw() function for about two seconds each time a mouse button is pressed and then pauses the program after that time has elapsed.

```
int frame = 0;

void setup() {
   size(100, 100);
}

void draw() {
   if (frame > 120) {          // If 120 frames since the mouse
     noLoop();                 // was pressed, stop the program
     background(0);            // and turn the background black.
   } else {                    // Otherwise, set the background
     background(204);          // to light gray and draw lines
     line(mouseX, 0, mouseX, 100);   // at the mouse position
     line(0, mouseY, 100, mouseY);
     frame++;
   }
}

void mousePressed() {
   loop();
   frame = 0;
}
```

7-28

The redraw() function runs the code in draw() one time and then halts the execution. It's helpful when the display needn't be updated continuously. The following example runs the code in draw() once each time a mouse button is pressed.

```
void setup() {
   size(100, 100);
   noLoop();
}

void draw() {
   background(204);
   line(mouseX, 0, mouseX, 100);
```

7-29

```
    line(0, mouseY, 100, mouseY);
}

void mousePressed() {
    redraw();   // Run the code in draw one time
}
```

Cursor icon

The cursor can be hidden with the noCursor() function and can be set to appear as a different icon or image with the cursor() function. When the noCursor() function is run, the cursor icon disappears as it moves into the display window. To give feedback about the location of the cursor within the software, a custom cursor can be drawn and controlled with the mouseX and mouseY variables.

```
void setup() {
    size(100, 100);
    strokeWeight(7);
    noCursor();
}

void draw() {
    background(204);
    ellipse(mouseX, mouseY, 10, 10);
}
```

If noCursor() is run, the cursor will be hidden while the program is running until the cursor() function is run to reveal it.

```
void setup() {
    size(100, 100);
    noCursor();
}

void draw() {
    background(204);
    if (mousePressed == true) {
        cursor();
    }
}
```

Add a parameter to the `cursor()` function to change it to another icon or image. Either load and use image, or use the self-descriptive options are ARROW, CROSS, HAND, MOVE, TEXT, and WAIT.

7-32

```
void setup() {
  size(100, 100);
}

void draw() {
  background(204);
  if (mousePressed == true) {
    cursor(HAND);    // Draw cursor as hand
  } else {
    cursor(CROSS);
  }
  line(mouseX, 0, mouseX, height);
  line(0, mouseY, height, mouseY);
}
```

These cursor icons are part of your computer's operating system and will appear different on different machines.

Exercises

1. Control the position of a shape with *mouseX* and *mouseY*. Strive to create a more interesting relation than one directly mimicking the position of the cursor.
2. Modify exercise 1 so the shape reacts differently when the *mousePressed* variable is *true*.
3. Draw a simple composition with two lines that changes when the D key is pressed.
4. Draw a circle in the display window that is affected differently by each of the four mouse event functions.
5. Create a custom cursor that changes as the mouse moves through the display window.

8 Repeat

This chapter focuses on controlling the flow of programs with looping structures.

Syntax introduced:
`while`, `for`

The early history of computers is the history of automating calculation. A "computer" was originally a person who did math by hand. What we know as a computer today emerged from machines built to automate tedious mathematical calculations. The earliest mechanical computers were calculators developed for speed and accuracy in performing repetitive calculations. Because of this heritage, computers are excellent at executing repetitive tasks accurately and quickly and therefore at drawing accurately and quickly.

Iterate

Iterative structures are used to shorten lines of repetitive code into a more compact, but equivalent expressions. Once a line (or a group of code) is written within an iterative structure, it can be run a single time or millions of times without increasing the length of the program. This makes programs easier to manage and can also help to reduce errors. In the visual realm, it makes is easier to generate dense and intricate patterns.

The table below shows equivalent programs written without an iterative structure and with a `for` loop. The original 14 lines of code on the left are reduced to the 4 lines on the right:

Original code:
```
size(200, 200);
line(20, 20, 20, 180);
line(30, 20, 30, 180);
line(40, 20, 40, 180);
line(50, 20, 50, 180);
line(60, 20, 60, 180);
line(70, 20, 70, 180);
line(80, 20, 80, 180);
line(90, 20, 90, 180);
line(100, 20, 100, 180);
line(110, 20, 110, 180);
line(120, 20, 120, 180);
line(130, 20, 130, 180);
line(140, 20, 140, 180);
```

Code expressed using a loop:
```
size(200, 200);
for (int i = 20; i < 150; i += 10) {
    line(i, 20, i, 180);
}
```

The preceding code without the loop is straightforward based on the previous chapters, while the new code is cryptic in comparison. However, the new way is more flexible and condensed and the strange quality of the syntax becomes familiar with explanation and practice. Before the for loop is discussed, we start with the while loop, a more primitive way of repeating a block of code.

while loop

The while loop allows a block of code to run many times. It is structured like this:

```
while (test) {
    statements
}
```

The while loop looks identical to the if structure (p. 72), but the code inside the while block will run continuously while the *test* expression is true. A while loop runs in the following sequence:

1. The *test* is evaluated to *true* or *false*
2. If the *test* is *false*, exit the loop and continue the program
3. If the *test* is *true*, run the statement(s) in the block

Therefore, a program will get stuck inside the loop unless there is some code inside the block that eventually makes the *test* expression false. Also like the if structure, if the *test* isn't true when the code is first run, the code in the block won't ever run.

 Most while loops use a variable in the *test* expression to calculate how many times the code inside should run. That variable is typically defined before the loop, used within the *test*, and then updated inside the block to eventually make the *test* evaluate to false. The following example defines a variable named counter and then updates that variable to control the number of repeats.

```
int counter = 0;                                    8-01
while (counter < 12) {
    int y = 20 + (counter * 5);
    line(20, y, 80, y+15);
    counter += 1;
}
```

The following two examples are similar, but they use the variable within the test expression and to define the position of the lines. In this way, the number of repetitions defined in the test is less clear, but the code has fewer variables and is therefore shorter. Both techniques are fine ways to write the code; it's up to each programmer to write the code she or he prefers.

General case while **structure**

```
while (test) {
  statements
}
```

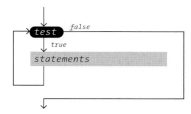

A specific while **structure**

```
int i = 0;
while (i < 80) {
  line(20, i, 80, i+15);
  i = i + 5;
}
```

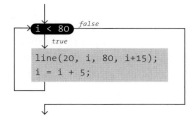

Figure 8-1 The while loop
The flow of a while *loop as a diagram. When the sketch reaches the* while *loop, it will run the code in the block if the test expression is* true, *otherwise it will skip that code. The code inside the block will continue to run until the test expression is* false.

```
int y = 20;                          8-02
while (y < 80) {
    line(20, y, 80, y+15);
    y += 5;
}
```

```
int x = -16;                         8-03
while (x < 100) {
    line(x, 0, x+15, 50);
    x += 10;
}
strokeWeight(4);
x = -8;
while (x < 100) {
    line(x, 50, x+15, 100);
    x += 10;
}
```

The while loop and the related for loop, discussed next, are general code structures for repetition. They have uses far beyond drawing a series of lines. For example, this short program counts down from 10 to 1 without drawing anything. After the counting, it writes "Blastoff!" to the console. Notice the loop is counting backward here, rather than forward. Unlike the other examples, the variable is made smaller each time through the loop so the *test* will eventually become false.

```
int n = 10;                          8-04
while (n > 0) {
    println(n);
    n--;
}
println("Blastoff!");
```

More reasons to use loops are discussed as the chapter unfolds.

for loop

A for loop puts the pieces of code needed to control a while loop together within a single structure. There's nothing one type of loop can do that the other cannot, but the for loop groups the parts together as a sequence of statements inside parentheses. Compare the structure to that of the while loop:

```
for (init; test; update) {
    statements
}
```

General case `for` loop

```
for (init; test; update) {
  statements
}
```

A specific `for` loop

```
for (int i = 20; i < 80; i += 5) {
  line(20, i, 80, i+15);
}
```

Figure 8-2 The `for` loop

The flow of a `for` loop as a diagram. These images reveal the central importance of the test statement in deciding whether to run the code in the block or to exit. The general case shows the generic format, and the specific case shows one example of how the format can be used within a sketch.

The *test* expression is the same, but the parentheses enclose three expressions: *init*, *test*, and *update*. The statements inside the block are run continuously while the *test* evaluates to true. The *init* portion assigns the initial value of the variable used in the *test*. The *update* is used to modify the variable after each iteration through the loop. A for loop runs in the following sequence:

1. Run the *init* statement
2. Evaluate the *test* to *true* or *false*
3. If the *test* is *false*, exit the loop and continue the program
4. If the *test* is *true*, run the statement(s) within the block
5. Run the *update* statement and return to step 2

The following examples demonstrate how the for loop is used to control the way shapes are drawn to the display window. For comparison, the first two examples are translations of prior while loop examples. In the first example, the *init* is int y = 20, the *test* is y < 80 and the *update* is y += 5. Notice the semicolon separating the first two elements, but not the third. The single line of code inside the braces will continue to draw a line until the y variable is greater than or equal to 80.

```
for (int y = 20; y < 80; y += 5) {
    // This line will continue to run until "y"
    // is greater than or equal to 80
    line(20, y, 80, y+15);
}
```
8-05

```
for (int x = -16; x < 100; x += 10) {
    line(x, 0, x+15, 50);
}
strokeWeight(4);
for (int x = -8; x < 100; x += 10) {
    line(x, 50, x+15, 100);
}
```
8-06

```
noFill();
for (int d = 150; d > 0; d -= 10) {
    ellipse(50, 50, d, d);
}
```
8-07

```
background(255);
strokeWeight(2);
for (int i = 0; i < 100; i += 4) {
    // The variable is used for the position and stroke
    stroke(i*2.5);
    line(i, 0, i, 200);
}
```
8-08

```
for (int x = 20; x <= 80; x += 5) {
  line(x, 20, x, 80);
}
```

```
for (int x = 20; x <= 80; x += 5) {
  line(20, x, 80, x);
}
```

```
for (int x = 20; x < 80; x += 5) {
  line(x+20, 20, x, 80);
}
```

```
for (float x = 80; x > 20; x -= 5) {
  line(20, x+20, 80, x);
}
```

```
for (float x = 20; x < 80; x *= 1.2) {
  line(x, 20, x, 80);
}
```

```
for (float x = 80; x > 20; x /= 1.2) {
  line(20, x, 80, x);
}
```

```
for (int x = 20; x <= 85; x += 5) {
  if (x <= 50) {
    line(x, 20, x, 60);
  } else {
    line(x, 40, x, 80);
  }
}
```

```
for (int x = 20; x <= 80; x += 5) {
  if ((x % 10) == 0) {
    line(20, x, 50, x);
  } else {
    line(50, x, 80, x);
  }
}
```

Figure 8-3 All for one and one for all

The for loop is flexible, but it always follows the rules. These examples show how it can be used to generate various patterns.

The variable name i is often used to control a for loop as in example 8-08, but as demonstrated in the other sample programs, any variable name can be used. As a group, these examples have shown how the for loop may be used to create visual patterns, but this is only one instance of what a for loop can do; it is a general technique for repeating a block of code like the while loop. As seen in the next examples, it can be used for iterative calculations.

8-09

```
// Calculates the powers of two from 2 to 1024
int p = 1;
for (int i = 0; i < 10; i++) {
  p = p * 2;
  println(p);
}
```

8-10

```
// Halves a number 10 times
float num = 20;
for (int i = 0; i < 10; i++) {
  num = num / 2.0;
  println(num);
}
```

Loop and draw()

When a while or for loop is used inside of draw(), the repetition happens multiple times within one program. By default, the program will calculate this sequence of repeats at sixty frames each second, once for each frame the program draws to the display window. This opens the possibility for the loop to be different each time it runs because it can be defined by changing variables. For instance, as the mouseX variable increases, the loop can increase or decrease the number of times it runs at each frame:

8-11

```
void setup() {
  size(100, 100);
  strokeWeight(2);
}

void draw() {
  background(204);
  // Draw more lines as mouseX increases
  for (int i = 10; i < mouseX; i+=5) {
    line(i, 10, i, 90);
  }
}
```

Sometimes a program will attempt to use a loop to animate something on screen. This can't work because the screen doesn't update within a loop. The display window

updates at the end of each `draw()`, so the incremental changes happening within a loop won't be seen; only the final result at the end of `draw()` are visible on screen. The following program shows an attempt to draw a line moving from left to right:

```
void setup() {
  size(100, 100);
}

void draw() {
  int x = 0;
  while (x < width) {
    line(x, 20, x, 80);
    x += 2;
  }
}
```

8-12

To modify this program to move the line, pull the variable declaration and assignment outside of `draw()` so it's global in scope and then remove the `while` loop so only one line is drawn each frame, rather than a series of lines. As the value of the x variable grows by 2 each frame, the line moves to the right:

```
int x = 0;

void setup() {
  size(100, 100);
}

void draw() {
  line(x, 20, x, 80);
  x += 2;
}
```

8-13

In later chapters, the `for` loop will be used with `setup()` and `draw()` to load and play back a series of images (see Animation, p. 431), to read through the entries in a data file (see Data, p. 489) and to work with arrays of software objects in an efficient way (see Arrays, p. 415, and Simulate, p. 453).

Nested loops

The `for` loop produces repetitions in one dimension. Nesting one of these structures into another compounds their effect, creating iteration in two dimensions. Instead of drawing 9 points and then drawing another 9 points, they combine to create 81 points; for each point drawn in the outer loop, 9 points are drawn in the inner loop. The inner loop runs through a complete cycle for each single iteration of the outer loop. In the

following examples, the two dimensions are translated into x-coordinates and y-coordinates:

```
// The variable y iterates from 10 to 90 to draw          8-14
// the point 9 times
for (int y = 10; y < 100; y += 10) {
  point(10, y);
}
```

```
// The variable x iterates from 10 to 90 to draw          8-15
// the point 9 times
for (int x = 10; x < 100; x += 10) {
  point(x, 10);
}
```

```
// The variable y iterates from 10 to 90 to draw          8-16
// the point 9 times and the variable x iterates from
// 10 to 90 to draw the point 81 times
for (int y = 10; y < 100; y += 10) {
  for (int x = 10; x < 100; x += 10) {
    point(x, y);
  }
}
```

This technique is useful for creating diverse patterns and effects. The numbers produced by embedding iterative elements can be applied to color, position, size, transparency, and any other visual attribute.

```
fill(0);                                                  8-17
noStroke();
for (int y = -10; y <= 100; y += 10) {
  for (int x = -40; x <= 100; x += 10) {
    ellipse(x + y/3.0, y + x/8.0, 4, 7);
  }
}
```

```
noStroke();                                               8-18
for (int y = 0; y < 100; y += 10) {
  for (int x = 0; x < 100; x += 10) {
    fill((x+y) * 1.4);
    rect(x, y, 10, 10);
  }
}
```

```
for (int y = 20; y <= 80; y += 5) {
  for (int x = 20; x <= 80; x += 5) {
    point(x, y);
  }
}
```

```
for (int y = 20; y <= 80; y += 3) {
  for (int x = 20; x <= 80; x += 10) {
    point(x, y);
  }
}
```

```
for (int y = 20; y <= 80; y += 10) {
  for (int x = 20; x <= y; x += 5) {
    line(x, y, x-3, y-3);
  }
}
```

```
for (float y = 20; y <= 80; y *= 1.2) {
  for (int x = 20; x <= 80; x += 5) {
    line(x, y, x, y-2);
  }
}
```

```
for (int y = 20; y <= 85; y += 5) {
  for (int x = 20; x <= 85; x += 5) {
    if (x <= 50) {
      line(x, y, x-3, y-3);
    } else {
      line(x, y, x-3, y+3);
    }
  }
}
```

```
for (int y = 20; y <= 80; y += 5) {
  for (int x = 20; x <= 80; x += 5) {
    if ((x % 10) == 0) {
      line(x, y, x+3, y-3);
    } else {
      line(x, y, x+3, y+3);
    }
  }
}
```

Figure 8-4 Embedding (nesting)
Embedding one for *loop inside another is a malleable technique for drawing patterns.*
These examples show only a few of the possible options.

```
for (int y = 1; y < 100; y += 10) {
    for (int x = 1; x < y; x += 10) {
        line(x, y, x+6, y+6);
        line(x+6, y, x, y+6);
    }
}
```

Nesting loops is a powerful idea that takes time to get comfortable with. Despite the fact it was just introduced, the following two examples take it further to show how to nest a third loop to create an even more complex visual pattern. To start, a one-dimension pattern, a series of embedded rectangles, is placed within a regular grid:

```
rectMode(CENTER);
for (int d = 18; d > 0; d -= 4) {
    rect(50, 50, d, d);
}
```

When this pattern is embedded into a nested loop to generate y- and x-coordinates, it repeats as a grid as in the preceding examples. A quick look at the code shows how each for loop is nested inside another. It is important for legibility to keep this spacing intact to show the structure at a quick glance.

```
background(255);
rectMode(CENTER);
for (int y = 9; y < height; y += 20) {
    for (int x = 9; x < width; x += 20) {
        for (int d = 18; d > 0; d -= 4) {
            rect(x, y, d, d);
        }
    }
}
```

Exercises
1. On paper, draw a 4 × 4 grid of squares. Draw a different regular pattern with five lines in each square.
2. Select one of the patterns from exercise 1 and code it with a while loop.
3. Rewrite the code from the exercise 2 with a for loop.
4. Place a conditional (if) inside a for loop to change what it draws during the loop. For example, half of the lines are short and the other half are long.
5. Draw a dense pattern by nesting two for loops.

9 Synthesis 1

This chapter discusses the idea of sketching with code and the iterative development process.

There are similarities between learning a programming language and learning a new spoken language. Initially, one learns basic elements of the new language—such as simple words and grammar rules—and mimics short phrases. Learning to communicate ideas and express emotions within the language takes more time. Similarly, the first step in computer programming is to understand the basic elements such as comments, variables, and functions. The next step is to learn to read and modify simple example programs. Later, one begins to write programs from scratch. The most interesting and difficult stage of learning to program comes later, as one gains the ability to put the language elements together to express ideas about form, motion, and behavior. Like learning a foreign language, becoming fluent in a programming language can take years.

Sketching software

Sketching ranges from informal exploration to focused refinement. It is used to create many variations within a short time or to develop a specific idea. Sketching forces the definition of vague ideas by making them physical. Sketches are powerful communication tools—they can get ideas out of one's head and into a format that others can better understand.

It is important to work out ideas on paper before investing time in writing code. Paper and pencil allow for fast iteration in the early stages of a project. The most important aspect of programming is figuring out what will be created and how it will function, so working out these ideas away from a computer keeps the focus on an idea, rather than on its implementation.

A good paper sketch for software will include a series of images that demonstrate how the narrative structure of the piece works, much like an animator's storyboard. In addition to images that will appear on screen, sketches often contain diagrams of the program's flow, data elements, and notation for showing how forms will move and interact. Programs can also be planned using combinations of image mock-ups, formal schematics, and text descriptions.

After refined ideas reach a point where working on paper is no longer useful, code can continue the development. The first step in creating code is a continuation of the sketching process. Write short pieces of code independently before worrying about the structure of the larger program. Writing small, focused programs makes a developer better at writing code when it matters most: when working on a more refined implementation.

Processing programs are called *sketches* to emphasize this method of working. The Processing sketchbook is a way of storing and organizing programs. Code sketches can be reviewed and developed incrementally, like drawings in a paper sketchbook. Ideas

that flash by while walking or just after waking up can be quickly made into code and stored for future use. The Processing environment encourages this type of writing because one need only select the "New" option from the File menu to start a new sketch.

Some programming languages encourage a sketching approach, and others make it difficult. Scripting languages, such as Perl or Python, are designed to encourage rapid development at the expense of running speed and control. Processing is not a scripting language, but is designed to "feel" like a scripting language while providing the same capabilities as a more complex language like Java. This topic is discussed in more depth in appendix F (p. 619).

Programming techniques

There are as many ways to write programs as there are people who write software. Some common strategies for creating programs include modification, augmentation, collage, and writing code from scratch. People learning to code often expect most programs to be written from scratch, but that is rarely the case, particularly for the style of work built with Processing. Learning to read and modify code helps programmers increase their skills. Even advanced programmers work from others' examples when learning new techniques.

Modification
Changing the values of variables in existing programs is a good way to explore code. Programs can be modified by trial and error or more deliberately. One way to start understanding a program is to change slightly the value of one variable and then run the code to see the result. If there is no obvious difference, change the value again. Making the correlation between a variable and a change in the way a program runs is a good first step to understanding how it works. Disabling lines of code by placing them inside a /* and */ comment block (called "commenting out") is another way to decrypt a program. A little understanding of the way a program is structured can facilitate logical guesses about what different lines of code are doing. These modification techniques aid in learning new skills or parsing an example. Making small changes to an existing program encourages exploration and getting a feel for the code.

Augmentation
Augmentation uses existing code as a base for further exploration. It is similar to but more ambitious than modification. General program examples can serve as a foundation for longer, more specific programs. For instance, an example that draws a Bézier curve can be used as a base for drawing a series of curves. A program that displays a photograph can form the basis of a collage application. Sample programs provide a concise reminder of syntax. The spartan programs presented in this book provide a broad base for making enhancements.

Collage

The collage technique involves cutting and pasting elements of different programs together to create a new program. It's analogous to creating music by sampling or making a visual collage from newspaper and magazine clippings. In order to avoid errors, combine code carefully by copying a few lines of code at a time and running the program to make sure it's always working. Copying large portions of code can introduce a number of simultaneous errors. Mindlessly copying and pasting code can create "Frankenstein" code that is difficult to debug. As an individual's knowledge of programming increases, using this technique becomes easier, and common problems can be avoided, such as adding multiple copies of the same function, like `draw()` or `setup()`, to the code.

Coding from scratch

Rarely do programmers write a complete program entirely from scratch. At the minimum, most people start with a template. A template is an outline with code infrastructure common to many programs. Sometimes it's not possible to find a related example or appropriate template and it's necessary to start with a blank page. In this case, comments are a great way to start building a program. Comments can be used to build an outline of the program's intention, logic, and flow. After this structure has been defined, lines of code can be slowly added and run in an attempt to realize those decisions.

Regardless of the technique used for programming, writing a few lines of code or making only a few changes at a time is a good tactic. Entering many lines of untested code before running the program increases the potential for multiple errors. The more errors in a program, the more difficult they become to find. Running a growing program piece by piece reduces the chance for multiple errors. As your comfort with code and your skills increase, it becomes possible to make more modifications between tests.

Examples

The previous chapters introduced concepts and techniques including coordinates, variables, conditionals, and looping. Understanding each of these in isolation is the first step toward learning how to program. Learning how to combine these elements is the next step. This is best done through writing more ambitious software and studying more complex programs written by others. The examples presented in this book are intended as raw materials to build more refined programs. The code and descriptions that follow are modified, augmented, and collaged from the earlier examples.

The first example draws two transparent circles that follow the cursor based on the `mouseX` value. One circle is drawn at the x-coordinate of the cursor; its size grows as the `mouseY` value increases. The other circle is drawn by reversing the values of the first circle. For instance, if the first circle is on the right, the other circle is on the left. If the first circle is large, the other circle is small. These inverted values are calculated by subtracting the `mouseX` value from the width of the display window and the `mouseY` value from the height. The result is an engaging choreography between the two shapes while the cursor is in motion.

Figure 9-1
Screen captures for code 9-01.

Figure 9-2
Screen captures for code 9-02.

```
void setup() {
    size(600, 600);
}

void draw() {
    background(0);
    stroke(102);
    line(0, height/2, width, height/2);
    noStroke();
    fill(255, 204);
    int d = mouseY/2+10;  // Diameter
    ellipse(mouseX, height/2, d, d);
    fill(255, 204);
    int iX = width-mouseX;    // Inverse X
    int iY = height-mouseY;   // Inverse Y
    int iD = (iY/2)+10;   // Inverse diameter
    ellipse(iX, height/2, iD, iD);
}
```

The following sketch builds on top of code 7-10 (p. 88). The if structure in the program calculates if the cursor is inside the black square or outside. When the cursor is outside, two diagonal lines are drawn within the square. When the cursor is inside, lines are drawn from each corner of the display window to each corner of the square. The logical AND operator (&&) is used to combine the relational expressions together to make sure they are all true before drawing the lines outside the square. The noCursor() function is used to hide the cursor; it is replaced by a small circle defined at the end of draw(). This sketch creates the illusion that the small circle is touching the square and causing a reaction.

```
void setup() {
    size(600, 600);
    strokeWeight(2);
    noCursor();
}

void draw() {
    background(102);

    noStroke();
    fill(0);
    rect(150, 150, 300, 300);
```

```
  stroke(255);
  if ((mouseX > 150) && (mouseX < 450) &&
      (mouseY > 150) && (mouseY < 450)) {
    line(0, 0, 150, 150);        // Upper-left
    line(600, 0, 450, 150);      // Upper-right
    line(450, 450, 600, 600);    // Lower-right
    line(0, 600, 150, 450);      // Lower-left
  } else {
    line(150, 150, 450, 450);    // Upper-left to lower-right
    line(150, 450, 450, 150);    // Lower-left to upper-right
  }

  noStroke();
  fill(0);
  ellipse(mouseX, mouseY, 12, 12);
}
```

The next example brings together the arc() function, the mouseX variable, and a
for loop. The length of each arc is based on the x-coordinate of the cursor. As the cursor
moves to the right, the length of the arcs increase. In the loop, the control variable i
sets the diameter and starting angle of each arc. The smallest is drawn first with each
following arc growing in diameter according to the gap variable.

```
int gap = 20;      // Distance between arcs
int thickness = 2;     // Thickness of each arc

void setup() {
  size(600, 600);
  noFill();
  strokeWeight(thickness);
  stroke(0);
}

void draw() {
  background(255);
  float arcLength = mouseX / 95.0;
  for (int i = gap; i < width-gap; i += gap) {
    float angle = radians(i);
    arc(width/2, height/2, i, i, angle, angle + arcLength);
  }
}
```

Figure 9-3
Screen captures for code 9-03.

Figure 9-4
Screen captures for code 9-04.

The final example in this section combines modified versions of previous examples into a single program. Each previous program is contained within a chain of if structures. The value of an integer variable called mode determines what will draw to the screen because it is used in the *test* expression for the conditionals. This code shows how one sketch can have multiple stages or screens. The length of this program is the longest yet, but think of it as a series of short programs collaged together to reduce the complexity. Each block of code defined by an if structure can be edited with focus the same way an individual paragraph within an essay can scrutinized. Learning how to code balances the understanding of an entire program with the details of specific sections.

9-04

```
int mode = 1;
int lastMode = 3;

void setup() {
  size(600, 600);
}

void draw() {
  background(204);
  if (mode == 1) {
    // Based on code 3-20
    fill(0);
    noStroke();
    ellipse(210, 0, 720, 720);
    ellipse(228, 377, 36, 36);
    ellipse(240, 605, 420, 420);
  } else if (mode == 2) {
    // Based on code 3-36
    stroke(0);
    strokeWeight(2);
    fill(255);
    rect(60, 60, 300, 300);
    noFill();
    rect(120, 120, 360, 360);
    rect(180, 180, 360, 360);
  } else {
    // Based on code 8-05
    stroke(0);
    strokeWeight(10);
    for (int y = 120; y < 480; y += 30) {
      line(120, y, 480, y + 90);
    }
  }
}
```

```
void mousePressed() {
  mode++;
  if (mode > lastMode) {
    mode = 1;
  }
}
```

10 Interviews: Image

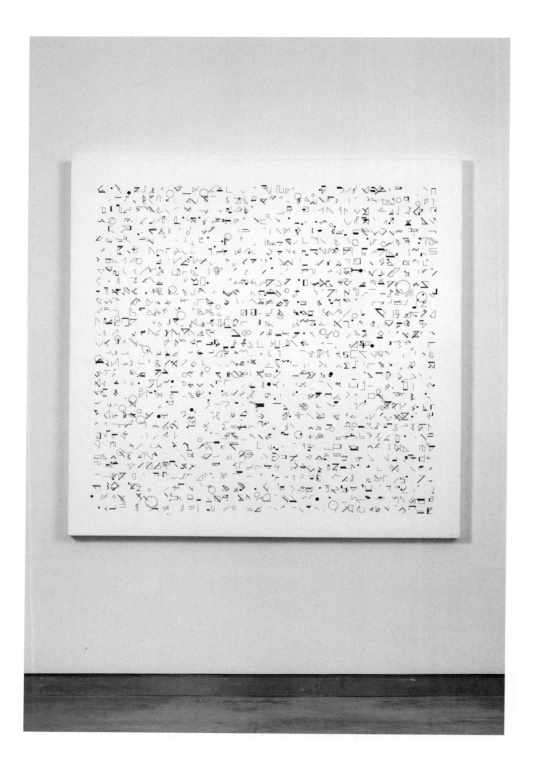

Une Esthetique Programmee *(Interview with Manfred Mohr)*

Creator	Manfred Mohr
Year	1971
Medium	Exhibition
Software	FORTRAN IV
URL	www.emohr.com

What is *Une Esthétique Programmée?*

In the early 1960s I was reading "AESTHETICA IV" by Prof. Max Bense, a German philosopher, whose writings went far beyond traditional art criticism. It led me into unfamiliar intellectual territory. He argued, besides many other interesting ideas, that art should be created by rational means rather than by emotions. At that time, however, the official "art" was abstract expressionism, which I totally appreciated and in which I saw many parallels to modern and free jazz, the music I was engaged in as an active jazz musician.

It came to me as a complete shock to read about "rational art," but somehow a chord was struck in my mind. This idea would not go away, and eventually I understood: If art is to reflect and embrace our social and technological world, it should also be created from the same "material." Struggling with these thoughts over some time, my views on aesthetics and art eventually changed dramatically. In fact, my whole life was turned upside down. The idea of programming an "idea," which meant writing down exactly what one wanted to do before doing it, became a fascinating goal, and my basic research became the invention and systematic development of two-dimensional signs, which I call "êtres-graphiques." These signs refer only to themselves, and their content is the history of their creation.

Since the early 1970s, I've worked exclusively with the fixed structure of a cube as my visual alphabet, which I later extended into the more complex structure of N-dimensional hyper cubes. Through programming I created a quasi-musical instrument with which I could play "algorithms" resulting in unimaginable visual constructs.

Why did you create *Une Esthétique Programmée?*

Une Esthétique Programmée is, so to speak, my personal state of mind, in the surge of finding a new frontier of artistic expression. To realize this, I first had to learn a programming language and also find a computer with a plotter, a drawing machine connected to a computer. In the 1960s, that was a very complicated task. There were no schools or universities to learn programming, and very few books about programming existed. To find a computer was even more challenging, because computer centers at that time consisted of millions of dollars' worth of hardware in large 2,000-square-foot air-conditioned rooms, which of course was not affordable by any single person and was not easy to find or to get access to.

The interesting thing about learning to program one's ideas, by logically defining what I wanted to do, gave me a complete new look at my own aesthetic research and a deeper understanding of my visual processes. The computer became a physical and intellectual extension in the process of creating my art and the results somehow became bigger than the sum of its parts. Subsequently, I called my art "generative work" because the signs were created by the rational structure of programming algorithms, established in advance by myself. My

work is therefore an algorithmic art, a "programmed aesthetic," which conceptually exists (as a program) before it is actually realized.

What software tools were used?

Before I can answer the question about software, I have to tell you again that hardware was at that time (1960s) as much of a problem as software to get hold of. Hardware was cumbersome and almost unobtainable, and written software did literally not exist. I lived in Paris, France, in the 1960s and 1970s, and only through lots of luck and persistency did I get access to the French Meteorology Computer Center in Paris. It was heaven on earth for me. I could use the biggest and fastest computers of that time, a CDC 6400, 6600, and eventually 7600. I also had access to a large Benson 1286 flatbed plotter. I was programming in FORTRAN IV, a language that to this day has its merits, even though it looks today like the C language. In those early days everybody had to write their own programs, because no written software existed as yet. Growing up with this habit, I still write, to this day, all my programs specifically for each work by myself. I understood right away, that the ability to program by myself is a powerful and precise tool to translate my thoughts into action without an external interpreter. It never came into my mind to use software written by someone else.

Why did you use these tools?

There was no other way to accomplish my task.

Why do you choose to work with software?

Programming has changed my life and my view on aesthetics. It became a normal extension of myself to define and clarify my ideas through programming. In fact, it became the basic way to express myself. Over the years it became so normal to me that even looking at other artists' work, for example, I could not help myself from trying to figure out the logical content of the work.

The main interest of my work and, of course for myself, is a visual discovery through its rational content. It is, however, not the system or logic I want to present in my work but the visual invention which results from it. My artistic goal is reached when a finished work can visually dissociate itself from its logical content and convincingly stand as an independent abstract entity. Even though I could not create or invent the visual outcome of my work without my software, it is clearly reflecting my thinking, my stylistic and artistic expression.

Top:
Installation view at bitforms gallery from *Manfred Mohr: 1964–2011, Réflexions sur une esthétique programmée*. September 9–October 15, 2011. Photo by John Berens. Image courtesy bitforms gallery nyc.

Bottom:
Manfred Mohr, *P-021*, 1970–1983. Plotter drawing ink on paper. 19.75 × 19.75"/50 × 50 cm.
Photo by John Berens. Image courtesy bitforms gallery nyc.

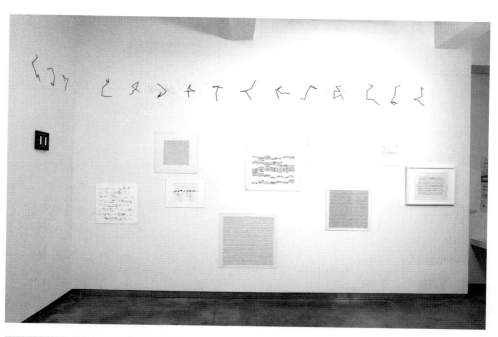

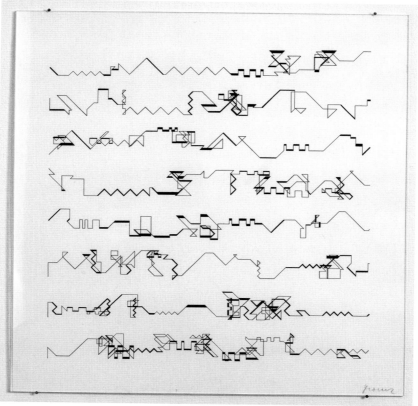

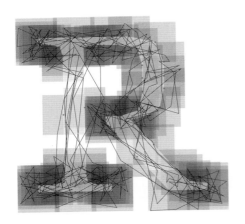
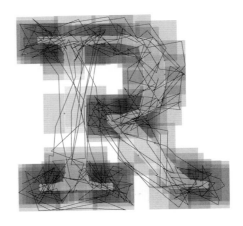
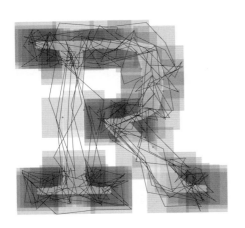

RandomFont Beowolf *(Interview with Erik van Blokland)*

Creators	Just van Rossum and Erik van Blokland (LettError)
Year	1990
Medium	Typeface
Software	PostScript Type 3 font
URL	www.letterror.com/foundry/beowolf

What is RandomFont Beowolf?

In 1989, after finishing the graphic and typographic design course at the Royal Academy of Arts in The Hague, Netherlands, Just and I were both experimenting with PostScript, a powerful programming language designed for graphics. The only machines we had access to that were capable of executing PostScript programs were laser printers, so we went through a lot of paper. We figured it should be possible to build a font with random functions applied to the letterforms when it prints. We made a test font containing one randomizing square to prove the concept. Later we used a typeface I had drawn in school, which after some iterations became Beowolf.

A font in PostScript in its most basic form is a dictionary with some standard entries and drawing instructions for each letter. Fonts like this were called "Type 3," and as long as you managed to get the file in the printer, the letters could use all the functionality of the PostScript language. So that's what we built. Another PostScript font format, "Type 1," was more compact and offered faster processing and hinting, but it was proprietary, encrypted and required secret tools to generate. In the summer of 1990 Adobe published the specifications of Type 1 but unfortunately the increased speed of printing with Type 1 fonts came at a price of a very limited instruction set.

Later we built "piggyback fonts," which incorporated both Type 1 and Type 3 formats. Fonts like this consisted of several Type 1 fonts and a special Type 3 font to contain logic to switch glyphs and fonts while rendering a text. The fonts were all bundled together in a single file, then the Macintosh printer driver would just download the whole thing, and all fonts would make it to the printer. It was a wonderful hack.

The demands of the graphic design workflow made it increasingly difficult to deploy Type 3 formats, and we stopped shipping them. We've always made a case for fonts with executable code; typography is a complex field which can benefit from programming on a font level. But we can't expect the entire digital design industry to accommodate our whims.

The current OpenType font format (developed by Adobe and Microsoft) actually contains ways to define rules for contextual substitution and positioning of glyphs.(Contextual substitution is the process by which letters are changed based on the letters around them. For instance, an f and i might be joined into a single glyph, a ligature that looks like fi.) Though nothing like a fully featured programming language, it's an improvement and fun to develop for. We have an OpenType font with a decent simulation of a RandomFont, much like our piggyback fonts. Visually it reconstructs the broken, edgy style Beowolf had, but conceptually these OpenType Beowolves have very little to do with the original one.

Why did you create RandomFont Beowolf?

Curiosity. We were both trained as type designers, and we were interested in computers and programming. At that time the fields of design and digital technology didn't really overlap. After the first versions we started thinking about the context and implications of randomization. Beowolf became an example of what digital type could be: not that the random aesthetic itself was so appealing, but it was proof that fonts were no longer physical objects but instructions. It also showed us that code and design can merge into a single process, a single object. Code has a major influence on design, and I think it is too important to leave it to anonymous engineers.

What software tools were used?

The first PostScript tests were written in a text editor. Then we took simple PostScript Type 3 fonts generated by Ikarus M (the first version, written by Petr van Blokland) and edited those. These fonts had simple, readable text instructions and absolute coordinates that were easy to modify. Later on, with some help from AltSys's Jim Von Ehr, we moved on to a more complex variation of Type 3 PostScript, editing in ResEdit. The last incarnation of the RandomFonts was piggybacking on a Type 1 font so that there would be some sort of (nonrandom) preview when used in a layout program; then later in the printer the Type 3 randomizing version would kick in and do the work. The piggyback fonts were also made with ResEdit.

Why did you use these tools?

Type design is a small field, so there aren't many developers interested in writing tools. AltSys wrote Fontographer, at the time the popular choice for editing fonts, but it didn't allow the things we had in mind. Petr van Blokland and David Berlow convinced Jim Von Ehr to give them access to the Fontographer source code and Petr started experimenting with adding a layer using awk, a programming language for processing text data. Just suggested using a new programming language that his brother had invented called Python. Python and Fontographer became RoboFog and gained a small but dedicated group of users. Python is fast to develop in, which allows a regular iterative design process. After the first time you write a program you know how it should have been done, and you can afford to start over and do it again, improving the understanding of the problem.

When Mac OS X was released we couldn't port RoboFog because the code base was so old. The FontLab font development software had added Python scripting to their font editor, so we started to work with that instead. We started reshaping their API into ours, and this grew into the RoboFab library, an object model and API built on top of FontLab's font and glyph objects. RoboFab now also has an implementation that works independently of FontLab.

Why do you choose to work with software?

In any creative discipline, the tools influence the process and, indirectly, the results. We try to be aware of this influence, and if it is something we don't like we try to change it. Every application makes certain things easy and others more difficult. This directs the average design project towards the things that are easy, even though other ideas might be more relevant.

Writing your own tools makes the ideas direct the development of software, rather than the other way round. Writing code is also an attractive process in itself. Analyzing problems, breaking them down into ideas that can be coded, and discovering alternative new ways to solve known problems is more universal than just the original design task.

Fractal.Invaders, Substrate *(Interview with Jared Tarbell)*

Creator	Jared Tarbell
Year	2003
Medium	Software, Prints
Software	Flash, Processing
URL	www.complexification.net

What are *Fractal.Invaders* and *Substrate*?

Fractal.Invaders *and* Substrate *are unique programs that both generate space-filling patterns on a two-dimensional surface. Each uses simplified algorithmic processes to render a more complex whole.*

Fractal.Invaders *begins with a rectangular region and recursively fills it with little "invader" objects. Each invader is a combination of black squares arranged in a 5 × 5 grid generated at random during runtime. The only rule of construction requires that the left side of the invader be a mirror copy of the right side. This keeps them laterally symmetric, which endows them with a special attractiveness to the human eye.*

There are a total of 32,768 (2¹⁵) possible invaders. The magnitude of 15 comes from the product of 3 columns and 5 rows (the last 2 columns of the grid are ignored since they are the same as the first 2). The 2 comes from the fact that each space in the grid can be either black or white.

A small bit of interactivity allows each invader to be clicked. Clicking an invader destroys it, although the empty space left behind is quickly filled with smaller invaders. In this way, the user is ultimately doomed.

Substrate *begins similarly with an empty rectangular region. It has been compared to crystal formation and the emergent patterns of urban landscapes. A single line (known internally as a "crack" since the algorithm was inspired by sunbaked mud cracks) begins drawing itself from some random point in some random direction. The line continues to draw itself until it either (a) hits the edge of the screen or (b) hits another line, at which point it stops and two more lines begin. The one simple rule used in the creation of new lines is that they begin at tangents to existing lines. This process is repeated until there are too many lines to keep track of or the program is stopped.*

Before writing the program, I only had a vague idea of what it might look like. It wasn't until the first couple of bug-free executions that I realized something incredible was happening. The resulting form was much more complex than the originating algorithm. This particular quality of software is what keeps me interested.

Interesting effects can be created by introducing small variations in the way the first couple of lines are drawn. One of my favorite initial conditions is the creation of three lines, each in its own localized space with a direction that varies from the others by about 30 degrees. After growing for a short time into coherent lattices, they eventually crash into each other, creating an affluence of odd shapes and unexpected mazes.

The watercolor quality of the rendering is achieved by placing large numbers of mostly transparent pixels perpendicular to each line's growth. The trick is to deposit precisely the same

number of pixels regardless of the length of the area being filled. This produces an interesting density modulation across an even mass of pixels.

Why did you create this software?

For me, one of the most enjoyable subjects in computer science is combination. I ask myself a question like, "Given some rules and a few simple objects, how many possible ways can they be combined?" Seldom can I answer this using thought alone, mainly because the complexity of even just a few elements is outside the realm of my imagination. Instead, I write computer programs to solve it for me. Fractal.Invaders is definitely one of these questions, and is answered completely with the rendering of every single invader. Substrate asks a similar question, but with results that, although beautiful, are a little less complete.

What software tools were used?

For Fractal.Invaders, I used a combination of Flash and custom software to create and capture the invaders, respectively. In Flash, all work was done using ActionScript. A single symbolic element (black square) exists in the library. Code takes this square and duplicates it hundreds of thousands of times. The entire generative process takes about five minutes to complete, depending on the size of the region to be filled and the speed of the execution. Capturing a high-resolution image of the result is accomplished with a program that scales the Shockwave Flash (SWF) file very large and saves the screen image out to a file.

Substrate was created entirely in Processing. Processing was particularly well suited for this because it excels at drawing, especially when dropping millions of deep-color pixels. Processing can also save out extremely large graphic images in an automated fashion. Oftentimes I will run a Processing project overnight. In the morning I awake to a vast collection of unique images, the best of which are archived as print editions.

Why did you use these tools?

I use Flash because I am comfortable working within it. I use Processing because it enables me to do things Flash simply cannot. Both environments allow me to take a program from concept to completion in a number of hours. Complex visual logic can be built up without the bulky overhead required in more traditional graphic programming languages.

Flash excels at rendering very high resolution images nicely, displaying native vector objects with a high degree of precision and full antialiasing. Processing gives me the computational speed to increase the number of objects in the system by a magnitude of 20 or more. Both programs allow me to produce work that is capable of being viewed by a large number of people worldwide.

Why do you choose to work with software?

With software, anything that can be imagined can be built. Software has a mysterious, undefined border. Programming is truly a process of creating something from nothing. I enjoy most John Maeda's perspective: "While engaged in the deepest trance of coding, all one needs to wish for is any kind of numerical or symbolic resource, and in a flash of lightning it is suddenly there, at your disposal."

Fractal.Invaders, 2004. Image courtesy of Jared Tarbell.

Perpetual Storytelling Apparatus

(Interview with Benjamin Maus)

Creator	Benjamin Maus and Julius von Bismarck
Year	2008
Medium	Patent Drawings, Software, Drawing Machine
Software	Custom Java Application
URL	http://storyteller.allesblinkt.com/

What is the Perpetual Storytelling Apparatus?

The Perpetual Storytelling Apparatus *is a drawing machine illustrating a never-ending story by the use of patent drawings. The machine translates words of a text (e.g., a novel) into a stream of patent drawings. Eight million patents—linked by over 22 million references—form the vocabulary. By using references to earlier patents, it is possible to find paths between the patents that have been found for word-combinations in the story. Those connections form a subtext. New visual connections and narrative layers emerge through the interweaving of the story with the depiction of technical developments.*

The apparatus takes a combination of words in the story and searches for a patent document, whose text contains those words. Then it extracts the main drawing from the patent document and draws it. Advancing in the story, it finds the next patent document. Between the found patent and the previously drawn patent, the patents that connect the two are drawn in between. This process repeats and ingests one story after another, and generates an endless stream of patent drawings.

The first two instances of the Perpetual Storytelling Apparatus *are using the database of the US Patent and Trademark Office. The third apparatus, which has recently been installed at the German Patent Office in Munich, uses the whole backlog of patents applied for in Germany.*

Why did you create the Perpetual Storytelling Apparatus?

We created the Perpetual Storytelling Apparatus *because Julius and I were (and still are) very interested in patents. They are a great way to look up technical principles when you are creating something to see how other people solved a problem.*

The patent database is a dictionary of inventions—a huge archive— but most people have never had a look at a patent document. The Apparatus is also an archeological approach to this huge amount of knowledge. It is meant to uncover what lies dormant. That is why there is also the patent number drawn next to each image. The viewers can first construct a story in their heads, but can also look up what is behind it.

Patents are also a mirror of their time. They show how individuals and corporations tried to solve (perceived) needs and challenges. For example, before the time psychotropic drugs were invented, you can find a lot of patents that describe methods for restraining people.

We constructed a drawing machine that translates the patent drawings back into an act of drawing. Most of the patent drawings are very detailed and speak a common visual language, even though some of them are centuries old.

What software tools were used?

Before we programmed the final systems, we tried out many individual aspects of the concept, like finding a path between two arbitrary patents or isolating the most concise drawing in a patent document. We wrote most of those prototypes in Processing, but we also tried out many of the algorithms manually before writing a single line of code to see if they worked. The final version is written in Java, but it still relies on a couple of things in Processing.

The only thing that relies on external software is the conversion of the scanned patent documents into drawable paths. That is handled by a small utility called AutoTrace, which was designed to digitize scanned samples of type.

Why did you use these tools?

Processing is very good for small sketches. It's only a matter of seconds to try something out. There is very little overhead, like setting up a toolchain and adding libraries. Sometimes it's not fast enough for production use, but it makes sense most of the time to use tools and algorithms that you already know and that are easy to use, even if they are not the most efficient from the standpoint of a computer scientist. One can always rewrite parts of the program that need to be faster at a later time.

We ended up writing most of the software ourselves, because there were either no tools available for the task or they did not allow the control we wanted. For example, the drawing paths output by the tool that traces the scanned documents are unordered and messy. When you draw them as they are, it's very disturbing to watch. So we spent a lot of time on determining the order and direction in which the lines are drawn. Direction matters, because most of the drawings have lot of hatching. We wanted this part to have a distinctly human feel, because the goal was to retranslate the documents through the action of drawing.

Why do you choose to work with software?

Working with software allows us to manifest the logic and behavior of an artwork. For a lot of things, that would be very hard to do without software. Still, we do not consider the Perpetual Storytelling Apparatus *to be a software artwork. Artists have used software for a few decades now, so it's only a matter of time before software as an artistic tool and medium will be absorbed into the mainstream.*

I don't like the fact that software and computer systems are still mystified. Software and algorithms have become omnipresent; we cannot flee from them. Almost all processes and actions in our daily lives are governed or at least backed up by software systems. For me, it is a worrisome state that most people do not have a basic understanding of how those systems work.

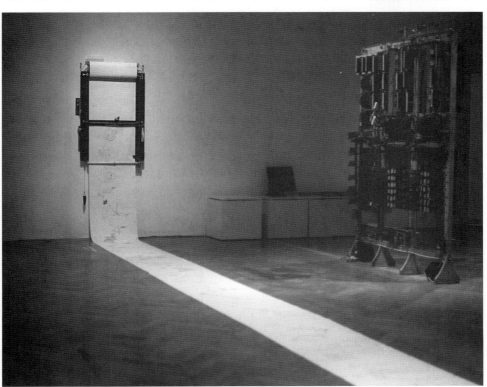

Installation photos of the *Perpetual Storytelling Apparatus*. Images courtesy of Benjamin Maus and Julius von Bismarck.

```
              .           #   $   %
&   '   (   )       *   +   ,
-   .   /   0   1   2   3
4   5   6   7   8   9   :
;   <   =   >   ?   @   A
B   C   D   E   F   G   H
I   J   K   L   M   N   O
P   Q   R   S   T   U   V
W   X   Y   Z   [   \   ]
^   _   `       a   b   c   d
e   f   g   h   i   j   k
l   m   n   o   p   q   r
s   t   u   v   w   x   y
```

11 Text

This chapter introduces code elements for working with language.

Syntax introduced:
```
char, String
"." (dot operator)
String.length(), String.startsWith(), String.endsWith(),
String.charAt(), String.subString(),
String.toLowerCase(), String.toUpperCase()
String.equals()
```

I SENSE THE SUN IN THE STREET,
ALL SPACE IN THE STREET.
BANG! THE SUN HAS SLID.

This poem was generated from software written by Margaret Masterman and was featured in the 1968 Cybernetic Serendipity exhibition at the Institute of Contemporary Arts (ICA) in London. This exhibition exposed the public to examples of software-generated poems, music, and drawings. While the poem may or may not conform to your ideas about great poetry, the exhibition was important for its early emphasis on using the computer as a language processing machine. A common misconception holds that computer programming is applicable only to technical fields. While there is a strong connection between programming and technology, it's not the only realm in which computers can make for interesting collaborators. Programming can be approached with an emphasis on language, making computers potentially interesting to a far broader audience.

Some of the earliest explorations of the computer outside scientific research focused on software as a language engine. The history of artificial intelligence (AI) has a strong component of language processing. John McCarthy's LISP programming language made processing text easy and became popular for early experimentation in AI. The controversial ELIZA software, written by Joseph Weizenbaum in 1966, parodies the dialog between a Rogerian therapist and a patient by rephrasing the patient's statements as questions. People input statements through a keyboard and the software constructs a reply. For example, if the patient types, "I feel depressed," ELIZA might respond, "Why do you say you are depressed?" Terry Winograd's SHRDLU project, c. 1970, used the same kind of interaction between keyboard input and text response, but it earnestly explored the computer's potential for understanding natural language. SHRDLU made it possible for a person to have a discussion with the computer about an arrangement of simulated blocks. For example, to the query "How many blocks are not in the box?" the software would respond "Four of them" based on the current status of the blocks.

Researchers have continued to explore language as a software interface. Emerging software services such as automated translation and speech-to-text conversions are not always reliable, but they are fascinating to explore. For example, if we take two simple English sentences...

Translation requires nuance. Can it be performed by a machine?

...and convert them to Italian using an online translation service, we are given this text:

La traduzione richiede la sfumatura. Può essere effettuata da una macchina?

If we take the Italian translation and convert it back to English, we now have

The translation demands the shading. Can be carried out from one machine?

Similarly, software designed to convert spoken language into written language has its limitations. Both technologies, however, can be used in controlled circumstances as unique ways of working with text and software.

This chapter does not discuss artificial intelligence or language parsing, but text is one of the most common types of data created and modified by software. The text created for email, publications, and web pages is a vast resource of data that can be stored and presented through the data types and functions introduced in what follows.

Characters

The char data type stores a single typographic symbol such as *A*, *d*, *5*, and *$*. The name *char* is short for *character*, and this type of data is distinguished from other typographic symbols in the program by surrounding single quotes. Character variables are declared and assigned in the same way as the int and float types.

```
char a = 'n';   // Assign 'n' to variable a
char b = n;     // ERROR! Without quotes, n is a variable
char c = "n";   // ERROR! The "" defines n as a String, not a char
char d = 'not'; // ERROR! The char type can hold only one character
```
11-01

The following example creates a new char variable, assigns values, and prints the values to the console.

```
char letter = 'A';  // Declare variable letter and assign 'A'
println(letter);    // Prints "A" to the console
letter = 'B';       // Assign 'B' to variable letter
println(letter);    // Prints "B" to the console
```
11-02

Many characters have a corresponding number on the standardized ASCII table. For example, *A* is 65, *B* is 66, *C* is 67, etc. You can find which character matches which number by looking at an ASCII table (such as in Appendix C, p. 604) or by testing with the `println()` function:

```
char letter = 'A';    // Declare variable letter and assign 'A'    11-03
println(letter);      // Prints "A" to the console
int n = letter;       // Assign the numerical value of 'A'
println(n);           // Prints "65" to the console
```

Appendix C also includes information about using non-ASCII characters (for instance, a character with an accent or an umlaut) or characters from non-Roman alphabets such as Japanese or Korean.

The mapping between numeric and alphabetic formats emphasizes the importance of data types. The following program prints the letters *A* to *Z* to the console by incrementing the `char` variable in a `for` loop.

```
char letter = 'A';    // Declare variable letter and assign 'A'    11-04
for (int i = 0; i < 26; i++) {
  print(letter);      // Prints a character to the console
  letter++;           // Add 1 to the value of the character
}
println('.');         // Adds a period to the end of the alphabet
```

Words, Sentences

Use the `String` data type to store words and sentences. Surrounding double quotes distinguish strings from characters and the rest of the program. Quotation marks define "s" as a string, while single quotes (apostrophes) define 's' as a character, and without either it could be a variable name. The `String` data type is different from the data types `int`, `float`, and `char` because it is a *class* (p. 359), a composite data type containing multiple data elements and functions. `String` variables are declared and assigned in the familiar way, but the word `String` must be capitalized:

```
String a = "Eponymous";    // Assign "Eponymous" to a           11-05
String b = 'E';            // ERROR! The '' define E as a char
String c = "E";            // Assign "E" to c
string d = "E";            // ERROR! String must be capitalized
```

The following example demonstrates some basic ways to use this data type:

```
// The String data type can contain long and short text elements    11-06
String s1 = "Rakete bee bee?";
```

```
String s2 = "Rrrrrrrrrrrrrrrrummmmmpffff tillffff tooooo?";
println(s1);   // Prints "Rakete bee bee?"
println(s2);   // Prints "Rrrrrrrrrrrrrrrrummmmmpffff tillffff
tooooo?"

// Strings can be combined with the + operator
String s3 = "Rakete ";
String s4 = "rinnzekete";
String s5 = s3 + s4;
println(s5);   // Prints "Rakete rinnzekete"
```

If you have a large quantity of text to display in a program, it's better to load the text into the program from a file than to store it in String variables. This process is explained in Data (p. 489).

Strings are objects

Variables created with the String data type are *objects*. Objects are software structures that combine variables with functions that operate on those variables. For instance, every String object has a built-in function that can capitalize its letters. Objects are visually distinguished from primitive data types like int and float with capitalization.

Variables within an object are called *fields*, and functions within an object are called *methods*. Fields and methods are accessed with the *dot operator*, a period placed between the name of the object and the name of a data element or function inside the object.

The String data type includes methods for examining the individual characters within, extracting parts of strings, converting an entire string to uppercase or lowercase characters, and comparing two String variables. Some of the most common String methods are introduced below, and more are discussed in the Processing reference.

The length() method returns the number of characters in a String object:

```
String s1 = "Azzurro";
String s2 = "A";
println(s1.length());   // Prints "7"
println(s2.length());   // Prints "1"
```

Later in the book, please notice the difference between the the String method length() and the code for getting the length of an array (p. 418). They both calculate the number of elements in their object, but because the technique for getting the number of elements in a String is a method, the parentheses are necessary.

The startsWith() and endsWith() methods test whether a string starts or ends with the string used as the parameter:

11-08

```
String s1 = "Arancione";
println(s1.startsWith("A"));     // Prints "true"
println(s1.startsWith("ione"));  // Prints "false"
println(s1.endsWith("ione"));    // Prints "true"
```

The charAt() method is used to read a single character within a string. This method has one parameter to define the character that is returned. Note that the first character in the string is at position 0, the second at position 1, etc.

11-09

```
String s = "Verde";
println(s.charAt(0));   // Prints "V"
println(s.charAt(2));   // Prints "r"
println(s.charAt(4));   // Prints "e"
```

The String method substring() returns a new string that is a part of the original. When the method is used with one parameter, the string is read from the position given as the parameter to the end of the string. When two parameters are used, the string between the two parameter positions is returned.

11-10

```
String s = "Giallo";
println(s.substring(2));          // Prints "allo"
println(s.substring(4));          // Prints "lo"
println(s.substring(1, 4));       // Prints "ial"
println(s.substring(0, s.length()-1));   // Prints "Giall"
```

The String method toLowerCase() returns a copy of the string with all of the characters made lowercase. The method toUpperCase() does the same for uppercase.

11-11

```
String s = "Nero";
println(s.toLowerCase());   // Prints "nero"
println(s.toUpperCase());   // Prints "NERO"
```

Because the String data type is an object, it's not possible to compare two strings with relational operators. Using == to compare two objects will compare only whether they are stored in the same location in memory, not their actual contents. Instead, the equals() method is used to determine whether two String variables contain the same characters.

11-12

```
String s1 = "Bianco";
String s2 = "Bianco";
String s3 = "Nero";
```

```
println(s1.equals(s2));   // Prints "true"
println(s2.equals(s1));   // Prints "true"
println(s1.equals(s3));   // Prints "false"
```

Now that the char and String data types have been introduced, they will be used to more interesting ends in the proceeding chapter on Typography and further within the book.

Exercises

1. *Create five* char *variables and assign a character to each. Write each to the console with* println()*.*
2. *Create two* String *variables and assign a word to each. Write each to the console with* println()*.*
3. *Store a long sentence in a* String *and write it to the console.*
4. *Change the values of the* String *variables in code 11-07 and notice how that affects the results printed to the console.*
5. *Create a series of* char *variables by extracting characters from a* String *with the* charAt() *method.*

12 Typography

This chapter introduces creating and setting fonts and displaying text on screen.

Syntax introduced:
```
text(), textSize()
createFont(), textFont(), PFont, loadFont()
textLeading(), textAlign(), textWidth()
```

The evolution of typographic reproduction and display technologies has and continues to impact human culture. Early printing techniques developed by Johannes Gutenberg in fifteenth-century Germany using letters cast from lead provided a catalyst for increased literacy and the scientific revolution. Automated typesetting machines, such as the Linotype invented in the nineteenth century, changed the way information was produced, distributed, and consumed. In the digital era, the way we consume text has changed drastically since the proliferation of personal computers in the 1980s and the rapid growth of the Internet in the 1990s. Text from emails, websites, and instant messages fill computer screens, and while many of the typographic rules of the past apply, type on screen requires additional considerations for enhanced communication and legibility.

Letters on screen are created by setting the color of pixels. The quality of the typography is constrained by the resolution of the screen. Because, historically, screens have a low resolution in comparison to paper, techniques have been developed to enhance the appearance of type on screen. The fonts on the earliest Apple Macintosh computers comprised small bitmap images created at specific sizes like 10, 12, and 24 points. Using this technology, a variation of each font was designed for each size of a particular typeface. For example, the character *A* in the San Francisco typeface used a different image to display the character at size 12 and 18. When the LaserWriter printer was introduced in 1985, Postscript technology defined fonts with a mathematical description of each character's outline. This allowed type on screen to scale to large sizes and still look smooth. Apple and Microsoft later developed TrueType, another outline font format. More recently, these technologies were merged into the OpenType format. In the meantime, methods to smooth text on screen were introduced. These anti-aliasing techniques use gray pixels at the edge of characters to compensate for low screen resolution.

The proliferation of personal computers in the mid-1980s spawned a period of rapid typographic experimentation. Digital typefaces are software, and the old rules of metal and photo type no longer apply. The Dutch typographers known as LettError explain, "The industrial methods of producing typography meant that all letters had to be identical... Typography is now produced with sophisticated equipment that doesn't impose such rules. The only limitations are in our expectations."[1] LettError expanded the possibilities of typography with their typeface Beowolf (p. 131). It printed every letter

differently so that each time an *A* is printed, for example, it will have a different shape. During this time, typographers such as Zuzana Licko and Barry Deck created innovative typefaces with the assistance of new software tools. The flexibility of software has enabled extensive font revivals and historic homages such as Adobe Garamond from Robert Slimbach and The Proteus Project from Jonathan Hoefler. Typographic nuances such as ligatures—connections between letter pairs such as fi and æ—made impractical by modern mechanized typography are flourishing again through software font tools.

Draw text

The `text()` function is used to draw letters, words, and paragraphs to the screen. In the simplest use, the first parameter can be a `String`, `char`, `int`, or `float`. The second and third parameters set the position of the text. By default, the second parameter defines the distance from the left edge of the window; the third parameter defines the distance from the text's baseline to the top of the window. The `textSize()` function defines the size the letters will draw in units of pixels. The number used to define the text size will not be the precise height of each letter, the difference depends on the design of each font. For instance, the statement `textSize(30);` won't necessarily draw a capital *H* at 30 pixels high. The `fill()` function controls the color and transparency of text. This function affects text the same way it affects shapes such as `rect()` and `ellipse()`, but text is not affected by `stroke()`.

```
fill(0);                                          12-01
text("LAX", 0, 40);   // Write "LAX" at coordinate (0,40)
text("AMS", 0, 70);   // Write "AMS" at coordinate (0,70)
text("FRA", 0, 100);  // Write "FRA" at coordinate (0,100)
```

```
textSize(32);   // Set text size to 32            12-02
fill(0);
text("LAX", 0, 40);
text("ORD", 0, 70);
text("DAY", 0, 100);
```

```
textSize(32);                                     12-03
fill(0);       // Fill color black
text("LAX", 0, 40);
fill(126);     // Fill color gray
text("HKG", 0, 70);
fill(255);     // Fill color white
text("PVG", 0, 100);
```

```
textSize(64);
fill(0, 140);   // Fill black with low opacity
text("8", 0, 60);
text("8", 15, 65);
text("8", 30, 70);
text("8", 45, 75);
text("8", 60, 80);
```

Another version of text() draws the characters inside a rectangle. In this use, the second and third parameters define the position of the upper-left corner of the box and fourth and fifth parameters define the width and height of the box. If the length of the text exceeds the dimensions of the defined box, the text will not display.

```
String s = "Five hexing wizard bots jump quickly.";
fill(0);
text(s, 10, 10, 60, 80);
```

```
String s = "Five hexing wizard bots jump quickly.";
fill(0);
text(s, 10, 10, 60, 55);   // Box too small
```

Load media

The examples in this chapter are the first to load external media into a sketch. Up to now, all examples have used only graphics generated within Processing through drawing functions such as line() and ellipse(). Processing is capable of loading and displaying other media, including fonts, images, vector files, formatted data, and sounds. While this chapter focuses on loading fonts and other chapters discuss specific information about other media types, there are a few things about loading media that apply to all categories. These similarities are discussed here.

Before external media can be used in a Processing sketch, it needs to be loaded each time the program is run. Media can be loaded directly from a sketch's folder, another location on the computer, or though the Internet. Most typically, the media is loaded directly from the sketch's folder. Media is usually placed into a folder called *data*; there are three ways to get media into this folder:

1. Add the file by selecting the "Add File" option in the Sketch menu of the Processing environment. Navigate to the file's location on your computer, select the file's icon or name, and click "Open" to add it to the sketch's data folder.

2. A file (or group of files) can be dragged and dropped into the Processing text area. If successful, a note will appear in the message area stating, for instance, "One file added to the sketch."

3. Files can be added manually by opening the sketch folder by selecting the "Show Sketch Folder" option from the Sketch menu. Create a folder inside called *data* if it doesn't exist and copy the file (or files) into that folder.

To confirm the file was added correctly, select "Show Sketch Folder" from the Sketch menu. The file will be inside the data folder. With the image file in the right place, it's ready to load. Be sure to include the file format extension as a part of the name and to put the entire name in quotes (e.g., *"pup.gif"*, *"kat.jpg"*, *"ignatz.png"*). When loading the file, be careful to use the correct capitalization when writing the file name. If the file is *arch.jpg,* trying to load *Arch.jpg* or *arch.JPG* will create an error. Also, avoid the use of spaces in file names, which can cause problems.

To make media files accessible from anywhere in a program, they are typically declared as globally available variables outside of setup() and draw(). Files are usually loaded inside setup() because they need only be loaded once and because it takes time to load them. Loading a file inside draw() reduces the frame rate of a program because it causes the file to reload each frame. Once a file is loaded in setup(), it may be utilized anywhere in the program. In most Processing programs, all files are loaded when the program starts.

Vector fonts

To work with fonts different than the default, more functions are needed to prepare a font to be used with Processing. The createFont() function is used to convert a TrueType font (.ttf) or OpenType font (.otf) so that is can display through text(). The textFont() function is used to define the current font to display. Any compatible font installed on the computer running Processing or stored in the sketch's data folder may be used. The following short program is used to print the list of the available installed fonts to the console:

```
String[] fontList = PFont.list();
printArray(fontList);
```
12-07

The printArray() function (p. 420) is used to write each font on a new line. The first few options printed to the console are general typographic classifications such as Serif, SansSerif, and Monospaced. Use these options to define a style, but not a specific font. When the list is generated on the computer used to write this book, a list of 573 font options are printed to the console. Your computer will produce different results depending on the operating system and custom fonts installed. The list starts with

general font categories that will work across platforms, then continues with specific font names. A short excerpt from our list follows:

```
[0]   "Serif"
[1]   "SansSerif"
[2]   "Monospaced"
[3]   "Dialog"
[4]   "DialogInput"
[5]   "ACaslonPro-Bold"
...
[567] "ZXX-Sans"
[568] "ZXX-Xed"
[569] "ZapfDingbatsITC"
[570] "Zapfino"
[571] "Ziggurat-Black"
[572] "Ziggurat-BlackItalic"
```

Before a font is used in a program, it must be converted and set as the current font. Processing has a unique data type called PFont to store font data. Make a new variable of the type PFont and use the createFont() function to convert the font. The first parameter to createFont() is the name of the font to convert and the second parameter defines the base size of the font. (Optional third and fourth parameters are defined in the Reference.) The textFont() function must then be used to set the current font. On our development computer, to work with Ziggurat Black, list option 571 above, the following code is run:

12-08

```
PFont zigBlack;

void setup() {
  size(100, 100);
  zigBlack = createFont("Ziggurat-Black", 32);
  textFont(zigBlack);
  fill(0);
}

void draw() {
  background(204);
  text("LAX", 0, 40);
  text("LHR", 0, 70);
  text("TXL", 0, 100);
}
```

To make this program work on your computer, you will likely need to modify line 5 to work with a font on your machine. This program is similar to code 12-01, but notice the differences in the letters in the Ziggurat font in relation to the default font.

To ensure a font will load on all computers, regardless if the font is installed, add the file to the sketch's data folder. (Fonts in the data folder don't print in the console list as demonstrated in code 12-07.) Follow the instructions on page 10 to add a font to the data folder. When fonts inside the data folder are used, the complete file name, including the data type extension, needs to be written as the parameter to createFont(). The following example is similar to the prior example, but it uses an OpenType font inside the data folder. It uses Source Code Pro, an open source typeface that can be found online and downloaded through a web browser.

```
PFont sourceLight;                                              12-09

void setup() {
  size(100, 100);
  sourceLight = createFont("SourceCodePro-Light.otf", 34);
  textFont(sourceLight);
  fill(0);
}

void draw() {
  background(204);
  text("LAX", 0, 40);
  text("LHR", 0, 70);
  text("TXL", 0, 100);
}
```

To use two fonts in one program, create two PFont variables and use the textFont() function to change the current font. Based on the prior two examples, the Ziggurat-Black font loads from its location on the local computer and Source Code Pro loads from the data folder.

```
PFont zigBlack, sourceLight;                                    12-10

void setup() {
  size(100, 100);
  zigBlack = createFont("Ziggurat-Black", 24);
  sourceLight = createFont("SourceCodePro-Light.otf", 34);
  fill(0);
}
```

```
void draw() {
    background(204);
    textFont(zigBlack);
    text("LAX", 0, 40);
    textFont(sourceLight);
    text("LHR", 0, 70);
    textFont(zigBlack);
    text("TXL", 0, 100);
}
```

12-10
cont.

Pixel fonts

Processing can also work with fonts that it converts into small image textures. These fonts aren't as flexible and crisp as fonts converted for Processing with createFont() and used with the default renderer, but they are more optimized for use with the P2D and P3D renderers. The difference between renderers is discussed on page 547. The pixel font format used by Processing was developed at the MIT Media Lab in the mid 1990s in the Visual Language Workshop (VLW). The VLW format stores each alphanumeric character as a grid of pixels. It is a quick way to render text and makes it possible to include a font with a sketch without including the vector data.

To convert a font to the VLW format, select the "Create Font" option from the Tools menu. A window opens and displays the names of the fonts installed on your computer that are compatible. Select a font from the list and click "OK." The font is generated and copied into the current sketch's data folder. To make sure the font is there, click on the Sketch menu and select "Show Sketch Folder." The Create Font tool offers the option to set the size of the font and to select whether it will have smooth, antialiased edges. This tool also offers the option to export "All Characters," which means every character in the font will be included and will therefore increase the file size.

The following example uses the same font as the prior createFont() example. The only difference is the replacement of that function with loadFont(). To run these examples, first use the "Create Font" tool to turn a font into a VLW file. Change the name of the parameter to loadFont() to match the name of the VLW file created.

```
PFont zigBlack;

void setup() {
    size(100, 100);
    zigBlack = loadFont("Ziggurat-Black-32.vlw");
    textFont(zigBlack);
    fill(0);
}
```

12-11

```
void draw() {
  background(204);
  text("LAX", 0, 40);
  text("LHR", 0, 70);
  text("TXL", 0, 100);
}
```

When the font is drawn at a different size from the size at which it was created, it is scaled and therefore does not always look as crisp and smooth. For example, if a font is created at 12 pixels and is displayed at 96 pixels, it will appear blurry.

```
PFont zigBlack;

void setup() {
  size(100, 100);
  zigBlack = loadFont("Ziggurat-Black-12.vlw");
  textFont(zigBlack);
  fill(0);
}

void draw() {
  background(204);
  textSize(12);
  text("A", 20, 20);
  textSize(96);
  text("A", 20, 90);
}
```

For the best results, draw a font at the size at which it was created. If the same font needs to be used at multiple sizes, consider rendering and loading it at these precise sizes. When VLW fonts are used in 3D, letters with different z-coordinates can sometimes occlude other letters. This can be corrected with a *hint*, see page 547.

Text attributes

Processing includes functions to control the leading (the spacing between lines of text) and alignment. Processing can also calculate the width of any character or group of characters, a useful technique for arranging shapes and typographic elements.

The textLeading() function sets the spacing between lines of text. It has one parameter that defines this space in units of pixels.

```
String lines = "L1 L2 L3";
textSize(12);
fill(0);
textLeading(10);
text(lines, 10, 15, 30, 100);
textLeading(20);
text(lines, 40, 15, 30, 100);
textLeading(30);
text(lines, 70, 15, 30, 100);
```

12-13

Letters and words can be drawn from their center, left, and right edges. The textAlign() function sets the alignment for drawing text through its parameter, which can be LEFT, CENTER, or RIGHT. It sets the display characteristics of the letters in relation to the x-coordinate stated in the text() function.

```
fill(0);
textSize(12);
line(50, 0, 50, 100);
textAlign(LEFT);
text("Left", 50, 20);
textAlign(RIGHT);
text("Right", 50, 40);
textAlign(CENTER);
text("Center", 50, 80);
```

12-14

The settings for textSize(), textLeading(), and textAlign() will be used for all subsequent calls to the text() function. However, note that the textSize() function will reset the text leading, and the textFont() function will reset both the size and the leading.

The textWidth() function calculates and returns the pixel width of any character or text string. This number is calculated from the current font and size as defined by the textFont() and textSize() functions. Because the letters of every font are a different size and letters within many fonts have different widths, this function is the only way to know how wide a string or character is when displayed on screen. For this reason, always use textWidth() to position elements relative to text, rather than hard-coding them into your program.

```
String s = "AEIOU";
float tw; // Text width
fill(0);
textSize(14);
tw = textWidth(s);
text(s, 4, 40);
rect(4, 42, tw, 5);
```

12-15

```
textSize(28);
tw = textWidth(s);
text(s, 4, 76);
rect(4, 78, tw, 5);
```

Typing

Drawing letters to the screen becomes more engaging when used in combination with the keyboard. The keyPressed() event function introduced on page 97 can be used to record each letter as it is typed. The following two examples use this function to read and analyze input from the keyboard by using the String methods introduced in the Text chapter (p. 143). In both, the String variable letters starts empty. Each key typed is added to the end of the string. The first example displays the string as it grows as keys are pressed and removes letters from the end when backspace is pressed. The second example builds on the first—when the Return or Enter key is pressed, the program checks if the word "gray" or "black" was typed. If one of these words was input, the background changes to that value.

```
String letters = "";

void setup() {
  size(100, 100);
  stroke(255);
  fill(0);
  textSize(16);
}

void draw() {
  background(204);
  float cursorPosition = textWidth(letters);
  line(cursorPosition, 0, cursorPosition, 100);
  text(letters, 0, 50);
}

void keyPressed() {
  if (key == BACKSPACE) {
    if (letters.length() > 0) {
      letters = letters.substring(0, letters.length()-1);
    }
  } else if (textWidth(letters+key) < width) {
    letters = letters + key;
  }
}
```

bla

black

gr

gray

```
String letters = "";
int back = 102;

void setup() {
  size(100, 100);
  textSize(16);
  textAlign(CENTER);
}

void draw() {
  background(back);
  text(letters, 50, 50);
}

void keyPressed() {
  if ((key == ENTER) || (key == RETURN)) {
    letters = letters.toLowerCase();
    println(letters);   // Print to console to see input
    if (letters.equals("black")) {
      back = 0;
    } else if (letters.equals("gray")) {
      back = 204;
    }
    letters = "";   // Clear the variable
  } else if ((key > 31) && (key != CODED)) {
    // If the key is alphanumeric, add it to the String
    letters = letters + key;
  }
}
```

Typography and interaction

Many people spend hours a day inputting letters into computers, but this action is very constrained. What features could be added to a text editor to make it more responsive to the typist? For example, the speed of typing could decrease the size of the letters, or a long pause in typing could add many spaces, mimicking a person's pause while speaking. What if the keyboard could register how hard a person is typing (the way a piano plays a soft note when a key is pressed gently) and could automatically assign attributes such as *italics for soft presses* and **bold for forceful presses**? These analogies suggest how conservatively current software treats typography and typing.

Many artists and designers are fascinated with type and have created unique ways of exploring letterforms with the mouse, keyboard, and more exotic input devices. A minimal yet engaging example is John Maeda's *Type, Tap, Write* software, created in

1998 as homage to manual typewriters. This software uses the keyboard as the input to a black-and-white screen representation of a keyboard. Pressing the number keys cause the software to cycle through different modes, each revealing a playful interpretation of keyboard data. In Jeffrey Shaw and Dirk Groeneveld's *The Legible City* (1989–91), buildings are replaced with three-dimensional letters to create a city of typography that conforms to the streets of a real place. In the Manhattan version, for instance, texts from the mayor, a taxi driver, and Frank Lloyd Wright comprise the city. The image is presented on a projection screen, and the user navigates by pedaling and steering a stationary bicycle situated in front of the projected image. Projects such as these demonstrate that software presents an extraordinary opportunity to extend the way we read and write.

Typographic elements can be assigned behaviors that define a personality in relation to the mouse or keyboard. A word can express aggression by moving quickly toward the mouse, or moving away slowly can express timidity. The following examples demonstrate basic applications of this area. In the first, the word *avoid* stays away from the mouse because its position is set to the inverse of the cursor position. In the second, the word *tickle* jitters when the cursor hovers over its position.

```
void setup() {                                              12-18
  size(100, 100);
  textSize(24);
  textAlign(CENTER);
}

void draw() {
  background(204);
  text("avoid", width-mouseX, height-mouseY);
}
```

```
float x = 33;                                               12-19
float y = 60;

void setup() {
  size(100, 100);
  textSize(24);
  noStroke();
}

void draw() {
  fill(204, 120);
  rect(0, 0, width, height);
  fill(0);
  // If cursor is over the text, change the position
```

```
        if ((mouseX >= x) && (mouseX <= x+55) &&
            (mouseY >= y-24) && (mouseY <= y)) {
          x += random(-2, 2);
          y += random(-2, 2);
        }
        text("tickle", x, y);
      }
```

12-19
cont.

Exercises

1. *Create a composition of letters in the display window. Define each with a different size, color, and location.*
2. *Use* createFont(), textFont(), *and* text() *to draw every letter of the alphabet to the display window.*
3. *Modify exercise 2 to work with a VLW font made with the Create Font tool.*
4. *Draw a paragraph of text to the display window. Carefully select the text and composition.*
5. *Use two different typefaces to display dialog between two characters.*

Note

1. Ellen Lupton, *Thinking with Type: A Critical Guide for Designers, Writers, Editors, & Students* (Princeton Architectural Press, 2004), p. 29.

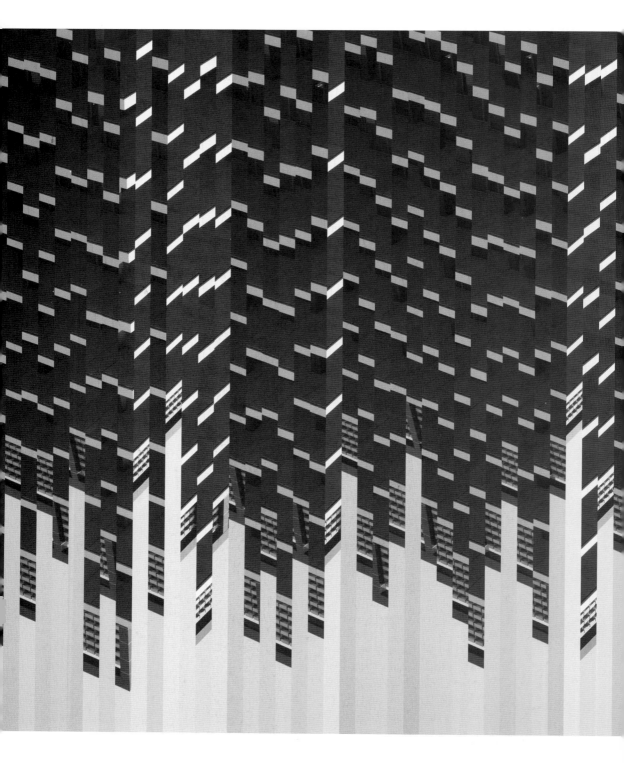

13 Image

This chapter introduces loading, displaying, tinting, moving, masking, and filtering images.

Syntax introduced:
`PImage`, `loadImage()`, `image()`, `imageMode()`
`tint()`, `noTint()`
`filter()`, `PImage.mask()`

Digital photographs are fundamentally different from analog photographs captured on film. Like computer screens, digital photos are rectangular grids of color. The dimensions of digital images are measured in units of pixels. If an image is 320 pixels wide and 240 pixels high, it has 76,800 total pixels. If an image is 1280 pixels wide and 1024 pixels high, the total number of pixels is 1,310,720 (1.3 megapixels). Every digital image has a color depth. The color depth refers to the number of bits (p. 51) used to store each pixel. If the color depth of an image is 1, each pixel can be one of two values, for example, black or white. If the color depth is 4, each pixel can be one of 16 values. If the color depth of an image is 8, each pixel can be one of 256 values. Looking at the same image displayed with different color depths reveals how this affects the image's appearance:

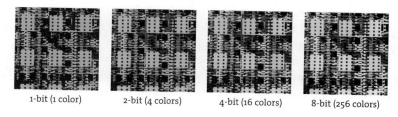

1-bit (1 color)　　2-bit (4 colors)　　4-bit (16 colors)　　8-bit (256 colors)

When the Apple Macintosh computer was introduced in 1984, it had a black-and-white screen. Since then, the reproduction of color on screen has rapidly improved. Many contemporary screens have a color depth of 24, which means each pixel can be one of 16,777,216 available colors. This number is typically referred to as "millions of colors."

Digital images are numbers that represent colors. The file format of an image determines how the numbers are ordered in the file. Some file formats store the color data in mathematically complex arrangements to compress the data and reduce the size of the resulting file. A program that loads an image file must know the file format of the image so it can translate the file's data into the expected image. Different types of digital image formats serve specific needs. Processing can load GIF, JPEG, and PNG images, along with some other formats as described in the reference. If you don't already have your images in one of these formats, convert other types of digital images to these formats with programs such as the GNU Image Manipulation Program (GIMP) or Adobe Photoshop. Refer to the documentation for these programs if you're unsure how to convert images.

How do you know which image format to use? They all have obscure names that don't help in making this decision, but each format's advantages becomes clear through comparison:

Format	Extension	Color depth	Transparency
GIF	.gif	1-bit to 8-bit	1-bit
JPEG	.jpg	24-bit	None
PNG	.png	1-bit to 24-bit	8-bit

GIF images are useful for simple graphics with a limited number of colors and transparency. PNG images have similar characteristics but support the full range of colors and transparency. The JPEG format works well for photos, and JPEG files will be smaller than most images saved as PNG. This is because JPEG is a "lossy" format, which means it sacrifices some image quality to reduce file size.

Display

Processing can load images, display them on the screen, and change their size, position, opacity, and tint. The data type for images is called PImage. The same way that integers are stored in variables of the int data type and values of true and false are stored in the boolean data type, images are stored in variables of the PImage data type. Before displaying an image, it's necessary to first load it with the loadImage() function. For the image to load, it must be in the data folder of the current sketch. See the Load Media section on page 151 for instructions.

The parameters for image() determine the image to draw and its position and size. The first parameter must be a PImage variable. By default, the second and third parameters set the position of the upper-left corner of the image. The image will display at its actual size (in units of pixels), but you can change the size by adding the optional forth and fifth parameters. Like the ellipseMode() and rectMode() functions, the imageMode() function changes the meaning of the parameters (see page 35). Like with PFont, image variables are usually defined at the top of the sketch, outside setup() and draw().

```
PImage img;

void setup() {
  size(100, 100);
  // Image must be in the sketch's "data" folder
  img = loadImage("dwp-01.jpg");
}

void draw() {
  image(img, 0, 0);
}
```

13-01

```
PImage img;

void setup() {
  size(100, 100);
  img = loadImage("dwp-01.jpg");
}

void draw() {
  image(img, 20, 20, 60, 60);
}
```

```
PImage img;

void setup() {
  size(100, 100);
  img = loadImage("dwp-01.jpg");
}

void draw() {
  imageMode(CORNER);
  image(img, 40, 40, 60, 60);
  imageMode(CENTER);
  image(img, 40, 40, 60, 60);
}
```

Each image in Processing stores its own width and height in units of pixels. Like with the String data type (p. 495), PImage has a series of fields and methods that act on the data inside. The width and height variables of the image are accessed with the dot operator. The following examples draws a black box at the right edge of the image that has the same width and height as the image:

```
PImage img;

void setup() {
  size(600, 360);
  img = loadImage("dwp-01.jpg");
  noStroke();
  fill(0);
}
```

```
void draw() {
  image(img, 20, 20);
  rect(20+img.width, 20, img.width, img.height);
}
```

Tint, Transparency

Images are colored with the tint() function. This function is used the same way as
fill() and stroke(), but it affects only images. All images drawn after running
tint() will be tinted by the color specified in the parameters. This has no permanent
effect on the images, and running the noTint() function disables the coloration for all
images drawn after it is run.

```
PImage img;

void setup() {
  size(100, 100);
  img = loadImage("dwp-02.jpg");
}

void draw() {
  tint(102); // Tint gray
  image(img, 0, 0);
  noTint(); // Disable tint
  image(img, 50, 0);
}
```

```
PImage img;

void setup() {
  size(100, 100);
  img = loadImage("dwp-02.jpg");
}

void draw() {
  tint(0, 153, 204); // Tint blue
  image(img, 0, 0);
  noTint(); // Disable tint
  image(img, 50, 0);
}
```

```
PImage img;
color yellow, green, tan;

void setup() {
  size(100, 100);
  img = loadImage("dwp-02.jpg");
  yellow = color(220, 214, 41);
  green = color(110, 164, 32);
  tan = color(180, 177, 132);
}

void draw() {
  tint(yellow);
  image(img, 0, 0);
  tint(green);
  image(img, 33, 0);
  tint(tan);
  image(img, 66, 0);
}
```

The parameters for tint() follow the color space determined by the colorMode() function (remember, the default color mode is RGB, with all values ranging from 0 to 255). If the color mode is changed to HSB or a different range, the tint values must be specified relative to that mode.

To make an image transparent without changing its color, set the tint to white and modify the alpha value. The value(s) to define white will depend on the current color mode, but the default is 255.

```
PImage img;

void setup() {
  size(100, 100);
  img = loadImage("dwp-03.jpg");
}

void draw() {
  background(255);
  tint(255, 102);  // Alpha 102 without changing the tint
  image(img, 0, 0, 100, 100);
  tint(255, 102, 0, 204);  // Tint orange, alpha to 204
  image(img, 20, 20, 100, 100);
}
```

```
PImage img;
```

```
void setup() {
  size(100, 100);
  img = loadImage("dwp-03.jpg");
}

void draw() {
  background(255);
  tint(255, 102);
  // Draw the image 5 times, moving each to the right
  for (int i = 0; i < 5; i++) {
    image(img, i*20, 0);
  }
}
```

GIF and PNG images retain their transparency when loaded and displayed in Processing. Anything drawn before the image is visible through the transparent sections of the image. GIF images have only 1-bit transparency; each pixel can only be completely opaque or completely transparent. The PNG format supports 8-bit transparency; each pixel has 256 levels of opacity. This means a GIF image cannot blend as well into the background as a PNG. In the following examples, notice the edges of the images.

```
PImage img;
```

```
void setup() {
  size(100, 100);
  // The GIF has 1-bit transparency
  // so the edges are rough
  img = loadImage("dwp-04.gif");
}

void draw() {
  background(0);
  image(img, 5, 0);
  image(img, 5, 24);
}
```

```
PImage img;
```

```
void setup() {
  size(100, 100);
  // The PNG has 8-bit transparency
```

```
  // so the edges are smooth
  img = loadImage("dwp-04.png");
}

void draw() {
  background(0);
  image(img, 5, 0);
  image(img, 5, 24);
}
```

Filter

Digital images can be easily reconfigured and combined with other digital images. Software now simulates complex and time-consuming operations formerly completed in a darkroom with light and chemistry. Every pixel in a digital image is a grouping of numbers that can be added, multiplied, or averaged with the numbers from any other pixel. Some of these calculations are based on simple arithmetic and others use the more complex mathematics of signal processing, but the visual results are most important. Software programs such as the GIMP and Adobe's Photoshop have made it possible to perform many of the more common and useful calculations without thinking about the math behind the effects. These programs allow users to easily perform technical operations such as converting images from RGB colors to grayscale values, increasing an image's contrast, or tweaking color balance. Such tools also allow users to apply filters that range from basic to kitschy. A filter might blur an image, mimic solarization, or simulate watercolor effects. The actions of filtering can easily be controlled with code to produce striking changes. Processing provides a function to filter images; it operates by transforming the pixel values of a single image or by performing an operation to merge pixels between two different images. The filter() function has eight parameter options: THRESHOLD, GRAY, INVERT, POSTERIZE, BLUR, OPAQUE, ERODE, and DILATE. Some of these options require a second parameter, and others do not. For example, the THRESHOLD mode converts every pixel in an image to black or white based on whether its value is above or below the value of the second parameter.

The following example applies the THRESHOLD filter to an image with the second parameter set to a value between 0 and 1, depending on the value of the v variable, which is defined by mouseX. For example, if the value of the v variable is 0.3, this defines that pixels with a gray value greater than 30 percent of the maximum brightness will be set to white and pixels below that value will be set to black.

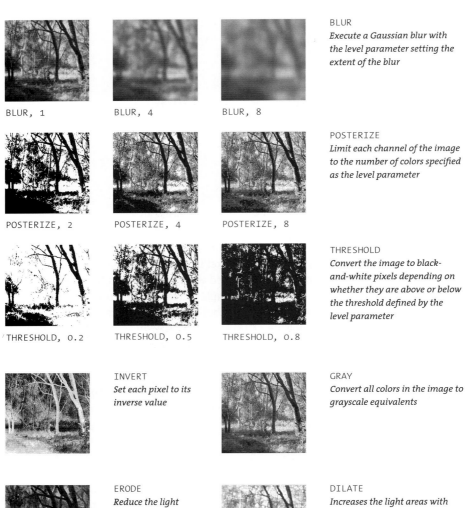

BLUR, 1 BLUR, 4 BLUR, 8

BLUR
Execute a Gaussian blur with the level parameter setting the extent of the blur

POSTERIZE, 2 POSTERIZE, 4 POSTERIZE, 8

POSTERIZE
Limit each channel of the image to the number of colors specified as the level parameter

THRESHOLD, 0.2 THRESHOLD, 0.5 THRESHOLD, 0.8

THRESHOLD
Convert the image to black-and-white pixels depending on whether they are above or below the threshold defined by the level parameter

INVERT
Set each pixel to its inverse value

GRAY
Convert all colors in the image to grayscale equivalents

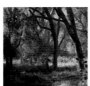

ERODE
Reduce the light areas with the amount defined by the level parameter

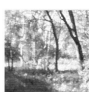

DILATE
Increases the light areas with the amount defined by the level parameter

Filter
The `filter()` *function modifies the pixels of the display window and images. The different kinds of filters seen here provide a range of ready-made options, but it's possible to write custom filters using the language elements introduced in the Image Processing chapter (p. 529).*

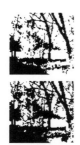

```
PImage img;

void setup() {
  size(100, 100);
  img = loadImage("topanga.jpg");
}

void draw() {
  image(img, 0, 0);
  float v = mouseX / 100.0;
  filter(THRESHOLD, v);
}
```

The filter() function affects only what has already been drawn. For example, if a program draws two lines and blur is created after one line is drawn, it does not affect the second line:

```
void setup() {
  size(100, 100);
  strokeWeight(5);
  noFill();
}

void draw() {
  background(204);
  line(0, 30, 100, 60);
  filter(BLUR, 3);
  line(0, 50, 100, 80);
}
```

Changing the parameter value of filter() with each frame creates movement. The effects of filter() are reset each time through draw(), but increasing or decreasing the second parameter results in the filter becoming more or less pronounced as the program runs:

```
float fuzzy = 0.0;

void setup() {
  size(100, 100);
  strokeWeight(5);
  noFill();
}

void draw() {
  background(204);
  if (fuzzy < 16.0) {
    fuzzy += 0.05;
  }
  line(0, 30, 100, 60);
  filter(BLUR, fuzzy);
  line(0, 50, 100, 80);
}
```

The PImage class has a filter() method that can isolate a filter to a specific image object. The following example shows how to use this method on an individual image without affecting the rest of the sketch.

```
PImage img1, img2;

void setup() {
  size(100, 100);
  img1 = loadImage("forest.jpg");
  img2 = loadImage("forest.jpg");
  img2.filter(INVERT);
}

void draw() {
  image(img1, 0, 0);
  image(img2, 50, 0);
}
```

Mask

The mask() method of PImage sets the transparency values of an image based on the contents of another image. The mask image should contain only grayscale data and must be the same size as the image to which it is applied. If the image is not grayscale, it may be converted with the filter() function (see p. 169). The light areas of the mask let the original image through, and the dark areas conceal the original. The following example uses mask() to composite the images shown here:

airport.jpg airportmask.jpg

The resulting image and the code to produce it follow:

13-16

```
PImage img, maskImg;

void setup() {
  size(100, 100);
  img = loadImage("airport.jpg");
  maskImg = loadImage("airportmask.jpg");
  img.mask(maskImg);
}

void draw() {
  background(255);
  image(img, 0, 0);
}
```

Exercises

1. *Create a composition with two complementary images.*
2. *Draw three images in the display window, each with a different tint.*
3. *Load a PNG image with transparency and create a dense collage by layering the image.*
4. *Load an image and alter it with* $filter()$. *Try different filters and their parameters to affect the image.*
5. *Modify code 13-16 to use your own image and mask image.*

14 Transform

This chapter introduces coordinate system transformations for translation, rotation, and scaling.

Syntax introduced:
`translate()`, `pushMatrix()`, `popMatrix()`
`rotate()`, `scale()`

The coordinate system introduced in the Draw chapter uses the upper-left corner of the display window as the origin with the x-coordinates increasing to the right and the y-coordinates increasing downward. This system can be modified with transformations. The coordinates can be translated, rotated, and scaled so shapes are drawn to the display window with different positions, orientations, and sizes. Transformations can make it easier to work with complex geometry by grouping shapes and vertices together so they can be changed with a single line of code. They obscure complicated calculations like figuring out the location of each vertex point on a shape while it's rotating. Used individually or together, the transformation functions are powerful tools for working with geometry in code.

Translate

The `translate()` function moves the origin from the upper-left corner of the screen to another location. It has two parameters—the first is the x-coordinate offset, and the second is the y-coordinate offset. The values of the parameters are added to any shapes drawn after the function is run. If 10 is used as the first parameter and 30 is used as the second parameter, a point drawn at coordinate (0,5) will instead be drawn at coordinate (10,35). Only elements drawn after the transformation are affected. The following examples show how this works.

```
rect(0, 5, 70, 30);
translate(10, 30);   // Shift 10 pixels right and 30 down
rect(0, 5, 70, 30);
```
14-01

```
rect(0, 5, 70, 30);
translate(10, -10);  // Shift 10 pixels right and up
rect(0, 5, 70, 30);
```
14-02

The translate() function is additive. If translate(10,30) is run twice, all the elements drawn after will display with an x-offset of 20 and a y-offset of 60.

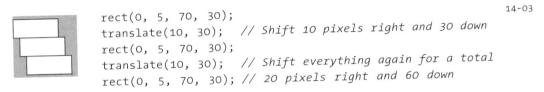

```
rect(0, 5, 70, 30);
translate(10, 30);   // Shift 10 pixels right and 30 down
rect(0, 5, 70, 30);
translate(10, 30);   // Shift everything again for a total
rect(0, 5, 70, 30); // 20 pixels right and 60 down
```

One might expect the additive nature of transformations to accumulate when used inside of the draw() loop. However, all transformation are returned to the default values with the start of each trip through the block. For instance, when example 14-01 is placed inside of draw() there is no change to the effect of the translate()—the rectangle doesn't move further and further to the right and down. In the following example, even though translate(10, 30) is run every time, the effect doesn't accumulate because the transformations are reset each time through draw().

```
void draw() {
    rect(0, 5, 70, 30);
    translate(10, 30);   // Shift 10 pixels right and 30 down
    rect(0, 5, 70, 30);
}
```

Controlling transformations

The functions to translate, rotate, and scale utilize the *transformation matrix*—a set of numbers that defines mathematically how geometry is drawn to the screen. Transformation functions such as translate() alter the numbers in this matrix and cause the geometry to draw differently. In the previous examples, we saw how transformations accumulate. To control these accumulations more carefully, the pushMatrix() function records the current state of all transformations. By using pushMatrix() with the companion function popMatrix(), a set of transformations can be stored and then restored later in the program.

Think of each matrix as a sheet of paper with the current list of transformations (translate, rotate, scale) written on the surface. When a function such as translate() is run, it changes the numbers on the paper. To save the current matrix for later use, add a new sheet of paper to the top of the pile and copy the information from the sheet below. Any new changes are made to the top sheet of paper, preserving the numbers on the sheet(s) below. To return to a previous coordinate matrix, remove and discard the top sheet of paper to reveal the saved transformations that follow:

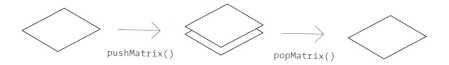

pushMatrix() popMatrix()

This is essentially how coordinate matrices are updated and stored, but more technical terms are used. Adding a sheet of paper is pushing, removing a sheet is popping, and the pile of pages is called a stack. The pushMatrix() function is used to add a new coordinate matrix to the stack, and popMatrix() is used to remove one from the stack. Each pushMatrix() must have a corresponding popMatrix(). The function pushMatrix() cannot be used without popMatrix() and vice versa.

Compare the two examples below. Both draw the same rectangles, but with different results. The second example employs pushMatrix() and popMatrix() to isolate the effects of the translate() function to apply only to the first rectangle. Because the other rectangle is drawn after the call to popMatrix() it draws from its x-coordinate without being affected by the translation.

```
translate(33, 0);   // Shift 33 pixels right
rect(0, 20, 66, 30);
rect(0, 50, 66, 30);
```

14-05

```
pushMatrix();
translate(33, 0);   // Shift 33 pixels right
rect(0, 20, 66, 30);
popMatrix();   // Remove the shift
// This shape is not affected by translate() because
// of the pushMatrix() and popMatrix()
rect(0, 50, 66, 30);
```

14-06

Embedding the pushMatrix() and popMatrix() functions can further control their range. In the following example, the first rectangle is affected by the first translation, the second rectangle is affected by the first and second translations, and the third rectangle is only affected by the first translation because the second translation is isolated with a pushMatrix() and popMatrix() pair. The fourth rectangle is not affected by any of the translations because the popMatrix() on the second-to-last line cancels the pushMatrix() on the first line.

```
pushMatrix();
translate(20, 0);
rect(0, 10, 70, 20);   // Draw at (20, 10)
pushMatrix();
```

14-07

```
translate(30, 0);
rect(0, 30, 70, 20);   // Draw at (50, 30)
popMatrix();
rect(0, 50, 70, 20);   // Draw at (20, 50)
popMatrix();
rect(0, 70, 70, 20);   // Draw at (0, 70)
```

Rotate

The rotate() function rotates the coordinate system so that shapes can be drawn to the screen at an angle. It has one parameter that sets the amount of the rotation as an angle. The rotate function assumes that the angle is specified in units of *radians* (p. 279). Shapes are always rotated around their position relative to the origin (0,0), and positive numbers rotate them in a clockwise direction.

As with all transformations, the effects of rotation are cumulative. If there is a rotation of π/4 radians and another of π/4 radians, objects drawn afterward will be rotated π/2 radians. The following examples show the most basic use of the rotate() function.

```
rect(55, 0, 30, 45);
rotate(PI/8);
rect(55, 0, 30, 45);
```

```
rect(10, 60, 70, 20);
rotate(-PI/16);
rect(10, 60, 70, 20);
rotate(-PI/8);
rect(10, 60, 70, 20);
```

These examples make it clear that rotating objects around the origin has limitations. To rotate an object at a different position, it's necessary to use translate() followed by rotate(). This is explained in the "Combining transformations" section that follows.

Scale

The scale() function modifies the coordinate system so that shapes are drawn larger or smaller. It has one or two parameters to set the amount of increase or decrease. When used with one parameter, it scales shapes in all dimensions. When used with two parameters, it scales the x-dimension separately from the y-dimension. The parameters to scale() are defined in terms of percentages expressed as decimals. Examples of

decimal percentages are 2.0 for 200%, 1.5 for 150%, and 0.5 for 50%. The following examples show the most basic use of the scale() function.

```
ellipse(32, 32, 30, 30);
scale(1.8);
ellipse(32, 32, 30, 30);
```

14-10

```
ellipse(32, 32, 30, 30);
scale(2.8, 1.8);
ellipse(32, 32, 30, 30);
```

14-11

As the previous examples show, the stroke weight is also affected by scale(). To keep the same stroke weight and scale a shape, divide the parameter of the strokeWeight() function by the scale value.

```
float s = 1.8;
ellipse(32, 32, 30, 30);
scale(s);
strokeWeight(1.0 / s);
ellipse(32, 32, 30, 30);
```

14-12

As with translate() and rotate(), the effects of each scale() accumulate each time the function is run.

```
rect(10, 20, 70, 20);
scale(1.7);
rect(10, 20, 70, 20);
scale(1.7);
rect(10, 20, 70, 20);
```

14-13

Combining transformations

The transformation functions are powerful ways to modify the geometry displayed to the screen. Using one at a time is straightforward, but combining them requires a greater understanding of how they work. The order in which transformation functions are run can affect the way they change the coordinates. When shapes are drawn to the screen, the translate(), rotate(), and scale() functions affect them in relation to the origin. For example, rotating a rectangle at coordinate (50,20) will cause the shape to orbit around the origin and not around its center or corner as you might expect:

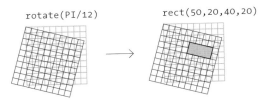

rotate(PI/12) rect(50,20,40,20)

To rotate this shape around its upper-left corner, you must place that point at the coordinate (0,0). A translation is used to put the shape into the desired position in relation to the global coordinates. When the rotate function is run, the shape now orbits around its upper-left corner, the origin of its local coordinate system:

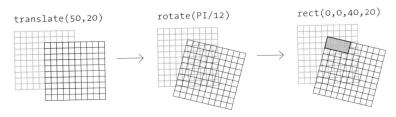

translate(50,20) rotate(PI/12) rect(0,0,40,20)

There are two ways to think about transformations. One method is to view the coordinate system as modified and the coordinates for shapes as converted to the new coordinate system. For example, if the coordinate system is rotated 30°, the coordinates of any shape drawn to the screen are converted into this modified system and displayed with a 30° tilt. The other school of thought applies the transformations directly to the shapes. In this same example, the shape itself is perceived to be rotated 30°.

The order in which transformations are made affects the results. The following two examples have the same lines of code, but the order of the translate() and rotate() functions is reversed :

```
translate(width/2, height/2);
rotate(PI/8);
rect(-25, -25, 50, 50);
```

14-14

```
rotate(PI/8);
translate(width/2, height/2);
rect(-25, -25, 50, 50);
```

14-15

These simple examples demonstrate the potential in combining transformations but also make clear that transformations require thought and planning. More combined examples follow:

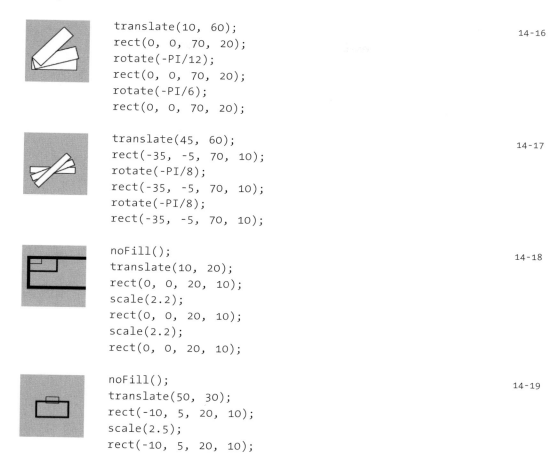

```
translate(10, 60);                                              14-16
rect(0, 0, 70, 20);
rotate(-PI/12);
rect(0, 0, 70, 20);
rotate(-PI/6);
rect(0, 0, 70, 20);
```

```
translate(45, 60);                                             14-17
rect(-35, -5, 70, 10);
rotate(-PI/8);
rect(-35, -5, 70, 10);
rotate(-PI/8);
rect(-35, -5, 70, 10);
```

```
noFill();                                                      14-18
translate(10, 20);
rect(0, 0, 20, 10);
scale(2.2);
rect(0, 0, 20, 10);
scale(2.2);
rect(0, 0, 20, 10);
```

```
noFill();                                                      14-19
translate(50, 30);
rect(-10, 5, 20, 10);
scale(2.5);
rect(-10, 5, 20, 10);
```

The effects of the transformation functions accumulate throughout the program, and these effects can be magnified with a for loop.

```
background(0);                                                 14-20
stroke(255, 120);
translate(66, 33);                    // Set initial offset
for (int i = 0; i < 18; i++) {    // 18 repetitions
  strokeWeight(i);     // Increase stroke weight
  rotate(PI/12);       // Accumulate the rotation
  line(0, 0, 55, 0);
}
```

Code 14-14 analyzed from two perspectives

Coordinate view
Reading the code from top to bottom

Translate Rotate Draw rectangle

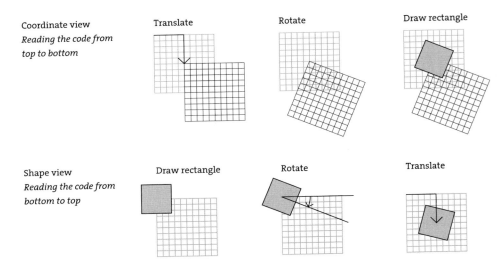

Shape view
Reading the code from bottom to top

Draw rectangle Rotate Translate

Code 14-15 analyzed from two perspectives

Coordinate view
Reading the code from top to bottom

Rotate Translate Draw rectangle

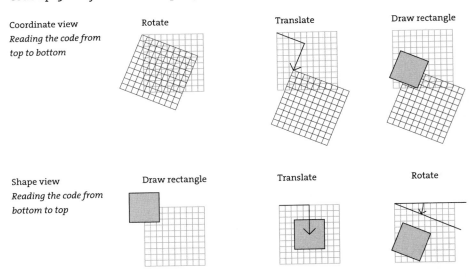

Shape view
Reading the code from bottom to top

Draw rectangle Translate Rotate

Figure 14-1 Transformation combinations
The order in which transformations occur in a sketch affects how they combine. For example, a rotate() *after a* translate() *will have a different effect than the reverse. These diagrams present two ways to think about the transformations in codes 14-14 and 14-15.*

```
background(0);
noStroke();
fill(255, 48);
translate(33, 66);                    // Set initial offset
for (int i = 0; i < 12; i++) {        // 12 repetitions
  scale(1.2);                         // Accumulate the scaling
  ellipse(4, 2, 20, 20);
}
```

Working with these examples will be more helpful than reading the explanation over and over. Try these examples inside Processing and make modifications to the numbers used and the sequence of translate, rotate, and scale to develop a sense of how these functions work.

Transformation and interaction

When using the transformation functions in a program that runs continuously with a draw() function, the most important thing to remember is the transformations are reset each trip through the draw() block, but they accumulate within the block. This is demonstrated in code 14-04. With this property as a foundation, the mouseX and mouseY values can control translation, rotation, and scale by using them as parameters in the transformation functions inside draw(). As one example, an ellipse can move around the screen by changing the parameters to translate() rather than by changing the x and y parameters of ellipse().

```
void setup() {
  size(100, 100);
  noStroke();
}

void draw() {
  background(126);
  translate(mouseX, mouseY);
  ellipse(0, 0, 33, 33);
}
```

Before using mouseX and mouseY as parameters to transformation functions, it's important to think first about how they relate to the expected parameters. For example, the rotate() function expects its parameters in units of radians (p. 279). To make a shape rotate 360 degrees as the cursor moves from the left edge to the right edge of the

window, the values of mouseX must be converted to values from 0.0 to 2π. In the following example, the map() function (p. 267) is used to make this conversion. The resulting value is used as the parameter to rotate() to turn the line as the mouse moves back and forth between the left and right edge of the display window.

14-23

```
void setup() {
  size(100, 100);
  strokeWeight(8);
}

void draw() {
  background(204);
  float angle = map(mouseX, 0, width, 0, TWO_PI);
  translate(50, 50);
  rotate(angle);
  line(0, 0, 40, 0);
}
```

The previous pair of basic examples unlock the possibilities for utilizing the transformation functions for movement and interaction. The principles are used and elaborated upon in later examples throughout the book.

New coordinate systems

The default position of the coordinate origin (0,0) is the upper-left corner of the display window, the x-coordinate numbers increase to the right, the y-coordinates increase from the top, and each coordinate maps directly to a pixel position. The transformation functions can change these defaults to modify the coordinate system. The following examples move the origin to the center and lower-left corner of the display window and modify the scale.

14-24

```
void draw() {
  background(204);
  // Shift the origin to the center
  translate(width/2, height/2);
  // Draw the origin
  line(-width/2, 0, width/2, 0);    // Draw x-axis
  line(0, -height/2, 0, height/2);  // Draw y-axis
  // Draw within the new coordinate system
  ellipse(0, 0, 45, 45);   // Draw at the origin
  ellipse(-width/2, height/2, 45, 45);
  ellipse(width/2, -height/2, 45, 45);
}
```

The `translate()` and `scale()` functions can combine to change the range of values. In the following example, the right edge of the screen is mapped to the x-coordinate of 1.0, the left edge to the x-coordinate -1.0, the top edge to the y-coordinate -1.0, and the bottom edge to the y-coordinate 1.0. This system will always scale to fit the entire display window. Run this program, but change the parameters to `size()` to see it work.

```
void draw() {                                              14-25
  background(204);
  // Shift the origin, scale the system
  scale(width/2, height/2);
  translate(1.0, 1.0);
  strokeWeight(1.0/width);
  // Draw the origin
  line(-1, 0, 1, 0);    // Draw x-axis
  line(0, -1, 0, 1);    // Draw y-axis
  // Draw within new coordinate system
  ellipse(0, 0, 0.9, 0.9);    // Draw at the origin
  ellipse(-1, 1, 0.9, 0.9);
  ellipse(1, -1, 0.9, 0.9);
}
```

The `translate()` and `scale()` functions can be combined to put the origin in the lower-left corner of the screen. Scaling the y-axis by -1 causes the y-coordinates to increment in the opposite direction. This can be useful when converting a program written using this coordinate system into Processing, rather than converting the y-coordinate of every point.

```
void draw() {                                              14-26
  background(204);
  // Shift the origin, scale the system
  translate(0, height);
  scale(1.0, -1.0);
  // Draw the origin
  line(0, 1, width, 1);     // Draw x-axis
  line(0, 1, 0, height);    // Draw y-axis
  // Draw within new coordinate system
  ellipse(0, 0, 45, 45);    // Draw at the origin
  ellipse(width/2, height/2, 45, 45);
  ellipse(width, height, 45, 45);
}
```

Exercises

1. *Draw a composition with two squares. Use* `translate()` *to reposition the shapes.*
2. *Modify exercise 1 to use* `pushMatrix()` *and* `popMatrix()` *to move only one of the squares.*
3. *Use* `rotate()` *to change the orientation of a shape.*
4. *Use* `scale()` *with a* `for` *loop to scale a shape multiple times.*
5. *Combine* `translate()` *and* `rotate()` *to spin a shape around its own center.*

15 Vertices

This chapter focuses on drawing lines, shapes, and curves from sequences of vertices.

Syntax introduced:
`beginShape()`, `endShape()`, `vertex()`
`curveVertex()`, `bezierVertex()`
`beginContour()`, `endContour()`

Geometric primitives such as lines and rectangles are simple and flexible, but a programmer may often desire more complex shapes. Fortunately, there are many ways to define visual form with software. This chapter introduces a way to define shapes as a series of coordinates, called vertices. A vertex is a position defined by an x- and y-coordinate. A line has two vertices, a triangle has three, a quadrilateral has four, and so on. Organic shapes such as blobs or the outline of a leaf are constructed by positioning many vertices in spatial patterns:

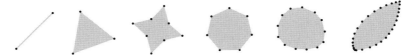

These shapes are simple compared to the possibilities. In contemporary video games, for example, highly realistic characters and environmental elements may be made up of many thousands of vertices. They represent more advanced uses of this technique, but they are created using similar principles.

Vertex

To create a shape from vertex points, first use the `beginShape()` function, then specify a series of points with the `vertex()` function and complete the shape with `endShape()`. The `beginShape()` and `endShape()` functions must always be used in pairs. The `vertex()` function has two parameters to define the x-coordinate and y-coordinate. By default, all shapes drawn with the `vertex()` function are filled white and have a black outline connecting all points except the first and last. The `fill()`, `stroke()`, `noFill()`, `noStroke()`, and `strokeWeight()` functions control the attributes of shapes drawn with the `vertex()` function, just as they do for those drawn with the shape functions discussed in the Draw chapter (p. 21). To close the shape, use the `CLOSE` constant as a parameter for `endShape()`.

```
noFill();
beginShape();
vertex(30, 20);
vertex(85, 20);
vertex(85, 75);
vertex(30, 75);
endShape();
```

```
noFill();
beginShape();
vertex(30, 20);
vertex(85, 20);
vertex(85, 75);
vertex(30, 75);
endShape(CLOSE);
```

The order of the vertex positions changes the way the shape is drawn. The following example uses the same vertex positions as code 15-01, but the order of the third and fourth points are reversed.

```
noFill();
beginShape();
vertex(30, 20);
vertex(85, 20);
vertex(30, 75);
vertex(85, 75);
endShape();
```

Adding more vertex points reveals more of the potential of these functions. The following examples show variations of turning off the fill and stroke attributes and embedding vertex() functions within a for loop.

```
fill(0);
noStroke();
beginShape();
vertex(10, 0);
vertex(100, 30);
vertex(90, 70);
vertex(100, 70);
vertex(10, 90);
vertex(50, 40);
endShape();
```

```
noFill();
strokeWeight(20);
beginShape();
vertex(52, 29);
vertex(74, 35);
vertex(60, 52);
vertex(61, 75);
vertex(40, 69);
vertex(19, 75);
endShape();
```

```
noStroke();
fill(0);
beginShape();
vertex(40, 10);
for (int i = 20; i <= 100; i += 5) {
  vertex(20, i);
  vertex(30, i);
}
vertex(40, 100);
endShape();
```

A shape can have thousands of vertex points, but drawing too many points can slow down your sketches.

Points, Lines

The beginShape() function can accept different parameters to define how to draw the vertex data. For instance, the same points can be used to create a series of points, an unfilled shape, or a continuous line. The parameters POINTS and LINES are used to create different configurations of points and lines from the coordinates defined in the vertex() functions. Remember to type these parameters in uppercase letters because Processing is case-sensitive (p. 18).

```
// Draw a point at each vertex
strokeWeight(4);
beginShape(POINTS);
vertex(30, 20);
vertex(85, 20);
vertex(85, 75);
vertex(30, 75);
endShape();
```

```
// Draw a line between each pair of vertices          15-08
beginShape(LINES);
vertex(30, 20);
vertex(85, 20);
vertex(85, 75);
vertex(30, 75);
endShape();
```

Geometry

Use the parameters TRIANGLES, TRIANGLE_STRIP, TRIANGLE_FAN, QUADS, and QUAD_STRIP with beginShape() to create other kinds of geometry. It's important to be aware of the spatial order of the vertex points when using these parameters because they affect how a shape is rendered. If the order required for each parameter is not followed, the expected shape will not draw. It's easy to change between working with TRIANGLES and a TRIANGLE_STRIP because the vertices can remain in the same spatial order, but this is not the case for changing between QUADS and a QUAD_STRIP. Refer to the following examples and figure 15-1 for more information.

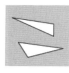

```
// Connect each grouping of three vertices as a triangle   15-09
beginShape(TRIANGLES);
vertex(75, 30);
vertex(10, 20);
vertex(75, 50);
vertex(20, 60);
vertex(90, 70);
vertex(35, 85);
endShape();
```

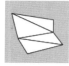

```
// Starting with the third vertex, connect each        15-10
// subsequent vertex to the previous two
beginShape(TRIANGLE_STRIP);
vertex(75, 30);
vertex(10, 20);
vertex(75, 50);
vertex(20, 60);
vertex(90, 70);
vertex(35, 85);
endShape();
```

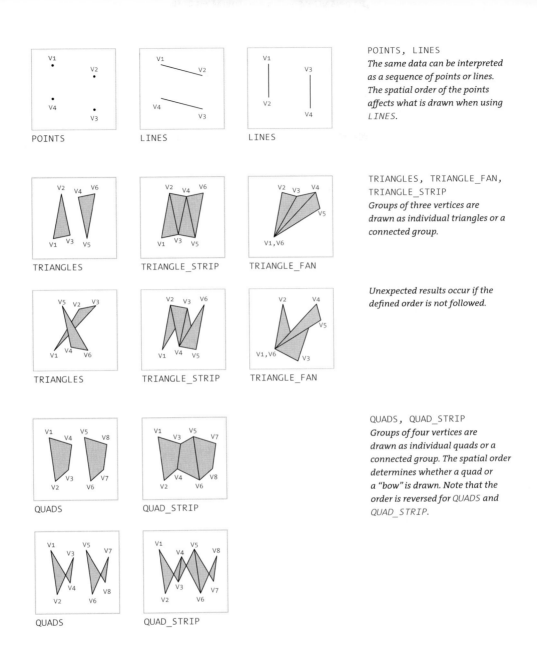

POINTS, LINES
The same data can be interpreted as a sequence of points or lines. The spatial order of the points affects what is drawn when using LINES.

POINTS

LINES

LINES

TRIANGLES, TRIANGLE_FAN, TRIANGLE_STRIP
Groups of three vertices are drawn as individual triangles or a connected group.

TRIANGLES

TRIANGLE_STRIP

TRIANGLE_FAN

Unexpected results occur if the defined order is not followed.

TRIANGLES

TRIANGLE_STRIP

TRIANGLE_FAN

QUADS, QUAD_STRIP
Groups of four vertices are drawn as individual quads or a connected group. The spatial order determines whether a quad or a "bow" is drawn. Note that the order is reversed for QUADS *and* QUAD_STRIP.

QUADS

QUAD_STRIP

QUADS

QUAD_STRIP

Figure 15-1 Parameters for beginShape()
There are a range of parameters for the beginShape() *function, and each interprets vertex data in a different way. The notation V1, V2, V3, etc., in these diagrams represents the order and position of each vertex point.*

```
// Connect the first vertex to each                    15-11
// following group of two
beginShape(TRIANGLE_FAN);
vertex(10, 20);
vertex(75, 30);
vertex(75, 50);
vertex(90, 70);
vertex(10, 20);
endShape();
```

```
// Connect each grouping of four vertices as a quad    15-12
beginShape(QUADS);
vertex(30, 25);
vertex(85, 30);
vertex(85, 50);
vertex(30, 45);
vertex(30, 60);
vertex(85, 65);
vertex(85, 85);
vertex(30, 80);
endShape();
```

```
// Notice the different vertex order for               15-13
// this example in relation to example 15-12
beginShape(QUAD_STRIP);
vertex(30, 25);
vertex(85, 30);
vertex(30, 45);
vertex(85, 50);
vertex(30, 60);
vertex(85, 65);
vertex(30, 80);
vertex(85, 85);
endShape();
```

Curves

The vertex() function works well for drawing straight lines, but if you want to create
shapes made of curves, the two functions curveVertex() and bezierVertex()
can be used to connect points with curves. These functions can be run between
beginShape() and endShape() only when beginShape() has no parameter.

The curveVertex() function is used to set a series of points that connect with a
curve. It has two parameters that set the x-coordinate and y-coordinate of the vertex.

The first and last `curveVertex()` within a `beginShape()` and `endShape()` act as control points, setting the curvature for the beginning and end of the line. The curvature for each segment of the curve is calculated from each pair of points in consideration of points before and after. Therefore, there must be at least four `curveVertex()` functions within `beginShape()` and `endShape()` to draw a segment.

```
noFill();                                                      15-14
beginShape();
curveVertex(20, 80);   // C1 (see p.194)
curveVertex(20, 40);   // V1
curveVertex(30, 30);   // V2
curveVertex(40, 80);   // V3
curveVertex(80, 80);   // C2
endShape();
```

Each `bezierVertex()` defines the position of two control points, followed by one anchor point. The first time `bezierVertex()` is used within `beginShape()`, it must be prefaced with `vertex()` to set the first anchor point. The line is drawn between the point defined by `vertex()` and the point defined by the x and y parameters to `bezierVertex()`. The first four parameters to the function position the control points to define the shape of the curve. The curve from code 3-24 (p. 30) was converted to this technique to yield the following example:

```
noFill();                                                      15-15
beginShape();
vertex(32, 20);   // V1 (see p.194)
bezierVertex(80, 5,  80, 75,  30, 75);   // C1, C2, V2
endShape();
```

Long, continuous curves can be made with `bezierVertex()`. After the first `vertex()` and `bezierVertex()`, each subsequent call to the function continues the shape by connecting each new point to the previous point.

```
noFill();                                                      15-16
beginShape();
vertex(15, 30);   // V1 (see p.194)
bezierVertex(20, -5, 70, 5, 40, 35);      // C1, C2, V2
bezierVertex(5, 70, 45, 105, 70, 70);     // C3, C4, V3
endShape();
```

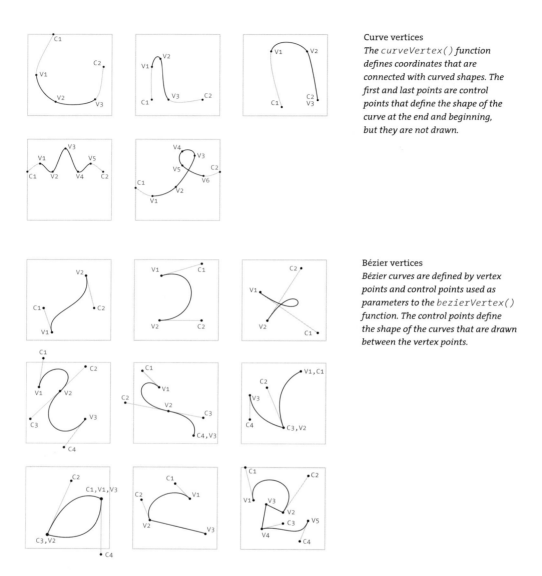

Curve vertices

The curveVertex() *function defines coordinates that are connected with curved shapes. The first and last points are control points that define the shape of the curve at the end and beginning, but they are not drawn.*

Bézier vertices

Bézier curves are defined by vertex points and control points used as parameters to the bezierVertex() *function. The control points define the shape of the curves that are drawn between the vertex points.*

Figure 15-2 Curves

These curves are converted to software with the vertex()*,* curveVertex()*, and* bezierVertex() *functions. The notation v1, v2, v3, etc., represents the order and position of each vertex point, and the notation C1, C2, C3, etc., represents the control points. Some of these curves are translated to software in codes 15-14 to 15-18.*

To make a sharp turn, use the same position to specify the vertex and the following control point.

```
fill(0);
beginShape();
vertex(90, 39);   // V1 (see p.194)
bezierVertex(90, 39, 54, 17, 26, 83);   // C1, C2, V2
bezierVertex(26, 83, 90, 107, 90, 39);  // C3, C4, V3
endShape();
```
15-17

Place the vertex() function within bezierVertex() functions to break the sequence of curves and draw a straight line.

```
noFill();
beginShape();
vertex(15, 40);   // V1 (see p.194)
bezierVertex(5, 0, 80, 0, 50, 55);   // C1, C2, V2
vertex(30, 45);                      // V3
vertex(25, 75);                      // V4
bezierVertex(50, 70, 75, 90, 80, 70);   // C3, C4, V5
endShape();
```
15-18

A good technique for creating complex shapes with beginShape() and endShape() is to draw them first in a vector drawing program such as Inkscape or Adobe Illustrator. The coordinates can be read as numbers in this environment and then used in Processing. Another strategy for drawing intricate shapes is to create them in a vector-drawing program and then import the coordinates as an SVG file. This is discussed in the Shapes chapter (p. 215).

Contours

The ability to cut holes into shapes, like the center the letter O, is another benefit to drawing shapes with the vertex() function. Cutouts within a shape are set by the beginContour() and endContour() functions. They are placed inside of a beginShape()/endShape() pair. First draw the vertices for the exterior shape in clockwise order, then for internal shapes, draw the vertices counter-clockwise. The following example shows the individual pieces, two triangles on top of a white line, and the code after shows how to cut the smaller triangle cut out of the larger by utilizing the beingContour()/endContour() pair.

```
size(100, 100);
background(0);
stroke(255);
strokeWeight(2);
line(33, 0, 85, 100);
noStroke();
fill(102);
// Start outer triangle
beginShape();
vertex(5, 12);
vertex(95, 12);
vertex(50, 92);
endShape();
fill(255);
// Start inner triangle
beginShape();
vertex(50, 20);
vertex(66, 50);
vertex(33, 50);
endShape();
```

```
size(100, 100);
background(0);
stroke(255);
strokeWeight(2);
line(33, 0, 85, 100);
noStroke();
fill(102);
// Start outer triangle
beginShape();
vertex(5, 12);
vertex(95, 12);
vertex(50, 92);
// Start inner triangle
beginContour();
vertex(33, 50);
vertex(66, 50);
vertex(50, 20);
endContour();
endShape();
```

Like making any shape out of vertex functions, a cutout can be as basic as the triangles in the above example or can be more detailed shapes made from thousands of points. Additionally, there can be more than one cutout. The following example points the way to more complicated shapes by introducing a second cutout. This example also

positions the shape with the center at the origin so it can be easily rotated around its center.

```
float angle = 0.0;                                          15-21

void setup() {
  size(100, 100);
  noStroke();
}

void draw() {
  background(0);
  fill(204);   // Light gray
  rect(0, 44, 100, 12);

  // Position in middle, scale 75%, and rotate
  translate(width/2, height/2);
  scale(0.75);
  rotate(angle);

  fill(102);
  beginShape();
  // Outer shape
  vertex(-25,-50);
  vertex( 25,-50);
  vertex( 25, 50);
  vertex(-25, 50);
  // Top hole
  beginContour();
  vertex(-15,-30);
  vertex(-15,-10);
  vertex( 15,-10);
  vertex( 15,-30);
  endContour();
  // Bottom Hole
  beginContour();
  vertex(-15, 10);
  vertex(-15, 30);
  vertex( 15, 30);
  vertex( 15, 10);
  endContour();
  endShape();

  angle += 0.01;
}
```

Exercises

1. Use *beginShape()* to draw a shape of your own design.
2. Explore different parameters for *beginShape()* in exercise 1 to change the way the vertices are drawn. For instance, try *POINTS* and *LINES*.
3. Like code 15-06, create a detailed, repetitive shape by using a *for* loop to generate vertices.
4. Draw a complex shape with both curved and straight segments by integrating *vertex()* with either *bezierVertex()* or *curveVertex()*.
5. Modify example 1 to cut a hole into the shape with *beginContour()* and *endContour()*.

16 3D Drawing

This chapter introduces drawing and transformations in 3D, lighting, camera settings, and textures.

Syntax introduced:
```
box(), sphere(), lights()
rotateX(), rotateY(), rotateZ()
camera()
directionalLight(), ambientLight(), pointLight(), spotLight()
ambient(), lightSpecular(), shininess(), specular(),
texture(), textureMode()
```

For as long as people have represented the three-dimensional world on two-dimensional surfaces, they have invoked the help of machines. The 3D graphics we know today have their origin in the theory of linear perspective, developed less than 600 years ago by the Florentine architect Filippo Brunelleschi. He used a variety of optical devices to determine that all sets of parallel lines appear to the eye to converge at a single "vanishing point" on the horizon. Shortly after the technique was codified, artists such as Albrecht Dürer began devising machines to help produce convincing representations of 3D scenes on 2D picture planes. The earliest on-screen 3D graphics appeared in the 1950s, not on digital computers but using oscilloscopes, machines designed to trace voltages in electronic circuits. It took thirty more years for 3D graphics to enter the home by way of games for personal computers. Today, artists, designers, engineers, and architects all make use of computers to create, manipulate, and output 3D form.

The goal of this chapter is to point out landmarks in the disciplines and bodies of techniques that surround 3D graphics. Processing provides a practical foundation for exploring ideas about interactive 3D environments. A phenomenal amount of academic and commercial activity is occurring in computational 3D graphics for medicine, architecture, art, engineering, and industrial design. Almost any field that deals with the physical world has call for computational models of it, and our ability to produce evocative simulated objects and environments is the domain of 3D graphics. Where we will take ourselves in our new artificial worlds—or whether we even retain the power to control them—is the subject of much speculation, but here we'll cover the absolute basics.

3D form

Before drawing 3D forms in Processing, it's necessary to tell the software to use a 3D renderer. A *renderer* is software that defines how geometry is turned into pixels to

represent that geometry on screen. The default renderer in Processing draws two-dimensional shapes, but there are additional options like the P3D renderer, which is capable or drawing 3D geometry. To use P3D, specify it as a third parameter to the `size()` function. For example:

```
size(600, 600, P3D);
```

A different coordinate system is used to draw in three dimensions. This new system builds on the 2D coordinate system of x- and y-coordinates and extends it with z-coordinates. Processing uses a coordinate system with the origin (0,0,0) in the front upper left with the z-coordinates decreasing from the front of the image:

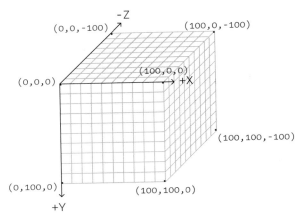

Processing has functions for drawing boxes and spheres. (The language doesn't include additional 3D primitive shapes such as cylinders and cones because we encourage people to craft their own.) A sphere has only one parameter to set its size. A box has three parameters to set the width, height, and depth, but can be used with a single parameter to make a cube. These shapes are drawn with their center point at the coordinate (0,0), so a translation is needed to place them on screen. The `translate()` function works the same way in 3D, but it has a third parameter to shift the coordinates along the z-axis. With translation, a shape can appear smaller or larger because the three-dimensional space is drawn with a simulated perspective.

16-01

```
size(100, 100, P3D);
background(0);
translate(0, height/2, -height/4);
box(60, 80, 60);
translate(width, 0, -height/2);
box(60, 80, 60);
```

```
size(100, 100, P3D);
background(0);
translate(0, height/2, -height/4);
sphere(50);
translate(width, 0, -height/2);
sphere(50);
```

16-02

Like the functions for drawing rectangles and other basic shapes, the 3D shapes are affected by `fill()` and `stroke()`. In the previous examples, it is clear that the outlines of the box and the triangles that define the sphere geometry are stroked in black by default. Unlike drawing in 2D, the colors can be affected by simulated lights placed within a program. Lighting is discussed on upcoming pages, but the default lights, turned on with the `lights()` function, define the contours and angles of the geometry when the stroke is turned off. The sides of a shape are each at a different angle in relation to the lights and reflect them differently.

```
size(100, 100, P3D);
noStroke();
background(0);
lights();
translate(0, height/2, -height/2);
fill(153);
box(50);
translate(width, 0, 0);
fill(255);
sphere(50);
```

16-03

Unlike `fill()` and `stroke()`, which are persistent throughout a program after they are defined, the `lights()` function must be run in the `draw()` block to set the lights each frame. To test this, modify the previous example to move the first four lines into `setup()` and the rest into `draw()` to see the difference.

The previously introduced `point()`, `line()`, and `vertex()` functions have additional parameters to set coordinates in 3D. These parameters are defined in the Processing reference, which can be accessed through the Help menu. Functions like `rect()` and `ellipse()`, that don't have 3D versions, can be placed in three dimensions with transformation functions. As with `translate()`, the transformation function `scale()` works the same way in 3D, with an added parameter for the z-dimension, but the `rotate()` function is replaced by three separate functions: `rotateX()`, `rotateY()`, and `rotateZ()`. The `rotateZ()` function is identical to the `rotate()` function, but `rotateX()` and `rotateY()` are unique to working in 3D. Each rotates the coordinates around the axis for which it is named:

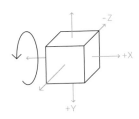
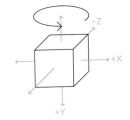
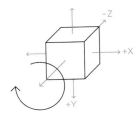

Rotate around the x-axis Rotate around the y-axis Rotate around the z-axis

The following example uses the mouseX and mouseY values to define the rotation about the x-axis and y-axis. As the mouse movement continuously changes the rotation values, the rectangle appears as a square, a line, and a range of parallelograms.

16-04

```
void setup() {
  size(100, 100, P3D);
  fill(153);
  strokeWeight(8);
}

void draw() {
  background(0);
  translate(width/2, height/2, -width);
  float rx = map(mouseY, 0, height, -PI, PI);
  float ry = map(mouseX, 0, width, -PI, PI);
  rotateX(rx);
  rotateY(ry);
  noStroke();
  rect(-50, -50, 100, 100);
  stroke(255);
  line(0, 0, -50, 0, 0, 50);
}
```

The pushMatrix() and popMatrix() functions work identically in 2D and 3D. Pushing and popping the transformation matrix is particularly useful in 3D graphics to establish a place of operation and then restore an old one. Use the pushMatrix() function to push a transform onto the stack and set up the coordinate transform as you want it, including scaling, translations, and rotations. Create the local geometry, and then use popMatrix() to return to the previous coordinate system.

```
void setup() {
  size(100, 100, P3D);
  noStroke();
}

void draw() {
  lights();
  background(0);
  translate(width/2, height/2, -height);
  float rz = map(mouseY, 0, height, 0, PI);
  float ry = map(mouseX, 0, width, 0, HALF_PI);
  rotateZ(rz);
  rotateY(ry);
  for (int y = -1; y <= 1; y++) {
    for (int x = -1; x <= 1; x++) {
      for (int z = -1; z <= 1; z++) {
        pushMatrix();
        translate(50*x, 50*y, -50*z);
        box(15);
        popMatrix();
      }
    }
  }
}
```

3D form is created with vertex points similarly to the way 2D shapes were created in Vertices (p. 187), but the extra z-coordinate makes it possible to define volumetric shapes. The following example constructs a parameterized tube shape and controls its orientation with the mouse. It has four parameters to set the top and bottom radius, the height, and the number of sizes. When the parameters are changed, the example can create different forms including a pyramid, cone, or cylinder of variable resolutions and sizes. The beginShape() function is used with values from sin() and cos() to construct these extruded circular forms. Click the mouse while running the program to more clearly see how the shapes are constructed.

```
int topRadius = 70;
int bottomRadius = 70;
int tall = 120;
int sides = 32;
float angleIncrement = TWO_PI / sides;

void setup() {
  size(100, 100, P3D);
}

void draw() {
  background(0);
  if (mousePressed) {
    noFill();
    stroke(255);
  } else {
    lights();
    noStroke();
    fill(255);
  }
  translate(width/2, height/2, -40);
  rotateY(map(mouseX, 0, width, 0, PI));
  rotateZ(map(mouseY, 0, height, 0, -PI));
  float angle = 0;
  beginShape(QUAD_STRIP);
  for (int i = 0; i <= sides; i++) {
    float ca = cos(angle);
    float sa = sin(angle);
    vertex(topRadius * ca, 0, topRadius * sa);
    vertex(bottomRadius * ca, tall, bottomRadius * sa);
    angle += angleIncrement;
  }
  endShape();
}
```

Camera

All 3D renderings rely on a model of a scene and a camera (eye) that observes it.
Processing offers an explicit mapping of the camera analogy through its functions,
which is derived from OpenGL. OpenGL is a specification for rendering computer
graphics that was first initiated by Silicon Graphics and is now managed by the
Khronos Group, an industry consortium. The OpenGL documentation (available online;

search for "OpenGL Red Book") offers an excellent explanation of the workings of its camera model. The perspective camera as modeled by OpenGL and Processing can be defined with just a few parameters: focal length, and near and far clip planes.

The camera contains the "picture plane," the theoretical membrane at which the image is captured. In a real camera, the film (or digital sensor) forms the picture plane. The focal length is a property that determines the field of view of a camera. It represents the distance behind the picture plane at which all the light coming into the camera converges. The longer the focal length, the tighter the field of view—it's like zooming in with a telephoto lens.

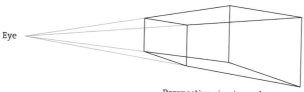

Perspective viewing volume

Rendering requires three transformations. The first transformation is called the *view* transformation. This transformation positions and orients the camera in the world. Establishing a view transformation implicitly defines "camera space," in which the focal point is the origin (the upper-left corner of the display window), the positive z-axis points out of the screen, the y-axis points straight down, and the x-axis points to the right. In Processing, the easiest way to establish a view transformation is with the camera() function. On top of the view transformation is the *model* transformation. Generally these two transformations are multiplied into each other and considered to be a unit known as the *model-view* matrix. The model transformation positions the scene relative to the camera. Finally there is the *projection* transformation, which is based on the camera's internal characteristics, such as focal length. The projection matrix is the last step; it maps 3D geometry into a 2D grid of pixels.

Processing by default establishes a set of transformations that make the picture plane in 3D coincide with the default 2D coordinate system. Essentially it is possible to forget entirely that you are in 3D and draw as though it were a 2D canvas while the z-coordinate is 0. This is useful because of the integration of 2D and 3D in Processing, although it differs from the default of other 3D environments. It also means that the model's origin is translated significantly in front of the picture plane so that it can often be viewed without further transformation.

The position and orientation of the camera is set with the camera() function. There are nine parameters, arranged in groups of three, to control the camera's position, the location it is pointing to, and the orientation. In the following example, the camera stays pointed at the center of a cube, while mouseY controls its height. The result is a cube that recedes into the distance when the mouse moves down.

```
void setup() {
  size(100, 100, P3D);
  fill(204);
  strokeWeight(2);
}

void draw() {
  lights();
  background(0);
  // Change height of the camera with mouseY
  camera(0.0, mouseY*2, 120.0, // eyeX, eyeY, eyeZ
         0.0, 0.0, 0.0, // centerX, centerY, centerZ
         0.0, 1.0, 0.0); // upX, upY, upZ
  noStroke();
  box(60);
  stroke(255);
  line(-80, 0, 0, 80, 0, 0);
  line(0, -80, 0, 0, 80, 0);
  line(0, 0, -80, 0, 0, 80);
}
```

Lights, Materials

After 3D form is constructed and transformed, it is often rendered into static images or frames of an animation. The state of the art advances so quickly that even graphics produced a few years ago look crude today. The primary goal of software rendering has been photorealism—the images produced should be indistinguishable from photographs. However, there have been significant innovations in nonphotorealistic rendering, which attempts to produce stylized images. For example, cartoon, charcoal, or painterly renderers mimic the effects of a hand and natural materials.

The work of 3D rendering is primarily the mathematical modeling and efficient computation of the interaction of light and surface. Ray-tracing and other variants influence the most popular methods of rendering. Ray-tracing models rays of light emerging from a light source and bouncing around the surfaces of a scene until they hit the picture plane. This is computationally costly and fails to predict certain important phenomena of natural lighting such as the "color bleed" when one colored surface reflects onto another. Techniques like radiosity model "global illumination," which accounts not only for light that comes directly from predefined light sources but also light reflected off of the regular surfaces in a scene.

There are three methods of rendering that do not require calculating lighting: wireframe, hidden-line, and flat-shaded:

Wireframe Hidden line Flat shading

Wireframe is the simplest rendering model. It renders lines and the edges of polygons in their basic color. This is achieved in Processing by drawing with a stroke color and without a fill. The hidden-line technique is next in complexity; only edges are drawn, but they are not visible where solid faces would occlude them. Processing does not support this directly, but it is possible to simulate the effect by using a fill identical to the background color. The last unlit model is flat-shaded, in which faces of objects are colored, but only using their base fill color.

Lighting and surface materials are modeled for images to look more realistic. The techniques used for calculating real-time lighting are different from the ray-tracing and radiosity methods discussed earlier. Those are too computationally expensive for fast rendering, although it is a safe bet that the computing speed available in the future will be able to supply it. Instead, several common simplified lighting techniques are used for real-time graphics. In order to understand them, we need to introduce the model of light and surface-material interaction that nearly all real-time 3D uses.

There are several different types of light that can be added to a scene: directional, ambient, point, and spot. Directional and ambient lights are the only kinds that do not have a position within the scene. Directional lights closely approximate a light source located infinitely far from the scene. They hit the scene at a specific direction regardless of location, so they are a good way to simulate sunlight. Other light types have positions and are therefore subject to *falloff*, the diminishing of light intensity with distance. In the real world, light intensity falls off proportionally to the square of the distance to the source. In 3D scenes, it is common to use little or no falloff so that fewer light sources are needed, which is more computationally efficient. Also, the extra light is needed because light doesn't bounce around a simulated scene the way it does in real life.

Directional lights defined by the `directionalLight()` function have six parameters to define a color and direction. The first three define the light color; the second group defines the direction from which light falls along the x-, y-, and z-axes. In the following example, click the mouse to see the light change from the left to the top of the sphere:

```
void setup() {
  size(100, 100, P3D);
  noStroke();
}

void draw() {
  background(0);
  if (mousePressed == true) {
    directionalLight(255, 255, 255, 0, 1, 0);
  } else {
    directionalLight(255, 255, 255, 1, 0, 0);
  }
  translate(width/2, height/2, 0);
  sphere(30);
}
```

Ambient lights are nondirectional and therefore have a different effect from a directional light. As mentioned earlier, they can be used without a position, but they can also have a position to determine their range (falloff). They are meant to model light in the environment that has bounced around so much it is impossible to know where it originally came from. All natural daytime scenes have a considerable amount of ambient light. When used without a position, the ambientLight() function has three parameters. It is used with six parameters to define a position. The following example raises the amount of ambient light within the environment as the mouse moves left and right.

```
void setup() {
  size(100, 100, P3D);
  noStroke();
}

void draw() {
  background(0);
  // The sphere is white by default so
  // the ambient light changes the color
  float r = map(mouseX, 0, width, 0, 255);
  ambientLight(r, 255, 255);
  translate(width/2, height/2, 0);
  sphere(30);
}
```

Point lights model a bare bulb hanging in a room. They have a position, and their directionality radiates outward from that position. They shine equally in all directions — but only in a specific direction relative to any other point in the scene. The

pointLight() function has six parameters. The first three are the color value; the second three are the position. In the following example, the position of a point light moves up and down with the cursor:

16-10

```
void setup() {
  size(100, 100, P3D);
  noStroke();
}

void draw() {
  background(0);
  pointLight(255, 255, 255, width/2, mouseY, 0);
  translate(0, height/2, 0);
  sphere(30);
  translate(width, 0, 0);
  sphere(30);
}
```

Spotlights have the most parameters of any light. The eleven parameters control color, position, direction, angle, and concentration. The angle affects how wide the spot light is open. A tiny angle casts a narrow cone of light, while a wider one illuminates more of the scene. The concentration parameter affects how the light falls off near the edge of the cone angle. Light in the center is brighter, and the edges of the cone are darker. While spotlights are the most flexible, they require more calculations than other types of lights and can therefore slow a program down. In the following program, the angle and concentration of a spotlight are controlled separately with the mouseX and mouseY variables:

16-11

```
void setup() {
  size(100, 100, P3D);
  noStroke();
}

void draw() {
  background(0);
  float angle = map(mouseY, 0, height, PI/8, PI/2);
  float concentration = map(mouseX, 0, width, 1, 20);
  spotLight(255, 255, 255,
            0, height/2, 0,
            1, 0, 0,
            angle, concentration);
  translate(width, height/2, -10);
  sphere(50);
}
```

The way lights engage with geometry is determined by the simulated material properties. The material properties define the way the geometry interacts with ambient light, how shiny the material is, and determines if the geometry emits light. The ambient color of a shape is specified with the ambient() function, which takes the same parameters as fill() and stroke(). A material with an ambient color of white (255, 255, 255) will reflect all of the ambient light that comes into it. A face with an ambient color of dark green (0, 128, 0) will reflect half of the green light it receives but none of the red or blue. The following program shows how the ambient material property affects the color of geometry when used with the default lights:

```
void setup() {                                              16-12
  size(100, 100, P3D);
  noStroke();
}

void draw() {
  background(0);
  lights(); // Default lights
  // The sphere is white by default so
  // the ambient light changes the color
  float r = map(mouseX, 0, width, 0, 255);
  ambient(r, r, 126);
  translate(width/2, height/2, 0);
  sphere(33);
}
```

The second directional component of light is specular reflection. This is light that is bounced off of the surface reflected across the normal. The more specular reflection a material has, the more reflective it appears. A perfect mirror, for example, has no diffuse reflection and all specular reflection. The lightSpecular() function sets the specular color for lights. The specular quality of a light interacts with the specular material qualities set through the specular() function. The specular() function sets the specular color of materials, which sets the color of the highlights.

Another property called *shininess*, controlled through the shininess() function, also factors into specular reflection. It is the rate of decay of specular reflection as the incoming ray deviates further from the normal. A high shininess will produce very intense bright spots on materials, as on shiny metal. Lower shininess will still allow for specular reflection, but the highlights will be softer. The following program varies the shininess as the mouse moves left to right.

```
void setup() {
    size(100, 100, P3D);
    noStroke();
}

void draw() {
    background(0);
    fill(0, 51, 102);
    ambientLight(102, 102, 102);
    lightSpecular(204, 204, 204);
    directionalLight(102, 102, 102, 0, 0, -1);
    specular(255, 255, 255);
    translate(width/2, height/2, 0);
    float s = map(mouseX, 0, width, 1, 10);
    shininess(s);
    sphere(33);
}
```

Shapes are treated as a set of *faces*. For example, each of the six sides of a cube is a single face. Each face has a *normal*, a direction vector that sticks straight out of it, like an arrow that extends perpendicularly from the center of the face. The normal is used to calculate the angle of a light relative to the object, so that objects facing the light are brighter and objects at an angle are less so. Ambient light, since it is without direction, is not affected by a surface's normal, but all other types of light are. The material reflects light in two ways. First is diffuse reflection. A material has a diffuse color that affects the amount of light that scatters in all directions when it is hit by light. When light hits the surface head-on (in line with the normal), the surface reflects all of its diffuse color; when the light is at 90 degrees to the normal, the surface reflects none. The closer to the normal a light hits a surface, the more diffuse light it will reflect (this is calculated using the cosine of the angle between the incoming light and the normal). The more diffuse a surface is, the rougher and less shiny it appears. Often the ambient and diffuse components of a material are manipulated together. Physically, they are essentially the same quantity. The `fill()` function in Processing sets both together, but the ambient color can be controlled separately with the `ambient()` function.

Texture maps

The texture of materials is an important component in a 3D scene's realism. Processing allows images to be mapped as textures onto the faces of objects. The textures deform as the objects deform, stretching the images with them. In order for a face to have an image mapped to it, the vertices of the face need to be given 2D texture coordinates:

Geometry Texture Texture mapped to geometry

These coordinates tell the 3D graphics system how to stretch the images to fit the faces. Good texture mapping is a craft. Most 3D file formats support saving texture coordinates with object geometry. With Processing, textures are mapped to geometry using a version of the the vertex() function with two additional parameters, *u* and *v*. These two values are the x-coordinates and y-coordinates from the texture image and are used to map the vertex position with which they are paired.

The most straightforward technique maps a rectangular photo onto geometry of the same shape. In the following example, the width and height of the rectangle defined by vertex() is 100 × 100 pixels. The photo that is loaded and mapped has a width and height of 200 × 200 pixels. These values are used in the vertex() functions to define the mapping.

16-14

```
PImage tex;

void setup() {
  size(100, 100, P3D);
  tex = loadImage("dwp-parallel.png");
  noStroke();
}

void draw() {
  background(0);
  translate(0, 0, -height/4);
  float ry = map(mouseX, 0, width, 0, TWO_PI);
  rotateY(ry);
  beginShape();
  texture(tex);
  vertex(0, 0, 0, 0, 0);
  vertex(100, 0, 0, 200, 0);
  vertex(100, 100, 0, 200, 200);
  vertex(0, 100, 0, 0, 200);
  endShape();
}
```

There are two ways to define the mapping coordinates; this is done with the textureMode() function. The default parameter, IMAGE, sets the mapping coordinates in relation to the number of pixels in the source image. The other option, NORMAL, sets the mapping to normalized values (numbers between 0.0 and 1.0), where 1.0 represents the maximum horizontal and vertical dimension of the image. The next program converts the prior to normalized texture values.

```
PImage tex;
```

```
void setup() {
  size(100, 100, P3D);
  tex = loadImage("dwp-parallel.png");
  noStroke();
  textureMode(NORMAL);
}

void draw() {
  background(0);
  translate(0, 0, -height/4);
  float ry = map(mouseX, 0, width, 0, TWO_PI);
  rotateY(ry);
  beginShape();
  texture(tex);
  vertex(0, 0, 0, 0, 0);
  vertex(100, 0, 0, 1, 0);
  vertex(100, 100, 0, 1, 1);
  vertex(0, 100, 0, 0, 1);
  endShape();
}
```

The final example in this chapter extrapolates on the preceding texture mapping techniques to work with irregular geometry. The same image is used as the prior code, but a custom shape is cut from the image, rather than displaying the entire square. The default texture mode IMAGE is used because most newcomers are more comfortable with using specific pixel coordinates rather than normalized values between 0 and 1. Because the source image is twice the size in pixels as the geometry, notice the numbers for the texture coordinates are correspondingly doubled.

```
PImage tex;

void setup() {
    size(100, 100, P3D);
    tex = loadImage("dwp-parallel.png");
    noStroke();
}

void draw() {
    background(0);
    translate(0, 0, -height/4);
    float ry = map(mouseX, 0, width, 0, TWO_PI);
    rotateY(ry);
    beginShape();
    texture(tex);
    vertex(0, 6, 0, 0, 12);
    vertex(100, 45, 0, 200, 90);
    vertex(100, 80, 0, 200, 160);
    vertex(0, 44, 0, 0, 88);
    endShape();
}
```

Exercises

1. Extend code 16-04 to draw a box and sphere in place of the rectangle and line. Explore a range of rotation values.
2. Modify code 16-07 to use different camera settings when the mouse is pressed.
3. Design a simple 3D scene with boxes and spheres and light it with the default `lights()` function.
4. Place custom lights in your code from exercise 3 to change the mood of the image.
5. Load an image and use it as a texture for an irregular shape of your own design.

17 Shapes

This chapter introduces loading and displaying 2D and 3D vector graphics, then demonstrates how to create new shapes.

Syntax introduced:
```
PShape, shape(), shapeMode()
PShape.disableStyle(), PShape.enableStyle()
createShape(), PShape.setFill(), PShape.setStroke()
PShape.getVertexX(), PShape.getVertexY(), PShape.setVertex(),
PShape.getVertexCount()
```

In contrast to working with image formats like JPG and PNG, other file types such as SVG (Scalable Vector Graphics) and OBJ store image data as vector geometry rather than as a grid of colors. This difference affects how a specific file may be used. For instance, bitmap image formats are best for displaying photographic imagery captured by a camera, while vector files are most appropriate for drawn geometry such as maps, typography, and logos. Vector files store graphics as coordinates and therefore don't have a native resolution like an image file. A bitmap PNG file saved at 480 × 270 pixels will distort if enlarged to 1920 × 1080 pixels while a vector-based SVG file can be scaled smaller or larger without distortion. Bitmap files and vector files are different enough from each other that specialized software programs are typically used to create each type. For example, Adobe Illustrator and Inkscape are used to create and edit vector files, while Adobe Photoshop and the GNU Image Manipulation Program (GIMP) are used to edit bitmap images. The early examples in this chapter reveal the benefits and drawbacks to loading vector files made in other programs in contrast to building them from scratch in Processing. The later examples show how to make and store shapes created directly as sequences of vertices in code.

Display SVG

The SVG format specifies 2D graphics. SVG is an open standard that stores data in XML format (p. 499). It is supported widely across programs, including all modern web browsers. To load and display an SVG file within a program, the PShape data type is used in tandem with the loadShape() and shape() functions. This is a parallel process to working with images and fonts. As with loading images and fonts, the SVG file must be in the data folder of the current sketch. See the Load Media section on page 151 for instructions.

The following example shows how these functions operate in sequence by loading a vector map of Antarctica and drawing it to the display window. As you can see, the

complexity of the Antarctica outline would be challenging and tedious to render using individual vertex() functions.

```
PShape land;

void setup() {
    size(100, 100);
    land = loadShape("antarctica.svg");
}

void draw() {
    background(204);
    shape(land, 10, 10);
}
```

Like the the image() function, the shape() function has two versions. The one in the above example has three parameters. The first is the name of the PShape variable and is followed by the x- and y-coordinates. The second version of the function has a fourth and fifth parameter to respectively set the width and height of the shape.

```
PShape land;

void setup() {
    size(100, 100);
    land = loadShape("antarctica.svg");
}

void draw() {
    background(204);
    shape(land, 10, 10, 80, 80);
}
```

The shapeMode() function, like imageMode(), changes the way the parameters to shape() are interpreted. In the next example, scaling the geometry as the mouse moves from left to right emphasizes this. It reveals how shapeMode(CENTER) draws the SVG from the middle.

```
PShape land;

void setup() {
  size(100, 100);
  land = loadShape("antarctica.svg");
  shapeMode(CENTER);
}

void draw() {
  background(204);
  translate(width/2, height/2);
  float scalar = map(mouseX, 0, width, 0.1, 2.5);
  scale(scalar);
  shape(land, 0, 0);
}
```

Also, like the PImage class, the PShape class has internal variables to store the width and height of the vector data as defined in the file. To scale the geometry at the same width to height ratio, multiply the dimension variables by the same value. In this example, the original geometry is larger than the 100 × 100 pixel display window, so a number smaller than one is used as the multiplier to decrease the size to fit within the window.

```
PShape land;

void setup() {
  size(100, 100);
  land = loadShape("antarctica.svg");
}

void draw() {
  background(204);
  float scalar = 0.36;
  shape(land, 8, 14,
        land.width*scalar, land.height*scalar);
}
```

The last item to discuss about SVG files is the styling. By default, the shapes are displayed as they are defined in the SVG, but it is possible to cancel these fill and stroke attributes in order to define new values through the code. Before setting new fill and stroke values, we need to tell the program to ignore the embedded styles. This is done by calling the disableStyle() method on the PShape object. After the styles are disabled, the fill() and stroke() functions in the code affect the appearance of the shape. The original styles are restored with the enableStyle() method. Disabling the

style is demonstrated in the following example to change the color of the map to white and gray:

```
PShape land;

void setup() {
    size(100, 100);
    land = loadShape("antarctica.svg");
    noStroke();
}

void draw() {
    background(204);
    land.disableStyle();
    fill(255);
    shape(land, -20, 0);
    fill(102);
    shape(land, 15, 0);
    land.enableStyle();
    shape(land, 50, 0);
}
```

The PShape class has a long list of additional methods to modify how a shape is drawn to the screen. It has a rotate(), scale(), and translate() to transform how a PShape object is drawn to the screen. These and additional functions described later in this chapter allow the vertex and style data stored inside a PShape to be modified.

Display OBJ

The OBJ file format stores 3D vector geometry. It is useful because it is relatively easy to read and write and therefore is a good way to import and export geometry. In additional to storing the vertex points, the OBJ format is capable of storing the texture coordinates and normals for each vertex. As discussed in the prior chapter, the normals are necessary for lighting. External material files may be referenced within the file format as well.

Before working with a 3D file, it's helpful to know the origin and the scale. For the following examples, the Utah teapot is used. This is a 3D file first created by computer graphics pioneer Martin Newell in 1975 that has subsequently appeared in examples within research papers and as an in-joke within animated films. For this version of the teapot, the origin coordinates (0, 0) are at the center and bottom and the range of the coordinates is small. The object is sized and positioned in the examples in relation to the coordinates of the model. The following example loads the teapot and displays it to

the screen. Note that P3D is used as a third parameters to `size()` to enable the ability to draw three-dimensional shapes.

17-06

```
PShape pot;

void setup() {
  size(100, 100, P3D);
  pot = loadShape("teapot.obj");
}

void draw() {
  background(0);
  float scalar = 12.0;  // Scalar
  shape(pot, 50, 70,
        pot.width*scalar, pot.height*scalar);
}
```

Unlike the map of Antarctica used in the SVG examples, the teapot is a 3D file, so it makes sense to add the ability to rotate the object in the code to see the complete model. This leads to a different way of thinking about how the model is positioned on screen that utilizes the transformation functions to position, scale, and rotate the model. The coordinates for the `shape()` function are changed to (0,0) so that the model rotates around the center point of its internal coordinates. It's moved to the desired screen position with `translate()`, and the size is changed with `scale()`. The `lights()` function simulates light across the model to reveal its surfaces.

17-07

```
PShape pot;
float angle = 0.0;

void setup() {
  size(100, 100, P3D);
  pot = loadShape("teapot.obj");
}

void draw() {
  background(0);
  lights();
  translate(50, 50);
  scale(12);
  rotateX(angle);
  shape(pot, 0, 0);
  angle += 0.05;
}
```

Different lights can be used to change the appearance of the model and like with SVG, the `disableStyle()` method allows the values to affect the colors.

Transform

In the previous teapot example, the scale and rotation functions were used to affect the teapot model. Alternatively, the model can be changed with its internal transformation methods. In fact, every `PShape` object has its own methods to rotate, transform, and scale it. There is one important difference. Unlike the main transformation functions described in the Transform chapter, the `PShape` methods are cumulative and relative. Let's look at an example, and then we'll explain what is happening.

17-08

```
PShape pot;

void setup() {
  size(100, 100, P3D);
  pot = loadShape("teapot.obj");
  pot.scale(12);
}

void draw() {
  background(0);
  lights();
  translate(50, 50);
  pot.rotateX(0.05);
  shape(pot, 0, 0);
}
```

The main transformation functions reset themselves each time through the `draw()` block, but add together within `draw()`, while the methods for `PShape` are cumulative. For example, the first time through `draw()`, the shape rotates 0.05 radians, the next time through `draw`, it rotates another 0.05 radians, so now the total rotation is 0.1 at that point in the program. Because the `scale()` method is in `setup()`, that code only runs once, so the scalar value for the teapot remains the same while the program runs. In comparison to example 17-07, the code is cleaner because the angle variable isn't needed, and the `scale()` happens only once in `setup()` rather than each time through `draw`.

It's important to say that one way of programming this little teapot example is not better than the other. They are different ways of thinking about the shapes, and each individual is best left to make a personal choice about what makes the most sense.

Create

Working with primitive shapes like rectangles and ellipses is a bit like working with blocks. A surprising amount of work can be done by composing primitives, but the level of detail is limited by the scale of the building block relative to the scale of the composite. It's often appropriate to craft a shape from individual vertices as discussed in the Vertices chapter. With a PShape, though, these custom shapes can be saved into a new object capable of utilizing the PShape methods. This often makes the code more legible and it can optimize the code to run faster. We'll start by modifying code 15-04 to create a new PShape object.

```
PShape zig;

void setup() {
  size(100, 100);
  zig = createShape();
  zig.beginShape();
  zig.fill(0);
  zig.noStroke();
  zig.vertex(10, 0);
  zig.vertex(100, 30);
  zig.vertex(90, 70);
  zig.vertex(100, 70);
  zig.vertex(10, 90);
  zig.vertex(50, 40);
  zig.endShape();
}

void draw() {
  background(204);
  shape(zig, 0, 0);
}
```

17-09

The new syntax in this example is the createShape() function. As the name suggests, this function is used to construct the shape so it's ready to be defined. As with the examples in the Vertices chapter, the beginShape() and endShape() functions are used to start and stop the list of geometry that is defined by a series of vertex() functions. The difference is that these functions are now used directly on the new PShape object, in this example it's called zig. The dot syntax is used here in the same manner as with Strings in the Text chapter. Each time a function such as fill() or vertex() is run following the name of the shape and the dot operator, the action applies directly to the shape. This is further discussed in the Objects chapter.

This code is longer than example 15-04, but it's also more modular and flexible—it's easier to do things with the shape now that it's a PShape. For example, the shape can be more simply rotated and scaled as shown here:

17-10

```
PShape zig;

void setup() {
    size(100, 100);
    zig = createShape();
    zig.beginShape();
    zig.fill(0);
    zig.noStroke();
    zig.vertex(10, 0);
    zig.vertex(100, 30);
    zig.vertex(90, 70);
    zig.vertex(100, 70);
    zig.vertex(10, 90);
    zig.vertex(50, 40);
    zig.endShape();
    zig.scale(0.7);
    zig.translate(-50, -50);
}

void draw() {
    background(204);
    shape(zig, 50, 50);
    zig.rotate(0.01);
}
```

Everything about defining geometry in the Vertices chapter applies to creating custom shapes including cutouts and curves. Both minimal and intricate forms can be created in this manner. The next example, based on code 15-17, shows a combination of two curves.

```
PShape petal;

void setup() {
  size(100, 100, P3D);
  petal = createShape();
  petal.beginShape();
  petal.noStroke();
  petal.fill(0);
  petal.vertex(90, 39);
  petal.bezierVertex(90, 39, 54, 17, 26, 83);
  petal.bezierVertex(26, 83, 90, 107, 90, 39);
  petal.endShape();
  petal.translate(-50, -50);
}

void draw() {
  background(204);
  shape(petal, 50, 50);
  petal.rotateX(0.01);
}
```

Modify

When a shape is created as a PShape object, it is stored by Processing in a way that makes it fast to draw to the screen. This is one of the great benefits of PShape objects in relation to how fast a program will run, but it makes it a little more difficult to change the shape after it is created. Drawing attributes such as color can be changed and the position of each vertex can be changed as well, but new functions are needed, because the fill() and vertex() functions only affect geometry about to be drawn and cannot change a drawing after the fact. For example, when a shape is first created, as in the previous examples, the fill() function is used to set the color of the vertices that are added after it. But, once the shape is created, the specialized setFill() method must be used to change the color. Requiring two separate functions to create and then later modify the shape may seem confusing, but it's necessary because they work differently.

There is a wide range of methods that can affect a shape, but here we'll focus on the most essential: setFill(), setStroke(), getVertexX(), getVertexY(), setVertex(). In the following example, code 17-09 is modified to draw with different gray values each time the shape is drawn. In comparison, note the noStroke() function was removed from the shape and CLOSE was added to endShape() to make the stroke wrap all of the way around. Most importantly, the setFill() and setStroke() are not as flexible as the companion functions fill() and stroke(). While fill(), for instance, can accept one number to define a gray value or three

numbers to define a color, setFill() has only a single parameter of the color data type. In this example, the color for the stroke and fill is changed each frame. The frame rate is slowed down to make this clearer.

17-12

```
PShape zig;

void setup() {
  size(100, 100);
  zig = createShape();
  zig.beginShape();
  zig.fill(0);
  zig.vertex(10, 0);
  zig.vertex(100, 30);
  zig.vertex(90, 70);
  zig.vertex(100, 70);
  zig.vertex(10, 90);
  zig.vertex(50, 40);
  zig.endShape(CLOSE);
  frameRate(4);
}

void draw() {
  background(204);
  color strokeVal = color(random(255));
  color fillVal = color(random(255));
  zig.setStroke(strokeVal);
  zig.setFill(fillVal);
  shape(zig, 0, 0);
}
```

The next and final example in this section shows how to get the coordinates of each vertex point and how to modify them. A for loop is used to move through each vertex in the shape, to grab the coordinates, and to move it slightly based on random values. The getVertexCount() method returns the total number of vertices in the shape; this value is used inside the loop to know when to stop counting.

```
PShape zig;

void setup() {
  size(100, 100);
  zig = createShape();
  zig.beginShape();
  zig.fill(0);
  zig.vertex(10, 0);
  zig.vertex(100, 30);
  zig.vertex(90, 70);
  zig.vertex(100, 70);
  zig.vertex(10, 90);
  zig.vertex(50, 40);
  zig.endShape(CLOSE);
}

void draw() {
  background(204);
  for (int i = 0; i < zig.getVertexCount(); i++) {
    float x = zig.getVertexX(i);
    float y = zig.getVertexY(i);
    x += random(-1, 1);
    y += random(-1, 1);
    zig.setVertex(i, x, y);
  }
  shape(zig, 25, 25);
}
```

There's a wide range of other things to do with PShape covered in the Processing reference and examples. Please check there for more ideas and details.

Exercises
1. *Create or find an SVG file and write a sketch to display it.*
2. *Modify your code from exercise 1 to disable the SVG's drawing attributes and override them with* fill() *and* stroke().
3. *Create or find an OBJ file and write a sketch to display and rotate it.*
4. *Similar to the custom shape in code 17-09, build a new shape vertex by vertex.*
5. *Add to your code from exercise 4 to modify the shape each time a key is pressed.*

18 Synthesis 2

This chapter discusses the iterative software development process and the activity of debugging code.

The code sketches up to this point in the book are short. Programs of this length can be written without much forethought, but planning becomes important when writing longer programs. The extent of the planning will be up to the programmer, but one aspect of programming is always the same: large, complex programs must be divided into series of short, simpler programs. Learning how to divide programs into manageable parts takes time and experience. As the scope of a program grows, the number of decisions involved in writing it multiplies. Making changes to a program, evaluating the result, and then making additional changes is an iterative process. Like a project in any medium, software improves through many cycles of changes and evaluations.

Longer programs also present a higher likelihood of mistakes. The flow of logic and data becomes less obvious in a larger program, and the errors—known as bugs— introduced are subtler. Learning to track down and fix errors is an important skill in writing software.

Iteration

There are many different models for software development, but they all contain elements of analysis, synthesis, and evaluation. A continuous cycle of synthesis and evaluation is the core of the iterative process. Every project demands variations on each of these stages, but the purpose of each remains consistent. A more detailed description of each stage illuminates how they interact.

Analysis
Analysis leads to an understanding of the software—its function, audience, and purpose. This stage can involve months of research or mere seconds of consideration, resulting in a proposal, project description, or other means of communicating the project to others.

Synthesis
The goals and concepts that emerge from the analysis are realized through synthesis. Early steps in synthesis often include paper sketches, followed by software sketches, and then refinement of the finished software. The results of this stage are evaluated, edited, and augmented with additional synthesis until the software is finished.

Evaluation

The results of the synthesis phase are evaluated in relation to the analysis to determine what remains to be done. Is the project complete or is another round of synthesis needed? What improvements can be made? What is working and what needs to be fixed? Depending on the nature of the project, the evaluation sometimes returns to analysis and the goals of the project are modified.

Programs change quickly, and sometimes the programmer prefers an earlier version. Save multiple versions of the sketch while working so that it is always possible to return to a previous iteration of the code. Simply select "Save As..." from the File menu to save a new version of the program with a different name. The "Archive Sketch" option from the Tools menu saves the code and all additional media for the current sketch inside a ZIP archive with the name of the current sketch and the date. Saving multiple versions of a sketch ensures that older, working examples of the code remain intact.

Debugging

When a person first starts programming, errors (bugs) occur frequently; learning how to find and fix (debug) them is an important part of learning to program. In *The Practice of Programming*, the authors explain: "Good programmers know that they spend as much time debugging as writing so they try to learn from their mistakes. Every bug you find can teach you how to prevent a similar bug from happening again or to recognize it if it does."[1]

Some bugs reveal themselves when the Run button is pressed, as they prevent the program from starting. Other bugs appear while the program is running, causing the program to stop. The message area (p. 9) turns red and reveals a summary of the problem. Sometimes the bug message text is too long to fit in this area, but the full message always appears in the console. The Processing environment always tries to highlight the line where the bug occurs, but since the bug may be the result of something that happened earlier in the program, the error does not always appear on the highlighted line. The highlighted line is usually related to the error, but perhaps not in an obvious way.

Not all bugs stop a program from running. Errors in logic or problems with equations are sometimes more difficult to find because they don't stop the program.

Fixing bugs is one of the more difficult and less satisfying aspects of programming. Sometimes they are obvious and quick to fix, but sometimes it can take hours. Finding a bug is like solving a mystery. It's necessary to search through the code to find clues in pursuit of the culprit. Try the following:

Scrutinize the newest code

If the program is constructed step by step, the bug is often in the newest code or is linked to it. Check these areas for bugs first.

Check related code
Sometimes a bug may linger within a program for a long time because the line containing the bug is not run. When code is introduced that runs a line with a bug, or when the value of a variable changes so that code within a previously unused if or for loop is run, the bug will reveal itself.

Display output
Displaying the data produced by a program while it's running can expose problems and lead to a better understanding of the code in general. The println() function can be used to display data as text to the console. This technique can answer questions about the status of a variable and can be used to check whether a specific line or block of code is running. The data can also be represented as positions or colors in the program's display.

Isolate the problem
It's often difficult to find a bug within a large program. If possible, try to reduce the problem to its essence. Is it possible to reproduce the bug by running only a few lines of code or a much simpler program?

Learn from previous bugs
All programmers—new and experienced—inadvertently introduce bugs into their code. The hardest time to find a particular bug is usually during its first occurrence. Learn from previous mistakes to avoid the same bug in the future.

Take a break
Sometimes the best way to fix a bug is to take a break. After hours of programming, the perspective gained from a diversion or rest can bring clarity.

As with all software, there are bugs in Processing, and some are added and removed with each release of the software. For the most current information about bugs in the Processing software, read the Frequently Asked Questions (FAQ) and Troubleshooting pages accessible from the Help menu.

Examples

Following on the theme of iteration, these examples start with a basic idea and move through the steps of realizing the idea by building the sketch one step at a time. The ultimate goal is to build a structure to tell a branching story, where decisions change the outcome of a narrative. Unlike a linear story that is told the same way each time, a nonlinear story may be told in a different order each time and can have multiple endings.

This type of story was introduced in software though games such as Colossal Cave Adventure and Zork released in the late 1970s. These games allow a player to move

through a world by typing instructions to perform actions. For instance, the player can walk through a forest or choose to enter a house. Each decision leads to new information and discoveries that affect the future of the story. Contemporary games like the Grand Theft Auto series and experimental works of electronic literature build on the early ideas pioneered through games, HyperCard stacks, and other precedents.

Before coding a nonlinear story, decisions need to be made about the content and structure. The specific reference for the following examples is the game Adventure released for the Atari 2600 in 1979. This game involves searching a maze for items and avoiding dragons with the ultimate goal of finding a chalice and taking it to the gold castle. Each screen in Adventure links to other screens to build a larger environment. We'd like to sketch out an environment of this scope, but these examples will start simpler by creating two rooms to explore. To reach the defined goals, three short programs are needed to sort out the details before they are brought together. These three sketches are:

1. Control the hero with the arrows keys
2. Design and draw the first room
3. Design and draw the second room

The sketch to control the hero is based on code 7-21. It uses the four arrow keys to move a circle, up, down, left, and right. This code is placed directly in draw() instead of the keyPressed() function so the hero moves continuously while a key is pressed, rather than once for each key press.

```
int x = 320;    // Hero x-coordinate                               18-01
int y = 240;    // Hero y-coordinate
int r = 40;     // Hero radius
float speed = 2.0;   // Hero speed

void setup() {
  size(640, 480);
  ellipseMode(RADIUS);
  noCursor();
}

void draw() {
  background(204);

  // Draw hero
  noStroke();
  fill(126);
  ellipse(x, y, r, r);
```

Figure 18-1
Screen captures for code 18-01.

```
// Move hero with arrow keys
if ((keyPressed == true) && (key == CODED)) {
  if (keyCode == UP) {
    y -= speed;
  } else if (keyCode == DOWN) {
    y += speed;
  } else if (keyCode == LEFT) {
    x -= speed;
  } else if (keyCode == RIGHT) {
    x += speed;
  }
}
}
```

18-01
cont.

The next two sketches are outlines of each room in the story environment. The first room has a gate, drawn as a column of dots, that keeps the hero from getting to a dagger. The only way out of the room is the right edge of the screen, which connects to the second room. This other room has only a key drawn with the beginShape() and vertex() functions. Both rooms have minimal text to help the player along.

```
// Master variables
int w = 40;      // Wall thickness
int tx = 620;    // Text x-coordinate
int ty = 420;    // Text y-coordinate
boolean gate = true;   // Is the gate closed or open?

// Room 1 variables
int gx = 260;    // Gate x-coordinate
int dx = 150;    // Dagger x-coordinate
int dy = 210;    // Dagger y-coordinate
```

18-02

Figure 18-2
Screen captures for code 18-02.

18-02
cont.

```
void setup() {
  size(640, 480);
  ellipseMode(RADIUS);
  noCursor();
  textSize(14);
  textAlign(RIGHT);
}

void draw() {

  // Walls
  background(255);
  noStroke();
  fill(0);
  rect(0, 0, width, w);      // Top
  rect(0, 0, w, height);     // Left
  rect(0, height-w, width, w);   // Bottom

  // Gate
  fill(0);
  if (gate == true) {
    for (int y = w; y <= height-w; y += 20) {
      ellipse(gx, y, 5, 5);
    }
    text("Use the arrow keys to explore", tx, ty);
  }

  // Dagger
  fill(102);
  triangle(dx, dy, dx+5, dy-10, dx+10, dy);
```

```
    rect(dx, dy, 10, 70);
    rect(dx-10, dy+45, 30, 10);
  }
```

```
// Master variables
int w = 40;      // Wall thickness
int tx = 620;    // Text x-coordinate
int ty = 420;    // Text y-coordinate
boolean gate = true;   // Is the gate closed or open?

// Room 2 variables
int kx = 440;    // Key x-coordinate
int ky = 230;    // Key y-coordinate

void setup() {
  size(640, 480);
  ellipseMode(RADIUS);
  noCursor();
  textSize(14);
  textAlign(RIGHT);
}

void draw() {

  // Walls
  background(255);
  noStroke();
  fill(0);
  rect(0, 0, width, w);   // Top
  rect(width-w, 0, w, height);   // Right
  rect(0, height-w, width, w);   // Bottom

  // Key
  if (gate == true) {
    fill(102);
    pushMatrix();
    translate(kx, ky);
    beginShape();
    vertex(0, 10);
    vertex(50, 10);
    vertex(50, 0);
    vertex(80, 0);
    vertex(80, 30);
```

Figure 18-3
Screen captures for code 18-03.

18-03
cont.

```
    vertex(50, 30);
    vertex(50, 20);
    vertex(30, 20);
    vertex(30, 30);
    vertex(20, 30);
    vertex(20, 20);
    vertex(10, 20);
    vertex(10, 30);
    vertex(0, 30);
    endShape();
    popMatrix();
  }

  // Text
  fill(0);
  if (gate == true) {
    text("Grab the key to open the gate", tx-w, ty);
  }
  else {
    text("You have the key. The gate is open!", tx-w, ty);
  }

}
```

After these short prototypes are working, they are put into a larger program and linked together to create transitions. For instance, the current room is determined by the mode variable, either a 1 or 2. When the hero moves off the right edge of the display window, the mode variable is set to 2, which triggers the if conditional to run the code for the second room. When the position of the hero is near the key, the gate "opens" in the first room because the boolean variable gate is set to false. When the hero moves off the left edge of the display window in the second room, the mode switches back to first

room. In both rooms, the hero is confined inside three walls with a series of conditional expressions.

```
// Master variables
int mode = 1; // Current room
int w = 40;   // Wall thickness
int tx = 620; // Text x-coordinate
int ty = 420; // Text y-coordinate
boolean gate = true;  // Is the gate closed or open?

// Hero variables
int x = 400; // Hero x-coordinate
int y = 240; // Hero y-coordinate
int r = 40;  // Hero radius
float speed = 2.0;  // Hero speed

// Room 1 variables
int gx = 260;  // Gate x-coordinate
int dx = 150;  // Dagger x-coordinate
int dy = 210;  // Dagger y-coordinate

// Room 2 variables
int kx = 440;  // Key x-coordinate
int ky = 230;  // Key y-coordinate

void setup() {
  size(640, 480);
  ellipseMode(RADIUS);
  noCursor();
  textSize(14);
  textAlign(RIGHT);
}

void draw() {

  if (mode == 1) {  // ROOM 1

    // Walls
    background(255);
    noStroke();
    fill(0);
    rect(0, 0, width, w); // Top
    rect(0, 0, w, height); // Left
    rect(0, height-w, width, w);  // Bottom
```

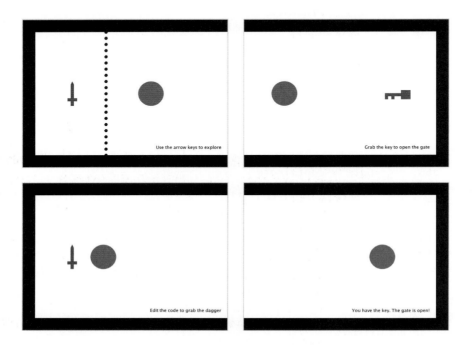

Figure 18-4
Screen captures for code 18-04.

```
  // Gate
  fill(0);
  if (gate == true) {
    for (int y = w; y <= height-w; y += 20) {
      ellipse(gx, y, 5, 5);
    }
    text("Use the arrow keys to explore", tx, ty);
  } else {
    text("Edit the code to grab the dagger", tx, ty);
  }

  // Dagger
  fill(102);
  triangle(dx, dy, dx+5, dy-10, dx+10, dy);
  rect(dx, dy, 10, 70);
  rect(dx-10, dy+45, 30, 10);

  // Stop the hero from walking through walls
  if (gate == true) {
    if (x < gx+r+5) {   // Check gate
      x = gx+r+5;
    }
  } else {
    if (x < w+r) {   // Check left wall
      x = w+r;
    }
  }
  if (y > height-w-r) {   // Check bottom wall
    y = height-w-r;
  }
  if (y < w+r) {   // Check top wall
    y = w+r;
  }

  // Move to room 2
  if (x > width+r)
    mode = 2;
    x = r;
  }

} else {   // ROOM 2
```

```
// Walls
background(255);
noStroke();
fill(0);
rect(0, 0, width, w);    // Top
rect(width-w, 0, w, height);   // Right
rect(0, height-w, width, w);   // Bottom

// Key
if (gate == true) {
  fill(102);
  pushMatrix();
  translate(kx, ky);
  beginShape();
  vertex(0, 10);
  vertex(50, 10);
  vertex(50, 0);
  vertex(80, 0);
  vertex(80, 30);
  vertex(50, 30);
  vertex(50, 20);
  vertex(30, 20);
  vertex(30, 30);
  vertex(20, 30);
  vertex(20, 20);
  vertex(10, 20);
  vertex(10, 30);
  vertex(0, 30);
  endShape();
  popMatrix();
}

// Text
fill(0);
if (gate == true) {
  text("Grab the key to open the gate", tx-w, ty);
}
else {
  text("You have the key. The gate is open!", tx-w, ty);
}
```

```
    // Check if hero is on top of the key
    if (x > kx && x < kx+80 && y > ky && y < ky+30) {
      gate = false;
    }

    // Stop the hero from walking through walls
    if (x < -r) {
      mode = 1;
      x = width-r;
    }
    if (x > width-w-r) {   // Check right wall
      x = width-w-r;
    }
    if (y > height-w-r) {   // Check bottom wall
      y = height-w-r;
    }
    if (y < w+r) {   // Check top wall
      y = w+r;
    }
    // Move to room 2
    if (x > width+r) {
      mode = 2;
      x = r;
    }
  }

  // Draw hero
  fill(126);
  ellipse(x, y, r, r);

  // Move hero with arrow keys
  if (keyPressed && key == CODED) {
    if (keyCode == UP) {
      y -= speed;
    } else if (keyCode == DOWN) {
      y += speed;
    } else if (keyCode == LEFT) {
      x -= speed;
    } else if (keyCode == RIGHT) {
      x += speed;
    }
  }
}
```

This program is so simple that it's not yet an exciting adventure, but it's the right complexity for this moment in learning to write code and it outlines how to continue to add rooms and experiences. For example, the next step might be to add code for the hero to pick up the dagger.

Now that the program is functioning, it's time to think more about the visual details. We decided to try an opposite approach to the clean geometry of the prototype. We scanned and edited drawings from Jem (age 4) and Jules (age 2) to build the world. These drawings were converted from color to grayscale and scaled to match the display window size. Because a single image can contain dense information, the length of the sketch is reduced by replacing code to draw a shape with a single image. This is most noticeable with the key. Note that all images are loaded inside setup() so they are ready at the beginning of the program. For more on loading and displaying images, refer to the Image chapter (p. 163).

18-05

```
// Master variables
int mode = 1;           // Current room
int w = 40;             // Wall thickness
int tx = 620;           // Text x-coordinate
int ty = 420;           // Text y-coordinate
boolean gate = true;    // Is the gate closed or open?
PImage scribbles;       // Background image
PFont heroFont;         // Font for the project

// Hero variables
PImage hero;        // Hero image
int x = 440;        // Hero x-coordinate
int y = 240;        // Hero y-coordinate
int r = 110;        // Hero radius
float speed = 2;    // Hero speed

// Room 1 variables
int gx = 220;       // Gate x-coordinate
int dx = 75;        // Dagger x-coordinate
int dy = 120;       // Dagger y-coordinate
PImage dagger;      // Dagger image

// Room 2 variables
int kx = 390;       // Key x-coordinate
int ky = 180;       // Key y-coordinate
PImage gateKey;     // Key image
```

```
void setup() {
  size(640, 480);
  noCursor();
  textAlign(RIGHT);
  hero = loadImage("figure.png");
  scribbles = loadImage("background.png");
  heroFont = createFont("SourceCodePro-Bold", 16);
  gateKey = loadImage("key.png");
  dagger = loadImage("dagger.png");
  textFont(heroFont);
}

void draw() {

  if (mode == 1) {  // ROOM 1

    // Walls
    imageMode(CORNER);
    image(scribbles, 0, 0);

    // Gate
    if (gate == true) {
      noStroke();
      fill(255);
      rect(gx, w, w, height-w*2);
      fill(0);
      text("Use the arrow keys to explore", tx, ty);
    } else {
      text("Edit the code to grab the dagger", tx, ty);
    }

    // Dagger
    image(dagger, dx, dy);

    // Stop the hero from walking through walls
    if (gate == true) {
      if (x < gx+r+5) {  // Check gate
        x = gx+r+5;
      }
    } else {
      if (x < w+r) {  // Check left wall
        x = w+r;
```

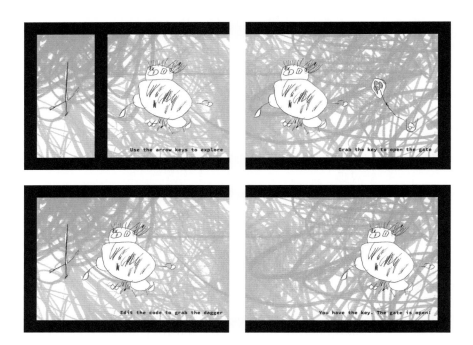

Figure 18-5
Screen captures for code 18-05.

```
        }
      }
      if (y > height-w-r) {    // Check bottom wall
        y = height-w-r;
      }
      if (y < w+r) {   // Check top wall
        y = w+r;
      }

      // Move to room 2
      if (x > width+r) {
        mode = 2;
        x = r;
      }

    } else {   // ROOM 2

      // Walls
      imageMode(CORNER);
      image(scribbles, -width, 0);

      // Key
      if (gate == true) {
        image(gateKey, kx, ky);
      }

      // Text
      fill(0);
      if (gate == true) {
        text("Grab the key to open the gate", tx-w, ty);
      }
      else {
        text("You have the key. The gate is open!", tx-w, ty);
      }

      // Check if hero is on top of the key
      if (x > kx && x < kx+gateKey.width && y > ky &&
          y < ky+gateKey.height) {
        gate = false;
      }
```

```
// Stop the hero from walking through walls
if (x > width-w-r) {   // Check right wall
   x = width-w-r;
}
if (y > height-w-r) {   // Check bottom wall
   y = height-w-r;
}
if (y < w+r) {   // Check top wall
   y = w+r;
}

// Move to room 1
if (x < -r) {
   mode = 1;
   x = width-r;
}
}

// Draw hero
imageMode(CENTER);
image(hero, x, y);

// Move hero with arrow keys
if ((keyPressed == true) && (key == CODED)) {
   if (keyCode == UP) {
      y -= speed;
   } else if (keyCode == DOWN) {
      y += speed;
   } else if (keyCode == LEFT) {
      x -= speed;
   } else if (keyCode == RIGHT) {
      x += speed;
   }
}
}
```

These sketches are just the start of what this story can be. With the code covered in the book so far, this game can continue with additional rooms and challenges, but the code will begin to feel long and unstructured. With the techniques learned in future chapters, this story can be written in a more modular way that allows it to grow while still being well organized. From a visual point of view, different typography, images,

and shapes can be added. To see some of the changes (and similarities) to graphics over the last thirty years, compare the original *Adventure* graphics (1979) with *Age of Conan* (2008) and *Sword & Sorcery* (2011). Additionally, the entire *adventure* theme for this example can be replaced with a different type of narrative. We encourage each reader to expand and change the narrative based on what you know now and to revisit it after you've finished the book.

Note

1. Brian W. Kernighan and Bob Pike, *The Practice of Programming* (Addison-Wesley, 1999), p. 117.

19 Interviews: Interaction

Lynn Hershman Leeson (LORNA)
Robert Winter (Ludwig van Beethoven: Symphony No. 9)
Josh On (They Rule)
Steph Thirion (Eliss)

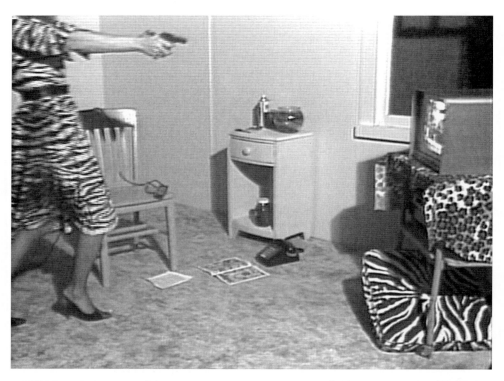

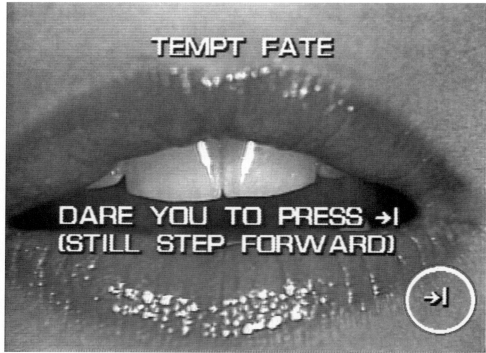

TEMPT FATE

DARE YOU TO PRESS →I
(STILL STEP FORWARD)

Screen captures from the *LORNA* laser disk. Image courtesy bitforms gallery nyc.

LORNA *(Interview with Lynn Hershman Leeson)*

Creator	Lynn Hershman Leeson
Year	1979–1983
Medium	LaserDisk
Software	Custom software
URL	www.lynnhershman.com

What is LORNA?

LORNA is an interactive installation as a vehicle for people to virtually adopt the persona of the lead character LORNA, an agoraphobic woman who lives in fear of the outside world. Fear is generated by ingested media that she sees via her remote unit on her TV set, which shows wars and pervasive advertising through which she is manipulated. Viewers use an identical remote unit to hers to transport themselves into her life and see the thirty-two chapters that define her.

A precondition to video is that it does not talk back. It absorbs rather than reflects. While video does not talk back, interactive works are like a two-way mirror that required dialogues. I found this possibility deeply subversive! Unlike my live performance Roberta, who existed by interactions in the world, LORNA, the main character of my first interactive videodisk, never left her one-room apartment.

The objects in her room were very much like those in an earlier installation, the Dante Hotel, *except the television set. As LORNA watched the news and ads, she became fearful—afraid to leave her tiny room. Viewers were invited to liberate LORNA from her web of fears by accessing buttons on their remote control unit that corresponded to numbers placed on the items in her room. Instead of being passive, the action was literally in the hands of the viewer—now a participant. Each numbered object accesses information about LORNA's past, future and personal conflicts. Many images on the screen are of the remote control device LORNA uses to change television channels. Because the participant also uses a nearly identical unit to direct the disc action, a metaphoric link or point of identification is established and surrogate decisions are made for LORNA.*

Participants chose to voyeuristically overhear conversations of different contexts as they trespassed the space of her hard-pressed life. There were three endings: LORNA shoots her television set, she commits suicide, or, what we Northern Californians consider the worst of all, she moves to Los Angeles. The plot has multiple variations that can be seen backwards, forwards, at increased or decreased speeds, and from several points of view. There is no hierarchy in the ordering of decisions.

Why did you create LORNA?

I wanted to create a vehicle that showed architectural space and time, and was simultaneously a virtual performance enacted by users. The word user did not yet exist, and I invented it as a way of explaining how people would guide the interaction. In fact, I had to invent most of the dialogue and iconic methods for interaction so people could understand how to manipulate or interact with it.

LORNA is literally captured by a mediated landscape. Her passivity (presumably caused by being controlled by media) is a counterpoint to the direct action of the player. As the branching path is deconstructed, the player becomes aware of the subtle yet powerful effects of fear caused by media and becomes more empowered (active) through this perception. Playing LORNA was designed to have viewer/participants transgress into an inverse labyrinth of themselves.

Despite some theories to the contrary, the dominant presumption is that making art is active and viewing it is passive. Radical shifts in communication technology, such as the marriage of image, sound, text, and computers, and consummation by the public of this consort, have challenged this assumption. Users of LORNA reported that they had the impression that they were empowered because they held the option of manipulating LORNA's life. Rather than being remotely controlled, the decision unit was literally placed in their hands. They were not simply watching a narrative with a structure predetermined by an invisible omniscient. Implications of the relationship reversal between individuals and technological media systems are immense. The media bath of transmitted prestructured and preedited information that surrounds (and some say alienates) people is washed away. It is hosed down by viewer input. Alteration of the basis for exchange of information is subversive in that it encourages participation and therefore creates a different audience dynamic.

Interactive systems require viewers to react. Their choices are facilitated by means of a keyboard, mouse, or touch-sensitive screen. As technology expands, there will be more permutations available, not only between the viewer and the system, but between elements within the system itself. Some people feel that computer systems will eventually reflect the personality and biases of their users. They depend upon the architectural strategy of the program. However, there is a space between the system and player in which a link, fusion, or transplant occurs. Content is codified. Truth and fiction blur. Action becomes icon and relies on movement and plasticity of time.

What software tools were used?

I wrote the design and flow chart, and Anna Marie Garti used traditional branching software used by the company Videodisk Publishing to create and link the modular sound and video unit into multiple narratives of infinite strategy.

Why did you use these tools?

Very little existed at the time; I started in 1979! So we improvised and designed what we needed to make the piece function. Because of its early inception, LORNA is generally inaccessible today. It was pressed in a limited edition of twenty-five, of which only four now exist. It is only occasionally installed in galleries or museums. Creating a truly interactive work demands that it exist on a mass scale, available and accessible to many people.

Why do you choose to work with software?

It was the only way to create this work that used invisible architecture for interaction. It creates the space and time for contemplation and interpretation on multiple and infinite levels.

Screen captures from the LORNA laser disk. Image courtesy bitforms gallery nyc.

TELEVISION REFLECTS OUR FEARS AND MIRRORS OUR DREAMS.

"TRUE" STORY

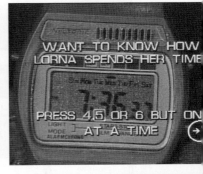
WANT TO KNOW HOW LORNA SPENDS HER TIME

PRESS 4,5 OR 6 BUT ON AT A TIME

FANTASY OR REALITY?

THIS IS LORNA'S LIVING ROOM. CAN YOU IMAGINE SPENDING THE LAST 16,325 DAYS HERE? JUST LOOK AT ALL THAT JUNK SHE KEEPS AROUND. GO AHEAD. LOOK. EACH OBJECT WILL GIVE YOU A CLUE ABOUT LORNA. SEARCH THE CHAPTERS OF EACH ONE AND SEE WHAT I MEAN.

SHE LIVES A REMOTE CONTROL LIFE

HOORAY! LORNA'S FRE

LORNA

LUDWIG VAN
BEETHOVEN
Symphony
No.9

- A POCKET GUIDE
- BEETHOVEN'S WORLD
- THE ART OF LISTENING
- A CLOSE READING
- THE NINTH GAME

? | ABOUT THIS CD COMPANION

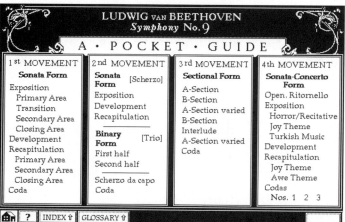

LUDWIG van BEETHOVEN
Symphony No. 9

A · POCKET · GUIDE

1st MOVEMENT	2nd MOVEMENT	3rd MOVEMENT	4th MOVEMENT
Sonata Form	**Sonata Form** [Scherzo]	**Sectional Form**	**Sonata-Concerto Form**
Exposition	Exposition	A-Section	Open. Ritornello
Primary Area	Development	B-Section	Exposition
Transition	Recapitulation	A-Section varied	Horror/Recitative
Secondary Area		B-Section	Joy Theme
Closing Area	**Binary Form** [Trio]	Interlude	Turkish Music
Development	First half	A-Section varied	Development
Recapitulation	Second half	Coda	Recapitulation
Primary Area			Joy Theme
Secondary Area	Scherzo da capo		Awe Theme
Closing Area	Coda		Codas
Coda			Nos. 1 2 3

🏠 | ? | INDEX ⇧ | GLOSSARY ⇧

Beethoven's World

INTRODUCTION

On May 7, 1824, Ludwig van Beethoven, aged 53, presided in Vienna over the premiere of his ninth and last symphony. Feeling unappreciated by the Viennese, he had threatened to introduce the work in Berlin.

Against the advice of many of his friends, the deaf composer had been persuaded by the theater manager to "participate in the general direction."

🏠 | ? | INDEX ⇧ | CHAPTERS ⇧ | GLOSSARY ⇧ | FIND | AGAIN | ◀ 2 of 124 ▶

Ludwig van Beethoven: Symphony No. 9

(Interview with Robert Winter)

Creator	Robert Winter
Year	1989
Medium	CD-ROM
Software	HyperCard
URL	www.artsinteractive.org

What is *Ludwig van Beethoven: Symphony No. 9*?

Our program was the first commercial CD-ROM about music, and it was for many people their first exposure to the new world of "multimedia." I authored it hoping that the appeal would extend from novices to experts—something the new medium not only allowed but encouraged.

Why did you create *Ludwig van Beethoven: Symphony No. 9*?

On January 1, 1989, Bob Stein showed up at our New Year's Day open house. Bob was the prophet behind the Voyager Company, and for two years he had already been filling my head with digital fantasies. This time he brought something with him: a preproduction Sony CD-ROM drive. It weighed about fifteen pounds and sounded something like a 747 on takeoff. Bob lugged it to my Macintosh Plus, whipped out an exotic SCSI cable, and fired the box up. After sticking in one of my CDs, he spent about five comical minutes making one play button. After demonstrating that I could start and stop the music anywhere on a track within tolerances of a thousandth of a second, and that play events could be linked to graphics, he asked: "Could I do anything with it?"

Twenty-three years and ten projects later, I'm still trying to answer that question. Characteristically, Bob told me that he needed something to show the Markle Foundation in New York the next week. They were handing out big money for something digital—and big. Bob told me that he needed one genuine "Oh-my-God" moment. After one sleepless night I thought: Why not use the same piece of music that the Philips-Sony team used in developing the Red Book CD spec? The Japanese contingent had insisted that a single disk be capable of holding the Leonard Bernstein recording of Beethoven's Ninth Symphony—an iconic work in the classical music pantheon. Until now it required four sides of a 33⅓ rpm LP. Serendipitously, I had already spent ten years studying and publishing about the sketches.

I chose the sudden and electrifying modulation in the Scherzo (the second of the four movements). I'd always believed I could teach anyone this seminal but otherwise complex process if I could pinpoint the moment for them. I created a visual effect in which BAM!!! popped up at the moment of the modulation. The breakthrough was that the user could repeat the process as many times as they wished (the Vienna Philharmonic never got tired) until they got it. It was better than me in a classroom. The Markle folks wrote Voyager a very healthy six-figure check.

What software tools were used?

We created the finished program in just a few intense months using Apple's new HyperCard application. For humanists, it has only been recently surpassed by RunRev's LiveCode, itself an extension of HyperCard and what we currently use for laptops, iPads, and mobile devices. Bill

Atkinson's HyperCard placed a lot of refreshing emphasis on text handling, including the first hot text links. It's amazing how many great ideas are created by a single person's vision rather than by the Microsoft mega-team approach. The only thing HyperCard lacked was text flow; twenty-three years later, I am still working without it. The best part was that my authoring environment looked almost exactly like the run-time version, so I could see and hear at every turn how the organism was evolving.

Why did you use these tools?

Although comparatively primitive by today's standards, HyperCard was the most cutting edge tool at the time. Almost every day Steve Riggins—the lead programmer—and I would engage in intense, sometimes heated, discussions about what was possible and what was not. The Apple engineers in Cupertino would tell Steve that the kinds of features I was demanding were impossible. When I would periodically conclude with regrets that I would have to give up, Steve would disappear for a few days and then call me to come in. He'd figured it out. He quietly performed miracle after miracle—instant page turns, authoring tools that gave me more control over the process, and ultimately the "bouncing bricks" over music notation or other descriptions that still make our work unique.

The limitations were draconian. We were held to whatever could fit on a single floppy disk (if memory serves, something like 800K). The 1-bit graphics (as the illustrations show) were lower in quality than the average comic book. Any sounds that I added were—like the game sounds of the time—in crunchy 8-bit. Yet somehow robotic-sounding Beethoven worked when it empowered users to understand what they were hearing. I used up every byte with—in addition to the Close Reading—sections on how to listen, the historical back-story, and (our coup de grâce) a multiple-choice game in which a lightly animated face of Beethoven commented on the veracity (or lack thereof) of your answers.

Why do you choose to work with software?

We all now understand that virtually everything in the digital world hinges on software, not hardware. When we started showing our little baby we were astonished at the reception. Reporters from major newspapers and magazines started showing up and writing stories with words like "pathbreaking" and "prophetic" in them. The head of ABC News wrote us a tearful note in which he said he had worshipped this piece for decades but never understood it until now. At Macworld conventions people would line up ten deep and watch my 67-minute "Close Reading" (textual commentary that follows the performance) from beginning to end. We had to ask people to stop using the game so that others could have a crack. People would ask me: "Are you the person who wrote Beethoven's Ninth Symphony?" I developed a string of ironic responses.

Peter Bogdanoff (my collaborator for two decades) and I are at just this moment in the process of retooling Beethoven (and our other early titles) for release on the full array of devices available today. We now have color. We have for all practical purposes no storage limitations. Processors are exponentially faster in 2012 than they were in 1989. Other differences are less comforting. In 1989 tens of thousands of people cheerfully put out $99.95 for their floppy and a recording of the Symphony by Hans Schmidt-Isserstedt with the Vienna Philharmonic. Many had little initial interest in classical music but just wanted to see what multimedia was all about. We are now post-CD-ROM crash and all looking up to the Cloud. Yet I sometimes wonder if we will ever create something as fresh again.

THE ART
of
LISTENING

Table of Contents

- Musical Architecture
- Sonata Form Demystified
- The Classical Orchestra
- Anatomy of a Symphony
 - Movement 1
 - Movement 2
 - Movement 3
 - Movement 4
- The Text of Schiller's Ode

| 🏠 | ? | INDEX ⇑ | CHAPTERS ⇑ | GLOSSARY ⇑ | FIND | AGAIN | ■ | 1 of 103 | ▶ |

THE ART *of* LISTENING

STRINGS

The core sound of the classical orchestra was provided by the strings, which include (from smallest to largest) the violin, viola, cello, and double bass. This passage from the beginning of the third movement combines the violins, violas, and cellos:

PLAY STRINGS

Cello Violin Viola Double Bass

| 🏠 | ? | INDEX ⇑ | CHAPTERS ⇑ | GLOSSARY ⇑ | FIND | AGAIN | ◀ | 47 of 103 | ▶ |

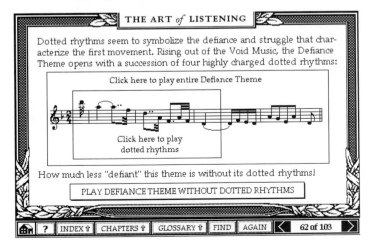

THE ART *of* LISTENING

Dotted rhythms seem to symbolize the defiance and struggle that characterize the first movement. Rising out of the Void Music, the Defiance Theme opens with a succession of four highly charged dotted rhythms:

Click here to play entire Defiance Theme

Click here to play
dotted rhythms

How much less "defiant" this theme is without its dotted rhythms!

PLAY DEFIANCE THEME WITHOUT DOTTED RHYTHMS

| 🏠 | ? | INDEX ⇑ | CHAPTERS ⇑ | GLOSSARY ⇑ | FIND | AGAIN | ◀ | 62 of 103 | ▶ |

They Rule *(Interview with Josh On)*

Creators	Josh On, Amy Balkin, and Amy Franceschini
Year	2001, 2004
Medium	Web
Software	Flash, PHP, MySQL
URL	www.theyrule.net

What is *They Rule*?

They Rule *aims to provide a glimpse of some of the relationships of the U.S. ruling class. It takes as its focus the boards of some of the most powerful U.S. companies, which share many of the same directors. Some individuals sit on five, six, or seven of the top 500 companies. It allows users to browse through these interlocking directories and run searches on the boards and companies. A user can save a map of connections complete with their annotations and email links to these maps to others.* They Rule *is a starting point for research into these powerful individuals and corporations.*

Why did you create *They Rule*?

America is a class-divided society. There is no greater contradiction in our society than the fact that the majority of the people who do the work are not the ones who reap the benefit. In 1998 the top 1 percent of the population owned 38 percent of the wealth; the top 5 percent owned over 60 percent. That was the situation in the "boom years." This inequality might be overlooked as long as the people at the bottom end of the scale have what they need. They don't. According to the CIA World Fact Book, 12.5 percent of Americans live below the poverty line. There is enough to go around; we just have a system that doesn't let it flow.

A few companies control much of the economy, and oligopolies exert control in nearly every sector of the economy. The people who head up these companies swap on and off the boards from one company to another, and in and out of government committees and positions. These people run the most powerful institutions on the planet, and we have almost no say in who they are. This is not a conspiracy. They are proud to rule, yet these connections of power are not always visible to the public eye.

Karl Marx once called this ruling class a "band of hostile brothers." They stand against each other in the competitive struggle for the continued accumulation of their capital, but they stand together as a family supporting their interests in perpetuating the profit system as a whole. Protecting this system can require the cover of a "legitimate" force—and this is the role that is played by the state. An understanding of this system cannot be gleaned from looking at the interpersonal relations of this class alone, but rather how they stand in relation to other classes in society. Hopefully They Rule *will raise larger questions about the structure of our society and in whose benefit it is run.*

I wanted They Rule *to provide a starting point for getting some facts.* They Rule *graphically reveals this one surface reality of an interconnected ruling class, but it also encourages visitors to dig deeper. It is easy to run a search on companies and individuals straight from the site. It is not uncommon for the first result in an Internet search engine query on a board member to come up with their name in connection with a government committee or*

advisory board, or even to reveal that they were in government for a time. The people in They Rule include an ex-president, an ex-secretary of the Treasury, and many ex-members of Congress. The ongoing Enron scandal, which sparked much activity on the site, revealed just how closely tied the state is to the corporate world. As Marx put it, the state is "the executive committee of the ruling class." Hopefully They Rule can help us confirm (or deny) this.

Far from being an exhaustive exposé of the ruling class, They Rule shows only the smallest section of the relationships of control. It does not show the patterns of ownership or wealth, the cultural ties, the institutional and social connections that these people have with each other and others in their class that do not enter the map. Neither does it show the source of their power, the exploitation of labor and nature. It is a challenge that stands before us to illustrate some of these relations in a way that is compelling and revealing.

What software tools were used?

I used a variety of tools, the main one being Flash, which I used for the client side. I used PHP, MySQL, and phpMyAdmin to build the back end and the databases. I used 3D Studio Max to make the little people. I used Photoshop to export them for use in Flash. I used TextPad to do lots of data formatting.

Why did you use these tools?

The main question was what to use for the front end. It may have been possible to build They Rule with HTML and JavaScript—but it would have been a nightmare to make it cross-browser compatible. Of all the other options available at the time, Flash had the biggest adoption and smallest download. I already had a copy of 3D Studio Max—so that was an obvious choice. Software for three-dimensional graphics is expensive, and there still doesn't seem to be a good consumer-level option. PHP is a great and very well documented scripting language. I am not the best programmer, so it is great to use a program with so many online examples to draw from. phpMyAdmin is the only software I have ever really used for creating databases. I stumbled into this with no knowledge, read minimal documentation—and created a clunky database (I would structure it differently now) that works just fine. Of course PHP and MySQL and phpMyAdmin are all open source projects that can be downloaded for free, which is how it should be!

Why do you choose to work with software?

No other medium allows the same combination of massive persistent social collaboration and interaction—particularly software on the Internet where so many people (by no means all) can connect through software and create meaningful relationships with each other. We have only just begun to see the potential of the Internet for aiding social change. Unfortunately, the NSA has also discovered its potential for social control. It is a contested arena, and it is important that artists are amongst those in the fight!

Browse the list of companies and select one.

Reveal the board of directors.

Select one board member and show the other boards on which he sits.

Search for and then display a path between two companies.

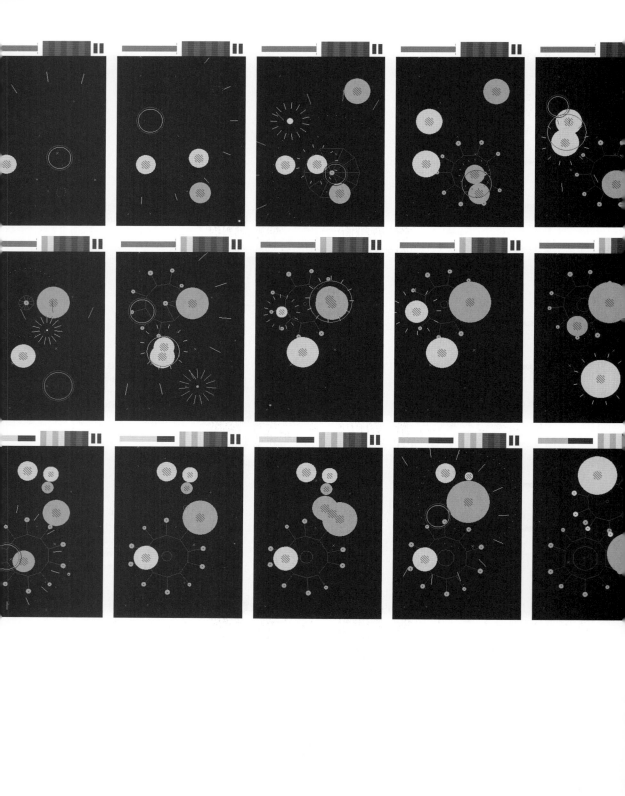

Eliss *(Interview with Steph Thirion)*

Creator	Steph Thirion
Year	2009
Medium	iPhone iOS
Software	Objective-C, OpenGL ES 1
URL	www.little--eyes.com

What is *Eliss*?

Eliss is a multi-touch video game. Your screen gradually fills with circles of colors. The basic idea is you can't let different colors touch. Additionally you have to place those circles inside outlets to clear them and make space, but a circle must match the size of the outlet. To adjust their size, you can split circles into two smaller circles, or combine two same colored circles into a larger one.

Eventually there's a lot going on at the same time and you need to use multiple fingers to control multiple circles. It's a mix of space management, strategic problem solving, quick observation and reflexes, and multi-touch agility. That's got to be good for the brain.

Why did you create *Eliss*?

At the time I was designing/developing web stuff for clients, and didn't feel particularly fulfilled. When the first generation of iOS devices (iPhone and iPod Touch) came out, people had access to cheap tiny computers with touch screens, and for the first time in the consumer space, multi-touch. When the App Store was announced as an easy way to get that content into thousands of those little machines, it seemed like the perfect cue to try something else. I said farewell to my clients and directed that freed energy into something I was excited to build from start to finish. I enjoyed working on sound, music, interaction, code, and graphic design. A video game seemed like a great place to gather all those aspirations together.

I started building a different game, but I got sidetracked with an accidental discovery. As I was getting my head around the multi-touch programming, I had this surprisingly fun piece of code where circles followed each finger. I wondered if there could be a game there, like what if I have to get one of those circles to a certain area without any circle touching another. In the end it got a little more complicated, but the game evolved from that idea.

What software tools were used?

I used TextMate for code editing, Xcode for resource linking and compiling, and Adobe Fireworks for some mockups. I used Apple Logic Pro and Native Instruments PRO-53, a plugin based on the classic Prophet-5 music synthesizer, to make the music and the sound effects. I programmed the game in Objective-C, and used OpenGL ES 1 for drawing, OpenAL for sound effects and AVFoundation for music playback. I regularly used Processing to sketch visual ideas, but also to build a little tool to create the simple vector fonts used in the game.

Why did you use these tools?

I wanted the game to be drawn by geometry, instead of using bitmaps. I enjoy the process of designing visuals with code, and here restricting myself to primitives helped me find an original style, and helped make it responsive and fluid.

I had three languages in my tool belt: ActionScript/Flash, Java/Processing and Ruby. These are all fairly high level languages—they abstract many technical details from the coder, which was appropriate for my graphic design education. But if you wanted to develop an app for the iPhone OS, it was necessary to use Objective-C or C++, which are lower level, more complicated, languages. I got used to it, but there was a learning curve. I focused on Objective-C; it's simpler than C++. I also had to learn OpenGL, which is a powerful but complex way of drawing pixels that Processing had nicely abstracted away. At the time, there were basically no frameworks for iOS. There was a lot of new complexity for me.

I missed Processing, where you simply call `rect()` or `ellipse()` and the shape appears on the screen. I spent a couple months learning and building layers of code to hide that complexity away—to free my brain from the technical details and focus on creating the game. I learned a lot by looking at the actual source code of Processing, and borrowed some useful ideas from there. It was a friendly lighthouse while I was at sea. I was also inspired by Flash to build a tree hierarchy system for the interface. I also used Processing itself for sketching, it allowed me to experiment with and isolate some ideas before adding them to the game.

I used the same synthesizer for both sound and music, because I wanted something that felt coherently tied to the feel of the game—like hardwired to the pixels, a little bit like what you feel with the sound and music of old video games when the sounds were generated from dedicated sound chips.

Why do you choose to work with software?

I drew comic books as a kid, with pen and paper. They looked pretty rough, like storyboards. A well-executed drawing required practice, and some mistakes forced me to start from scratch. That friction made it less interesting than actually making the story advance, and I never found the patience to learn how to draw well. Software later on gave me flexibility. Things like "undo" gave a shorter path to trial and error and back. The less friction when you iterate, the more you can afford to change things until they feel just right. Software helped me give more attention to detail in my work; it helped me become better at making things.

Programming pushed that flexibility into a whole new dimension. The limits of the tools themselves became elastic. Learning to code has been a long process, but constantly rewarding, every new thing you learn gives you more power, like a wizard learning new spells from an ancient book. It's an endless source of new possibilities. And, being so powerful and yet so precise, it's also a great source of accidental discoveries.

Screen capture sequence while playing *Eliss*. Images courtesy Steph Thirion.

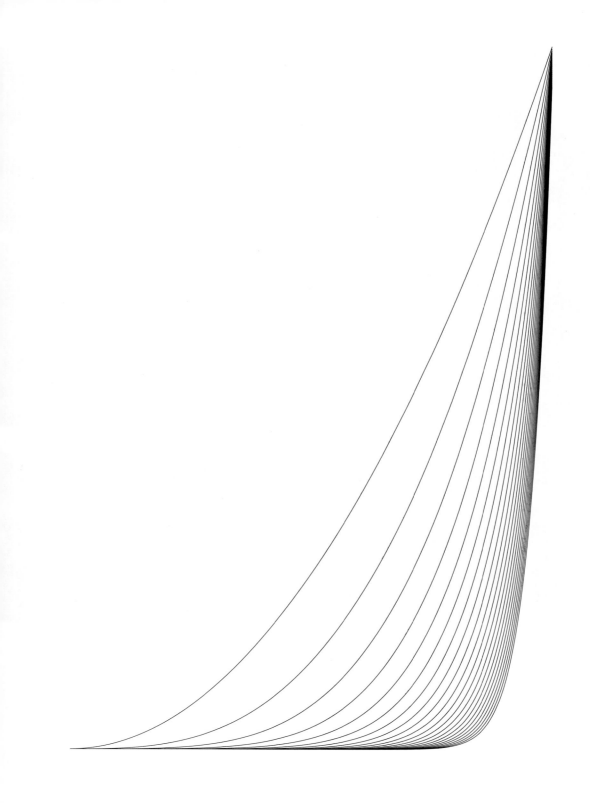

20 Calculate

This chapter introduces mathematical functions that can be applied to motion and interaction techniques.

Syntax introduced:
```
sq(), sqrt(), pow(), norm(), lerp(), map()
ceil(), floor(), round(), min(), max(), constrain(), abs(), dist()
PI, QUARTER_PI, HALF_PI, TWO_PI, radians(), degrees()
sin(), cos(), atan2()
```

Basic mathematical expressions can be used to draw shapes to the screen and modify their attributes. These techniques are the foundation for examples in the forthcoming Motion and Dynamic Drawing chapters. They can control movement and the way elements respond to user input. The numbers produced by these functions are useful to accelerate and decelerate shapes in motion and move objects along curved paths; they can modify and augment the data from interface devices to make new interaction techniques possible. Likewise, the trigonometric functions sine and cosine generate repeating numbers that can be used to draw waves, circles, and spirals and to move shapes along these paths. These functions are different from those for drawing shapes, such as `line()` and `ellipse()`, because they *return* values. This means the function outputs a number that can be assigned to a variable.

Exponents, Roots

The `sq()` function is used to square a number and return the result. The result is always a positive number, because multiplying two negative numbers yields a positive result. For example, $-1 * -1 = 1$. This function has one parameter, which can be any number.

```
float a = sq(1);    // Assign 1.0 to a, equivalent to 1 * 1          20-01
float b = sq(-5);   // Assign 25.0 to b, equivalent to -5 * -5
float c = sq(9);    // Assign 81.0 to c, equivalent to 9 * 9
```

The `sqrt()` function is used to calculate the square root of a number and return the result. It is the opposite of `sq()`. The square root of a number is always positive, even though there may be a valid negative root. The square root s of number a satisfies the equation $s * s = a$. This function has one parameter, which must be a positive number.

```
float a = sqrt(6561);   // Assign 81 to a
float b = sqrt(625);    // Assign 25 to b
float c = sqrt(1);      // Assign 1 to c
```

The pow() function calculates a number raised to an exponent. It has two parameters. The first parameter is the number to multiply, and the second is the exponent, the number of times to perform the calculation. The following example shows how it is used:

```
float a = pow(1, 3);    // Assign 1.0 to a, equivalent to 1*1*1
float b = pow(3, 4);    // Assign 81.0 to b, equivalent to 3*3*3*3
float c = pow(3, -2);   // Assign 0.11 to c, equivalent to 1 / 3*3
float d = pow(-3, 3);   // Assign -27.0 to d, equivalent to -3*-3*-3
```

Any number (except 0) raised to the zero power equals 1. Any number raised to the power of one equals itself.

```
float a = pow(8, 0);    // Assign 1 to a
float b = pow(3, 1);    // Assign 3 to b
float c = pow(4, 1);    // Assign 4 to c
```

Normalize, Map

Numbers are often converted to the range 0.0 to 1.0 for making calculations. This is called *normalizing* the values. When numbers between 0.0 and 1.0 are multiplied together, the result is never less than 0.0 or greater than 1.0. This allows any number to be multiplied by another or by itself many times without leaving this range. For example, multiplying the value 0.2 by itself 5 times (0.2 * 0.2 * 0.2 * 0.2 * 0.2) produces the result 0.00032. Because normalized numbers have a decimal point, all calculations should be made with the float data type.

To normalize a number, divide it by the maximum value that it represents. For example, to normalize a series of values between 0.0 and 255.0, divide each by 255.0:

Initial value	Calculation	Normalized value
0.0	0.0 / 255.0	0.0
102.0	102.0 / 255.0	0.4
255.0	255.0 / 255.0	1.0

This can also be accomplished via the norm() function. It has three parameters. The number used as the first parameter is converted to a value between 0.0 and 1.0. The

second and third parameters set the respective minimum and maximum values of the number's current range. If the first parameter is outside the range set by the second and third parameters, the result may be less than 0 or greater than 1. The following example shows how to use the function to make the same calculations as the preceding table.

20-05

```
float x = norm(0.0, 0.0, 255.0);      // Assign 0.0 to x
float y = norm(102.0, 0.0, 255.0);    // Assign 0.4 to y
float z = norm(255.0, 0.0, 255.0);    // Assign 1.0 to z
```

After normalization, a number can be converted to another range through arithmetic. For example, to convert numbers between 0.0 and 1.0 in a range between 0.0 and 500.0, multiply by 500.0. To put numbers between 0.0 and 1.0 to numbers between 200.0 and 250.0, multiply by 50 then add 200. The following table presents a few sample conversions. The parentheses are used to improve readability:

Initial range of x	Desired range of x	Conversion
0.0 to 1.0	0.0 to 255.0	x * 255.0
0.0 to 1.0	-1.0 to 1.0	(x * 2.0) - 1.0
0.0 to 1.0	-20.0 to 60.0	(x * 80.0) - 20.0

The lerp() function can be used to accomplish these calculations. The name "lerp" is a contraction for "linear interpolation." The function has three parameters. The first and second parameters define, in order, the minimum and maximum values. The third parameter defines the value to interpolate between the values; it should always be between 0.0 and 1.0. The following example shows how to use lerp() to make the value conversions on the last line of the previous table.

20-06

```
float x = lerp(-20.0, 60.0, 0.0);    // Assign -20.0 to x
float y = lerp(-20.0, 60.0, 0.5);    // Assign 20.0 to y
float z = lerp(-20.0, 60.0, 1.0);    // Assign 60.0 to z
```

The map() function is useful to convert directly from one range of numbers to another. Because its five parameters are hard to keep track of, we'll break them down one by one:

```
map(value, start1, stop1, start2, stop2)
```

The first parameter is the number to re-map. Similar to the norm function, the second and third parameters are the minimum and maximum values of the number's current range. The fourth and fifth parameters are the minimum and maximum values for the

```
x = map(m, 0, 400, 0, 255)   // Values from 0–400 to 0–255
```

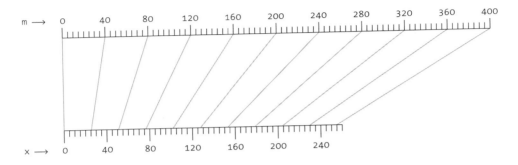

```
s = map(a, -1, 1, 0, 7)   // Values from -1–1 to 0–7
```

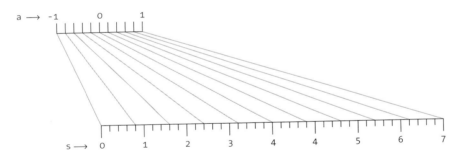

Figure 20-1 Mapping values
The map () function changes the value of a number from one range of numbers to another. For example,
mouseX is always between 0 and the width of the window (e.g. 1024 pixels), but if a project idea requires
the mouseX variable to control a color, its range needs to be converted to values between 0 and 255. The
single function call map(mouseX, 0, width, 0, 255) calculates this conversion for each value of
mouseX. When mouseX is 0, the result is also 0. When mouseX is at the width of the window, the result
is 255, regardless of the width of the sketch. All values between the minimum and maximum are scaled
relative to actual and desired range.

new range. The next example shows how to use map() to convert values from the range 0 to 255 into the range -1 to 1. This is the same as first normalizing the value, then multiplying and adding to move it from the range 0 to 1 into the range -1 to 1.

20-07

```
float x = map(20.0, 0.0, 255.0, -1.0, 1.0);    // Assign -0.84 to x
float y = map(0.0, 0.0, 255.0, -1.0, 1.0);     // Assign -1.0 to y
float z = map(255.0, 0.0, 255.0, -1.0, 1.0);   // Assign 1.0 to z
```

The way map() works is easier to see through an interactive example. Here, the mouseX variable is mapped to a series of different ranges. As the mouseX variable changes from 0 to 100 (the width of the display window in the example) as the cursor moves left to right those numbers are transformed to three different ranges from top to bottom: 0–20, -20–80, and 20–60.

20-08

```
void setup() {
  size(100, 100);
}

void draw() {
  background(204);
  float x1 = map(mouseX, 0, width, 0, 20);
  float x2 = map(mouseX, 0, width, -20, 80);
  float x3 = map(mouseX, 0, width, 20, 60);
  ellipse(x1, 25, 40, 40);
  ellipse(x2, 50, 40, 40);
  ellipse(x3, 75, 40, 40);
}
```

Simple curves

Exponential functions are useful to create simple curves. Normalized values are used with the pow() function to produce exponentially increasing or decreasing numbers that never exceed the value 1. These equations have the form:

$$y = x^n$$

where the value of x is between 0.0 and 1.0 and the value of n is any integer. In these equations, as the x value increases linearly the resulting y value increases exponentially. When continuously plotted, these numbers produce this diagram:

X	Y
0.0	0.0
0.2	0.0016
0.4	0.0256
0.6	0.1296
0.8	0.4096
1.0	1.0

$y = x^4$

The following example shows how to put this equation into code. It iterates over numbers from 0 to 100 and normalizes the values before making the curve calculation.

20-09

```
for (int x = 0; x < 100; x++) {
  float n = norm(x, 0.0, 100.0);   // Range 0.0 to 1.0
  float y = pow(n, 4);   // Calculate curve
  y *= 100;   // Range 0.0 to 100.0
  point(x, y);
}
```

Other curves can be created by changing the parameters to pow() in line 3.

20-10

```
for (int x = 0; x < 100; x++) {
  float n = norm(x, 0.0, 100.0);   // Range 0.0 to 1.0
  float y = pow(n, 0.4);   // Calculate curve
  y *= 100;   // Range 0.0 to 100.0
  point(x, y);
}
```

The following set of examples demonstrates how the same curve (y = x⁴) is used to draw different shapes and patterns. The first draws a series of circles along the curve, the second draws lines to the height of the curve, and the third draws a gradient, with the gray values determined by the values of the curve.

20-11

```
noFill();
for (int x = 0; x < 100; x += 5) {
  float n = norm(x, 0.0, 100.0);   // Range 0.0 to 1.0
  float y = pow(n, 4);   // Calculate curve
  y *= 100;   // Scale y to range 0.0 to 100.0
  strokeWeight(n * 5);   // Increase thickness
  ellipse(x, y, 120, 120);
}
```

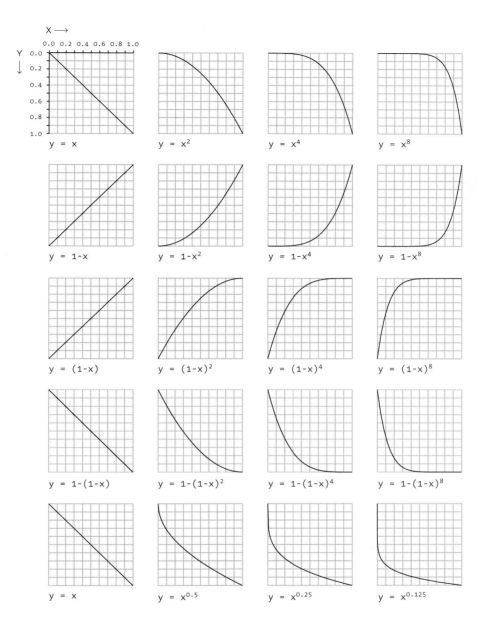

Figure 20-2 Exponential equations

Each of these curves shows the relationship between x and y determined by an equation. The linear equations in the left column are contrasted with exponential curves to the right. Codes 20-09 and 20-10 demonstrate how to translate these curves into code.

```
for (int x = 5; x < 100; x += 5) {                         20-12
    float n = map(x, 5, 95, -1, 1);
    float p = pow(n, 4);
    float ypos = lerp(20, 80, p);
    line(x, 0, x, ypos);
}
```

```
for (int x = 0; x < 100; x++) {                            20-13
    float n = norm(x, 0.0, 100.0);   // Range 0.0 to 1.0
    float val = n * 255.0;
    stroke(val);
    line(x, 0, x, 50);   // Draw top gradient
    float valSquare = pow(n, 4) * 255.0;
    stroke(valSquare);
    line(x, 50, x, 100);   // Draw bottom gradient
}
```

Exponential curves are used in this chapter to generate form, but codes 22-08 and 34-24 in subsequent chapters demonstrate their use to control motion.

Constraining numbers

The ceil(), floor(), round(), min(), and max() functions are used to perform calculations on numbers that the standard arithmetic operators can't. The ceil() function calculates the closest int value that is greater than or equal to the value of its parameter:

```
int w = ceil(2.0);   // Assign 2 to w                      20-14
int x = ceil(2.1);   // Assign 3 to x
int y = ceil(2.5);   // Assign 3 to y
int z = ceil(2.9);   // Assign 3 to z
```

The floor() function calculates the closest int value that is less than or equal to the value of its parameter:

```
int w = floor(2.0);   // Assign 2 to w                     20-15
int x = floor(2.1);   // Assign 2 to x
int y = floor(2.5);   // Assign 2 to y
int z = floor(2.9);   // Assign 2 to z
```

The `round()` function calculates the `int` value closest to the value of its parameter. Values ending with .5 round up to the next `int` value:

```
int w = round(2.0);   // Assign 2 to w
int x = round(2.1);   // Assign 2 to x
int y = round(2.5);   // Assign 3 to y
int z = round(2.9);   // Assign 3 to z
```

20-16

Even though `ceil()`, `floor()`, and `round()` act on floating-point numbers, the result is always an integer, because that's the way the result will most often be useful. To convert to a `float`, simply assign the result to a float variable.

```
float w = round(2.1);   // Assign 2.0 to w
```

20-17

The `min()` function determines the smallest value in a sequence of numbers. The `max()` function determines the largest value in a sequence of numbers. Both functions work with two or three parameters:

```
int u = min(5, 9);            // Assign 5 to u
int v = min(-4, -12, -9);     // Assign -12 to v
float w = min(12.3, 230.24);  // Assign 12.3 to w
int x = max(5, 9);            // Assign 9 to x
int y = max(-4, -12, -9);     // Assign -4 to y
float z = max(12.3, 230.24);  // Assign 230.24 to z
```

20-18

The `constrain()` function limits a number to a range and can therefore be used to restrict drawing to parts of the screen. It has three parameters: the first parameter is the number to limit, the second parameter is the minimum possible value, and the third parameter is the maximum possible value. This function returns the number defined as the second parameter if the first parameter is less than or equivalent, returns the number defined as the third parameter if the first parameter is greater than or equivalent, and returns the number defined as the first parameter without change if it is between the second and third parameter values.

```
int x = constrain(35, 10, 90);       // Assign 35 to x
int y = constrain(5, 10, 90);        // Assign 10 to y
float z = constrain(1.2, 0.5, 1.0);  // Assign 1.0 to z
```

20-19

When used with the mouseX or mouseY variables, this function can set maximum and minimum values for the mouse coordinate data.

```
void setup() {
  size(100, 100);
  noStroke();
}

void draw() {
  background(0);
  // Limits variable mx between 35 and 65
  int mx = constrain(mouseX, 35, 65);
  // Limits variable my between 40 and 60
  int my = constrain(mouseY, 40, 60);
  fill(102);
  rect(20, 25, 60, 50);
  fill(255);
  ellipse(mx, my, 30, 30);
}
```

Calculating the absolute value of a number is yet another way to constrain a value. The absolute value is the magnitude of a number, regardless of whether it is a positive or negative quantity. The name of the function is condensed to abs(), and it has a single parameter. The following example shows how it works:

```
float x = abs(10);    // Assign 10.0 to x
float y = abs(0);     // Assign 0.0 to y
float z = abs(-60);   // Assign 60.0 to z
```

Distance

The distance between two points is calculated with the dist() function. It has four parameters. The first and second parameters define the coordinate of the first point, and the third and fourth parameters define the coordinate of the second point. The distance between the two points is calculated as a floating-point number and is returned:

```
float x = dist(0, 0, 50, 0);      // Assign 50.0 to x
float y = dist(50, 0, 50, 90);    // Assign 90.0 to y
float z = dist(30, 20, 80, 90);   // Assign 86.023254 to z
```

The value returned from dist() can be used to set the properties of shapes so they respond to the mouse position and movement. In the next example, the distance between the position of the cursor and the center of the display window is calculated continuously and set as the radius of a circle.

20-23

```
void setup() {
  size(100, 100);
}

void draw() {
  background(0);
  float r = dist(width/2, height/2, mouseX, mouseY);
  ellipse(width/2, height/2, r*2, r*2);
}
```

A similar calculation can be made for multiple positions on screen. In the following example, a grid of circles are drawn with an embedded for loop. The size of each circle is calculated depending on the distance between each circle and the cursor.

20-24

```
float maxDistance;

void setup() {
  size(100, 100);
  noStroke();
  fill(0);
  maxDistance = dist(0, 0, width, height);
}

void draw() {
  background(204);
  for (int i = 0; i <= width; i += 20) {
    for (int j = 0; j <= height; j += 20) {
      float mouseDist = dist(mouseX, mouseY, i, j);
      float diameter = (mouseDist / maxDistance) * 66.0;
      ellipse(i, j, diameter, diameter);
    }
  }
}
```

Easing

Easing, also called interpolation, is a technique for moving between two numbers with nonlinear increments. Easing is often used to smooth out irregular inputs and to move between two points on screen. It's most easily seen through animation, so a related example will be discussed here. By moving a fraction of the total distance each frame, a shape can decelerate (or accelerate) as it approaches a target location. Figure 20-3 shows what happens when a point always moves part of the way between its current position and the destination. As the shape approaches the target position, the distance moved each frame decreases; therefore, the shape slows down.

In the following example, the x variable is the current horizontal position of the circle and the targetX variable is the destination position. The easing variable sets the fraction of the distance between the circle's current position and the position of the mouse that the circle moves each frame. The value of the easing variable changes how quickly the circle will reach the target. The value must always be between 0.0 and 1.0, and numbers closer to 0.0 cause the easing to take more time. An easing value of 0.5 means the circle will move half the distance each frame and an easing value of 0.01 means the circle will move one hundredth of the distance each frame. To show the difference clearly in this example, the top ellipse is drawn at the targetX position, and the bottom ellipse is drawn at the interpolated position.

20-25

```
float x = 0.0;
float easing = 0.05;   // Numbers 0.0 to 1.0

void setup() {
  size(100, 100);
}
void draw() {
  background(0);
  float targetX = mouseX;
  x += (targetX - x) * easing;
  ellipse(mouseX, 30, 40, 40);
  ellipse(x, 70, 40, 40);
}
```

To apply the same principle simultaneously to the x- and y-coordinate values, add an additional set of variables and test for the distance for both. In this example, the small circle is always at the target position controlled by the cursor, and the large circle is positioned with the easing equation.

easing = 0.02

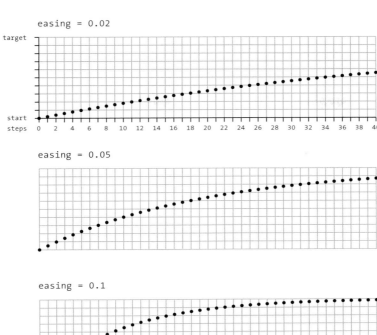

target

start
steps 0 2 4 6 8 10 12 14 16 18 20 22 24 26 28 30 32 34 36 38 40

easing = 0.05

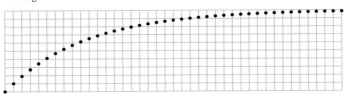

easing = 0.1

easing = 0.4

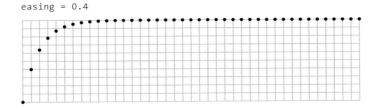

Figure 20-3 Easing

Easing is used to create a smooth transition between values. It's a technique where one number moves closer to another based on a percentage of the distance between them. For example, if the current value is 0 and it moves half way to 10, the new number will be 5. When 5 is used as the starting value and it again moves half way to 10, the new value will be 7.5. At the first step, the value changed by 5; at the second step it changed by 2.5. When this calculation is made over and over, the change at each step gets smaller as the numbers get closer.

```
float x = 0.0;
float y = 0.0;
float easing = 0.05;   // Numbers 0.0 to 1.0

void setup() {
  size(100, 100);
  noStroke();
}

void draw() {
  background(0);
  float targetX = mouseX;
  float targetY = mouseY;
  x += (targetX - x) * easing;
  y += (targetY - y) * easing;
  fill(153);
  ellipse(mouseX, mouseY, 20, 20);
  fill(255);
  ellipse(x, y, 40, 40);
}
```

The previous two examples continue to make the easing calculation for the circle position even after it has reached the destination. This is inefficient, and if there are thousands of circles all easing between positions, it will slow down the program. To stop the calculations when they are no longer necessary, test to see if the target position and destination position are near the same and stop the calculation if they are. The abs() function is used to take the absolute value of a number; this is necessary because the values used in easing are either negative or positive depending on whether the position is to the left or to the right of the target. An if structure is used to update the position only if it's not at the same pixel as the target.

```
float x = 0.0;
float easing = 0.05;   // Numbers 0.0 to 1.0

void setup() {
  size(100, 100);
}

void draw() {
  background(0);
  float targetX = mouseX;
  // Distance from position and target
  float dx = targetX - x;
```

```
// If the distance between the current position and the
// destination is greater than 1.0, update the position
if (abs(dx) > 1.0) {
    x += dx * easing;
}
ellipse(mouseX, 30, 40, 40);
ellipse(x, 70, 40, 40);
}
```

20-27
cont.

Angles, Waves

While *degrees* are a common way to measure angles (a right angle is 90°, halfway around a circle is 180°, and the full circle is 360°), in working with trigonometry, angles are measured in units called *radians*. With radians, the angle values are expressed in relation to the mathematical value π, written in Latin characters as "pi" and pronounced "pie." In terms of radians, a right angle is π/2, halfway around a circle is simply π, and the full circle is 2π. The numerical value of π is the ratio of the circumference of a circle to its diameter. When writing Processing code, use the mathematical constant PI to represent this number. Other commonly used values of π are expressed as QUARTER_PI, HALF_PI, and TWO_PI. Figure 20-4 compares these measurements. Run the following line of code to see the value of π to 8 significant digits.

```
println(PI);    // Print the value of PI to the console
```

20-28

In casual use, the numerical value of π is 3.14, and 2π is 6.28. Angles can be converted from degrees to radians with the radians() function, or vice versa using degrees(). This short program demonstrates the conversions between these representations:

```
float r1 = radians(90);
float r2 = radians(180);
println(r1);    // Prints "1.5707964"
println(r2);    // Prints "3.1415927"
float d1 = degrees(PI);
float d2 = degrees(TWO_PI);
println(d1);    // Prints "180.0"
println(d2);    // Prints "360.0"
```

20-29

To work with degree measurements instead of radians, use the radians() function to convert the degree values for use with functions that require radian values.

The sin() and cos() functions are used to determine the sine and cosine value of any angle. Each of these functions requires one parameter, which is always specified as a radian value. The values returned from these functions are always floating-point

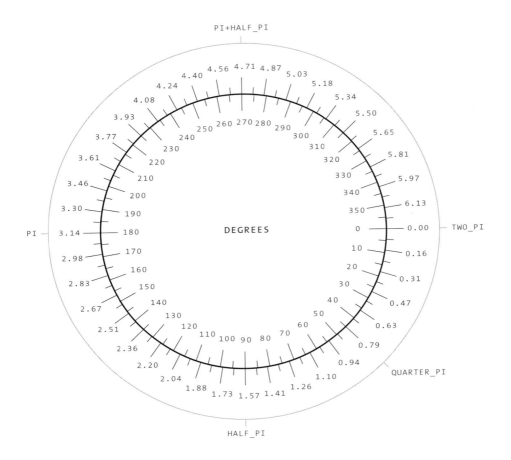

RADIANS

PI+HALF_PI

DEGREES

PI

TWO_PI

QUARTER_PI

HALF_PI

Figure 20-4 Degrees and Radians

Angles can be measured with degrees and radians. There are 360 degrees around a circle and 6.28 radians. The diagram on this page fills in the gaps. Radians measurements are based on π. In Processing, π is written in code as PI, *rather than with the symbol. Math functions like* cos() *and* rotate() *require angles to be defined in radians. Angles can be converted from radians to degrees and vice versa with the* radians() *and* degrees() *functions.*

values between -1.0 and 1.0. The relationship between sine values and angles are shown in figure 20-5.

As angles increase in value, the sine values repeat. At the angle 0.0, the value of sine is also 0.0, and this value increases as the angle increases. When the angle reaches 90.0° ($\pi/2$), the sine value decreases until is it zero again at the angle 180.0° (π), then it continues to decrease until the angle reaches 270.0° ($\pi + \pi/2$), at which point it begins increasing until the angle reaches 360.0° (2π). At this point, the values repeat the cycle. The sine values can been seen by putting a `sin()` function inside a `for` loop and iterating while changing the angle value:

```
for (int degree = 0; degree < 360; degree++) {
    float angle = radians(degree);
    println(sin(angle));
}
```
20-30

Because the values from `sin()` are numbers between -1.0 and 1.0, they are easy to use in controlling a composition. Multiply the numbers by 50.0, for example, to yield values between -50.0 and 50.0.

```
for (float angle = 0; angle < TWO_PI; angle += PI/24.0) {
    println(sin(angle) * 50.0);
}
```
20-31

To convert the sine values to a range of positive numbers, first add the value 1.0 to create numbers between 0.0 and 2.0. Divide that number by 2.0 to get a number between 0.0 and 1.0, which can then be simply remapped to any range. Alternatively, the `map()` function can be used to convert the values from `sin()` to any desired range. In this example, the values from `sin()` are put into the range between 0 and 1000.

```
for (float angle = 0; angle < TWO_PI; angle += PI/24.0) {
    float newValue = map(sin(angle), -1, 1, 0, 1000);
    println(newValue);
}
```
20-32

If we set the y-coordinates for a series of points with the numbers returned from the `sin()` function and continually increase the value of the angle parameter before each new coordinate is calculated, the sine wave emerges:

Degrees	O	90	180	270	360
Radians	O	π/2	π	π+π/2	2π
Decimal radians	O	1.57	3.14	4.71	6.28
Constants	O	HALF_PI	PI	PI+HALF_PI	TWO_PI

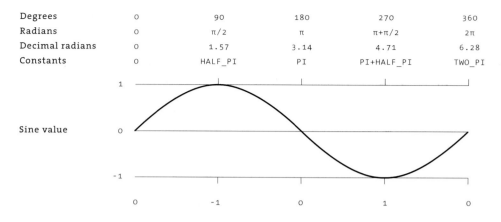

Figure 20-5 Sine wave
This curve, a sine wave, shows the values of the sin() *function as its* angle *parameter changes.*
As the angle value continues to increase or decrease, the curve repeats.

```
void setup() {                                                    20-33
  size(700, 100);
  noStroke();
  fill(0);
}

void draw() {
  float angle = 0.0;
  for (int x = 0; x < width; x += 5) {
    float y = 50 + (sin(angle) * 35.0);
    rect(x, y, 2, 4);
    angle += PI/40.0;
  }
}
```

When the fixed numbers in the previous program are replaced with variables, the waveform can be more easily changed by altering the variables. In the following examples, the offset variable controls the y-coordinate of the wave, the scaleVal variable controls the height of the wave, and the angleInc variable controls the speed at which the angle increases, thereby creating a wave with a higher or lower frequency.

Adding the variables increased the length of the code, but makes it easier to modify and play with.

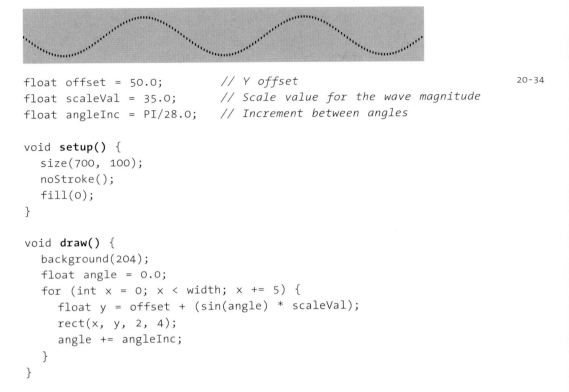

20-34

```
float offset = 50.0;        // Y offset
float scaleVal = 35.0;      // Scale value for the wave magnitude
float angleInc = PI/28.0;   // Increment between angles

void setup() {
  size(700, 100);
  noStroke();
  fill(0);
}

void draw() {
  background(204);
  float angle = 0.0;
  for (int x = 0; x < width; x += 5) {
    float y = offset + (sin(angle) * scaleVal);
    rect(x, y, 2, 4);
    angle += angleInc;
  }
}
```

The cos() function returns values in the same range and pattern as sin(), but the numbers are offset by π/2 radians (90°). The following example draws the cosine wave in black on top of the white sine wave.

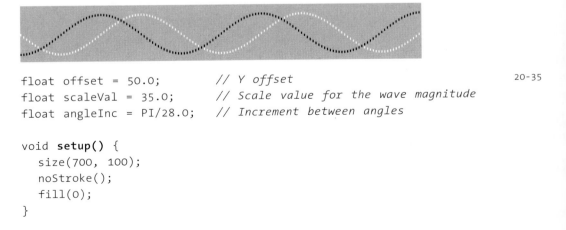

20-35

```
float offset = 50.0;        // Y offset
float scaleVal = 35.0;      // Scale value for the wave magnitude
float angleInc = PI/28.0;   // Increment between angles

void setup() {
  size(700, 100);
  noStroke();
  fill(0);
}
```

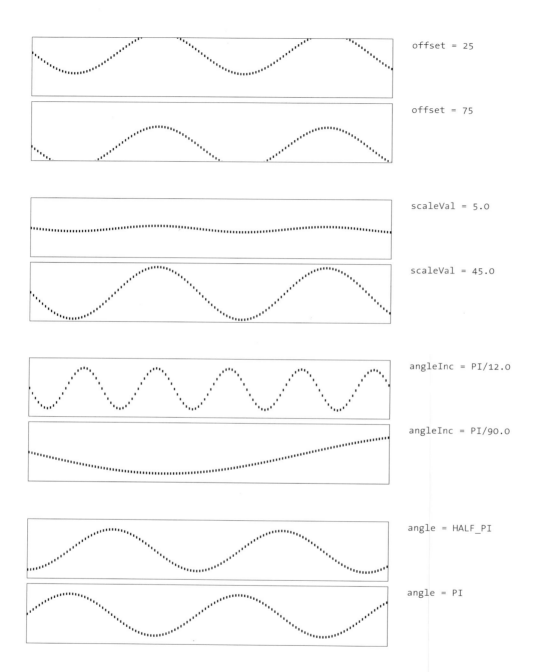

Figure 20-6 Modulating a sine wave
Different values for the variables in code 20-34 create a range of waves. Notice how each variable affects a different attribute of the wave.

```
void draw() {
  background(204);
  float angle = 0.0;
  for (int x = 0; x < width; x += 5) {
    float y1 = offset + (sin(angle) * scaleVal);
    fill(255);
    rect(x, y1, 2, 4);
    float y2 = offset + (cos(angle) * scaleVal);
    fill(0);
    rect(x, y2, 2, 4);
    angle += angleInc;
  }
}
```

The next group of examples demonstrate ways to use the numbers from the sin()
function to generate shapes created from vertices and lines.

```
float offset = 50.0;
float scaleVal = 30.0;
float angleInc = PI/56.0;

void setup() {
  size(700, 100);
}

void draw() {
  background(204);
  float angle = 0.0;
  beginShape(TRIANGLE_STRIP);
  for (int x = 4 ; x <= width+5; x += 5) {
    float y = sin(angle) * scaleVal;
    if ((x % 2) == 0) {  // Every other time through the loop
      vertex(x, offset + y);
    } else {
      vertex(x, offset - y);
    }
    angle += angleInc;
  }
  endShape();
}
```

```
float offset = 126.0;
float scaleVal = 126.0;
float angleInc = 0.2;

void setup() {
  size(700, 100);
}

void draw() {
  float angle = 0.0;
  for (int x = -52; x < width; x += 1) {
    float y = offset + (sin(angle) * scaleVal);
    stroke(y);
    line(x, 0, x+50, height);
    angle += angleInc;
  }
}
```

20-37

```
float scaleVal = 6.0;
float angleInc = 0.19;

void setup() {
  size(700, 100);
  stroke(255);
}

void draw() {
  background(0);
  float angle = 0.0;
  for (int offset = -10; offset < width+10; offset += 5) {
    for (int y = 0; y <= height; y += 2) {
      float x = offset + (sin(angle) * scaleVal);
      line(x, y, x, y+2);
      angle += angleInc;
```

20-38

```
    }
      angle += PI;
    }
  }
}
```

Circles, Spirals

In addition to waves, the sine and cosine values can also draw circles. The cosine values control the x-coordinates and the sine values for the same angle control the y-coordinates. The following example utilizes an angle value that increments at 12° to count from 0° to 360°. On each step through the for loop, the cos() and sin() values of the angle are used to calculate the x- and y-coordinates of the circle. Because sin() and cos() return numbers between −1.0 and 1.0, the result is multiplied by the radius variable to draw a circle with radius 38. The value 50 is added to the x and y positions to set the center of the circle to coordinate (50,50).

```
int radius = 38;

void setup() {
  size(100, 100);
  fill(0);
}

void draw() {
  background(204);
  for (int deg = 0; deg < 360; deg += 12) {
    float angle = radians(deg);
    float x = 50 + (cos(angle) * radius);
    float y = 50 + (sin(angle) * radius);
    ellipse(x, y, 4, 4);
  }
}
```

If the angle increments only part of the way around the circle, an arc is drawn instead of a circle. For example, changing line 10 in the preceding program to include a variable based on mouseX gives the following result:

```
int radius = 38;                                            20-40

void setup() {
  size(100, 100);
  fill(0);
}

void draw() {
  background(204);
  int piece = int(map(mouseX, 0, width, 0, 360));
  for (int deg = 0; deg <= piece; deg += 12) {
    float angle = radians(deg);
    float x = 50 + (cos(angle) * radius);
    float y = 50 + (sin(angle) * radius);
    ellipse(x, y, 4, 4);
  }
}
```

To create a spiral, multiply the sine and cosine values by a scalar value that increases or decreases. In the following examples, the spiral grows as the radius variable increases:

```
void setup() {                                              20-41
  size(100, 100);
  fill(0);
  noStroke();
}

void draw() {
  background(204);
  float scalar = map(mouseX, 0, width, 4, 20);
  float radius = 1.0;
  for (int deg = 0; deg < 360*6; deg += scalar) {
    float angle = radians(deg);
    float x = 75 + (cos(angle) * radius);
    float y = 42 + (sin(angle) * radius);
    ellipse(x, y, 4, 4);
    radius = radius + 0.34;
  }
}
```

```
float cx = 33.0;   // Center x-coordinate
float cy = 66.0;   // Center y-coordinate

void setup() {
  size(100, 100);
}

void draw() {
  background(204);
  float radius = 0.15;
  float radVal = map(mouseX, 0, width, 1.05, 1.1);
  for (int deg = 0; deg < 360*5; deg += 12) {
    float angle = radians(deg);
    float x = cx + (cos(angle) * radius);
    float y = cy + (sin(angle) * radius);
    line(x, y, x, y+2);
    radius = radius * radVal;
  }
}
```

Direction

The atan2() function, a version of the trigonometric arctangent function, is used to calculate the angle from any point to the coordinate (0,0). It has two parameters:

atan2(y, x)

The *y* parameter is the y-coordinate of the point from which to find the angle, and the *x* parameter is the x-coordinate of the point. Angle values are returned in radians in the range of π to -π . Note that the order of the *y* and *x* parameters are reversed from other functions we've seen. The next examples shows how the angle increases as the mouse moves from the upper-right corner to the lower-left corner of the display window.

```
void setup() {
  size(100, 100);
  fill(0);
}

void draw() {
  float angle = atan2(mouseY, mouseX);
  float deg = degrees(angle);
  background(204);
```

```
  text(int(deg), 50, 50);
  ellipse(mouseX, mouseY, 8, 8);
  rotate(angle);
  line(0, 0, 150, 0);
}
```

The code is explained with these diagrams:

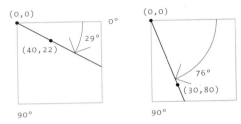

To calculate atan2() relative to another point instead of (0,0), subtract the coordinates of that point from the *y* and *x* parameters. Use the *translate()* function to position the elements on screen, rotate or orient them using the result of atan2(), and use pushMatrix() and popMatrix() to isolate the transformations. This procedure is discussed in more depth in Transformation (p. 175).

```
int x = 50;
int y1 = 33;
int y2 = 66;

void setup() {
  size(100, 100);
  noStroke();
}

void draw() {
  background(0);
  // Top triangle
  float angle = atan2(mouseY-y1, mouseX-x);
  pushMatrix();
  translate(x, y1);
  rotate(angle);
  triangle(-20, -8, 20, 0, -20, 8);
  popMatrix();
  // Bottom triangle
  float angle2 = atan2(mouseY-y2, mouseX-x);
  pushMatrix();
  translate(x, y2);
```

```
        rotate(angle2);
        triangle(-20, -8, 20, 0, -20, 8);
        popMatrix();
    }
```

The content of this chapter is applied to controlling movement in Motion (p. 305) and to interaction techniques in Dynamic Drawing (p. 439).

Exercises

1. *Use the numbers from the curve y = x⁸ to draw something unique.*
2. *As shown in code 20-13, compose a range of gradients.*
3. *Create a composition with the numbers generated from* `sin()`.
4. *Explore drawing circles and arcs with* `sin()` *and* `cos()`. *Develop a composition from the results of the exploration.*
5. *Use* `atan2()` *to make a line follow the cursor around the display window.*

21 Random

This chapter introduces the basics of random numbers and explains how to utilize them for generating form.

Syntax introduced:
`random()`, `randomSeed()`, `noise()`, `noiseSeed()`

Random compositional choices have a long history in modern art. In 1913, Marcel Duchamp's *3 Stoppages Étalon* employed the curves of dropped threads to derive novel units of measurement. Jean Arp used chance operations to define the position of elements in his collages. The composer John Cage sometimes tossed coins to determine the order and duration of notes in his scores. Artists integrate chance, randomness, and noise into their work either as a creative exercise or as a way of relinquishing some control to an external force. Actions like dropping, throwing, rolling, and so forth deprive the artists of certain aspects of decisions. The world's chaos can be channeled into making images and objects with physical media. In contrast, computers are machines that make consistent and accurate calculations and must therefore simulate random numbers to approximate the kind of chance operations used in nondigital art.

There is an obvious contrast between rigid structure and complete chaos, and some of the most satisfying aesthetic experiences are created by infusing one with the other. The tension between order and chaos can actively engage our attention:

If a composition is obviously ordered, it will not hold attention beyond a quick glance.

Conversely, if a composition is entirely chaotic, it will also not retain one's gaze.

A balance between the two can yield a more satisfying result.

Unexpected values

While it's easy to generate unpredictable values by rolling a die or flipping a coin, the problem of creating random numbers in a computer has occupied researchers for decades. In 1955, the Rand Corporation published the landmark book *A Million Random Digits with 100,000 Normal Deviates* to provide a table of random numbers for research to compensate for the inability to generate random numbers dynamically through software. As computers got faster and algorithms advanced, random numbers generated on computers improved.

It is now possible to rely on random numbers created in software for most purposes. As a result, the Processing software is capable of creating random numbers of sufficient unpredictability for generative graphics. The random() function is used to create erratic values within the range specified by its parameters. When one parameter is passed to the function, it returns a float from zero up to (but not including) the value of the parameter. The function call random(5.0) returns values from 0.0 up to 5.0. If two parameters are used, the function returns a value between the two parameters. Running random(-5.0, 10.2) returns values from -5.0 up to 10.2.

The numbers returned from random() are always floating-point values; therefore, they cannot be assigned to an int variable. The int() function can be used to convert a float value to an int.

```
float f = random(5.2);      // Assign a float value from 0 to 5.2 to f   21-01
int i = random(5.2);        // ERROR! Can't assign a float to an int
int j = int(random(5.2));   // Assign an int value from 0 to 5 to j
```

Because the numbers returned from random() are not predictable, each time the program is run, the result is different. The numbers from this function can be used to control almost any aspect of a program.

21-02

```
strokeWeight(10);
stroke(0, 130);
line(random(100), 0, random(100), 100);
line(random(100), 0, random(100), 100);
line(random(100), 0, random(100), 100);
line(random(100), 0, random(100), 100);
line(random(100), 0, random(100), 100);
```

The version of random() with two parameters provides more control over the results of the function. Unexpected values can be generated as a range between any two numbers, rather than between 0 and the parameter value. As the next example shows, storing the results of random() into a variable makes it possible to use the value more than once in the program. This program uses the random value r1 to set both the x-coordinate of the first point of the line and its stroke value.

21-03

```
strokeWeight(20);
float r1 = random(5, 45);
float r2 = random(55, 95);
stroke(r1 * 4, 230);
line(r1, 0, r2, 100);
r1 = random(5, 45);
r2 = random(55, 95);
stroke(r1 * 4, 230);
line(r1, 0, r2, 100);
```

Using random() within a for loop is an easy way to generate many random numbers with a small amount of code.

```
size(700, 100);
stroke(255, 102);
background(0);
for (int i = 0; i < width; i += 6) {
  float r = random(-10, 10);
  strokeWeight(abs(r));
  line(i-r, 100, i+r, 0);
}
```

21-04

When the random() function is placed within a draw() block, new values are calculated each trip through the block, which is 60 frames per second, by default. Run this program to see the frenetic result:

```
void setup() {
  size(700, 100);
  stroke(255, 102);
}

void draw() {
  background(0);
  for (int i = 0; i < width; i += 6) {
    float r = random(-10, 10);
    strokeWeight(abs(r));
    line(i-r, 100, i+r, 0);
  }
}
```

21-05

To use random values to determine the flow of the program, place the result of the random() function in a relational expression. In the first example below, either a line or a circle is drawn, depending on whether the result of the random() function is less than 50 or greater than or equal to 50, respectively. In the second example, between 1 and 50 vertical lines are drawn according to the result of the random() function. In both programs, the frame rate is set to 2 frames per second to show the results more clearly.

21-06

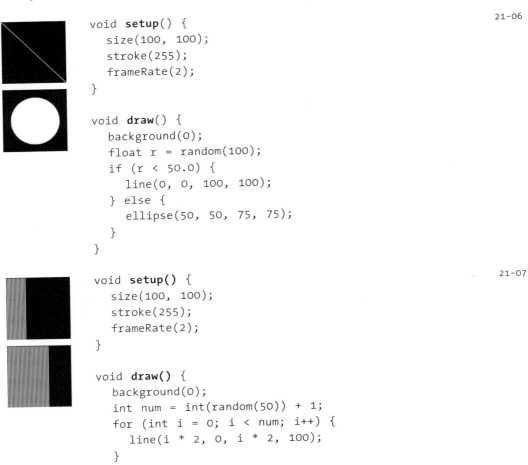

```
void setup() {
  size(100, 100);
  stroke(255);
  frameRate(2);
}

void draw() {
  background(0);
  float r = random(100);
  if (r < 50.0) {
    line(0, 0, 100, 100);
  } else {
    ellipse(50, 50, 75, 75);
  }
}
```

21-07

```
void setup() {
  size(100, 100);
  stroke(255);
  frameRate(2);
}

void draw() {
  background(0);
  int num = int(random(50)) + 1;
  for (int i = 0; i < num; i++) {
    line(i * 2, 0, i * 2, 100);
  }
}
```

Distributions

Defining the position of things on screen is one common use for random values. Combining numbers returned from random() with calculation techniques from the

previous chapter opens up possibilities for distributing shapes, images, typography, and so forth on screen in a balance between control and chaos.

The first example of this places points at random positions within a rectangle. The total number of points is defined by the numPoints variable in relation to the loop. The boundaries are defined by the parameters to random(), with the points positioned by the x and y variables. Notice that the x-coordinate range is 20–80, and the y-coordinate range is 10–90.

```
int numPoints = 2000;
noSmooth();
for (int i = 0; i < numPoints; i++) {
  float x = random(20, 80);
  float y = random(10, 90);
  point(x, y);
}
```

21-08

The preceding code calculates each point to have the same possibility to appear at any position within the rectangle. A variation to the code produces a condition with the pow() function to weight the values to have a higher probability to draw toward the top of the shape. The values from random() are set to between 0 and 1 so that the pow() function will also return values between 0 and 1. The result is then multiplied and added to bring the numbers into the desired screen coordinates. Try different numbers for the power variable to see how the gradient changes.

```
int power = 8;
int numPoints = 4000;
noSmooth();
for (int i = 0; i < numPoints; i++) {
  float x = random(20, 80);
  float y = random(1);
  y = 10 + (pow(y, power) * 80);
  point(x, y);
}
```

21-09

To position a series of points within a circular form, the coordinates need to be determined as radial coordinates. The location of each point is defined by an angle and radius first, then converted to the x- and y-coordinates required for screen display. Try changing the parameters to the random() functions for the angle and scalar variables to explore the visual flexibility of this program.

```
int numPoints = 900;
noSmooth();
for (int i = 0; i < numPoints; i++) {
  float angle = random(0, TWO_PI);
  float scalar = random(10, 40);
  float x = 50 + (cos(angle) * scalar);
  float y = 50 + (sin(angle) * scalar);
  point(x, y);
}
```

In another direction within the space of this topic, a regular grid may be used to set
a foundation for slight or extreme random divergence. As the values returned from
random() are controlled to grow larger, the original order disintegrates. In the
following example, nested loops are used to define a grid and random values within a
range straddling zero are used to distort it. As the value of the d variable grows, the
entropy increases.

```
int d = 2;
noSmooth();
for (int y = 10; y <= 90; y+=4) {
  for (int x = 10; x <= 90; x+=4) {
    float dx = random(-d, d);
    float dy = random(-d, d);
    point(x+dx, y+dy);
  }
}
```

A similar technique uses a random value to determine if the grid unit is drawn or not. If
the value calculated by random() is greater than the threshold variable, the point
draws.

```
float threshold = 0.2;
noSmooth();
for (int y = 10; y <= 90; y+=4) {
  for (int x = 10; x <= 90; x+=4) {
    float r = random(1);
    if (r > threshold) {
      point(x, y);
    }
  }
}
```

A random value can also be used within a grid structure to determine if one shape or another shape will draw into the grid. The following program is an interpretation of the one-line BASIC program 10 PRINT CHR$(205.5+RND(1)); : GOTO 10, a fascinating program discussed at length in the book of that name by Nick Montfort et al. For each unit of the grid, a random value is used to make a choice between two options, like flipping a coin. If the value is greater that 0.5, a left-leaning diagonal line is drawn; if the value is less than or equal to 0.5, a right-leaning line is drawn. The result visually joins the grid units though positive and negative shapes to create a mazelike image.

```
int u = 5;
float threshold = 0.5;
noSmooth();
for (int y = 0; y < 100; y += u) {
  for (int x = 0; x < 100; x += u) {
    float r = random(1);
    if (r > threshold) {
      line(x, y, x+u, y+u);
    } else {
      line(x, y+u, x+u, y);
    }
  }
}
```

Random seed

It's sometimes desirable to include unpredictable numbers in your programs but to force the same sequence of numbers each time the program is run. The randomSeed() function is the key to producing such numbers; it has one parameter that must be an integer. Use the same parameter in a program each time it is run to force the same random numbers to be produced in the same order. There is a unique sequence of random values for every integer value. You might find, for example, that using the number 1843 as the parameter produces numbers that suit your needs, while the number 258 will not.

The following program is a slight variation on code 21-04. Adding randomSeed() ensures it will produce the same values every time it is run. Change the seed parameter assigned to randomSeed() to generate a different set of numbers and thereby change the image produced by the program.

s=6

s=12

```
int s = 6;    // Seed value
size(700, 100);
stroke(255, 102);
randomSeed(s);    // Produce the same numbers each time
background(0);
for (int i = 0; i < width; i += 6) {
    float r = random(-10, 10);
    strokeWeight(abs(r));
    line(i-r, 100, i+r, 0);
}
```

When randomSeed() is used in a program that has a setup() and draw(), put it in setup() to start the program the same way each time. Place it in draw() to force the same random value(s) to be generated each run through the draw().

Noise

The noise() function is a more controllable way to create unexpected values. It uses the Perlin Noise technique, developed by Ken Perlin. Originally used for simulating natural textures through subtle irregularities, Perlin Noise is now also used for generating shapes and realistic motion. It works by interpolating between random values to create smoother transitions than the numbers returned from random().

The noise function has between one and three parameters. The version of the function with one parameter is used to create a single sequence of random numbers. Additional parameters produce noise in more dimensions. For example, the version with two parameters can be used to create a two-dimensional texture. The version with three parameters can be used to create a three-dimensional shape or texture or an animated two-dimensional texture. Regardless of the number or value of the parameters, this function always returns values between 0.0 and 1.0. If other values are desired, an equation can be applied to the result to change the range.

The numbers returned by noise() can be made closer to or farther from the previous value by way of changes in the rate at which the parameter increases. As a general rule, the smaller the difference, the smoother the resulting noise sequence will be. A small change generates numbers that are closer to the previous value than a large increase would. Steps of 0.005–0.03 work best for most applications, but this will differ

depending on use and personal taste. The following program uses the inc variable to define the difference between each noise value. Notice the differences between the results as the value of inc increases. The noiseSeed() function, which works like randomSeed(), is used to produce the same sequence of numbers each time the program runs.

inc=0.01

inc=0.1

```
float v = 0.0;                                                    21-15
float inc = 0.1;

void setup() {
  size(700, 100);
  noStroke();
  fill(0);
  noiseSeed(0);
  noLoop();
}

void draw() {
  for (int i = 0; i < width; i = i+4) {
    float n = noise(v) * 70.0;
    rect(i, 10 + n, 3, 20);
    v = v + inc;
  }
}
```

Add a second parameter to noise() to open the possibility of creating a two-dimensional texture. In the following example, embedded for loops are used to generate continuous noise values on the x-axis and y-axis. The values returned from noise() are used to set the gray values for a grid of points drawn to the screen.

```
float xnoise = 0.0;
float ynoise = 0.0;
float inc = 0.04;

void setup() {
  size(700, 100);
  noLoop();
  noSmooth();
}

void draw() {
  background(0);
  for (int y = 0; y < height; y++) {
    for (int x = 0; x < width; x++) {
      float gray = noise(xnoise, ynoise) * 255;
      stroke(gray);
      point(x, y);
      xnoise = xnoise + inc;
    }
    xnoise = 0;
    ynoise = ynoise + inc;
  }
}
```

21-16

Diverse textures can be created using noise() in collaboration with sin(). The following example deforms a regular sequence of bars created with sin() into a texture reminiscent of one found in nature. The power variable sets the amount the texture deforms from the lines and the density parameter sets the granularity of the texture.

d=128

d=16

d=32

21-17

```
float power = 3.0;   // Turbulence power
float d = 16.0;   // Turbulence density

void setup() {
  size(700, 100);
  noLoop();
  noSmooth();
}

void draw() {
  for (int y = 0; y < height; y++) {
    for (int x = 0; x < width; x++) {
      float total = 0.0;
      for (float i = d; i >= 1; i = i/2.0) {
        total += noise(x/d, y/d) * d;
      }
      float turbulence = 128.0 * total / d;
      float base = (x * 0.2) + (y * 0.12);
      float offset = base + (power * turbulence / 256.0);
      float gray = abs(sin(offset)) * 256.0;
      stroke(gray);
      point(x, y);
    }
  }
}
```

Examples that apply noise to movement are featured in the Motion chapter (p. 305).

Exercises

1. Use three variables assigned to random values to create a composition that is different every time the sketch is run.
2. Create a composition with a *for* loop and *random()* to generate a different visual density each time the sketch is run.
3. Add *randomSeed()* to exercise 2. Try different values and select a small set of numbers that you feel make the strongest compositions.
4. Extend code 21-12 by increasing the size of the display window and working with a different shape and grid density.
5. Modify code 21-17 by exploring a wider range of values for the *power* and *density* variables.

22 Motion

This chapter introduces basic techniques for creating motion with code; it also defines different qualities of motion with shapes and typography to create mood and meaning.

A deep understanding of motion, and how to use it to communicate, guides the artistry of the animator, dancer, and filmmaker. Practitioners of the media arts can employ motion in everything from dynamic websites to video games. The most fundamental component of motion is time, or more precisely, how elements change over time. Static images can communicate motion (think of Impressionist and Futurist paintings), and time-based media such as video, film, and software can express it directly. Defining motion through code displays the power and flexibility of the medium.

Programmers determine how elements in their software will move. These decisions influence how viewers interpret the forms. Over the course of evolution, humans have developed instincts and attitudes toward the motion in the world around us. We classify and categorize elements in the world by how they move or do not move; through observing motion, we make distinctions between different types of organisms and inanimate things. Motion in software can take advantage of humans' innate understanding of movement or ignore it. Software makes possible countless types of motion, but two major categories of interest here are mechanical and organic movement.

Controlling motion

To put a shape into motion, use a variable to change its attributes. We have already presented a few simple programs that move a shape across the screen in Flow (p. 65). This example builds on those programs through the addition of variables to control the speed and size of the shape. The background() function at the beginning of draw() clears the screen.

```
float y = 50.0;                                          22-01
float speed = 1.0;
float radius = 15.0;

void setup() {
  size(100, 100);
  noStroke();
  ellipseMode(RADIUS);
}

void draw() {
  background(0);
  ellipse(33, y, radius, radius);
```

```
    y = y + speed;
    if (y > height+radius) {
      y = -radius;
    }
  }
}
```

Motion blur is created by drawing a transparent rectangle to cover the entire display window within draw() as an alternative to using background(). It can produce a subtle fade rather than a complete refresh. The effect of drawing this transparent rectangle slowly increases frame by frame to erase the previously drawn elements. The amount of blur is controlled by the transparency value in fill() that affects the rectangle. Numbers closer to 255 will refresh the screen quickly because the rectangle will be more opaque, and numbers closer to 0 will create a longer fade.

 In the following example, the circle bounces between the top and bottom edges of the display window. This requires a variable to store the direction of motion. When the direction variable is 1, the circle moves down and when the variable is -1, the circle moves up. When the circle reaches the top or bottom of the screen, this variable changes by inverting its value. If direction is 1, then -direction will become -1 and vice versa.

```
float y = 50.0;
float speed = 1.0;
float radius = 15.0;
int direction = 1;

void setup() {
  size(100, 100);
  noStroke();
  ellipseMode(RADIUS);
}

void draw() {
  fill(0, 12);
  rect(0, 0, width, height);
  fill(255);
  ellipse(33, y, radius, radius);
  y += speed * direction;
  if ((y > height-radius) || (y < radius)) {
    direction = -direction;   // Change direction
  }
}
```

For the shape in the prior example to change its position relative to the left and right edges of the display window, a second set of variables for the x-coordinate are required. The following example uses the same principle as the previous one, but now defines the position of the shape on both the x-axis and y-axis. The shape reverses its direction when it reaches any edge.

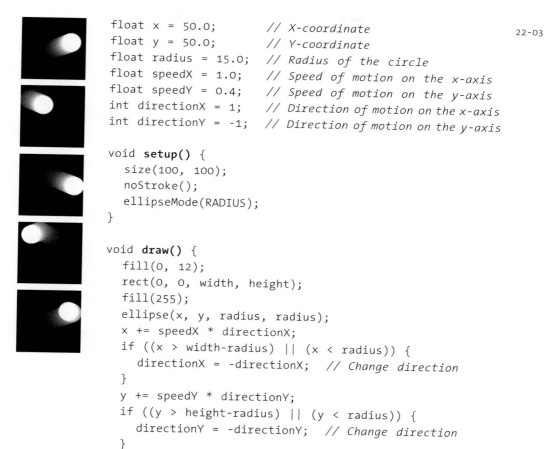

```
float x = 50.0;              // X-coordinate
float y = 50.0;              // Y-coordinate
float radius = 15.0;         // Radius of the circle
float speedX = 1.0;          // Speed of motion on the x-axis
float speedY = 0.4;          // Speed of motion on the y-axis
int directionX = 1;          // Direction of motion on the x-axis
int directionY = -1;         // Direction of motion on the y-axis

void setup() {
  size(100, 100);
  noStroke();
  ellipseMode(RADIUS);
}

void draw() {
  fill(0, 12);
  rect(0, 0, width, height);
  fill(255);
  ellipse(x, y, radius, radius);
  x += speedX * directionX;
  if ((x > width-radius) || (x < radius)) {
    directionX = -directionX;   // Change direction
  }
  y += speedY * directionY;
  if ((y > height-radius) || (y < radius)) {
    directionY = -directionY;   // Change direction
  }
}
```

With the same programming techniques, it's possible to change other aspects of a shape beyond position. For example, the background value, stroke and fill values, and size can be animated with variables. This next example changes the sizes of four ellipses using the same code for reversing direction used in the previous two examples.

```
float d = 20.0;
float speed = 1.0;
int direction = 1;

void setup() {
    size(100, 100);
    noStroke();
    fill(255, 204);
}

void draw() {
    background(0);
    ellipse(0, 50, d, d);
    ellipse(100, 50, d, d);
    ellipse(50, 0, d, d);
    ellipse(50, 100, d, d);
    d += speed * direction;
    if ((d > width) || (d < width/10)) {
        direction = -direction;    // Change direction
    }
}
```

In contrast to the motion presented in the previous examples, shapes can explicitly move from one position to another. This type of motion requires setting a start position and an end position, and then moving between them over a series of frames. In the code below, the beginX and beginY variables define the start position and the endX and endY variables define the final position. The x and y variables are the current position, the step variable determines the fraction of the total distance to travel each frame, and the pct variable keeps track of the total percentage of the distance traveled. The values of the step and pct variables must always be between 0.0 and 1.0. As the program runs, the step increases to change the position of the x and y variables, and when the percentage is no longer less than 1.0, the motion stops.

```
float beginX = 20.0;    // Initial x-coordinate
float beginY = 10.0;    // Initial y-coordinate
float endX = 70.0;      // Final x-coordinate
float endY = 80.0;      // Final y-coordinate
float distX;            // X-axis distance to move
float distY;            // Y-axis distance to move
float x = 0.0;          // Current x-coordinate
float y = 0.0;          // Current y-coordinate
float step = 0.02;      // Size of each step (0.0 to 1.0)
float pct = 0.0;        // Percentage traveled (0.0 to 1.0)

void setup() {
  size(100, 100);
  noStroke();
  distX = endX - beginX;
  distY = endY - beginY;
}

void draw() {
  fill(0, 12);
  rect(0, 0, width, height);
  pct += step;
  if (pct < 1.0) {
    x = beginX + (pct * distX);
    y = beginY + (pct * distY);
  }
  fill(255);
  ellipse(x, y, 20, 20);
}
```

The easing technique introduced in Calculate (p. 265) can be used to slow the shape down as it reaches its end position. The following example adapts the code from the previous example to make the shape decelerate as it approaches its destination.

```
float x = 20.0;        // Initial x-coordinate
float y = 10.0;        // Initial y-coordinate
float endX = 70.0;     // Destination x-coordinate
float endY = 80.0;     // Destination y-coordinate
float easing = 0.05;   // Size of each step along the path

void setup() {
  size(100, 100);
  noStroke();
}

void draw() {
  fill(0, 12);
  rect(0, 0, width, height);
  float d = dist(x, y, endX, endY);
  if (d > 1.0) {
    x += (endX - x) * easing;
    y += (endY - y) * easing;
  }
  fill(255);
  ellipse(x, y, 20, 20);
}
```

Motion along curves

The simple curves explained in Calculate (p. 265) can provide paths for shapes in motion. Instead of drawing the entire curve in one frame as in the previous code examples, it's possible to calculate each step of the curve on consecutive frames. The following example presents a general way to write this code. Change the variables at the top of the code to change the start and end position, the curve shape, and the number of steps to take along the curve.

```
float beginX = 20.0;        // Initial x-coordinate
float beginY = 10.0;        // Initial y-coordinate
float endX = 70.0;          // Final x-coordinate
float endY = 80.0;          // Final y-coordinate
float distX;                // X-axis distance to move
float distY;                // Y-axis distance to move
float exponent = 0.5;       // Determines the curve
float x = 0.0;              // Current x-coordinate
float y = 0.0;              // Current y-coordinate
float step = 0.01;          // Size of each step along the path
float pct = 0.0;            // Percentage traveled (0.0 to 1.0)

void setup() {
  size(100, 100);
  noStroke();
  distX = endX - beginX;
  distY = endY - beginY;
}

void draw() {
  fill(0, 2);
  rect(0, 0, width, height);
  pct += step;
  if (pct < 1.0) {
    x = beginX + (pct * distX);
    y = beginY + (pow(pct, exponent) * distY);
  }
  fill(255);
  ellipse(x, y, 20, 20);
}
```

All of the basic curves presented on page 271 can be scaled and combined to generate unique paths of motion. Once a step along one curve has been reached, the program can switch to calculating positions based on a different curve.

```
float beginX = 20.0;     // Initial x-coordinate
float beginY = 10.0;     // Initial y-coordinate
float endX = 70.0;       // Final x-coordinate
float endY = 80.0;       // Final y-coordinate
float distX;             // X-axis distance to move
float distY;             // Y-axis distance to move
float exponent = 3.0;    // Determines the curve
float x = 0.0;           // Current x-coordinate
float y = 0.0;           // Current y-coordinate
float step = 0.01;       // Size of each step along the path
float pct = 0.0;         // Percentage traveled (0.0 to 1.0)
int direction = 1;

void setup() {
  size(100, 100);
  noStroke();
  distX = endX - beginX;
  distY = endY - beginY;
}

void draw() {
  fill(0, 2);
  rect(0, 0, width, height);
  pct += step * direction;
  if ((pct > 1.0) || (pct < 0.0)) {
    direction = direction * -1;
  }
  if (direction == 1) {
    x = beginX + (pct * distX);
    float e = pow(pct, exponent);
    y = beginY + (e * distY);
  } else {
    x = beginX + (pct * distX);
    float e = pow(1.0-pct, exponent*2);
    y = beginY + (e * -distY) + distY;
  }
  fill(255);
  ellipse(x, y, 20, 20);
}
```

As a shape moves along a curve, its speed changes with the angle of the curve. This property can be used to control the speed of a visual element that moves on a straight line. For instance, when the curve is mostly horizontal (flat), there is very little vertical distance, but as the curves become more vertical (steep), the distance along the y-axis

increases exponentially. The diagrams below shows how the x values in the equation $y=x^4$ are increased at a constant rate, the y values grow exponentially. The diagram on the left displays the y values corresponding to x values from 0.0 to 1.0 at increments of 0.1. The diagram on the right displays only the y value without the context of the x value to reveal the increasing changes:

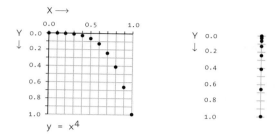

$$y = x^4$$

Following these diagrams, the next example shows how to change the speed of a shape using a curve. The circle begins very slowly, gradually accelerates, and then stops at the bottom of the display window. The exponent variable defines the slope of the curve, which changes the rate of motion. Click the mouse to select a new starting point.

22-09

```
float beginX = 20.0;    // Initial x-coordinate
float beginY = 10.0;    // Initial y-coordinate
float endX = 70.0;      // Final x-coordinate
float endY = 80.0;      // Final y-coordinate
float distX;            // X-axis distance to move
float distY;            // Y-axis distance to move
float exponent = 3.0;   // Determines the curve
float x = 0.0;          // Current x-coordinate
float y = 0.0;          // Current y-coordinate
float step = 0.01;      // Size of each step along the path
float pct = 0.0;        // Percentage traveled (0.0 to 1.0)

void setup() {
  size(100, 100);
  noStroke();
  distX = endX - beginX;
  distY = endY - beginY;
}

void draw() {
  fill(0, 2);
  rect(0, 0, width, height);
  if (pct < 1.0) {
    pct = pct + step;
```

```
        float rate = pow(pct, exponent);
        x = beginX + (rate * distX);
        y = beginY + (rate * distY);
      }
      fill(255);
      ellipse(x, y, 20, 20);
    }

    void mousePressed() {
      pct = 0.0;
      beginX = x;
      beginY = y;
      distX = mouseX - x;
      distY = mouseY - y;
    }
```

Mechanical motion

In the catalog for the Museum of Modern Art's 1934 Machine Art exhibition, Alfred Barr described characteristics of the machines of that time: "Machines are, visually speaking, a practical application of geometry. Forces which act in straight lines are changed in direction and degree by machines which are themselves formed of straight lines and curves. The lever is geometrically a straight line resting on a point. The wheel and axle is composed of concentric circles and radiating straight lines." He further explained that motion "increases their aesthetic interest, principally through the addition of temporal rhythms." While machines and society's ideas about machines have changed dramatically in the last eighty years, Barr's insights remain relevant in defining the characteristics of mechanical motion. Prototypical examples of machine motion include the clock, the metronome, and the piston. These mechanisms' movements are all characterized by regular rhythm, repetition, and efficiency. Writing code to produce these qualities of motion communicates the essence of the machines through software.

The sin() function is often used to produce elegant motion. It can generate an accelerating and decelerating speed as a shape moves from one frame to another. The following diagrams show how the speed along a sine wave is consistent if the angle is increased at a constant rate, but the speed along the y-axis decreases at the top and bottom of the curve. The diagram on the left displays the changing sine value as the angle grows. The diagram on the right compresses the x-axis to a line to emphasize the changes in speed along the y-axis:

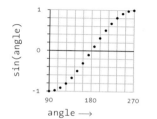 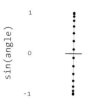

The values from the sin() function are used to create the motion for a shape in the following example. The angle variable increases continually to produce changing values from sin() in the range of -1 to 1. These numbers are multiplied by the radius variable to magnify the values. The result is assigned to the yoffset variable and is then used to determine the y-coordinate of the ellipse on the following line. Run the code; notice how the circle slows down at the top and bottom of the screen and accelerates in the middle.

```
float angle = 0.0;      // Current angle
float speed = 0.1;      // Speed of motion
float radius = 60.0;    // Range of motion

void setup() {
  size(100, 100);
  noStroke();
}

void draw() {
  fill(0, 12);
  rect(0, 0, width, height);
  fill(255);
  angle += speed;   // Update the angle
  float sinval = sin(angle);
  float yoffset = sinval * radius;
  ellipse(50, 50 + yoffset, 80, 80);
}
```

22-10

Adding values from sin() and cos() can produce more complex movement that remains periodic. In this example, a small dot moves in a circular pattern using values from sin() and cos(). A larger dot uses the same values for its base position but adds additional sin() and cos() calculations to produce an offset. You can see the difference between the two movements by looking at the positions of each point as the program runs.

```
float angle = 0.0;      // Current angle
float speed = 0.05;     // Speed of motion
float radius = 30.0;    // Range of motion
float sx = 2.0;
float sy = 2.0;

void setup() {
  size(100, 100);
  noStroke();
}

void draw() {
  fill(0, 4);
  rect(0, 0, width, height);
  angle += speed;  // Update the angle
  float sinval = sin(angle);
  float cosval = cos(angle);
  // Set the position of the small circle based on new
  // values from sine and cosine
  float x = 50 + (cosval * radius);
  float y = 50 + (sinval * radius);
  fill(255);
  ellipse(x, y, 2, 2);  // Draw smaller circle
  // Set the position of the large circles based on the
  // new position of the small circle
  float x2 = x + cos(angle * sx) * radius/2;
  float y2 = y + sin(angle * sy) * radius/2;
  ellipse(x2, y2, 6, 6);  // Draw larger circle
}
```

The *phase* of a function is one iteration through its possible values—for example, a single rise and fall sequence of a sine curve. *Phase shifting* occurs when the function is offset to start at a different point within the phase, such as the downward part of a sine curve rather than the top. Musical, visual, and numeric sequences all have phases, as do physical phenomena such as light waves. In the sound domain, Steve Reich's *Piano Phases* is a composition in which two pianos play the same sequence of notes, but one musician plays faster, creating a continuous phase shift as notes move in and out of synchrony. The player with the faster tempo periodically moves back into phase with the slower player, but it is first offset by one note, then two notes, then three, and so on. The performance ends when both pianos are back in phase and are playing the notes at the same time. In the visual domain, phase shifting creates the complex moiré patterns that result when two identical patterns are superimposed and shifted. In trigonometry, a cosine wave is a sine wave offset by 90° (p. 283). Shifting the angle used to generate

values from `sin()` provides the same sequence of numbers, but shifted across frames of animation:

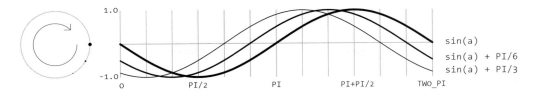

The following two examples change the x-coordinate and diameter of circles to demonstrate phase shifting. In the first example, each circle has the same horizontal motion, but the motion is offset in time. In the second example, each circle has the same position and rate of growth, but the cycle is offset.

22-12

```
float angle = 0.0;
float speed = 0.1;

void setup() {
  size(100, 100);
  noStroke();
}

void draw() {
  background(0);
  angle = angle + speed;
  ellipse(50 + (sin(angle + PI) * 5), 25, 30, 30);
  ellipse(50 + (sin(angle + HALF_PI) * 5), 55, 30, 30);
  ellipse(50 + (sin(angle + QUARTER_PI) * 5), 85, 30, 30);
}
```

22-13

```
float angle = 0.0;
float speed = 0.05;

void setup() {
  size(100, 100);
  noStroke();
  fill(255, 180);
}

void draw() {
  background(0);
  float d1 = 65 + (sin(angle) * 45);
  ellipse(50, 50, d1, d1);
  float d2 = 65 + (sin(angle + QUARTER_PI) * 45);
```

```
      ellipse(50, 50, d2, d2);
      float d3 = 65 + (sin(angle + HALF_PI) * 45);
      ellipse(50, 50, d3, d3);
      angle += speed;
    }
```

22-13
cont.

Organic motion

Examples of organic movement include a leaf falling, an insect walking, a bird flying, a
person breathing, a river flowing, and smoke rising. This type of motion is often
considered idiosyncratic and stochastic. Early explorations in photography led to a new
understanding of human and animal motion. Étienne-Jules Marey and Eadweard
Muybridge focused the lenses of their cameras on bodies in motion. In the 1880s Marey
captured birds in flight, revealing the changing shapes of wings in image montages.
Muybridge's sensational photographs of horses in motion used fifty cameras in
sequence along a track to capture still images of a running horse. These photographs
provided visual evidence regarding the horse's stride that had previously been
impossible to collect. In the 1930s, Harold Edgerton invented technologies for capturing
unique movements such as the beating of a hummingbird's wings and the motion of a
starfish across the sea floor. Such images and films have changed the way the world is
understood and can inform the way organic motion is approached using software.

Software explorations within the last twenty years have also provided a new
understanding of organic motion. The Boids (p. 486) software created by Craig Reynolds
in 1986 simulates the flocking behavior found in birds and fish and has led to new ideas
about the emergent behaviors of animal groups. Karl Sims's Evolved Virtual Creatures
from 1994 presents an artificial evolution, focusing on locomotion, where virtual block
creatures engage in walking, jumping, and swimming competitions. The simple blocks
demonstrate extraordinary emotive qualities as they twist and turn, appearing to
struggle in their pursuit of locomotion.

Brownian motion, named in honor of the botanist Robert Brown, is jittery,
stochastic motion that was originally ascribed to the movements of tiny particles
within fluids or the air; it appears entirely random. This motion can be simulated in
software by setting a new position for a particle each frame, without preference as to
the direction of motion. Leaving a trail of the previous positions of an element is a good
technique for tracing its path through space.

```
float x = 50.0;          // X-coordinate                        22-14
float y = 80.0;          // Y-coordinate

void setup() {
  size(100, 100);
  randomSeed(0);          // Force the same random values
  background(0);
  stroke(255);
  strokeWeight(2);
}

void draw() {
  x += random(-2, 2);     // Assign new x-coordinate
  y += random(-2, 2);     // Assign new y-coordinate
  point(x, y);
}
```

The sin() and cos() functions can be used to create unpredictable motion when
employed with the random() function. The following example presents a line with a
position and direction. The position of the line at each frame is based on its current
position and its direction. Each frame, the direction is changed by a small value. The
cos() function uses the angle to calculate the next x-coordinate for the line, and the
sin() function uses the same angle to calculate the next y-coordinate.

```
float x = 0.0;           // X-coordinate                        22-15
float y = 50.0;          // Y-coordinate
float angle = 0.0;       // Direction of motion
float speed = 0.5;       // Speed of motion

void setup() {
  size(100, 100);
  background(0);
  stroke(255, 130);
  randomSeed(121);        // Force the same random values
}

void draw() {
  angle += random(-0.3, 0.3);
  x += cos(angle) * speed;    // Update x-coordinate
  y += sin(angle) * speed;    // Update y-coordinate
  translate(x, y);
  rotate(angle);
  line(0, -10, 0, 10);
}
```

The noise() function is another resource for producing organic motion. Because the numbers returned from noise() are easy to control, they are a good way to add subtle irregularity to movement. The following example draws two lines to the screen and sets their endpoints based on numbers returned from noise().

22-16

```
float inc1 = 0.1;
float n1 = 0.0;
float inc2 = 0.09;
float n2 = 0.0;

void setup() {
  size(100, 100);
  stroke(255);
  strokeWeight(40);
}

void draw() {
  background(0);
  float y1 = (noise(n1) - 0.5) * 30.0; // -15 to 15
  float y2 = (noise(n2) - 0.5) * 30.0; // -15 to 15
  line(0, 50, 30, 50 + y1);
  line(100, 50, 70, 50 + y2);
  n1 += inc1;
  n2 += inc2;
}
```

The noise() function can also be used to generate kinetic textures. In the following example, the first two parameters are used to produce a two-dimensional texture and the third parameter increases its value each frame to vary the texture. The density parameter defines the grid size of the texture in units of pixels. The inc parameter changes the texture resolution.

```
float inc = 0.06;
int density = 4;
float znoise = 0.0;

void setup() {
  size(100, 100);
  noStroke();
}

void draw() {
  float xnoise = 0.0;
  float ynoise = 0.0;
  for (int y = 0; y < height; y += density) {
    for (int x = 0; x < width; x += density) {
      float n = noise(xnoise, ynoise, znoise) * 255;
      fill(n);
      rect(y, x, density, density);
      xnoise += inc;
    }
    xnoise = 0.0;
    ynoise += inc;
  }
  znoise += inc;
}
```

Kinetic typography

Despite the potential for kinetic type on film, animated typography didn't begin to flourish until the 1950s with the film title work of Saul Bass, Maurice Binder, and Pablo Ferro. These designers and their peers set a high standard with their kinetic title sequences for films such as *North by Northwest* (1959), *Dr. No* (1962), and *Bullitt* (1968). They explored the evocative power of kinetic letterforms to set a mood and express additional layers of meaning in relation to written language. In subsequent years the design of film titles matured and is now augmented by experimental typography for television and the Internet.

Software has played a large role in extending the possibilities of type in motion. The Visual Language Workshop (VLW), founded by Muriel Cooper at the MIT Media Lab in 1985, applied rigorous design thinking to the presentation of kinetic and spatial typography. Researchers including Suguru Ishizaki, Lisa Strausfeld, Yin Yin Wong, and David Small produced progressive typographic explorations ranging from the expression of animated phrases to the navigation of vast typographic landscapes. Because programs did not exist to perform these experiments, the researchers developed custom software to realize their ideas. While at the VLW, David Small created

the *Talmud Project* to explore reading in a unique way. It displays the Talmud and related commentaries on the screen simultaneously. A dial controls the legibility of each text through blurring and fading, while keeping each source in context. Peter Cho, building on the explorations of the VLW, wrote software that continued to push the boundaries of expressive kinetic typography. His *Letterscapes* software presents every letter of the Roman alphabet as a character with a unique motion and response in relation to its form. With his *Takeluma* project, Cho went even further by inventing a kinetic alphabet for visualizing speech.

In the last fifteen years, many software tools have been released that facilitate working with kinetic typography. Initially, Adobe's Flash software provided new freedom for working with type on the web, and Adobe After Effects supports more sophisticated typography in film and television. JavaScript and Cascading Style Sheets (CSS) have brought motion directly into modern web browsers.

To put type into motion in code, draw it at a different position each frame. Words can move in an orderly fashion if their position is changed slightly each frame, and they can move without apparent order if placed in an arbitrary position each frame. (Before working with these examples, see the Typography chapter for information about using fonts in Processing.)

```
PFont font;
float x1 = 0.0;
float x2 = 100.0;

void setup() {
  size(100, 100);
  font = createFont("SourceCodePro-Light.otf", 36);
  textFont(font);
  fill(0);
}

void draw() {
  background(204);
  text("Right", x1, 50);
  text("Left", x2, 75);
  x1 += 1.0;
  if (x1 > 100) {
    x1 = -150;
  }
  x2 -= 0.8;
  if (x2 < -150) {
    x2 = 100;
  }
}
```

22-18

```
PFont font;

void setup() {
   size(100, 100);
   font = createFont("SourceCodePro-Light.otf", 48);
   textFont(font);
   noStroke();
}

void draw() {
   fill(204, 24);
   rect(0, 0, width, height);
   fill(0);
   text("flicker", random(-100, 100), random(-20, 120));
}
```

Typography need not move in order to change over time. More subtle transformations, such as changes in the gray value or transparency of the text, can be made by changing the value of a variable within draw().

```
PFont font;
int opacity = 0;
int direction = 1;

void setup() {
   size(100, 100);
   font = createFont("SourceCodePro-Light.otf", 24);
   textFont(font);
}

void draw() {
   background(204);
   opacity += 2 * direction;
   if ((opacity < 0) || (opacity > 255)) {
      direction = -direction;
   }
   fill(0, opacity);
   text("FADE", 4, 60);
}
```

Applying the transformations translate(), scale(), and rotate() can also create motion.

```
PFont font;
String s = "VERTIGO";
float angle = 0.0;

void setup() {
  size(100, 100);
  font = createFont("SourceCodePro-Light.otf", 60);
  textFont(font);
  fill(0);
}

void draw() {
  background(204);
  angle += 0.02;
  pushMatrix();
  translate(33, 50);
  scale((cos(angle/4.0) + 1.2) * 2.0);
  rotate(angle);
  text(s, 0, 0);
  popMatrix();
}
```

Another technique, called rapid serial visual presentation (RSVP), displays words on the screen sequentially to define a fundamentally different way to think about reading. Run this program and change the frame rate to see how it affects the process of reading. To store the words within one variable called *words*, this example uses a data element called an Array (see p. 415).

```
PFont font;
String[] words = { "Three", "strikes", "and", "you're",
                   "out...", " "    };
int whichWord = 0;

void setup() {
  size(100, 100);
  font = createFont("SourceCodePro-Light.otf", 24);
  textFont(font);
  textAlign(CENTER);
  frameRate(4);
  fill(0);
}
```

```
void draw() {
    background(204);
    text(words[whichWord], width/2, 55);
    whichWord++;
    if (whichWord == words.length) {
        whichWord = 0;
    }
}
```

22-22
cont.

Individually animated letters offer more flexibility than entire moving words. Building
words letter by letter, each with a different movement or speed, can convey a more
specific meaning or tone. Working in this way requires patience and often more
elaborate programs, but the results can be more rewarding because of the increased
possibilities. The following example shows one possibility; the size of each letter grows
and shrinks from left to right.

22-23

```
PFont font;
String s = "AREA";
float angle = 0.0;

void setup() {
    size(100, 100);
    font = createFont("SourceCodePro-Light.otf", 48);
    textFont(font);
    fill(0);
}

void draw() {
    background(204);
    angle += 0.05;
    for (int i = 0; i < s.length(); i++) {
        float c = sin(angle + i/PI);
        textSize((c + 1.0) * 15 + 10);
        text(s.charAt(i), i*20, 60);
    }
}
```

Exercises

1. *Use code 22-03 as a base to write a sketch to bounce two shapes around the display window.*
2. *Choreograph a repeating animation of a shape moving from one position to another position and back to the starting point.*
3. *Make a shape move with numbers returned from* `sin()` *and* `cos()`.
4. *Modify code 22-15 to create a more advanced simulated organism.*
5. *Select a noun and an adjective that lends itself to motion. Animate the noun as text on screen according to the behavior of the adjective.*

23 Time

This chapter introduces time and date data as variables to control a program.

Syntax introduced:
`second()`, `minute()`, `hour()`, `millis()`, `day()`, `month()`, `year()`

Past civilizations used sundials and water clocks to visualize the passage of time, but today, most people use a digital numeric clock or a twelve-hour circular clock with a minute, second, and hour hand. Each of these representations reflects its technology. A numeric digital readout is appropriate for a digital clock in need of a bright, inexpensive display; a clock built from circular gears lends itself to a circular presentation of time. The tower-sized clocks of the past with enormous gears and weights have evolved and shrunk into devices so inexpensive and abundant that digital devices such as home appliances, phones, and computers all display the time and date.

Reading the current time and date into a program opens an interesting area of exploration. Knowledge of the current time makes it possible to write a sketch that triggers a video at a specific time of day, changes its colors each day depending on the date, or to make a digital clock that plays an animation every hour. The ability to input time and date information enables software tools that remember, remind, and amuse.

Seconds, Minutes, Hours

Processing programs can read the value of the computer's clock. The current second is read with the `second()` function, which returns values from 0 to 59. The current minute is read with the `minute()` function, which also returns values from 0 to 59. The current hour is read with the `hour()` function, which returns values in the 24-hour time notation from 0 to 23. In this system midnight is 0, noon is 12, 9:00 a.m. is 9, and 5:00 p.m. is 17. Run this program to see the current time:

```
int s = second();   // Returns values from 0 to 59              23-01
int m = minute();   // Returns values from 0 to 59
int h = hour();     // Returns values from 0 to 23
println(h + ":" + m + ":" + s);   // Prints the time to the console
```

Place these functions inside `draw()` to read the time continuously. The following example reads the current time and updates the console with the passage of each second:

```
int lastSecond = 0;
```
```
void setup() {
  size(100, 100);
}

void draw() {
  int s = second();
  int m = minute();
  int h = hour();
  // Only prints once when the second changes
  if (s != lastSecond) {
    println(h + ":" + m + ":" + s);
    lastSecond = s;
  }
}
```

Create a clock with a numerical display by using the text() function to draw the
numbers to the display window. The nf() function (p. 490) is used to space the
numbers equally from left to right. Single-digit numbers are padded on their left with a
zero so that all numbers occupy a two-digit space at all times.

```
PFont font;

void setup() {
  size(100, 100);
  font = createFont("mono", 16);
  textFont(font);
  textAlign(CENTER);
}

void draw() {
  background(0);
  int s = second();
  int m = minute();
  int h = hour();
  // The nf() function spaces the numbers nicely
  String t = nf(h,2) + ":" + nf(m,2) + ":" + nf(s,2);
  text(t, 50, 55);
}
```

In the next example, vertical lines mark the current second, hour, and minute. The left
edge of the display window is 0, and the right edge is the maximum for each time

LIVERPOOL JOHN MOORES UNIVERSITY
LEARNING SERVICES

component. Because the values from the time functions range from 0 to 59 and from 0 to 23, they are modified to have the range of 0 to 99.

23-04

```
void setup() {
  size(100, 100);
  noSmooth();
  stroke(255);
}

void draw() {
  background(0);
  float s = map(second(), 0, 59, 0, 99);
  float m = map(minute(), 0, 59, 0, 99);
  float h = map(hour(), 0, 23, 0, 99);
  line(s, 0, s, 33);
  line(m, 34, m, 66);
  line(h, 67, h, 100);
}
```

Mapping the time values can also be used to simulate the second, minute, and hour hands on a traditional clock face. In this case, the values are mapped to the range 0 to 2π to display the time as points around a circle. Because the hour() function returns values in 24-hour time, the program converts the hour value to the 12-hour time scale by calculating the hour % 12 (the % symbol, the modulus operator, is introduced on p. 57).

23-05

```
void setup() {
  size(100, 100);
  stroke(255);
}

void draw() {
  background(0);
  fill(80);
  noStroke();
  // Angles for sin() and cos() start at 3 o'clock;
  // subtract HALF_PI to make them start at the top
  ellipse(50, 50, 80, 80);
  float s = map(second(), 0, 60, 0, TWO_PI) - HALF_PI;
  float m = map(minute(), 0, 60, 0, TWO_PI) - HALF_PI;
  float h = map(hour() % 12, 0, 12, 0, TWO_PI) - HALF_PI;
  stroke(255);
  line(50, 50, cos(s)*38 + 50, sin(s)*38 + 50);
  line(50, 50, cos(m)*30 + 50, sin(m)*30 + 50);
  line(50, 50, cos(h)*25 + 50, sin(h)*25 + 50);
}
```

Milliseconds

In addition to reading the current time, each Processing program counts the time passed since the program started. This time is stored in milliseconds (thousandths of a second). For instance, two thousand milliseconds is 2 seconds, and 200 milliseconds is 0.2 seconds. This number is obtained with the `millis()` function and can be used to trigger events and calculate the passage of time. The following example uses `millis()` to start a line in motion three seconds after the program starts.

```
int x = 0;                                                              23-06

void setup() {
  size(100, 100);
}

void draw() {
  if (millis() > 3000) {
    x++;
  }
  line(x, 0, x, 100);
}
```

This same technique can be used to time a longer sequence by checking for more than one time. The following example displays a different shape each second. After the final shape is displayed, the program loops and displays the first again.

```
int mode = 0;                                                           23-07
int nextTime = 0;
int timer = 1000;

void setup() {
  size(100, 100);
  nextTime = millis() + timer;
  noFill();
  stroke(255);
}

void draw() {
  background(0);
  if (mode == 0) {
    line(10, 10, 90, 90);
  } else if (mode == 1) {
    ellipse(50, 50, 80, 80);
```

```
  } else if (mode == 2) {
      rect(10, 10, 80, 80);
  }

  if (millis() > nextTime) {
      mode++;
      if (mode > 2) {
         mode = 0;
      }
      nextTime = millis() + timer;
  }
}
```

The millis() function returns an int, but it is sometimes useful to convert it to a float that represents the number of seconds elapsed since the program started. The resulting number can be used to control the sequence of events in an animation with smaller numbers than the raw milliseconds. Compare this program to 23-06.

```
int x = 0;

void setup() {
   size(100, 100);
}

void draw() {
   float sec = millis() / 1000.0;
   if (sec > 3.0) {
      x++;
   }
   line(x, 0, x, 100);
}
```

Date

Date information is read in a similar way as the time data. The current day is read with the day() function, which returns values from 1 to 31. The current month is read with the month() function, which returns values from 1 to 12 where 1 is January, 6 is June, and 12 is December. The current year is read with the year() function, which returns the four-digit integer value of the present year. Run this program to see the current date in the console:

```
int d = day();      // Returns values from 1 to 31
int m = month();    // Returns values from 1 to 12
```

```
int y = year();    // Returns four-digit year (2007, 2008, etc.)
println(y + " " + m + " " + d);
```
23-09
cont.

The following example runs continuously and checks to see if it is the first day of the
month. If it is, the code prints the message "Welcome to a new month!" to the console.

```
void draw() {
  int d = day();   // Values from 1 to 31
  if (d == 1) {
    println("Welcome to a new month!");
  }
}
```
23-10

The next example is similar to the previous, but it uses the month() function as well to
check if it is New Year's Day. If so, the message "Today is the first day of the year!" is
printed to the console.

```
void draw() {
  int d = day();      // Values from 1 to 31
  int m = month();    // Values from 1 to 12
  if ((d == 1) && (m == 1)) {
    println("Today is the first day of the year!");
  }
}
```
23-11

Exercises
1. *Create a simple composition that uses the current value of the* second() *function
to change.*
2. *Make a simple clock to run an animation for two seconds at the beginning of
each minute.*
3. *Create an abstract clock that communicates the passage of time through graphical
quantity rather than numbers.*
4. *Modify code 23-07 to choreograph a longer sequence of events.*
5. *Write a sketch to draw images to the display window based on specific dates (e.g.,
display a pumpkin on Halloween).*

24 Functions

This chapter introduces basic concepts and syntax for writing functions. This leads to a discussion about parameterized and recursive form.

Syntax introduced:
`void, return`

A function is a self-contained programming module. You've been using the functions included with Processing such as `size()`, `line()`, `stroke()`, and `translate()` to write your programs. It is also possible to write your own, unique functions to make your programs more modular. Functions make redundant code more concise by extracting the common elements into new blocks of code that can be run many times within a program. This makes the code easier to read and update and reduces the chance of errors.

What do we already know about functions? Functions often have parameters to define their actions. For example, the `line()` function has four parameters that define the position of the two endpoints. Functions can operate differently depending on the number of parameters used. For example, a single parameter to the `fill()` function defines a gray value, two parameters define a gray value with transparency, and three parameters define an RGB color.

A function can be imagined as a box with mechanisms inside that act on data. There is typically an input into the box and code inside that utilizes the input to produce an output:

$$x \longrightarrow \boxed{?} \longrightarrow f(x)$$

For example, a function can be written to add 10 to any number or to multiply two numbers:

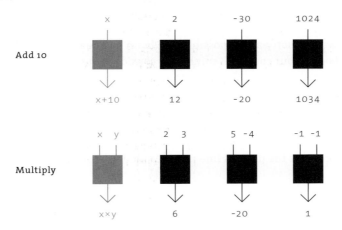

The previous function examples are simple, but the concept can be extended to other processes that may be less obvious:

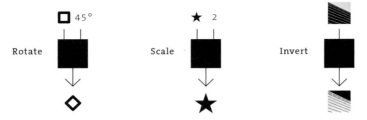

The code inside an advanced function might be hard to understand, but the beauty of using functions is that it is not necessary to understand precisely how they work. It is usually enough to know how to use them—to know what the inputs are and how they affect the output. This technique of ignoring the details of a process is called *abstraction*. It helps place the focus on the overall design of the program rather than the details.

Abstraction

In the terminology of software, the word *abstraction* has a different meaning from how it is used to refer to drawings and paintings. It refers to hiding details in order to focus on the result. For instance, the interface of the wheel and pedals in a car allows the driver to ignore details of the car's operation, such as firing pistons and the flow of gasoline. The most important understanding required by the person driving is that the steering wheel turns the vehicle left and right, the accelerator speeds it up, and the brake slows it down. Ignoring the details of the engine allows the driver to maintain focus on the task at hand; the mind need not be cluttered with thoughts about the details of execution.

The idea of abstraction can also be discussed in relation to the human body. For example, we can control our breathing, but we usually breathe involuntarily. Imagine if we had to directly control every aspect of our body. Having to continually control the beating of the heart, the release of chemicals, and the firing of neurons would make reading a book and writing software impossible. The brain abstracts the basic functions of maintaining the body so our conscious minds can consider other aspects of life.

The idea of abstraction is essential to writing software. In Processing, drawing functions such as `line()`, `ellipse()`, and `fill()` obscure the complexity of their actions so the programmer can focus on results rather than implementation. If a programmer wants to draw a line, she probably wants to think only about its position, thickness, and color. She doesn't want to think about the many lines of code that run behind the scenes to convert the defined line into a sequence of pixels.

Why functions?

Before explaining in detail how to write your own functions, we'll first look at an example of why you might want to use them. The following examples show how to make a program shorter and more modular by adding a function. This makes the code easier to read, modify, and expand.

It's common to draw the same shape to the screen many times. We've created the shape you see below on the left, and now we want to draw it to the screen in the pattern on the right:

We start by drawing it once, to make sure the code is working.

24-01

```
void setup() {
  size(100, 100);
  noStroke();
}

void draw() {
  background(204);
  fill(255);
  ellipse(50, 50, 60, 60);       // White circle
  fill(0);
  ellipse(50+10, 50, 30, 30);    // Black circle
  fill(255);
  ellipse(50+16, 45, 6, 6);      // Small, white circle
}
```

The previous program presents a sensible way to draw the shape once, but when another shape is added, we see a trend that continues for each additional shape. When a second shape is added inside draw(), it doubles the amount of code. Because it takes 6 lines of code to draw each shape, we now have 12 lines. Our desired pattern with 6 of these shapes will require 36 lines of code. Imagine if we wanted to draw 30 of them—the code inside draw() would bloat to 180 lines.

```
void setup() {
  size(100, 100);
  noStroke();
}

void draw() {
  background(204);
  // Right shape
  fill(255);
  ellipse(65, 44, 60, 60);
  fill(0);
  ellipse(75, 44, 30, 30);
  fill(255);
  ellipse(81, 39, 6, 6);
  // Left shape
  fill(255);
  ellipse(20, 50, 60, 60);
  fill(0);
  ellipse(30, 50, 30, 30);
  fill(255);
  ellipse(36, 45, 6, 6);
}
```

Because the shapes are identical, a function can be written to draw it. The function introduced in the next example has two inputs that set the x-coordinate and y-coordinate. The lines of code inside the function block render the circles needed to draw one shape.

```
void setup() {
  size(100, 100);
  noStroke();
}

void draw() {
  background(204);
  eye(65, 44);
  eye(20, 50);
}

void eye(int x, int y) {
  fill(255);
  ellipse(x, y, 60, 60);
  fill(0);
```

```
      ellipse(x+10, y, 30, 30);
      fill(255);
      ellipse(x+16, y-5, 6, 6);
    }
```

The function is 8 lines of code, but it only has to be written once. The code in the function runs each time it is referenced in draw(). Using this strategy, it would be possible to draw 30 shapes with only 38 lines of code.

A closer look at the flow of this program reveals how functions work and affect the program flow. Each time the function is used within draw(), the 6 lines of code inside the function block are run. The normal flow of the program is diverted by the function call, the code inside the function is run, and then the program returns to read the next line in draw().

```
size(100, 100)                      Start with code in setup( )

noStroke( )
background(204)                     Enter draw( )
                                    Divert to the eye function
fill(255)

ellipse(65, 44, 60, 60)

fill(0)

ellipse(75, 44, 30, 30)

fill(255)

ellipse(81, 39, 6, 6)

fill(255)                           Back to draw( ), divert to the eye function a second time

ellipse(20, 50, 60, 60)

fill(0)

ellipse(30, 50, 30, 30)

fill(255)

ellipse(36, 45, 6, 6)

background(204)                     Enter draw( ) a second time

Etc...
```

Now that the function is working, it can be used each time we want to draw that shape. If we want to use the shape in another program, we can copy and paste the function. We no longer need to think about how the shape is being drawn or what each line of code inside the function does. We only need to remember how to control the position with the two parameters.

```
void setup() {
  size(100, 100);
  noStroke();
}

void draw() {
  background(204);
  eye(65,  44);
  eye(20,  50);
  eye(65,  74);
  eye(20,  80);
  eye(65,  104);
  eye(20,  110);
}

void eye(int  x,  int  y) {
  fill(255);
  ellipse(x,  y,  60,  60);
  fill(0);
  ellipse(x+10,  y,  30,  30);
  fill(255);
  ellipse(x+16,  y-5,  6,  6);
}
```

Create functions

To write a function, start with a clear idea about what the function will do. Does it draw a specific shape? Calculate a number? Filter an image? After you know what the function will do, think about the parameters and the data type for each. Have a goal and break the goal into small steps.

In the following example, we first put together a program to explore some of the details of the function before writing it. Then, we start to build the function, adding one parameter at a time and testing the code at each step.

```
void setup() {
  size(100, 100);
}

void draw() {
  background(204);
  // Draw thick, light gray X
  stroke(160);
  strokeWeight(20);
```

```
    line(0, 5, 60, 65);
    line(60, 5, 0, 65);
    // Draw medium, black X
    stroke(0);
    strokeWeight(10);
    line(30, 20, 90, 80);
    line(90, 20, 30, 80);
    // Draw thin, white X
    stroke(255);
    strokeWeight(2);
    line(20, 38, 80, 98);
    line(80, 38, 20, 98);
}
```

To write a function capable of drawing the three X's in the previous example, first write a function to draw just one. The function is named drawX() to make its purpose clear. The code in the block draws a light gray X in the upper-left corner. Because this function has no parameters, it will always draw the same X each time its code is run. The keyword void appears before the function's name, which means the function does not return a value (see p. 347 for more on void).

```
void setup() {
    size(100, 100);
}

void draw() {
    drawX();
}

void drawX() {
    background(204);
    // Draw thick, light gray X
    stroke(160);
    strokeWeight(20);
    line(0, 5, 60, 65);
    line(60, 5, 0, 65);
}
```

A parameter must be added to the function to draw the X differently. In the next example the gray parameter variable controls the gray value of the X drawn in the block. Inside the parentheses after the function name, the parameter variable must include its data type and its name, in this case the type is int and the name is gray.

When the function is called from within draw(), the value within the parentheses to the right of the function name is assigned to gray. In this example, the value o is assigned to gray, so the stroke is set to black.

```
void setup() {
   size(100, 100);
}

void draw() {
   background(204);
   drawX(0);   // Passes 0 to drawX(), runs drawX()
}

void drawX(int gray) {   // Declares and assigns gray
   stroke(gray);         // Uses gray to set the stroke
   strokeWeight(20);
   line(0, 5, 60, 65);
   line(60, 5, 0, 65);
}
```

A function can have more than one parameter. Each parameter for the function must be placed between the parentheses after the function name, each must state its data type, and commas must separate multiple parameters. In this example, the additional parameter weight is added to control the thickness of the line through the strokeWeight() function inside the block.

```
void setup() {
   size(100, 100);
}

void draw() {
   background(204);
   drawX(0, 30);   // Passes values to drawX(), runs drawX()
}

void drawX(int gray, int weight) {
   stroke(gray);
   strokeWeight(weight);
   line(0, 5, 60, 65);
   line(60, 5, 0, 65);
}
```

The next example extends drawX() with three additional parameters to control the position and size of the X.

```
void setup() {
  size(100, 100);
}

void draw() {
  background(204);
  drawX(0, 30, 40, 30, 36);
}

void drawX(int gray, int weight, int x, int y, int size) {
  stroke(gray);
  strokeWeight(weight);
  line(x, y, x+size, y+size);
  line(x+size, y, x, y+size);
}
```

24-09

By carefully building our function one step at a time, we have reached the original goal of writing a general function capable of drawing the three X's in code 24-05 (p. 338). The finished drawX() function has five parameters to define the visual aspects of each shape. Notice below that each function call inside draw() has five parameters. The number and data type of each parameter put into a function call must match the number and data type as defined in the function.

If a function call is drawX(160.2, 20, 0, 5, 60) there will be an error because first parameter must be an integer. If a function call is drawX(160, 20, 0, 5) there will be an error because it has only four parameters.

```
void setup() {
  size(100, 100);
}

void draw() {
  background(204);
  drawX(160, 20, 0, 5, 60);  // Draw thick, light gray X
  drawX(0, 10, 30, 20, 60);  // Draw medium, black X
  drawX(255, 2, 20, 38, 60); // Draw thin, white X
}
```

24-10

```
void drawX(int gray, int weight, int x, int y, int size) {
    stroke(gray);
    strokeWeight(weight);
    line(x, y, x+size, y+size);
    line(x+size, y, x, y+size);
}
```

24-10
cont.

Now that the drawX() function exists, it is possible to write programs that would
not be practical without it. For example, calls to drawX() can be placed inside a for
loop to create many repetitions. With a variable, each X drawn can be differently by
passing unique parameters into the function.

24-11

```
void setup() {
    size(100, 100);
}

void draw() {
    background(204);
    for (int i = 0; i < 20; i++) {
        drawX(200-i*10, (20-i)*2, i, i/2, 70);
    }
}

void drawX(int gray, int weight, int x, int y, int size) {
    stroke(gray);
    strokeWeight(weight);
    line(x, y, x+size, y+size);
    line(x+size, y, x, y+size);
}
```

```
void setup() {
  size(700, 100);
  frameRate(4);
}

void draw() {
  background(204);
  for (int i = 0; i < 70; i++) {   // Draw 70 X shapes
    int grayValue = int(random(255));
    int thickness = int(random(30));
    int x = int(random(-50, width));
    int y = int(random(-50, height));
    drawX(grayValue, thickness, x, y, 100);
  }
}

void drawX(int gray, int weight, int x, int y, int size) {
  stroke(gray);
  strokeWeight(weight);
  line(x, y, x+size, y+size);
  line(x+size, y, x, y+size);
}
```

In the next series of examples, a leaf() function is created from code 15-17 (p. 195) to draw a leaf shape, and a vine() function is created to arrange a group of leaves onto a line. These examples demonstrate how functions can run inside other functions. The leaf() function has four parameters that determine the position, size, and orientation:

int x	X-coordinate
int y	Y-coordinate
int size	Width of the leaf in pixels
int dir	Direction, either 1 (right) or -1 (left)

This simple program draws one leaf and shows how the parameters affect its attributes.

```
void setup() {
  size(100, 100);
  noStroke();
}

void draw() {
  background(0);
  leaf(26, 83, 60, 1);
}

void leaf(int x, int y, int size, int dir) {
  pushMatrix();
  translate(x, y);   // Move to position
  scale(size);       // Scale to size
  beginShape();      // Draw the shape
  vertex(1.0*dir, -0.7);
  bezierVertex(1.0*dir, -0.7, 0.4*dir, -1.0, 0.0, 0.0);
  bezierVertex(0.0, 0.0, 1.0*dir, 0.4, 1.0*dir, -0.7);
  endShape();
  popMatrix();
}
```

The vine() function has parameters to set the position, the number of leaves, and the size of each leaf:

int x	X-coordinate
int numLeaves	Total number of leaves on the vine
int leafSize	Width of the leaf in pixels

This function determines the form of the vine by applying a few rules to the parameter values. The code inside vine() first draws a white vertical line, then determines the space between each leaf based on the height of the display window and the total number of leaves. The first leaf is set to draw to the right of the vine, and the for loop draws the number of leaves specified by the numLeaves parameter. The x parameter determines the position, and leafSize sets the size of each leaf. The y-coordinate of each leaf is slightly different each time the program is run because of the random() function.

```
void setup() {
  size(100, 100);
  frameRate(2);
}

void draw() {
  background(0);
  int leaves = int(random(2, 15));
  vine(33, leaves, 16);
}

void vine(int x, int numLeaves, int leafSize) {
  stroke(255);
  line(x, 0, x, height);
  noStroke();
  int gap = height / numLeaves;
  int direction = 1;
  for (int i = 0; i < numLeaves; i++) {
    int r = int(random(gap));
    leaf(x, gap*i + r, leafSize, direction);
    direction = -direction;
  }
}

// Insert the leaf() function from code 24-13
```

The vine() function was written in steps and was gradually refined to its present code. In these examples, the vine() function is called from draw() and the qualities of the vine are set by different parameters. It could be extended with more parameters to control other aspects of the vine such as the color, or to draw on a curve instead of a straight line.

Shorter programs aren't the only benefit of using functions, but having fewer lines of code has advantages beyond a reduction in typing. Shorter programs lead to fewer errors—the more lines of code, the more chances for mistakes. Functions structure a program to make them easier to understand. To make an analogy, imagine a novel written as a continuous paragraph without indentations or line breaks. Functions act as paragraphs that make your program easier to read. The practice of reducing complex processes into smaller, easier-to-comprehend units helps structure ideas. But it's not simply a matter of making lots of functions. Each function should be a unit of code that clearly expresses a single idea, calculation, or unit of form.

Once a group of code is put into a function, the program is easy to modify because that line of code need only be changed once. For instance, in code 24-02, six lines of code are needed to draw each shape. If we wanted to change one small detail—for example,

the position of the small white circle in relation to the black circle—the corresponding line would need to be changed several times. If we were drawing nine shapes, nine lines of code would have to be changed.

Functions can also make programs easier to write because they encourage reusing code. A custom function can be reused in another program. As you write more programs, you'll build a collection of functions that are useful across much of your work. In fact, parts of Processing evolved from function collections that the authors used in their own work.

Overload functions

Multiple functions can have the same name, as long as they have different parameters. This may sound confusing, but it's a powerful idea. Creating different functions with the same name is called *function overloading*, and it's what allows Processing to have more than one version of functions like fill(), image(), and text(), each with different parameters. For instance, the fill() function can have one, two, three, or four parameters. Each version of fill() sets the fill value for shapes, but the number of parameters determines whether the fill value is gray, color, or includes transparency.

A program can also have two functions with the same number of parameters, but only if the data type for at least one of the parameters is different. For example, there are two versions of the fill() function with one parameter. The first uses a parameter of type int to set a color or hexadecimal value, while the second uses a parameter of type float to set a gray value. The Processing language would be frustrating if a separate function name were needed for each kind of fill.

As an example, the following program uses two different drawX() functions— both with the same name. The software knows which function to run by matching the number and data types of the parameters.

```
void setup() {                                              24-15
  size(100, 100);
}

void draw() {
  background(204);
  drawX(255);   // Run first drawX()
  drawX(0, 2, 44, 48, 36);   // Run second drawX()
}

// Draw an X with the gray value set by the parameter
void drawX(int gray) {
  stroke(gray);
  strokeWeight(20);
```

```
    line(0, 5, 60, 65);
    line(60, 5, 0, 65);
}

// Draw an X with the gray value, thickness,
// position, and size set by the parameters
void drawX(int gray, int weight, int x, int y, int s) {
    stroke(gray);
    strokeWeight(weight);
    line(x, y, x+s, y+s);
    line(x+s, y, x, y+s);
}
```

Calculate and return values

In the examples discussed so far, the output of a custom function has been shapes drawn to the screen. However, sometimes the preferred output is a number or any other type of data. Data output from a function is called the *return* value. All functions are expected to return a value, such as an int or a float. If the function does not return a value, the special type void is used. The type of data returned by a function is always written to the left of the function declaration. We've discussed functions that return values in previous chapters. For example, random() returns a float, and the color() function returns a value of the color data type.

The keyword return is used to exit a function and return to the location from which it was called. The return statement is typically the last line of a function because functions exit immediately after a return. The data to be returned by the function is written directly to the right of the return keyword.

Within a sketch, if a function returns a value, the function almost always appears to the right of an assignment operator or as a part of a larger expression. A function that does not return a value is commonly used as a complete statement. In the following example, notice how the value returned from the random() function is assigned to a variable, but the ellipse() function is not associated with a variable. If the random() function is not assigned to a variable, the value will be calculated but not stored.

```
float d = random(0, 100);
ellipse(50, 50, d, d);
```

When using functions that return values, it's important to be aware of the data type that is returned. For example, the random() function returns floating-point values. If the result of the random() function is assigned to an integer, an error will occur.

```
int d = random(0, 100);   // ERROR! random() returns a float        24-17
ellipse(50, 50, d, d);
```

The data-type conversion functions (p. 59) are useful for converting data into the format needed within a program. The previous example can be modified with the int() conversion function to match the type of data returned from random() to the type of data the result is assigned to:

```
int d = int(random(0, 100)); // int() converts the float value      24-18
ellipse(50, 50, d, d);
```

Consult the reference for each function to learn what data type is returned. Functions are not limited to returning numbers; they can return a PImage, String, boolean, or any other data type.

To write your own functions that return values, replace void with the data type you want to return. Include the return keyword inside your function to define the data to output. The value of the expression following the return will be output from the function. The following examples make useful calculations and return the values into variables.

```
void setup() {                                                       24-19
  float f = average(12.0, 6.0);   // Assign 9.0 to f
  println(f);
}

float average(float num1, float num2) {
  float av = (num1 + num2) / 2.0;
  return av;
}
```

```
void setup() {                                                       24-20
  float c = fahrenheitToCelsius(451.0); // Assign 232.77779 to c
  println(c);
}

float fahrenheitToCelsius(float t) {
  float f = (t-32.0) * (5.0/9.0);
  return f;
}
```

It is also important to note that you cannot overload the return value of a function. Unlike functions that behave differently when given float or int values, it's not possible to have two functions with the same name that differ only in the type of data they return.

Parameterize

Software provides a medium for exploring form in a unique way, and writing custom functions enables such exploration. Using functions to generate shapes that vary based on their parameters is called parameterized form. The leaf shape introduced in code 24-13 (p. 344) is an example of parameterized form. Different parameters passed into the `leaf()` function generate different forms:

Parameterized form can grow in complexity when several functions are combined. This combination of functions allows one parameter to produce more diversity. Code 24-14 (p. 345) defines how the `vine()` function places a series of leaves. Changing the parameters to `vine()` produces a wide variety of shapes:

In the examples that use `leaf()`, the shape of the element remains the same, but the size and orientation changes. In the examples that use `vine()`, the size and quantity of elements change, but the leaf shapes remain constant. Parameterized form can also be used to change the shape of an element.

The clever Ars Magna cards created by Tatsuya Saito are an example of a modular image system. Nine images are each split into two cards:

Any front card can be used with any back card to produce unexpected results:

A program for producing random combinations of the cards follows.

24-21

```
size(120, 100);
int front = int(random(1, 10));   // Select the front card
int back = int(random(1, 10));    // Select the back card
PImage imgFront = loadImage(front + "f.jpg");
PImage imgBack = loadImage(back  + "b.jpg");
image(imgFront, 0, 0);
image(imgBack, 60, 0);
```

The Ars Magna system can create many unexpected image juxtapositions, but it offers only a finite number of possible options. Another way to create parameterized form uses the values input to a function to create continuous changes in the shape of a visual element. This is one of the greatest advantages of creating visual form with code.

A simple arch() function created using bezierVertex(), for example, can be continuously modulated by changes to a single parameter value. The parameter for arch() is a floating-point number, so it can be varied at extremely small measurements. A change in the parameter from 25.0001 to 25.0002 won't look different on screen, but will define a slightly different shape. The differences in shapes formed by using larger increments imply the possible shapes that lie between:

c=15.0

c=25.0

c=35.0

c=45.0

c=55.0

```
float c = 25.0;

void setup() {
  size(100, 100);
}

void draw() {
  background(204);
  arch(c);
}

void arch(float curvature) {
  float y = 90.0;
  strokeWeight(6);
  noFill();
  beginShape();
  vertex(15.0, y);
  bezierVertex(15.0, y-curvature, 30.0, 55.0, 50.0, 55.0);
  bezierVertex(70.0, 55.0, 85.0, y-curvature, 85.0, y);
  endShape();
}
```

Within a parameterized system such as the arch() function, the value of one variable can affect the value of others. This is called coupling. If we change the code inside of the arch() function, the input parameter curvature can control the stroke thickness as well as the curvature.

c=15.0

c=35.0

c=55.0

```
void arch(float curvature) {
  float y = 90.0;
  float sw = (65.0 - curvature) / 4.0;
  strokeWeight(sw);
  noFill();
  beginShape();
  vertex(15.0, y);
  bezierVertex(15.0, y-curvature, 30.0, 55.0, 50.0, 55.0);
  bezierVertex(70.0, 55.0, 85.0, y-curvature, 85.0, y);
  endShape();
}
```

This is a modest example. The single input into arch() could be used to change every aspect of its display, including its values, rotation, size, and so forth. The following sketches present more ideas related to the concept of parameterized form.

```
x=110
u=20
a=0.13
```

```
x=119
u=25
a=0.18
```

```
x=20
u=14
a=-0.12
```

```
x=40
u=9
a=-0.08
```

```
x=9
u=17
a=-0.18
```

```
int x = 20;        // X-coordinate
int u = 14;        // Units
float a = -0.12;   // Angle

void setup() {
  size(100, 100);
  stroke(255, 204);
}

void draw() {
  background(0);
  tail(x, u, a);
}

void tail(int xpos, int units, float angle) {
  pushMatrix();
  translate(xpos, 0);
  for (int i = units; i > 0; i--) {   // Count in reverse
    strokeWeight(i);
    line(0, 0, 0, 8);
    translate(0, 8);
    rotate(angle);
  }
  popMatrix();
}
```

The next example is an animated extension of the previous code. Here the angle
variable for the tail() function is continually changing to produce a swaying motion.
Because the angles for each shape accumulate with each unit, the longest shapes with
the most units swing from side to side with a greater curvature.

```
float inc = 0.0;

void setup() {
  size(100, 100);
  stroke(255, 204);
}

void draw() {
  background(0);
  float angle = sin(inc)/10.0 + sin(inc*1.2)/20.0;
  tail(18, 9, angle/1.3);
  tail(33, 12, angle);
  tail(44, 10, angle/1.3);
```

```
        tail(62, 5, angle);
        tail(88, 7, angle*2);
        inc += 0.01;
    }

    // Insert the tail() function from code 24-24
```

24-25
cont.

The next example draws a simple face based on the values of the three variables defined at the top of the code. As the images reveal, the face() function can draw a range of options through adjusting these values.

24-26

x=20
y=80
g=26

x=40
y=80
g=12

x=70
y=40
g=15

```
int x = 40;   // X-coordinate
int y = 30;   // Y-coordinate
int g = 20;   // Gap between eyes

void setup() {
    size(100, 100);
    fill(0);
}

void draw() {
    background(204);
    face(x, y, g);
}

void face(int x, int y, int gap) {
    stroke(0);
    line(x, 0, x, y);                        // Nose Bridge
    line(x, y, x+gap, y);                    // Nose
    line(x+gap, y, x+gap, 100);
    int mouthY = height - (height-y)/2;
    line(x, mouthY, x+gap, mouthY);          // Mouth
    noStroke();
    ellipse(x-gap/2, y/2, 5, 5);             // Left eye
    ellipse(x+gap, y/2, 5, 5);               // Right eye
}
```

Recursion

A function can also contain a line of code that refers to itself—a technique called *recursion* that can be used in many ways to produce form and make calculations. A common example of recursion outside of software is standing between two mirrors to see infinite reflections. In software, recursion means that a function can call itself within its own block. To prevent this from continuing forever (as with the mirrors), it's necessary to have some way for the function to exit. The following two programs produce the same result by different means, the first using a for loop and the second using recursion.

```
void setup() {
  size(100, 100);
  drawLines(5, 15);
}

void drawLines(int x, int num) {
  for (int i = 0; i < num; num -= 1) {
    line(x, 20, x, 80);
    x += 5;
  }
}
```
24-27

```
void setup() {
  size(100, 100);
  drawLines(5, 15);
}

void drawLines(int x, int num) {
  line(x, 20, x, 80);
  if (num > 0) {
    drawLines(x+5, num-1);
  }
}
```
24-28

The recursive example uses more of the computer's resources to complete the task. For such a simple calculation, using the for loop is advised, but the recursive approach opens other possibilities. The following two examples utilize the custom drawT() function to show the effects of recursion.

```
x=24        int x = 50;    // X-coordinate of the center
y=65        int y = 100;   // Y-coordinate of the bottom
a=45        int a = 35;    // Half the width of the top bar

x=50        void setup() {
y=100         size(100, 100);
a=35          noLoop();
            }

x=76        void draw() {
y=50          drawT(x, y, a);
a=12        }

            void drawT(int xpos, int ypos, int apex) {
              line(xpos, ypos, xpos, ypos-apex);
              line(xpos-(apex/2), ypos-apex,
                   xpos+(apex/2), ypos-apex);
            }
```

The drawT() function is made recursive by the inclusion of a call to itself within the function block. A fourth parameter called num is added to set the number of recursions. This value is decremented by 1 each time the function calls itself. When the value is no longer greater than 0, the recursion stops, the program returns to the draw() block, and the image is drawn to the screen.

```
x=50        int x = 50;    // X-coordinate of the center
a=20        int y = 100;   // Y-coordinate of the bottom
n=8         int a = 35;    // Half the width of the top bar
            int n = 3;     // Number of recursions

x=50        void setup() {
a=35          size(100, 100);
n=3         }

x=50        void draw() {
a=45          background(204);
n=12          drawT(x, y, a, n);
            }

            void drawT(int x, int y, int apex, int num) {
              line(x, y, x, y-apex);
              line(x-apex, y-apex, x+apex, y-apex);
              // This relational expression must eventually be
              // false to stop the recursion and return to draw()
```

```
     if (num > 0) {
         drawT(x-apex, y-apex, apex/2, num-1);
         drawT(x+apex, y-apex, apex/2, num-1);
     }
 }
```

A binary tree structure (one that has two branches from each node) like the one above can be visualized in different ways. This program draws a circle at every node. The y-coordinate for each node is the same, and the radius for each circle is halved at each layer.

x=63
r=100
n=8

x=63
r=85
n=6

x=63
r=70
n=4

```
int x = 63;   // X-coordinate
int r = 85;   // Starting radius
int n = 6;    // Number of recursions

void setup() {
    size(100, 100);
    noStroke();
}

void draw() {
    background(204);
    drawCircle(x, r, n);
}

void drawCircle(int x, int radius, int num) {
    float tt = 126 * num/4.0;
    fill(tt);
    ellipse(x, 50, radius*2, radius*2);
    if (num > 0) {
        drawCircle(x - radius/2, radius/2, num-1);
        drawCircle(x + radius/2, radius/2, num-1);
    }
}
```

A slight modification yields a radical alteration of the form. Circles in every subsequent layer are given random positions relative to the previous position. The resulting images have a balance between order and disorder. At each level of recursion, the size of the circles decrease, their distance from the previous level decreases, and their values grow darker. The number used as the parameter to randomSeed() is updated twice each second to produce a different composition.

```
int x = 350;    // X-coordinate
int y = 50;     // Y-coordinate
int r = 80;     // Starting radius
int n = 7;      // Number of recursions
int rs = 0;     // Random seed value

void setup() {
  size(700, 100);
  noStroke();
  frameRate(2);
}

void draw() {
  background(0);
  randomSeed(rs);
  drawCircle(x, y, r, n);
  rs++;
}

void drawCircle(float x, float y, int radius, int num) {
  float value = 255 * num / 6.0;
  fill(value, 153);
  ellipse(x, y, radius*2, radius*2);
  if (num > 1) {
    num = num - 1;
    int branches = int(random(2, 6));
    for (int i = 0; i < branches; i++) {
      float a = random(0, TWO_PI);
      float newx = x + cos(a) * 16.0 * num;
```

24-32

```
      float newy = y + sin(a) * 6.0 * num;
      drawCircle(newx, newy, radius/2, num);
    }
  }
}
```

24-32
cont.

Exercises

1. *Write a function to draw a shape. Use it to draw the shape to the screen multiple times, each at a different position.*
2. *Extend the function created for exercise 1. Add more parameters to control additional aspects the shape.*
3. *Create a function to draw a chair. Use two parameters to change its position and two more to change the shape. Use the function to draw nine chairs in the display window in a regular 3 × 3 matrix. Use different parameters to give each chair a unique shape (e.g., does it have a high or low back?).*
4. *Write a function to calculate and return a value. For instance, convert inches to centimeters. Write a sketch to show how to use it.*
5. *Modify code 24-30 to explore recursion in more depth.*

25 Objects

This chapter introduces the concept of object-oriented programming and presents the code elements for working with objects.

Syntax introduced:
`class, Object, new`
`extends, super`

Object-oriented programming is a coding technique to formalize the relationships between interconnected variables and functions. A *class* defines a group of related methods (functions) and fields (variables) and an *object* is a single instance of a class. To use two analogies, a class is like a blueprint, and an object is a building constructed from that blueprint; a class is like a recipe for a cake, and an object is the cake. Like blueprints and recipes, many objects can be constructed from a single class definition. Objects can provide a powerful way to think about structuring your ideas in code, and you'll find a number of examples with objects throughout the rest of this text.

Object-oriented programming is a different approach to programming, but it builds on the previously introduced concepts. The technology for object-oriented programming existed long before the practice became popular in the mid-1980s and gradually went on to become the dominant way to think about software. Many people find it a more intuitive way to think about programming. In addition to providing a helpful conceptual model, object-oriented programming becomes more useful when a program includes many elements or when it grows larger than a few pages of code.

All software written in Processing consists of objects, but this fact is initially hidden so that object-oriented programming concepts can be introduced later. Unless code is made explicitly object-oriented, clicking the Run button transparently adds extra syntax that wraps a sketch as an object.

Object-oriented programming

A modular program is composed of code modules, each of which performs a specific task. Variables are the most basic way to think about reusing elements within a program. They allow a single value to appear many times within a program and to be easily changed. Functions abstract a specific task and allow code blocks to be reused throughout a program. Typically, one is concerned only with what a function does, not with how it works. This frees the mind to focus on the goals of the program rather than on the complexities of infrastructure. Object-oriented programming further extends the modularity of using variables and writing functions by allowing related functions and variables to be grouped together.

It is possible to make an analogy between software objects and real-world artifacts. To get you in the spirit of thinking about the world through the object-oriented lens, we've created a list of everyday items and a few potential fields and methods for each.

Name	*Apple*
Fields	*color, weight*
Methods	*grow(), fall(), rot()*

Name	*Butterfly*
Fields	*species, gender*
Methods	*flapWings(), land()*

Name	*Radio*
Fields	*frequency, volume*
Methods	*turnOn(), tune(), setVolume()*

Name	*Car*
Fields	*make, model, color, year*
Methods	*accelerate(), brake(), turn()*

Extending the apple example reveals more about the process of thinking about the world in relation to software objects. To make a software simulation of the apple, the grow() method might have inputs for temperature and moisture. The grow() method can increase the weight field of the apple based on these inputs. The fall() method can continually check the weight and cause the apple to fall to the ground when the weight goes above a threshold. The rot() method could then take over, beginning to decrease the value of the weight field and change the color fields.

As explained in the introduction, objects are created from a class and a class describes a set of fields and methods. An object, an instance of a class, is a variable. Like other variables, an object must have a unique name within the program. If more than one object is created from a class, each must have a unique name. For example, if one object named fuji and one named golden are created using the Apple class, each can have its own values for its fields:

Name	*fuji*
Fields	*color: red*
	weight: 6.2

Name	*golden*
Fields	*color: yellow*
	weight: 8.4

Before writing a class in code, it's common to build a diagram. Two popular styles of class diagrams are tables and a circular format inspired by biological cells. Each diagram style shows the name of the class, the fields, and the methods. It is useful to diagram classes in this way to define their characteristics before starting to code. The diagrams are also useful because they show the components of a class without including too much detail. Look at the `Apple` class and the `fuji` and `golden` objects created from it, to see an example of how these diagrams work:

Apple		fuji		golden
color *weight*		red 6.2		yellow 8.4
grow() *fall()* *rot()*		grow() fall() rot()		grow() fall() rot()

Apple class fuji object golden object

The circular diagrams reinforce the idea of *encapsulation*, that an object's fields should not be accessible from the outside. The methods of an object should act as a buffer between code outside the class and the data contained within:

Apple class fuji object golden object

The fields and methods of an object are accessed with the dot operator, a period. To get the color value from the `fuji` object, the syntax `fuji.color` accesses the value of the color field inside the `fuji` object. The syntax `golden.color` accesses the value of the color field inside the golden object. The dot operator is also used to activate (or "call") the methods of the object. To run the `grow()` method inside the golden object, the syntax `golden.grow()` is used.

With the concepts and terminology discussed in this chapter (object, class, field, method, encapsulation, and dot operator), you are equipped to begin the journey into object-oriented programming.

Classes and objects

Defining a class is creating a unique data type. Unlike the primitive types int, float, and boolean, a class is a composite type like String, PImage, and PFont, which means it can hold many variables and methods inside one name. When creating a class, first think carefully about what you want the code to do. As mentioned, it's common to make a list of variables required (these will be the fields) and figure out what type they should be.

The code on the following pages creates the same image of a white dot on the black background, but the code is written in different ways. In the first example program, a circle is positioned on screen. It needs two fields to store the location. These variables are float values that will provide more flexibility to control the circle's movement. The circle also needs a size, so we've created the diameter field to store its diameter:

float x	*X-coordinate of the circle*
float y	*Y-coordinate of the circle*
float diameter	*Diameter of the circle*

The name of a class should be carefully considered. The name can be nearly any word, adhering to the same naming conventions as variables (p. 54); however, class names should always be capitalized. This helps separate a class like String or PImage from the lowercase names of primitive types like int or boolean. The name Spot was chosen for this example because a spot is drawn to the screen (the name "Circle" also would have made sense). As with variables, it can be helpful to assign a class a name that matches its purpose.

Once the fields and name for the class definition have been determined, consider how the program would be written without the use of an object. In the following example, the data for the ellipse's position and diameter is a part of the main program. In this case, that's not a problem, but the use of several ellipses or complex motion would make the program unwieldy.

25-01

```
float x = 33.0;
float y = 50.0;
float diameter = 30.0;

void setup() {
  size(100, 100);
  noStroke();
}

void draw() {
  background(0);
  ellipse(x, y, diameter, diameter);
}
```

To make this code more generally useful, the next example moves the fields that pertain to the ellipse into their own class. The first line in the program declares the object sp of the type Spot. The Spot class is defined after setup() and draw(). The sp object is constructed within setup() with the keyword new, after which its fields can be accessed and assigned. The next three lines assign values to the fields within Spot. These values are accessed inside draw() to set the position and size of the ellipse. The dot operator is used to assign and access the variables within the class.

```
Spot sp;                      // Declare the object                  25-02

void setup() {
  size(100, 100);
  noStroke();
  sp = new Spot();            // Construct the object
  sp.x = 33;                  // Assign 33 to the x field
  sp.y = 50;                  // Assign 50 to the y field
  sp.diameter = 30;           // Assign 30 to the diameter field
}

void draw() {
  background(0);
  ellipse(sp.x, sp.y, sp.diameter, sp.diameter);
}

class Spot {
  float x, y;                 // The x- and y-coordinate
  float diameter;             // Diameter of the circle
}
```

The Spot class as it exists is not very useful, but it's a start. This next example builds on the previous one by adding a method to the Spot class—this is one more step toward using object-oriented programming to its advantage. A display() method has been added to the class definition to draw the element to the screen:

```
void display()        Draws the spot to the display window
```

In the following code, the last line inside draw() runs the display() method for the sp object by writing the name of the object and the name of the method connected with the dot operator. Also notice the difference in the parameters of the ellipse function in codes 25-02 and 25-03. In code 25-03, the name of the object is not used to access the x, y, and diameter fields. This is because the ellipse() function is called from within the Spot object. Because this line of code is a part of the object's display() function, it can access its own variables without specifying an object's name.

It's important to reinforce the difference between the Spot class and the sp object in this example. Although the code might make it look like the fields x, y, and diameter and the method display() belong to Spot, this is just the definition for any object created from this class. Each of these elements belongs to (is encapsulated by) the sp variable, which is one instance of the Spot data type.

25-03

```
Spot sp;              // Declare the object

void setup() {
  size(100, 100);
  noStroke();
  sp = new Spot();   // Construct the object
  sp.x = 33;
  sp.y = 50;
  sp.diameter = 30;
}

void draw() {
  background(0);
  sp.display();
}

class Spot {
  float x, y, diameter;

  void display() {
    ellipse(x, y, diameter, diameter);
  }
}
```

The next example introduces a new programming element called a *constructor*. A constructor is a block of code activated as the object is created. The constructor always has the same name as the class and is typically used to assign values to an object's fields as it comes into existence. (If there is no constructor, the value of every numeric field is set to zero.) The constructor is like other methods except that it is not preceded with a data type or the keyword void because there is no return type possible. In the following example, when the object sp is created, the parameters 33, 50, and 30 are assigned in order to the variables xpos, ypos, and dia within the constructor. Within the constructor block, these values are assigned to the object's fields x, y, and diameter. For the fields to be accessible within every method of the object, they must be declared outside of the constructor. Remember the rules of variable scope (p. 81)—if the fields are declared within the constructor, they cannot be accessed outside the constructor.

```
Spot sp;                        // Declare the object        25-04

void setup() {
   size(100, 100);
   noStroke();
   sp = new Spot(33, 50, 30);   // Construct the object
}

void draw() {
   background(0);
   sp.display();
}

class Spot {
   float x, y, diameter;

   Spot(float xpos, float ypos, float dia) {
      x = xpos;            // Assign 33 to x
      y = ypos;            // Assign 50 to y
      diameter = dia;      // Assign 30 to diameter
   }

   void display() {
      ellipse(x, y, diameter, diameter);
   }
}
```

The behavior of the Spot class can be extended by the addition of more methods and fields to the definition. The following example extends the class so that the ellipse moves up and down the display window and changes direction when it collides with the top or bottom. Since the circle will be moving, it needs a variable to set the speed, and because it will change directions, it needs another to hold the current direction. We've named these fields speed and direction to make their uses clear and the names short. We decided to make the speed a float value to give a broader range of possible speeds. The direction field is an int so that it can be easily incorporated into the math for its movement:

float speed	Distance moved each frame
int direction	Direction of motion (1 is down, -1 is up)

To create the desired motion, we need to update the position of the circle on each frame. The direction also has to change at the edges of the display window. To test for an edge, the code checks whether the y-coordinate is smaller than the circle's radius or larger than the height of the window minus the circle's radius. Make sure to include the

radius value; then the direction will change when the outer edge of the circle (rather than its center) reaches the edge. In addition to deciding what the methods need to do and what they should be called, we must also consider the return type. Because nothing is returned from this method, the keyword void is used:

```
void move()          Update the circle's position and direction
```

The code within the move() and display() methods could have been combined in one method; they were separated to make the example more clear. Changing the position of the object is a separate task from drawing it to the screen, and using separate methods reflects this. These changes allow every object created from the Spot class to have its own size and position. The objects will also move up and down the screen, changing directions at the edge.

25-05

```
class Spot {
    float x, y;           // X-coordinate, y-coordinate
    float diameter;       // Diameter of the circle
    float speed;          // Distance moved each frame
    int direction = 1;    // Direction of motion (1 is down, -1 is up)

    // Constructor
    Spot(float xpos, float ypos, float dia, float sp) {
        x = xpos;
        y = ypos;
        diameter = dia;
        speed = sp;
    }

    void move() {
        y += (speed * direction);
        if ((y > (height - diameter/2)) || (y < diameter/2)) {
            direction *= -1;
        }
    }

    void display() {
        ellipse(x, y, diameter, diameter);
    }
}
```

To save space and to keep the focus on the reuse of objects, examples from here to the end of the chapter won't reprint the code for the Spot class in examples that require it. Instead, when you see a comment like // Insert Spot class, cut and paste the code

for the class into this position to make the code work. Run the following code to see the result of the move() method updating the fields and the display() method drawing the sp object to the display window.

25-06

```
Spot sp; // Declare the object

void setup() {
  size(100, 100);
  noStroke();
  sp = new Spot(33, 50, 30, 1.5);  // Construct the object
}

void draw() {
  fill(0, 15);
  rect(0, 0, width, height);
  fill(255);
  sp.move();
  sp.display();
}

// Insert Spot class
```

Like a function, a well-written class enables the programmer to focus on the resulting behavior and not the details of execution. Objects should be built for the purpose of reuse. After a difficult programming problem is solved and encoded inside a class, that code can be used later as a tool for building new code. For example, the functions and classes used in Processing grew out of many commonly used functions and classes that were part of the authors' own code.

As long as the interface to the class remains the same, the code within can be updated and modified without requiring changes to a sketch that uses the object. For example, as long as the object is constructed with the x-coordinate, y-coordinate, and diameter and the names of move() and display() remain the same, the actual code inside Spot can be changed. This allows the programmer to refine the code for each object independently from the entire program.

Like other types of variables, additional objects are added to a program by declaring more, each with a unique name. The following program has three objects made from the Spot class. These objects, named sp1, sp2, and sp3, each has its own set of fields and methods. A method for each object is run by stating its name, followed by the dot operator and the method name. For example, the code sp1.move() runs the move() method, which is a part of the sp1 object. When these methods are run, they access the fields within their object. When sp3 runs move() for the first time, the field value y is updated by the speed field value of 1.5 because that value was passed into sp3 through the constructor.

```
Spot sp1, sp2, sp3;   // Declare the objects

void setup() {
   size(100, 100);
   noStroke();
   sp1 = new Spot(20, 50, 40, 0.5);   // Construct sp1
   sp2 = new Spot(50, 50, 10, 2.0);   // Construct sp2
   sp3 = new Spot(80, 50, 30, 1.5);   // Construct sp3
}

void draw() {
   fill(0, 15);
   rect(0, 0, width, height);
   fill(255);
   sp1.move();
   sp2.move();
   sp3.move();
   sp1.display();
   sp2.display();
   sp3.display();
}

// Insert Spot class
```

It is difficult to summarize the basic concepts and syntax of object-oriented programming using only one example. To make the process of creating objects easier to comprehend, we've created the Egg class to compare and contrast with Spot. The Egg class is built with the goal of drawing an egg shape to the screen and wobbling it left and right. The Egg class began as an outline of the fields and methods it needed to have the desired shape and behavior:

float x	X-coordinate for middle of the egg
float y	Y-coordinate for bottom of the egg
float tilt	Left and right angle offset
float angle	Amount of tilt (rotation)
float scalar	Height of the egg
void wobble()	Move the egg back and forth
void display()	Draw the egg

After the class requirements were established, it developed the same way as the Spot class. The Egg class started minimally, with only x and y fields and a display() method. The class was then added to a program with setup() and draw() to check the result. The scale() function was added to decrease the size of the egg. When this basic program was working to our satisfaction, the rotate() function and tilt field

were added to change the angle. Finally, the code was written to make the egg move. The angle field was added as a continuously changing number to set the tilt. The wobble() method was added to increment the angle and calculate the tilt. The cos() function was used to accelerate and decelerate the wobbling from side to side. After many rounds of incremental additions and testing, the final Egg class was working as initially planned.

```
class Egg {                                                          25-08
    float x, y;      // X-coordinate, y-coordinate
    float tilt;      // Left and right angle offset
    float angle;     // Used to define the tilt
    float scalar;    // Height of the egg

    // Constructor
    Egg(int xpos, int ypos, float t, float s) {
      x = xpos;
      y = ypos;
      tilt = t;
      scalar = s / 100.0;
    }

    void wobble() {
     tilt = cos(angle) / 8;
     angle += 0.1;
    }

    void display() {
      noStroke();
      fill(255);
      pushMatrix();
      translate(x, y);
      rotate(tilt);
      scale(scalar);
      beginShape();
      vertex(0, -100);
      bezierVertex(25, -100, 40, -65, 40, -40);
      bezierVertex(40, -15, 25, 0, 0, 0);
      bezierVertex(-25, 0, -40, -15, -40, -40);
      bezierVertex(-40, -65, -25, -100, 0, -100);
      endShape();
      popMatrix();
    }
}
```

The `Egg` class is included in `setup()` and `draw()` the same way as in the `Spot` examples. An object of type `Egg` called `humpty` is created outside of `setup()` and `draw()`. Within `setup()`, the `humpty` object is constructed and the coordinates and initial tilt value are passed to the constructor. Within `draw()`, the `wobble()` and `display()` methods are run in sequence, causing the egg's angle and tilt values to update. These values are used to draw the shape to the screen. Run this code to see the egg wobble from left to right.

```
Egg humpty;   // Declare the object                              25-09

void setup() {
  size(100, 100);
  // Inputs: x-coordinate, y-coordinate, tilt, height
  humpty = new Egg(50, 100, 0, 80);
}

void draw() {
  background(0);
  humpty.wobble();
  humpty.display();
}

// Insert Egg class
```

The `Ring` class is another example. It defines a circle that can be turned on, at which point it expands to a fixed width and then stops displaying to the screen by turning itself off. When this class is added to the example below, a new ring turns on each time a mouse button is pressed. The fields and methods for `Ring` make this behavior possible:

`float x`	*X-coordinate of the ring*
`float y`	*Y-coordinate of the ring*
`float diameter`	*Diameter of the ring*
`boolean on`	*Turns the display on and off*
`void grow()`	*Increases the diameter if on is true*
`void display()`	*Draws the ring*

As with `Spot` and `Egg`, `Ring` was first developed as a simple class. Its features emerged through a series of iterations. As a variation, this class has no constructor; its values are not set until the `start()` method is called within the program.

```
class Ring {
  float x, y;          // X-coordinate, y-coordinate
  float diameter;      // Diameter of the ring
  boolean on = false;  // Turns the display on and off

  void start(float xpos, float ypos) {
    x = xpos;
    y = ypos;
    diameter = 1;
    on = true;
  }

  void grow() {
    if (on == true) {
      diameter += 0.5;
      if (diameter > 400) {
        on = false;
        diameter = 1;
      }
    }
  }

  void display() {
    if (on == true) {
      noFill();
      strokeWeight(4);
      stroke(204, 153);
      ellipse(x, y, diameter, diameter);
    }
  }
}
```

There are many ways to use the Ring class in a program. The following example restarts the growth each time the mouse is pressed. An example with an array of objects created from the Ring class is found on page 426.

```
Ring r;

void setup() {
    size(100, 100);
    r = new Ring();
}

void draw() {
    background(0);
    r.grow();
    r.display();
}

void mousePressed() {
    r.start(mouseX, mouseY);
}

// Insert Ring class
```

The Spot, Egg, and Ring classes are three simple examples used to convey the basic syntax and concepts involved in object-oriented programming. More classes and objects are defined through the remainder of the book.

Multiple files

The programs written before this chapter have used one file for all of their code. As programs become longer, a single file can become inconvenient. When programs grow to hundreds and thousands of lines, breaking programs into modular units helps manage different parts of the program. Processing manages files with the Sketchbook, and each sketch can have multiple files that are managed with tabs.

The arrow button to the right of the sketch name, below the toolbar buttons in the Processing Development Environment (PDE), is used to manage these files. Click this button to reveal options to create a new tab, rename the current tab, and delete the current tab.

To see how tabs work, separate code 25-04 into separate files to make it into a more modular program. First open or retype this program into Processing and name it "Example4." Now click on the arrow button and select the New Tab option from the list that appears. A prompt asking for the name of the new tab appears. Type the name you want to assign to the file and click "OK" to continue. Because that tab will be storing the Spot class, use the name "Spot." You now have a new file called *Spot.pde* in your sketch folder. Select "Show Sketch Folder" from the Sketch menu to see this file.

Next, click on the original tab and select the text for the Spot class. Cut the text from this tab, change to the Spot tab, and paste. Save the sketch for good measure, and

Figure 25-1 Multiple Files
Sketches can be divided into different files and represented as tabs within the PDE. This makes it easier to manage complicated code.

press the Run button to see how the two files combine to create the final program. The file *Spot.pde* can be added to any sketch folder to make the Spot class accessible for that sketch.

When a sketch is created with multiple files, one of the files must have the same name as the folder containing the sketch to be recognized by Processing. This file is the main file for the sketch and always appears as the leftmost tab. The setup() and draw() for the sketch should be in this file. Only one of the files in a sketch can have a setup() and draw(). The other tabs appear in alphabetical order from left to right.

When a sketch is run, all of the PDE files that comprise a sketch are converted to one file before the code is compiled and run. Additional functions and variables across all tabs have access to all global variables defined in the main file. Advanced programmers may want a different behavior; a more detailed explanation can be found in the reference.

Multiple constructors

A class can have multiple constructors to assign the fields in different ways. Sometimes it's beneficial to specify every aspect of an object's data by assigning parameters to the fields through a constructor, but other times it might be appropriate to define only one or a few.

In the next example, one constructor sets the x-coordinate, y-coordinate, and diameter, while the other uses preset values. When the object is created, the program chooses the constructor to use depending on the number and type of variables specified. At the end of setup(), the sp1 object is created using the first version of the Spot constructor, and the sp2 object is created using the second version.

```
Spot sp1, sp2;                                          25-12

void setup() {
  size(100, 100);
  // Run the constructor without parameters
  sp1 = new Spot();
  // Run the constructor with three parameters
  sp2 = new Spot(66, 50, 20);
}

void draw() {
  background(204);
  sp1.display();
  sp2.display();
}
```

```
class Spot {
    float x, y, diameter;

    // First version of the Spot constructor;
    // the fields are assigned default values
    Spot() {
        x = 33;
        y = 50;
        diameter = 8;
    }

    // Second version of the Spot constructor;
    // the fields are assigned with parameters
    Spot(float xpos, float ypos, float d) {
        x = xpos;
        y = ypos;
        diameter = d;
    }

    void display() {
        ellipse(x, y, diameter, diameter);
    }
}
```

Composite objects

An object can include several other objects. Creating such *composite objects* is a good way to use the principles of modularity and build higher levels of abstraction. In the natural world, objects often possess components that operate independently but in relation to other components. To use a biological analogy, a cell class might be combined into muscle tissue and nervous tissue. These tissues can be combined into organs, and the organs into an organism. With multiple layers of abstraction, each step is built from composites of the previous layer. A bicycle class provides a different sort of example. It could be composed of objects for its frame, wheels, brakes, drivetrain, and so forth, and each of these units could be built from other classes. For example, the drivetrain could be built from objects for the pedals, crankset, and gears.

The following program combines the Egg class (p. 369) and the Ring class (p. 371) to create a new class called EggRing. It has one Egg object called ovoid, created in the constructor, and one Ring object called circle, created at the base of the class. The transmit() method calls the methods for both classes and resets circle when the object reaches its maximum size. As in all the examples using classes, the referenced classes must be included in the sketch for the project to run.

```
class EggRing {
  Egg ovoid;
  Ring circle = new Ring();

  EggRing(int x, int y, float t, float sp) {
    ovoid = new Egg(x, y, t, sp);
    circle.start(x, y - sp/2);
  }

  void transmit() {
    ovoid.wobble();
    ovoid.display();
    circle.grow();
    circle.display();
    if (circle.on == false) {
      circle.on = true;
    }
  }
}
```

When the EggRing class is used in a program, each instance draws an egg to the screen with one Ring object growing from its center.

```
EggRing er1, er2;

void setup() {
  size(100, 100);
  er1 = new EggRing(33, 66, 0.1, 33);
  er2 = new EggRing(66, 90, 0.05, 66);
}

void draw() {
  background(0);
  er1.transmit();
  er2.transmit();
}
```

Inheritance

A class can be defined using another class as a foundation. In object-oriented programming terminology, one class can *inherit* fields and methods from another. An object that *inherits* from another is called a *subclass*, and the object it inherits from is called a *superclass*. A subclass extends the superclass. When one class *extends* another, all of the methods and fields from the superclass are automatically included in the subclass. New fields and methods can be added to the subclass to build on the data and behavior of its superclass. Typically a more specialized class extends a more general class, where the behavior of the specialized class selectively alters and extends the subclass by replacing and adding fields and methods.

If a method name is repeated within the subclass and has the same prototype (the same number of parameters with the same data types) as the one in the superclass, the method in the subclass *overrides* the other, thereby replacing it. When a method or field from the superclass is called from within the subclass, the name is prefaced with the keyword super to let the software know this method or field is a part of the superclass. The following examples clarify these new terms and concepts.

The Spin class was created to help explain the concept of inheritance. This minimal class has fields for setting the x-coordinate, y-coordinate, speed, and angle. It has one method to update the angle.

```
class Spin {                                                      25-15
    float x, y, speed;
    float angle = 0.0;

    Spin(float xpos, float ypos, float s) {
        x = xpos;
        y = ypos;
        speed = s;
    }

    void update() {
        angle += speed;
    }
}
```

The SpinArm class inherits elements from Spin and draws a line using the superclass's data. The constructor for SpinArm simply calls the constructor of the superclass. The display() function uses the inherited x, y, angle, and speed fields to draw a rotating line. Notice that the declarations for these fields are not repeated in the subclass because they are inherently accessible to the subclass.

In the SpinArm constructor, super() is used to call the constructor of the Spin superclass. If super() with parameters is not used in the constructor of a subclass, a

line calling super() with no parameters will be inserted behind the scenes. For this reason, any class meant to be extended will usually require a version of its constructor with no parameters, except in cases like this example where all subclasses call super() explicitly.

25-16

```
class SpinArm extends Spin {

  SpinArm(float x, float y, float s) {
    super(x, y, s);
  }

  void display() {
    strokeWeight(1);
    stroke(0);
    pushMatrix();
    translate(x, y);
    angle += speed;
    rotate(angle);
    line(0, 0, 100, 0);
    popMatrix();
  }
}
```

The SpinSpots class also inherits the elements of Spin. Like the SpinArm class, it uses its superclass's fields and constructor, but it builds even further on Spin by adding another field. The dim field was added to give the option to change the size of the circles. Notice that this field is declared at the top of the class, assigned in the constructor, and accessed in the display() method to set the size of the circles.

25-17

```
class SpinSpots extends Spin {
  float dim;

  SpinSpots(float x, float y, float s, float d) {
    super(x, y, s);
    dim = d;
  }

  void display() {
    noStroke();
    pushMatrix();
    translate(x, y);
    angle += speed;
    rotate(angle);
```

```
      ellipse(-dim/2, 0, dim, dim);
      ellipse(dim/2, 0, dim, dim);
      popMatrix();
   }
}
```

The process of creating objects from a subclass is identical to that of creating objects from a normal class. The class is the data type, and object variables of this type are declared, created, and accessed with the dot operator. In the following program, one SpinSpot object and one SpinArm object are declared and created. Their update() methods are used to increment the angle and draw to the screen. The class definitions for Spin, SpinSpots, and SpinArm must be included in the same page or put in separate tabs within the same sketch.

```
// Requires the Spin, SpinSpots, and SpinArm class          25-18

SpinArm arm;
SpinSpots spots;

void setup() {
   size(100, 100);
   arm = new SpinArm(width/2, height/2, 0.01);
   spots = new SpinSpots(width/2, height/2, -0.02, 33.0);
}

void draw() {
   background(204);
   arm.update();
   arm.display();
   spots.update();
   spots.display();
}
```

While modular programming is an important technique, it can be too much of a good thing. Be careful to not make your code abstract to a point where it becomes cumbersome. For instance, in the Button example on p. 510, the definition of this simple button behavior with three classes is not practical. It was created this way to demonstrate key concepts of object-oriented programming, but could (and probably should) be simplified to one or two classes.

Exercises

1. Add new methods to extend the behavior of the Spot class from code 25-05.
2. Create an object from the new class from exercise 1 as shown in code 25-06.
3. Write an Apple class as defined in the diagrams on p. 361. For now, only implement the fall() method.
4. Write a sketch to use the Apple class from exercise 3 in a new program of your own design.
5. As demonstrated in code 25-16, write a new class to extend the Spin class and use it in a new sketch.

26 Synthesis 3

This chapter follows the development of a basic sketch into an object-oriented program.

Along with variables, conditionals, and loops, the techniques for working with functions and object-oriented coding are among the most essential components of learning to code. As demonstrated in the last two chapters, we recommend that beginners first write sketches without functions and classes, adding those after the logic and variables are figured out. The idea is to start the program in a way that is familiar and more basic, then to refine it with these more advanced techniques. With more experience, functions and classes can be outlined and used from the beginning. In the spirit of this approach, this chapter starts with a sketch that uses no custom functions or objects. Through a series of iterative sketches, the chapter builds a completely object-oriented sketch.

Modularity, reusability

Before digging into the examples, this section reviews *why* it is important to work with functions and objects. As the examples in the related chapters showed, it is almost always best to avoid writing code in a repetitive way. Sections of code that are largely redundant should be rewritten into a function or class to make the code shorter and more reusable. For instance, comparing code 24-02, 24-03, and 24-04 shows that writing a function to draw the eye shape makes the sketch shorter, easier to read, and easier to adapt. Once the few lines of code that put those shapes together were figured out, putting it into a function made it simple to reuse. Once a function or class is written, it is not only reusable within a single sketch, but these blocks of code can also be cut and pasted to be used in *any* sketch.

Modularity is the other great advantage to working with functions and objects. This ability extends the feature of reusability to utilizing code in a different way based on parameters. For instance, a function that draws a cube can draw it at different sizes based on the value of an input parameter. As explained in the Parameterize section (p. 349) of the Functions chapter, parameters are powerful tools to control the action and output of a function. A well-designed set of modular functions and classes sets the foundation for realizing ideas in code and can even encourage new ideas by making it easier to think about specific goals and problems in different ways.

Algorithm

The ideas behind defining and using *algorithms* are essential to concepts of reusability and modularity in functions and objects. While the word "algorithm" may sound complicated, its meaning is not. In an informal sense, an algorithm is any set of

instructions for doing something—for instance, an algorithm for poaching an egg or an algorithm for knitting a scarf.

In this chapter's examples, the code needs to calculate if a circle is overlapping with a rectangle. This can be determined with an algorithm that calculates if there is an intersection based on the geometry of the circle (the position and diameter) and the geometry of the rectangle (the position, width, and height). When this calculation is encoded inside a function, it can be reused anywhere within the program without having to write it more than once. This algorithm is made modular through including parameters so it can work with all circles and rectangles.

Examples

This example series is based on the classic videogame genre of paddle and ball games, including Pong, Breakout, and Arkanoid, where a rectangular paddle hits a square or circular ball. In addition to working up to functions and objects, these examples use the calculation, motion, and random value techniques introduced after the last Synthesis chapter. The motion techniques are used to animate the ball and to bounce it off the edges of the display window. The random numbers are used to set a new position and speed for the ball each time a point is scored. Before putting all of these pieces together, a series of short examples is presented to encode each step of the game into a short sketch. The follows steps are needed to play a simple ball and paddle game:

1. Control a paddle with the mouse
2. Serve a ball, bounce off the screen top and bottom
3. Calculate when the ball touches the paddle

Please run these sketches and modify them to get comfortable with the code. The first sketch draws a paddle at the right edge of the screen. It is controlled with the mouseY variable and is locked onto the screen with the constrain() function.

```
int paddleX;                                              26-01
int paddleY;
int paddleHeight = 100;
int paddleWidth = 20;

void setup() {
  size(600, 600);
  paddleX = width-paddleWidth*2;
}

void draw() {
  background(0);
```

```
    // Update paddle
    paddleY = mouseY - paddleHeight/2;
    paddleY = constrain(paddleY, 0, height-paddleHeight);

    // Draw paddle
    fill(102);
    noStroke();
    rect(paddleX, paddleY, paddleWidth, paddleHeight);
}
```

The next sketch outlines the behavior of the ball by combining code fragments from the Motion chapter. There are two main conditional blocks. The first resets the position of the ball after it moves off the right edge of the screen. The y-coordinate of the ball is set to a random value within a range, and the speed along the x- and y-axis is set to new values. The second conditional defines the behavior when the ball touches the top or bottom of the screen.

```
float ballX;
float ballY;
float ballSpeedX = random(3, 5);
float ballSpeedY = random(-2, 2);
float ballDiameter = 20.0;
float ballRadius = ballDiameter/2;

void setup() {
  size(600, 600);
  ballX = -ballRadius;
  ballY = height/2;
}

void draw() {
  background(0);

  // Draw ball
  fill(255);
  noStroke();
  ellipse(ballX, ballY, ballDiameter, ballDiameter);

  // Update ball location
  ballX = ballX + ballSpeedX;
  ballY = ballY + ballSpeedY;
```

Figure 26-1
Screen captures for code 26-01.

Figure 26-2
Screen captures for code 26-02.

Figure 26-3
Screen captures for code 26-03.

```
  // Reset position if ball leaves the screen
  if (ballX > width + ballRadius) {
    ballX = -ballRadius;
    ballY = random(height*0.25, height*0.75);
    ballSpeedX = random(3, 5);
    ballSpeedY = random(-6, 6);
  }

  // If ball hits top or bottom, change direction of Y
  if (ballY > height - ballRadius) {
    ballY = height - ballRadius;
    ballSpeedY = ballSpeedY * -1;
  } else if (ballY < ballRadius) {
    ballY = ballRadius;
    ballSpeedY = ballSpeedY * -1;
  }
}
```

The third preliminary sketch defines the code needed to test if a circle is intersecting with a rectangle. This algorithm is placed within the hitPaddle() function so that it is reusable and can be referenced within the draw() block. The function returns a boolean value, true if the shapes overlap and false if not. To test it with a short program, the circle is static in the center of the screen and the rectangle is moved with the cursor.

```
float ballX = 300.0;
float ballY = 300.0;
float ballDiameter = 200.0;

int paddleX;
int paddleY;
int paddleHeight = 150;
int paddleWidth = 50;

void setup() {
  size(600, 600);
  noCursor();
}

void draw() {
  background(0);

  // Update paddle
  paddleX = mouseX;
  paddleY = mouseY;
```

```
  // Draw paddle
  fill(102);
  noStroke();
  rect(paddleX, paddleY, paddleWidth, paddleHeight);

  // Draw ball
  fill(255);
  noStroke();
  ellipse(ballX, ballY, ballDiameter, ballDiameter);

  // Set variable to true if shapes are overlapping, false if not
  boolean collision = hitPaddle(paddleX, paddleY,
                           paddleWidth, paddleHeight,
                           ballX, ballY, ballDiameter/2);

  if (collision == true) {
    stroke(204);
    strokeWeight(10);
    line(0, 0, width, height);
    line(0, width, height, 0);
  }
}

boolean hitPaddle(int rx, int ry, int rw, int rh,
                  float cx, float cy, float cr) {

  float circleDistanceX = abs(cx - rx - rw/2);
  float circleDistanceY = abs(cy - ry - rh/2);

  if (circleDistanceX > (rw/2 + cr)) { return false; }
  if (circleDistanceY > (rh/2 + cr)) { return false; }
  if (circleDistanceX <= rw/2) { return true; }
  if (circleDistanceY <= rh/2) { return true; }

  float cornerDistance = pow(circleDistanceX - rw/2, 2) +
                         pow(circleDistanceY - rh/2, 2);
  if (cornerDistance <= pow(cr, 2)) {
    return true;
  } else {
    return false;
  }
}
```

Once the preliminary sketches are working, it's time to combine them into one longer program. Because this code is the longest program in the book so far, it may be tempting to be overwhelmed by it. Please resist this temptation. It is true that the code is longer, but that doesn't necessarily make it more complicated. When this program is looked at closely, it is clear that each part is collaged from one of the three first sketches in this chapter. The one additional component to this sketch is the behavior to change the direction along the x-axis when the ball hits the paddle. This is at the bottom of the draw() block.

```
float ballX;                                                    26-04
float ballY;
float ballSpeedX = random(3, 5);
float ballSpeedY = random(-2, 2);
float ballDiameter = 20.0;
float ballRadius = ballDiameter/2;

int paddleX;
int paddleY;
int paddleHeight = 100;
int paddleWidth = 20;

void setup() {
  size(600, 600);
  paddleX = width-paddleWidth*2;
  ballX = -ballRadius;
  ballY = height/2;
  noCursor();
}

void draw() {
  background(0);

  // Update paddle
  paddleY = mouseY - paddleHeight/2;
  paddleY = constrain(paddleY, 0, height-paddleHeight);

  // Draw paddle
  fill(102);
  noStroke();
  rect(paddleX, paddleY, paddleWidth, paddleHeight);
```

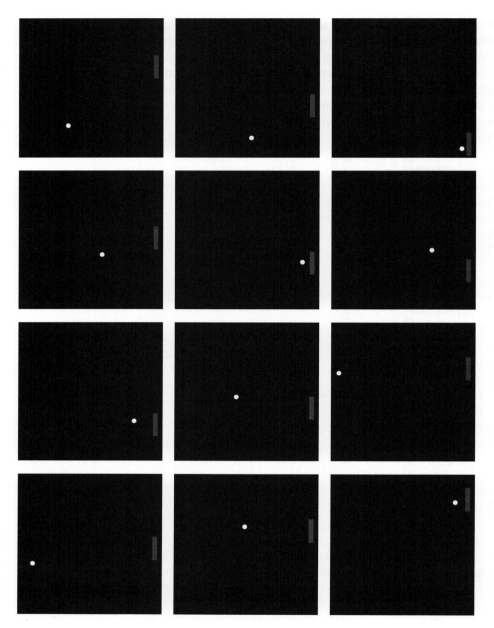

Figure 26-4
Screen captures for code 26-04 and 26-05.

```
// Draw ball
fill(255);
noStroke();
ellipse(ballX, ballY, ballDiameter, ballDiameter);

// Update ball location
ballX = ballX + ballSpeedX;
ballY = ballY + ballSpeedY;

// Reset position if ball leaves the screen
if (ballX > width + ballRadius) {
  ballX = -ballRadius;
  ballY = random(height*0.25, height*0.75);
  ballSpeedX = random(3, 5);
  ballSpeedY = random(-6, 6);
}

// If ball hits the left edge, change direction of X
if (ballX < ballRadius) {
  ballX = ballRadius;
  ballSpeedX = ballSpeedX * -1;
}

// If ball hits top or bottom, change direction of Y
if (ballY > height - ballRadius) {
  ballY = height - ballRadius;
  ballSpeedY = ballSpeedY * -1;
}
else if (ballY < ballRadius) {
  ballY = ballRadius;
  ballSpeedY = ballSpeedY * -1;
}

// Set variable to true if shapes are overlapping, false if not
boolean collision = hitPaddle(paddleX, paddleY,
                    paddleWidth, paddleHeight,
                    ballX, ballY, ballDiameter/2);

// Change ball direction when paddle is hit
// and bump it back to the edge of the paddle
```

```
    if (collision == true) {
      ballSpeedX = ballSpeedX * -1;
      ballX += ballSpeedX;
    }
}

boolean hitPaddle(int rx, int ry, int rw, int rh,
                  float cx, float cy, float cr) {

  float circleDistanceX = abs(cx - rx - rw/2);
  float circleDistanceY = abs(cy - ry - rh/2);

  if (circleDistanceX > (rw/2 + cr)) { return false; }
  if (circleDistanceY > (rh/2 + cr)) { return false; }
  if (circleDistanceX <= rw/2) { return true; }
  if (circleDistanceY <= rh/2) { return true; }

  float cornerDistance = pow(circleDistanceX - rw/2, 2) +
                         pow(circleDistanceY - rh/2, 2);
  if (cornerDistance <= pow(cr, 2)) {
    return true;
  } else {
    return false;
  }
}
```

Now that the basic features of the program are working together, it's time to work on making its elements more reusable and modular. In its current state, all of the variables and functions are global. Using object-oriented techniques, we want to group related variables with related functions. This restructuring will make the code more legible and easier to extend. The groupings needed are easy to see from the preliminary programs. The Paddle class will need the following:

float x	X-coordinate of the paddle
float y	Y-coordinate of the paddle
float w	Width of the paddle
float h	Height of the paddle
void update()	Change paddle position with cursor
void display()	Draw paddle to the display window

The `Ball` class will need the following:

float x	X-coordinate of the ball
float y	Y-coordinate of the ball
float diameter	Diameter of the ball
float radius	Radius of the ball
float speedX	Speed along the x-axis
float speedY	Speed along the y-axis
void update()	Change ball position
void display()	Draw ball to the display window
void hit()	Change ball direction when paddle is hit

The new code with a `Paddle` and `Ball` class follows. This sketch operates identically to the previous sketch, but it is formatted in a new way. Notice the difference between the `setup()` and `draw()` functions in this program in relation to the previous. Not only is this new example cleaner, but it is also easier to read. For instance, the `paddle.display()` method call is more evocative of the code intent than a sequenced `fill()` and `rectangle()` function.

```
Ball ball;                                                          26-05
Paddle paddle;

void setup() {
  size(600, 600);
  paddle = new Paddle();
  ball = new Ball();
  noCursor();
}

void draw() {
  background(0);

  paddle.update();    // Update paddle
  paddle.display();   // Draw paddle

  ball.update();      // Update ball
  ball.display();     // Draw ball

  // Set variable to true if shapes are overlapping, false if not
  boolean collision = hitPaddle(paddle, ball);
```

```
    if (collision == true) {
      ball.hit();
    }
}

boolean hitPaddle(Paddle p, Ball b) {

  float circleDistanceX = abs(b.x - p.x - p.w/2);
  float circleDistanceY = abs(b.y - p.y - p.h/2);

  if (circleDistanceX > (p.w/2 + b.radius)) { return false; }
  if (circleDistanceY > (p.h/2 + b.radius)) { return false; }
  if (circleDistanceX <= p.w/2) { return true; }
  if (circleDistanceY <= p.h/2) { return true; }

  float cornerDistance = pow(circleDistanceX - p.w/2, 2) +
                         pow(circleDistanceY - p.h/2, 2);
  if (cornerDistance <= pow(b.radius, 2)) {
    return true;
  } else {
    return false;
  }
}

class Ball {

  float x;   // X-coordinate of the ball
  float y;   // Y-coordinate of the ball
  float diameter = 20.0;   // Diameter of the ball
  float radius = diameter/2;      // Radius of the ball
  float speedX = random(3, 5);    // Speed along the x-axis
  float speedY = random(-2, 2);   // Speed along the y-axis

  Ball() {
    x = -radius;
    y = height/2;
  }

  // Change ball position
  void update() {
    // Update ball coordinates
    x = x + speedX;
    y = y + speedY;
```

```
    // Reset position if ball leaves the screen
    if (x > width + radius) {
      x = -radius;
      y = random(height*0.25, height*0.75);
      speedX = random(5, 15);
      speedY = random(-6, 6);
    }

    // If ball hits the left edge, change direction of X
    if (x < radius) {
      x = radius;
      speedX = speedX * -1;
    }

    // If ball hits top or bottom, change direction of Y
    if (y > height - radius) {
      y = height - radius;
      speedY = speedY * -1;
    }
    else if (y < radius) {
      y = radius;
      speedY = speedY * -1;
    }
  }

  // Draw ball to the display window
  void display() {
    fill(255);
    noStroke();
    ellipse(x, y, diameter, diameter);
  }

  // Change ball direction when paddle is hit
  // and bump it back to the edge of the paddle
  void hit() {
    speedX = speedX * -1;
    x += speedX;
  }

}
```

```
class Paddle {

    int x;   // X-coordinate of the paddle
    int y;   // Y-coordinate of the paddle
    int w = 20;    // Width of the paddle
    int h = 100;   // Height of the paddle

    Paddle() {
        x = width-w*2;
        y = height/2;
    }

    // Change paddle position with cursor
    void update() {
        y = mouseY - h/2;
        y = constrain(y, 0, height-h);
    }

    // Draw paddle to the display window
    void display() {
        fill(102);
        noStroke();
        rect(x, y, w, h);
    }

}
```

Before wrapping up this chapter, there are a few notes to mention about moving the example into object-oriented notation. First, when the variables for the paddle and ball go inside their respective classes, the names can be shortened because they are encapsulated in the classes. There is no longer a reason to use the variable name ballX, for instance, because the variable is *inside* the Ball class, it can be shortened to x. Next, the hitPaddle() function was changed to use the ball and paddle objects as parameters to make it easier to use. In comparison to the previous example that needed seven parameters, this version needs only two, one for each object.

The sketch has started to get relatively long, but it's easy to imagine ways to enhance it that will make it even longer. Some next steps might be to create a variable to keep track of the score and additional code to update and display it. A second paddle can be added so two people can play each other. The game might be extended by making a second ball appear, thus making it more difficult, and the like. There's really no end to what might be imagined to extend this game sketch.

Interesting and detailed programs often grow to hundreds, thousands, and tens of thousands lines of code. Writing a program can be the intellectual equivalent of writing

a poem or a novel, a song or a symphony. Short, elegant programs have value, as do intricate and expansive programs. As mentioned, the example sketches in this book are intended as exercises and raw material for realizing more visionary ideas in software. This chapter has grown a program from three short sketches to almost the longest program in this book. We hope that now, or in time, readers can follow the same process to write the software they want to create.

27 Interviews: Motion, Performance

Larry Cuba (Calculated Movements)
Bob Sabiston, (Waking Life)
Golan Levin and Zachary Lieberman (Messa di Voce)
SUE.C. (Mini Movies)

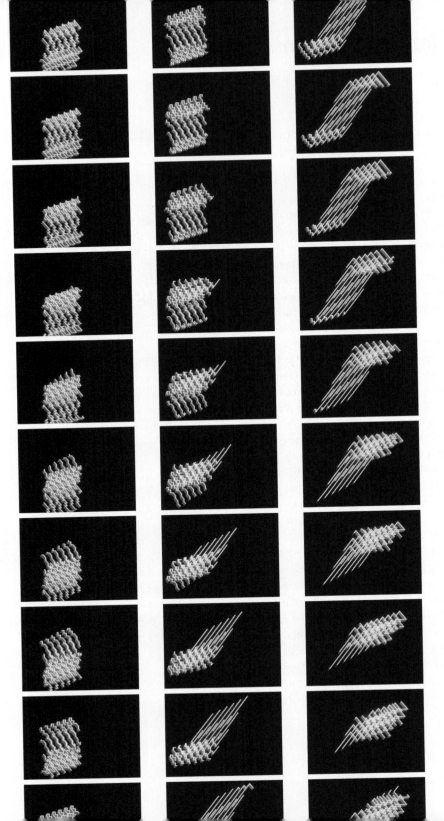

Frames from the 16 mm film *Calculated Movements*. Images courtesy Larry Cuba.

Calculated Movements *(Interview with Larry Cuba)*

Creator Larry Cuba
Year 1985
Medium 16 mm film
Software Custom written in Z-Grass Programming Language
URL www.well.com/~cuba/

What is *Calculated Movements*?

Calculated Movements *is a six-minute computer-animated film/video I made in 1985. It is the third work in a series of three generative animation pieces that began in 1978 with* 3/78 (Objects and Transformations) *and was followed the next year by* Two Space. *Each of these works is the result of extensive experimentation with algorithmic structure and the abstract, geometric forms that these structures generate. A simple, primitive figure (like a point or a line) traverses a set trajectory through space. As this figure is copied over itself multiple times, it is transformed in space and time producing a more complex figure that itself is then copied multiple times and transformed in space and time producing an even more complex multi-level graphic event. The trajectory and all aspects of the figures' repetitions and transformations at every level are determined by a hierarchical structure of mathematical functions and parameters. After evolving a portfolio of animation trials and software refinements, a selection of these experiments is combined into a composition.*

In the case of Calculated Movements, *the structure of the composition consists of five movements. The odd-numbered sections (#1, #3, #5) each consists of one long graphic event that spans the length of the scene from beginning to end. The even-numbered sections (#2, #4) are compilations of forty short events that appear throughout the scene, coming and going at different times, and sometimes overlapping. The appearance of these events is determined by a fixed on/off pattern that repeats throughout the scene. Because they are also divided into four voices with the cycle of each voice given a different on/off ratio, they beat out of phase. I worked with the composer, Rand Weatherwax, who programmed the same cyclical patterns into his Emu Emulator II for each of the four voices. The Emulator II was one of the first studio synthesizers to incorporate sampled sounds. We selected sounds from Rand's library of percussion instruments and distorted them to make them less recognizable and more abstract. Each graphic voice was then coded with its own sound. The soundtracks of the other three scenes are more melodic and were composed by Larry Simon (#1, #3) and Craig Harris (#5).*

By adding the soundtrack after the animation was complete, I avoided having an existing piece of music dictate the formal structure of the visuals. All of the experimentation was for the purpose of discovering the rules that subconsciously guide the esthetics of visual/temporal composition. Beginning with the soundtrack would have subverted that goal. The soundtrack was composed to complement the visual composition rather than the other way around. Although it would have been preferable, technical limitations prevented me from simultaneously generating both sound and image with a single algorithm.

Why did you create *Calculated Movements*?

I'd been exploring the relationship between mathematics, moving form, and perception. The possibility of generating temporal, visual compositions from mathematical relationships is what attracted me to computer animation in 1972. In the '70s, the personal computer was not yet powerful enough for the calculation-intensive work needed for my animation. Consequently, as prerequisite to creative work, I had to beg access time on the room-sized, institutional computers, a process that involved long negotiations, security clearances, paperwork, and so forth. When access was granted, it was limited to off-hours, requiring that I work the night shift.

In 1982, an affordable microcomputer, optimized for graphic operations, was developed, the Datamax UV-1. Purchased with a grant from the American Film Institute, my UV-1 finally enabled me to work at home, in my studio, on my own computer (during daylight hours!), and therefore the work on Calculated Movements could begin. However, because the computer was slow and the need for experimentation great—over two hours worth of material was generated—the film took three years to complete.

What software tools were used? Why did you use these tools?

At the time Calculated Movements was made, software tools were not the commodity they have since become. People would write programs in a language that was available on the particular computer they were using. The UV-1 computer was designed to run a single graphics programming language: Z-Grass, so named because it was Tom Defanti's GRAphics Symbiosis System ported to the Z-80 chip. Born on a much larger machine in the 70s, the GRASS language was developed specifically to make programming computer animation accessible to artists, without the need for serious technical training. The Z-Grass language continued that tradition on a smaller, affordable machine. Previously I had moved to Chicago for a year to produce my film 3/78 on the original GRASS system at the University of Illinois.

In all my work, it's been important for me to use a high-level programming language that is concise and responsive. Since the process consists of continuous experimentation, my software is in a constant state of change. For a programming language to support this approach, it must facilitate rapid development and give the artist immediate feedback. Although interpretive languages such as BASIC and Forth were appearing on the first PCs, the larger machines with the graphics hardware relied on the more technically oriented, compiled languages of FORTRAN and C, which made extensive experimentation impractical. The GRASS language was the first to deliver the power of expensive high-end graphics hardware via an interpretive programming language as simple and responsive as BASIC.

Why do you choose to work with software?

Programming for me has always been a vehicle for exploring an unknown and uncharted visual/auditory realm. Writing computer code is creating a (linguistic) pattern that generates a (visual) pattern. What is the connection between the abstraction of alphanumeric symbols and abstract form in motion? Can you develop a visual language with a symbolic language? At heart I'm driven to experiment. Unpredictable visual compositions emerge from mathematical structure. If I could picture the results of a particular process in advance, then the end would be known and running the program would serve no purpose. I collaborate with an animation-producing robot whose behavior I designed. Over time, the algorithms, the imagery, and the artist coevolve.

Two stills from the 16 mm film *Calculated Movements*. Images courtesy Larry Cuba.

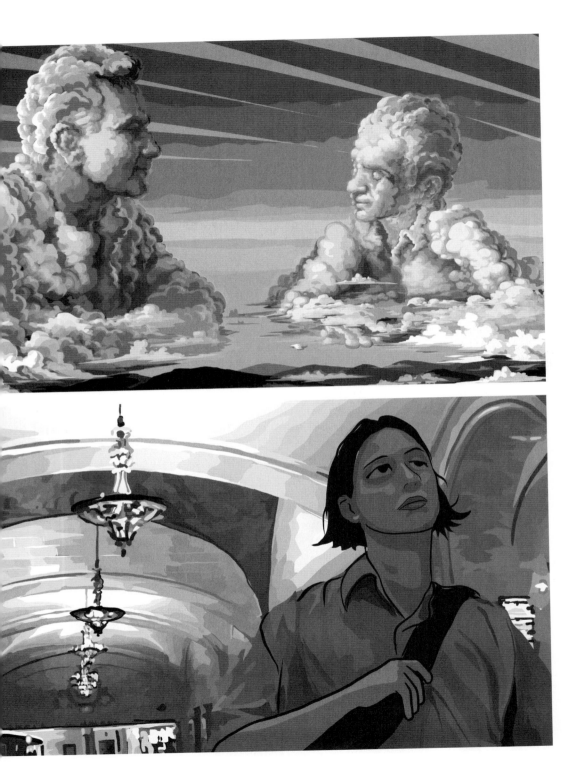

Waking Life (Interview with Bob Sabiston)

Creators	Richard Linklater (writer/director), Bob Sabiston (software/animation director)
Year	2001
Medium	Feature film, 35 mm
Software	Rotoshop (rotoscoping application written in C++ for Macintosh)
URL	www.wakinglifemovie.com, www.flatblackfilms.com

What is *Waking Life*?

Waking Life *is an animated feature film that takes place entirely within the main character's dream. The film was animated with Rotoshop, a rotoscoping application that produces a floating style of animation well suited to the story. I didn't create the film or have much to do with its content—rather, my contribution is the specific style of animation that* Waking Life *employs and the software used to produce it.*

Why did you create *Waking Life*?

Waking Life *gave me the opportunity to make the type of animated feature film that I would want to watch. I like animation that isn't your garden-variety kid's cartoon, so the chance to do a relatively plotless R-rated philosophical adventure by the director of* Slacker *really was a dream come true.*

What software tools were used?

Rotoshop, the custom rotoscoping software application I have been working on since 1997, was used to animate the film. Thirty artists were hired to manually trace over frames of live-action video footage—interpolation tools in the software allowed them to skip frames of video that didn't change significantly from previous frames. It took roughly a month for an artist to rotoscope one minute of footage. Contrary to many assumptions about the process, there is no element of image processing, filtering, or autotracing in the software. All the software does is interpolate between lines and shapes drawn by the artists—they do all the hard work themselves!

Waking Life *was shot in live action on consumer-level digital videocameras. It was one of the first feature films edited with Final Cut Pro (FCP). Rotoshop uses QuickTime for its source video—the video that you trace—so I exported the finished live-action footage from FCP into five QuickTime reels. At this step the frame rate was reduced to twelve frames per second in order to cut in half the number of frames that artists would have to draw.*

We had sixteen Mac G3 and G4 computers networked, each outfitted with a Wacom graphics tablet. The computers had ten-gigabyte hard drives with a copy of the live-action QuickTime on each machine. Animators traced over this footage to create their animation. We assigned each artist a small section of the film at a time—generally, they were able to work in their own style and weren't required to conform to model sheets or predetermined designs. Finished work was exported across the network to a single computer, where a QuickTime compilation of the completed animation was automatically maintained by the software.

Why did you write your own software tools?

I created the software back in 1996 for an MTV contest. My friends and I had an idea just to animate some real people, documentary subjects that we would go out and interview. I wanted to capture the emotion on people's faces by quickly tracing frame-by-frame in a gestural or life-drawing style. Wrongly I assumed that software was out there to trace over the frames of video—Photoshop could do it, but it was clunky and each frame had to be a separate file. It wasn't quick enough. So, having experience with programming, it seemed like a simple enough thing to write.

The first version took about a week to ten days. Using it I realized that I was drawing the same lines over and over to make a face and that they didn't change a whole lot frame to frame. It was a small step to have the software connect corresponding lines between frames, interpolating to fill in any gaps. Conceptually, this required drawing lines in a certain order from frame to frame, which is not intuitive. You get used to it, though.

By the time Waking Life *came around in 1999, I had used Rotoshop for several animated short films. It had evolved from the simple black-and-white tracing program into more of a full-fledged application. However, the prospect of doing a full feature film inspired a big push to expand the software's capabilities. While Richard Linklater and Sandra Adair were editing the live-action footage, I holed up for a month or two to hammer out improvements in the software. Some of the things added for* Waking Life *were translucency, antialiasing of lines and shapes, hierarchical grouping of layers, and the ability to output to any resolution. I also revamped the user interface for the film's 16 × 9 aspect ratio so that the film frame took up as much of the screen as possible and all the UI controls were pushed into a strip along the bottom of the screen.*

During production, a whole slew of new issues arose simply from having to coordinate and keep track of hundreds of animated scenes. I developed a system for assembling and archiving animation and QuickTime files that worked automatically within the software. As animators finished scenes, they could "publish" them to the movie as a whole so that we always had a watchable version of the movie's current state.

Why do you choose to work with software?

Software has always seemed to me like a variant of the creative process used to write books or paint pictures. It is more constructive and has more limitations, but there is still a great deal of the same inventiveness in play. What's more, when you are finished you have made something that actually does something. To work on software for use in a larger creative project like a film is even more exciting. There is a satisfaction in building a set of tools that a group of people can use toward pursuit of a common creative goal. It is also very nice to be able to fix problems when they arise and to mold the software to satisfy the needs of the project.

As someone who enjoys the comparatively less technical activity of animation and rotoscoping, it has been rewarding to be able to bounce back and forth between working on software and then just using the software. The two pursuits play off one another and keep me moving forward.

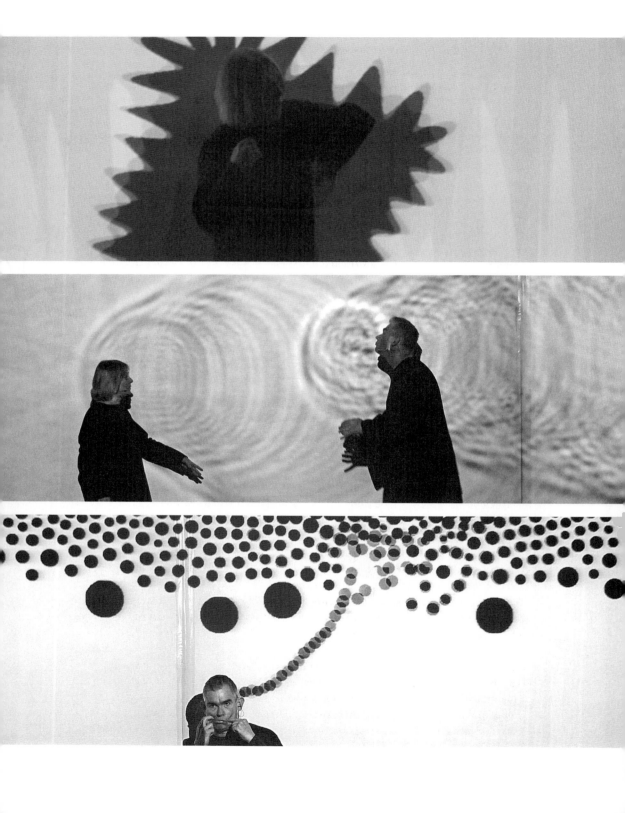

Messa di Voce *(Interview with Golan Levin and Zachary Lieberman)*

Creators	Tmema (Golan Levin and Zachary Lieberman), with Joan La Barbara and Jaap Blonk
Year	2003
Medium	Interactive installation or performance with custom software
Software	Custom software for Windows, written in C++
URL	www.tmema.org/messa

What is *Messa di Voce*?

Messa di Voce *is an audiovisual performance and installation in which the speech, shouts, and songs produced by two vocalists are augmented in real time by custom interactive visualization software. The project touches on themes of abstract communication, synesthetic relationships, cartoon language, and writing and scoring systems, within the context of a sophisticated and playful virtual world.*

Our software transforms every vocal nuance into correspondingly complex, subtly differentiated and highly expressive graphics. These visuals not only depict the users' voices, but also serve as controls for their acoustic playback. While the voice-generated graphics thus become an instrument with which the users can perform, body-based manipulations of these graphics additionally replay the sounds of the users' voices, creating a cycle of interaction that fully integrates the visitors into an ambience consisting of sound, virtual objects, and real-time processing.

Messa di Voce *lies at an intersection of human and technological performance extremes, melding the unpredictable spontaneity of the unconstrained human voice with the latest in computer vision and speech analysis technologies. Utterly wordless, yet profoundly verbal,* Messa di Voce *is designed to provoke questions about the meaning and effects of speech sounds, speech acts, and the immersive environment of language.*

Why did you create *Messa di Voce*?

Messa di Voce *grew out of two prior interactive installations that we developed in 2002:* RE:MARK, *which explored the fiction that speech could cast visible shadows, and* The Hidden Worlds of Noise and Voice, *a multiperson augmented reality in which the users' speech appeared to emanate visually from their mouths. These installations analyzed a user's vocal signal and, in response, synthesized computer-graphic shapes that were tightly coupled to the user's vocal performance. After making these pieces, we had the feeling that we hadn't taken full advantage of everything we had learned about analyzing vocal signals. Although* RE:MARK *and* Hidden Worlds *were reasonably successful with a general audience, we wanted to step up to a much greater challenge: could we develop voice-interactive software that could somehow equal or keep pace with the expressivity of a professional voice artist?*

We invited the well-known experimental vocalist/composers Joan La Barbara and Jaap Blonk to join us in creating the Messa di Voce *performance. Although Joan and Jaap come from very different backgrounds—she works in contemporary art music, while he comes from a background in sound poetry—both of them share a practice in which they use their voices in extremely unusual and highly sophisticated ways, and both use a visual language to describe*

the sounds they make. The software was really designed in collaboration with them—there are even specific sections or modules of the software that were directly inspired by improvisation sessions that we held together. Once the performance was finished, we realized that some sections could only ever be performed by trained experts like Joan and Jaap, but that other software modules could actually be experienced by anyone uninhibited enough to get up and yell or sing. We gathered up five or so of these—about a third of the original concert software— and that's how we redeveloped Messa di Voce into an installation. We're proud that these software pieces could be used to good effect by expert vocalists, but even more pleased, in a way, that children can enjoy them too.

What software tools were used?

We developed Messa di Voce in C++, using the Metrowerks Codewarrior development environment. Some of the sound analysis was accomplished with Intel's commercial IPP library. We also incorporated a large number of open source sound and graphics toolkits, including OpenCV, OpenGL, and PortAudio.

Why do you choose to work with software?

Because software is the only medium, as far as we know, that can respond in real time to input signals in ways that are continuous, linear or nonlinear as necessary, and—most importantly—conditional. The medium that we're interested in, to borrow a phrase from Myron Krueger, is response itself, and only software is able to respond in such a rich manner and with such a flexible repertoire.

Why did you write your own software tools?

There isn't any other software that does what we want to do—and most importantly, that does it in the way we imagine it could be done. In the specific example of Messa di Voce— although a significant aspect of the project is entirely conceptual (the idea of visualizing the voice in such a way that the graphics appear to emerge from the user's mouth), an equally important dimension is the quality and degree of craft that is applied to the creation of the work, and which is evident in its execution. Although the idea of Messa di Voce could have been implemented by any number of other artists (and indeed, systems illustrating related ideas have been created by others, such as Toshio Iwai, Josh Nimoy, Mark Coniglio, and Steven Blyth), we'd like to believe that nobody else could have created it with the particular character and texture we did.

That said, it would be a mistake to believe that we wrote Messa di Voce completely from scratch. As we mentioned earlier, we made extensive use of both commercial and open source software libraries in order to develop it. It's not even clear what "completely from scratch" would mean for our project, unless we were to somehow construct our own CPU and develop our own assembly language for it! We incorporated features and functionality from the other software libraries whenever we didn't know how to do something ourselves, or could simply save time by doing so. Our work was built on the efforts of probably thousands of other people.

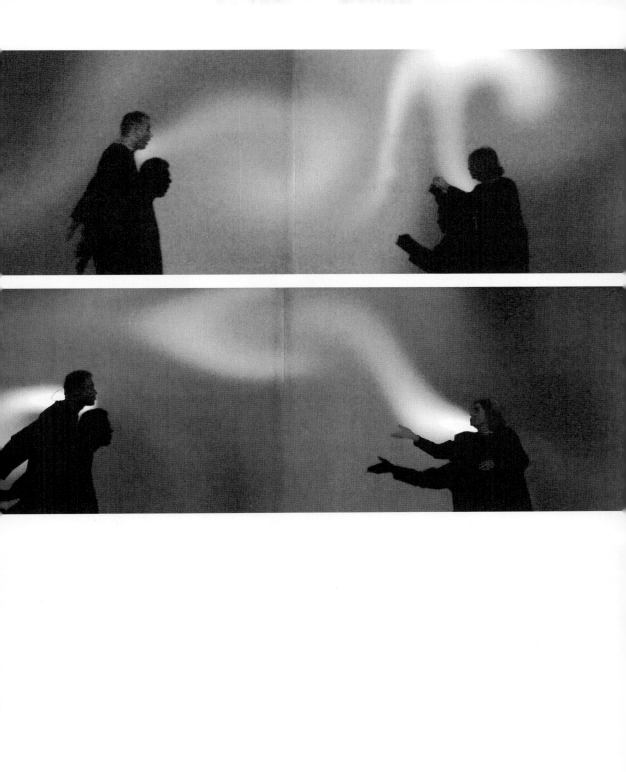

Mini Movies *(Interview with SUE.C)*

Creators	AGF+SUE.C
Year	2005
Medium	Performance, CD/DVD
Software	Max/MSP/Jitter, Radial
URL	www.minimoviemovement.net

What is *Mini Movies*?

Mini Movies is a CD/DVD collaboration between the musician Antye Greie and the visual artist Sue Costabile. It is an audiovisual collection of mini-lives in an urban and political context. The liberation of the still image. A breakaway of recorded music. Mini Movies *is also the current chapter in the live performance presented by AGF+SUE.C.*

Why did you create *Mini Movies*?

We began performing live sound and image together several years ago in an entirely improvisational fashion. Through the medium of live performance we discovered many commonalities between Antye's aural language and my visual language. Both of us see life as a series of miniature movies, some silent, some only a soundtrack waiting for the image to appear. The increasing consumability of the DVD format made it accessible to us as artists and we decided to present our own abstraction of the Hollywood feeling. The movie industry has made much of society accustomed to their mode of behavior and means of delivering entertainment. This is our way of slipping our own observations of life and audiovisual memories into the preestablished user interface and industry distribution network. In a live context our mini movies become larger than life, projected onto a giant screen and filling all available space with sound.

What software tools were used?

Our main studio production tools are Max/MSP/Jitter, Logic, Radial, and Final Cut Pro. As performers we both improvise a great deal, using very little recorded media and relying heavily on the human brain for interaction between sound and image. In our live performances we use Max/MSP/Jitter and Radial, along with a MPC, microphones, photographs, drawings, shiny objects, and many different miniature lighting rigs. These physical objects are an augmentation of the software and serve as a means through which we can interact more creatively with the tools.

Why did you use these tools?

Max/MSP/Jitter offers us the ability to create our own customized tools but also to easily incorporate elements of other people's tools. We were often meeting artists that were using this software environment to do wonderful and interesting things, and that led to each of us exploring and using it. We find the environment very flexible and open to experimentation. There is a structure to the language but there is also a freedom to explore sound and image as pure data. This leads fluidly to all kinds of manipulations, transformations, and translations. Our focus has been on developing a software-based environment that responds readily to human input and interaction. Antye uses her voice as the main input source, and I use a live camera pointed at various layers of physical objects and lights that are animated by my hands.

Still images from *Mini Movies*, 2005. Images courtesy AGF+SUE.C.

These analog inputs are processed by the software, which adds another layer of abstraction and emotion.

Why do you choose to work with software?

It wasn't an entirely conscious choice to work with software. We were both very intrigued by computers, the Internet, and digital media in general but once we discovered how expressive one could be with certain software products, we gravitated toward using them more and more. It provides us with broad artistic freedom since there is very little aesthetic preconception in the Max/MSP/Jitter environment. As artists we have been able to grow but not outgrow our tools. This is due in large part to the fact that we can program our own software tools inside of the environment. As our ideas change and expand the tools can do the same. As a video artist, I found the popular VJ software and hardware setups to be quite restricting. The idea for using a live camera as the only video signal input evolved out of frustration with working with a confined set of video clips and combining them in a limited number of ways. Jitter allows for a seemingly infinite array of compositing modes, and quite easily communicates with any digital camera. After a long period of experimentation, the software has become an instrument that I have learned to play. The program is a simple compositing machine but allows for complex interactions and animations, and the flexibility of the programming environment means that I can add and subtract features at will. Antye felt a similar restraint from popular live performance tools for audio until she discovered Radial. This software allows her to control samples of her voice in a very responsive way and leads to associations and multilayered narratives with an organic character. We both appreciate the unpredictability that our software brings to our live performance. It is an amplification of our live presence, which, as a performer, lies at the heart of the show.

28 Arrays

This chapter introduces arrays of data.

Syntax introduced:
```
Array, [] (array access), Array.length, printArray()
append(), shorten(), expand(), arrayCopy()
```

The term *array* refers to a structured grouping or an imposing number: "The dinner buffet offers an array of choices," "The city of Boston faces an array of problems." In computer programming, an array is a set of data elements stored under the same name. Arrays can be created to hold any type of data, and each element can be individually assigned and read. There can be arrays of numbers, characters, sentences, boolean values, and so on. Arrays might store vertex data for complex shapes, recent keystrokes from the keyboard, or data read from a file.

For instance, an array can store five integers (1919, 1940, 1975, 1976, 1990), the years to date that the Cincinnati Reds won the World Series, rather than defining five separate variables. Let's call this array "dates" and store the values in sequence:

dates	1919	1940	1975	1976	1990
	[0]	[1]	[2]	[3]	[4]

Array elements are numbered starting with zero, which may seem confusing at first but is an important detail for many programming languages. The first element is at position [0], the second is at [1], and so on. The position of each element is determined by its offset from the start of the array. The first element is at position [0] because it has no offset; the second element is at position [1] because it is offset one place from the beginning. The last position in the array is calculated by subtracting 1 from the array length. In this example, the last element is at position [4] because there are five elements in the array.

Arrays can make the task of programming much easier. While it's not necessary to use them, they can be valuable structures for managing data. Let's begin with a set of data points to construct a bar chart.

x	50	61	83	69	71	50	29	31	17	39
	[0]	[1]	[2]	[3]	[4]	[5]	[6]	[7]	[8]	[9]

The following examples to draw this chart demonstrates some of the benefits of using arrays, like avoiding the cumbersome chore of storing data points in individual variables. Because the chart has ten data points, inputting this data into a program requires either creating 10 variables or using one array. The code on the left demonstrates using separate variables. The code on the right shows how the data elements can be logically grouped together in an array.

```
int  x0  =  50;
int  x1  =  61;
int  x2  =  83;
int  x3  =  69;
int  x4  =  71;
int  x5  =  50;
int  x6  =  29;
int  x7  =  31;
int  x8  =  17;
int  x9  =  39;
```

One array

```
int[]  x  =  {  50,  61,  83,  69,  71,
               50,  29,  31,  17,  39  };
```

Using what we know about drawing without arrays, ten variables are needed to store the data; each variable is used to draw a single rectangle. This is tedious:

```
int  x0  =  50;
int  x1  =  61;
int  x2  =  83;
int  x3  =  69;
int  x4  =  71;
int  x5  =  50;
int  x6  =  29;
int  x7  =  31;
int  x8  =  17;
int  x9  =  39;

fill(0);
rect(0,  0,  x0,  8);
rect(0,  10,  x1,  8);
rect(0,  20,  x2,  8);
rect(0,  30,  x3,  8);
rect(0,  40,  x4,  8);
rect(0,  50,  x5,  8);
rect(0,  60,  x6,  8);
rect(0,  70,  x7,  8);
rect(0,  80,  x8,  8);
rect(0,  90,  x9,  8);
```

28-01

In contrast, the following example shows how to use an array within a program. The data for each bar is accessed in sequence with a `for` loop. The syntax and usage of arrays is discussed in more detail in the following pages.

```
int[] x = { 50, 61, 83, 69, 71, 50, 29, 31, 17, 39 };   28-02

fill(0);
// Read one array element each time through the for loop
for (int i = 0; i < x.length; i++) {
  rect(0, i*10, x[i], 8);
}
```

Define an array

Arrays are declared similarly to other data types, but they are distinguished with
brackets, [and]. When an array is declared, the type of data it stores must be specified.
(Each array can store only one type of data.) After the array is declared, it must be
created with the keyword new, just like working with objects. This additional step
allocates space in the computer's memory to store the array's data. After the array is
created, the values can be assigned. There are different ways to declare, create, and
assign arrays. In the following examples that explain these differences, an array with
five elements is created and filled with the values 19, 40, 75, 76, and 90. Note the
different way each technique for creating and assigning elements of the array relates to
setup().

```
int[] data;                 // Declare                          28-03

void setup() {
  size(100, 100);
  data = new int[5];        // Create
  data[0] = 19;             // Assign
  data[1] = 40;
  data[2] = 75;
  data[3] = 76;
  data[4] = 90;
}
```

```
int[] data = new int[5];    // Declare, create                  28-04

void setup() {
  size(100, 100);
  data[0] = 19;             // Assign
  data[1] = 40;
  data[2] = 75;
  data[3] = 76;
  data[4] = 90;
}
```

```
int[] data = { 19, 40, 75, 76, 90 };   // Declare, create, assign
```
28-05

```
void setup() {
  size(100, 100);
}
```

Although each of the three previous examples defines an array in a different way, they are all equivalent. They show the flexibility allowed in defining the array data. Sometimes, all the data a program will use is known at the start and can be assigned immediately. At other times, the data is generated while the code runs. Each sketch can be approached differently using these techniques.

Arrays can also be used in programs that don't include a setup() and draw(), but the three steps to declare, create, and assign are needed. If arrays are not used with these functions, they can be created and assigned in the ways shown in the following examples.

28-06
```
int[] data;             // Declare
data = new int[5];      // Create
data[0] = 19;           // Assign
data[1] = 40;
data[2] = 75;
data[3] = 76;
data[4] = 90;
```

28-07
```
int[] data = new int[5];    // Declare, create
data[0] = 19;               // Assign
data[1] = 40;
data[2] = 75;
data[3] = 76;
data[4] = 90;
```

28-08
```
int[] data = { 19, 40, 75, 76, 90 };   // Declare, create, assign
```

Read array elements

After an array is defined and assigned values, its data can be accessed and used within the code. An array element is accessed with the name of the array variable, followed by brackets around the element position to read.

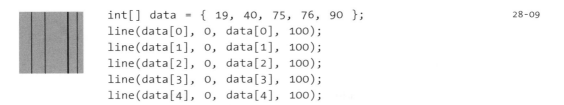

```
int[] data = { 19, 40, 75, 76, 90 };                              28-09
line(data[0], 0, data[0], 100);
line(data[1], 0, data[1], 100);
line(data[2], 0, data[2], 100);
line(data[3], 0, data[3], 100);
line(data[4], 0, data[4], 100);
```

Remember, the first element in the array is in the 0 position. If you try to access a member of the array that lies outside the array boundaries, your program will terminate and give an ArrayIndexOutOfBoundsException.

```
int[] data = { 19, 40, 75, 76, 90 };                              28-10
println(data[0]);   // Prints "19" to the console
println(data[2]);   // Prints "75" to the console
println(data[5]);   // ERROR! The last element of the array is 4
```

The length field stores the number of elements in an array. This field is stored within the array and is accessed with the dot operator (p. 363–379). The following example demonstrates how to utilize it.

```
int[] data1 = { 19, 40, 75, 76, 90 };                             28-11
int[] data2 = { 19, 40 };
int[] data3 = new int[127];
println(data1.length); // Prints "5" to the console
println(data2.length); // Prints "2" to the console
println(data3.length); // Prints "127" to the console
```

Usually, a for loop is used to access array elements, especially with large arrays. The following example draws the same lines as code 28-09 but uses a for loop to iterate through every value in the array.

```
int[] data = { 19, 40, 75, 76, 90 };                              28-12
for (int i = 0; i < data.length; i++) {
   line(data[i], 0, data[i], 100);
}
```

A for loop can also be used to put data inside an array. For instance, it can calculate a series of numbers and then assign each value to an array element. The following example stores the values from the sin() function in an array within setup() and then displays these values as the stroke values for lines within draw().

```
float[] sineWave;

void setup() {
  size(100, 100);
  sineWave = new float[width];
  for (int i = 0; i < sineWave.length; i++) {
    // Fill array with values from sin()
    float r = map(i, 0, width, 0, TWO_PI);
    sineWave[i] = abs(sin(r));
  }
}

void draw() {
  for (int i = 0; i < sineWave.length; i++) {
    // Set stroke values to numbers read from array
    stroke(sineWave[i] * 255);
    line(i, 0, i, height);
  }
}
```

Use the printArray() function to view the contents of an array in the console. This function writes the values of an array to the console on separate lines, each preceded by the element number.

```
int[] data = { 19, 40, 75, 76, 90 };
printArray(data);   // Prints [0] 19, [1] 40, etc.
```

Record data

As one example of how arrays may be used, this section shows how to use arrays to store data from the mouse. The pmouseX and pmouseY variables store the cursor coordinates from the previous frame, but there is no built-in way to access the cursor values from earlier frames. At every frame, the mouseX, mouseY, pmouseX, and pmouseY variables are replaced with new numbers and their previous numbers are discarded. Creating an array is the easiest way to store the history of these values. In the following example, the most recent 100 values from mouseY are stored and displayed on screen as a line from the left to the right edge of the screen. At each frame, the values in the array are shifted to the right and the newest value is added to the beginning.

```
int[] y;

void setup() {
  size(100, 100);
  y = new int[width];
}

void draw() {
  background(204);
  // Read the array from the end to the
  // beginning to avoid overwriting the data
  for (int i = y.length-1; i > 0; i--) {
    y[i] = y[i-1];
  }
  // Add new values to the beginning
  y[0] = mouseY;
  // Display each pair of values as a line
  for (int i = 1; i < y.length; i++) {
    line(i, y[i], i-1, y[i-1]);
  }
}
```

Apply the same code simultaneously to the mouseX and mouseY values to store the position of the cursor. Displaying these values each frame creates a trail behind the cursor.

```
int num = 50;
int[] x = new int[num];
int[] y = new int[num];

void setup() {
  size(100, 100);
  noStroke();
  fill(255, 102);
}

void draw() {
  background(0);
  // Shift the values to the right
  for (int i = num-1; i > 0; i--) {
    x[i] = x[i-1];
    y[i] = y[i-1];
  }
  // Add the new values to the beginning of the array
```

```
x[0] = mouseX;
y[0] = mouseY;
// Draw the circles
for (int i = 0; i < num; i++) {
  ellipse(x[i], y[i], i/2.0, i/2.0);
}
}
```

The following example produces the same result as the previous one but uses a more efficient technique. Instead of shifting the array elements in each frame, the program writes the new data to the next available array position. The elements in the array remain in the same position once they are written, but they are read in a different order each frame. Reading begins at the location of the oldest data element and continues to the end of the array. At the end of the array, the % operator (p. 57) is used to wrap back to the beginning. This technique, commonly known as a *ring buffer*, is especially useful with larger arrays, to avoid unnecessary copying of data that can slow down a program.

28-17

```
int num = 50;
int[] x = new int[num];
int[] y = new int[num];
int indexPosition = 0;

void setup() {
  size(100, 100);
  noStroke();
  fill(255, 102);
}

void draw()  {
  background(0);
  x[indexPosition] = mouseX;
  y[indexPosition] = mouseY;
  // Cycle between 0 and the number of elements
  indexPosition = (indexPosition + 1) % num;
  for (int i = 0; i < num; i++) {
    // Set the array position to read
    int pos = (indexPosition + i) % num;
    float radius = (num-i) / 2.0;
    ellipse(x[pos], y[pos], radius, radius);
  }
}
```

Array functions

Processing provides a group of functions that assist in managing array data. Only four of these functions are introduced here, but more are explained in the Processing reference included with the software.

The append() function expands an array by one element, adds data to the new position, and returns the new array:

```
String[] trees = { "ash", "oak" };                         28-18
append(trees, "maple"); // INCORRECT! Does not change the array
printArray(trees); // Prints [0] "ash", [1] "oak"
println();
trees = append(trees, "maple"); // Add "maple" to the end
printArray(trees); // Prints [0] "ash", [1] "oak", [2] "maple"
println();
// Add "beech" to the end of the trees array, and creates a new
// array to store the change
String[] moretrees = append(trees, "beech");
// Prints [0] "ash", [1] "oak", [2] "maple", [3] "beech"
printArray(moretrees);
```

The shorten() function decreases an array by one element by removing the last element and returns the shortened array:

```
String[] trees = { "lychee", "coconut", "fig" };           28-19
trees = shorten(trees);   // Remove the last element from the array
printArray(trees);   // Prints [0] "lychee", [1] "coconut"
println();
trees = shorten(trees);   // Remove the last element from the array
printArray(trees);   // Prints [0] "lychee"
```

The expand() function increases the size of an array. It can expand to a specific size, or if no size is specified, the array's length will be doubled. If an array needs to have many additional elements, it's faster to use expand() to double the size than to use append() to continually add one value at a time. The following example saves a new mouseX value to an array every frame. When the array becomes full, the size of the array is doubled and new mouseX values proceed to fill the enlarged array.

```
int[] x = new int[100];   // Array to store x-coordinates     28-20
int count = 0;   // Positions stored in array

void setup() {
  size(100, 100);
}
```

```
void draw() {
    x[count] = mouseX;          // Assign new x-coordinate to the array
    count++;                    // Increment the counter
    if (count == x.length) {    // If the x array is full,
        x = expand(x);          // double the size of x
        println(x.length);      // Write the new size to the console
    }
}
```

Array values cannot be copied with the assignment operator because they are objects. The most common way to copy elements from one array to another is to use special functions or to copy each element individually within a for loop. The arrayCopy() function is the most efficient way to copy the entire contents of one array to another. The data is copied from the array used as the first parameter to the array used as the second parameter. Both arrays must be the same length for it to work in the configuration shown here.

```
String[] north = { "OH", "IN", "MI" };
String[] south = { "GA", "FL", "NC" };
arrayCopy(north, south); // Copy from north array to south array
printArray(south); // Prints [0] "OH", [1] "IN", [3] "MI"
println();

String[] east = { "MA", "NY", "RI" };
String[] west = new String[east.length]; // Create a new array
arrayCopy(east, west); // Copy from east array to west array
printArray(west); // Prints [0] "MA", [1] "NY", [2] "RI"
```

New functions can be written to perform operations on arrays, but arrays behave differently than data types such as int and char. As with objects, when an array is used as a parameter to a function, the address (location in memory) of the array is transferred into the function instead of the actual data. No new array is created, and changes made within the function affect the array used as the parameter.

In the following example, the data[] array is used as the parameter to halve(). The address of data[] is passed to the d[] array in the halve() function. Because the address of d[] and data[] is the same, they both point to the same data. Changes made to d[] on line 14 modify the value of data[] in the setup() block. The draw() function is not used because the calculation is made only once and nothing is drawn to the display window.

```
float[] data = { 19.0, 40.0, 75.0, 76.0, 90.0 };
```
28-22
```
void setup() {
  halve(data);
  println(data[0]);    // Prints "9.5"
  println(data[1]);    // Prints "20.0"
  println(data[2]);    // Prints "37.5"
  println(data[3]);    // Prints "38.0"
  println(data[4]);    // Prints "45.0"
}

void halve(float[] d) {
  for (int i = 0; i < d.length; i++) {   // For each array element,
    d[i] = d[i] / 2.0;                    // divide the value by 2
  }
}
```

Changing array data within a function without modifying the original array requires some additional lines of code. In the following example, the array is passed into the function as a parameter, a new array is made, the values from the original array are copied in the new array, changes are made to the new array, and finally the modified array is returned.

```
float[] data = { 19.0, 40.0, 75.0, 76.0, 90.0 };
float[] halfData;
```
28-23
```
void setup() {
  halfData = halve(data);   // Run the halve() function
  println(data[0], halfData[0]);   // Prints "19.0, 9.5"
  println(data[1], halfData[1]);   // Prints "40.0, 20.0"
  println(data[2], halfData[2]);   // Prints "75.0, 37.5"
  println(data[3], halfData[3]);   // Prints "76.0, 38.0"
  println(data[4], halfData[4]);   // Prints "90.0, 45.0"
}

float[] halve(float[] d) {
  float[] numbers = new float[d.length];   // Create a new array
  arrayCopy(d, numbers);
  for (int i = 0; i < numbers.length; i++) {   // For each element,
    numbers[i] = numbers[i] / 2.0;   // divide the value by 2
  }
  return numbers;   // Return the new array
}
```

Arrays of objects

Working with arrays of objects is technically similar to working with arrays of other data types, but it opens the amazing possibility to create as many instances of a custom-designed class as desired. Like all arrays, an array of objects is distinguished from a single object with brackets, the [and] characters. However, because each array element is an object, each must be created with the keyword new before it can be used. The steps for working with an array of objects are:

1. Declare the array
2. Create the array
3. Create each object in the array

These steps are translated into code in the following example. It uses the Ring class from page 371, so copy it over or retype it. This code creates a rings[] array to hold fifty Ring objects. Space in memory for the rings[] array is allocated in setup() and each Ring object is created. The first time a mouse button is pressed, the first Ring object is turned on and its x and y variables are assigned to the current values of the cursor. Each time a mouse button is pressed, a new Ring is turned on and displayed in the subsequent trip through draw(). When the final element in the array has been created, the program jumps back to the beginning of the array to assign new positions to earlier Rings.

28-24

```
Ring[] rings;    // Declare the array
int numRings = 50;
int currentRing = 0;

void setup() {
  size(100, 100);
  rings = new Ring[numRings];   // Create the array
  for (int i = 0; i < rings.length; i++) {
    rings[i] = new Ring();   // Create each object
  }
}

void draw() {
  background(0);
  for (int i = 0; i < rings.length; i++) {
    rings[i].grow();
    rings[i].display();
  }
}
```

```
// Click to create a new Ring
void mousePressed() {
  rings[currentRing].start(mouseX, mouseY);
  currentRing++;
  if (currentRing >= numRings) {
    currentRing = 0;
  }
}

// Insert Ring class
```

The next example requires the Spot class from page 363. Unlike the prior example, variable values are generated within the setup() and are passed into each array elements through the object's constructor. Each element in the array starts with a unique set of x-coordinate, diameter, and speed values. Because the number of objects is dependent on the width of the display window, it is not possible to create the array until the program knows how wide it will be. Therefore, the array is declared outside of setup() to make it *global* (see p. 12), but it is created inside setup, after the width of the display window is defined.

```
Spot[] spots;   // Declare array                              28-25

void setup() {
  size(700, 100);
  int numSpots = 70;              // Number of objects
  int dia = width/numSpots;       // Calculate diameter
  spots = new Spot[numSpots];     // Create array
  for (int i = 0; i < spots.length; i++) {
    float x = dia/2 + i*dia;
    float rate = random(0.1, 2.0);
```

```
    // Create each object
    spots[i] = new Spot(x, 50, dia, rate);
  }
  noStroke();
}

void draw() {
  fill(0, 12);
  rect(0, 0, width, height);
  fill(255);
  for (int i=0; i < spots.length; i++) {
    spots[i].move(); // Move each object
    spots[i].display(); // Display each object
  }
}

// Insert Spot class
```

Working with arrays of objects gives us the opportunity to access each object with a code structure called an *enhanced for loop* to simplify the code. Unlike the for loop used previously in this chapter, the enhanced loop automatically goes through each element in an array one by one without needing to define the start and stop conditions. An enhanced loop is structured by stating the data type of the array elements, a variable name to assign to each element of the array, and the name of the array. For instance, the for loop in code 28-25 is rewritten like this:

```
for (Spot s : spots) {
  s.move();
  s.display();
}
```

Each object in the array is in turn assigned to the variable s, so the first time through the loop, the code s.move() runs the move() method for the first element in the array, then the next time through the loop, s.move() runs the move() method for the second element in the array, etc. The two statements inside the block run for each element of the array until the end of the array. This way of accessing each element in an array of objects is used for the remainder of the book.

Two-dimensional arrays

Data can also be stored and retrieved from arrays with more than one dimension. Using the example from the beginning of this chapter, the data points for the chart are put into a 2D array, where the second dimension adds a gray value:

x	[0]	50	61	83	69	71	50	29	31	17	39
	[1]	0	204	51	102	0	153	0	51	102	204
		[0]	[1]	[2]	[3]	[4]	[5]	[6]	[7]	[8]	[9]

A 2D array is essentially a list of 1D arrays. It must first be declared, then created, and then the values can be assigned just as in a 1D array. The following syntax converts the diagram above into to code:

```
int[][] x = { {50,   0}, {61,204}, {83,51}, {69,102}, {71,   0},                28-26
              {50,153}, {29,   0}, {31,51}, {17,102}, {39,204} };
```

```
println(x[0][0]);   // Prints "50"
println(x[0][1]);   // Prints "0"
println(x[4][2]);   // ERROR! This element is outside the array
println(x[3][0]);   // Prints "69"
println(x[9][1]);   // Prints "204"
```

This sketch shows how it all fits together.

```
int[][] x = { {50, 0}, {61,204}, {83,51}, {69,102},                28-27
              {71, 0}, {50,153}, {29, 0}, {31,51},
              {17,102}, {39,204} };

void setup() {
  size(100, 100);
}

void draw() {
  for (int i = 0; i < x.length; i++) {
    fill(x[i][1]);
    rect(0, i*10, x[i][0], 8);
  }
}
```

It is possible to continue and make 3D and 4D arrays by extrapolating these techniques. However, multidimensional arrays can be confusing, and often it is a better idea to maintain multiple 1D or 2D arrays.

Exercises
1. Visualize the data from code 28-09 in a different way.
2. Explore and extend code 28-13 with the goal of making a wide range of gradients at different sizes.

3. *Write a function to multiply the values from two arrays together and return the result as a new array. Print the results to the console.*

4. *Write your own unique* Spot *class that has a different behavior from the one presented in code 28-25. Create a kinetic composition with one hundred of them.*

5. *Modify code 28-16 to use one 2D array in place of the separate* x *and* y *arrays.*

29 Animation

This chapter introduces techniques for displaying sequences of images successively, creating animation.

Syntax introduced:
`save()`, `saveFrame()`

Animation occurs when a series of images, each slightly different, are presented in quick succession. A diverse medium with a century of history, animation has progressed from the initial experiments of Winsor McCay to the commercial and realistic innovations of early Walt Disney studio productions, to the experimental films by such animators as Lotte Reiniger and James Whitney in the mid-twentieth century. The high volume of animated special effects in live-action film and the deluge of animated children's films are changing the role of animation in popular culture.

There is a long history of using software to extend the boundaries of animation. Some of the first computer graphics were presented as animation on film during the 1960s. Because of the cost and expertise required to make these films, they emerged from high-profile research facilities such as Bell Laboratories and IBM's Scientific Center. Kenneth C. Knowlton, then a researcher at Bell Labs, is an important protagonist in the story of early computer animation. He worked separately with artists Stan VanDerBeek and Lillian Schwartz to produce some of the first films made using computer graphics. VanDerBeek and Knowlton's *Poem Field* films, produced throughout the 1960s, utilized Knowlton's BEFLIX code and punch cards to produce permutations of visual micropatterns. Schwartz and Knowlton's *Pixillation* (1970) featured a wide range of effects made by contrasting geometric forms with organic motion. John Whitney worked in collaboration with Jack Citron at IBM to make a number of films including the innovative *Permutations*. This film expresses Whitney's ideas about relationships to music and abstract form by permuting an array of dots into infinite kinetic patterns. Other artists pioneering programmed animation in the 1970s were Peter Foldes, Larry Cuba, and Ed Emshwiller.

The paths of contemporary animation and software development often overlap. The 3D visualization of the Death Star in *Star Wars* (1977) was one of the first uses of computer-generated animation in a feature film. Custom software was written to produce a wire-frame fly-through of the massive ship. Interest in computer animation briefly peaked with Disney's *Tron* in 1982, but soon receded due to the film's perceived failure. The industry gradually rebuilt itself into its current role as a major force in contemporary film. Pixar, the hugely successful animation studio that produced *Toy Story* and *The Incredibles*, operated for many years as a software development company. Pixar's RenderMan software (1989) enabled the rendering of 3D computer graphics as photorealistic images. RenderMan became an industry standard and Pixar continues to

develop custom software for each film. The success of the company's films reflects its successful marriage of technical virtuosity and masterful storytelling.

Creating unique and experimental animation with software is no longer restricted to research labs and film studios. The Internet has become a vast repository for experimental software animation. In the late 1990s, *Turux* was created with works by Vienna-based artists Dextro and Lia. This online collection of intricate animated images and sounds synthesizes a digital glitch aesthetic with organic qualities. The drawings continually change and sometimes respond to viewer input. James Paterson, a Canadian animator, develops *Presstube.com*, where he produces thousands of drawings, typically organizing tight loops of elements that materialize and dissipate. This technique allows him to arrange these loops in nearly any order while maintaining a fluid progression of growth and decay. The sequences of David Crawford's *Stop Motion Studies* are series of photographs—typically of people in subways in different cities around the world. These photographs are taken in quick succession; presented again in a nonlinear sequence of animated frames, they reveal an incredibly complex and subtle range of human gesture.

Arrays of images

Before a series of images can be presented sequentially in a program, all the images must first be loaded. The image variables should be declared outside of setup() and draw() and then assigned within setup(). The following program loads these twelve images from James Paterson...

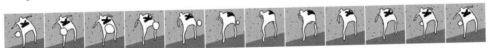

...and then draws them to the display window in numeric order.

```
int numFrames = 12;  // The number of animation frames     29-01
int frame = 0;  // The frame to display
PImage[] images = new PImage[numFrames];  // Image array

void setup() {
  size(100, 100);
  frameRate(30);  // Maximum 30 frames per second
  images[0]  = loadImage("ani-000.gif");
  images[1]  = loadImage("ani-001.gif");
  images[2]  = loadImage("ani-002.gif");
  images[3]  = loadImage("ani-003.gif");
  images[4]  = loadImage("ani-004.gif");
  images[5]  = loadImage("ani-005.gif");
  images[6]  = loadImage("ani-006.gif");
```

```
     images[7]  = loadImage("ani-007.gif");
     images[8]  = loadImage("ani-008.gif");
     images[9]  = loadImage("ani-009.gif");
     images[10] = loadImage("ani-010.gif");
     images[11] = loadImage("ani-011.gif");
   }

   void draw() {
     image(images[frame], 0, 0);
     frame++;
     if (frame == numFrames) {
        frame = 0;
     }
   }
 }
```

29-01
cont.

The next example shows an alternative way of loading images by utilizing a for loop. These lines of code can load between 1 and 999 images by changing the value of the numFrames variable. This shortens the code that flips through each image and returns to the first image at the end of the animation. The nf() function (p. 490) on line 10 is used to format the name of the image to be loaded. The names of frames with small numbers are prefaced with zeros so that the images remain in the correct sequence in their folder. For example, instead of *ani-1.gif*, the file is named *ani-001.gif*. The nf() function pads the small numbers created in a for loop with zeros on the left of the number, so 1 becomes 001, 2 becomes 002, etc. The % operator (p. 57) on line 17 uses the frameCount variable to make the frame variable increase by 1 each frame and return to 0 once it exceeds 11.

```
int numFrames = 12;   // The number of animation frames
PImage[] images = new PImage[numFrames];   // Image array

void setup() {
  size(100, 100);
  frameRate(30);   // Maximum 30 frames per second
  // Automate the image loading
  for (int i = 0; i < images.length; i++) {
    // Construct the name of the image to load
    String imageName = "ani-" + nf(i, 3) + ".gif";
    images[i] = loadImage(imageName);
  }
}
```

29-02

```
void draw() {
  // Calculate the frame to display, use % to cycle through frames
  int frame = frameCount % numFrames;
  image(images[frame], 0, 0);
}
```

Displaying the images in random order and for different amounts of time enhances the visual interest of a few frames of animation. Replaying a sequence at irregular intervals, in a random order with random timing, can give the appearance of more different frames than actually exist.

```
int numFrames = 5;   // The number of animation frames
PImage[] images = new PImage[numFrames];

void setup() {
  size(100, 100);
  for (int i = 0; i < images.length; i++) {
    String imageName = "ani-" + nf(i, 3) + ".gif";
    images[i] = loadImage(imageName);
  }
}

void draw() {
  int frame = int(random(0, numFrames));   // The frame to display
  image(images[frame], 0, 0);
  frameRate(random(1, 60.0));
}
```

There are many ways to control the speed at which an animation plays. The frameRate() function provides the simplest way. Place the frameRate() function in setup(), as seen in the previous example. Use this function to ensure that the software will run at the same speed on other machines.

If you want other elements to move independently of the sequential images, set up a timer and advance the frame only when the timer value grows larger than a predefined value. In the following example, the animation playing in the top of the window is updated each frame and the speed is controlled by the parameter to frameRate(). The animation in the bottom frame is updated only twice a second; the timer checks the milliseconds since the last update and changes the frame only if 500 milliseconds (half a second) have elapsed.

```
int numFrames = 12;    // The number of animation frames
int topFrame = 0;      // The top frame to display
int bottomFrame = 0;   // The bottom frame to display
PImage[] images = new PImage[numFrames];
int lastTime = 0;

void setup() {
  size(100, 100);
  frameRate(30);
  for (int i = 0; i < images.length; i++) {
    String imageName = "ani-" + nf(i, 3) + ".gif";
    images[i] = loadImage(imageName);
  }
}

void draw() {
  image(images[bottomFrame], 0, 50);
  topFrame = (topFrame + 1) % numFrames;
  image(images[topFrame], 0, 0);
  if ((millis() - lastTime) > 500) {
    bottomFrame = (bottomFrame + 1) % numFrames;
    lastTime = millis();
  }
}
```

Animation format, resolution

Saving images from a software application can be useful as a documentation technique or as a way to create frame-by-frame animation. The rate at which software can draw to the screen is always limited by the speed of the computer. When software is intended to be viewed live, the image quality often has to be reduced because of the need to draw many frames each second. But if the software is for still images and animation, each image can draw over a period of hours or days instead of in 1/30 of a second. This control over time enables the composition of images containing more visual elements or the use of rendering techniques such as advanced filters and lighting. After images are saved, they can be loaded into image editing programs, video editing programs, or the Processing Movie Maker tool to be converted into movies.

Files will be saved at different sizes and aspect ratios depending on the desired animation format. For instance, the NTSC video format used widely in the Americas and the PAL format used widely in Europe, Africa, and Asia each have different frame rates. If you're making images for television, DVD, or high-definition video, you'll save images at different sizes and rates.

A 30-second animation for an NTSC requires 30 frames each second for a total of 900 frames. The same animation for the PAL format requires 25 frames each second for a total of 750 frames.

Creating an animation for the web requires deciding on the pixel dimensions, the aspect ratio, and the type of compression. The most common aspect ratio at the moment is 16:9, which means the image is 16 units wide by 9 units high. The standardized high definition resolutions in this ratio are 1280 × 720 pixels and 1920 × 1080 pixels. Make your decisions regarding the pixel dimensions and compression formats by considering the type of content, how much space you have to store the files, and how comfortable you are with degrading the video quality through compression.

Regardless of the format or delivery of your animations, the process involves saving a series of frames, loading them into a separate application, and saving them as a movie.

Save sequential images

The save() function saves an image of the display window. It requires one parameter, a String that becomes the name of the saved image file. Images are saved in a variety of formats depending on the extension used in the filename parameter. For example, the parameter *myFile.tif* will save a TIFF file, and the value *myFile.tga* will save a TARGA file. If no extension is included in the filename, the image will save as TIFF and .*tif* will be added to the name. Be sure to remember to put the name of the file in quotes to distinguish it as a String. The image is saved into the current sketch's folder.

29-05

```
line(0, 0, width, height);
line(width, 0, 0, height);
// Saves the TIFF file "x.tif" to the current sketch's folder
save("x.tif");
```

Only the elements drawn before save() will be included in the image; those drawn afterward will not. In this example, only the first line is saved in the file *line.tif* but both lines are displayed on the screen.

29-06

```
line(0, 0, width, height);
// Saves the TIFF file "line.tif" to the current sketch's folder
save("line.tif");
line(width, 0, 0, height);
```

If the save() function appears within draw(), the file is continually rewritten each time draw() is run. The file saved during the previous frame is replaced with a file from the current frame. A sequence of numbered files can be created with the alternate saveFrame() function. If saveFrame() is used without a parameter, it saves the files as *screen-0000.tif, screen-0001.tif, screen-0002.tif,* and so on. The parameter to the

function, `filename-####.ext`, can be changed to any name, and the `.ext` component can be set to a number of different image file extensions, such as *.tif* or *.png*. The `####` portion of the name specifies the number of digits. When the files are saved, the four #'s are replaced with the value of the `frameCount` variable (p. 66). For example, the 127th frame will be called *filename-0127.tif* and the 1732nd frame will be called *filename-1732.tif*. Add an extra # symbol to support 10,000 frames or more.

Using `saveFrame()` inside an `if` structure allows the program to save images only if a certain condition is met. For example, you may want to save a sequence of 200 frames after the mouse is pressed. Or you may want to save one frame and then skip a few before saving another. The following code fragments present ways to achieve similar objectives.

29-07

```
// Save the first 50 frames
void draw() {
  background(0);
  ellipse(mouseX, 50, 40, 40);
  if (frameCount <= 50) {
    saveFrame("circles-####.tif");
  }
}
```

29-08

```
// Save 24 frames, from x-1000.tif to x-1023.tif
void draw() {
  background(204);
  line(mouseX, mouseY, pmouseX, pmouseY);
  if ((frameCount > 999) && (frameCount < 1024)) {
    saveFrame("line-####.tif");
  }
}
```

29-09

```
// Save every fifth frame (i.e., x-0005.tif, x-0010.tif, x-0015.tif)
void draw() {
  background(204);
  line(mouseX, mouseY, pmouseX, pmouseY);
  if ((frameCount % 5) == 0) {
    saveFrame("line-####.tif");
  }
}
```

Exercises

1. Draw twelve sequential images or create twelve sequential photographs and save them as GIF or PNG files.
2. Modify code 29-02 to animate the images you created for exercise 1.
3. Invent a way to display the twelve files from exercise 1 based on the position of the cursor.
4. Save a TIFF image from one of your previously created sketches.
5. Save a sequence of numbered images from one of the early examples in the chapter.

30 Dynamic Drawing

This chapter discusses drawing in relation to software and presents code for basic drawing programs as well as constraining and augmenting mouse data.

The activity of drawing translates an individual's perception and imagination into visual form. The differences between the drawings of different people demonstrate the fact that every hand and mind is unique. Drawings range from the mechanical grids of Sol LeWitt to the playful lines of Paul Klee to the expressionist figures of Egon Schiele and far beyond. Each surface and instrument determines a different tactile experience. Ink, charcoal, crayon, vellum, and cloth all enable unique sorts of drawing. Less conventional materials, such as chocolate, dirt, glue, and light, have been used with significant results. Materials can be applied with fingers, toes, or elbows or with utensils like pencils, brushes, and sticks. Every choice of material and application influences the viewer's perception of the composition.

The idea of drawing with digital computers dates back to the 1960s. Ivan Sutherland created the remarkable Sketchpad software for his PhD dissertation in 1963. Sketchpad, the progenitor of computer-aided drawing software (CAD) such as Autodesk's AutoCAD and Adobe Illustrator, used the newly invented light pen input device to draw directly on the screen. The software had features to convert imprecise marks into perfect straight lines, arcs, and circles. It could also constrain marks to make them identical, parallel, or perpendicular. Most example drawings demonstrated the features and accuracy of the system for making technical drawings, but Sutherland also discussed the use of his software for other purposes and created an example of an animated portrait.

Logo is another innovative software drawing system with origins in the 1960s. Seymour Papert developed Logo's turtle graphics as a way to get children thinking about geometry. Logo uses text commands to control a turtle on the screen that leaves a trail as it travels. The command RT 90 turns the turtle 90° to the right, and FD 100 moves the turtle forward 100 units. One early Logo implementation employed a robotic turtle named Irving that moved around the room according to the children's instructions.

In contrast to the interactive approach of Sketchpad and Logo, most early software drawing systems translated input directly from code to paper. Software drawing pioneers of the early 1960s included A. Michael Noll, Frieder Nake, Georg Nees, and Charles Csuri. Their images were realized with computer-driven plotters, a common output device of that time. A plotter is a pen attached to a moving mechanical arm controlled by motors through a computer. Many drawings from this period utilized the technology in a way that showcased the precision of the tools. Another wave of individuals utilizing software plotters emerged in the 1970s and 1980s. These artists included Vera Molnar, Manfred Mohr, Jean-Pierre Hébert, and Mark Wilson.

Bridging the era of plotters to present-day technologies, Harold Cohen's *AARON* is arguably the most sophisticated drawing software ever written. The software has undergone continuous development since it was first created in 1973. *AARON*'s drawings have been featured in some of the world's most prominent museums, including the Tate Gallery in London and the Stedelijk Museum in Amsterdam. *AARON* initially created abstract drawings and over the years was refined to add rocks, then plants, and finally people. Cohen encoded his ideas about drawing as a set of rules that comprise the *AARON* software. The program operates autonomously and makes a unique drawing each time it is run. The software makes every composition decision and produces drawings that often surprise Cohen.

While contemporary artists continue to write innovative software to enable unique approaches to drawing, current input tools can severely limit drawing with software. The quality of drawing with a device such as the mouse is constrained by the small amount of information transferred from the hand into the software. The hand, with its strength and flexibility, is capable of gestures of the smallest nuance in pressure and direction, but the mouse receives only position information. Such limitations were diminished with the introduction of drawing tablets and stylus devices capable of reading pressure and direction, but no matter how much these devices improve, they will only approximate the quality of using physical instruments and media.

Rather than applying a "traditional" model of drawing to the software medium, another approach is to address the possibilities tangential to the constraints. When using a new medium, why constrain oneself to imitating other media? In the context of this book, we consider the potential of software in contrast to physical media and address drawing methods that are unique to software and drawing on a screen.

Simple tools

The easiest way to draw with Processing is to omit the background() function inside draw(). This allows the display window to accumulate pixels from frame to frame. The following examples use this technique to draw a series of dots, lines that connect the current mouse position with the most recent position, and lines that display only when a mouse button is pressed.

```
void setup() {
  size(100, 100);
  noSmooth();
}

void draw() {
  point(mouseX, mouseY);
}
```

```
void setup() {
  size(100, 100);
}

void draw() {
  line(mouseX, mouseY, pmouseX, pmouseY);
}
```

```
void setup() {
  size(100, 100);
}

void draw() {
  if (mousePressed == true) {
    line(mouseX, mouseY, pmouseX, pmouseY);
  }
}
```

```
void setup() {
  size(100, 100);
}

void draw() {
  if (mousePressed == true) { // If mouse is pressed,
    stroke(255);              // set the stroke to white
  } else {                    // Otherwise,
    stroke(0);                // set to black
  }
  line(mouseX, mouseY, pmouseX, pmouseY);
}
```

Drawing with software is not restricted to making a single mark that follows the cursor. For instance, a for loop enables more complex drawings with fewer lines of code. The following examples use a for loop to draw many elements to the screen at each frame.

```
void setup() {
  size(100, 100);
}

void draw() {
  for (int i = 0; i < 50; i += 2) {
    point(mouseX+i, mouseY+i);
  }
}
```

```
void setup() {
  size(100, 100);
}

void draw() {
  for (int i = -14; i <= 14; i += 2) {
    point(mouseX+i, mouseY);
  }
}
```

```
void setup() {
  size(100, 100);
  noStroke();
  fill(255, 40);
  background(0);
}

void draw() {
  if (mousePressed == true) {
    fill(0, 26);
  } else {
    fill(255, 26);
  }
  for (int i = 0; i < 6; i++) {
    ellipse(mouseX + i*i, mouseY, i, i);
  }
}
```

Draw with media

Images and shapes can also be used as drawing tools. If an image or shape is positioned in relation to the cursor at each frame, its pixels can be used to create visually complex

compositions. In the following examples, the images and shapes follow the position of the cursor.

30-08

```
PImage lineImage;

void setup() {
  size(100, 100);
  // This image is 100 pixels wide, but one pixel tall
  lineImage = loadImage("imageline.jpg");
}

void draw() {
  image(lineImage, mouseX-lineImage.width/2, mouseY);
}
```

30-09

```
PImage alphaImg;

void setup() {
  size(100, 100);
  // This image is partially transparent
  alphaImg = loadImage("alphaArch.png");
}

void draw() {
  int ix = mouseX - alphaImg.width/2;
  int iy = mouseY - alphaImg.height/2;
  image(alphaImg, ix, iy);
}
```

30-10

```
PShape map;

void setup() {
  size(100, 100);
  map = loadShape("antarctica.svg");
  map.disableStyle();
  stroke(255, 10);
  noFill();
  background(0);
  shapeMode(CENTER);
}
```

```
void draw() {
  shape(map, mouseX, mouseY);
}
```

Speed

The speed of the mouse is calculated by comparing the current position with the previous position. For instance, if the mouse is moving quickly, this value is large, and if the mouse isn't moving, it's zero. This is done by measuring the distance between the mouseX, mouseY, pmouseX, and pmouseY values using the dist() function (p. 274). The following example calculates the speed of the mouse and converts this value into the stroke weight of a continuous line.

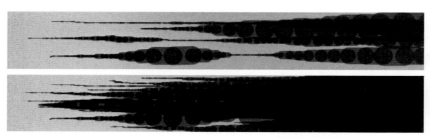

```
void setup() {
  size(700, 100);
  stroke(0, 102);
}

void draw() {
  if (mousePressed == true) {
    float weight = dist(mouseX, mouseY, pmouseX, pmouseY);
    strokeWeight(weight);
    line(mouseX, mouseY, pmouseX, pmouseY);
  }
}
```

The previous example shows the instantaneous speed of the mouse as the thickness of the line. The numbers produced are extreme—they jump between zero and large values from one frame to the next. The easing calculation from code 20-25 (p. 276) can be used to increase and decrease size and position more smoothly.

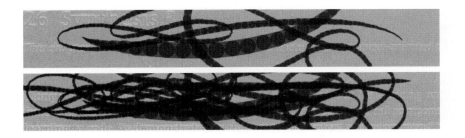

```
float x, y;                                                    30-12
float px, py;
float easing = 0.1;

void setup() {
  size(700, 100);
  stroke(0, 102);
}

void draw() {
  float targetX = mouseX;
  float targetY = mouseY;
  x += (targetX - x) * easing;
  y += (targetY - y) * easing;
  float weight = dist(x, y, px, py);
  strokeWeight(weight);
  if (mousePressed == true) {
    line(x, y, px, py);
  }
  py = y;
  px = x;
}
```

Orientation

The angle of drawing elements in relation to the position of the mouse can be
calculated with the atan2() function (p. 289). This technique can be used to draw lines
in relation to the current position of the cursor to create more structure within a
drawing. In the following example, lines are drawn to point toward the center of the
display window.

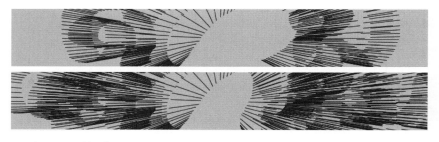

```
void setup() {
  size(700, 100);
}

void draw() {
  if (mousePressed == true) {
    float angle = atan2(mouseY-height/2, mouseX-width/2);
    pushMatrix();
    translate(mouseX, mouseY);
    rotate(angle);
    line(0, 0, 50, 0);
    popMatrix();
  }
}
```

30-13

A small modification to the preceding program makes it possible to use a mouse click to set a new center for the lines. The global clickX and clickY variables are set each inside the mousePressed() event function each time a button is pressed.

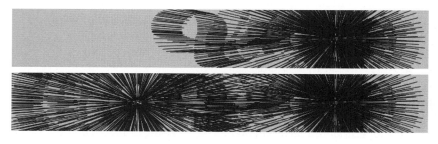

```
int clickX, clickY;

void setup() {
  size(700, 600);
}
```

30-14

```
void draw() {
  if (mousePressed == true) {
    float angle = atan2(mouseY-clickY, mouseX-clickX);
    pushMatrix();
    translate(mouseX, mouseY);
    rotate(angle);
    line(0, 0, 50, 0);
    popMatrix();
  }
}

void mousePressed() {
  clickX = mouseX;
  clickY = mouseY;
}
```

Drawings in motion

The experimental animation techniques of drawing, painting, and scratching directly onto film are all predecessors to software-based kinetic drawings. The immediacy and freshness of short films such as Norman McLaren's *Hen Hop* (1942), Len Lye's *Free Radicals* (1957), and Stan Brakhage's *The Garden of Earthly Delights* (1981) are due to the extraordinary qualities of physical gesture that software later made more accessible. In his 1948 essay "Animated Films," McLaren wrote, "In one operation, which is drawing directly onto the 35mm clear machine leader with an ordinary pen nib and India ink, a clean jump was made from the ideas in my head to the images on what would normally be called a developed negative." He further explains, "The equivalents of Scripting, Drawing, Animating, Shooting, Developing the Negative, Positive Cutting, and Negative Cutting were all done in one operation."[1] Like working directly on film, programming provides the ability to produce kinetic forms with immediate feedback.

Software animation tools further extend film techniques by allowing the artist to edit and animate elements continuously after they have been drawn. In 1991, Scott Snibbe's *Motion Sketch* extended to software the techniques explored by McLaren, Lye, and Brakhage. The application translates hand motion to visual elements on the screen. Each gesture creates a shape that moves in a one-second loop. The resulting animations can be layered to create a work of spatial and temporal complexity reminiscent of Oskar Fischinger's style. Snibbe extended this concept further with *Motion Phone* (1995), which enabled people to work simultaneously in a shared drawing space via the Internet.

Many artists have developed their own software in pursuit of creative animation. Since 1996, Bob Sabiston has developed Rotoshop, a set of tools for drawing and positioning graphics on top of video frames. He refined the software to make the ambitious animated feature *Waking Life* (p. 403). The *Mobility Agents* software (1989–

2005) created by John F. Simon Jr. augments lines drawn by hand with additional lines drawn by the software. Drawn lines are augmented by or replaced with lines that correspond to the angle and speed at which the initial lines are drawn. Zach Lieberman's *Drawn* software (2005) explores a hybrid space of physical materials and software animation. Marks made on paper with a brush and ink are brought to life through the clever use of a video camera and computer vision techniques. The camera takes an image and the software calculates a mark's location and shape, at which point the mark can respond like any other reactive software form.

Artists explore software as a medium for pushing drawing in new directions. Drawing with software provides the ability to integrate time, response, and behavior with drawn marks. Information from the mouse (introduced in Interaction, p. 83) can be combined with techniques of motion (introduced in Motion, p. 305) to produce animated drawings that capture the kinetic gestures of the hand and reinterpret them as intricate motion. Other unique inputs, such as voice captured through a microphone and body gestures captured through a camera, can be used to control drawings.

Active tools

Software drawing instruments can follow a rhythm or abide by rules independent of drawn gestures. This is a form of collaborative drawing in which the draftsperson controls some aspects of the image and the software controls others. In the examples that follow, the drawing elements obey their own rules, but the draftsperson controls each element's origin. In the next example, the drawing tool pulses from a small to a large size, supplementing the motion of the hand.

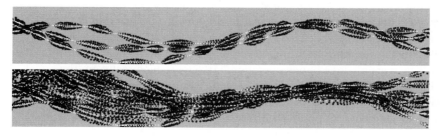

```
int angle = 0;
```
<div align="right">30-15</div>

```
void setup() {
  size(700, 100);
  noStroke();
  fill(0, 102);
}
```

```
void draw() {
  if (mousePressed == true) {
    angle += 10;
    float val = cos(radians(angle)) * 6.0;
    // Draw a cluster of circles
    for (int a = 0; a < 360; a += 75) {
      float xoff = cos(radians(a)) * val;
      float yoff = sin(radians(a)) * val;
      fill(0);
      ellipse(mouseX + xoff, mouseY + yoff, val/2, val/2);
    }
    fill(255);
    ellipse(mouseX, mouseY, 2, 2);
  }
}
```

In the next example, the Blade class defines a drawing tool that creates a growing diagonal line when the mouse is not moving and resets the line to a new position when the mouse moves.

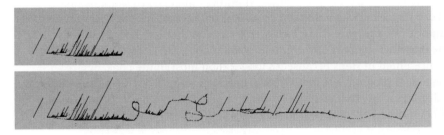

```
Blade diagonal;

void setup() {
  size(700, 100);
  noSmooth();
  diagonal = new Blade(30, 80);
}

void draw() {
  diagonal.grow();
}

void mouseMoved() {
  diagonal.seed(mouseX, mouseY);
}
```

```
class Blade {
  float x, y;

  Blade(int xpos, int ypos) {
    x = xpos;
    y = ypos;
  }

  void seed(int xpos, int ypos) {
    x = xpos;
    y = ypos;
  }

  void grow() {
    x += 0.5;
    y -= 1.0;
    point(x, y);
  }
}
```

Individual drawing elements with their own behavior can produce drawings with or without input from a person. Though created by a series of predetermined rules and actions, the drawings are partially or totally autonomous. The code for the next example is presented in steps because it's longer than most in the book. Before writing the longer program, we first wrote a small program to test the desired effect. This code displays a line that changes position very slightly with each frame. Over a long period of time, the line's position changes significantly. This is similar to code 22-14 (p. 319), but it is subtler.

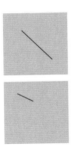

```
float x1, y1, x2, y2;

void setup() {
  size(100, 100);
  x1 = width / 4.0;
  y1 = x1;
  x2 = width - x1;
  y2 = x2;
}

void draw() {
  background(204);
  x1 += random(-0.5, 0.5);
  y1 += random(-0.5, 0.5);
```

```
      x2 += random(-0.5, 0.5);
      y2 += random(-0.5, 0.5);
      line(x1, y1, x2, y2);
   }
```

If several such lines are drawn, the drawing will degrade over time as each line continues to wander from its original position. In the next example, the code from above was modified to create the MovingLine class. Five hundred of these MovingLine objects populate the display window. When the lines are first drawn, they vibrate but maintain their form. Over time, the image degrades into chaos as each line wanders across the surface of the window.

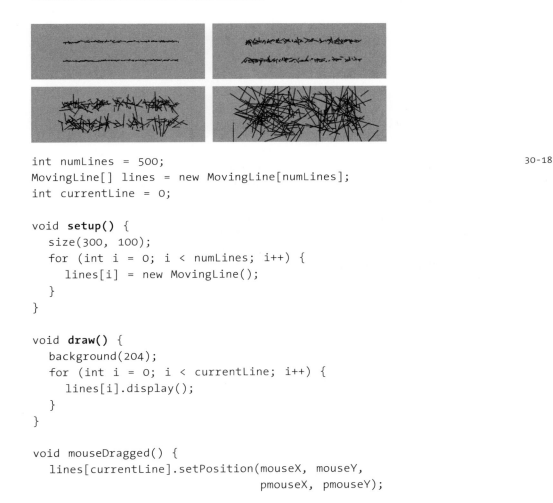

```
int numLines = 500;
MovingLine[] lines = new MovingLine[numLines];
int currentLine = 0;

void setup() {
  size(300, 100);
  for (int i = 0; i < numLines; i++) {
    lines[i] = new MovingLine();
  }
}

void draw() {
  background(204);
  for (int i = 0; i < currentLine; i++) {
    lines[i].display();
  }
}

void mouseDragged() {
  lines[currentLine].setPosition(mouseX, mouseY,
                                 pmouseX, pmouseY);
```

30-18
cont.

```
    if (currentLine < numLines - 1) {
      currentLine++;
    }
  }
}

class MovingLine {
  float x1, y1, x2, y2;

  void setPosition(int x, int y, int px, int py) {
    x1 = x;
    y1 = y;
    x2 = px;
    y2 = py;
  }

  void display() {
    x1 += random(-0.1, 0.1);
    y1 += random(-0.1, 0.1);
    x2 += random(-0.1, 0.1);
    y2 += random(-0.1, 0.1);
    line(x1, y1, x2, y2);
  }
}
```

Exercises

1. *Make a custom drawing tool that changes its color when a mouse button is pressed.*
2. *Create a custom drawing tool that changes its form when different keys are pressed.*
3. *Edit and load a photograph to use as a drawing tool. Create and save a few drawings.*
4. *Modify code 30-15 to design and create a new active drawing instrument.*
5. *Design and create visual elements that change after they have been drawn to the display window.*

Note

1. Norman McLaren, "Animated Films," in *Experimental Animation*, edited by Robert Russett and Cecile Starr (Da Capo Press, 1976), p. 122.

31 Simulate

This chapter discusses the concept of software simulation and the topics of cellular automata and autonomous agents as well as physical simulations for particle systems and springs.

Simulation is used within physics, economics, the social sciences, and other fields to gain insight into the complicated systems that comprise our world. Software simulations employ the most powerful computers to model aspects of the world such as weather and traffic patterns. A tremendous amount of intellectual energy in the field of computer graphics has been dedicated to accurate simulation of lighting, textures, and the movement of physical materials such as cloth and hair. An entire genre of computer games exists that simulate city planning, military campaigns, and even everyday life. Computers constitute a powerful medium for simulating the processes of the world, and increasing computer speeds offer more sophisticated possibilities.

Within the arts, new technologies have been used for centuries to represent and simulate nature. For instance, in the eighteenth century precise gears provided the technical infrastructure for lifelike sculptures such as Vaucanson's Duck, which could "open its wings and flap them, while making a perfectly natural noise as if it were about to fly away."[1] In our contemporary world, computers and precision motors enable dancing robots and realistic children's toys that speak and move. One of the most fascinating simulations in recent art history is Wim Delvoye's *Cloaca* machine, which chemically and physically simulates the human digestive system.

Physical simulation, a technique that creates relationships between software elements and the rules of the physical world, helps people relate to what they see on screen. Many technical papers and books have been written about this topic. Video game and 3D computer animation communities have devoted tremendous energy to simulating aspects of the world such as the collision of solid objects and physical phenomena such as fire and water. Because a discussion of physical simulation could occupy an entire book, this chapter will only present some of the basic concepts. The domain of physical simulation is introduced through terminology and presented as two flexible simulation techniques, for particle systems and springs.

Motion

To simulate physical phenomena in software, a mathematical model is required. Newtonian physics, developed circa 1687 by Isaac Newton, provides an adequate model based on velocity, acceleration, and friction. These terms are introduced and explained in sequence through the examples that follow.

The first example to generate motion (code 22-01, p. 305) uses a variable named *speed* to create movement. At each frame of animation, the variable named y is updated by the *speed* variable:

```
y = y + speed
```

Using this code, the position of a circle set by the variable y is changed by the same amount every frame. The code does not take into account other forces that might be exerted on the circle. For example, the circle might have a large mass, or gravity may apply a strong force, or it might be moving across a rough surface so that high friction slows it down. These forces are omnipresent in the physical world, but they affect a software simulation only if they are included as parts of the design. They need to be calculated at each frame to exert their influence.

Instead of relying solely on a variable representing speed to mimic realistic motion, variables are created to store the velocity and acceleration. The velocity changes the position of the element, and acceleration changes the velocity.

Velocity defines the speed and direction as one number. For example, a velocity of -5 moves the position in a negative direction at a speed of 5. A velocity of 12 moves the position in a positive direction at a speed of 12. Speed is defined as the magnitude (absolute value) of the velocity.

Acceleration defines the rate of change in the velocity. An acceleration value greater than zero means the velocity will increase each frame, and an acceleration value less than zero means the velocity will decrease each frame. Using the velocity and acceleration values to control the position of a visual element causes it to change direction and to increase or decrease its speed. The position of an object is updated with two steps:

```
velocity = velocity + acceleration
y = y + velocity
```

The following example is similar to code 22-01, but it uses velocity and acceleration variables instead of a single speed variable. Because the acceleration value is 0.01, the velocity increases, therefore moving the circle faster each frame.

```
float y = 50.0;
float radius = 15.0;
float velocity = 0.0;
float acceleration = 0.01;

void setup() {
  size(100, 100);
  noStroke();
  ellipseMode(RADIUS);
}

void draw() {
  fill(0, 10);
  rect(0, 0, width, height);
  fill(255);
  ellipse(33, y, radius, radius);
  velocity += acceleration;   // Increase the velocity
  y += velocity;              // Update the position
  if (y > height+radius) {    // If over the bottom edge,
    y = -radius;              // move to the top
  }
}
```

In the following example, the circle continually slows down until it eventually stops and changes direction. This happens because the negative acceleration value gradually decreases the velocity until it becomes negative.

```
float y = 50.0;
float radius = 15.0;
float velocity = 9.0;
float acceleration = -0.05;

void setup() {
  size(100, 100);
  noStroke();
  ellipseMode(RADIUS);
}

void draw() {
  fill(0, 12);
  rect(0, 0, width, height);
  fill(255);
  ellipse(33, y, radius, radius);
```

```
      velocity += acceleration;
      y += velocity;
      if (y > height+radius) {
        y = -radius;
      }
    }
```

Friction is a force that impacts velocity. The speed of a book pushed across a table is affected by friction between the two surfaces. A paper airplane is affected by the friction of the air. In code, friction is a number between 0.0 and 1.0 that decreases the velocity. In the next example, the friction value is multiplied by the velocity value each frame to gradually decrease the distance traveled by the circle each frame. Change the value of the friction variable in the code below to see its effect on the circle's movement.

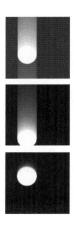

```
float y = 50.0;
float radius = 15.0;
float velocity = 8.0;
float friction = 0.98;

void setup() {
  size(100, 100);
  noStroke();
  ellipseMode(RADIUS);
}

void draw() {
  fill(0, 12);
  rect(0, 0, width, height);
  fill(255);
  ellipse(33, y, radius, radius);
  velocity *= friction;
  y += velocity;
  if (y > height+radius) {
    y = -radius;
  }
}
```

The direction and speed components of the velocity can be altered independently. Reversing the direction of the velocity simulates bouncing. The following example inverts the velocity when the edge of the circle touches the bottom of the display window. The acceleration of 0.3 simulates gravity, and the friction gradually reduces the velocity to stop the bouncing eventually.

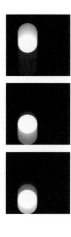

```
float x = 33.0;
float y = 5.0;
float velocity = 0.0;
float radius = 15.0;
float friction = 0.99;
float acceleration = 0.3;

void setup() {
  size(100, 100);
  noStroke();
  ellipseMode(RADIUS);
}

void draw() {
  fill(0, 12);
  rect(0, 0, width, height);
  fill(255);
  velocity += acceleration;
  velocity *= friction;
  y += velocity;
  if (y > (height-radius)) {
    y = height - radius;
    velocity = -velocity;
  }
  ellipse(x, y, radius, radius);
}
```

Particle systems

A particle system, an array of particles that responds to the environment or to other particles, serves to simulate and render phenomena such as fire, smoke, and dust. Hollywood films and video game companies frequently employ particle systems to create realistic explosions and water effects. Particles are affected by forces and are typically used to simulate physical laws for generating motion.

Writing a simple Particle class can help manage the complexity of a particle system. The Particle class has fields for the radius and gravity and pairs of fields to store the position and velocity. Gravity acts like the acceleration variable in previous examples. The class methods update the position and draw the particle to the

display window. The parameters to the constructor set the initial position, velocity, and radius.

```
class Particle {
    float x, y;             // The x- and y-coordinates
    float vx, vy;           // The x- and y-velocities
    float radius;           // Particle radius
    float gravity = 0.1;

    Particle(int xpos, int ypos, float velx, float vely, float r) {
        x = xpos;
        y = ypos;
        vx = velx;
        vy = vely;
        radius = r;
    }

    void update() {
        vy += gravity;
        y += vy;
        x += vx;
    }

    void display() {
        ellipse(x, y, radius*2, radius*2);
    }
}
```

The following example shows how to use the Particle class. Here, as in most examples that use objects, an object variable is declared outside of setup() and draw(), it is created within setup(), and its methods are run within draw(). The example throws a particle across the display window from the lower-left to the upper-right corner. After the particle moves off the screen, its values continue to update, but it can no longer be seen.

```
// Requires Particle class

Particle p;

void setup() {
  size(100, 100);
  noStroke();
  p = new Particle(0, height, 2.2, -4.2, 20.0);
}

void draw() {
  fill(0, 12);
  rect(0, 0, width, height);
  fill(255);
  p.update();
  p.display();
}
```

The Particle class is very limited, but allows the extension and creation of more applicable behavior. The GenParticle class extends the Particle class so the particle returns to its origin after it moves outside the display window. This allows for a continuous flow of particles with a fixed number of objects. In the example below, the two variables originX and originY store the coordinates of the origin, and the regenerate() method repositions the particle when it is outside the display window and resets its velocity.

```
class GenParticle extends Particle {
  float originX, originY;

  GenParticle(int xpos, int ypos, float velx, float vely,
              float r, float ox, float oy) {
    super(xpos, ypos, velx, vely, r);
    originX = ox;
    originY = oy;
  }
```

```
void regenerate() {
    if ((x > width+radius) || (x < -radius) ||
        (y > height+radius) || (y < -radius)) {
      x = originX;
      y = originY;
      vx = random(-1.0, 1.0);
      vy = random(-4.0, -2.0);
    }
  }
}
```

The GenParticle object is used the same way as a Particle object, but the regenerate() method also needs to be run to ensure an endless supply of flowing particles. In the following example, 200 particles are created within an array and individually modified.

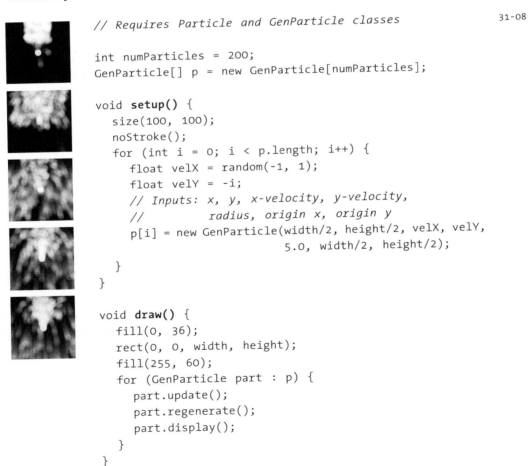

```
// Requires Particle and GenParticle classes

int numParticles = 200;
GenParticle[] p = new GenParticle[numParticles];

void setup() {
  size(100, 100);
  noStroke();
  for (int i = 0; i < p.length; i++) {
    float velX = random(-1, 1);
    float velY = -i;
    // Inputs: x, y, x-velocity, y-velocity,
    //         radius, origin x, origin y
    p[i] = new GenParticle(width/2, height/2, velX, velY,
                           5.0, width/2, height/2);
  }
}

void draw() {
  fill(0, 36);
  rect(0, 0, width, height);
  fill(255, 60);
  for (GenParticle part : p) {
    part.update();
    part.regenerate();
    part.display();
  }
}
```

The LimitedParticle class extends the Particle class to change the direction of the velocity when a particle hits the bottom of the display window. It also introduces friction so the motion of each particle is reduced each frame.

```
class LimitedParticle extends Particle {                              31-09
    float friction = 0.99;

    LimitedParticle(int xpos, int ypos, float velx,
                    float vely, float r) {
        super(xpos, ypos, velx, vely, r);
    }

    void update() {
        vy *= friction;
        vx *= friction;
        super.update();
        limit();
    }

    void limit() {
        if ((x < radius) || (x > width-radius)) {
            vx = -vx;
            x = constrain(x, radius, width-radius);
        }
        if (y > height-radius) {
            vy = -vy;
            y = height-radius;
        }
    }
}
```

The LimitedParticle class is used in the following examples to create a screen full of small bouncing elements. Each starts with a different velocity, but they all slow down and eventually come to rest at the bottom of the screen.

```
int num = 80;
LimitedParticle[] p = new LimitedParticle[num];
float radius = 1.2;

void setup() {
  size(100, 100);
  noStroke();
  for (int i = 0; i < p.length; i++) {
    float velX = random(-2, 2);
    float velY = -i;
    // Inputs: x, y, x-velocity, y-velocity, radius
    p[i] = new LimitedParticle(width/2, height/2,
                               velX, velY, 2.2);

  }
}

void draw() {
  fill(0, 24);
  rect(0, 0, width, height);
  fill(255);
  for (LimitedParticle part : p) {
    part.update();
    part.display();
  }
}
```

The particles in the previous examples are drawn as circles to make the code simple to read. Particles can, however, be drawn as any shape. The following example makes another class from the original Particle class. This ArrowParticle class uses the fields and methods from its superclass to control the velocity and position of the particle, but it adds code to calculate an angle and to draw an arrow shape. The atan2() function is used to determine the current angle of the arrow. The arrow is positioned horizontally, but the rotation changes it to point up or down.

```
class ArrowParticle extends Particle {                          31-11
  float angle = 0.0;
  float shaftLength = 20.0;

  ArrowParticle(int xpos, int ypos, float velx, float vely, float r) {
    super(xpos, ypos, velx, vely, r);
  }
```

```
  void update() {
    super.update();
    angle = atan2(vy, vx);
  }

  void display() {
    stroke(255);
    pushMatrix();
    translate(x, y);
    rotate(angle);
    scale(shaftLength);
    strokeWeight(1.0 / shaftLength);
    line(0, 0, 1, 0);
    line(1, 0, 0.7, -0.3);
    line(1, 0, 0.7, 0.3);
    popMatrix();
  }
}
```

In the next example, each arrow is assigned a random value within a range. The x-velocity ranges from 1.0 to 8.0 and the y-velocity from -5.0 to -1.0. At each frame, the force of gravity is applied to each particle and the angle of each arrow slowly turns toward the ground until it eventually disappears off the bottom of the screen.

```
// Requires Particle, ArrowParticle classes
```

```
int num = 320;
ArrowParticle[] p = new ArrowParticle[num];
float radius = 1.2;

void setup() {
  size(700, 100);
  for (int i = 0; i < p.length; i++) {
    float velX = random(1, 8);
    float velY = random(-5, -1);
```

```
    // Parameters: x, y, x-velocity, y-velocity, radius    31-12
    p[i] = new ArrowParticle(0, height/2, velX, velY, 1.2);    cont.
  }
}

void draw() {
  background(0);
  for (ArrowParticle part : p) {
    part[i].update();
    part[i].display();
  }
}
```

Springs

A spring is an elastic device, usually a coil of metal wire, that returns to its original shape after it has been extended or compressed. Software simulations of springs approximate the behavior of their physical analogs. The physics of a spring is simple and versatile. Like gravity, a spring is represented as a force. The force is calculated based on how "stiff" the spring is and how far it is stretched. The force of a spring is inversely proportional to how far it is stretched. This is known as Hooke's law. The equation for calculating the force of a spring is:

$$f = -kx$$

In this equation, k is the spring stiffness constant, and the variable x is how far the spring is stretched. The inverse of k is multiplied by x to yield the force. The value of k is always between 0.0 and 1.0. This equation can be rewritten for clarity:

```
springForce = -stiffness * stretch
```

The *stretch* variable is the difference between the position and the target position:

```
springForce = -stiffness * (position - restPosition)
```

The equation can be simplified slightly to remove the negation:

```
springForce = stiffness * (restPosition - position)
```

A damping (frictional) force can be added to resist the motion. The value of the *damping* variable is always between 0.0 (so much friction that there is no movement)

and 1.0 (no friction). The velocity of the spring is calculated by adding the spring force to the current velocity and then multiplying by the damping constant:

```
velocity = damping * (velocity + springForce)
```

These equations enable the writing of a simple spring simulation. The following example uses them to set the position of a rectangle. The targetY variable is the resting position and the y variable is the current position of the spring. Try changing the values for the stiffness and damping variables to see how they affect the behavior of the rectangle. Both of these values should be in the range of 0.0 to 1.0.

31-13

```
float stiffness = 0.1;
float damping = 0.9;
float velocity = 0.0;
float targetY = 0.0;
float y = 0.0;

void setup() {
  size(100, 100);
  noStroke();
}

void draw() {
  fill(0, 12);
  rect(0, 0, width, height);
  fill(255);
  float force = stiffness * (targetY - y);   // f = -kx
  velocity = damping * (velocity + force);
  y += velocity;
  rect(10, y, width-20, 12);
  targetY = mouseY;
}
```

Mass is another component to simulate when working with springs. The mass of a spring affects how much effect a force will have. Commonly confused with weight, mass is the amount of matter an object consists of and is independent of the force of gravity; weight is the force applied by gravity on an object. If an object has more matter, gravity has a stronger effect on it and it therefore weighs more. Newton's second law states that the sum of the forces acting on an object is equal to the object's mass multiplied by the object's acceleration:

$$F = ma$$

This equation can be rearranged to solve for the acceleration:

$a = F/m$

Using the code notation we've introduced, the equation can be written as follows:

$acceleration = springForce / mass$

This arrangement highlights the fact that an object with more mass will have less acceleration than one with less.

The following example is similar to code 31-13, but it positions two rectangles on the screen and therefore requires additional variables. It demonstrates the effect of mass on the spring equations. The rectangle on the right has a mass six times larger than that of the rectangle on the right.

31-14

```
float y1, y2;
float velocity1, velocity2;
float mass1 = 1.0;
float mass2 = 6.0;
float stiffness = 0.1;
float damping = 0.9;

void setup() {
  size(100, 100);
  noStroke();
}

void draw() {
  fill(0, 12);
  rect(0, 0, width, height);
  fill(255);

  float targetY = mouseY;

  float forceA = stiffness * (targetY - y1);
  float accelerationY1 = forceA / mass1;
  velocity1 = damping * (velocity1 + accelerationY1);
  y1 += velocity1;
  rect(10, y1, 40, 15);
```

```
            float forceB = stiffness * (targetY - y2);
            float accelerationY2 = forceB / mass2;
            velocity2 = damping * (velocity2 + accelerationY2);
            y2 += velocity2;
            rect(50, y2, 40, 15);
        }
```

The Spring2D class encapsulates the concepts and equations from the previous
examples into a reusable code unit. It calculates the spring values separately for the
x- and y-axis and adds a gravitational force by combining the gravity value with the
forceY value.

```
class Spring2D {
  float vx, vy;    // The x- and y-axis velocities
  float x, y;      // The x- and y-coordinates
  float mass;
  float gravity;
  float radius = 10.0;
  float stiffness = 0.2;
  float damping = 0.7;

  Spring2D(float xpos, float ypos, float m, float g) {
    x = xpos;
    y = ypos;
    mass = m;
    gravity = g;
  }

  void update(float targetX, float targetY) {
    float forceX = (targetX - x) * stiffness;
    float ax = forceX / mass;
    vx = damping * (vx + ax);
    x += vx;
    float forceY = (targetY - y) * stiffness;
    forceY += gravity;
    float ay = forceY / mass;
    vy = damping * (vy + ay);
    y += vy;
  }
```

```
void display(float nx, float ny) {
    noStroke();
    ellipse(x, y, radius*2, radius*2);
    stroke(255);
    line(x, y, nx, ny);
  }
}
```

The following example has two `Spring2D` objects. The position of the top element in the chain is controlled by the cursor, and the rest position of the bottom element is controlled by the position of the top. Try changing the value of the `gravity` variable to increase and decrease the space between the elements.

```
// Requires Spring2D Class

Spring2D s1, s2;
float gravity = 5.0;
float mass = 2.0;

void setup() {
    size(100, 100);
    fill(0);
    // Inputs: x, y, mass, gravity
    s1 = new Spring2D(0.0, width/2, mass, gravity);
    s2 = new Spring2D(0.0, width/2, mass, gravity);
}

void draw() {
    background(204);
    s1.update(mouseX, mouseY);
    s1.display(mouseX, mouseY);
    s2.update(s1.x, s1.y);
    s2.display(s1.x, s1.y);
}
```

In the following example, an array is used to store more `Spring2D` objects. The rest position for each object is set by the object that immediately precedes it in the chain. The motion propagates through each element.

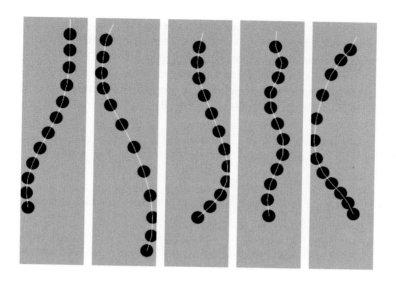

// Requires Spring2D Class

```
int numSprings = 12;
Spring2D[] s = new Spring2D[numSprings];
float mass = 3.0;
float gravity = 5.0;

void setup() {
  size(100, 400);
  fill(0);
  for (int i = 0; i < s.length; i++) {
    s[i] = new Spring2D(width/2, i*(height/numSprings), mass, gravity);
  }
}

void draw() {
  background(204);
  s[0].update(mouseX, mouseY);
  s[0].display(mouseX, mouseY);
  for (int i = 1; i < s.length; i++) {
    s[i].update(s[i-1].x, s[i-1].y);
    s[i].display(s[i-1].x, s[i-1].y);
  }
}
```

Metal springs each have a length to which they return after being pulled or pushed. In the spring simulations in this book, the final step is to give the spring a fixed length. This makes the springs more like their counterparts in the physical world. The FixedSpring class extends the Spring2D class to force the spring to have a specific length. The distance between the masses in the previous examples was created by a large gravitational force, but here the displacement is enforced by the springLength variable.

```
class FixedSpring extends Spring2D {                                          31-18
    float springLength;

    FixedSpring (float xpos, float ypos, float m, float g, float s) {
        super(xpos, ypos, m, g);
        springLength = s;
    }

    void update(float newX, float newY) {
        // Calculate the target position
        float dx = x - newX;
        float dy = y - newY;
        float angle = atan2(dy, dx);
        float targetX = newX + cos(angle) * springLength;
        float targetY = newY + sin(angle) * springLength;
        // Activate update method from Spring2D
        super.update(targetX, targetY);
        // Constrain to display window
        x = constrain(x, radius, width-radius);
        y = constrain(y, radius, height-radius);
    }
}
```

The FixedSpring class was written to extend the Spring2D class, but it also could have been written as its own class. It was written as a subclass to utilize the existing code, but this decision meant that the default values for the stiffness and damping fields introduced in Spring2D became the default values for FixedSpring. To avoid this restriction, the class can be modified to pass these values as parameters to the constructor. When creating a class you decide which fields to pass through the constructor by using your best judgment, but there is usually no single correct way to structure a program. There are many ways to write any program, and while the decisions about how to modularize the code should be made carefully, they can always be changed.

The following example calculates and draws one fixed-length spring to the display windows. Unlike the previous spring examples where the mass dangles from the cursor, a fixed-length spring always tries to maintain its length. It can be balanced on top of the cursor as well as hung from the end.

```
// Requires Spring2D and FixedSpring classes                    31-19

FixedSpring s;
float gravity = 0.5;

void setup() {
  size(100, 100);
  fill(0);
  // Inputs: x, y, mass, gravity, length
  s = new FixedSpring(0.0, 50.0, 1.0, gravity, 40.0);
}

void draw() {
  background(204);
  s.update(mouseX, mouseY);
  s.display(mouseX, mouseY);
}
```

Fixed springs can be connected to other springs to create new forms. In the following example, two springs are joined so that the position of each spring affects the position of the other. When they are pushed too close together or pulled too far apart, they return to their defined distance from one another. Because a gravitational force is applied, they always fall to the bottom of the display window, but the force that keeps them apart is stronger, so they appear to move as a single, solid object.

```
// Requires Spring2D and FixedSpring classes                    31-20

FixedSpring s1, s2;
float gravity = 1.2;

void setup() {
  size(100, 100);
  fill(0);
  // Inputs: x, y, mass, gravity, length
  s1 = new FixedSpring(45, 33, 1.5, gravity, 40.0);
  s2 = new FixedSpring(55, 66, 1.5, gravity, 40.0);
}
```

```
void draw() {
    background(204);
    s1.update(s2.x, s2.y);
    s2.update(s1.x, s1.y);
    s1.display(s2.x, s2.y);
    s2.display(s1.x, s1.y);
    if (mousePressed == true) {
        s1.x = mouseX;
        s1.y = mouseY;
    }
}
```

The method used for calculating spring values in these examples is called the Euler integration technique. This is the easiest way to calculate these values, but its accuracy is limited. The Euler method works well for simple spring simulations, but it can cause problems with more complex simulations as small inaccuracies compound and cause the numbers to approach infinity. When this happens, people often say the simulation "exploded." For instance, shapes controlled by an Euler integrator might fly off the screen. A more stable but more complicated technique is the Runge-Kutta method. For sake of brevity, it is not covered here, but it can be found in other texts.

Cellular automata

A cellular automaton (CA) is a self-operating system comprising a grid of cells and rules stating how each cell behaves in relation to its neighbor. CAs were first considered by John von Neumann in the 1940s; they became well known in the 1970s after the publication of John Conway's Game of Life CA in a *Scientific American* article by Martin Gardner. CAs are intriguing because of their apparent simplicity in relation to the unexpected results they produce.

Steven Wolfram made important innovations in CA research in the early 1980s. His one-dimensional CAs use a single row of cells and a set of rules. The value of each cell is determined by its own value and those of its two neighbors. For example, if the current cell is white and its neighbors are black, it may also become black in the next frame. A set of rules determines when cells change their values. Since there are three cells with only two possible values (black or white), there are eight possible rules. In the following diagram, the three rectangles on the top are the three neighboring cells. The cell in the top middle is the current cell being evaluated, and those on the left and right are its neighbors. Depending on the current cell's value and that of its neighbors, the cell beneath the current cell is changed to black or white. The rules give rise to a number of possible variations and produce diverse results. One potential set of rules follows:

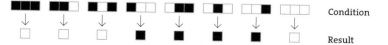

Condition

Result

The CA starts with an initial state and is then updated to the next frame based on its rules. Each cell in the row is evaluated in relation to its two adjacent cells. Visual patterns begin to emerge from the minimal configuration of all white cells with one black cell in the middle:

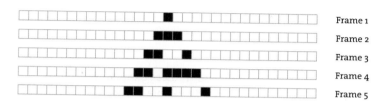

Frame 1

Frame 2

Frame 3

Frame 4

Frame 5

The new one-dimensional image at each frame refers only to the previous frame. Because each frame is one-dimensional, it can be combined with the others to create a two-dimensional image, revealing the history of each frame of the CA within a single image that can be read from top to bottom:

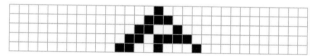

The rules for this one-dimensional CA can be encoded as an array of 0s and 1s. Using the diagram above as reference, if the configuration in the top row stays the same, the resulting bottom row can be defined as an array of 8 values, each a 1 or 0. This configuration can be coded as 0, 0, 0, 1, 1, 1, 1, 0, where 0 is white and 1 is black. Each of the other 255 possible configurations can be coded as a sequence of 8 numbers. Changing these numbers in the following example of a one-dimensional CA creates different images. The images on page 475 present some of the possible rules and their results.

```
int[] rules = { 0, 0, 0, 1, 1, 1, 1, 0 };                              31-21
int gen = 1;   // Generation
color on = color(255);
color off = color(0);

void setup() {
  size(101, 101);
  frameRate(8);   // Slow down to 8 frames each second
  background(0);
  set(width/2, 0, on);   // Set the top middle pixel to white
}
```

```
void draw() {
    // For each pixel, determine new state by examining current
    // state and neighbor states and ignore edges that have only
    // one neighbor
    for (int x = 1; x < width-1; x++) {
        int left = get(x-1, gen-1);       // Left neighbor
        int me = get(x, gen-1);           // Current pixel
        int right = get(x+1, gen-1);      // Right neighbor
        if (rules(left, me, right) == 1) {
            set(x, gen, on);
        }
    }
    gen++;                                 // Increment the generation by 1
    if (gen > height-1) {   // If reached the bottom of the screen,
        noLoop();           // stop the program
    }
}

// Implement the rules
int rules(color a, color b, color c) {
    if ((a == on ) && (b == on ) && (c == on )) { return rules[0]; }
    if ((a == on ) && (b == on ) && (c == off)) { return rules[1]; }
    if ((a == on ) && (b == off) && (c == on )) { return rules[2]; }
    if ((a == on ) && (b == off) && (c == off)) { return rules[3]; }
    if ((a == off) && (b == on ) && (c == on )) { return rules[4]; }
    if ((a == off) && (b == on ) && (c == off)) { return rules[5]; }
    if ((a == off) && (b == off) && (c == on )) { return rules[6]; }
    if ((a == off) && (b == off) && (c == off)) { return rules[7]; }
    return 0;
}
```

The preceding code, and the rest of the code in this chapter, uses the get() and set() functions. They are discussed later in the book in Image Processing (p. 529). In this context, the set() function sets the color value of one pixel and the get() function reads the color value of one pixel. Together, these functions read and write the pixels of the display window to calculate the cellular automata.

John Conway's Game of Life predates Wolfram's discoveries by more than a decade. Gardner's article in *Scientific American* describes Conway's invention as "a fantastic solitaire pastime he calls 'life.' Because of its analogies with the rise, fall and alternations of a society of living organisms, it belongs to a growing class of what are called 'simulation games'—games that resemble real-life processes."[2] Life was not originally run with a computer, but early programmers rapidly became fascinated with it, and working with the Game of Life in software enabled new insight into the patterns that emerge as it runs.

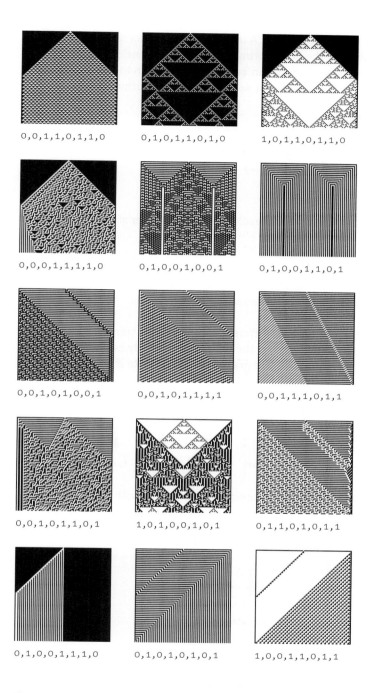

0,0,1,1,0,1,1,0 0,1,0,1,1,0,1,0 1,0,1,1,0,1,1,0

0,0,0,1,1,1,1,0 0,1,0,0,1,0,0,1 0,1,0,0,1,1,0,1

0,0,1,0,1,0,0,1 0,0,1,0,1,1,1,1 0,0,1,1,1,0,1,1

0,0,1,0,1,1,0,1 1,0,1,0,0,1,0,1 0,1,1,0,1,0,1,1

0,1,0,0,1,1,1,0 0,1,0,1,0,1,0,1 1,0,0,1,1,0,1,1

Figure 31-1 Wolfram's one-dimensional cellular automata
Use the numbers below each image as the data for the rules[] *array in code
31-21 to watch each pattern generate.*

The Game of Life is a two-dimensional CA in which the rules for determining the value of each cell are defined by the neighboring cells in two dimensions. Each cell has eight neighboring cells, each of which can be named in relation to the directional orientation of the cell—north, northeast, east, southeast, south, southwest, west, northwest:

NW	N	NE
W		E
SW	S	SE

The rules for turning a cell on (alive) and off (dead) relate to the number of neighboring cells:

1. Death from isolation: Each live cell with less than two live neighbors dies in the next generation.
2. Death from overpopulation: Each cell with four or more live neighbors dies in the next generation.
3. Birth: Each dead cell with exactly three live neighbors comes to life in the next generation.
4. Survival: Each live cell with two live neighbors survives in the next generation.

Applying these rules to a cell reveals how different configurations translate into survival, death, and birth. In the next image, the cell being currently evaluated is in the center and is black if alive; neighbor cells are gray if alive and white if empty:

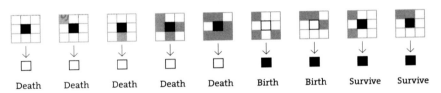

Death Death Death Death Death Birth Birth Survive Survive

Different spatial configurations of cells create repeating patterns with each new generation. Some shapes are stable (do not change at each frame), some repeat, and some move across the screen:

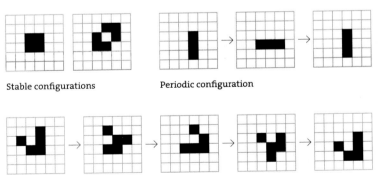

Stable configurations Periodic configuration

Moving object (this configuration moves one unit right and down over three generations)

Shapes called gliders are arrangements of cells that move across the grid, go through frames of physical distortion, and then arrive back at the same shape shifted by one grid unit. Repeating this pattern propels them across the grid.

The current state for the Game of Life is stored in a two-dimensional array of integers. A second grid hosts the next generation. At the end of each frame, the newly created generation becomes the old generation, and the process repeats. Cells are marked alive with the number 1 and dead with 0. This makes it simple to count the number of neighbors by adding the values of neighboring cells. The neighbors() function looks at neighbors and counts the values of the adjacent cells. These numbers are used to set white or black pixels within draw().

```
int[][] grid, futureGrid;
```

```
void setup() {
  size(540, 100);
  frameRate(8);
  grid = new int[width][height];
  futureGrid = new int[width][height];
  float density = 0.3 * width * height;
  // Set a random initial state
  for (int i = 0; i < density; i++) {
    int rx = int(random(width));
    int ry = int(random(height));
    grid[rx][ry] = 1;
  }
  background(0);
}

void draw() {
  for (int x = 1; x < width-1; x++) {
    for (int y = 1; y < height-1; y++) {
      // Check the number of neighbors (adjacent cells)
      int nb = neighbors(x, y);
      if ((grid[x][y] == 1) && (nb <  2)) {
        futureGrid[x][y] = 0;   // Isolation death
        set(x, y, color(0));
      } else if ((grid[x][y] == 1) && (nb >  3)) {
        futureGrid[x][y] = 0;   // Overpopulation death
        set(x, y, color(0));
      } else if ((grid[x][y] == 0) && (nb == 3)) {
        futureGrid[x][y] = 1;   // Birth
        set(x, y, color(255));
      } else {
```

```
                futureGrid[x][y] = grid[x][y];  // No change
        }
    }
  }
  // Swap current and future grids
  int[][] temp = grid;
  grid = futureGrid;
  futureGrid = temp;
}

// Count the number of adjacent cells 'on'
int neighbors(int x, int y) {
  return grid[x][y-1] +      // North
         grid[x+1][y-1] +    // Northeast
         grid[x+1][y] +      // East
         grid[x+1][y+1] +    // Southeast
         grid[x][y+1] +      // South
         grid[x-1][y+1] +    // Southwest
         grid[x-1][y] +      // West
         grid[x-1][y-1];     // Northwest
}
```

Changing the `neighbors()` function in code 31-22 to utilize the modulo operator (%) makes it possible for the cells to wrap from one side of the screen to the other. The `for` loops inside `draw()` also need to change to loop from 0 to `width` and 0 to `height`.

```
int neighbors(int x, int y) {
  int north = (y + height-1) % height;
  int south = (y + 1) % height;
  int east = (x + 1) % width;
  int west = (x + width-1) % width;
  return grid[x][north] +      // North
         grid[east][north] +   // Northeast
         grid[east][y] +       // East
         grid[east][south] +   // Southeast
         grid[x][south] +      // South
         grid[west][south] +   // Southwest
         grid[west][y] +       // West
         grid[west][north];    // Northwest
}
```

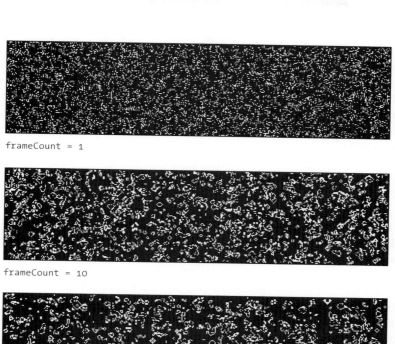

frameCount = 1

frameCount = 10

frameCount = 20

frameCount = 30

frameCount = 40

Figure 31-2 Conway's Game of Life
Using a few simple rules defined in code 31-22, the values of adjacent pixels create a dynamic ecosystem.

Research into cellular automata did not stop with Conway and Wolfram. Others have developed continuous CAs that are not limited to on/off states. Probabilistic CAs, for example, can partially or totally determine their rules through probabilities rather than absolutes. CAs have the ability to simulate lifelike phenomena in spite of their basic format. For example, the patterns created with a one-dimensional CA can mimic patterns found in the shells of organisms such as cone snails. Other CAs produce images similar to those created by biochemical reactions.

Autonomous agents

An autonomous agent is a system that senses and acts on its environment according to its own agenda. People, spiders, and plants are all autonomous agents. Each agent uses input from the environment as a basis for its actions. Each pursues its own goals, either consciously or through reflex. In his book *The Computational Beauty of Nature*, Gary William Flake defines an autonomous agent as "a unit that interacts with its environment (which probably consists of other agents) but acts independently from all other agents in that it does not take commands from some seen or unseen leader."[3] Agents aren't part of a coordinated global plan, but structure does emerge from their interactions with other agents and the environment. The seemingly coordinated behavior of an ant colony and the order within a school of fish illustrate structured behavior emerging from the collective actions of individual agents.

Like the examples of cellular automata presented above, autonomous agents can also exist in a grid world. Chris Langton's ant is a fascinating example. The ant can face only one of four directions: north, south, east, or west. Like cellular automata, the ant moves one frame at a time, behaving according to the following rules:

1. Move one frame forward.
2. If on a white pixel, change the pixel to black and turn 90 degrees right.
3. If on a black pixel, change the pixel to white and turn 90 degrees left.

As the ant moves through the environment, it returns to the same pixel many times and each visit reverses the color of the pixel. Therefore, the future position of the ant is determined by its past movements. The remarkable thing about this ant is that with any starting orientation (north, south, east, or west), a sequence of actions that produce a straight path always emerges. From the seemingly chaotic mess upon which the ant embarks, an ordered path always develops. This program is not intended as a simulation of a real insect. It's an example of a software agent with extremely simple rules behaving in an entirely unexpected but ultimately predictable and structured manner. The instruction to eventually construct a straight path is never given, but it emerges through the rules of the ant in relation to its environment. The environment contains the memory of the ant's previous frames, which the ant uses to determine its next move.

In this example program, the ant's world wraps around from each edge of the screen to the opposite edge. Wrapping around to the other side of the screen, the ant is disrupted by its previous path. The order eventually emerges and the ant begins a new periodic sequence producing linear movement. In the code, directions are expressed as numbers. South is 0, east is 1, north is 2, and west is 3. At each frame, the ant moves one pixel forward based on its current orientation and then checks the color of the pixel at its location. It turns right by subtracting 1 and turns left by adding 1. Run the code to see the sequence change through time.

```
int SOUTH = 0;   // Direction numbers with names
int EAST = 1;    // so that the code self-documents
int NORTH = 2;
int WEST = 3;
int direction = NORTH;   // Current direction of the ant
int x, y;                // Ant's current position

color on = color(255);   // Color for an 'on' pixel
color off = color(0);    // Color for an 'off' pixel

void setup() {
  size(100, 100);
  x = width/2;
  y = height/2;
  background(0);
}

void draw() {
  if (direction == SOUTH) {
    y++;
    if (y == height) {
      y = 0;
    }
  } else if (direction == EAST) {
    x++;
    if (x == width) {
      x = 0;
    }
  } else if (direction == NORTH) {
    if (y == 0) {
      y = height-1;
    } else {
      y--;
    }
  }
```

```
  } else if (direction == WEST) {
    if (x == 0) {
      x = width-1;
    } else {
      x--;
    }
  }

  if (get(x, y) == on) {
    set(x, y, off);
    if (direction == SOUTH) {
      direction = WEST;
    } else {
      direction--;
    }
  } else {
    set(x, y, on);
    if (direction == WEST) {
      direction = SOUTH;
    } else {
      direction++;
    }
  }
}
```

Mitchel Resnick's termite is another example that demonstrates order emerging from extremely simple rules. Like Langton's ant, this termite is not intended as a simulation of a real organism, but it exhibits remarkable behavior. The termite exists on a grid where a white unit represents open space and black represents a wood chip. The termite wanders through the space, and when it finds a wood chip it picks it up and wanders until it runs into another wood chip. Finding a wood chip causes it to drop its current load, turn around, and continue to wander. Over time, ordered piles emerge as a result of its effort.

In the code that creates the termite and its environment, the angles[] array contains the possible directions in which the termite can move. At each frame the termite moves one space on the grid. The angles specify which neighboring pixel it can move into:

NW	N	NE
-1,-1	0,-1	1,-1
W		E
-1,0		1,0
SW	S	SE
-1,1	0,1	1,1

When space in front of the termite is open, it moves to the next space in the current direction or the next space in an adjacent direction. For example, if the current direction is south, it will move to the next space in the south, southeast, or southwest direction. If the current direction is northeast, it will move to the next space in the northeast, east, or north direction. When the termite does not have space in front and it is carrying a wood chip, it will reverse its direction and move one space in the new direction. When it does not have a space in front and it is not carrying a wood chip, it moves into the space occupied with the wood chip and picks it up.

```
int[][] angles = {{ 0,  1 }, { 1,  1 }, { 1, 0 }, { 1,-1 },          31-25
                   { 0,-1 }, {-1,-1 }, {-1, 0 }, {-1, 1 }};

int numAngles = angles.length;
int x, y, nx, ny;
int dir = 0;
color black = color(0);
color white = color(255);

void setup() {
  size(100, 100);
  background(255);
  x = width/2;
  nx = x;
  y = height/2;
  ny = y;
  float woodDensity = width * height * 0.5;
  // Set random distribution of wood chips
  for (int i = 0; i < woodDensity; i++) {
    int rx = int(random(width));
    int ry = int(random(height));
    set(rx, ry, black);
  }
}

void draw() {
  int rand = int(random(-2, 2));  // -1, 0, or 1
  dir = (dir + rand + numAngles) % numAngles;
  nx = (nx + angles[dir][0] + width) % width;
  ny = (ny + angles[dir][1] + height) % height;

  if ((get(x,y) == black) && (get(nx,ny) == white)) {
    // Move the chip one space
    set(x, y, white);
    set(nx, ny, black);
```

```
      x = nx;
      y = ny;
    } else if ((get(x,y) == black) && (get(nx,ny) == black)) {
      // Move in the opposite direction
      dir = (dir + (numAngles/2)) % numAngles;
      x = (x + angles[dir][0] + width) % width;
      y = (y + angles[dir][1] + height) % height;
    } else {
      // Not carrying
      x = nx;
      y = ny;
    }
    nx = x;   // Save the current position
    ny = y;
  }
```

Other simulations of autonomous agents have been created without restrictive grids. These agents are allowed to move freely through their environment. Because they use floating-point numbers for position, they have more potential variations in location and orientation than the gridded CAs. Two of the best-known autonomous agents are Valentino Braitenberg's Vehicles and Craig Reynolds's Boids.

The neuroanatomist Valentino Braitenberg published *Vehicles: Experiments in Synthetic Psychology* in 1984. In this small, delightful book he presents conceptual schematics for fourteen unique synthetic creatures he calls Vehicles. Vehicle 1 has one sensor and one motor that are connected so that a strong stimulus will make the motor turn quickly and a weak stimulus will make the motor turn slowly. If the sensor registers nothing, the vehicle will not move. Vehicle 2 has two sensors and two motors. If they are correlated the same way as in Vehicle 1 they create Vehicle 2a and if they are crossed they create Vehicle 2b. If the sensor is attracted to light, for example, and there is a light in the room, Vehicle 2a will turn away from the light and Vehicle 2b will approach the light. Braitenberg characterizes these machines as correspondingly cowardly and aggressive to feature the anthropomorphic qualities we assign to moving objects:

Vehicle 2a Vehicle 2b

Vehicle 2a and 2b movement in relation to a stimulus

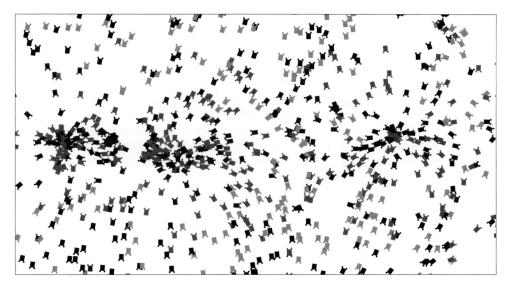

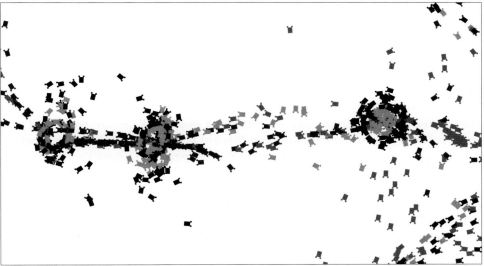

Figure 31-3 Braitenberg's Vehicles
Five hundred vehicles move through the environment. Each gray value represents a different category of vehicles.
The vehicles in each category share the same behavior (follow the same rules), so over time they form groups.

Vehicle 3a and 3b are identical to Vehicle 2a and 2b but the correlation between the sensor and the motor is reversed—a weak sensor stimulus will cause the motor to turn quickly and a strong sensor stimulus causes the motors to stop. Vehicle 3a moves toward the light and stops when it gets too close, and 3b approaches the light but turns and leaves when it gets too close. If more than one stimulus is placed in the environment, these simple configurations can yield intricate paths of movement as they negotiate their attention between the competing stimuli.

In 1986, Craig Reynolds developed the Boids software model to simulate coordinated animal motion like that of flocks of birds and schools of fish. To refute the common idea that these groups of creatures navigate by following a leader, Reynolds presented three simple behaviors that simulated a realistic flocking behavior without the need for a hierarchy. These behaviors define how each creature behaves in relation to its neighbors:

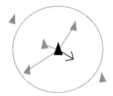 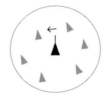

Separation:
Steer to avoid crowding local flockmates

Alignment:
Steer toward the average heading of local flockmates

Cohesion:
Steer to move toward the average position of local flockmates

The flocking rules provide an evocative example of emergence, the phenomenon of a global behavior originating from the interactions of simple, local behaviors. The flocking behavior of the group is not overtly programmed, but emerges through the interaction of each software unit based on the simple rules.

The autonomous agent simulations presented here were at the cutting edge of research over twenty years ago. They have since become some of the most popular examples for presenting the ideas of agency and emergence. The ideas from research in autonomous agents have been extended into many disciplines within art and science, including sculpture, game design, and robotics.

Exercises
1. *Find a ball; drop it and observe. What is the same and what is different from what you see in the code examples? What is the potential and what are the limitations of simulated physics.*
2. *Move a shape in code using velocity and acceleration calculations.*
3. *Make your own extension to the* Particle *class and build a sketch to show how it works.*

4. *Increase the size of the grid for Wolfram's one-dimensional CA. There are 256 possible rule sets for this system, and only 13 are presented in this unit. Explore other options. Which do you find the most interesting? Can the diverse results be put into categories?*
5. *Increase the size of the grid for Conway's Game of Life. Search for other stable, periodic, or moving configurations. What do you see?*

Notes

1. Alfred Chapuis and Edmond Droz, *Automata: A Historical and Technological Study*, translated by Alec Reid (Editions du Griffon, 1958).

2. Martin Gardner, "Mathematical Games: The Fantastic Combinations of John Conway's New Solitaire Game 'Life,'" *Scientific American* 223 (October 1970), pp. 120–123.

3. Gary William Flake, *The Computational Beauty of Nature* (MIT Press, 1998), p. 261.

32 Data

This chapter introduces data formatting and file writing and reading.

Syntax introduced:
```
nf(), saveStrings(), exit()
PrintWriter, createWriter(), PrintWriter.flush(), PrintWriter.close()
loadStrings(), split()
Table, loadTable(), Table.getRowCount(), Table.getInt(),
Table.getString(), TableRow, Table.rows()
XML, loadXML(), XML.getChildren(), XML.getContent(), XML.getString()
JSONArray, loadJSONArray(), JSONArray.size()
JSONObject, JSONArray.getJSONObject(), JSONObject.getString(),
JSONObject.getInt(), JSONObject.getFloat()
```

Digital files are not tangible like their paper namesakes. Despite the diverse content stored in digital files, the material of each is the same—a sequence of 1s and 0s stored on a hard drive or other media. Almost every task performed with computers involves working with files. Editing a single text file involves first reading from dozens of other files that comprise the text editor application itself. When the document is saved, the file is given a name and stored for later retrieval.

The primary reason to save a file is to store data so that it is available after a program stops running. When it is running, a program uses part of the computer's memory to store its data temporarily. When the program is stopped, the program gives control of this memory back to the operating system so other programs can access it. If the data created by the program is not saved to a file, it is lost when the program closes.

All software files have a *file format*, a convention for ordering data so that software applications know how to interpret the data when it is read from memory. Formats are often referred to by their *extension*, usually three or four letters following a period at the end of the file's name. Some common extensions include TXT for plain text files, MP3 for storing sound, and EXE for executable programs on Windows. Common formats for image data include JPEG and GIF and formats for documents include ODT and DOC. The XML and JSON formats have become popular in recent years as general-purpose data formats that can be extended to hold specific types of data in an easy-to-read file.

Format data

Text files contain characters that are not visible (referred to as nonprintable) and are used to define the spacing of the visible characters. The two most common are *tab* and *new line*. These characters can be represented in code as \t and \n, respectively. The

combination of the \ (backslash) character with another is called an *escape sequence*. These escape sequences are treated as one character by the computer. The backslash begins the escape sequence and the second character defines the meaning. A new line is helpful for controlling layout to make a file easier to read, while using a tab to delimit text in a file can make it easier to load it back into a program and separate pieces of data.

```
// Prints "tab     space"                                            32-01
println("tab\tspace");
```

```
// Prints each word after "\n" on a new line:                        32-02
// line1
// line2
// line3
println("line1\nline2\nline3");
```

Data can also be formatted with functions such as nf() to control the number of digits in a number. (The function name nf() is short for *number format*.) In addition to formatting the data, the nf() function converts the data into the String type so it can be output to the console or saved to a text file. This function has two or three parameters to control how a number is formatted. The first parameter is always the number to format, an int, float, or array of numbers. When one additional parameter is used, it adds zeros before the number to set the total number of digits. For example:

```
println(nf(200, 10));     // Prints "0000000200"                     32-03
println(nf(40, 5));       // Prints "00040"
println(nf(90, 3));       // Prints "090"
```

When two additional parameters are used with nf(), the first sets the number of digits to the left of the decimal, and the second sets the number of digits after the decimal. Setting either parameter to zero means "any" number of digits.

```
println(nf(200.94, 10, 4));  // Prints "0000000200.9400"            32-04
println(nf(40.2, 5, 3));     // Prints "00040.200"
println(nf(9.012, 0, 5));    // Prints "9.01200"
```

Export files

Saving files is a useful way to store data so it can be viewed after a program has stopped running. Data can either be saved continuously while the program runs or stored in variables while the program is running; and then it can be saved to a file in one batch.

The saveStrings() function writes an array of strings to a file, with each string written to a new line. This file is saved to the sketch's folder and can be accessed by selecting the "Show Sketch Folder" item from the Sketch menu. The following example uses the saveStrings() function to write data created while drawing lines to the screen. Each time a mouse button is pressed, a new value is added to the x[] and y[] arrays, and when a key is pressed the data stored in these arrays is written to a file called *lines.txt*. The exit() function then stops the program.

```
int[] x = new int[0];                                          32-05
int[] y = new int[0];

void setup() {
  size(100, 100);
}

void draw() {
  background(204);
  stroke(0);
  noFill();
  beginShape();
  for (int i = 0; i < x.length; i++) {
    vertex(x[i], y[i]);
  }
  endShape();
  // Show the next segment to be added
  if (x.length >= 1) {
    stroke(255);
    line(mouseX, mouseY, x[x.length-1], y[x.length-1]);
  }
}

void mousePressed() {  // Click to add a line segment
  x = append(x, mouseX);
  y = append(y, mouseY);
}

void keyPressed() {  // Press a key to save the data
  String[] lines = new String[x.length];
  for (int i = 0; i < x.length; i++) {
    lines[i] = x[i] + "\t" + y[i];
  }
  saveStrings("lines.txt", lines);
  exit();  // Stop the program
}
```

The PrintWriter class provides another way to export files. Instead of writing the entire file at one time as saveStrings() does, the createWriter() method opens a file to write to and allows data to be added continuously to the file while the program is running. To make the file save correctly, the flush() method must be used to write any remaining data to the file. The close() method is also needed to finish writing the file properly. The following example uses the PrintWriter to save the cursor position to a file while a mouse button is pressed.

```
PrintWriter output;                                                     32-06

void setup() {
  size(100, 100);
  // Create a new file in the sketch directory
  output = createWriter("positions.txt");
  frameRate(12);
}

void draw() {
  if (mousePressed) {
    point(mouseX, mouseY);
    // Write the coordinate to a file with a
    // "\t" (TAB character) between each entry
    output.println(mouseX + "\t" + mouseY);
  }
}

void keyPressed() {       // Press a key to save the data
  output.flush();         // Write the remaining data
  output.close();         // Finish the file
  exit();                 // Stop the program
}
```

The file created with the previous program has a simple format. The x-coordinate of the cursor is written followed by a tab, then followed by the y-coordinate. Code 32-08 shows how to load this file back into another sketch and use the data to redraw the saved points.

The next example is a variation of the previous one, but it uses the spacebar and Enter key to control when data is written to the file and when the file is closed. When a key is pressed, the character is added to the letters variable. When the spacebar is pressed, the String is written to the *words.txt* file. When the Enter key is pressed, the file is flushed and then closed, and the program exits.

```
String letters = "";
PrintWriter output;

void setup() {
  size(100, 100);
  fill(0);
  // Create a new file in the sketch folder
  output = createWriter("words.txt");
}

void draw() {
  background(204);
  text(letters, 5, 50);
}

void keyPressed() {
  if (key == ' ') {              // Spacebar pressed
    output.println(letters);     // Write data to words.txt
    letters = "";                // Clear the letter String
  } else {
    letters = letters + key;
  }
  if ((key == ENTER) || (key == RETURN)) {
    output.flush();              // Write the remaining data
    output.close();              // Finish the file
    exit();                      // Stop the program
  }
}
```

Data structure

Files are the easiest way to store and load data, but before you load a data file into a program, it is essential to know how the file is formatted. In a plain text file, the control characters for tab and new line are used to differentiate and align the data elements. Separating the individual elements with a tab or space character and each line with a new line character is a common formatting technique. Here is one example excerpted from a data file:

```
00214 +43.005895 -071.013202 U PORTSMOUTH 33 015
00215 +43.005895 -071.013202 U PORTSMOUTH 33 015
00501 +40.922326 -072.637078 U HOLTSVILLE 36 103
```

```
00544  +40.922326  -072.637078  U  HOLTSVILLE  36  103
00601  +18.165273  -066.722583     ADJUNTAS    72  001
00602  +18.393103  -067.180953     AGUADA      72  003
00603  +18.455913  -067.145780     AGUADILLA   72  005
```

If you see a file formatted in a similar way, you can use a text editor to tell whether there are tabs or spaces between the elements by moving the cursor to the beginning of a line and using the arrow keys to navigate left or right through the characters. If the cursor jumps from one element to another, there is a tab between the elements; if the cursor moves via a series of steps through the whitespace, spaces were used to format the data. In addition to knowing how the data elements are separated, it's essential to know how many data elements each line contains and the data type of each element. For example, the file above has data that should be stored as String, int, and float variables.

In addition to loading data from plain text files, it's common to load data from XML and JSON files. Both are file structures based on *tagging* information. Each defines a structure for ordering data, but leaves the content and categories of the data elements open. For example, in an XML structure designed for storing book information, each element might have an entry for title and publisher:

```
<book>
    <title>Processing</title>
    <publisher>MIT Press</publisher>
</book>
```

In an XML structure designed for storing a list of websites, each element might have an entry for the name of the website and the URL.

```
<website>
    <name>Processing.org</name>
    <url>http://processing.org</url>
</website>
```

In these two examples, notice that the names of the element tags are different, but the structure is the same. Each entry is defined with a tag to begin the data and a corresponding tag to end the entry. Because the tag for each data element describes the type of content, XML files are often more self-explanatory than files delimited by tabs. Processing can load and parse simple, strictly formatted XML files.

JSON files work similarly to XML files, but the notation is different. The data in JSON files, the acronym is for JavaScript Object Notation, is defined by braces and

colons, rather than with angle brackets. The two XML examples above may be translated to JSON as follows:

```
{

    "title": "Processing",
    "publisher": "MIT Press"

}

{

    "name": "Processing.org",
    "url": "http://processing.org"

}
```

Tab-delimited, XML, and JSON data are each useful in different contexts. Many "feeds" available from the web are available in XML and JSON format. These include, for instance, weather service updates from the NOAA and the RSS feeds common to many websites. In these cases, the data is both varied and hierarchical, making it suitable for these configurations. For information exported from a database, a tab-delimited file is more appropriate, because the additional metadata included in XML wastes considerable space and takes longer to load into a program. JSON is generally more lightweight than XML, but it's still extra markup that is often not needed. For example, the excerpt presented above is from a file that contains 40,000 lines. Because the data comprises seven straightforward columns, adding additional tags or structure is not necessary or desired.

Strings

The basic way to bring external data into Processing is to load and parse a TXT file to extract the individual data elements. A TXT file format stores only plain text characters, which means there is no formatting such as bold, italics, and colors. The loadStrings() function reads the contents of a file and creates a string array of its individual lines—one array element for each line of the file. As with any media loaded into Processing, the file must be located in the sketch's data folder. For example, if the text file *numbers.txt* is in the current sketch's data folder, its data can be read into Processing with this line of code:

```
String[] lines = loadStrings("numbers.txt");
```

The lines[] array is first declared and then assigned the String array created by the loadStrings() function. It holds the contents of the file, with each element in the array containing one line of the text in the file. This code reads through each element of the array and prints its contents to the Processing console:

```
for (int i = 0; i < lines.length; i++) {
  println(lines[i]);
}
```

The following example loads the text file created with code 32-06. This file contains the mouseX and mouseY variable separated by a tab and formatted like this:

```
x1        y1
x2        y2
x3        y3
x4        y4
x5        y5
```

The program is designed to read the entire file into an array; then it reads each line of the array and extracts the two coordinate values into another array. The file checks to make sure the data is formatted as expected by confirming that there are two elements on each line, then converts these elements to integer values and uses them to draw a point to the screen.

32-08

```
String[] lines;
int index = 0;

void setup() {
  size(100, 100);
  lines = loadStrings("positions.txt");
  noSmooth();
  frameRate(12);
}

void draw() {
  if (index < lines.length) {
    String[] pieces = split(lines[index], '\t');
    if (pieces.length == 2) {
      int x = int(pieces[0]);
      int y = int(pieces[1]);
      point(x, y);
    }
    // Go to the next line for the next run through draw()
    index++;
  }
}
```

The split() function is used to divide each line of the text file into its separate elements. This function splits a string into pieces using a character or string as the

divider. The first parameter to the function is the string to separate into smaller pieces. The next parameter is the data delimiter; frequently a comma, tab, or space. It can be a char or String and does not appear in the returned String[] array. A simplified example to show how it works follows:

32-09

```
String s = "a, b";
String[] p = split(s, ", ");
println(p[0]);   // Prints "a"
println(p[1]);   // Prints "b"
```

Table

The coordinate data loaded as strings in code 32-08 can be loaded in a different way with Processing's Table class. The Table class stores data in a matrix of rows and columns. It has methods to access and modify this data. The Table class is well suited to working with files that combine multiple types of data, but it can also manage data as simple as a series of x- and y-coordinates. The following example translates code 32-08 to utilize a table.

32-10

```
Table xy;
int index = 0;

void setup() {
  size(100, 100);
  xy = loadTable("positions.txt", "tsv");
  noSmooth();
  frameRate(12);
}

void draw() {
  if (index < xy.getRowCount()) {
    int x = xy.getInt(index, 0);
    int y = xy.getInt(index, 1);
    point(x, y);
    // Go to the next line for the next run through draw()
    index++;
  }
}
```

The loadTable() function is used to put the data from the *positions.txt* file into the table structure. The second parameter to loadTable() tells the function about the data format. In this case, the data is separated by tabs, so the parameter "tsv" is used to define "tab separated values." (Note that if the file name ends with .tsv, it's not

COLUMNS

[0]
[1]
[2]
[3]
[4]
[5]
...

ROWS

[0] [1] [2] [3] [4] [5] [6] [7] ...

Figure 32-1 Table
A table is a data matrix defined by rows that run top to bottom and columns that run left to right. Each data element has a location defined by its row and column.

necessary to add the second parameter.) Once this is finished, the data can be read, changed, added to, and deleted through the many Table class methods. These methods are listed in detail in the Processing reference. This example uses the getRowCount() method as well as getInt(). The getRowCount() and its companion, getColumnCount() methods return the dimensions of the table. In the case of this data, there are two columns, one to store the x-coordinate data and one to store the y-coordinate data. There are 206 rows because that is the number of lines in the file. Next, the getInt() method returns the data at the location defined by the parameters as an integer.

Files often contain multiple kinds of data, and these more complicated files are also handled well with the Table class. It's important to know what kind of data is inside a file so that it can be parsed into variables of the appropriate type. The next example loads data about automobiles to demonstrate more features of working with tables. In the file used for this example, text data is mixed with numbers:

```
ford galaxie 500    15  8  429  198  4341  10   70  1
chevrolet impala    14  8  454  220  4354  9    70  1
plymouth fury iii   14  8  440  215  4312  8.5  70  1
pontiac catalina    14  8  455  225  4425  10   70  1
```

This small excerpt of the file shows its content and formatting. Each element is separated with a tab and corresponds to a different aspect of each car. This file stores the miles per gallon, cylinders, displacement, and like information for more than 400 different cars. The next example loads the data into a table, uses a for loop to read the name and miles per gallon for each car, then prints that data to the console. The

enhanced `for` loop is used to access each table row in order from first to last with a minimal syntax.

```
Table cars;
```

```
void setup() {
  size(100, 100);
  cars = loadTable("cars.tsv", "header");
  for (TableRow row : cars.rows()) {
    String id = row.getString("name");
    int mpg = row.getInt("mpg");
    println(id + ",  " + mpg + " miles per gallon");
  }
}
```

The new things in this example are the `"header"` parameter with `loadTable()`, the `TableRow` class and `rows()` methods within the `for` loop, and the `getString()` method to read text content from the file. The "header" parameter is used to tell the program that the first row in the data file lists the categories for each column. This allows the columns to be referenced by a string rather than with a number. For example, the seventh line in code 32-11 can also be written like this:

```
String id = row.getString(0);
```

rather than the preferred manner in the example. The code is clearer when the column is referenced as "name," and less prone to errors if the columns are reordered in the file.

The Table class has additional methods to remove rows and columns, `removeRow()` and `removeColumn()`, and to add new data, `addRow()` and `addColumn()`. Table data can also be searched with methods such as `findRow()` and `matchRow()`. Examples for these, and more Table methods, are provided in the Processing reference.

XML

As referenced earlier, XML files structure data within a set of tags defined by angle brackets. Notice how each tag is repeated twice. The first time placed within clean angle brackets (e.g. `<tag>`) and the second time with a forward slash following the first bracket (e.g. `</tag>`). The first set of brackets is the start tag and the second is the end tag. They are always used as a pair, except in the case of an empty-element tag (e.g. `<tag />`). The name of the tags can change with each XML file to model the content appropriately, but the structure of the tags applies in the same way to all XML files. The most important idea about XML structure is the way tags are nested inside other tags. This relationship is referred to as *parent* and *child* nodes. If one tag has another

embedded inside, it is the parent and the embedded tag is the child. In this example from the Processing reference, the "mammals" node has three child nodes:

```
<?xml version="1.0"?>
<mammals>
    <animal id="0" species="Capra hircus">Goat</animal>
    <animal id="1" species="Panthera pardus">Leopard</animal>
    <animal id="2" species="Equus zebra">Zebra</animal>
</mammals>
```

This short XML document also reveals the difference between the content of the file and the markup. The content in the third line of the file is the word "Goat," with the rest of the line providing the markup. The "id" and "species" are called attributes. In this case, the value of the "id" attribute of the Goat is 0 and the value of the "species" attribute is *Capra hircus*.

The following short piece of code reads the preceding XML file and prints the number of child nodes to the console. First the XML files is loaded with the loadXML() function. Next, an array of XML objects are created by getting the child nodes from the root <mammal> node that are tagged with <animal>. Last, the length of the array length is printed to the console with println().

32-12

```
XML xml;

void setup() {
    xml = loadXML("mammals.xml");
    XML[] animals = xml.getChildren("animal");
    println(animals.length);
}
```

The next example takes the previous further by extracting the contents of the file. This is done with a for loop to read each element. The getContent() method to read the content from the tag and the getString() method to read the value of the "species" attribute:

32-13

```
XML xml;

void setup() {
    xml = loadXML("mammals.xml");
    for (XML a : xml.getChildren("animal")) {
        String name = a.getContent();
        String species = a.getString("species");
        println(name + ", " + species);
    }
}
```

The previous examples show the basic mechanics of working with XML, but they stop short of working with the data. The next series of examples goes further by first reading and then using the data. They include functions discussed earlier in the book to help in working with strings and arrays. The data is simplified seven-day forecast information from Cambridge, MA downloaded from *http://forecast.weather.gov*. It is formatted as follows:

```
<?xml version="1.0"?>
<data type="forecast">
    <location>
        <description>Cambridge, MA</description>
        <point latitude="42.37" longitude="-71.1"/>
    </location>
    <temperature type="maximum" units="Fahrenheit">
        <name>Daily Maximum Temperature</name>
        <value>29</value>
        <value>26</value>
        <value>32</value>
        <value>27</value>
        <value>33</value>
        <value>38</value>
        <value>36</value>
    </temperature>
    <temperature type="minimum" units="Fahrenheit">
        <name>Daily Minimum Temperature</name>
        <value>18</value>
        <value>13</value>
        <value>23</value>
        <value>18</value>
        <value>11</value>
        <value>25</value>
        <value>24</value>
    </temperature>
</data>
```

The temperature data is contained within the `<value>` tags, a few levels deep into the file. The file has two children tagged `<temperature>`, but one has the type "maximum" and the other "minimum." The first child, defined by the `<location>` tag, includes the name of the city and its location. After the file is loaded, there are numerous ways to make use of the data in a Processing program. In this instance, the example has two arrays, one to store the maximum forecasted temperatures, the highs, and the other to store the minimums, the lows.

```
XML cambridge;   // Data for Cambridge, MA

int[] lows = new int[0];
int[] highs = new int[0];

void setup() {
  cambridge = loadXML("cambridge.xml");
  for (XML temps : cambridge.getChildren("temperature")) {
    String type = temps.getString("type");
    if (type.equals("maximum")) {
      for (XML val : temps.getChildren("value")) {
        int t = int(val.getContent());
        highs = append(highs, t);
      }
    }
    else {
      for (XML val : temps.getChildren("value")) {
        int t = int(val.getContent());
        lows = append(lows, t);
      }
    }
  }
  printArray(lows);
  printArray(highs);
}
```

In addition to the XML methods recently introduced, this example uses the append()
function to add data to the array one element at a time, and the String method
equals() is used to figure out if the temperature data is a daily maximum or
minimum to select the correct array to store the values.

Now that the data is stored in the lows and highs arrays, it can be used to
position geometry to *visualize* the data. The next example moves through each element
in the arrays to draw a shape from the sequence of high and low temperatures. In
addition, a new function is introduced to load the XML data so that it is more modular
and the setup() block is cleaner.

```
XML cambridge;   // Data for Cambridge, MA
```

```
int[] lows = new int[0];
int[] highs = new int[0];
```

```
void setup() {
  size(700, 100);
  cambridge = loadXML("cambridge.xml");
  lows = getData(cambridge, "minimum");
  highs = getData(cambridge, "maximum");
}

void draw() {
  background(204);
  // Shape defined by daily highs and lows
  noStroke();
  fill(0);
  beginShape(QUAD_STRIP);
  for (int i = 0; i < lows.length; i++) {
    float x = map(i, 0, lows.length-1, 0, width);
    vertex(x, height-lows[i]);
    vertex(x, height-highs[i]*2);
  }
  endShape();
  // Lines for temperatures, 0 (bottom) to 50 (top)
  stroke(255, 153);
  for (int y = height-1; y > 0; y -= 10) {
    line(0, y, width, y);
  }
}

int[] getData(XML city, String minOrMax) {
  int[] values = new int[0];
  for (XML temps : city.getChildren("temperature")) {
    String type = temps.getString("type");
    if (type.equals(minOrMax)) {
      for (XML val : temps.getChildren("value")) {
        int t = int(val.getContent());
        values = append(values, t);
      }
    }
  }
  return values;
}
```

The next steps in this visualization might add labels to the bottom and left to define the range of the values. Additional changes might include defining the shapes with curves to imply continuous temperature values or to load the temperatures from another city to compare and contrast.

JSON

JSON files are actually JavaScript code, and the format was formalized as a way to store data for use with JavaScript programs without the need to parse it. Many of the same ideas about data structure discussed with XML apply to JSON files. JSON is on one hand, a different notation for similarly structured data. On the other hand, JSON files are built around the model of objects and arrays. In JSON, an object is a collection of key and value pairs connected with a colon. Each set of key/value pairs are separated by a comma and enclosed within braces. JSON array elements are enclosed within brackets and separated by commas. To make this even more flexible (and potentially confusing for a beginner) JSON arrays can be embedded in objects, and vice versa.

For comparison to XML, the short XML file written previously in the chapter can be converted to JSON notation like this:

```
[
  {
    "id": 0,
    "species": "Capra hircus",
    "name": "Goat"
  },
  {
    "id": 1,
    "species": "Panthera pardus",
    "name": "Leopard"
  },
  {
    "id": 2,
    "species": "Equus zebra",
    "name": "Zebra"
  }
]
```

This file is an array of three objects. Each object is defined by a pair of braces and has values for "id", "species", and "name." Each of the key/value pairs is separated by commas. The larger array is defined by the outer brackets and each individual object is separated by a comma. In contrast to the XML file, each object is not defined as an "animal" and the entire structure is not defined as "mammals." The comparison is more complete with an example:

```
JSONArray animals;

void setup() {
  animals = loadJSONArray("animals.json");
  println(animals.size());
}
```

32-16

Because this file is an array of JSON objects, the JSONArray class is used to create the animals object to store the data. The loadJSONArray() function is used to load the data. Finally, the size() method counts the number of objects in the array and that number prints to the console through println(). The next example goes one step further by reading the file's data from the animals object:

```
JSONArray animals;

void setup() {
  animals = loadJSONArray("animals.json");
  for (int i = 0; i < animals.size(); i++) {
    JSONObject a = animals.getJSONObject(i);
    String name = a.getString("name");
    String species = a.getString("species");
    println(name + ", " + species);
  }
}
```

Here, the JSONObject class is used to store each of the objects in the array, one at a time. The getString() method is used to read the values associated with the "name" and "species," with the results printed to the console.

The final JSON examples show some strategies for using the data after a file is loaded. The new data for these examples is information about books, specifically the title, author, and dimensions. The JSON format is related to the previous example, but there is an array inside each object to store the book dimensions. The structure of the document is an array of book objects that each store simplified book data. A shortened version of the file follows:

```
[
    {
        "title": "Six Years",
        "author": "Lippard",
        "ISBN-10": 0520210131,
        "dimensions": [ 7.0, 8.0, 0.8 ]
    },
    {
        "title": "Beyond Modern",
        "author": "Burnham",
        "ISBN-10": 0987654321,
        "dimensions": [ 7.6, 9.2, 1 ]
    }
]
```

Before pushing into new ideas, the next example starts with a familiar program to load the data inside setup(). The new component of this example is loading the dimensions JSONArray within each object. To recap, the JSON file is an array of book objects, and each book has an array of dimensions.

32-18

```
JSONArray bookData;

void setup() {
    bookData = loadJSONArray("books.json");
    for (int i = 0; i < bookData.size(); i++) {
        JSONObject b = bookData.getJSONObject(i);
        String title = b.getString("title");
        JSONArray dims = b.getJSONArray("dimensions");
        float w = dims.getFloat(0);
        float h = dims.getFloat(1);
        float d = dims.getFloat(2);
        println(title, w, h, d);
    }
}
```

For the next step, a custom Book class is added to store the data from each JSON book object. This class mimics the data structure inside of the JSON file. There are strings to store the title and author, an integer to store the book number, and three floating-point values to store the dimensions. Unlike the previous example, the individual values within each JSON book object are pulled out within the constructor for the object, rather than in setup(). Finally, after the JSON data is loaded and stored in an array of objects, the data is used to draw a series of boxes to the screen to match the relative dimensions of each book.

32-19

```
JSONArray bookData;
Book[] books;

void setup() {
    size(100, 100, P3D);
    bookData = loadJSONArray("books.json");
    books = new Book[bookData.size()];
    for (int i = 0; i < books.length; i++) {
        JSONObject b = bookData.getJSONObject(i);
        books[i] = new Book(b);
    }
}

void draw() {
    background(204);
```

```
      translate(50, 20, -50);
      scale(10);
      strokeWeight(0.1);
      float angle = map(mouseX, 0, width, -1, 1);
      rotateY(angle);   // Rotate with mouseX
      for (Book b : books) {
        b.display();
        translate(0, b.getDepth(), 0);
      }
    }

class Book {

    String title;
    String author;
    int isbn;
    float w, h, d;

    Book(JSONObject b) {
      title = b.getString("title");
      author = b.getString("author");
      isbn = b.getInt("ISBN-10");
      JSONArray dims = b.getJSONArray("dimensions");
      w = dims.getFloat(0);
      h = dims.getFloat(1);
      d = dims.getFloat(2);
      println(title, author, isbn, w, h, d);
    }

    float getDepth() {
      return d;
    }

    void display() {
      fill(0);
      stroke(255);
      box(w, d, h);
    }
}
```

This example shows how JSON files are capable of storing a variety of data types and how to pull the data out of them in the data type that a Processing sketch wants. The getString(), getInt(), and getFloat() methods are all used in the Book class's constructor to demonstrate the basic cases. The example also shows how to capture the

data from a JSON file into object-oriented notation so it can be easily used within a sketch. The tricky aspect of working with JSON and XML files is often sorting out the way a specific file encodes the data as objects and arrays and as child and parent nodes. When working with a new data file, write the code to bring in the data one step at a time. As shown here, first load the file, then get the basic data, then start digging deeper after everything is working.

Exercises

1. Use *nf()* to reformat the value 12.2 into these configurations: 0012.20000, 12.20, 00012.2.
2. Use code 32-06 to save the cursor data to a file. Modify code 32-08 to visualize this data in a unique way.
3. Add a *draw()* block to code 32-11 to visualize the data in the *cars* table.
4. Design an XML file to store data about something you collect (e.g., books, music, etc.) Write a program to draw the data to the display window.
5. Convert your data from exercise 4 into the JSON format. Adapt the code from exercise 4 to work with the JSON file.

33 Interface

This chapter introduces and discusses code for graphical interface elements.

The graphical user interface (GUI), also known as the direct manipulation interface, helped bring computers out of laboratories and into homes, offices, and schools. The combination of the mouse and graphical interfaces made computer use more intuitive. Common navigation techniques such as pointing, clicking, and dragging require a device like the mouse that controls an on-screen cursor or on contemporary touch screens, a finger or stylus. Most GUIs comprise icons representing the hierarchy of files and folders on the hard drive. The user performs actions by selecting icons and moving them directly.

Before touch screens and pointing devices were developed, the most common way to interface with a computer was through a command line interface (CLI). A CLI requires text commands such as cp (copy), mv (move), and mkdir (make directory) to perform actions on files. For instance, moving the file *data.txt* from its current folder to a different folder named *base* is achieved in UNIX, known for its CLI, with the text:

```
mv data.txt base/
```

Unlike the GUI, in which the *data.txt* icon is dragged to a folder icon titled *base*, working professionally with a CLI requires the user to maintain a mental model of the folder structures and remember the names of commands. Some actions are easier to perform with one style of interface, some with the other; both have their benefits and difficulties.

Operating systems like Mac OS and Windows have a distinct visual appearance and style of interaction, which is determined by the sum of the behaviors of individual elements in the interface. The visual difference between operating systems is obvious. For example, using older versions of Windows felt like working inside a concrete bunker, while versions of Mac OS X resembled working inside a brightly lit candy store. The different style of interaction required by each GUI is less obvious but more important. Details such as the way in which a window opens, or how a file is deleted, create the dynamics for the environment we mentally inhabit while using a computer.

Writing GUI programs can be more difficult than writing CLI programs because of the additional code needed to draw elements to the screen and define their behavior. Specialized libraries for creating GUI elements help reduce the time spent coding. Microsoft, for example, developed the Visual Basic programming environment to assist people in assembling windows with menus, buttons, and behaviors; it allows them to select from available graphic elements and assign them behaviors with menus. HTML defines a range of interface elements with the <input> tag that can be controlled through JavaScript. Creating a program with a basic interface requires understanding interface techniques and common GUI elements such as buttons, check boxes, radio buttons, and scrollbars. With clear knowledge of how each GUI element works, the

programmer can understand how to modify them to improve the way people interface with computers.

Rollover, Button

The first step in building an interface element is to make the shape aware of the mouse. The two shapes that will most easily recognize the mouse within their boundaries are the circle and the rectangle. The OverCircle and OverRect classes presented below have been written to make it clear when the mouse is over these elements.

The OverCircle class has four fields. They set the x-coordinate, y-coordinate, diameter, and gray value. The update() method checks if the mouse is over the element, and the display() method draws the element to the screen. The position and size of the circle are set within the constructor, and the default gray value is set to black. The dist() function within update() calculates the distance from the cursor to the center of the circle; if the distance is less than the circle's radius, the gray value is set to white.

33-01

```
class OverCircle {
    int x, y;          // The x- and y-coordinates
    int diameter;      // Diameter of the circle
    int gray;          // Gray value

    OverCircle(int xp, int yp, int d) {
        x = xp;
        y = yp;
        diameter = d;
        gray = 0;
    }

    void update(int mx, int my) {
        if (dist(mx, my, x, y) < diameter/2) {
            gray = 255;
        } else {
            gray = 0;
        }
    }

    void display() {
        fill(gray);
        ellipse(x, y, diameter, diameter);
    }
}
```

The fields and methods for the OverRect class are identical to those in OverCircle, but the size field now sets the width and height of the rectangle rather than the diameter of a circle. The relational expression inside update() tests to see if the incoming mouseX and mouseY values are within the rectangle.

33-02

```
class OverRect {
    int x, y;    // The x- and y-coordinates
    int size;    // Dimension (width and height) of the rectangle
    int gray;    // Gray value

    OverRect(int xp, int yp, int s) {
        x = xp;
        y = yp;
        size = s;
        gray = 0;
    }

    void update(int mx, int my) {
        if ((mx > x) && (mx < x+size) && (my > y) && (my < y+size)) {
            gray = 255;
        } else {
            gray = 0;
        }
    }

    void display() {
        fill(gray);
        rect(x, y, size, size);
    }
}
```

In the next example, objects are created from the OverRect and OverCircle class and are placed within the display window. When the mouse moves over each element, the color changes from black to white.

33-03

```
// Requires the OverRect and OverCircle classes

OverRect r;
OverCircle c;

void setup() {
    size(100, 100);
    r = new OverRect(9, 30, 36);
    c = new OverCircle(72, 48, 40);
```

```
        noStroke();
    }

    void draw() {
        background(204);
        r.update(mouseX, mouseY);
        r.display();
        c.update(mouseX, mouseY);
        c.display();
    }
```

Both of these classes can be extended further. For example, changing the update()
method for both OverCircle and OverRect can create a smooth value transition
when the mouse is over the shape. The following code fragment shows how to do this
for OverCircle. Use the update() method below in place of the original update()
in the last example to see the difference. This gradual transition detail gives interface
elements a subtlety that enhances their behavior.

```
void update(int mx, int my) {
    if (dist(mx, my, x, y) < diameter/2) {
        if (gray < 255) {
            gray++;
        }
    } else {
        if (gray > 0) {
            gray--;
        }
    }
}
```

The code from OverRect can be continued to create a rectangular button element. The
Button class is distinct from the OverRect class in that it has an additional state.
While OverRect acknowledges when the mouse is over the shape, the Button class
makes it possible to determine whether the mouse is over the shape and when the
mouse clicks on the shape. If the mouse is over the button it can trigger an event, and
when the mouse is pressed it can trigger a separate event.

Like OverRect, the Button class has a position, a size, and a default gray value.
The constructor for Button receives six parameters; the last three set the default gray
value, the gray value when the mouse is over the button, and the gray value when the
mouse is over the button and is pressed. The update() method sets the boolean field
over to true or false depending on the location of the mouse. The press() method
should be run from within the main program's mousePressed() function. When run,
it sets the boolean field press to true if the mouse is currently over the button and
to false if not. The release() method should be run from within the main program's

mouseReleased() function. When the mouse is released the boolean field pressed is set to false, which prepares the button to be pressed again. The display() method draws the button to the screen and sets its gray value based on the current status of the mouse in relation to the button.

```
class Button {
    int x, y;                    // The x- and y-coordinates
    int size;                    // Dimension (width and height)
    color baseGray;              // Default gray value
    color overGray;              // Value when mouse is over the button
    color pressGray;             // Value when mouse is over and pressed
    boolean over = false;        // True when the mouse is over
    boolean pressed = false;     // True when the mouse is over and pressed

    Button(int xp, int yp, int s, color b, color o, color p) {
        x = xp;
        y = yp;
        size = s;
        baseGray = b;
        overGray = o;
        pressGray = p;
    }

    // Updates the over field every frame
    void update() {
        if ((mouseX >= x) && (mouseX <= x+size) &&
            (mouseY >= y) && (mouseY <= y+size)) {
            over = true;
        } else {
            over = false;
        }
    }

    // Respond to mousePressed() event
    boolean press() {
        if (over == true) {
            pressed = true;
            return true;
        } else {
            return false;
        }
    }
```

```
  // Respond to mouseReleased() event
  void release() {
    pressed = false;   // Set to false when the mouse is released
  }

  void display() {
    if (pressed == true) {
      fill(pressGray);
    } else if (over == true) {
      fill(overGray);
    } else {
      fill(baseGray);
    }
    stroke(255);
    rect(x, y, size, size);
  }
}
```

To use the Button class, add it to a sketch and call its methods from within the mouse event functions. Like most objects, it should be created within setup() and updated and displayed within draw(). The methods of the object related to the mouse status must be explicitly run from within the mousePressed() and mouseReleased() functions.

```
// Requires the Button class

Button button;

void setup() {
  size(100, 100);
  // Inputs: x, y, size,
  // base color, over color, press color
  button = new Button(25, 25, 50,
                      color(204), color(255), color(0));
}

void draw() {
  background(204);
  stroke(255);
  button.update();
  button.display();
}
```

```
void mousePressed() {
  button.press();
}

void mouseReleased() {
  button.release();
}
```

Buttons are typically used to trigger events or update values. The previous example showed how to use a `Button` object in isolation, and the next shows how to utilize it to modify the flow of a program. In this example, the buttons turn white when the mouse rolls over them, giving visual feedback that shows they are active elements. When the mouse is pressed over a button, the button turns black to provide feedback. When a button is selected, it updates the `mode` variable in the program. The left button sets `mode` to 1, the middle sets it to 2, and the right button sets it to 3. In the program's `draw()` method, different lines of code are run depending on the value of this variable. In the following example, only the position of an ellipse changes, but the different modes could be used to move between scenes in a complex animation or to change the values of one or more variables.

```
// Requires the Button class

Button button1, button2, button3;
int mode = 1;

void setup() {
  size(100, 100);
  color gray = color(204);
  color white = color(255);
  color black = color(0);
  button1 = new Button(10, 80, 10, gray, white, black);
  button2 = new Button(25, 80, 10, gray, white, black);
  button3 = new Button(40, 80, 10, gray, white, black);
}

void draw() {
  background(204);
  manageButtons();
  noStroke();
  fill(0);
  if (mode == 1) {
    ellipse(0, 40, 60, 60);
  } else if (mode == 2) {
    ellipse(50, 40, 60, 60);
```

```
  } else if (mode == 3) {
    ellipse(100, 40, 60, 60);
  }
}

void manageButtons() {
  button1.update();
  button2.update();
  button3.update();
  button1.display();
  button2.display();
  button3.display();
}

void mousePressed() {
  if (button1.press() == true) { mode = 1; }
  if (button2.press() == true) { mode = 2; }
  if (button3.press() == true) { mode = 3; }
}

void mouseReleased() {
  button1.release();
  button2.release();
  button3.release();
}
```

Using the same technique for rolling over a circle, it is straightforward to make a circular button. It's also possible to make a button with an irregular shape, but this requires a different technique.

Drag and drop

The next example extends the Button class (p. 513). The extended class allows the cursor to move the button to different positions on the screen. This is one of the primary actions of most computer interfaces. The DragButton class inherits the behavior of responding to mouse events and extends this with the ability to move when it is clicked and dragged by the mouse. This subclass uses the existing update() and display() methods, augments the press() method, and adds a drag() method to update its position when the mouse is dragged.

```
class DragButton extends Button {
  int xoff, yoff;

  DragButton(int xp, int yp, int s, color b, color o, color p) {
    super(xp, yp, s, b, o, p);
  }

  boolean press() {
    xoff = mouseX - x;   // Store x-offset from shape origin
    yoff = mouseY - y;   // Store y-offset from shape origin
    return super.press();
  }

  void drag() {
    if (pressed == true) {
      x = mouseX - xoff;   // Apply x-offset
      y = mouseY - yoff;   // Apply y-offset
    }
  }
}
```

The following example shows this new DragButton class embedded into a sketch.
Its methods are run from the mouse event functions to register the status of the mouse
with the icon object.

```
// Requires DragButton and Button classes

DragButton icon;

void setup() {
  size(100, 100);
  color gray = color(204);
  color white = color(255);
  color black = color(0);
  icon = new DragButton(21, 42, 50, gray, white, black);
}

void draw() {
  background(204);
  icon.update();
  icon.display();
}
```

```
void mousePressed()  { icon.press(); }
void mouseReleased() { icon.release(); }
void mouseDragged()  { icon.drag(); }
```

Check boxes

Check boxes and radio buttons form another category of interface elements. They frequently appear in windows for configuring software or for filling out forms on the web. The appearance of these elements is less important than their behavior, but check boxes are usually square and radio buttons are typically circular. Check boxes operate independently from others, while the status of a radio button is dependent on that of the others in its group. Thus check boxes are used as an interface element when more than one option can be selected, and radio buttons are used when only one element within a list of options can be selected.

A check box is a button with two states, ON and OFF, that change when the element is selected. If the current state is OFF and the box is selected it changes its state to ON, and vice versa. The Check class presented below defines the form and behavior of a check box. The fields and methods are similar to those in the Button class, but the display() method is unique. When the press field is true, an X is drawn in the center of the box to show that the state is ON.

```
class Check {
  int x, y;                        // The x- and y-coordinates
  int size;                        // Dimension (width and height)
  color baseGray;                  // Default gray value
  boolean checked = false;         // True when the check box is selected

  Check(int xp, int yp, int s, color b) {
    x = xp;
    y = yp;
    size = s;
    baseGray = b;
  }

  // Updates the boolean variable checked
  void press(float mx, float my) {
    if ((mx >= x) && (mx <= x+size) && (my >= y) && (my <= y+size)) {
      checked = !checked;  // Toggle the check box on and off
    }
  }
}
```

```
// Draws the box and an X inside if the checked variable is true    33-10
void display() {                                                    cont.
    stroke(255);
    fill(baseGray);
    rect(x, y, size, size);
    if (checked == true) {
        line(x, y, x+size, y+size);
        line(x+size, y, x, y+size);
    }
  }
}
```

When a Check object is used in a program, the display() method should be run from draw() and the press() method should be run from mousePressed(). The next example presents one Check object in the center of the screen to show its behavior, and the example after that creates an array of Check objects and sets their positions to make a matrix.

```
// Requires the Check class                                         33-11

Check check;

void setup() {
    size(100, 100);
    // Inputs: x, y, size, fill color
    check = new Check(25, 25, 50, color(0));
}

void draw() {
    background(204);
    check.display();
}

void mousePressed() {
    check.press(mouseX, mouseY);
}
```

```
// Requires the Check class

int numChecks = 25;
Check[] checks = new Check[numChecks];

void setup() {
  size(100, 100);
  int x = 14;
  int y = 14;
  for (int i = 0; i < checks.length; i++) {
    checks[i] = new Check(x, y, 12, color(0));
    x += 15;
    if (x > 80) {
      x = 14;
      y += 15;
    }
  }
}

void draw() {
  background(0);
  for (Check ch : checks) {
    ch.display();
  }
}

void mousePressed() {
  for (Check ch : checks) {
    ch.press(mouseX, mouseY);
  }
}
```

Radio buttons

Like a check box, a radio button also has two states, ON and OFF. Unlike check boxes, radio buttons are used in groups of two or more, and only one element in the group can be selected at a time. Each radio button must be able to turn the other elements OFF at the moment it's selected. The Radio class is unique from all other classes presented thus far in the book because it is designed to use itself as one of its parameters. This makes it possible for each element within the Radio class array to reference the other elements in the array.

Look at the last parameter in the Radio constructor on line 9 of code 33-13. The data type of the input is an array of Radio objects. The array is passed through the

constructor and is then assigned to the others[] array, which also has the data type of an array of Radio objects. Inside the press() method, each Radio object sets the state of all the other Radio objects in the array to OFF if it has been clicked (turned ON). If the state for the object is ON, a black interior circle is drawn within the display() method.

```
class Radio {
  int x, y;                      // The x- and y-coordinates
  int size, dotSize;             // Dimension of circle, inner circle
  color baseGray, dotGray;       // Circle gray value, inner gray value
  boolean checked = false;       // True when the button is selected
  int me;                        // ID number for this Radio object
  Radio[] others;                // Array of all objects in the group

  Radio(int xp, int yp, int s, color b, color d, int m, Radio[] o) {
    x = xp;
    y = yp;
    size = s;
    dotSize = size - size/3;
    baseGray = b;
    dotGray = d;
    me = m;
    others = o;
  }

  // Update the boolean value checked, returns true or false
  boolean press(float mx, float my) {
    if (dist(x, y, mx, my) < size/2) {
      checked = true;
      for (int i = 0; i < others.length; i++) {
        if (i != me) {
          others[i].checked = false;
        }
      }
      return true;
    } else {
      return false;
    }
  }
}
```

```
// Draw the element to the display window
void display() {
  noStroke();
  fill(baseGray);
  ellipse(x, y, size, size);
  if (checked == true) {
    fill(dotGray);
    ellipse(x, y, dotSize, dotSize);
  }
}
}
```

As mentioned, the most notable aspect of this example is the ability of the Radio objects to access the other members of their array. Notice the call to the constructor in code 33-14 below. The last parameter is the name of the array of radio objects. The Radio object's display() method is run from draw(), and the press() method is run from mousePressed(). The next example presents two Radio objects, and the example after it demonstrates the use of a for loop to iterate through a larger number of objects.

```
// Requires the Radio class

Radio[] buttons = new Radio[2];

void setup() {
  size(100, 100);
  // Inputs: x, y, size, base color, fill color,
  //         id number, array of all radio buttons
  buttons[0] = new Radio(33, 50, 30, color(255), color(0),
                         0, buttons);
  buttons[1] = new Radio(66, 50, 30, color(255), color(0),
                         1, buttons);
}

void draw() {
  background(204);
  buttons[0].display();
  buttons[1].display();
}

void mousePressed() {
  buttons[0].press(mouseX, mouseY);
  buttons[1].press(mouseX, mouseY);
}
```

```
// Requires the Radio class

int numButtons = 7;
Radio[] buttons = new Radio[numButtons];

void setup() {
  size(100, 100);
  for (int i = 0; i < buttons.length; i++) {
    int x = 14 + i*12;
    buttons[i] = new Radio(x, 50, 10, color(255),
                           color(0), i, buttons);

  }
}

void draw() {
  background(204);
  for (Radio r : buttons) {
    r.display();
  }
}

void mousePressed() {
  for (Radio r : buttons) {
    r.press(mouseX, mouseY);
  }
}
```

Scrollbar

A scrollbar is an interface element for selecting a value from a range of possible values. It can move through long lists of information such as web pages and text documents. Scrollbars are typically narrow rectangular elements with a positionable interior element called a *thumb*. The user can move the thumb between the endpoints of the scrollbar by dragging it to a new position. The minimal Scrollbar class presented below creates horizontal scrollbars. There are multiple fields and methods for this class, but these values and their behavior will be familiar from the previous examples.

The Scrollbar class is similar to the other classes in the chapter, but the locked field is unique, making it possible for the cursor to continue to update the position of the thumb even if the cursor moves off the scrollbar area. This common GUI feature lets people be less precise when moving the thumb element. If the mouse is pressed when the cursor is over the scrollbar, moving the mouse off the bar will continue to update the scrollbar until released. This class was designed so that each Scrollbar object has its own minimum and maximum values, defined by the parameters to the constructor.

The `getPos()` method returns the current value of the thumb element within the scrollbar's range as defined by the `minVal` and `maxVal` fields.

```
class Scrollbar {
    int x, y;                   // The x- and y-coordinates
    float sw, sh;               // Width and height of scrollbar
    float pos;                  // Position of thumb
    float posMin, posMax;       // Min and max thumb positions
    boolean rollover;           // True when the mouse is over
    boolean locked;             // True when its the active scrollbar
    float minVal, maxVal;       // Min and max values for the thumb

    Scrollbar (int xp, int yp, int w, int h, float miv, float mav) {
        x = xp;
        y = yp;
        sw = w;
        sh = h;
        minVal = miv;
        maxVal = mav;
        pos = x + sw/2 - sh/2;   // Move thumb to middle
        posMin = x;
        posMax = x + sw - sh;
    }

    // Update the boolean value over and the position of the thumb
    void update(int mx, int my) {
        if (over(mx, my) == true) {
            rollover = true;
        } else {
            rollover = false;
        }
        if (locked == true) {
            pos = constrain(mx-sh/2, posMin, posMax);
        }
    }

    // Lock the thumb so the mouse can move off and still update
    void press(int mx, int my) {
        if (rollover == true) {
            locked = true;
        } else {
            locked = false;
        }
    }
}
```

```
   // Reset the scrollbar to neutral
   void release() {
      locked = false;
   }

   // Return true if the cursor is over the scrollbar
   boolean over(int mx, int my) {
      if ((mx > x) && (mx < x+sw) && (my > y) && (my < y+sh)) {
         return true;
      } else {
         return false;
      }
   }

   // Draw the scrollbar to the screen
   void display() {
      fill(255);
      rect(x, y, sw, sh);   // Draw bar
      if ((rollover == true) || (locked == true)) {
         fill(0);
      } else {
         fill(102);
      }
      rect(pos, y, sh, sh);   // Draw thumb
   }

   // Return the current value of the thumb
   float getPos() {
      float scalar = sw/(sw-sh);
      float ratio = ((pos - x) * scalar) / sw;
      float thumbPos = minVal + (ratio * (maxVal-minVal));
      return thumbPos;
   }
}
```

The Scrollbar class is nearly the longest code we've presented in this book, but integrating it into a program takes a single step. Like the other GUI elements in this chapter, a Scrollbar object is declared at the top of the code, created in setup(), displayed and updated in draw(), and controlled by the mouse events mousePressed() and mouseReleased(). The next example features a pair of scrollbars with the same x-coordinates but different ranges. The top scrollbar selects integer numbers between 0 and 100, and the bottom scrollbar selects floating-point numbers between 0.0 and 1.0.

```
// Requires Scrollbar class

Scrollbar bar1, bar2;
PFont font;

void setup() {
  size(100, 100);
  noStroke();
  // Inputs: x, y, width, height, minVal, maxVal
  bar1 = new Scrollbar(10, 35, 80, 10, 0.0, 100.0);
  bar2 = new Scrollbar(10, 55, 80, 10, 0.0, 1.0);
  font = createFont("Courier New", 30);
  textFont(font);
  textAlign(CENTER);
}

void draw() {
  background(204);
  fill(0);
  int pos1 = int(bar1.getPos());
  text(nf(pos1, 2), 50, 30);
  float pos2 = bar2.getPos();
  text(nf(pos2, 1, 2), 50, 90);
  bar1.update(mouseX, mouseY);
  bar2.update(mouseX, mouseY);
  bar1.display();
  bar2.display();
}

void mousePressed() {
  bar1.press(mouseX, mouseY);
  bar2.press(mouseX, mouseY);
}

void mouseReleased() {
  bar1.release();
  bar2.release();
}
```

The number returned from the scrollbar's getPos() method can be used to control any aspect of a program. The following example uses this number to set the position of an image.

```
Scrollbar bar;
PImage img;

void setup() {
  size(100, 100);
  noStroke();
  // Inputs: x, y, width, height, minVal, maxVal
  bar = new Scrollbar(10, 45, 80, 10, -200.0, 0.0);
  img = loadImage("landscape.jpg");
}

void draw() {
  background(204);
  int x = int(bar.getPos());
  image(img, x, 0);
  bar.update(mouseX, mouseY);
  bar.display();
}

void mousePressed() {
  bar.press(mouseX, mouseY);
}

void mouseReleased() {
  bar.release();
}
```

Exercises

1. *Extend code 33-03 by adding more circles and rectangles to create a new composition.*
2. *Modify the* Button *class to work with circles instead of squares.*
3. *Create a composition with check boxes and radio buttons. Sketch it in code with the* Check *and* Radio *classes.*
4. *Extend the* Scrollbar *class to have arrow buttons on the left and right that move the thumb one step each time an arrow is pressed.*
5. *Create a unique subclass from the* Button *class and write a sketch to use it.*

34 Image Processing

This chapter introduces techniques for directly accessing the pixels and how to read the individual components of a color.

Syntax introduced:
`get()`, `set()`, `copy()`
`red()`, `green()`, `blue()`, `alpha()`, `hue()`, `saturation()`, `brightness()`
`pixels[]`, `loadPixels()`, `updatePixels()`

An image is a rectangular grid of pixels in which each element is a number specifying a color. Because the screen itself is an image, its individual pixels are also defined as numbers. The color values of individual pixels can be read and changed. Image processing is a general term for manipulating and modifying images, whether for the purpose of correcting a defect, improving aesthetic appeal, or facilitating communication. Programs such as GIMP and Adobe Photoshop provide their users with ways to process images including changing the contrast, blurring, and warping. This chapter explains how some image processing features work to provide a better understanding of their application.

Read pixels

When a Processing program starts, the display window opens at the dimension requested in `size()`. The program gains control over that area of the screen and sets the color value for each pixel. The display window communicates with the operating system, so when the window moves, it takes control of its new area of the screen and gives back control of its previous space to the operating system.

The `get()` function can read the color of any pixel in the display window. It can also grab a rectangular section of the whole display window or the entire window. There are three versions of this function, one for each use. If `get()` is used without parameters, a copy of the entire display window is returned as a `PImage`. The version with two parameters returns the color value of a single pixel at the location specified by the first and second parameters. A rectangular area of the display window is returned if the additional third and fourth parameters are used.

If `get()` grabs the entire display window or a section of the window, the returned data must be assigned to a variable of type `PImage`. These images can be redrawn to the screen in different positions and resized.

```
strokeWeight(8);                                              34-01
line(0, 0, width, height);
line(0, height, width, 0);
PImage cross = get();    // Get the entire window
image(cross, 0, 50);     // Draw the image in a new position
```

```
strokeWeight(8);                                              34-02
line(0, 0, width, height);
line(0, height, width, 0);
noStroke();
ellipse(18, 50, 16, 16);
PImage cross = get();             // Get the entire window
image(cross, 42, 30, 40, 40);     // Resize to 40 x 40 px
```

```
strokeWeight(8);                                              34-03
line(0, 0, width, height);
line(0, height, width, 0);
PImage slice = get(0, 0, 20, 100); // Get window section
image(slice, 18, 0);
image(slice, 50, 0);
```

The get() function always grabs the pixels in the display window in the same way, regardless of what is drawn to the window. In the previous examples, the get() function grabbed the images of the lines after they had been converted to pixels for display on screen. The following example is the same as code 34-01, but a photograph is first loaded into the display window, so get() grabs that image.

```
PImage trees, crop;                                           34-04

void setup() {
  size(100, 100);
  trees = loadImage("topanga.jpg");
}

void draw() {
  image(trees, 0, 0);
  crop = get();         // Get the entire window
  image(crop, 0, 50);   // Draw the image in a new position
}
```

When used with an x- and y-coordinate, the get() function returns values that should be assigned to a variable of the color data type. These values can be used to set the color of other pixels or can serve as parameters to functions like fill() and

stroke(). In the following example, the color of one pixel is used to set the color of the rectangle.

```
PImage trees;

void setup() {
  trees = loadImage("topanga.jpg");
  noStroke();
}

void draw() {
  image(trees, 0, 0);
  color c = get(20, 30);   // Get color at (20, 30)
  fill(c);
  rect(20, 30, 40, 40);
}
```

34-05

The cursor coordinates can be used as the parameters to the get() function. This allows the cursor to select colors from the display window. In the following example, the pixel beneath the cursor is read and defines the fill value for the rectangle on the right.

```
PImage trees;

void setup() {
  size(100, 100);
  noStroke();
  trees = loadImage("topangaCrop.jpg");
}

void draw() {
  image(trees, 0, 0);
  color c = get(mouseX, mouseY);
  fill(c);
  rect(50, 0, 50, 100);
}
```

34-06

The get() function can be used within a for loop to grab many pixels or groups of pixels. In the following example, the values from each row of pixels in the image are used to set the values for the lines on the right. Run this code and move the mouse up and down to see the relation between the image on the left and the bands of color on the right.

```
PImage trees;

void setup() {
  size(100, 100);
  trees = loadImage("topangaCrop.jpg");
}

void draw() {
  image(trees, 0, 0);
  int y = constrain(mouseY, 0, 99);
  for (int x = 0; x < 50; x++) {
    color c = get(x, y);
    stroke(c);
    line(x+50, 0, x+50, 100);
  }
  stroke(255);
  line(0, y, 49, y);
}
```

Every PImage variable has its own get() to grab pixels from the image. This allows pixels to be grabbed from an image independently of the pixels in the display window. Because a PImage is an object, the get() method is accessed with the name of the image and the dot operator. In the following example, the pixels are grabbed directly from the image and not from the screen, so white lines drawn to the display window are not grabbed.

```
PImage trees, treesCrop;

void setup() {
  trees = loadImage("topanga.jpg");
  stroke(255);
  strokeWeight(12);
}

void draw() {
  image(trees, 0, 0);
  line(0, 0, width, height);
  line(0, height, width, 0);
  treesCrop = trees.get(20, 20, 60, 60);
  image(treesCrop, 20, 20);
}
```

Write pixels

The pixels in Processing's display window can be written directly with the set() function. There are two versions of this function, each with three parameters. When the third parameter is a color, set() changes the color of the pixel defined by the first and second parameter. When the third parameter is an image, set() writes an image at the coordinates specified by the first two parameters.

```
color black = color(0);
set(20, 80, black);
set(20, 81, black);
set(20, 82, black);
set(20, 83, black);
```
34-09

```
for (int x = 0; x < 55; x++) {
  for (int y = 0; y < 55; y++) {
    color c = color((x+y) * 1.8);
    set(30+x, 20+y, c);
  }
}
```
34-10

The set() function can write an image to the display window at any location. Using set() to draw an image is faster than using the image() function because the pixels are copied directly. However, images drawn with set() cannot be resized or tinted, and they are not affected by the transformation functions.

```
PImage trees;

void setup() {
  size(100, 100);
  trees = loadImage("topangaCrop.jpg");
}

void draw() {
  int x = constrain(mouseX, 0, 50);
  set(x, 0, trees);
}
```
34-11

Every PImage variable has its own set() method to write pixels directly to the image. This allows pixels to be written to an image independently of the display window. Because a PImage is an object, the set() method is used with the name of the image

and the dot operator. In the following example, four white pixels are set into the image variable `trees`, and the image is then drawn to the display window.

```
PImage trees;

void setup() {
    size(100, 100);
    trees = loadImage("topangaCrop.jpg");
    color white = color(255);
    trees.set(0, 50, white);
    trees.set(1, 50, white);
    trees.set(2, 50, white);
    trees.set(3, 50, white);
}

void draw() {
    background(0);
    image(trees, 20, 0);
}
```

Copy pixels

The `copy()` function has two versions, each of which has a large number of parameters, so we'll list them:

```
copy(sx, sy, sw, sh, dx, dy, dw, dh)
copy(src, sx, sy, sw, sh, dx, dy, dw, dh)
```

The version of `copy()` with eight parameters replicates a region of pixels from the display window in another area of the display window. The version with nine parameters copies all or a portion of the image specified by the `src` parameter into the display window. If the source and destination regions are of different sizes, the pixels will automatically be resized to fit the destination width and height. The `copy()` function differs from the previously discussed `get()` and `set()` functions because it can both get pixels from one location and set them to another. The following examples demonstrate the function.

```
PImage img;

void setup() {
    size(100, 100);
    img = loadImage("topanga.jpg");
}
```

```
void draw() {
  background(204);
  image(img, 0, 0);
  copy(0, 0, 100, 50, 0, 50, 100, 50);
}
```

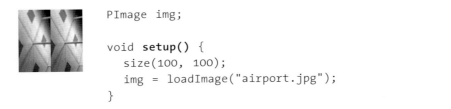

```
PImage img1, img2;

void setup() {
  size(100, 100);
  img1 = loadImage("topanga.jpg");
  img2 = loadImage("airport.jpg");
}

void draw() {
  background(255);
  image(img1, 0, 0);
  int y = constrain(mouseY, 0, 67);
  copy(img2, 0, y, 100, 33, 0, y, 100, 33);
}
```

The PImage class has a copy() method that uses the same parameters as the function described earlier. It can be used to copy portions of one image to itself or areas of one image to another. The following example shows this method in action.

```
PImage img;

void setup() {
  size(100, 100);
  img = loadImage("airport.jpg");
}

void draw() {
  img.copy(50, 0, 50, 100, 0, 0, 50, 100);
  image(img, 0, 0);
}
```

Color components

Colors are stored in software as numbers. Each color is defined by its component elements. When color is defined by RGB values, there are three numbers that store the red, green, and blue components and an optional fourth number that stores a

transparency value. When working with HSB values, three numbers store the hue, saturation, and brightness values and a fourth denotes the transparency. The visible color is a combination of these components. Adjusting the individual color properties in isolation from the others is a useful technique for dynamically changing a single color value or the entire palette for a program.

In Processing, the `color` data type is a single number that stores the individual components of a color. This value combines the red, green, blue, and alpha (transparency) components. Behind the scenes, this value is actually an `int`, and it can be used interchangeably with an `int` variable anywhere in a program. The `color` data type stores the components of the color as a series of values from 0 to 255 embedded into this larger number. We can look at an abstracted view of a color with this table:

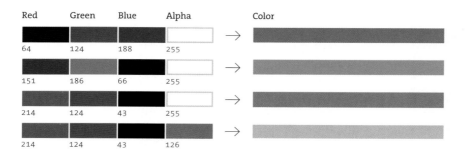

Red	Green	Blue	Alpha		Color
64	124	188	255	→	
151	186	66	255	→	
214	124	43	255	→	
214	124	43	126	→	

The `red()`, `green()`, and `blue()` functions are used for reading the components of a color. The `red()` function extracts the red component, the `green()` function extracts the green component, and the `blue()` function extracts the blue component.

```
color c1 = color(0, 126, 255); // Create a new color                34-16
float r = red(c1);             // Assign 0.0 to r
float g = green(c1);           // Assign 126.0 to g
float b = blue(c1);            // Assign 255.0 to b
println(r, g, b);              // Prints "0.0 126.0 255.0"
color c2 = color(102);         // Create a new gray value
float r2 = red(c2);            // Assign 102.0 to r2
float g2 = green(c2);          // Assign 102.0 to g2
float b2 = blue(c2);           // Assign 102.0 to b2
println(r2, g2, b2);           // Prints "102.0 102.0 102.0"
```

The `alpha()` function reads the alpha value of the color. Remember, a fourth value added to the `color()` function sets the transparency value for this color. If no alpha value is set, the default 255 is used.

```
color c = color(0, 51, 102);          // Create a new color          34-17
color g = color(0, 126, 255, 220);    // Create a new color
float a = alpha(c);                    // Assign 255.0 to a
float b = alpha(g);                    // Assign 220.0 to b
println(a, b);                         // Prints "255.0, 220.0"
```

The hue(), saturation(), and brightness() functions work like red(), green(), and blue(), but return different components of the color. It makes sense to use these functions with the HSB color mode, but it's sometimes helpful to read these values while using the default RGB color mode as shown in code 34-24.

```
colorMode(HSB, 360, 100, 100);    // Set color mode to HSB          34-18
color c = color(210, 100, 40);    // Create a new color
float h = hue(c);                 // Assign 210.0 to h
float s = saturation(c);          // Assign 100.0 to s
float b = brightness(c);          // Assign 40.0 to b
println(h, s, b);                 // Prints "210.0 100.0 40.0"
```

```
color c = color(217, 41, 117);    // Create a new color          34-19
float r = red(c);                 // Assign 217.0 to r
float h = hue(c);                 // Assign 236.64774 to h
println(r, h);                    // Prints "217.0 236.64774"
```

The values from all of these functions are scaled based on the current color mode settings. If the range for color values is changed with colorMode(), the values returned will be scaled within the new range.

```
colorMode(RGB, 1.0);                // Sets color mode to RGB          34-20
color c = color(0.2, 0.8, 1.0);     // Creates a new color
float r = red(c);                   // Assign 0.2 to r
float h = hue(c);                   // Assign 0.5416667 to h
println(r, h);                      // Prints "0.2 0.5416667"
```

The values returned from these color functions are always floating-point values; therefore, you'll receive an error if you try to assign the result to an integer value. If you need the result to be an integer, you can convert the value using the int() function (p. 61).

```
color c = color(118, 22, 24);    // Create a new color          34-21
int r1 = red(c);                 // ERROR! red() returns a float
float r2 = red(c);               // Assign 118.0 to r2
int r3 = int(red(c));            // Assign 118 to r3
```

In the following examples, the get() function is used to access the color at the current cursor position. The components of these colors are extracted and used to set the drawing properties.

```
void setup() {                                             34-22
  size(100, 100);
  fill(204, 0, 0);
}

void draw() {
  background(0);
  noStroke();
  ellipse(66, 46, 80, 80);
  color c = get(mouseX, mouseY);
  float r = red(c); // Extract red component
  stroke(255-r);    // Set the stroke based on red value
  line(mouseX, 0, mouseX, height);
  line(0, mouseY, width, mouseY);
}
```

```
PImage img;                                                34-23

void setup() {
  size(100, 100);
  img = loadImage("sample.png");
  stroke(255);
}

void draw() {
  image(img, 0, 0);
  color c = get(mouseX, mouseY);
  float r = red(c);        // Extract red
  float g = green(c);      // Extract green
  float b = blue(c);       // Extract blue
  fill(r, 0, 0);
  rect(32, 20, 12, 60);    // Red component
  fill(0, g, 0);
  rect(44, 20, 12, 60);    // Green component
  fill(0, 0, b);
  rect(56, 20, 12, 60);    // Blue component
}
```

Values extracted with the red(), green(), and blue() functions can be used in many different ways. For instance, the numbers can be used to control aspects of motion or

the flow of the program. In the following example, the brightness of pixels in an image controls the speed of 600 points moving across the screen. Each point moves across the screen from left to right. The pixel value in the image with the same coordinate as a point is read and used to set the speed at which the point moves. Each point moves slowly through dark areas and quickly through lighter areas. Run the code and try a different photo to see how the same program can be used to create different patterns of motion.

34-24

```
int num = 600;
float[] x = new float[num];
float[] y = new float[num];
PImage img;

void setup() {
  size(100, 100);
  img = loadImage("figure.jpg");
  for (int i = 0; i < num; i++) {
    x[i] = random(width);
    y[i] = random(height);
  }
  stroke(255);
}

void draw() {
  background(0);
  for (int i = 0; i < num; i++) {
    color c = img.get(int(x[i]), int(y[i]));
    float b = brightness(c) / 255.0;
    float speed = pow(b, 2) + 0.05;
    x[i] += speed;
    if (x[i] > width) {
      x[i] = 0;
      y[i] = random(height);
    }
    point(x[i], y[i]);
  }
}
```

Pixel array

The get() and set() functions are convenient ways to read and write pixels, but they are relatively slow in relation to directly accessing the pixels. Each image in Processing, including the display window, is stored as a one-dimensional array of colors. Each color in this array is one pixel of an image. The number of elements in the pixel array is determined by multiplying the width of an image by its height. For instance, if an image is 100 pixels wide and 100 pixels high, the array will have 10,000 elements. If an image is 200 pixels wide and 2 pixels high, the array will have 400 elements. The first position in the array is the pixel in the upper-left corner of the image, and the last position in the array is the pixel in the lower-right corner. The width and height of an image are used to map each element's position in the one-dimensional array to the two-dimensional position on screen. To make this clear, let's look at an array belonging to a small image of the size 10 × 6 pixels:

When this image is loaded into Processing, its one-dimensional pixel array contains each row of the two-dimensional image, one after another:

Because the image is 10 × 6 pixels, the array has 60 elements. The first element is at position [0] and the last at position [59]. Storing images in this format makes it efficient to apply algorithms to the color values.

The pixels[] array in Processing stores a color value for each pixel of the display window. The loadPixels() function must be called before the pixels[] array is used. The modified array is updated with the updatePixels() function. In general, like beginShape() and endShape(), loadPixels() and updatePixels() should appear together. However, if pixels are only being read, there is no reason to use updatePixels(). The updatePixels() function is required to finalize changes to the pixels[] array.

The following example changes the color of the pixels in the display window by changing one pixel each frame based on the current second value. Over time, the pixels are set in order from left to right and top to bottom. The shift from white to black happens with each minute—when the value from seconds() jumps from 59 to 0. When the last pixel in the array is set, the program starts again at the beginning of the array.

```
void setup() {
  size(100, 100);
}

void draw() {
  float gray = map(second(), 0, 59, 0, 255);
  int index = frameCount % (width*height);
  loadPixels();
  pixels[index] = color(gray);
  updatePixels();
}
```

The loadPixels() and updatePixels() functions ensure that the pixels[] array is ready to be manipulated and that the changes are applied back to the array. Be sure to place them around any block of code that manipulates the array, but use them only when necessary because overuse can make your program run slowly.

Reading and writing data directly to and from the pixels[] array is a different way to perform the same action as get() and set(). The x-coordinate and y-coordinate can be mapped to the corresponding position within the array by multiplying the y-coordinate value by the width of the display window and then adding the x-coordinate value. To calculate the location of any pixel in the array, use the formula (y*width)+x.

```
// These 3 lines of code are equivalent to: set(25, 50, color(0))
loadPixels();
pixels[50*width + 25] = color(0);
updatePixels();
```

To convert to the opposite direction, divide the pixel's position in the array by the width of the display window to get the y-coordinate, and take the modulo value (p. 57) of the position and the width to get the x-coordinate:

```
// These 3 lines are equivalent to: pixels[5075] = color(0)
int y = 5075 / width;
int x = 5075 % width;
set(x, y, color(0));
```

In programs that manipulate many pixels at a time, reading and writing values to the pixels[] array is faster than using get() and set(). The following two examples show how to achieve the functionality of get() and set() using the pixels[] array. These examples will actually be slower than using get() and set(), but later examples have the potential to be faster.

```
void setup() {                                              34-28
  size(100, 100);
}

void draw() {
  // Constrain to not exceed the boundary of the array
  int x = constrain(mouseX, 0, 99);
  int y = constrain(mouseY, 0, 99);
  loadPixels();
  pixels[y*width + x] = color(0);
  updatePixels();
}
```

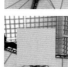

```
PImage arch;                                                34-29

void setup() {
  size(100, 100);
  noStroke();
  arch = loadImage("arch.jpg");
}

void draw() {
  image(arch, 0, 0);
  // Constrain to not exceed the boundary of the array
  int x = constrain(mouseX, 0, 99);
  int y = constrain(mouseY, 0, 99);
  loadPixels();
  color c = pixels[y*width + x];
  fill(c);
  rect(20, 20, 60, 60);
}
```

Each image has its own pixels[] array that is accessed with the dot operator. This array makes it possible to change an image while leaving the pixels in other images and the display window untouched. In the next example, pixels inside an image are colored black according to the position of the mouse.

```
PImage arch;

void setup() {
  size(100, 100);
  arch = loadImage("arch.jpg");
}

void draw() {
  image(arch, 0, 0);
  int x = constrain(mouseX, 0, 99);
  int y = constrain(mouseY, 0, 99);
  arch.loadPixels();
  arch.pixels[y*width + x] = color(0);
  arch.updatePixels();
  image(arch, 50, 0);
}
```

Using the pixels[] array rather than the image() function to draw the image to the display window provides more control and leaves room for variation in displaying the image. Small calculations modifying the for loop and the pixels[] array reveal some of the potential of this technique.

```
PImage arch = loadImage("arch.jpg");
size(arch.width, arch.height);
int count = width * height;
arch.loadPixels();
loadPixels();
for (int i = 0; i < count; i += 2) {
  pixels[i] = arch.pixels[i];
}
updatePixels();
```

```
PImage arch = loadImage("arch.jpg");
size(arch.width, arch.height);
int count = width * height;
arch.loadPixels();
loadPixels();
for (int i = 0; i < count; i += 3) {
  pixels[i] = arch.pixels[i];
}
updatePixels();
```

```
PImage arch = loadImage("arch.jpg");
size(arch.width, arch.height);
int count = width * height;
arch.loadPixels();
loadPixels();
for (int i = 0; i < count; i++) {
  pixels[i] = arch.pixels[count - i - 1];
}
updatePixels();
```
34-33

```
PImage arch = loadImage("arch.jpg");
size(arch.width, arch.height);
int count = width * height;
arch.loadPixels();
loadPixels();
for (int i = 0; i < count; i++) {
  pixels[i] = arch.pixels[i/2];
}
updatePixels();
```
34-34

Pixel components

The red(), green(), and blue() functions can be used with the pixels[] array to modify an image. For example, if each value is multiplied by 2, the image will become lighter; if each value is divided by 2, the image will become darker. Using a for loop makes it easy to read and change every pixel in the display window. Because the pixels[] array is a one-dimensional array, only one for loop is necessary to modify every pixel in the image. The following example shows how to invert an image.

```
PImage arch = loadImage("arch.jpg");
image(arch, 0, 0);
loadPixels();
for (int i = 0; i < width*height; i++) {
  color p = pixels[i];            // Grab pixel
  float r = 255 - red(p);         // Modify red value
  float g = 255 - green(p);       // Modify green value
  float b = 255 - blue(p);        // Modify blue value
  pixels[i] = color(r, g, b);     // Assign modified value
}
updatePixels();
```
34-35

Values from the keyboard and the mouse can be used to change the way the `pixels[]` array is altered while the program runs. In the following example, a color image is converted to gray values by averaging its components. These values are incremented by mouseX to make the image lighter as the mouse moves to the right.

34-36

```
PImage arch;

void setup() {
  size(100, 100);
  arch = loadImage("arch.jpg");
}

void draw() {
  image(arch, 0, 0);
  loadPixels();
  for (int i = 0; i < width*height; i++) {
    color p = pixels[i];       // Read color from screen
    float r = red(p);
    float g = green(p);
    float b = blue(p);
    float bw = (r + g + b) / 3.0;
    bw = constrain(bw + mouseX, 0, 255);
    pixels[i] = color(bw);     // Assign modified value
  }
  updatePixels();
  line(mouseX, 0, mouseX, height);
}
```

The functions for extracting individual color components are accurate and easy to use, but they are slow. When an idea requires using these functions hundreds or thousands of times each frame, they can be replaced with a technique called bit-shifting (p. 615) or with a shader. Shaders are a more advanced technique not discussed in this book. There are Shader examples included with the Processing software.

Exercises

1. *Load an image and use* get() *to create a collage by overlaying different sections of the same image.*
2. *Load an image and use* mouseX *and* mouseY *with* get() *to read the color of a single pixel beneath the cursor. Use this value to change some aspect of the sketch.*
3. *Use* copy() *to modify the sketch you wrote for exercise 1.*
4. *Write a sketch to print the red, green, and blue values of the first one hundred pixels of an image to the console.*
5. *Write your own image filter by modifying and updating the values of* pixels[].

35 Render Techniques

This chapter introduces techniques for drawing to offscreen graphics buffers.

Syntax introduced:
`hint()`, `PGraphics`, `createGraphics()`, `beginDraw()`, `endDraw()`,
`PGraphics.clear()`

Throughout this book, everything has drawn to the primary display window. Sometimes, however, there is an advantage in drawing to another graphics surface. All of the drawing features available in the display window can be applied to an offscreen drawing surface and then drawn back into the display window as an image or texture. This technique makes it easier to imagine a program as a stack of layers similar to the technique used in photo editing and vector drawing software. Similarly, drawing surfaces in Processing can be moved around, drawn using blending effects and transparency, and drawn in different orders to change how the layers combine. Before the discussion moves to multiple drawing surfaces, this chapter starts with a discussion of the different renderers used by Processing.

Renderers

Each drawing function in Processing renders geometry as pixels. For instance, the line function draws to the screen connecting two points together by coloring the pixels between these points. The precise way the line is drawn is determined by the *renderer*. Each renderer has its own good and bad points. The default render that Processing uses is accurate, but slow, while the P3D renderer is often faster, but some shapes are less smooth, or it's often slower for pixel-based operations. Programmers decides which renderer to use depending on their goals.

Processing has three primary renderers: the default renderer, P3D, and P2D. The default renderer is used for the majority of the programs in this book; it's for 2D drawing. It's used when one of the other renders aren't defined as the third parameter to `size()`. The P3D renderer for drawing in three dimensions is discussed in the 3D Drawing chapter (p. 21). The P2D renderer is an alternative 2D renderer that is substantially faster than the default renderer for most tasks, but it sacrifices some visual quality for speed. Both P2D and P3D utilize a software specification called OpenGL that is supported on many GPUs (the Graphics Processing Unit on a computer's graphics card) to accelerate drawing. The visual quality of the OpenGL renderers, P2D and P3D, can be adjusted with the `smooth()` and `hint()` functions.

All programs have smoothing enabled by default, but an optional parameter to `smooth()` can improve the quality of the OpenGL rendering with P2D and P3D. For instance, `smooth(4)` will enhance the quality of anti-aliasing to improve the image

quality. The optional parameters from low to high are 2, 4, and 8, with 2 as the default. These options are only available on graphics cards that support them and may slow a program down or require more memory.

The hint() function is available for advanced users to modify details about how geometry is drawn to the screen. By default, when rendering a scene, each renderer makes decisions about drawing order, shape occlusion, perspective distortion, and so on based on what is more likely to be useful and efficient for the largest number of users. Hints are used to change these defaults if other decisions are better for a specific program. There is a single hint() function, but the parameters for it enable and disable a range of rendering decisions. For example, to make lines appear in perspective, write hint(ENABLE_STROKE_PERSPECTIVE) and to turn this back off, write hint(DISABLE_STROKE_PERSPECTIVE). This feature is not enabled by default because it's slower and will make lines in predominantly flat scenes appear strangely. But it's a useful necessity when drawing many lines that make use of a large 3D space. The parameters to hint() change over time, so please consult the Processing reference for the current options.

Another drawing surface

New drawing surfaces can be the same size as the display window, but they can also be smaller or larger. Each drawing surface in Processing is an instance of the PGraphics class. The display window is the default surface to draw to; every function renders there by default. For example, to draw a circle into the display window, run the ellipse() function:

```
background(0);
ellipse(50, 50, 75, 75);
```

35-01

To draw the same shape into a new surface, first create a new PGraphics object, then draw to it by typing the name of the object and dot operator before the name of the drawing functions. This new surface is placed in the display window with the image() function.

```
PGraphics circle = createGraphics(100, 100);
circle.beginDraw();
circle.background(0);
circle.ellipse(50, 50, 75, 75);
circle.endDraw();
image(circle, 0, 0);
```

35-02

The createGraphics() function generates the new drawing surface at the size in pixels defined by the parameters. This step only happens once to initialize it. The beginDraw() function is used to start working with a custom PGraphics object and the endDraw() method is used to stop. Both are needed each time a change is made. Finally, the surface may be drawn to the display window with the image() function. All of the parameters to image() to control the position and size may be used to change the way the surface is drawn.

In practice, new PGraphics layers are most often used with programs that have setup() and draw(). To work together, the PGraphics object is declared as global, it is created inside setup(), then can be modified in draw().

```
PGraphics circle;

void setup() {
    size(100, 100);
    circle = createGraphics(100, 100);
}

void draw() {
    circle.beginDraw();
    circle.background(0);
    circle.ellipse(50, 50, 75, 75);
    circle.endDraw();
    image(circle, 0, 0);
}
```

Based on this example, the most obvious differences to working with PGraphics objects are the additional lines of code and the extra step of prepending each drawing function with the name of the object. This example is simplified to demonstrate the mechanics of the technique, but it doesn't do anything to justify it. The following example reveals a typical issue that creating a new drawing surface can fix. The goal of the program is to use a crosshair to show the position of the cursor and to draw a new circle to the screen each time the mouse is clicked. For the circles to accumulate on screen, the background() function isn't used. This has the unintended effect of also accumulating the crosshairs as seen in this code:

```
void setup() {
  size(100, 100);
  background(0);
  noCursor();
}
```

```
void draw() {
  stroke(255);
  line(mouseX, 0, mouseX, height);
  line(0, mouseY, width, mouseY);
}
```

```
void mousePressed() {
  noStroke();
  fill(255, 100);
  ellipse(mouseX, mouseY, 40, 40);
}
```

To allow for the circles to accumulate in the display window, but to have a different effect for the crosshairs, a new drawing surface is created to render the circles, while the crosshairs are drawn in the main display window. The surface with the circles is redrawn each frame in draw(), followed by the lines so they are on top of the circles layer.

```
PGraphics circles;

void setup() {
  size(100, 100);
  circles = createGraphics(width, height);
  circles.beginDraw();
  circles.background(0);
  circles.noStroke();
  circles.fill(255, 100);
  circles.endDraw();
  noCursor();
}

void draw() {
  image(circles, 0, 0);
  stroke(255);
  line(mouseX, 0, mouseX, height);
  line(0, mouseY, width, mouseY);
}
```

```
void mousePressed() {
  circles.beginDraw();
  circles.ellipse(mouseX, mouseY, 40, 40);
  circles.endDraw();
}
```

The setup() is this example defines the default values for the new drawing surface. The background is set to black, the fill color is set to transparent white, and the stroke is turned off. These attributes apply to the circles layer for the entire program, so each time a circle is drawn inside mousePressed(), it draws without a stroke and with a transparent white.

Another good reason to use a PGraphics object is to render geometry a single time, but to display it many times within the program as a texture unit. The following example draws an ellipse at a random location on an surface that's only 50 × 50 pixels, then follows to draw that surface in a grid by placing the image() function inside a nested loop.

```
PGraphics tile;

void setup() {
  size(700, 100);
  tile = createGraphics(50, 50);
  background(0);
}

void draw() {
  runTile();
  for (int y = 0; y < height; y += tile.height) {
    for (int x = 0; x < width; x += tile.width) {
      image(tile, x, y);
    }
  }
}

void runTile() {
  float x = random(20, tile.width-20);
  float y = random(20, tile.height-20);
```

```
      tile.beginDraw();
      tile.noStroke();
      tile.fill(0, 20);
      tile.rect(0, 0, tile.width, tile.height);
      tile.fill(255);
      tile.ellipse(x, y, 10, 10);
      tile.endDraw();
}
```

This example clarifies two things about working with PGraphics objects. First, each object has its own width and height field, just like the main display window. Second, while the drawing functions such as noStroke() and rect() are applied to the drawing surface through the dot operator, variables still belong to the main program. Notice that the x and y variables in the runTile() function aren't defined as belonging to the tile object.

OpenGL surfaces

Just as the the size() function defines the main renderer for a program, each createGraphics() function defines the renderer for the PGraphics object with a third, optional parameter. When the third parameter isn't used, as in the examples seen already in this chapter, the default renderer is set. The P2D and P3D renderers are the other options. For instance, to create a new drawing surface for 3D shapes, use P3D as the third parameter to size() and createGraphics():

```
PGraphics cube;

void setup() {
    size(100, 100, P3D);
    cube = createGraphics(width, height, P3D);
}

void draw() {
    background(0);
    drawCube();
    image(cube, 0, 0);
}

void drawCube() {
    cube.beginDraw();
    cube.lights();
    cube.background(0);
    cube.noStroke();
```

```
      cube.translate(width/2, height/2);
      cube.rotateX(frameCount/100.0);
      cube.rotateY(frameCount/200.0);
      cube.box(40);
      cube.endDraw();
    }
```

As implied by the previous example, the only rule to remember about selecting renderers for new drawing surfaces is to match the renderer defined in size() and createGraphics(). The exception to this rule is using the default renderer and P2D as alternate options when P3D is the main renderer defined in size(). For example, the following code won't run because it's not possible to run a 3D renderer when the default is used as the primary renderer:

```
PGraphics cube;

void setup() {
  size(100, 100);
  cube = createGraphics(width, height, P3D);   // Error
}

void draw() {
  cube.beginDraw();
  cube.box(40);
  cube.endDraw();
  image(cube, 0, 0);
}
```

Combine surfaces

The final section in this chapter demonstrates techniques for combining more than one drawing surface together within the display window. This builds on the code earlier in the chapter, but extends it further. The next example builds on code 35-07 with two changes. First, another drawing surface was added and second, the background() was removed from each layer and replaced with clear(). The clear() method is similar to defining the background because it erases everything in the drawing surface, but it makes each pixel transparent instead of filling each with a color. Here, clear() is used to make it easier to combine the two drawing surfaces together because the shapes drawn into each buffer are surrounded by transparent pixels. Transparent backgrounds aren't possible for the display window, the default PGraphics object. They are one of the primary advantages of creating a new drawing surface.

```
PGraphics cubeA;
PGraphics cubeB;

void setup() {
  size(200, 200, P3D);
  cubeA = createGraphics(width, height, P3D);
  cubeB = createGraphics(width, height, P3D);
}

void draw() {
  background(0);
  drawCubeA();
  drawCubeB();
  float alphaA = map(mouseX, 0, width, 0, 255);
  float alphaB = map(mouseY, 0, height, 0, 255);
  tint(255, alphaA);
  image(cubeA, 0, 0);
  tint(255, alphaB);
  image(cubeB, 0, 0);
}

void drawCubeA() {
  cubeA.beginDraw();
  cubeA.lights();
  cubeA.clear();
  cubeA.noStroke();
  cubeA.translate(width/2, height/2);
  cubeA.rotateX(frameCount/100.0);
  cubeA.rotateY(frameCount/200.0);
  cubeA.box(80);
  cubeA.endDraw();
}

void drawCubeB() {
  cubeB.beginDraw();
  cubeB.lights();
  cubeB.clear();
  cubeB.noStroke();
  cubeB.translate(width/2, height/2);
  cubeB.rotateX(frameCount/150.0);
  cubeB.rotateY(frameCount/250.0);
  cubeB.box(80);
  cubeB.endDraw();
}
```

Move the cursor around in the display window to modify the transparency of each layer. The visibility of each other is set by the tint() that precedes the image() function. A quick look at the drawCubeA() and drawCubeB() functions reveal there might be a better way to write the program. Both functions are nearly identical with three differences: the name of the surface to draw to, the rotation amount for the x-axis, the rotation amount for the y-axis. These values can be passed into a function as parameters so a single function can be used in place of two. The unknown syntax is how to pass in a PGraphics object as a parameter to a function. Fortunately, it follows the same pattern as all parameters, the name of the data type is followed by a variable name. The updated program follows.

35-10

```
PGraphics cubeA;
PGraphics cubeB;

void setup() {
  size(200, 200, P3D);
  cubeA = createGraphics(width, height, P3D);
  cubeB = createGraphics(width, height, P3D);
}

void draw() {
  background(0);
  drawCube(cubeA, 100, 200);
  drawCube(cubeB, 150, 250);
  float alphaA = map(mouseX, 0, width, 0, 255);
  float alphaB = map(mouseY, 0, height, 0, 255);
  tint(255, alphaA);
  image(cubeA, 0, 0);
  tint(255, alphaB);
  image(cubeB, 0, 0);
}

void drawCube(PGraphics cube, float xd, float yd) {
  cube.beginDraw();
  cube.lights();
  cube.clear();
  cube.noStroke();
  cube.translate(cube.width/2, cube.height/2);
  cube.rotateX(frameCount/xd);
  cube.rotateY(frameCount/yd);
  cube.box(80);
  cube.endDraw();
}
```

When the cubeA object is passed into the drawCube() function in the second line of draw(), the drawCube() functions renders into that object. When the cubeB object is passed into the drawCube() function in the third line of draw(), the drawCube() function renders into that object. This ability is the power of the revised program; it shows a modular technique for drawing into any PGraphics object through parameterization.

The next example is similar to the previous example, but it blends the two drawing surfaces together with the blendMode() function. The blend mode is defined at the end of setup() and is then applied for the duration of the program.

35-11

```
PGraphics cubeA;
PGraphics cubeB;

void setup() {
    size(200, 200, P3D);
    cubeA = createGraphics(width, height, P3D);
    cubeB = createGraphics(width, height, P3D);
    blendMode(DARKEST);
}

void draw() {
    background(255);
    drawCube(cubeA, 100, 200);
    drawCube(cubeB, 150, 250);
    image(cubeA, 0, 0);
    image(cubeB, 0, 0);
}

void drawCube(PGraphics cube, float xd, float yd) {
    cube.beginDraw();
    cube.lights();
    cube.clear();
    cube.noStroke();
    cube.translate(cube.width/2, cube.height/2);
    cube.rotateX(frameCount/xd);
    cube.rotateY(frameCount/yd);
    cube.box(80);
    cube.endDraw();
}
```

In general, blend modes and controlling transparency with tint() are the primarily ways to easily mix the pixels from two PGraphics objects together in the main display window. Try experimenting with this using the last example in the chapter. Keep in mind that the default blend mode is blendMode(BLEND) to reset to the way a program

draws. Also, some blend modes don't work with all background values. For example, if the background is white, then using blendMode(LIGHTEST) will always be a white screen because no pixel will ever be lighter than the background value. Conversely, blendMode(DARKEST) and blendMode(MULTIPLY) don't have results with a black background.

Exercises

1. Draw a simple responsive composition in a PGraphics object, then draw it to the display window.

2. Like code 35-06, use a for loop to draw a grid of the PGraphics object created for exercise 1.

3. Like code 35-11, collage the PGraphics objects created for exercise 1 together with different blend modes.

4. Use a PGraphics object with the texture() function (p. 211) to create a generative texture.

5. Use a PGraphics object with the mask() method (p. 172) to create a dynamic image mask.

36 Synthesis 4

This chapter presents a series of example *sketches that bring together the wide range of topics presented in the book.*

After working through the chapters of this book, it is now possible to integrate elements of software including variables, conditionals, objects, and arrays in tandem with visual elements, motion, and response to create exciting and inventive software. The examples presented in this chapter are the most challenging in the book, but they include only ideas and code that are discussed in the text. To get the most from them, move back and forth through the book to review and clarify the content. Each is the start of an exploration following an idea, rather than the end. Try pushing this code further and into new directions.

The ultimate challenge for each reader is to imagine code of the complexity in this chapter and to write sketches from scratch or by assembling and modifying the book examples. We hope this series of examples establishes a process and encourages more ambitious projects.

Collage engine

The following two programs demonstrate a software version of a random composition. This is a technique explored nearly a century ago by visual artists and Dada poets. Here, the actions of dropping and pulling things from a hat are replaced with the Processing random number generator. With or without code, random values can reveal new and unexpected way to build a composition. The images used in these sketches were cut and scanned from the first section of the *New York Times* of June 9, 2006, during the production of the first edition of this book.

The first example reveals how an image can be placed in a random position and rotated to a random angle. The second and third parameters to image() are negative values based on the dimensions of the image so it rotates around its center. This program uses noLoop() to stop the draw() block from running continuously. The redraw() function is placed inside the mousePressed() event function so the draw() is run once each time the mouse is pressed.

```
PImage img;

void setup() {
  size(400, 400);
  img = loadImage("nyt_13.jpg");
  noLoop();
}
```

36-01

Figure 36-1
Image captures for code 36-01.

Figure 36-2
Image captures for code 36-02.

```
void draw() {
  float x = random(width);
  float y = random(height);
  float a = random(0, TWO_PI);
  background(0);
  translate(x, y);
  rotate(a);
  image(img, -img.width/2, -img.height/2);
}

void mousePressed() {
  redraw();
}
```

Arrays are added to the sketch to work with more than one image. Specifically, the next iteration of the sketch pulls in twenty-nine images from the data folder. A new class called Photo was written to store each image along with its x- and y-coordinates and angle. Like the examples in the Animation chapter, the name of each image is built by combining Strings together with a formatted integer. Each image file name is passed through to the constructor for each Photo object in the array. In comparing this example to the previous, notice how the code for positioning and drawing the images was moved from draw() into the display() method in the Photo class.

```
Photo[] photos = new Photo[29];

void setup() {
  size(1200, 600);
  for (int i = 0; i < photos.length; i++) {
    String imageName = "nyt_" + nf(i+1, 2) + ".jpg";
    photos[i] = new Photo(imageName);
  }
  noLoop();
}

void draw() {
  background(0);
  for (Photo e : photos) {
    e.display();
  }
}

void mousePressed() {
  redraw();
}
```

```
class Photo {
  float x, y, a;
  PImage img;

  Photo(String imageName) {
    img = loadImage(imageName);
  }

  void display() {
    x = random(width);
    y = random(height);
    a = random(0, TWO_PI);
    pushMatrix();
    translate(x, y);
    rotate(a);
    image(img, -img.width/2, -img.height/2);
    popMatrix();
  }
}
```

Waves

As an homage to the painter Bridget Riley, the next sequence of examples start with a curve created with a sine function and results in a dynamic, undulating texture. As discussed in the Calculate chapter, a sine wave oscillates between -1 and 1 as its parameter changes. These values can be used to define the curve of a line. Here, a QUAD_STRIP is used to define a line as segments and to set the line thickness. The geometry is outlined to reveal the structure. The shape of the curve is defined by the mouseY variable.

```
float curveWidth = 30.0;
float curveThickness = 50.0;

void setup() {
  size(200, 600);
  noFill();
  stroke(0);
}

void draw() {
  background(255);
```

```
float angleIncrement = map(mouseY, 0, height, 0.0, 0.1);
float angle = 0.0;

beginShape(QUAD_STRIP);
for (int y = 0; y <= height; y += 10) {
  float x = width/2 + (sin(angle)* curveWidth);
  vertex(x, y);
  vertex(x + curveThickness, y);
  angle += angleIncrement;
}
endShape();
}
```

36-03
cont.

The next step makes the thickness of the curve variable so that it is thicker in some parts than others. The curve is defined as a QUAD_STRIP, so each quad can have its own thickness. Because the width of each quad is only a little thinner or thicker than the neighbor quads, a curve is defined. The shape of the curve is set by a second sine value that is close in value to the first. Example 22-12 and the diagram on page 317 show the relationship between the sine values of two similar angles as a foundation for this sketch.

```
float curveWidth = 30.0;
float curveThickness = 50.0;
float angleOffset = 0.9;

void setup() {
  size(200, 600);
  noFill();
  stroke(0);
}

void draw() {
  background(255);

  float angleIncrement = map(mouseY, 0, height, 0.0, 0.1);
  float angleA = 0.0;
  float angleB = angleA + angleOffset;

  beginShape(QUAD_STRIP);
  for (int y = 0; y <= height; y += 10) {
    float x1 = width/2 + (sin(angleA)* curveWidth);
    float x2 = width/2 + (sin(angleB)* curveWidth);
    vertex(x1, y);
    vertex(x2 + curveThickness, y);
```

36-04

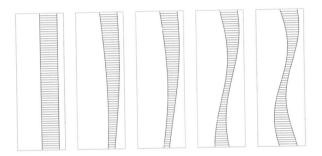

Figure 36-3
Image captures for code 36-03.

Figure 36-4
Image captures for code 36-04.

Figure 36-5
Image captures for code 36-05.

```
    angleA += angleIncrement;
    angleB = angleA + angleOffset;
  }
  endShape();
}
```

Three visual changes are made in the next step. First, a `for` loop is used to draw a series of these waves from left to right. Second, each wave is drawn with a solid gray value that is assigned in a gradient from black on the left to white on the right. Third, the angle values that change to define the waves continue to grow as each wave is drawn, so each wave is different, but related to the others. Notice that the code length of the last sketch and this sketch are nearly identical, but the output is extremely different. The challenges for this program were all overcome in the last example; this new example utilizes the same system, but adds a layer of visual decisions on top of the bones figured out in the previous example.

```
float curveWidth = 10.0;
float curveThickness = 10.0;
float angleOffset = 0.9;

void setup() {
  size(1200, 600);
}

void draw() {
  background(255);

  float angleIncrement = map(mouseY, 0, height, 0.0, 0.2);
  float angleA = 0.0;
  float angleB = angleA + angleOffset;

  for (int mx = 0; mx < width; mx += curveWidth*3) {
    float gray = map(mx, 0, width, 0, 255);
    noStroke();
    fill(gray);
    beginShape(QUAD_STRIP);
    for (int y = 0; y <= height; y += 10) {
      float x1 = mx + (sin(angleA)* curveWidth);
      float x2 = mx + (sin(angleB)* curveWidth);
      vertex(x1, y);
      vertex(x2 + curveThickness, y);
      angleA += angleIncrement;
      angleB = angleA + angleOffset;
    }
```

```
      endShape();
   }
}
```

3D letter

With 3D graphics comes the potential for 3D typography. While letterforms are optimized for legibility in 2D, working with type in 3D in print, film, games, and apps is an open and exciting area to explore. A complete 3D typography system is too complex for these short examples, but the basics of working with individual letters opens the area for further exploration. For these sketches, the letter K is used; the geometry is imported as an SVG file. The vertex points that define the letter are in a layer in the file called "Path" so the getChild() method is used to grab them. (The getChild() method for PShape isn't discussed in this book, but it is demonstrated in the Processing reference.) After the PShape is created, the geometry is extracted point by point with the getVertexX() and getVertexY() methods and drawn to the screen with the vertex() function.

```
PShape k;

void setup() {
  size(600, 600);
  k = loadShape("K.svg");    // Load the file
  k = k.getChild("Path");    // Get the path data
}

void draw() {
  background(204);
  strokeWeight(2);
  noFill();
  translate(width/2, height/2);
  scale(1.5);
  beginShape();
  for (int i = 0; i < k.getVertexCount(); i++) {
    int offset = 200;
    float x = k.getVertexX(i)-offset;
    float y = k.getVertexY(i)-offset;
    vertex(x, y);
  }
  endShape();
}
```

Once the sketch is loading and separating the vertices of the letter, it's time to build the 3D geometry from the 2D data. The next sketch outlines the letter and extrudes it along the z-axis while ignoring the original fill. The mouseX variable controls depth of the extrusion to test different values, while the mouseY variable affects the rotation of the letter. A QUAD_STRIP is used to connect the vertex points into a continuous surface.

36-07

```
PShape k;

void setup() {
  size(600, 600, P3D);
  k = loadShape("K.svg");   // Load the file
  k = k.getChild("Path");   // Get the path data
}

void draw() {
  float ry = map(mouseY, 0, height, 0, TWO_PI);
  float d = map(mouseX, 0, width, 2, 100);

  background(0);
  lights();
  translate(width/2, height/2);
  scale(1.5);
  rotateY(ry);

  noStroke();
  beginShape(QUAD_STRIP);
  for (int i = 0; i < k.getVertexCount(); i++) {
    int offset = 200;
    float x = k.getVertexX(i)-offset;
    float y = k.getVertexY(i)-offset;
    vertex(x, y, d);
    vertex(x, y, -d);
  }
  endShape();
}
```

The previous sketch is a good test to make sure the extrusion is working, but making the process more modular will be useful for a larger program. The next sketch features a custom function called extrudeShape() that constructs a new 3D PShape object from an input 2D shape. This function uses the 2D letter as an input and it outputs the modified 3D version to be stored in a new PShape variable. After this process is complete, the new geometry can be drawn with the shape() function.

Figure 36-6
Image captures for code 36-06.

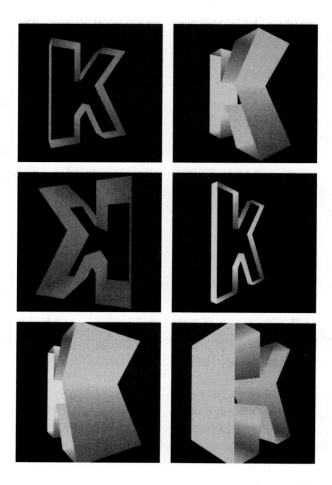

Figure 36-7
Image captures for code 36-07
and 36-08.

```
PShape k;      // The letter K
PShape k3D;    // Extruded letter K

void setup() {
  size(600, 600, P3D);
  k = loadShape("K.svg");    // Load the file
  k = k.getChild("Path");    // Get the path data
  k3D = extrudeShape(k);     // Construct 3D letter
}

void draw() {
  float ry = map(mouseX, 0, width, 0, TWO_PI);
  background(0);
  lights();
  translate(width/2, height/2);
  scale(1.5);
  rotateY(ry);
  shape(k3D, 0, 0);
}

PShape extrudeShape(PShape in) {
  PShape out = createShape();
  out.beginShape(QUAD_STRIP);
  out.noStroke();
  for (int i = 0; i < in.getVertexCount(); i++) {
    int offset = 200;
    float x = in.getVertexX(i)-offset;
    float y = in.getVertexY(i)-offset;
    out.vertex(x, y, 25);
    out.vertex(x, y, -25);
  }
  out.endShape(CLOSE);
  return out;
}
```

Noise landscape

The next set of examples utilizes the Perlin noise algorithm (p. 300), and we tip our hats to the 1979 *Unknown Pleasures* album design by Peter Saville to create a flowing landscape. A grayscale noise field similar to code 21-16 is the foundation, but these new sketches slowly increment the noise values to create a smooth motion. The first sketch demonstrates the 60 × 60 pixel noise texture that will be used to create the landscape.

```
float xnoise = 0.0;
float ynoise = 0.0;
float inc = 0.05;

background(0);
translate(20, 20);
for (int y = 0; y < 60; y++) {
  for (int x = 0; x < 60; x++) {
    float n = noise(xnoise, ynoise) * 255.0;
    stroke(n);
    point(x, y);
    xnoise = xnoise + inc;
  }
  xnoise = 0.0;
  ynoise = ynoise + inc;
}
```

The next iteration of this sketch does two important things. First, is brings the noise calculations into draw() so they can run continuously to create motion. The yOffset variable changes each time through draw() to shift the noise texture up the screen. Second, the small texture is expanded to fill a larger screen. Each point in the original sketch is drawn as a 10 × 10 pixel rectangle as defined in the gridSize variable.

```
float xnoise = 0.0;
float ynoise = 0.0;
float inc = 0.05;
float yOffset = 0.0;
int gridSize = 10;

void setup() {
  size(600, 600);
}

void draw() {
  background(0);

  xnoise = 0.0;
  ynoise = yOffset;

  for (int y = 0; y < 60; y++) {
    for (int x = 0; x < 60; x++) {
      float n = noise(xnoise, ynoise) * 255.0;
      fill(n);
      rect(x*gridSize, y*gridSize, gridSize, gridSize);
```

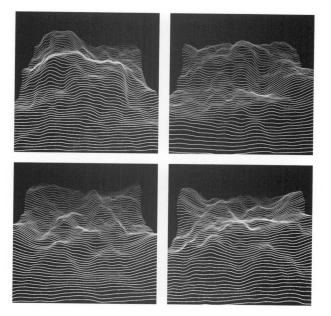

Figure 36-8
Image captures for code 36-10.

Figure 36-9
Image captures for code 36-11.

```
      xnoise = xnoise + inc;
    }
    xnoise = 0.0;
    ynoise = ynoise + inc;
  }

  yOffset += inc/6.0;
}
```

The final iteration presented here uses the values of each point in the noise texture to set the z-axis position of a series of lines. The renderer is changed to P3D to allow the sketch to draw in 3D. One horizontal line is drawn for each row of points in the texture. From back to front, each line has an alpha value applied so the lines fade from entirely opaque to transparent. This augments the perspective and illusion of depth started by the rotateX() and translate() functions.

```
float xnoise = 0.0;
float ynoise = 0.0;
float inc = 0.05;
float yOffset = 0.0;
int gridSize = 10;

void setup() {
  size(600, 600, P3D);
}

void draw() {
  background(0);

  xnoise = 0.0;
  ynoise = yOffset;

  translate(0, 120, -300);
  rotateX(0.7);

  for (int y = 0; y < 60; y++) {
    noFill();
    beginShape();
    for (int x = 0; x < 60; x++) {
      float z = noise(xnoise, ynoise) * 255.0;
      float alpha = map(y, 0, 60, 0, 255);
      stroke(255, alpha);
      vertex(x*gridSize, y*gridSize, z);
      xnoise = xnoise + inc;
```

```
      }
   xnoise = 0.0;
   ynoise = ynoise + inc;
   endShape();
  }

  yOffset += inc/6.0;
}
```

36-11
cont.

Network

This final series of examples draws a network of lines between circles that overlap. To do this, the program needs to know the position of each circle and its radius. With this information, the code calculates if the circles are overlapping. If they are, the code draws a line between the center points of each circle. This sketch is written as object-oriented code where each circle is one object created from the custom-written Node class. An array of objects is used to manage the multiple elements. Before starting with the object-oriented version of the code, a preliminary sketch was written to sort out the code to determine the overlap.

In this sketch, there are two circles, each with unique coordinates and a shared radius value. One circle is fixed in the center of the screen, while the other is controlled with the cursor through the x2 and y2 variables. A line is drawn between the centers of the circles when the calculation in the overlap() function returns a boolean value of true.

```
int x1, y1;
int x2, y2;
int radius = 50;

void setup() {
  size(300, 300);
  ellipseMode(RADIUS);
  x1 = width/2;
  y1 = width/2;
}

void draw() {
  x2 = mouseX;
  y2 = mouseY;
  background(204);
  noStroke();
  fill(0, 40);
  ellipse(x1, y1, radius, radius);
```

36-12

Figure 36-10
Image captures for code 36-12.

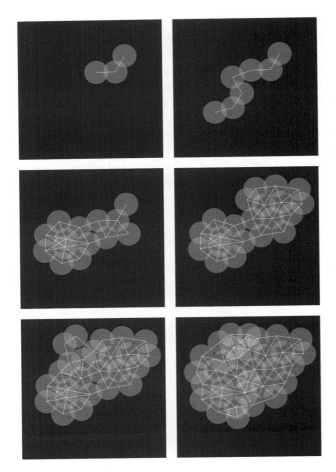

Figure 36-11
Image captures for code 36-13.

```
    ellipse(x2, y2, radius, radius);
    if (overlap() == true) {
      stroke(0);
      line(x1, y1, x2, y2);
    }
  }
}

boolean overlap() {
  float distanceFromCenters = dist(x1, y1, x2, y2);
  float diameter = radius*2;
  if (distanceFromCenters < diameter) {
    return true;
  } else {
    return false;
  }
}
```

In the next iteration of this sketch, the variables that define each circle, the code to draw the circle, and the code to calculate for overlaps are moved into a class called Node. In general, this code is similar to a number of examples in the book, but there is one thing that makes it more interesting—each node knows about all of the other node objects because the array of objects is a part of each object. This gives each node in the array the ability to check its position in relation to all of the other objects. At each frame, every node is compared to every other node to check for overlaps. Look closely at the code inside the displayNetwork() method in the class. Each node compares itself to only the nodes that come after it in the array. This technique avoids checking the same combination twice. For example, if there are three nodes, if the first node checks the second and third node, then the second node need not check itself in relation to the first node, because that comparison already happened, so it only compares itself to the third node. In relation to the last sketch, notice once again how working with objects has made the main part of the program, the setup() and draw(), less cluttered and easier to read, while the variables and functions are combined more clearly in the class.

```
Node[] nodes = new Node[100];
int nodeCount = 0;

void setup() {
  size(600, 600);
  for (int i = 0; i < nodes.length; i++) {
    // Each element stores the same reference to the nodes array
    nodes[i] = new Node(i, nodes);
  }
}
```

```
void draw() {
  background(0);
  for (int i = 0; i < nodeCount; i++) {
    nodes[i].display();
    nodes[i].displayNetwork(nodeCount);
  }
}

void mousePressed() {
  if (nodeCount < nodes.length) {
    nodes[nodeCount].setPosition();
    nodeCount++;
  }
}

class Node {
  int x;   // X-coordinate
  int y;   // Y-coordinate
  int radius = 50;   // Radius
  int id;   // The index within the array
  Node[] otherNodes;   // Reference to the array of Nodes

  Node(int tempId, Node[] tempOthers) {
    id = tempId;
    otherNodes = tempOthers;
  }

  // Define the location
  void setPosition() {
    x = mouseX;
    y = mouseY;
  }

  // Draw to the display window
  void display() {
    ellipseMode(RADIUS);
    noStroke();
    fill(255, 40);
    ellipse(x, y, radius, radius);
  }

  // Draw the lines between overlapping Nodes
  void displayNetwork(int nodeCount) {
    stroke(255);
```

```
    for (int i = id+1; i < nodeCount; i++) {
      if (overlap(otherNodes[i])) {
        line(x, y, otherNodes[i].x, otherNodes[i].y);
      }
    }
  }

  // Calculate if this Node is overlapping with another
  boolean overlap(Node n) {
    float distanceFromCenters = dist(x, y, n.x, n.y);
    float diameter = radius + n.radius;
    if (distanceFromCenters < diameter) {
      return true;
    } else {
      return false;
    }
  }
}
```

37 Interviews: Environment

Mark Hansen (Listening Post)
Jürg Lehni (Hektor and Scriptographer)
Jennifer Steinkamp (Madame Curie)
Ash Nehru (Origin)

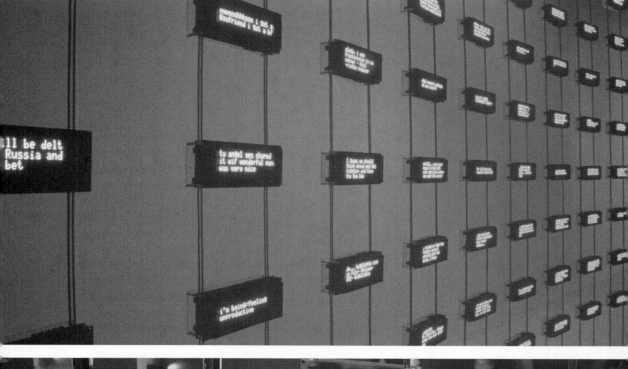

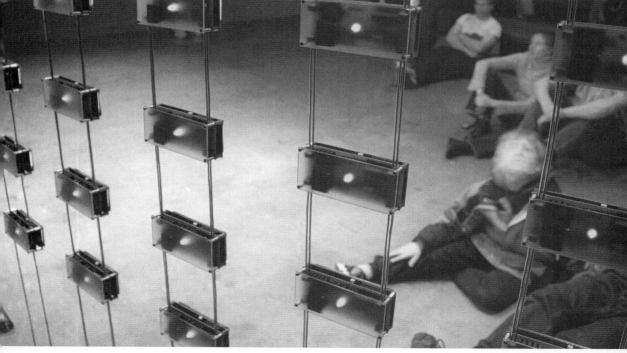

Listening Post *(Interview with Mark Hansen)*

Creators	Mark Hansen and Ben Rubin
Year	2001–2002
Medium	Installation
Software	Perl, C, Max/MSP, C++, sh/tcsh, R
URL	www.earstudio.com/2010/09/29/listening-post/

What is *Listening Post*?

Listening Post is an art installation that culls text fragments in real time from unrestricted Internet chat rooms, bulletin boards, and other public forums. The texts are read (or sung) by a voice synthesizer, and simultaneously displayed across a suspended grid of 231 small electronic screens (11 rows and 21 columns). Listening Post cycles through a series of seven movements (or scenes), each with a different arrangement of visual, aural, and musical elements and each with its own data-processing logic.

Why did you create *Listening Post*?

Ben and I met in November of 1999 at an event sponsored by Lucent Technologies (my former employer) and the Brooklyn Academy of Music. For our first project, we created a "sonification" of the browsing activity across a large, corporate website. Sonification refers to the use of sound to convey information about, or to uncover patterns in, data; it seemed like a reasonable place to start for a sound artist (Ben) and a statistician (me). We spent several weeks creating an algorithm that translated patterns of user requests into music. The mapping was pretty direct, differentiating traffic through major areas within the site (defined by a handful of top-level directories) and the depth to which people wandered (again, measured in terms of the site's directory structure). Unfortunately, it was tough to get anyone to take notice; even the site's content providers were hard-pressed to find a reason to listen. After a month or so we decided that perhaps navigation statistics (a by-product of the actions people take on the web) were less interesting than the substance of their online transactions, the content being exchanged. We also agreed that the act of web browsing wasn't very "expressive" in the sense that our only glimpse of the users came from patterns of clicks, lengths of visits, and the circle of pages they requested. These considerations led us to online forums like chat and bulletin boards. (Of course, this was early 2000; had we started our collaboration today, blogs or YouTube might have been more natural next steps.)

In retrospect, it was pretty easy to create a data stream from these forums, sampling posts from various places around the web. Doing something with it, representing it in some way, responding to its natural rhythms or cycles, proved to be much harder. Text as a kind of data is difficult to describe (or model) mathematically. To make matters worse, online forums are notoriously bad in terms of spelling and grammar and many of the other bread-and-butter assumptions underlying techniques for statistical natural language processing. However, I think our interest in online forums went beyond summarizing or distilling their content (reducing the stream to a ticker of popular words or topics). Instead, we wanted to capture the moments of human connection; and in most cases these refused to be mathematized. Early in our process,

we decided to let the data speak for itself in some sense, creating scenes that organized (or, formally, clustered) and subset the content in simple, legible ways.

Building on our experience with the web sonification project, our first experiments with chat were sound pieces: A text-to-speech (TTS) engine gave the data a voice (or voices, as there might be up to four speaking at one time), and we created different data-driven compositional strategies to produce a supporting score. As we listened, however, we found ourselves constantly referring to a text display I hacked together to monitor the data collection. While we were led to this simple visual device to help make up for deficiencies in the TTS program ("Did someone really type that?"), it soon became an important creative component. This visual element evolved from a projection with four lines of text (at a live performance at the Kitchen in 2000), to a 10 by 11 suspended flat grid of VFDs, vacuum fluorescent displays (the first installation of Listening Post at the Brooklyn Academy of Music in 2001), and finally to the arched grid of 231 VFDs (first exhibited in 2002 at the Whitney Museum of American Art). Listening Post's visual expansion was accompanied by the introduction of a new TTS engine that let us literally fill the room with voices (as many as a hundred at one time).

What software tools were used?

The behavior of each individual VFD is ultimately directed by an onboard microcontroller running a custom C program written primarily by Will Pickering at Parallel Development. The screens are then divided into 7 groups of 33 (each an 11 by 3 subset of the entire grid) and are fed messages by 7 servers that listen for commands to display text along columns or on particular screens. The basic screen server is written in Perl. One layer up, the arched VFD grid is choreographed via a series of scene programs, again written in Perl.

The audio portion of Listening Post involves dynamic musical composition orchestrated by Max/MSP; messages are sent to Max from the scene programs via the Open Sound Control (OSC) protocol. It's worth noting that the programming interfaces for the audio and visual portions of Listening Post are very different; while Max is a visual programming environment, meaning that Ben directs output from one sound component to another by making connections in a "patch," I hack about in an Emacs window combining subroutines from a main scene module. The last major piece of software directly involved in the presentation of Listening Post is the TTS engine. Like Max, the TTS engine receives messages from the scene programs; unlike with Max, however, we had to write a custom C++ wrapper to handle the network communication. Aside from Max and the TTS engine, there are also other, perhaps less obvious, software components hidden in the system. The installation itself involves eight speakers and, during each scene, the voices and other musical elements move around the room. While Max handles much of this motion, a Yamaha Digital Mixing Engine (DME) is also used, which in turn requires a separate program for each of the scenes.

Finally, we made use of a slightly different set of software tools during scene development. At a practical level, each new scene consists of a Perl program orchestrating the visual elements and controlling the overall scene structure and a Max patch/DME program pair creating the scene-specific audio. (At this point, we treat the VFD grid and the TTS engine as fixed-output devices whose programming does not change with scene; they respond to a predetermined set of commands.) The design of each scene emerged through an iterative process that cycled between making observations about the data and an evolving set of basic compositional scene elements. To make sense of our stream of text data, we relied on Perl for text parsing and feature

extraction, some flavor of UNIX shell for process control, and the R programming environment for data analysis, modeling, and statistical graphics.

Why did you write your own software tools?

Given that the display "device" (the combined audio and visual components of the installation) was entirely new, we had little choice but to write our own software to control it.

For the most part, the software side of Listening Post is constructed from what could be best described as "scripting languages." While it's a bit hard to pin down a precise definition for this term, it is often the case that such languages let you build up projects (programs or scripts) quickly in a fluid, interactive process that is distinct from programming in a "systems language" like C. For example, Perl is, by design, great for manipulating text (taking inspiration from previous UNIX shell facilities like awk); and over the years programmers and developers have created a stunning number of extensions to the language, including extensive tools for network programming. By working with Perl, I can output data to the VFD grid and quickly experiment with different scene dynamics, many of which involve parsing and computing with text. Using OSC, this same Perl program can also coordinate audio by sending messages to a Max/MSP process and to the TTS engine. Authoring scenes for Listening Post is an exercise in interprocess communication.

Since 2000, the language Python has emerged as a strong competitor to Perl in this kind of application; Python even runs on many Nokia phones! If our development were taking place today, we would have to think seriously about programming in Python instead of Perl. The lesson here is that programming tools, and information technologies in general, are constantly in flux. If you choose software as a medium, your practice has to keep up with these changes. You need to be able to "read" a new language, assess its strengths and weaknesses, and determine which computations are "natural" (those that its designers have made easy to perform) and (if possible) why.

Why do you choose to work with software?

Software, or perhaps more generically computing, is the way I have come to know data.

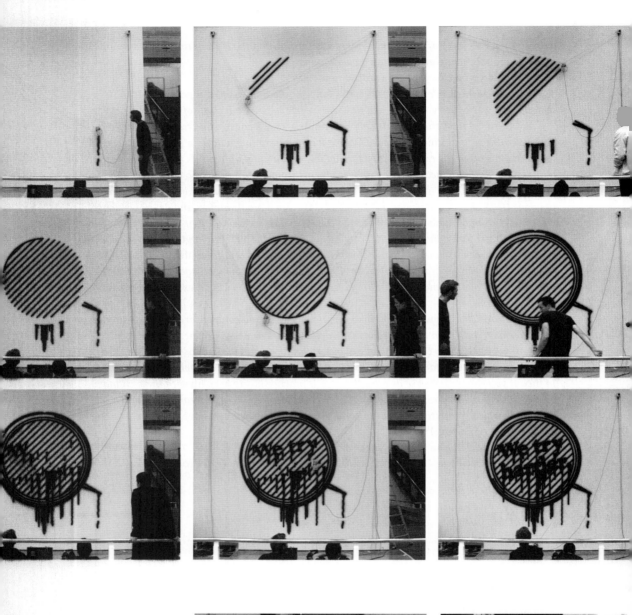

Hektor in its case (left) and undergoing testing (right).
Images courtesy of Jürg Lehni and Uli Franke.

Hektor and Scriptographer (Interview with Jürg Lehni)

We Try Harder, 2002. Cornel Windlin and Hektor for the *Public Affairs* exhibition at the Kunsthaus Zurich, Switzerland. Images courtesy of Jürg Lehni and Uli Franke.

Creators	Jürg Lehni and Uli Franke
Year	2001–2002
Medium	Custom Hardware, Plugin Software for Illustrator
Software	Scriptographer (C++, Java, JavaScript), PIC-Assembler
URL	http://juerglehni.com, www.scriptographer.com

What are *Hektor* and *Scriptographer*?

Hektor is a portable spray-paint output device for laptop computers. It was created in close collaboration with the engineer Uli Franke for my diploma project at écal (École Cantonale d'Art de Lausanne) in 2002. Hektor's light and fragile installation consists only of two motors, toothed belts, and a can holder that handles regular spray cans. The can is moved along drawing paths, and during operation the mechanism sometimes trembles and wobbles and the paint often drips. The contrasts between these low-tech aspects and the high-tech touch of the construction hold ambiguous and poetic qualities and make Hektor enjoyable to watch in action. Hektor has been used for many projects in different contexts, often in collaboration with other designers and artists.

Hektor works with vector drawings and is controlled directly from Adobe Illustrator through the use of Scriptographer, a scripting plug-in for Illustrator that is developed as open source software and is available under the GPL license. It is written in C++ and Java and exposes Illustrator's functionality to a Java virtual machine that is embedded in the application itself. It uses the Rhino JavaScript engine to execute scripts. This allows users with some knowledge of the JavaScript language to extend the functionality of Illustrator with their own definition of tools: mouse handlers, generative scripts, automated repeating tasks, and so on. More advanced tools can also be written directly in Java, and Rhino's Java bridge can be used to interface with any Java library and the Java Core API directly from scripts. This leads to a great number of possibilities, from serial port or network communication to database connections and advanced image manipulation, just to name a few.

Why did you create *Hektor* and *Scriptographer*?

Hektor was created with a certain attitude toward design and the use of tools. In the beginning there was an urge to go beyond the limitations of today's clean computer, screen, and vector graphic–based design. Intuition played an important role in the search for a new output device that would convey the abstract geometries contained in vector graphics in a different way than normal printers.

The aim was to make a statement about design by providing a new tool for other designers and artists to experiment with, a tool with an inherently particular and distinctive aesthetic. Making the technology available to others and not only using it for my own purposes was an important step in the project. It was very interesting to see what people from different backgrounds were seeing in this machine and how they were working with the technical limitations and using them in the results rather than trying to hide them.

Today's desktop publishing design chain with all its standards and softwares has a strong influence on the aesthetics of the products. The tools offer predefined ways of working, and

escaping these is not easy; it requires the user to be conscious of the limitations. Current software is mostly based on commonly known metaphors and simulation of real tools, but software is inherently different. It is modular and programmable and offers much more flexibility. Unfortunately the applications from most of the big companies still work the other way around—they are often predefined, inflexible, and monolithic.

The motivation for creating Scriptographer and making it freely available was to provide a way to open up one of the main applications for graphic designers and to create a community around it that finds different approaches to graphic design by integrating programming in the workflow and the tools they already use.

What software tools were used?

The circuit board for Hektor was designed with Eagle. The controller software was written in PIC Assembler. Scriptographer was used to develop the algorithm for Hektor's damping movements to make sure the can does not start to tremble too much. A geometrical solution was found that adds tangential circles and tangents between them at places where too harsh movements would happen in the vector drawings.

Scriptographer also directly controls the stepper motors through the serial port interface and the PIC controller, to which it sends the movements for the drawings. In order for it to do so, the geometries must be converted from a Cartesian coordinate system into one based on triangulation.

Why did you write your own software tools?

As already stated, there were certain ideological motivations for creating Hektor and Scriptographer. But both projects are tools that are actually used, and both the ideological and the pragmatic parts of the projects are equally important. A year later I would have probably used Processing for the same task, but when work on Scriptographer started I was not aware of it, and the fact that Scriptographer nests itself in an existing application that plays an important role in graphic design helped underline the motivations of both projects.

Why do you choose to work with software?

Computers fascinated me at an early age, when I started to tinker around with the Commodore VC-20 and later with my brother's Commodore 64. This fascination was mostly based on the optical and audible outputs of these machines and has never really left me since. Over the years this led to learning many languages and concepts around computers. Programming is still my main tool of choice, which I constantly try to exploit and question in my work. I consider the ability to write programs (or better, formulate processes) as a freedom in the way computers are used, and I hope that it will become more and more common to work in such ways. Computers are the abstraction of tools that can simulate virtually any other tool. I believe that beyond the step of simulation there are many other possibilities to be discovered.

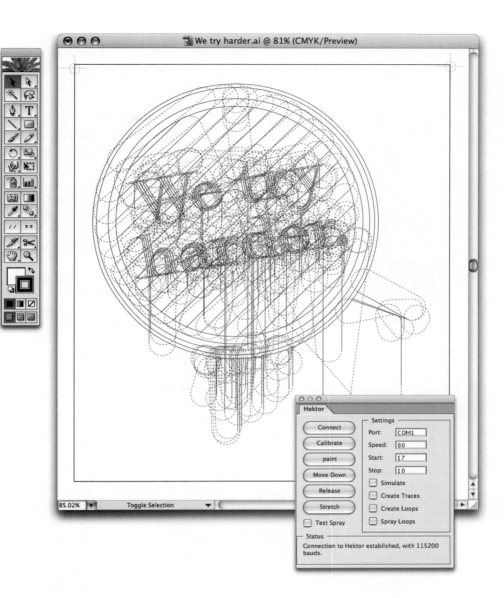

The *Scriptographer* plug-in for Adobe Illustrator by Jürg Lehni, running the Hektor
software that computes motion paths and directly communicates with the hardware.
Image courtesy of Jürg Lehni.

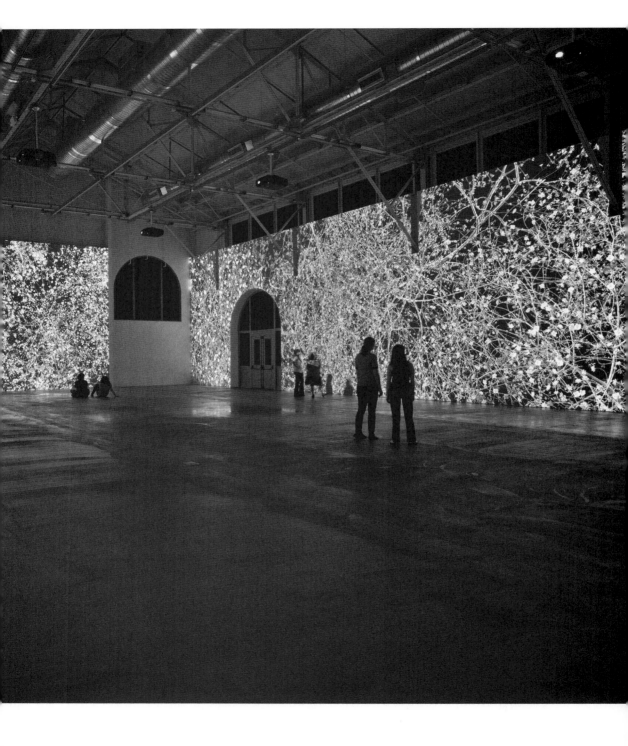

Madame Curie *(Interview with Jennifer Steinkamp)*

Creator	Jennifer Steinkamp
Year	2011
Medium	Site-specific software animation
Software	Autodesk Maya, Adobe After Effects, Apple QuickTime, Macromedia Director
URL	www.jsteinkamp.com

What is *Madame Curie*?

I was commissioned to create a site-specific video animation work to respond to the interior architecture of the Museum of Contemporary Art, San Diego. The building was formerly used as a baggage building for the Santa Fe Railway; it was built in 1915. Madame Curie is the title of the seven-channel, synchronized panoramic projection. The installation is made as a dedication to the extraordinary physicist Marie Skłodowska-Curie. She was born in Poland in 1867. The art consists of seven Christie 15,000 lumen projectors, eight AOpen computers, and a special octopus serial cable I created. The images from the projectors are frame blended together to create three large surfaces: 83.5 × 21.9 feet (25.5 × 6.7 meters), 83.5 × 18.6 feet (25.5 × 5.7 meters), 22.6 × 22.2 feet (6.9 × 6.8 meters). The images are synchronized by data sent to each machine's serial port from a computer used as a clock.

Why did you create *Madame Curie*?

This installation is inspired by my research into atomic energy, atomic explosions, and the effects of these forces on nature. The San Onofre nuclear plant is located halfway between San Diego and Los Angeles off the 405 freeway dangerously close to the ocean. Every time I traveled to the museum in San Diego, I nervously drove past the two nuclear spheres in fear for the world. During my research into radiation for the project I was reconnected to Marie Curie who was the joint recipient of two Nobel Prizes for creating the theory of radioactivity and discovering the elements radium and polonium. Madame Curie was an amazing scientist and force; she excelled beyond the sexism of her time. I chose to repurpose my fears of nuclear disaster and change them into a positive. It turns out Marie Curie was an avid lover of plants. When she was a student at the Paris Sorbonne University, she would purchase cut flowers before food. There are more than forty plants mentioned throughout Marie Curie's biography written by her second daughter, Ève Curie. Her first daughter Irène Joliot-Curie, following in her mother's footsteps, also won a Nobel Prize, becoming the second woman in history to receive the honor.

The animation in Madame Curie consists of flowers which grow as bushes or trees mentioned in the biography traveling left to right and right to left across the huge expanse of the 83.5 foot wall. Rambler Roses seem to be the star. Marie Curie planted rambler roses at the Radium Institute in France where she was the director. There are also daisies, apple blossoms, chestnut blooms, cypress, eucalyptus, and wisteria, to name a few.

The Tōhoku earthquake and tsunami and the level 7 meltdowns at three reactors in the Fukushima Daiichi Nuclear Power Plant occurred soon after installing this piece, March 11 2011.

This was the second largest nuclear disaster in history; Chernobyl in 1986 was the largest. I wonder if I would of made an entirely different piece if the earthquake happened before I finished?

What software tools were used?

I used Autodesk Maya Paint Effects to create and animate the flora. Adobe Photoshop was used to make paintings of the leaves, flowers, and bark used as texture maps. Adobe After Effects was used to composite the animation loops and render out to Apple QuickTime, HDMI 1024 × 768 movies. Macromedia Director was used to loop the QuickTime movies and synchronize the computers. I also used Director to make a vector drawing program to mask out the architecture. (I use the old non-Adobe version of Director.)

Why did you use these tools?

I use Maya and Photoshop because they are very deep, capable programs. There is a lot of unexplored territory there; one could spend years exploring a multitude of artistic ideas. Director is a pretty fast, handy method to control QuickTime movies. I can use Director to make a stand-alone program to run on a PC and automatically start when the PC powers on. This is good for the collectors, gallery, and museum people who know little about computers.

Why do you choose to work with software?

I have been using software since 1982. I first came across computer animation when I enrolled in Gene Youngblood's video art course at Caltech, where I saw some of the first computer generated artwork. Youngblood is well known for his book Expanded Cinema, which discusses some of the first computer generated art and structuralist cinema. I saw computer graphics as a means to explore new ideas, images and motion; I still possess this excitement. I use 3D software to create virtual objects and space; I then place these into real space. Both the real and the virtual spaces are transformed by each other; forming an in-between space, a space your body can understand.

Preparatory installation diagram of *Madame Curie*. Image courtesy Jennifer Steinkamp.

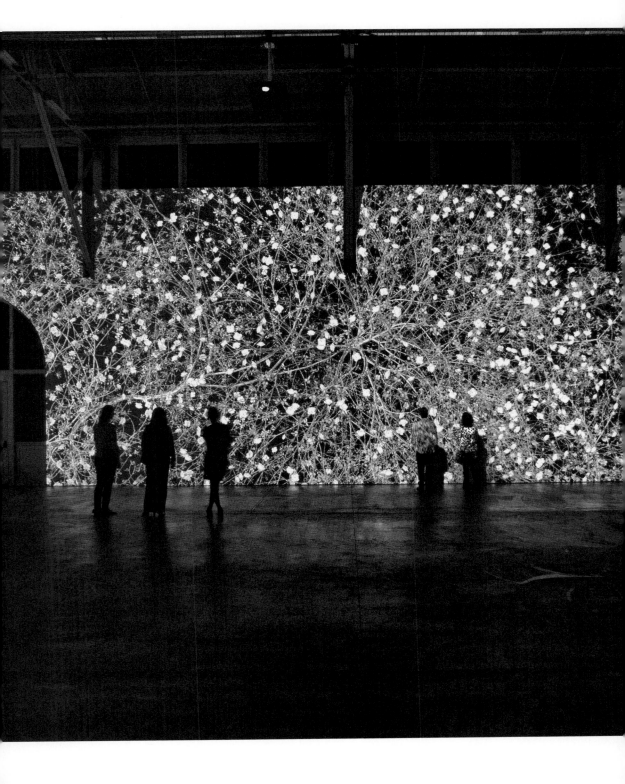

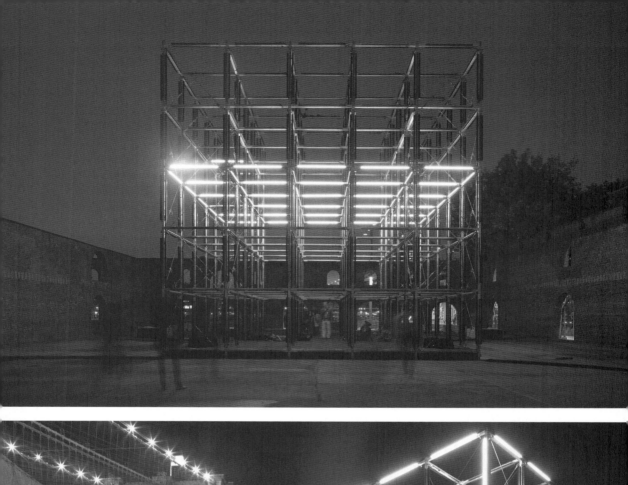
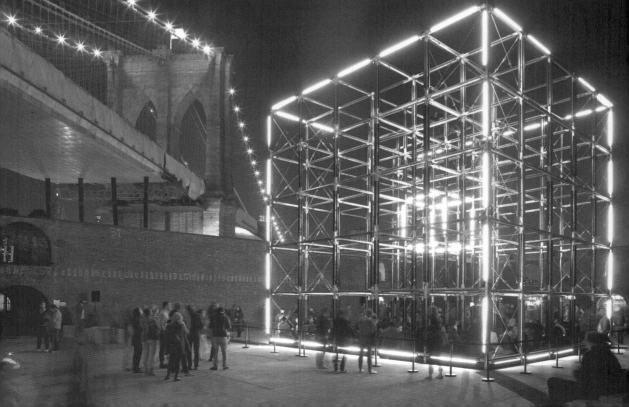

Origin *(Interview with Ash Nehru)*

Creator	UnitedVisualArtists
Year	2011
Medium	Large-scale LED sculpture
Software	d3, Max/Msp
URL	www.uva.co.uk

What is *Origin*?

Physically, Origin *is an aluminum cubic lattice 10 meters across, with a unit-cube size of 2 meters. Each strut is clad with either two or four LED strips, each with 118 addressable RGB pixels. Sound is delivered by a four-channel 2K audio rig. We worked with the audio composer Scanner to create an interlinked system of audiovisual pulses—waves of activation that pass through the grid trigger light and sound. In action,* Origin *feels like an electrical power station that has gone out of control, swinging from seductive to aggressive seemingly on a whim, charging up to a chaotic frenzy and then calming down again.* Origin *arose from our ongoing interest in the idea of creating a "living machine"—specifically exploring ways in which simple algorithms can create the illusion of mind and presence without relying on anthropomorphism.* Origin *can also be read as a wry comment on our tendency to fixate on idols (whether human, religious, or technological), and project upon them qualities from our inner life.*

Why did you create *Origin*?

UVA's roots are in creating live performances on stages, in which the audience is physically separate from the installation and passively receives the performance. Origin's *lineage can be traced back to the experimental work* Monolith *we created in 2004.* Monolith *was a simple rectangular LED slab placed at the center of the John Madejski Garden at the Victoria and Albert Museum. As the viewer approached, it would emit colors and sounds that were either soothing and welcoming, or (if you got too close) harsh and repellent. Despite its simplicity,* Monolith *created a powerful sensation of a being that wanted company, but jealously guarded its own personal space.*

While Monolith *was a flawed experiment in many ways, it had a very strong effect on its audience, which was something that we wanted to build upon. It led directly to a series of works exploring the different ways to erase the line between stage and audience, to allow people to come up close to the technology and become active participants in the experience.* Tryptich *(2005) created a more performative environment, encouraging extroversion and exhibitionism;* Volume *(2006) foregrounded social collaboration, exploration, and musical composition;* Array *(2007) posited the whimsy of a virtual entity, shy and curious in equal measure, inhabiting a grid of light that you could walk through. The idea of the "living machine" was one that emerged slowly from these experiments. Coming from the arena of live performance, we had always been interested in working at large scales. When we were approached by The Creators Project with a new commission, we were given a chance to create something really big—something that by its sheer size carries an implicit command to worship, to kneel, to submit.*

What software tools were used?

We used d3, a software toolkit that we develop in-house for the visual component and Max/MSP for the audio. d3 can be thought of as a framework for generative rendering applications with a sculptural component. It's based around a real-time 3D stage simulator that allows the designer to work at all times with an accurate 3D representation of the final work. It also takes care of the details of ensuring that the correct signals end up at the correct fixtures, freeing the designer from mundane concerns of wiring and signal formatting. Within d3, we create works by writing generative rendering modules—loosely equivalent to Processing apps—which can then be sequenced, organized, and composited together to create the final experience.

Why did you use these tools?

We use the best tool for the job. We'll often use Processing for sketches because it lets you try things out quickly, and we've used openFrameworks in the past for installations as well. d3 tends to get chosen for our live shows and responsive sculptural installations because it provides a tried-and-tested mix of workflows and capabilities that we've found we need on every project. But we'll only use it when it's appropriate. The choice of Max/MSP, in the same way, isn't binding—audio programming isn't a core competency at UVA, so we tend to commission new audio systems on a case-by-case basis. We've also used SuperCollider in the past, and we've rolled our own audio engines within d3.

Why do you choose to work with software?

Tools constrain what can be practically achieved with a finite set of time and resources; so having control of those tools is the only way to liberate oneself from those constraints. But tools do more than just enable or limit capacity—they actively suggest new ideas and directions. Their affordances and blind spots directly affect the essential nature and spirit of the works created with them. This may be a prejudice of mine, but I do feel that if you're using the same tools as everybody else, it's harder to be distinctive, at least in this medium. Personally, I work with software because it's what I do. If I didn't have a computer, I'd scratch programs into clay tablets with a stick. It's not really a choice, in other words, and hasn't been since I was ten years old.

Installation views of *Origin*. Images courtesy UnitedVisualArtists.

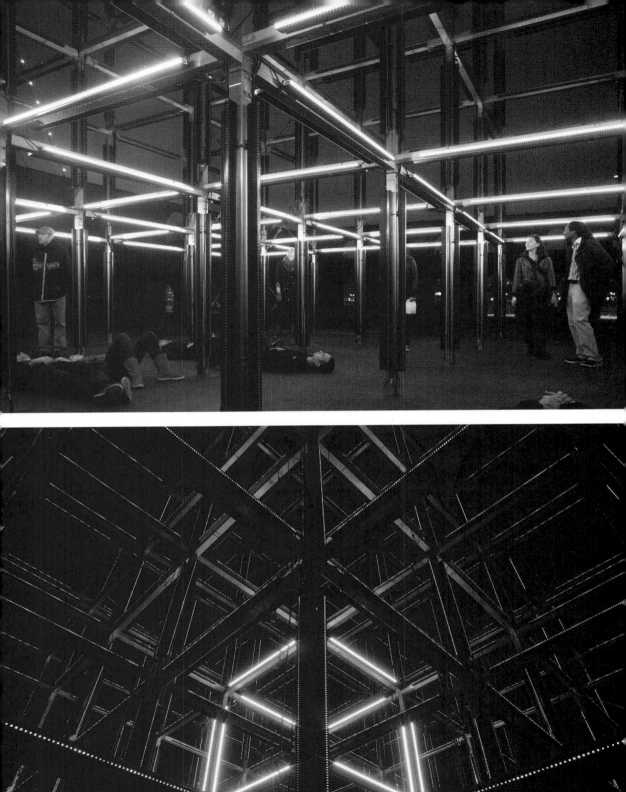

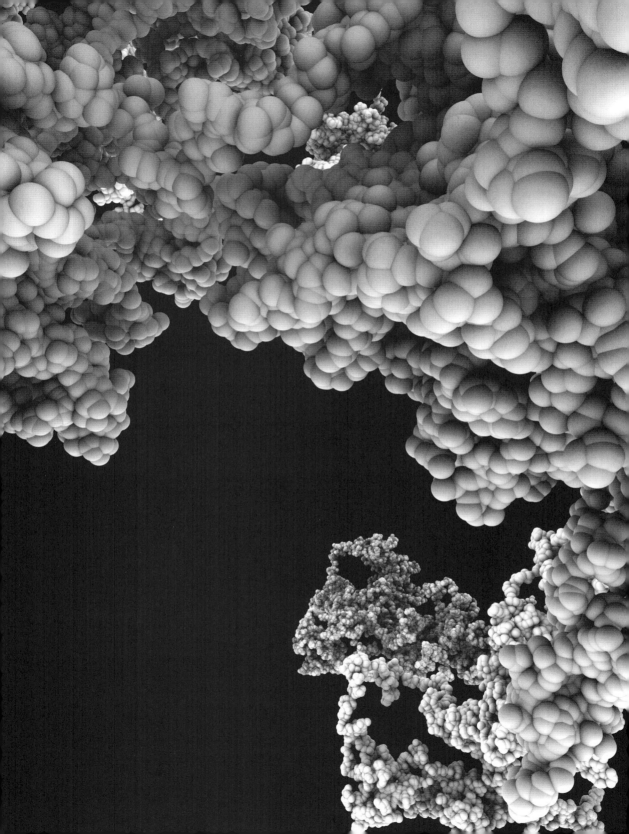

38 Continuing...

It often takes a few years to become comfortable expressing ideas through software. The core concepts are not difficult, but they represent a different way of thinking unfamiliar to most people. This book introduces elements of software within the context of the arts, with the aim of bringing ideas from computer programming within reach of a new audience. People have different aptitudes for learning computer programming, and the context in which it is introduced affects how well individuals learn it. The way into computer programming introduced in this book has proved effective for many people, but others interested in programming prefer a different path. The core software principles introduced in this text are applicable to many different programming languages and contexts.

This book is not about a specific programming language. It strives to make clear the abstract concepts behind programing, but to do this, it is necessary to use examples from a language. The Processing Language and environment was chosen for this book because it was developed expressly for the purpose of teaching fundamentals of programming to the audience of designers and artists, and does so in a way that fosters their future exploration of diverse programming contexts. The reader can explore programming further using Processing, and there are many other programming languages and environments to try. A programming language is usually designed for a specific context, and depending on the nature of a project, some languages will be more appropriate than others.

If this book has piqued your interest in programming, it is probably not the only book you'll want or need on the topic. While this book has discussed many of the ideas that are essential to writing software, it presents the first steps. Everyone must decide how far she or he will proceed in learning more about the technical aspects of writing software. Some people will find the material covered in this book sufficient to realize their goals, and others will want to go further. One of the aims of this book is to enable the reader to benefit from more advanced and complete programming texts. There are many excellent books about programming, but the overwhelming majority of them assume some prior programming knowledge. This text covers the basics so as to make those more advanced texts accessible.

Extend Processing

The programming elements introduced and discussed in this book comprise a subset of the entire Processing language. The complete reference offers more areas to explore; you can access it by selecting the "Reference" option from the Help menu or by visiting *www.processing.org/reference*. The reference includes functions for more advanced drawing techniques and data manipulation. The additional functions are demonstrated

Karsten Schmidt. *Sunflow*, 2007. Image courtesy of the artist.

with examples in the reference and in the examples included with the Processing software.

By design, the Processing language has a narrow focus. It was built for creating images, motion, and responses to common input devices like the mouse and keyboard. Also by design, Processing can be extended beyond these areas. Processing libraries extend Processing to sound generation, networking, video input, and many other topics of media programming. Libraries are classified into two groups: core libraries and contributed libraries. The core libraries, including Sound, Network, Serial, PDF Export, and DXF Export, are distributed with the software and documented on the Processing website. Contributed libraries are created and documented by members of the Processing community. The contributed libraries range from physics simulations to computer vision to tools for facilitating data transfer. Newly contributed libraries are continually added, and it is hard to predict what will be developed in the future. A list of libraries is included with your software and is online at *www.processing.org/ reference/libraries*. New libraries can be added to Processing with the Library Manager. Select "Import Library..." from the Sketch menu, then select "Add Library..." to access the manager.

A reference, or link, to a library must be added to a program before the library can be used. This link is one line of code that points to the location of the library's code. The line can be added by selecting the "Import Library..." option from the Sketch menu, or it can be typed. For example, to use the PDF library, add this line to a program:

```
import processing.pdf.*;
```

This code tells the program to import all of the classes in the *processing.pdf* package. The asterisk (*) symbol is not used as the multiplication operator; it specifies that all the classes in the package should be imported. The Processing libraries have been and will continue to be an exciting area of growth for Processing. Rather than continual incorporation of new features within Processing, libraries will remain the primary way to extend the software.

Much as a library is used to extend the Processing language, tools are used to extend the Processing Development Environment. Standard tools include a color selector and a way to make movies from individual files, but other developers have contributed tools that support features to help manage tabs and to provide an outline view of a sketch. Information about creating a contributed library and tool can be found on the Processing wiki: *https://github.com/processing/processing/wiki*.

The Processing Development Environment is intentionally minimal so that it is easy to use, but advanced users will find that it lacks some of the features included in many professional programming environments. Processing was designed for software sketches that consist of one to a dozen source files plus, maybe a library or two, and that draw to a display component. A larger project may become cumbersome to develop within the Processing Development Environment and can be loaded instead into a different programming environment with more features. Eclipse (*www.eclipse.org*) is an open source development environment that integrates well with Processing.

Instructions on porting Processing projects to Eclipse can be found on the Processing website. Most Java development environments should work, and the gaps between Processing and Java application development are reduced as members of the community contribute documentation and examples.

We encourage you to actively participate in Processing. The software's success depends on the participation of community members. If you write a library for Processing, please consider sharing your code, in keeping with the way that Processing and its code are shared. If you write programs for your own enjoyment, as a part of your studies, or for professional practice, please upload them to the web and share your discoveries. The community thrives when people share what they've learned and help answer questions for others.

Processing and Java

The Processing application is written in Java, a programming language introduced by Sun Microsystems in 1995. The language was originally designed for set-top boxes and was later adapted for the web and named Java. In the years since, the focus of Java development broadened to include server-side applications, stand-alone desktop applications, and applications for smaller devices such as mobile phones and tablets.

When a Processing sketch is run, it is translated into Java and then run as a Java program. This relationship enables Processing programs to be run as applications for Linux, Macintosh, and Windows operating systems. It also allows Processing to make use of the extensive existing software components for Java.

Processing has a simplified programming style that allows users to program initially without understanding more advanced concepts like object-oriented programming, double-buffering, and threading, while still making those tools accessible for advanced users. These technical details must be specifically programmed in Java, but they are integrated into Processing, making its programs shorter and easier to read. While Processing makes it possible to omit some elements of the Java language, it's also fine to leave them in.

Other programming languages

If this book is your first introduction to computer programming, you're probably not aware of the many different language environments available for writing software. It's very common for a person to know how to program in a few different languages; new language skills are often acquired while knowledge of previously learned languages fades. Ben and Casey, for example, have written programs in languages including ActionScript, AutoLISP, BASIC, C, C++, DBN, Fortran, HyperTalk, JavaScript, Lingo, Logo, MATLAB, Pascal, PHP, Perl, Postscript, Python, R, and Scheme. This list may sound exotic and impressive, but it's not. After years of programming, one finds that different projects with different needs require diverse languages. In fact, many projects require

a few languages to get the job done. For example, Ben's projects often use Perl to first manipulate text data, and then use Processing to display this data to the screen. There is no "best" language for programming, any more than a pencil is better than a pen or a brush; rather, it's important to use the tools that best suit the task. If you continue programming, you'll certainly learn a few different programming languages. Fortunately, after you have learned one language, learning others comes more easily.

Scores of programming languages have been invented since people first started to program digital computers in the 1940s. In the 1950s, scientists and engineers created the first computer-generated images. These individuals were the only people with access to the scarce, expensive, and complex technology needed to make this work. Even in 1969, Jasia Reichardt, then a curator at the Institute of Contemporary Arts in London, wrote, "So far only three artists that I know have actually produced computer graphics, the rest to date having been made by scientists."[1] The works created during this time were typically made as collaborations between engineers at research labs and invited artists. The number of artists writing their own software has increased significantly in the last forty years, especially since the introduction of the personal computer. Another increase in software literacy was started by the rapid adoption of the Internet in the mid-1990s.

Many programming languages have been appropriated by artists and designers to serve their own needs, and specialized languages have been written to fulfill the unique desires of this audience. The programming elements introduced in this book are relevant to many popular programming languages. The basic concepts of variables, arrays, objects, and control structures are shared with most other languages, but the C, C++, JavaScript, PHP, and Perl languages in particular share many specific syntax elements with Processing. The Java language was heavily influenced by C, and because C++, PHP, and Perl were all designed with references to C, they share similarities with Java and therefore with Processing.

This book and the Processing website contain information about additional programming languages. Appendix F (p. 619) introduces features of different programming languages and includes a brief description of selected languages commonly used within the arts.

Note

1. Jasia Reichardt. "Computer Art," in *Cybernetic Serendipity*, edited by Jasia Reichardt (Praeger, 1969), p. 71.

Appendix A

Order of Operations

An operator is a symbol that performs an operation. There are operators for arithmetic, relational, logical, and bitwise operations. The order of operations determines which operations are performed before others. For example, in the following expression, is the addition or multiplication calculated first?

```
2 + 3 * 4
```

You may remember the mnemonic "My Dear Aunt Sally" (MDAS) from math class. MDAS, short for Multiply, Divide, Add, Subtract, states the order in which mathematical operations in an expression should be performed. Regardless of the order from left to right, the multiplication should happen first (3 * 4), and the result should then be added (2 + 12). If this order is not followed, the expression will not evaluate to the correct result.

The order of operations goes beyond arithmetic and applies to all of the operators within a programming language. The list of operators presented here reveals the order in which they are evaluated within Processing. The operators higher in this list are evaluated before those on lower lines. This is not a complete list of the operators available in Processing, but it contains those used within this book's examples.

Name	Symbol	Examples
Parentheses	()	a*(b+c)
Postfix, Unary	++ - !	a++ --b !c
Multiplicative	* / %	a * b
Additive	+ -	a + b
Relational	< > <= >=	if (a < b)
Equality	== !=	if (a == b)
Logical AND	&&	if (mousePressed && (a > b))
Logical OR	\|\|	if (mousePressed \|\| (a > b))
Assignment	= += -= *= /= %=	a = 44

The following examples clarify how the order of operations works:

```
// The expression 4 + 5 evaluates to 9, then the
// value 9 is assigned to the variable x
int x = 4 + 5;
```
A-01

```
// The expression 5 * 10 evaluates to 50, then the
// expression 4 + 50 evaluates to 54, then the
// value 54 is then assigned to the variable x
int x = 4 + 5 * 10;
```
A-02

In the previous example, even though * is the last operator on the line, it is evaluated first because the multiplicative operators have precedence over the additive and assignment operators. Parentheses are used to control the evaluation of an expression if a different order of operation is desired. In this example, they are used to evaluate the addition before the multiplication:

A-03

```
// The expression 4 + 5 evaluates to 9, then the
// expression 9 * 10 evaluates to 90, then the
// value 90 is assigned to the variable x
int x = (4 + 5) * 10;
```

When operators with the same evaluation order (e.g., + and -, * and /) appear within an expression, they are evaluated from left to right. The following example demonstrates this rule:

A-04

```
float w = 12.0 - 6.0 + 3.0;    // Assigns 9 to w
float x = 3.0 + 6.0 / 12.0;    // Assigns 3.5 to x
float y = 12.0 / 6.0 * 3.0;    // Assigns 6 to y
float z = 3.0 * 6.0 / 12.0;    // Assigns 1.5 to z
```

When in doubt, it is helpful to include parentheses to specify the desired order of operations. This can be a useful reminder when returning to the code after some time, and it can help clarify the intent for others reading the code.

Appendix B

Reserved Words

Some words are essential to the Processing language, and their use is restricted to their intended use. For example, the `int` data type is an integral component of the language. It can be used only to declare a variable of that type and cannot be used as the name for a variable. The following program produces an error:

```
float int = 50;    // ERROR! Unexpected token: float
line(int, 0, int, 100);
```
B-01

Many of these language components are inherited from the Java programming language (Processing is built using Java), but some are unique to Processing. The names of the functions, variables, and constants such as `line`, `fill`, `width`, `mouseX`, and `PI` found in the Processing reference should be used only as intended. For example, while it is possible to make a variable called `line`, it can make a program confusing to read. When someone sees the word `line` in a program, there is an expectation that it will be used to run the `line()` function. The following program demonstrates how ignoring this suggestion can make a program baffling:

```
int line = 50;            // This does not create a program error
line(line, 0, line, 100); // but it's very confusing
```
B-02

In addition to the words used for variables and functions in the Processing language, the following list presents words that cannot be used as names for functions, variables, and classes within a Processing program. Most of these will cause an error that may be quite hard to identify because of the way it confuses the compiler.

Processing's reserved words

abstract	do	implements	protected	throw
assert	double	import	public	throws
boolean	else	init	return	transient
break	enum	instanceof	short	true
byte	extends	int	start	try
case	false	interface	static	update
catch	final	long	stop	void
char	finally	native	strictfp	volatile
class	float	new	super	while
const	for	null	switch	
continue	goto	package	synchronized	
default	if	private	this	

ASCII, Unicode

ASCII (pronounced AS-kee) is an acronym for American Standard Code for Information Interchange. It was designed as a code to associate the letters, numbers, and punctuation in the English language with numeric values. Characters must be translated into numbers so they can be used as data in software, and ASCII is a standard for making this conversion. Processing distinguishes between the number and character representation of a value based on the data type. For example, the binary sequence 01000001 will be used as the character *A* if the data type is char and will be used as the number 65 if the data type is int.

The ASCII standard also has encodings for control characters (nonprintable characters) such as tab, backspace, enter, escape, line feed, and the like, which can control external devices such as printers and format whitespace in a file. Control characters are important when writing and reading files and for reading keys such as Tab, Del, and Esc on the keyboard.

ASCII became a standard in 1967 and was last updated in 1986. Over time it has been replaced by newer standards such as UTF-8 and Unicode, which define a wider range of characters and therefore can be used for text written in non-English languages. ASCII remains extremely useful because of its simplicity and ubiquity.

The tables on the opposite page present the relations between the various representations of each character. Additional control characters can be seen in a full ASCII chart but are omitted here for brevity.

Because of its heritage, each ASCII character consists of only seven bits, covering the numbers 0 through 127. Because a byte is 8 bits and can express numbers between 0 and 255, the values from 128 to 255 vary widely between operating systems and locales. Because each platform interprets values between 128 and 255 differently, a plain-text file that contains a *ü* character that is created on Mac OS will be interpreted incorrectly on a Windows machine unless the software is told that the file is using a Macintosh encoding. It is common to see web pages that contain strange characters instead of a slanted double quote or an em dash. This is the result of viewing a web page that was created on a Macintosh on a PC (or vice versa). To prevent this situation, the HTML specification has its own method of encoding characters as plain ASCII, even though many don't use it. A table that translates between each of these encodings appears at the end of this appendix.

The Unicode standard (*www.unicode.org*) is an attempt to create a universal character set that encompasses many international languages. Most commonly, Unicode characters are represented as two bytes, which means that 65,536 characters can be specified. A char in Processing is a single Unicode character. Unicode information is often stored in a format called UTF-8, which uses a clever packing mechanism to store the 16-bit values as mostly 8-bit data.

ASCII Characters (Numeric value followed by the corresponding character)

32	(space)	51	3	70	F	89	Y	108	l	
33	!	52	4	71	G	90	Z	109	m	
34	"	53	5	72	H	91	[110	n	
35	#	54	6	73	I	92	\	111	o	
36	$	55	7	74	J	93]	112	p	
37	%	56	8	75	K	94	^	113	q	
38	&	57	9	76	L	95	_	114	r	
39	'	58	:	77	M	96	`	115	s	
40	(59	;	78	N	97	a	116	t	
41)	60	<	79	O	98	b	117	u	
42	*	61	=	80	P	99	c	118	v	
43	+	62	>	81	Q	100	d	119	w	
44	,	63	?	82	R	101	e	120	x	
45	-	64	@	83	S	102	f	121	y	
46	.	65	A	84	T	103	g	122	z	
47	/	66	B	85	U	104	h	123	{	
48	0	67	C	86	V	105	i	124		
49	1	68	D	87	W	106	j	125	}	
50	2	69	E	88	X	107	k	126	~	

ASCII Control Characters (Abridged)

Number	Abbreviation	Escape Sequence	Processing Constant
0	NUL		
4	EOT (EOF)		
6	ACK		
7	BEL		
8	BS	\b	BACKSPACE
9	HT	\t	TAB
10	LF	\n	ENTER
13	CR	\r	RETURN
27	ESC		ESC
127	DEL		DELETE

When including non-ASCII characters in a Processing program, it's a good idea to use each character's *escape sequence* (p. 490), rather than the actual character, so that problems aren't introduced when the file is opened on another platform (e.g., source code for a sketch is sent by email or posted as a text file on the web). The escape sequence consists of \u followed by four digits that represent the character's Unicode value in hexadecimal. The chart below also includes the escape sequences for many characters. For instance, instead of the following:

```
text("Zoë", 50, 50);
```

this is more compatible and therefore safer:

```
text("Zo\u00EB", 50, 50);
```

Some fonts, such as Arial Unicode, support thousands of characters in a single font. When the Create Font tool is used with such a font, it's possible to include all available characters by selecting the "All characters" option. As might be expected, this can produce enormous files and may even cause an OutOfMemoryError. Without the "All characters" option selected, fonts are encoded with all ASCII values, plus the characters found in the following table. This table is based on the most common Roman-language encodings for Mac OS and Windows (Mac Roman and CP1250), plus ISO Latin-1, a third encoding that defines the Unicode characters 128 through 255.

Character Format Conversion Table for the Processing Character Set

Character	Processing Escape	Unicode Decimal	Mac Roman	Windows CP1250	HTML Escape
'	\u0082	130			‚
f	\u0083	131			ƒ
„	\u0084	132			„
...	\u0085	133			…
†	\u0086	134			†
‡	\u0087	135			‡
ˆ	\u0088	136			ˆ
‰	\u0089	137			‰
Š	\u008A	138			Š
‹	\u008B	139			‹
Œ	\u008C	140			Œ
[RI]	\u008D	141			
Ž	\u008E	142			Ž
[SS3]	\u008F	143			
[DCS]	\u0090	144			
`	\u0091	145			‘
'	\u0092	146			’
"	\u0093	147			“
"	\u0094	148			”
•	\u0095	149			•
–	\u0096	150			–
—	\u0097	151			—
˜	\u0098	152			˜
™	\u0099	153			™
š	\u009A	154			š
›	\u009B	155			›
œ	\u009C	156			œ
[OSC]	\u009D	157			
ž	\u009E	158			ž
Ÿ	\u009F	159			Ÿ
[NBSP]	\u00A0	160	202	160	
¡	\u00A1	161	193		¡
¢	\u00A2	162	162		¢
£	\u00A3	163	163		£
¤	\u00A4	164	219	164	¤
¥	\u00A5	165	180		¥
¦	\u00A6	166		166	¦
§	\u00A7	167	164	167	§
¨	\u00A8	168	172	168	¨
©	\u00A9	169	169	169	©
ª	\u00AA	170	187		ª
«	\u00AB	171	199	171	«
¬	\u00AC	172	194	172	¬
[SHY]	\u00AD	173		173	­
®	\u00AE	174	168	174	®
¯	\u00AF	175	248		¯

°	\u00B0	176	161	176	°
±	\u00B1	177	177	177	±
²	\u00B2	178			²
³	\u00B3	179			³
´	\u00B4	180	171	180	´
µ	\u00B5	181	181	181	µ
¶	\u00B6	182	166	182	¶
·	\u00B7	183	225	183	·
¸	\u00B8	184	252	184	¸
¹	\u00B9	185			¹
º	\u00BA	186	188		º
»	\u00BB	187	200	187	»
¼	\u00BC	188			¼
½	\u00BD	189			½
¾	\u00BE	190			¾
¿	\u00BF	191	192		¿
À	\u00C0	192	203		À
Á	\u00C1	193	231	193	Á
Â	\u00C2	194	229	194	Â
Ã	\u00C3	195	204		Ã
Ä	\u00C4	196	128	196	Ä
Å	\u00C5	197	129		Å
Æ	\u00C6	198	174		Æ
Ç	\u00C7	199	130	199	Ç
È	\u00C8	200	233		È
É	\u00C9	201	131	201	É
Ê	\u00CA	202	230		Ê
Ë	\u00CB	203	232	203	Ë
Ì	\u00CC	204	237		Ì
Í	\u00CD	205	234	205	Í
Î	\u00CE	206	235	206	Î
Ï	\u00CF	207	236		Ï
Ð	\u00D0	208			Ð
Ñ	\u00D1	209	132		Ñ
Ò	\u00D2	210	241		Ò
Ó	\u00D3	211	238	211	Ó
Ô	\u00D4	212	239	212	Ô
Õ	\u00D5	213	205		Õ
Ö	\u00D6	214	133	214	Ö
×	\u00D7	215		215	×
Ø	\u00D8	216	175		Ø
Ù	\u00D9	217	244		Ù
Ú	\u00DA	218	242	218	Ú
Û	\u00DB	219	243		Û
Ü	\u00DC	220	134	220	Ü
Ý	\u00DD	221		221	Ý
Þ	\u00DE	222			Þ
ß	\u00DF	223	167	223	ß
à	\u00E0	224	136		à
á	\u00E1	225	135	225	á
â	\u00E2	226	137	226	â
ã	\u00E3	227	139		ã

ä	\u00E4	228	138	228	ä
å	\u00E5	229	140		å
æ	\u00E6	230	190		æ
ç	\u00E7	231	141	231	ç
è	\u00E8	232	143		è
é	\u00E9	233	142	233	é
ê	\u00EA	234	144		ê
ë	\u00EB	235	145	235	ë
ì	\u00EC	236	147		ì
í	\u00ED	237	146	237	í
î	\u00EE	238	148	238	î
ï	\u00EF	239	149		ï
ð	\u00F0	240			ð
ñ	\u00F1	241	150		ñ
ò	\u00F2	242	152		ò
ó	\u00F3	243	151	243	ó
ô	\u00F4	244	153	244	ô
õ	\u00F5	245	155		õ
ö	\u00F6	246	154	246	ö
÷	\u00F7	247	214	247	÷
ø	\u00F8	248	191		ø
ù	\u00F9	249	157		ù
ú	\u00FA	250	156	250	ú
û	\u00FB	251	158		û
ü	\u00FC	252	159	252	ü
ý	\u00FD	253		253	ý
þ	\u00FE	254			þ
ÿ	\u00FF	255	216		ÿ
Ă	\u0102	258		195	Ă
ă	\u0103	259		227	ă
Ą	\u0104	260		165	Ą
ą	\u0105	261		185	ą
Ć	\u0106	262		198	Ć
ć	\u0107	263		230	ć
Č	\u010C	268		200	Č
č	\u010D	269		232	č
Ď	\u010E	270		207	Ď
ď	\u010F	271		239	ď
Đ	\u0110	272		208	Đ
đ	\u0111	273		240	đ
Ę	\u0118	280		202	Ę
ę	\u0119	281		234	ę
Ě	\u011A	282		204	Ě
ě	\u011B	283		236	ě
ı	\u0131	305	245		ı
Ĺ	\u0139	313		197	Ĺ
ĺ	\u013A	314		229	ĺ
Ľ	\u013D	317		188	Ľ
ľ	\u013E	318		190	ľ
Ł	\u0141	321		163	Ł
ł	\u0142	322		179	ł
Ń	\u0143	323		209	Ń

Char	Unicode	Dec			Entity
ń	\u0144	324		241	ń
Ň	\u0147	327		210	Ň
ň	\u0148	328		242	ň
Ő	\u0150	336		213	Ő
ő	\u0151	337		245	ő
Œ	\u0152	338	206		Œ
œ	\u0153	339	207		œ
Ŕ	\u0154	340		192	Ŕ
ŕ	\u0155	341		224	ŕ
Ř	\u0158	344		216	Ř
ř	\u0159	345		248	ř
Ś	\u015A	346		140	Ś
ś	\u015B	347		156	ś
Ş	\u015E	350		170	Ş
ş	\u015F	351		186	ş
Š	\u0160	352		138	Š
š	\u0161	353		154	š
Ţ	\u0162	354		222	Ţ
ţ	\u0163	355		254	ţ
Ť	\u0164	356		141	Ť
ť	\u0165	357		157	ť
Ů	\u016E	366		217	Ů
ů	\u016F	367		249	ů
Ű	\u0170	368		219	Ű
ű	\u0171	369		251	ű
Ÿ	\u0178	376	217		Ÿ
Ź	\u0179	377		143	Ź
ź	\u017A	378		159	ź
Ż	\u017B	379		175	Ż
ż	\u017C	380		191	ż
Ž	\u017D	381		142	Ž
ž	\u017E	382		158	ž
ƒ	\u0192	402	196		ƒ
ˆ	\u02C6	710	246		ˆ
ˇ	\u02C7	711	255	161	ˇ
˘	\u02D8	728	249	162	˘
˙	\u02D9	729	250	255	˙
˚	\u02DA	730	251		˚
˛	\u02DB	731	254	178	˛
˜	\u02DC	732	247		˜
˝	\u02DD	733	253	189	˝
Ω	\u03A9	937	189		Ω
π	\u03C0	960	185		π
–	\u2013	8211	208	150	–
—	\u2014	8212	209	151	—
'	\u2018	8216	212	145	‘
'	\u2019	8217	213	146	’
‚	\u201A	8218	226	130	‚
"	\u201C	8220	210	147	“
"	\u201D	8221	211	148	”
„	\u201E	8222	227	132	„
†	\u2020	8224	160	134	†
‡	\u2021	8225	224	135	‡
•	\u2022	8226	165	149	•
…	\u2026	8230	201	133	…
‰	\u2030	8240	228	137	‰
‹	\u2039	8249	220	139	‹
›	\u203A	8250	221	155	›
/	\u2044	8260	218		⁄
€	\u20AC	8364		128	€
™	\u2122	8482	170	153	™
ə	\u2202	8706	182		∂
∆	\u2206	8710	198		∆
∏	\u220F	8719	184		∏
Σ	\u2211	8721	183		∑
√	\u221A	8730	195		√
∞	\u221E	8734	176		∞
∫	\u222B	8747	186		∫
≈	\u2248	8776	197		≈
≠	\u2260	8800	173		≠
≤	\u2264	8804	178		≤
≥	\u2265	8805	179		≥
◊	\u25CA	9674	215		◊
	\uF8FF	63743	240		
ﬁ	\uFB01	64257	222		ﬁ
ﬂ	\uFB02	64258	223		ﬂ

Bit, Binary, Hex

Bit

A bit (binary digit) is the most basic information unit in computing. A bit is often thought of as a 1 or 0, but a bit has no numeric meaning. It's simply a way to distinguish between two mutually exclusive states. Over the years, bits were stored as holes punched in a card, a positive or negative magnetic charge on a floppy disk, and an indent in the surface of a compact disk. The amazing innovation of binary notation is the ability to encode many types of data and logic with only two different states. This was made possible by George Boole's contributions to logic in the mid-nineteenth century and Claude Shannon's development of information theory in the 1930s. The information that comprises images, video, text, and software is all encoded into binary notation and later decoded as colors, shapes, and words that we are able to understand. A group of 8 bits is called a byte. Storage on computers is measured in bytes. For example, a kilobyte (K, KB, kB, Kbyte) is 1024 bytes, a megabyte (MB) is 1,048,576 bytes, and a gigabyte (GB, Gbyte) is 1,073,741,824 bytes.[1]

Binary

The binary number system, also called base-2, represents numbers as sequences of 1s and 0s. This is different from the more common decimal representation, also called base-10. Here we can compare the powers of 10 and the powers of 2:

Base-10	10^0	10^1	10^2	10^3	10^4	10^5
	1	10	100	1,000	10,000	100,000

Base-2	2^0	2^1	2^2	2^3	2^4	2^5
	1	2	4	8	16	32

When using a computer, it's clear that many frequently used numbers are a result of base-2 notation. For example, colors are specified in values from 0 to 255 (2^8, the number of unique values for one byte), and screens are often 1024 pixels wide (2^{10}).

In base-10 numbers, each digit is multiplied by the power of 10 associated with its position. For example, the number 243 is expressed as follows:

200	+	40	+	3	= 243
2*100	+	4*10	+	3*1	= 243
$2*10^2$	+	$4*10^1$	+	$3*10^0$	= 243

Base-2 numbers work the same way, but the digits are multiplied by the powers of 2. Every whole number can be made by adding values that are powers of two. The following example breaks down the binary equivalent of the decimal number 23 (16 + 4 + 2 + 1), which is 10111:

16	+	0	+	4	+	2	+	1	=	23
$1*16$	+	$0*8$	+	$1*4$	+	$1*2$	+	$1*1$	=	23
$1*2^4$	+	$0*2^3$	+	$1*2^2$	+	$1*2^1$	+	$1*2^0$	=	23

Each file format specifies how information is encoded into binary notation and how software is used to decode the information according to the standards for each format. For example, using the ASCII standard (p. 604 for text, the word Process is encoded as the numeric and binary sequence like this:

Character	P	r	o	c	e	s	s
ASCII	80	114	111	99	101	115	115
Binary	01010000	01110010	01101111	01100011	01100101	01110011	01110011

Bitwise operations

The integer and floating-point representations of numbers are operated on with arithmetic operators such as + and *. The binary representations of numbers have different operators. Bitwise operators & (bitwise AND) and | (bitwise OR) are used for comparing binary representations. The bitwise operators << and >> are used to shift bits left and right.

The bitwise AND operator compares each corresponding bit according to these rules:

Expression	Evaluation
1 & 1	1
1 & 0	0
0 & 0	0

A larger calculation follows:

```
  11010110
& 01011100
----------
  01010100
```

The bitwise OR operator compares each corresponding bit according to these rules.

Expression	Evaluation
1 \| 1	1
1 \| 0	1
0 \| 0	0

A larger calculation follows:

```
  11010110
| 01011100
  _____

  11011110
```

The bitwise operators << and >> shift bits left and right.

```
int a = 205;    // In binary:   00000000000000000000000011001101      D-01
int b = 45;     // In binary:   00000000000000000000000000101101
a = a << 24;    // Converts to  11001101000000000000000000000000
b = b << 8;     // Converts to  00000000000000000010110100000000
```

Hex

Hexadecimal notation encodes an entire 8-digit byte with just two characters, one character for each nibble (4 bits, or half a byte). Because there are only 16 possible byte configurations for a nibble, each can be encoded with the following 16 distinct alphanumeric characters.

0000	0	0100	4	1000	8	1100	C
0001	1	0101	5	1001	9	1101	D
0010	2	0110	6	1010	A	1110	E
0011	3	0111	7	1011	B	1111	F

For example, the binary sequence...

```
01010000  01110010  01101111  01100011  01100101  01110011  01110011
```

...is reduced to this hexadecimal encoding:

```
50  72  6F  63  65  73  73
```

Hex notation is an established way to define color within software and on the web. For example, the three decimal RGB color value 255, 204, 51 is converted to FFCC33 in hexadecimal notation. In Processing, a # sign is front of six digits denotes a web color. To use hexadecimal notation for other uses besides color, place 0x (the number zero followed by a lowercase x) in front of the digits.

Note

1. There are two definitions each for kilobyte, megabyte, and gigabyte. The alternative quantities are, respectively, 1,000 (one thousand), 1,000,000 (one million), and 1,000,000,000 (one billion).

Appendix E

Optimization

Optimization is making changes to a program so that it will run faster. This can provide tremendous benefit by increasing the number of frames displayed per second or by allowing more to be drawn to the screen each frame. Increasing the speed can also make a program more responsive to mouse and keyboard input.

Code should usually not be optimized until a late stage in a program's development. Energy diverted to optimization detracts from refining the concept and aesthetic considerations of the software. Optimization can be rewarding because of increased performance, but such technical details should not be allowed to distract you from the ideas. There are a few important heuristics to guide the process:

Work slowly and carefully. It's easy to introduce new bugs when optimizing, so work with small pieces of code at a time. Always keep the original version of the code. You may want to comment out the old version of a function and keep it present in your program while you work on its optimization.

Optimize the code that's used most. The majority of code in a program gets used very little, so make sure that you're focusing on a section that needs work. Advanced programmers can use a *profiler* for this task—a tool that identifies the amount of time being spent in different sections of code. Profilers are too specific to be covered here, but books and online references cover profiling Java code, and this methodology can be applied to Processing programs.

If the optimization doesn't help, revert to the original code. Lots of things seem like they'll improve performance but actually don't (or they don't improve things as much as hoped). The "optimized" version of the code will usually be more difficult to read—so if the benefits aren't sufficient, the clearer version is better.

There are many techniques to optimize programs; some that are particularly relevant to Processing sketches are listed in what follows.

Bit-shifting color data

The red(), green(), blue(), and alpha() functions are easy to use and understand, but because they take the colorMode() setting into account, using them is much slower than making direct operations on the numbers. With the default color mode, the same numerical results can be achieved with greater speed by using the >> (right shift) operator to isolate the components and then use the bit mask 0xFF to remove any unwanted data. These operators are explained in appendix D (p. 609). The following example shows how to shift color data to isolate each component.

```
color c = color(204, 153, 102, 255);
int r = (c >> 16) & 0xFF;    // Faster version of red(c)
int g = (c >> 8) & 0xFF;     // Faster version of green(c)
int b = c & 0xFF;            // Faster version of blue(c)
int a = (c >> 24) & 0xFF;    // Faster version of alpha(c)
println(r, g, b, a);
```

Each component of a color is 8 bits. The bits in a pixel are ordered like this:

AAAAAAAARRRRRRRRGGGGGGGGBBBBBBBB

where the A's are alpha bits, R's are red, G's are green, and B's are blue. After the red component is shifted 16 to the right (the >> 16 above), the pixel values looks like this:

0000000000000000AAAAAAAARRRRRRRR

The hexadecimal value 0xFF is 8 bits all set to 1 (equivalent to 255). The bitwise AND operator is applied to remove the other bits and just save the 8 bits needed for the color component itself:

```
    0000000000000000AAAAAAAARRRRRRRR
&   00000000000000000000000011111111
    ————————————————————————————————
    000000000000000000000000RRRRRRRR
```

This calculation completely isolates the red component of the color. To put a color "back together," use the following code:

```
int a = 255;
int r = 102;
int g = 51;
int b = 255;
color c = (a << 24) | (r << 16) | (g << 8) | b;
```

The following code is useful when the alpha setting is opaque, because no shift is needed:

```
color c = 0xFF000000 | (r << 16) | (g << 8) | b;
```

The hex digits 0xFF000000 (p. 612) are equivalent to 255 shifted to the left by 24. Hex digits can be used to replace the red and green components as well.

Bit shifting is much faster than using the color() function, because it ignores the colorMode() setting. For the same reason, specifying colors using hex notation (e.g., #FFCC00) has zero overhead.

Avoid creating objects in `draw()`

Creating an object slows a program down. When possible, create the objects within `setup()` so they are created only once within the program. The following two examples show common misunderstandings about creating objects that slow programs down.

```
// AVOID loading an image within draw(); it is slow          E-03
void draw()  {
  PImage img = loadImage("tower.jpg");
  image(img, 0, 0);
}
```

```
// AVOID creating an array inside draw(); it is slow          E-04
void draw()  {
  int[] values = new int[200];
  // Do something with the array here
}
```

In this case, the array will be re-created and destroyed on each trip through the `draw()` function, which is extremely wasteful. The programs 25-07 (p. 368) and 30-18 (p. 451) show faster ways of creating objects.

Using the `pixels[]` array

The `get()` and `set()` functions are easy to use, but they are not as fast as accessing and setting the pixels of an image directly through the `pixels[]` array (p. 540). The following examples show four different ways of accessing the data within the `pixels[]` array, each faster than the previous one.

```
// Converts (x,y) coordinates into a position in the pixels[] array   E-05
loadPixels();
for (int y = 0; y < height; y++) {
  for (int x = 0; x < width; x++) {
    pixels[y*width + x] = color(102);
  }
}
updatePixels();
```

```
// Replaces the multiplication y*width with an addition   E-06
int offset = 0;
loadPixels();
for (int y = 0; y < height; y++) {
```

```
  for (int x = 0; x < width; x++) {
    pixels[offset + x] = color(102);
  }
  offset += width; // Avoids the multiply
}
updatePixels();
```

```
// Avoid the calculation y*height+width
int index = 0;
loadPixels();
for (int y = 0; y < height; y++) {
  for (int x = 0; x < width; x++) {
    pixels[index++] = color(102);
  }
}
updatePixels();
```

```
// Avoids (x,y) coordinates
int wh = width*height;
loadPixels();
for (int index = 0; index < wh; index++) {
    pixels[index] = color(102);
}
updatePixels();
```

```
// Only calculate the color once
int wh = width*height;
color c = color(102);
loadPixels();
for (int index = 0; index < wh; index++) {
    pixels[index] = c;
}
updatePixels();
```

When manipulating pixels[], use the loadPixels() and updatePixels() functions only once within draw(). When possible, use color() outside of loops. It is not very fast because it must take into account the current color mode.

Tips for working with arrays

Adding one value at a time to an array is slower than doubling the size of the array when it is full. If a program will be continually adding data to the end of an array, use

the expand() function once each time the array fills up in place of running append() many times. Code 28-20 (p. 423) shows how to manage a growing array with expand().

The arrayCopy() function is the fastest way of copying data from one array to another. Copying the data from one array to another inside a for loop is much slower when copying data from large arrays. The arrayCopy() function is demonstrated in code 28-23 (p. 425). Arrays are also much faster than the Java classes ArrayList and Vector.

Avoid repeating calculations

If the same calculation is made more than once, it's faster to make the calculation once and store it in a variable. Instead of writing

```
float x = (width/2) * 4;
float y = (width/2) * 8;
```

save the result of the division in a variable and substitute it for the calculation:

```
float half = width/2;
float x = half * 4;
float y = half * 8;
```

Multiplications and divisions from inside a for loop can slow a program down significantly, especially if there are more than 10,000 iterations. When possible, make these calculations outside of the structure. This is demonstrated in code E-08.

Because of the way computers make calculations, addition is faster than multiplication and multiplication is faster than division. Multiplication can often be converted to addition by restructuring the program. For example, compare the difference in run time between code E-05 and code E-06.

Lookup tables

The idea behind a lookup table is that it is faster to make reference to a value stored within a data structure than to make the calculation. One example is making calculations for sin() and cos() at each frame. These numbers can be generated once within setup() and stored within an array so they may be quickly retrieved. The following example shows how it's done.

```
int res = 16;                    // Number of data elements        E-10
float[] x = new float[res];      // Create x-coordinate array
float[] y = new float[res];      // Create y-coordinate array
```

```
void setup() {
  size(100, 100);
  for (int i = 0; i < res; i++) {
    x[i] = cos(PI/res * i);      // Sets x-coordinates
    y[i] = sin(PI/res * i);      // Sets y-coordinates
  }
}

void draw() {
  for (int i = 0; i < res; i++) {      // Access each point
    point(50 + x[i]*40, 50 + y[i]*40); // Draws point on a curve
  }
}
```

You can change the resolution of the values by altering the length of the array.

Optimizers beware!

Optimized code can sometimes be more difficult to read. When deciding whether to optimize, balance the need for speed against the value of legibility. For example, in the bit-shifting example presented earlier, the expression

```
red(color)
```

is clearer than its optimized equivalent:

```
(color >> 16) & OxFF
```

The name of the red() function clearly states its purpose, whereas the bit shift and mask are cryptic to everyone except those familiar with the technique. The confusion can be alleviated with comments, but always consider whether the optimization is more important than the simplicity of your code.

Appendix F

Programming Languages

There are hundreds of different programming languages, and artists and designers use many of them. Like human languages, programming languages can be grouped into related sets. French and Spanish are similar because they share similar origins, and the Java and C++ programming languages are similar because they too share similar origins. The etymology of a programming language determines many of its characteristics. Is it appropriate for sketching? Can it be used to program a mobile phone? Is the code highly optimized? Programming languages evolve over a long period of time, and a new language frequently adopts conventions from its predecessors. This appendix describes the characteristics of a variety of languages and their role as tools for artists and designers.

Text vs. visual languages

The first programming languages were text languages, and the majority of programming languages used in the twenty-first century are text languages. Visual programming languages (VPL or VL) are used less often, but they may be employed by a higher percentage of people involved in the arts than in other areas. VPLs often appeal to people who think spatially and prefer to organize their thoughts as visual relationships between elements. For example, the following short text program...

```
ellipse(mouseX, mouseY, 50, 50);
```

...might be written in a visual programming language like this:

Because VPLs represent software less abstractly, they have proved more effective within specific domains than as general-purpose programming languages. They have found a niche in applications for generating sound, editing video, and building GUIs. A VPL places a greater distance between the programmer and the low-level technical details of the software. For example, a color can be selected directly and curves can be modified and drawn with the mouse rather than specified with numbers. VPLs are themselves written using general-purpose text languages such as C++ and Java; therefore, adding intrinsic features to a VPL requires text programming.

Some researchers feel VPLs have the power to reach an audience that has previously not been attracted to programming. There is logic in this hypothesis, considering that the introduction of the GUI in the 1980s brought the personal computer to a vast new audience. The Scratch project, developed by Mitchel Resnick's research group at the MIT Media Laboratory, was created to enable children to make their own games and animated stories. Programs are created by snapping together visual blocks and setting parameters. There are different block types for mouse events, iteration, and other programming fundamentals. The software is used in the Computer Clubhouse network of after-school centers in low-income communities.

One category of languages is not intrinsically better than the other. Each should be evaluated, and the selection should be made in relation to the programming context and the preferences of the programmer.

Compiled vs. interpreted languages

A program written in a compiled language must be converted into a different format before it is run. The program goes through a process to change it from its human-readable text format into a machine-readable format. This is called *compiling* the program. A program called a *compiler* makes this transition. The program is converted from the representation created by the programmer to a reduced set of instructions (machine code) that can be executed by the computer's microprocessor. A program written in an interpreted language is not compiled—it is *interpreted* by another program while it runs. An *interpreter* is a program that analyzes each statement in the program while it runs and determines what to do. In contrast, all of the necessary decisions about a compiled program are made during the compilation process.

Both types of programming techniques have their strengths. For example, compiled programs run faster than interpreted programs, but interpreted programs can be modified while the program is running. This makes interpreted programs ideal for writing live performance software. Because each language type has advantages, large software projects often utilize both, for different parts of the project where each strength is needed.

The Java language system has aspects of both a compiled and an interpreted language. Before a Java program is run, it's compiled into byte code that is run on the Java Virtual Machine (JVM). The JVM is a software processor that acts as a buffer between the byte code and the machine's physical microprocessor. Because there is a standardized JVM for many different types of computers, the same Java code can theoretically run on all of these different machines without requiring platform-specific changes. The byte code technique makes it easier for code to be readable across platforms without the speed reduction of an interpreted language.

Many interpreted languages are categorized as *scripting languages*. There is no clear definition of a scripting language, but there are properties commonly used to identify one. They are typically created for specific domains or applications. For example, MEL was developed for Maya, ActionScript for Flash, and JavaScript for the web. A scripting

language provides easy access to specific tasks relevant to a particular context. For example, AppleScript for Mac OS can be used to process a folder full of images and then upload them to a server or send them via email. Programs can usually be written more quickly in a scripting language, but they often run slower and use more of the computer's memory. It can take less time to write programs in a scripting language because it does not require the programmer to be as specific. For example, scripting languages are often not typed, meaning the data types for variables need not be declared. There's a stereotype that scripting languages are useful only for writing short, simple programs. While they are good for this purpose, scripting languages such as Perl and Python are frequently used to create long, complex programs.

Java was chosen as the basis for Processing because it represented a good balance between performance and simplicity of use. If we didn't care about speed, a scripting language like Python or Ruby might make more sense in a sketching environment. If we didn't care about transition to more advanced languages, we might not use Java/C++ style syntax. Java makes a nice starting point for a sketching language because it's far more forgiving than C++ and also allows users to export sketches for distribution on multiple operating systems.

Programming languages used by artists and designers

The following list is a small sampling of the many languages in use by artists and designers. It is not possible to compile a comprehensive list, and this list does not aspire to meet that challenge. In addition to the languages mentioned here, there have been many historically important languages for the arts including GRASS, BEFLIX, Logo, AutoLISP, and PostScript. There are also many domain-specific languages that are not mentioned here.

ActionScript. ActionScript is a language written for Adobe's Flash software. Flash was originally created as web animation software, and ActionScript was later added to provide scripting capabilities for MovieClips, the basic content unit of a Flash project. ActionScript is based on ECMAScript (the foundation of JavaScript), so knowledge of one transfers easily to the other.
http://www.adobe.com/devnet/actionscript

Arduino. (See Wiring) *http://www.arduino.cc*

BASIC. Originally designed in 1963 as a language to allow students in nontechnical fields to use computers, BASIC became prevalent on home computers in the 1980s. It was the first language learned by millions of children growing up with home computers at this time. BASIC was designed to be easy for beginners but also usable as a general-purpose language. There are many dialects of BASIC, including the PIC BASIC and PBASIC languages for programming microcontrollers.
http://en.wikipedia.org/wiki/BASIC_programming_language

C, C++. The C language was developed in the early 1970s and is still used widely today. Many languages designed subsequently (including PHP and Processing) have used C as a model. In addition to its widespread use for writing system software and applications for PCs, it's a popular language for programming microcontrollers. C++ was designed to enhance the C language through the addition of object-oriented concepts. The ++ symbol in C means to add the number 1. The name C++ is geeky way to acknowledge its status as an enhanced version of C. Because C was so widely used, C++ became one of the most popular object-oriented languages. If well programmed, applications written in C and C++ are fast and efficient. Neither language has a built-in way of drawing; they are interfaced with a graphics library such as OpenGL to write images to the screen.
http://en.wikipedia.org/wiki/C_programming_language
http://en.wikipedia.org/wiki/C++_programming_language

ChucK. ChucK is an audio programming language for real-time synthesis, composition, and performance. Code can be added and modified while the program is running. The language offers precise timing control.
http://chuck.cs.princeton.edu

Design By Numbers (DBN). Design By Numbers was developed for teaching general programming concepts to artists and designers with no prior programming experience. DBN is an extremely minimal language and environment; thus, it is easy to learn but limited in its potential for creating advanced graphics applications. DBN was originated by John Maeda, director of the Aesthetics and Computation Group (ACG) at the MIT Media Laboratory. Processing also originated in the ACG because of Ben and Casey's involvement with the DBN project.
http://dbn.media.mit.edu

DrawBot. DrawBot, a language developed specifically for teaching, combines Python with a 2D graphics library and simple development environment. Images created can be output in different formats including PDF. This software is available only for Macintosh.
http://www.drawbot.com

Java. Java was created by Sun Microsystems in the 1990s as an alternative to C++. The language focuses on creating cross-platform programs with built-in support for networking. The popularity of Java dramatically increased as the web emerged because of Java applets, programs that can run through a web browser. In contrast to C and C++, Java programs are faster to write, but run more slowly. The Java language has grown at a tremendous rate since its conception and is now used for programming contexts including embedded devices, phones, server-side programs, and stand-alone applications.
http://www.oracle.com/technetwork/java/

JavaScript. JavaScript was originally developed as a scripting language for enhancing web pages. Despite its name, JavaScript is not directly related to the Java programming language. It was originally developed by Netscape and named LiveScript, but the name was changed to JavaScript around the time that Netscape began including Java with its web browser. JavaScript was later sent to the ECMA standards body and codified as the ECMAScript standard. JavaScript is used as the scripting language for a growing number of code libraries for the web including Paper.js, three.js, and D3.
http://en.wikipedia.org/wiki/JavaScript

Lingo. Lingo is the language written for Macromedia's Director software. Director was once the dominant environment for designers and artists making CD-ROM projects, but it declined in popularity during the web era during the early success of Flash. Lingo is integrated into a GUI environment that uses theater terms like "stage" and "cast" to describe different project elements. The Lingo language is characterized by its verbose English-like syntax. More recent features added to Director are accessible through JavaScript syntax. Director has been modified in recent years to support object-oriented structures and 3D graphics.
http://www.adobe.com/support/director/lingo.html

Max. Max, named after the computer music pioneer Max Mathews, was originally a visual programming language for controlling MIDI data. The Max GUI is based on the metaphor of an analog, modular synthesizer. Different modules (objects) are visually connected with patch cords to determine the data flow. The MSP objects were added ten years later to enable the software to generate live audio. The subsequent Jitter objects extended Max to control video and 3D graphics. Versions 4.5 and higher allow JavaScript and Java code to be used in tandem with the visual programming elements. Max is commonly used for creating live audiovisual performances.
http://cycling74.com/products/max

Maya Embedded Language (MEL). MEL is a scripting language used with Alias's Maya software. It is useful for automating repetitive tasks and for grouping sets of frequently used commands together into reusable scripts. The syntax is similar to C, and the language does not yet have object-oriented capabilities.
http://en.wikipedia.org/wiki/Maya_Embedded_Language

Perl. A goal of the Perl language is to make easy tasks easy and difficult tasks possible. It succeeds because it is a flexible and extensive language. The Perl syntax is a pastiche of many languages including C, awk, sed, sh, and others. Perl is used widely for web development and network programming and is therefore sometimes called the "the duct tape of the Internet"; its popularity surged in the 1990s and later inspired web scripting languages like PHP. Perl is excellent at parsing and manipulating text; its ability to process such data makes it useful for an art and design audience.
http://www.perl.org

PHP. PHP is a simple but powerful scripting language originally designed for programming dynamic web content. The syntax is similar to C and is easily combined with HTML. PHP is often used to read and write data from a database.
http://www.php.net

Pure Data (Pd). Pd is a visual programming language developed for creating computer music and live images. Pd was initiated by Miller Puckette, the father of Max, as an open-source alternative to the original proprietary software. It extended beyond the original Max with the additional of real-time audio synthesis. As in Max, programs are written with visual patches. As an open-source project, the Pd software and distributions contain many contributions from developers around the world. Pd is a popular language for creating live audiovisual performances.
http://puredata.info

Python. Python is considered to be an excellent teaching language because of its clear syntax and structure. Python is typically used for nongraphic applications. It doesn't have a native graphics library, but graphics applications may be created by using graphics toolkits, some of which are cross-platform. The language is characterized by a concise syntax and a huge variety of modules that extend the possibilities of the language.
http://www.python.org

Quartz Composer. Quartz Composer is a visual programming language included with Mac OS X for processing and rendering graphical data using OpenGL. The basic element of the language is a patch, the visual equivalent of a function. Input and output ports on a patch are connected with lines to define the flow of data within the program. Compositions, as programs written with Quartz Composer are called, can be run autonomously or incorporated into applications.
http://en.wikipedia.org/wiki/Quartz_Composer

Ruby. Ruby is an object-oriented scripting language. It has many features to process text files and to perform system management tasks. The Ruby syntax provides programmers great flexibility in structuring their code. This makes the language "expressive," but can also make it more difficult for other people to read. It has gained popularity because of Ruby on Rails, a framework for making web applications. Ruby is a relatively new language (it was created in 1995), and its user base is growing quickly.
http://www.ruby-lang.org

SQL (Structured Query Language). SQL is the most common programming language used to create, modify, retrieve, and manipulate database content. Its origins date back to 1969, but it only became standardized in 1986. While not a language for building applications per se, it provides a syntax for searching and collecting information from a database through queries and procedures.
http://en.wikipedia.org/wiki/Sql

SuperCollider. SuperCollider is an environment for real-time audio synthesis. It features a built-in programming language, an object-oriented class system, a GUI builder for creating a patch control panel, a graphical interface for creating wave tables and breakpoint envelopes, MIDI control, a large library of signal processing and synthesis functions, and a large library of functions for list processing musical data. The programming language has elements of the Smalltalk and C languages.
http://supercollider.sourceforge.net

vvvv. The vvvv software focuses on real-time video synthesis, connecting physical devices, and developing interactive media applications and systems. It is a visual programming language with aspects similar to Max and Pure Data, but with a unique interface and less emphasis on audio. It features hardware-accelerated 3D graphics and makes it easy to create multiscreen projections. This software is available only for Windows and is free for noncommercial use.
http://vvvv.org

Wiring. Wiring is a language for programming microcontrollers. It is used to teach the basic concepts of working with electronics and skills in prototyping electronic devices. The language is based on Processing but tailored for electronics. Programs are developed within a modified version of the Processing Environment. When a Wiring program is compiled, it is translated into C code and then compiled as a C program. Wiring is also the programming language for the Arduino electronics boards.
http://www.wiring.org.co

Related Media

This book is an introduction to working with software in the domain of the visual arts. There are many related texts, websites, and software that explore these topics in greater depth. This list includes some that we think are particularly important.

Color

Albers, Joseph. *The Interaction of Color*. Yale University Press, 1975.
> *Compelling book on color from the Bauhaus/Black Mountain/Yale artist-teacher.*

Bourke, Paul. Personal website: Colour Spaces. *http://paulbourke.net/texture_colour/colourspace/*.
> *Diagrams, code, and explanations of many different color models.*

Itten, Johannes. *The Elements of Color*. Van Nostrand Reinhold, 1970.

Walch, Margaret, and Augustine Hope. *Living Colors: The Definitive Guide to Color Palettes through the Ages*. Chronicle Books, 1995.
> *Presents color palettes extracted from historical artworks and artifacts.*

Computer graphics

Ammeraal, Leendert. *Computer Graphics for Java Programmers*. John Wiley & Sons, 1998.

Foley, James D., and Andries van Dam, et al. *Computer Graphics: Principles and Practice in C*. Second edition. Addison-Wesley, 1995.

Hearn, Donald, and M. Pauline Baker. *Computer Graphics: C Version*. Second edition. Prentice Hall, 1986.

OpenGL Architecture Review Board. *OpenGL Programming Guide*. Seventh edition. Addison-Wesley, 2009.
> *Original and definitive guide to OpenGL, but not for the beginning programmer. An earlier edition is available free online at http://www.opengl.org/documentation/red_book.*

Drawing

Cohen, Harold. AARON. 21 March 2006. *http://www.aaronshome.com/*.
> *Links to Cohen's essays written about AARON, 1973-1999.*

Klee, Paul. *Pedagogical Sketchbook*. Translated by Sibyl Moholy-Nagy. Frederick A. Praeger, 1953.
> *Whimsical journey through Klee's ideas about drawing.*

Simon, John F. Jr. *Mobility Agents: A Computational Sketchbook*. Printed Matter and Whitney Museum of American Art, 2005.
> *CD of software applications exploring ideas about computational drawing.*

Sutherland, Ivan. "Sketchpad: A Man-Machine Graphical Communication System." PhD dissertation, Massachusetts Institute of Technology, 1963.
> *Original documentation for the pioneering Sketchpad system. Available online at www.cl.cam.ac.uk/TechReports/UCAM-CL-TR-574.pdf.*

History of software as art

Burnham, Jack. *Great Western Salt Works: Essays on the Meaning of Post-Formalist Art*. George Braziller, 1974.

Davis, Douglas. *Art and the Future: A History/Prophecy of the Collaboration between Science, Technology, and Art*. Henry Holt & Company, 1975.

Franke, H. W. *Computer Graphics Computer Art*. Phaidon, 1971.

> *Discusses methods for creating computer art and introduces the brief history preceding this early publication.*

Glimcher, Marc. *Logical Conclusions: 40 Years of Rule-Based Art*. Pace Wildenstein, 2005.

Lippard, Lucy R. *Six Years: The Dematerialization of the Art Object, 1966 to 1972*. University of California Press, 1973.

Medien Kunst Netz. 10 July 2006. *http://www.medienkunstnetz.de.*

> *Online repository of historic and contemporary media art concepts and works.*

Paul, Christiane. *Digital Art*. Thames & Hudson, 2003.

> *Well-structured overview of the field.*

Reichardt, Jasia. *The Computer in Art*. Studio Vista, 1971.

> *Small book (98 pages) introducing the relation between software and image.*

Reichardt, Jasia. *Cybernetics, Art, and Ideas*. New York Graphic Society, 1971.

UbuWeb. 20 July 2006. *http://www.ubu.com.*

> *Online "resource dedicated to all strains of the avant-garde, ethnopoetics, and outsider arts."*

Whitney, John. *Digital Harmony: On the Complementary of Music and Visual Art*. Byte Books (McGraw-Hill), 1980.

Wilson, Mark. *Drawing with Computers*. Putnam, 1985.

> *Surveys the technology of the era and presents many examples for drawing to plotters and screen.*

Youngblood, Gene. *Expanded Cinema*. Dutton, 1970.

> *Documents the state of experimental film and animation circa 1970. Part 4 introduces "Cybernetic Cinema and Computer Films."*

Image

Efford, Nick. *Digital Image Processing: A Practical Introduction Using Java*. Addison-Wesley, 2000.

> *Excellent introduction to the concepts, math, and code of image processing.*

Myler, Harley R. *The Pocket Handbook of Image Processing Algorithms*. Prentice Hall, 1993.

> *Small black book of essential image processing algorithms.*

Sontag, Susan. *On Photography*. Anchor Books, 1977.

> *Thoughtful and provocative essays about photographic images and their role in culture.*

Information visualization

Bertin, Jacques. *Semiology of Graphics: Diagrams, Networks, Maps*. University of Wisconsin Press, 1983.

> *English translation and later edition of French text first published in 1967. A seminal work in the field.*

Card, Stuart K., et al., eds. *Readings in Information Visualization: Using Vision to Think*. Morgan Kaufmann, 1999.

> *Compiled technical papers on information visualization.*

Fry, Benjamin. *Computational Information Design*. PhD dissertation, Massachusetts Institute of Technology, Program in Media Arts & Sciences, 2004.

Fry, Benjamin. "Organic Information Design." Master's thesis, Massachusetts Institute of Technology, Program in Media Arts & Sciences, 2000.

Tufte, Edward. *Envisioning Information*. Graphics Press, 1990.

Tufte, Edward. *The Visual Display of Quantitative Information*. Graphics Press, 1983.

Input

Apple Computer Inc. *Macintosh Human Interface Guidelines*. Addison-Wesley, 1992.

> *Introduces the design considerations and elements of designing human-computer interfaces.*

Engelbart, Douglas, and Bill Paxton. NLS Demo. Joint Computer Conference, San Francisco Convention Center, 9 December 1968.

Video documentation of the seminal demonstration introducing the mouse input device. Online at http://sloan. stanford.edu/MouseSite/1968Demo.html.

Maeda, John. *Reactive Books.* Digitalogue, 1994–1999. Online at *www.maedastudio.com/2004/rbooks2k.*

Software exploring sound, mouse, clock, keyboard, and video input channels.

Stephenson, Neal. *In the Beginning Was the Command Line.* Harper Perennial, 1999.

Online at http://www.cryptonomicon.com/beginning.html.

Math

Bourke, Paul. Personal website: Geometry, Surfaces, Curves, Polyhedra. *http://paulbourke.net/geometry/.*

Online repository of curve equations including images and explanation.

Famous Curves Index. *www-history.mcs.st-and.ac.uk/Curves/Curves.html.*

Collection of equations and corresponding software to control the shape of curves.

Tan, Manny, et al. *Flash Math Creativity.* Friends of Ed, 2002.

Collection of math techniques for producing images and motion.

Van Lerth, James, and Lars Bishop. *Essential Mathematics for Games and Interactive Applications.* Morgan Kaufmann, 2004.

Weisstein, Eric. MathWorld. *http://mathworld.wolfram.com.*

Extensive online math resource.

Motion

Laybourne, Kit. *The Animation Book: A Complete Guide to Animated Filmmaking, From Flip-Books to Sound Cartoons to 3-D Animation.* Revised edition. Three Rivers Press, 1998.

General introduction to techniques of animation across many media.

Muybridge, Eadweard. *Animals in Motion.* Dover, 1957.

Sequential photographs revealing details of motion.

Peters, Keith. *ActionScript Animation: Making Things Move!* Friends of Ed, 2005.

Full of great algorithms for programming motion.

Russett, Robert, and Cecile Starr. *Experimental Animation: Origins of a New Art.* Da Capo Press, 1976.

Excellent text and visual documentation of pioneers of experimental animation.

Thomas, Frank, and Ollie Johnston. *Disney Animation: The Illusion of Life.* Abbeville Press, 1981.

In-depth introduction to principles of character animation.

Shape

Dondis, Donis A. *A Primer of Visual Literacy.* MIT Press, 1973.

Comprehensive introduction to basic elements and techniques of visual messages.

Hofmann, Armin. *Graphic Design Manual: Principles and Practice.* Van Nostrand Reinhold, 1965.

Elegant book from a master teacher-designer.

Itten, Johannes. *Design and Form: The Basic Course at the Bauhaus and Later.* Revised edition. John Wiley & Sons, 1975.

Moholy-Nagy, Laszlo. *Vision in Motion.* Paul Theobald, 1947.

Simulation

Boden, Margaret A., ed. *The Philosophy of Artificial Life*. Oxford University Press, 1996.

 Excellent collection of noteworthy essays.

Braitenberg, Valentino. *Vehicles: Experiments in Synthetic Psychology*. MIT Press, 1984.

 Playful text about imaginary vehicles and their relation to biology.

Flake, Gary William. *The Computational Beauty of Nature*. MIT Press, 1998.

Gardner, Martin. "Mathematical Games: The Fantastic Combinations of John Conway's New Solitaire Game 'Life.' "

 Scientific American 223 (October 1970): 120–123.

Kelly, Kevin. *Out of Control: The New Biology of Machines, Social Systems, and the Economic World*.

 Addison-Wesley, 1994.

Levy, Steven. *Artificial Life: The Quest for a New Creation*. Pantheon Books, 1992.

 Friendly introduction to AL, with vivid profiles of its founders.

Resnick, Mitchel. *Turtles, Termites, and Traffic Jams: Explorations in Massively Parallel Microworlds*.

 MIT Press, 1997.

 Documents ideas behind the StarLogo language for teaching children about decentralized systems.

Shiffman, Dan. *The Nature of Code*, 2012.

 The definitive book about simulation taught through Processing.

Sims, Karl. "Evolving Virtual Creatures." *Computer Graphics*. Proceedings of Siggraph '94, July 1994, pp. 15–22.

 Brief technical explanation of an important AL work.

Whitelaw, Mitchell. *Metacreation: Art and Artificial Life*. MIT Press, 2004.

Wolfram, Steven. *A New Kind of Science*. Wolfram Media, 2002.

Software data, control, structure

Flanagan, David. *Java in a Nutshell*. Fifth edition. O'Reilly Media, 2005.

Flanagan, David. *JavaScript: The Definitive Guide*. Fourth edition. O'Reilly Media, 2001.

Gamma, Erich, Richard Helm, Ralph Johnson, and John Vlissides. *Design Patterns: Elements of Reusable Object-*

 Oriented Software. Addison-Wesley Professional, 1995.

Kernighan, Brian, and Rob Pike. *The Practice of Programming*. Addison-Wesley, 1999.

 Includes techniques and advice for writing better software.

Kernighan, Brian, and Dennis Ritchie. *C Programming Language*. Second edition. Prentice Hall, 1998.

 Dense, canonical introduction to the C language.

Maeda, John. *Design by Numbers*. MIT Press, 2001.

 A fresh, clear introduction to core concepts of computer graphics and software.

Oualline, Steve. *Practical C++ Programming*. Second edition. O'Reilly Media, 2003.

Prata, Stephen. *C Primer Plus*. Fifth edition. Sams, 2004.

 Practical, well-written introduction to the C language.

Sun Microsystems. *The Java Tutorial: Learning the Java Language*. http://java.sun.com/docs/books/tutorial/java.

Taylor, David A. *Object Technology: A Manager's Guide*. Second edition. Addison-Wesley, 1998.

 Introduces object-oriented programming as a concept and defines its attributes and advantages.

Software culture and theory

Alexander, Amy, Olga Goriunove, Alex McLean, and Alexei Shulgin. Runme.org. *http://www.runme.org*.

 Eclectic online software art repository.

Fuller, Matthew. *Behind the Blip.* Autonomedia, 2003.

Galloway, Alexander R. *Protocol: How Control Exists after Decentralization.* MIT Press, 2004.

Gere, Charlie. *Digital Culture.* Reaktion Books, 2002.

Ludovico, Alessandro. *Neural* magazine and website. *www.neural.it.*

 Magazine and website featuring reviews and articles on the topics of new media art, electronic music, and hacktivism.

Maeda, John. *Creative Code: Aesthetics + Computation.* Thames & Hudson, 2004.

 Visual introduction to the work of the MIT Media Lab's Aesthetics and Computation Group.

Maeda, John. *Maeda@Media.* Thames & Hudson, 2000.

Manovich, Lev. *The Language of New Media.* MIT Press, 2001.

McCullough, Malcolm. *Abstracting Craft: The Practiced Digital Hand.* MIT Press, 1997.

 Thoughtful reflection on the nature of craft and production utilizing software.

Packer, Randall, and Ken Jordan, eds. *Multimedia from Wagner to Virtual Reality.* Norton, 2001.

Søndegaard, Morton. *Get Real: Art + Real-time: History, Practice, Theory.* George Braziller, 2005.

Wardrip-Fruin, Noah, and Nick Montfort. *The New Media Reader.* MIT Press, 2003.

 Extensive introduction to the origins and current practices of new media through essays, software, and video.

Typography

Blockland, Erik van, and Just van Rossum. *LettError.* Drukkerij Rosbeek, 2000.

Bringhurst, Robert. *The Elements of Typographic Style.* Version 3.0. Hartley & Marks, 2004.

 Impressive compendium of typographic history, conventions, and technologies.

Kunz, Willi. *Typography: Macro- and Micro Aesthetics.* Niggli, 1998.

Lupton, Ellen. *Thinking with Type: A Critical Guide for Designers, Writers, Editors, & Students.* Princeton Architectural Press, 2004.

 Compact, clear introduction to typography for designers, writers, editors, and students. Information online at www.thinkingwithtype.com.

Ruder, Emil. *Typography.* Niggli, 1967.

 Thorough introduction to the formal space of typographic exploration.

Weingart, Wolfgang. *My Way to Typography.* Lars Müller Publishers, 2000.

 Generously produced publication exposing the thoughts of a master of typography and form.

```
newy += sin(angle);

if(dist(ox, oy, newx, newy) > he        .8)
{
  newx = x = ox;
  newy = y = oy;
  angle = random(TWO_PI);
}

// Interpolate positions
float tempx = newx   x
  f(abs(tempx) > 1 0)

        mpx/10.0

   float                                                        mpy = newy
  f(abs(tempy) >   0)

  y    tempy/10.0;
}

over = 0;

// Check if overlapping each element
for(int i=id; i<others.length; i++)
{
  float dx = others[i].newx   new
  float dy   others[i].newy   new
  float radiusAdd   others[i]                 + cellradius
  float    ius Add y                 iusAd
  float diff       x  dy

  // If overlapping another element
    f(diff < (radiusAdd radiusAdd

    float rotationAngle   atan2( dy

    others[i] move( rotationAngle
       of rotationAngle + PI  inc

              oth ers[i]          hers[i].y);

                             he line if shorter than
             ike(r

            line( x  y  othe          others[i].y

            (diff   adiusAdd

}
}

if(over > 0)   // Turn if touching another
{
  float inc = over * ((1.0-(r/scalar)) / 6.0);
  angle += inc;
}
}
}
}
```

Glossary

This list defines programming terminology and redefines common words that are used differently within the context of software.

abstraction Refers to hiding details of a process to focus on the result. For example, the `line()` function abstracts the many lines of code necessary to draw a line to the screen, so the programmer can focus on the line's position.

additive color Color system for working with light. The additive primary colors red, green, and blue are combined to produce millions of variations. The absence of light is black, and adding the primaries together creates white.

AIFF (Audio Interchange File Format) Audio file format developed by Apple. Stores uncompressed data in pulse-code modulation (PCM) format.

algorithm A series of instructions that performs a mathematical task. Usually used to refer to a complicated bit of code that solves a problem like sorting a list or searching for text.

alpha The opacity component of a color value. By default, the value 255 makes a color entirely opaque, and 0 sets a color as entirely transparent.

antialiasing Minimizing the aliasing (jagged edges) within a low-resolution display to simulate a higher-resolution image.

API (application programming interface) A set of functions that comprises the way to use a programming system. The Processing API consists of commands like `line()` and `point()`, and is referred to as the Processing Language.

applet Java program that can run within a compatible web browser. Processing programs could be exported as applets prior to version 2.0.

array A list of data *elements* referenced with one name. Each element is accessed according to its order within the list.

ASCII (American Standard Code for Information Interchange) Code for associating the letters, numbers, and punctuation in the English language with numeric values. For example, *K* is 75 and *Y* is 89.

bit The most basic information unit in computing. Often represented as a 0 or 1.

block A group of code defined by matching braces, the { and } characters. Blocks are used to group code into classes, functions, `if` structures, and `for` loops.

bug An error within a program that causes a program to not run or to behave differently from what is intended by the programmer.

byte A byte is a group of 8 bits.

class A template defining a related group of fields and methods. Classes are the building blocks of object-oriented programming. An object is an instance of a class.

color depth Number of bits used to define a color. An 8-bit number can be values between 0 and 255 (2^8). A 4-bit number can be values between 0 and 15 (2^4).

compile To translate source code into executable software. When a Processing program is run, it is translated from code notation into a notation that can be run by a computer. This is called compilation.

data type The category of data that can be stored within a variable. For example, individual letters can be stored in variable of the `char` data type and whole numbers can be stored in variables of the `int` data type.

debug To remove errors from a program.

delimit To separate elements of data within a file. For example, a tab-delimited file separates data with the tab character.

dot operator The period character (.). Fields and methods of a class are accessed with the dot operator.

dpi (dots per inch) A measurement of printing resolution. A higher DPI printer can produce clearer images of higher resolution.

encapsulation Technique of hiding the data and the functions that operate on the data within a class. A class can be thought of as a black box, where the implementation within the class is less of a focus than how the class is used. The internal code of a class can be changed, while the way it interacts with other elements of the program can remain unchanged. Related to *abstraction*.

escape sequence A means of specifying unprintable characters (such as Tab or Enter) or quotes inside a String constant (which is defined using quote characters). Inside text, the combination of the \ (backslash) character with another character. The backslash begins the escape sequence and the second character defines the meaning. For example, the sequence \t is a tab.

event An action such as a key being pressed, the mouse moving, or a new piece of data becoming available to be read. An event interrupts the normal flow of a program to run the code within an event block.

expression A combination of operators, variables, and literals. An expression always has a value, determined by its elements. For example, the expression 6/2 evaluates to 3 and the expression 5>4 evaluates to true. An expression can be as simple as a single number or can contain a long sequence of elements.

field A variable defined within a class.

file A collection of data referenced as a unit.

file format A specific way to store data within a computer file. There are different formats for storing images, sound, text, etc.

function A modular program unit within a large program. Functions have parameters to define their actions and can return values. In other programming languages functions may be called subroutines or procedures. A *method* is a function that belongs to a class.

function prototype Defines the parameters (inputs) for a function and their data types.

GIF (Graphics Interchange Format) Image file format commonly used for displaying graphics on the web. The format supports compression, multiple color depths, and 1-bit transparency.

GUI (graphical user interface) Computer interface in which users control the machine by manipulating visual icons.

hex Abbreviation for hexadecimal.

hexadecimal Base-16 number system utilizing the symbols 0–9 and A–F. In Processing, a hexadecimal value is prefaced with a # or 0x. Hexadecimal notation is often used to define color values. For example, the RGB color value (0,102,153) is converted to hexadecimal notation as #006699.

HSB (hue, saturation, brightness) Color model that defines a value through the quantities of hue (color), saturation (intensity), and brightness (light or dark). HSB is a more intuitive model than RGB.

IDE (integrated development environment) Software that assists people in the activity of programming. An IDE usually has a text editor, a compiler and/or interpreter, and a debugger. The Processing IDE is called the Processing Development Environment (PDE) or the Processing Environment.

inheritance A property of the relationship between classes and their sub- and superclasses. A class automatically contains the fields and methods defined in its superclass. If a class is a subclass of another, it inherits these components of that class.

instance An object of a particular class. For example, in code 25-03 (p. 364), the sp object is an instance of the Spot class. An instance is created with the new keyword.

instance variable A variable created when an object is instantiated from a class. Each object has its own instance of each variable defined in the class template.

JAR (Java ARchive) File format for grouping Java classes into a single unit. These files can be opened with any program that can open a ZIP file.

JPEG (Joint Photographic Experts Group) Image format that compresses photographic images well. Common format for display on the World Wide Web. These files use the .jpg extension.

keyword A word used by a programming language. This word cannot be used for names of variables or functions.

memory A computer component that stores data. RAM (random access memory) is fast, but data is only stored there temporarily while a computer is on. Memory is stored more permanently on hard drives, either as rotating magnetic disks or flash memory that can be electrically erased and rewritten.

method A function defined within a class.

new Used to create a new instance of an object. For example: sp = new Spot() (p. 363)

null Specifies an undefined value. An object variable that has not been assigned contains null. Null can also be assigned to a variable to set it empty.

OBJ File format for defining 3D geometry, first created by Wavefront Technologies.

object An instance of a class. All objects created from one class have the same field names and methods, but the variables of each can contain different data.

operand Data that is operated on by an operator. The operands in the expression 4+5 are the numbers 4 and 5.

operator A symbol that performs an operation. The *, =, +, %, >, and ! symbols are all operators. Processing has arithmetic, relational, logical, and bitwise operators.

packet A block of formatted information transferred over a computer network. A packet has a header, data, and a trailer. Large pieces of data are broken down into multiple packets, each sent over the network separately and reassembled when they arrive at their destination.

parameter Data input to a function that affects the output. For example, the point() function can have two or three parameters to set the *x*, *y*, and *z* coordinates. The prototype for a function shows the number and data types of the parameters for a function.

PDE (Processing Development Environment) The Processing application, including the text editor, menu, toolbar, message area, and tabs. PDE is also the name of the Processing file format (*.pde*).

pixel One color element (picture element) on a computer monitor or of a digital image.

PNG (Portable Network Graphics) Highly flexible image file format capable of variable levels of transparency. Developed as a successor to GIF.

PPI (pixels per inch) The pixel density of a computer screen.

radian Angle measurement in relation to π. The measurement of π is equivalent to 180 degrees, and 2π is equivalent to 360 degrees. The π symbol is represented within Processing as the constant PI.

relational expression An expression comprising a relational operator and values to its left and right. A relational expression always evaluates to true or false. For example, the expression 4<5 evaluates to true, and 4>5 evaluates to false.

relational operator An operator such as > (greater than), < (less than), and != (not equal to) that determines the relation between the values to the left and right of the symbol.

return Used within a function to note the value that is returned as its result. The return statement is typically the last line of code in a function.

RGB (red, green, blue) Color model that defines a spectrum of colors in terms of their red, green, and blue components. RGB is the default color system used in Processing. It is considered less intuitive than HSB color because RGB is based on technical rather than perceptual attributes.

scope The region of a program where a variable can be accessed. A variable can be accessed within the block where it is defined and in all blocks defined within its block.

sketch Refers to a program written with Processing. Because Processing programs are intended to be written quickly and casually, they are often referred to as software sketches.

stack A data structure that stores elements in order so that they can be added and removed only from the top. Data is pushed (saved to the stack) and popped (removed from the top of the stack). The Processing functions `pushMatrix()` and `popMatrix()` perform this operation on the stack that controls the position, scaling, and rotation of the coordinate system.

statement A complete instruction to the computer. Statements are the primary building blocks of a program. A statement can define a variable, assign a variable, run a function, or construct an object. A statement always has a semicolon at the end.

statement terminator The semicolon symbol. Marks the end of a statement.

subclass A class derived from another (its superclass). A subclass inherits the template of its superclass.

super A keyword used within a subclass to refer to its superclass.

superclass A class from which another class is derived.

SVG (Scalable Vector Graphics) An open standard file format used to define 2D vector graphics. The file is formatted as XML and can therefore be read and edited in a text editor.

TARGA Image file format that can store images without compression and with varying levels of transparency. These files use the *.tga* extension.

this A reference to the current object; also used within an object to refer to itself. For example, if a variable *x* is referred to within its own object, the code `this.x` can be used.

TIFF (Tagged Image File Format) Image file format used to store high-quality images without compression. These files use the *.tif* extension.

variable A data element that is referenced with a name. Every variable has a value, data type, and scope.

vertex A point that terminates, lies at the intersection of, or defines the shape of a line or curve.

VLW The Processing font format. The VLW (Visual Language Workshop) was a research group at the MIT Media Laboratory from 1985 to 1996. The researchers created the font format to display anti-aliased typography in 3D. Because of its usefulness in interactive graphics, it was made part of Processing and named VLW in reference to its origin.

void Used in a function declaration to state that the function does not return a value (does not output data).

WAV Audio file format developed by Microsoft and IBM. Stores uncompressed data in pulse-code modulation (PCM) format.

XML (eXtensible Markup Language) Data formatting standard that is easy to read and customize.

Code Index

This index contains all of the Processing language elements introduced within this book. The page numbers refer to the first use.

Index

This index contains mostly people, software, artwork, and programming languages. For topics, see the table of contents; for code, see the Code Index.